The
Digital
Photography

The step-by-step secrets for how to
make your photos look like the pros'!

Book

VOLUME 1

Scott Kelby

The Digital Photography Book, volume 1

The Digital Photography Book, volume 1 Team

CREATIVE DIRECTOR
Felix Nelson

TECHNICAL EDITORS
Kim Doty
Cindy Snyder

EDITORIAL CONSULTANT
Bill Fortney

TRAFFIC DIRECTOR
Kim Gabriel

PRODUCTION MANAGER
Dave Damstra

GRAPHIC DESIGN
Jessica Maldonado

COVER DESIGNED BY
Scott Kelby

STUDIO SHOTS
Dave Gales
Brad Moore

PUBLISHED BY
Peachpit Press

©2007, 2009 Scott Kelby

FIRST EDITION: August 2006

Composed in Myriad Pro (Adobe Systems Incorporated) and Lucida Grande (Bigelow & Holmes Inc.) by Kelby Media Group Inc.

Trademarks
All terms mentioned in this book that are known to be trademarks or service marks have been appropriately capitalized. Peachpit Press cannot attest to the accuracy of this information. Use of a term in the book should not be regarded as affecting the validity of any trademark or service mark.

Photoshop and Lightroom are registered trademarks of Adobe Systems, Inc.
Nikon is a registered trademark of Nikon Corporation.
Canon is a registered trademark of Canon Inc.

Warning and Disclaimer
This book is designed to provide information about digital photography. Every effort has been made to make this book as complete and as accurate as possible, but no warranty of fitness is implied.

The information is provided on an as-is basis. The author and Peachpit Press shall have neither the liability nor responsibility to any person or entity with respect to any loss or damages arising from the information contained in this book or from the use of the discs or programs that may accompany it.

ISBN 10: 0-321-47404-X
ISBN 13: 978-0-321-47404-9

26

Printed and bound in the United States of America

www.peachpit.com
www.kelbytraining.com

Dedicated to the amazing
Dr. Stephanie Van Zandt
for her excellent advice, for taking
such good care of my wife, and
for delivering the sweetest
little baby girl in the whole world.

Acknowledgments

Although only one name appears on the spine of this book, it takes a team of dedicated and talented people to pull a project like this together. I'm not only delighted to be working with them, but I also get the honor and privilege of thanking them here.

This is my 37th book, and in each book I write, I always start by thanking my amazing, wonderful, beautiful, hilarious, and absolutely brilliant wife Kalebra. She probably stopped reading these acknowledgments 20 or more books ago because I keep gushing on and on about her, and despite how amazingly beautiful, charming, and captivating she is, she's a very humble person (which makes her even more beautiful). And even though I know she probably won't read this, I just have to thank her anyway because not only could I not do any of this without her, I simply wouldn't want to. She's just "it." It's her voice, her touch, her smile, her heart, her generosity, her compassion, her sense of humor, and the way she sneaks around behind the scenes trying to make sure my life is that much better, that much more fun, that much more fulfilling, and you just have to adore someone like that. She is the type of woman love songs are written for, and as any of my friends will gladly attest—I am, without a doubt, the luckiest man alive to have her as my wife. I love you madly, sweetheart!

I also want to thank my crazy, fun-filled, wonderful little eleven-year-old boy Jordan. He won't read this either, because as he says, "It embarrasses him." And since I know he won't read it (or even let me read it to him), I can safely gush about him, too. Dude, you rock! You are about the coolest little boy any dad could ask for—you love *Star Wars* (and our lightsaber battles in the kitchen), you dig Bon Jovi, you're always up for a game of golf, you love to go to the movies with me, and you get as excited about life as I do. You are nothing but a joy, I'm so thrilled to be your dad, and you're a great big brother to your little sister. I am very, very proud of you little buddy.

I also want to thank my beautiful daughter Kira, who is the best-natured, happiest little girl in the whole wide world. You're only three years old, but you're already reflecting your mom's sweet nature, her beautiful smile, and her loving heart. You're too young to know what an amazing mother you have, but before long, just like your brother, you'll realize that your mom is someone very special, and that thanks to her you're in for a really fun, exciting, hug-filled, and adventure-filled life. Also, thanks to my big brother Jeff. Brothers don't get much better than you, and that's why Dad was always so proud of you. You are truly one of the "good guys" and I'm very, very lucky to have you in my life.

Special thanks to my home team at Kelby Media Group. I love working with you guys and you make coming into work an awful lot of fun for me. I'm so proud of what you all do—how you come together to hit our sometimes impossible deadlines, and as always, you do it with class, poise, and a can-do attitude that is truly inspiring. I'm honored to be working with you all.

Thanks to my layout and production crew. In particular, I want to thank my friend and Creative Director Felix Nelson (creator of all things that look cool). Thanks to my in-house editors Kim Doty and Cindy Snyder, who put the techniques through rigorous testing and tried to stop me from slipping any of my famous typos past the goalie. Also, thanks to Dave Damstra and his amazing crew for giving the book such a tight, clean layout.

My personal thanks to my buddy and fellow photographer Brad Moore, who shot most of the product shots for this edition of the book. Also, thanks to my friend Dave Gales who shot the initial product shots for the original edition of the book.

Thanks to my best buddy Dave Moser, whose tireless dedication to creating a quality product makes every project we do better than the last. Thanks to Jean A. Kendra for her steadfast support, and an extra special thanks to my Executive Assistant Kathy Siler for keeping everything running smoothly while I'm out traveling and writing books. You are, without a doubt, the best!

Thanks to my publisher Nancy Aldrich-Ruenzel, marketing maverick Scott Cowlin, production hound Ted Waitt, and the incredibly dedicated team at Peachpit Press. It's a real honor to get to work with people who really just want to make great books. Also, my personal thanks to Patrick Lor at iStockphoto.com for enabling me to use some of their wonderful photography in this book.

I owe a special debt of gratitude to my good friend Bill Fortney for agreeing to give the book a good "once over" and it's infinitely better because of his comments, ideas, and input. Bill is just an amazing individual, a world-class photographer, a testament to how to live one's life, and I'm truly honored to have gotten the chance to work with someone of his caliber, integrity, and faith.

I want to thank all the talented and gifted photographers who've taught me so much over the years, including Moose Peterson, Vincent Versace, Bill Fortney, David Ziser, Jim DiVitale, Helene Glassman, George Lepp, and Eddie Tapp.

Thanks to my mentors whose wisdom and whip-cracking have helped me immeasurably, including John Graden, Jack Lee, Dave Gales, Judy Farmer, and Douglas Poole.

Most importantly, I want to thank God, and His son Jesus Christ, for leading me to the woman of my dreams, for blessing us with such a special little boy and an amazing little girl, for allowing me to make a living doing something I truly love, for always being there when I need Him, for blessing me with a wonderful, fulfilling, and happy life, and such a warm, loving family to share it with.

Other Books By Scott Kelby

The Photoshop CS4 Book for Digital Photographers

Photoshop Down & Dirty Tricks

Photoshop CS2 Killer Tips

The Photoshop Channels Book

Photoshop Classic Effects

The Digital Photography Book, volume 2

The iPhone Book

The iPod Book

The Adobe Photoshop Lightroom 2 Book for Digital Photographers

InDesign CS/CS2 Killer Tips

The Mac OS X Leopard Book

Mac OS X Leopard Killer Tips

Getting Started with Your Mac and Mac OS X Tiger

About the Author

Scott Kelby

Scott is Editor and Publisher of *Photoshop User* magazine, Editor and Publisher of *Layers* magazine (the how-to magazine for everything Adobe), and co-host of the popular weekly video show *Photoshop® User TV*.

Scott is President and co-founder of the National Association of Photoshop Professionals (NAPP) and is President of the software training, education, and publishing firm Kelby Media Group.

Scott is a photographer, designer, and an award-winning author of more than 50 books, including *The Photoshop Book for Digital Photographers*, *Photoshop Down & Dirty Tricks*, *The Photoshop Channels Book*, *Photoshop Classic Effects*, *The iPod Book*, and is Series Editor for the *Killer Tips* book series from New Riders.

Scott's books have been translated into dozens of different languages, including Russian, Chinese, French, Dutch, Korean, Spanish, Polish, Czechoslovakian, Greek, German, Japanese, Italian, and Swedish, among others.

For four years straight, Scott has been awarded the distinction of being the world's #1 best-selling author of all computer and technology books, across all categories.

Scott is Training Director for the Adobe Photoshop Seminar Tour and Conference Technical Chair for the Photoshop World Conference & Expo. He's featured in a series of Adobe Photoshop training DVDs and has been training Adobe Photoshop users since 1993.

For more information on Scott, visit www.scottkelby.com.

Table of Contents

Table of Contents

Table of Contents

Table of Contents

Table of Contents

Table of Contents

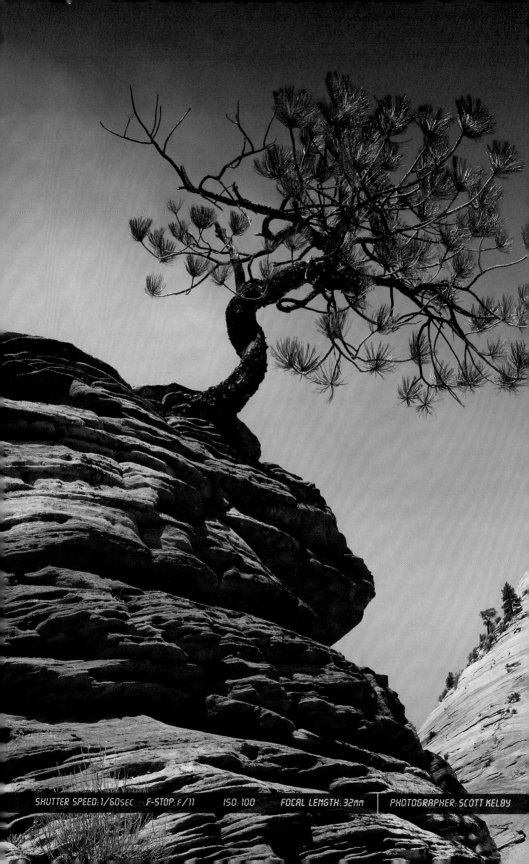

SHUTTER SPEED: 1/60SEC F-STOP: F/11 ISO: 100 FOCAL LENGTH: 32mm PHOTOGRAPHER: SCOTT KELBY

Chapter One

Pro Tips for Getting Really Sharp Photos

If Your Photos Aren't Sharp, the Rest Doesn't Matter

Having photos that are sharp and in focus is so vitally important to pro photographers that they actually have coined a term for them. They call them "tack sharp." When I first heard that term tossed around years ago, I naturally assumed that it was derived from the old phrase "sharp as a tack," but once I began writing this book and doing some serious research into its history, I was shocked and surprised at what I found. First of all, it's not based on the "sharp as a tack" phrase at all. Tack sharp is actually an acronym. TACK stands for Technically Accurate Cibachrome Kelvin (which refers to the color temperature of light in photographs), and SHARP stands for Shutter Hyperfocal At Refracted Polarization. Now, these may seem like highly technical terms at first, but once you realize that I totally made them up, it doesn't seem so complicated, does it? Now, you have to admit, it sounded pretty legitimate at first. I mean, I almost had ya, didn't I? Come on, you know I had you, and I'll bet it was that "color temperature of light" thing I put in parenthesis that helped sell the idea that it was real, right? It's okay to admit you were fooled, just like it's okay to admit that you've taken photos in the past that weren't tack sharp (just in case you were wondering, the term "tack sharp" is actually formed from the Latin phrase *tantus saeta equina* which means "there's horsehair in my tantus"). Anyway, what's really important at this point is whatever you do, keep your spotted palomino away from anything with a sharp, pointy end used to attach paper to a bulletin board. That's all I'm saying.

The Real Secret to Getting Sharp Photos

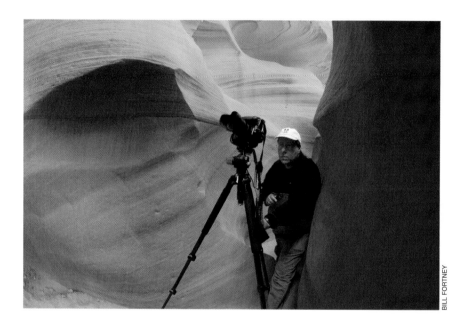

BILL FORTNEY

Hey, before we get to "The Real Secret to Getting Sharp Photos," I need to let you in on a few quick things that will help you big time in getting the most from this book (sorry about duping you with "The Real Secret to Getting Sharp Photos" headline, but don't worry—that subject and more are coming right up, but first I have to make sure you totally understand how this book works. Then it will all make sense and we can worry about sharp photos). The idea is simple: You and I are out on a photo shoot. While we're out shooting, you have lots of questions, and I'm going to answer them here in the book just like I would in real life—straight and to the point, without teaching you all the technical aspects and behind-the-scenes technology of digital photography. For example, if we were out shooting and you turned to me and said, "Hey Scott, I want to take a shot where that flower over there is in focus, but the background is out of focus. How do I do that?" I wouldn't turn to you and give you a speech about smaller and larger apertures, about how exposure equals shutter speed plus aperture, or any of that stuff you can read in any book about digital photography (and I mean any book—it's in every one). In real life, I'd just turn to you and say, "Put on your zoom lens, set your aperture at f/2.8, focus on the flower, and fire away." That's how this book works. Basically, it's you and me out shooting, and I'm giving you the same tips, the same advice, and the same techniques I've learned over the years from some of the top working pros, but I'm giving it to you in plain English, just like I would in person, to a friend.

The Other Most Important Secret

Again, ignore that headline. It's just a cheap come-on to get you to keep reading. Anyway, that's the scoop. Now, here's another important thing you need to know: To get the kind of quality photos I think you're looking for, sometimes it takes more than changing an adjustment in the camera or changing the way you shoot. Sometimes, you have to buy the stuff the pros use to shoot like a pro. I don't mean you need to buy a new digital camera, but instead, some accessories that the pros use in the field every day. I learned a long time ago that in many fields, like sports for example, the equipment doesn't really make that big a difference. For example, go to Wal-Mart, buy the cheapest set of golf clubs you can, hand them to Tiger Woods, and he's still Tiger Woods—shooting 12 under par on a bad day. However, I've never seen a field where the equipment makes as big a difference as it does in photography. Don't get me wrong, hand Jay Maisel a point-and-shoot camera and he'll take point-and-shoot shots that could hang in a gallery, but the problem is we're not as good as Jay Maisel. So, to level the playing field, sometimes we have to buy accessories (crutches) to make up for the fact that we're not Jay Maisel. Now, I don't get a kickback, bonus, or anything from any of the companies whose products I recommend. I'm giving you the same advice I'd give you if we were out shooting (which is the whole theme behind this book). This is *not* a book to sell you stuff, but before you move forward, understand that to get pro results sometimes you have to use (and that means buy) what the pros use.

Perhaps Even More Important Than That!

Still a fake headline. Don't let it throw you. Now, although we want pro-quality photos, we don't all have budgets like the pros, so when possible, I break my suggestions down into three categories:

 I'm on a budget. These are denoted with this symbol. It simply means you're not loose with money (meaning you're probably married and have kids).

 I can swing it. If you see this symbol, it means photography is your passion and you don't mind if your kids have to work a part-time job once they get to college to buy books. So you're willing to spend to have some better-than-average equipment.

 If you see this symbol, it means you don't really have a budget (you're a doctor, lawyer, venture capitalist, U.S. Senator, etc.), so I'll just tell you which one I would buy if I was one of those rich bas*%$#s. (Kidding. Kind of.)

To make things easy, I put up a webpage at www.scottkelbybooks.com/gearguide with direct links to these goodies if you're so inclined. Again, I don't get a red cent if you use these links or buy this stuff, but I don't mind because I made such a killing on you buying this book. Again, I kid. Now, where do these links actually go? (See next page.)

If You Skip This, Throw Away Your Camera

Hey, how do you like that grabber of a headline? Sweet! Totally a scam, but sweet none-theless. Now, those links on the webpage lead to one of two places: (1) to the individual manufacturer who sells the product, if they only sell direct, or (2) to B&H Photo's website. So, why B&H? Because I trust them. I've been buying all my personal camera gear from them for years (so do all my friends, and most of the pros I know) and since you're now going to be one of my shooting buddies, this is where I would tell you to go without a doubt. There are three things I like about B&H, and why they have become something of a legend among pro photographers: (1) They carry just about every darn thing you can think of, no matter how small or insignificant it may seem. Lose your Nikon brand lens cap? They've got 'em in every size. Lose your neck strap with Canon stitched on it? They've got them too. Lose that tiny little cap that covers the input for your remote shut-ter release? They've got it. (2) When you call them, you talk to a real photographer, and my experience is that they give you the real straight scoop on what to buy. I've called up with something in mind, and have had their reps tell me about something better that's cheaper. That's rare these days. And finally (3), their prices are very, very competitive (to say the least). If you're ever in New York City, make it a point to drop by their store. It is absolutely amazing. It's like Disneyland for photographers. I could spend a day there (and I have). Anyway, they're good people. Now, does the headline scam thing continue on the next page? You betcha.

If You Do This Wrong, It Will Lock Up

It's not as good as the last fake headline, but we're only one more page away from the real chapter content, so I'm backing it off a little. Now, once you turn the page you'll notice lots of photos of Nikon and Canon cameras, and it might make you think that I'm partial to these two brands. It's not just me. Apparently most of the world is partial to these two brands, so you'll see lots of shots of them (mostly the Nikon D90 and the Canon 50D—two incredible digital cameras for the money, and ones which many working pros use). Now, what if you don't shoot with a Nikon or Canon camera? No sweat—most of the techniques in this book apply to any digital SLR camera, and many of the point-and-shoot digital cameras as well, so if you're shooting with a Sony or an Olympus or a Sigma, don't let it throw you that a Nikon or Canon is pictured. This book is about taking dramatically better photos—not about how to set up your Nikon or Canon, even though since most people are shooting with one or the other, I usually show one or the other camera or menus. So, if I'm talking about white balance, and I'm showing the Canon white balance menu, but you're not shooting with a Canon, simply breathe deeply and say to yourself, "It's okay, my [insert your camera name here] also has a white balance setting and it works pretty much like this one." Remember, it's about choosing the right white balance, not exactly which buttons to push on your camera, because if we were really out shooting together, we might not have the same brand of camera.

It's Time to Get Serious

I have good news: Not only are we at the end of this "fake headline" thing, you'll also be happy to know that from here on out, the rest of the book isn't laced with the wonderfully inspired (lame) humor you found on these first few pages. Well, the intro page to each chapter has more of this stuff, but it's only one page and it goes by pretty quickly. My books have always had "enlightened" chapter intros (meaning I wrote them when I was plastered) and the chapter names are usually based on movies, song names, or band names (the actual chapter name appears below the fake chapter name). The other reason I do it is because I need a chance to write something that doesn't use any of the terms shutter, aperture, or tripod. In a book like this, there's not much room to interject personality (if you want to call it that), and since the rest of the book is me telling you just what you need to know, there's little time for my brand of humor. In fact, in life there's little time for my brand of humor, so I sneak it in there. I have so little. Anyway, as you turn the page, keep this in mind: I'm telling you these tips just like I'd tell a shooting buddy, and that means oftentimes it's just which button to push, which setting to change, and not a whole lot of reasons why. I figure that once you start getting amazing results from your camera, you'll go out and buy one of those "tell me all about it" digital camera books (see page 192 for some suggestions). In all seriousness, I truly hope this book ignites your passion for photography by giving you some insight into how the pros get those amazing shots, and showing you how to get results you always hoped you'd get from your digital photography. Now pack up your gear, it's time to head out for our shoot.

Getting "Tack Sharp" Starts with a Tripod

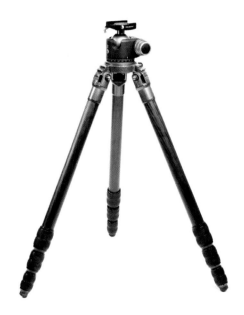

There's not just one trick that will give you the sharp photos the pros get—it's a combination of things that all come together to give you "tack sharp" shots. (Tack sharp is the term pro photographers use to describe the ultimate level of sharpness. Sadly, we aren't the best at coming up with highly imaginative names for things.) So, while there are a number of things you'll need to do to get tack-sharp photos, the most important is shooting on a tripod. In fact, if there's one single thing that really separates the pros from the amateurs, it's that the pros always shoot on a tripod (even in daylight). Yes, it's more work, but it's the key ingredient that amateurs miss. Pros will do the little things that most amateurs aren't willing to do; that's part of the reason their photos look like they do. Keeping the camera still and steady is a tripod's only job, but when it comes to tripods, some do a lot better job than others. That's why you don't want to skimp on quality. You'll hear pros talking about this again and again, because cheap tripods simply don't do a great job of keeping your camera that steady. That's why they're cheap.

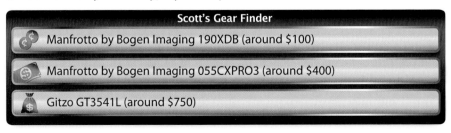

Scott's Gear Finder

Manfrotto by Bogen Imaging 190XDB (around $100)

Manfrotto by Bogen Imaging 055CXPRO3 (around $400)

Gitzo GT3541L (around $750)

A Ballhead Will Make Your Life Easier

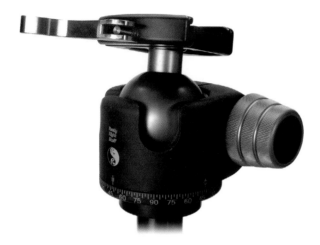

Here's the thing: when you buy a pro-quality tripod, you get just the tripod. It doesn't come with a tripod head affixed like the cheap-o tripods do, so you'll have to buy one separately (by the way, this ballhead thing isn't necessarily about getting sharp images, but it is about keeping your sanity, so I thought I'd better throw it in). Ballheads are wonderful because with just one knob they let you quickly and easily aim and position your camera accurately at any angle (which you'll find is a huge advantage). Best of all, good ballheads keep your camera locked down tight to keep your camera from "creeping" (slowly sliding one way or the other) after you've set up your shot. Like tripods, a good ballhead isn't cheap, but if you buy a good one, you'll fall in love with it.

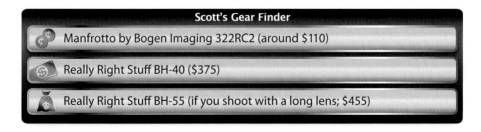

Scott's Gear Finder

Manfrotto by Bogen Imaging 322RC2 (around $110)

Really Right Stuff BH-40 ($375)

Really Right Stuff BH-55 (if you shoot with a long lens; $455)

Don't Press the Shutter (Use a Cable Release)

Okay, so now you're lugging around a tripod, but your photos are looking much sharper. Not tack sharp yet, but much sharper. What will take you to the next level of sharpness? A cable release. This is simply a cable that attaches to your digital camera (well, to most semi-pro or high-end consumer dSLRs anyway) and it has a button on the end of it. That way, when you press this button on the end of the cable, it takes the photo, but without you actually touching the shutter button on the camera itself. So, why is this such a big deal? It's because, believe it or not, when you press the shutter button on the camera, it makes the camera move just enough to keep your photos from being tack sharp. I know, it sounds like a little thing, but this one is bigger than it sounds. Using it is easier than you might think, and these days most cameras support wireless remotes too, and they're fairly inexpensive as well. Now your photos are just that much sharper.

Forgot Your Cable Release? Use a Self Timer

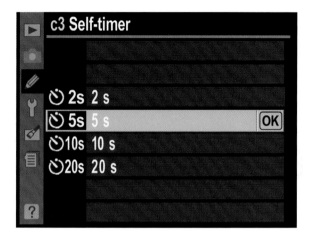

If you don't want to spring for a cable release (or wireless remote), or if you're out shooting and forgot yours (which has happened to me on numerous occasions), then the next best thing is to use your digital camera's built-in self timer. I know, you normally think of using this so you can run and get in the shot real quick, but think about it—what does the self timer do? It takes the shot without you touching the camera, right? Right! So, it pretty much does the same job of keeping your camera from moving—you just have to wait about 10 seconds. If you hate waiting (I sure do), then see if your camera allows you to change the amount of time it waits before it shoots. I've lowered mine to just five seconds (see the Nikon menu above). I press the shutter button and then five seconds later, the shot fires (I figure that five seconds is enough time for any movement caused by my pressing the shutter release to subside).

A Better Cable Release

If you're thinking of getting a cable release to reduce vibration, you're better off getting an electronic cable release rather than one that actually presses the shutter button with a plunger-style wire. Because, even though it's better than you pressing the button with your big ol' stubby vibration-causing finger, it doesn't compare with an electronic (or wireless) version that doesn't touch the camera at all.

Getting Super Sharp: Locking the Mirror

Nikon

Canon

All right, we're starting to get a bit obsessed with camera shake, but that's what this chapter is all about—removing any movement so we get nothing but the sharpest, cleanest photo possible. The next feature we're going to employ is called Exposure Delay Mode on a Nikon or Mirror Lockup on a Canon. What this essentially does is locks your camera's mirror in the up position, so when you take the shot, the mirror does not move until after the exposure is made—limiting the movement inside your camera during the exposure, and therefore giving you that much sharper a photo. How much does this matter? It's probably second only to using a solid tripod! So, you'll need to find out where the mirror lock-up control is for your camera (most of today's dSLR cameras have this feature because you also use this to clean your sensor). Once you set your camera to mirror lock-up, on a Nikon you now have to press the shutter release button (on your remote or cable release) once; on a Canon you have to press it twice—once to lift the mirror, and then a second time to actually take the shot. Now, this technique sounds a bit nitpicky. Does it make that big a difference? By itself, no. But add this to everything else, and it's another step toward that tack sharp nirvana.

Turn Off Vibration Reduction (or IS)

The big rage in digital lenses these days are the Vibration Reduction (VR) lens from Nikon and the Image Stabilization (IS) lens from Canon, which help you get sharper images while hand-holding your camera in low-light situations. Basically, they let you hand-hold in more low-light situations by stabilizing the movement of your lens when your shutter is open longer, and honestly, they work wonders for those instances where you can't work on a tripod (like weddings, some sporting events, when you're shooting in a city, or just places where they simply won't let you set up a tripod). If you're in one of those situations, I highly recommend these VR or IS lenses, but depending on which one you use, there are some rules about when you should turn them off. For example, we'll start with Nikon. If you are shooting on a tripod with a Nikon VR lens, to get sharper images turn the VR feature off (you do this right on the lens itself by turning the VR switch to the Off position). The non-technical explanation why is, these VR lenses look for vibration. If they don't find any, they'll go looking for it, and that looking for vibration when there is absolutely none can cause (you guessed it) some small vibration. So just follow this simple rule: When you're hand-holding, turn VR or IS on. When you're shooting on a tripod, for the sharpest images possible, turn VR or IS off. Now, there are some Nikon VR lenses and some older Canon IS lenses that can be used on a tripod with VR or IS turned on. So, be sure to check the documentation that came with your VR or IS lens to see if yours needs to be turned off.

Shoot at Your Lens' Sharpest Aperture

SCOTT KELBY

Another trick the pros use is, when possible, shoot at your lens' sharpest aperture. For most lenses, that is about two full stops smaller than wide open (so the f-stop number you use will go higher by two stops). For example, if you had an f/2.8 lens, the sharpest apertures for that lens would be f/5.6 and f/8 (two full stops down from 2.8). Of course, you can't always choose these apertures, but if you're in a situation where you can (and we'll talk about this later in the book), then shooting two stops down from wide open will usually give you the sharpest image your lens can deliver. Now, that being said, this isn't true for all lenses, and if that's not the case with your lens, you'll find your lens' sweet spot (its sharpest aperture) in short order if you keep an eye out for which aperture your sharpest images seem to come from. You can do that by looking at your photos' EXIF data (the background information on your shots embedded by your digital camera into the photos themselves) in Photoshop by going under Photoshop's File menu and choosing File Info. Then click on Camera Data. It will show the aperture your shot was taken at. If you find most of your sharpest shots are taken with a particular aperture, then you've found your sweet spot. However, don't let this override the most important reason you choose a particular aperture, and that is to give you the depth of field you need for a particular shot. But it's just nice to know which f-stop to choose when your main concern is sharpness, not controlling depth of field.

Good Glass Makes a Big Difference

Does buying a really good lens make that big a difference in sharpness? Absolutely! A few weeks back I went shooting with a friend in Zion National Park in Utah. He had just bought a brand new Canon EF 24–70mm f/2.8L, which is a tack-sharp lens. It's not cheap, but like anything else in photography (and in life), the really good stuff costs more. His other lens was a fairly inexpensive telephoto zoom he had been using for a few years. Once he saw the difference in sharpness between his new, good quality lens and his cheap lens, he refused to shoot with the telephoto again. He had been shooting with it for years, and in one day, after seeing what a difference a really sharp lens made, he wouldn't shoot with his old lens again. So, if you're thinking of buying a zoom lens for $295, sharpness clearly isn't your biggest priority. A quality lens is an investment, and as long as you take decent care of it, it will give you crystal clear photos that inexpensive lenses just can't deliver.

Scott's Pro-Speak TRANSLATOR

When talking about the quality of lenses, we don't use the word "lens." It's too obvious. Instead, we say stuff like, "Hey, Joe's got some really good glass," or, "He needs to invest in some good glass," etc. Try this the next time you're at the local camera store, and see if the guy behind the counter doesn't get that "you're in the club" twinkle in his eye.

Avoid Increasing Your ISO, Even in Dim Light

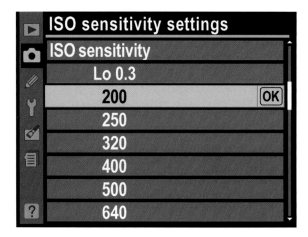

When you're shooting on a tripod in dim or low light, don't increase your ISO (your digital equivalent of film speed). Keep your ISO at the lowest ISO setting your camera allows (ISO 200, 100, or 50, if your camera's ISO goes that low, as shown on the Nikon menu above) for the sharpest, cleanest photos. Raising the ISO adds noise to your photos, and you don't want that (of course, if you're hand-holding and have no choice, like when shooting a wedding in the low lighting of a church, then increasing the ISO is a necessity, but when shooting on a tripod, avoid high ISOs like the plague—you'll have cleaner, sharper images every time).

So what do you do if you can't use a tripod (i.e., the place where you're shooting won't allow tripods)? In this case, if there's plenty of light where you're shooting, you can try using very fast shutter speeds to minimize hand-held camera shake. Set your camera to shutter priority mode and choose a speed that matches or exceeds the focal length of your lens (a 180mm lens means you'll shoot at 1/200 of a second).

Zoom In to Check Sharpness

Canon

Nikon

Here's a sad fact of digital photography—everything looks sharp and in focus when you first look at the tiny LCD screen on the back of your digital camera. When your photo is displayed at that small size, it just about always looks sharp. However, you'll soon learn (once you open your photo on your computer) that you absolutely can't trust that tiny little screen—you've got to zoom in and check the sharpness. On the back of your camera there's a zoom button that lets you zoom in close and see if the photo is really in focus. Do this right on the spot—right after you take the shot, so you still have a chance to retake the photo if you zoom in and find out it's blurry. The pros always check for sharpness this way, because they've been burned one too many times.

Custom Quick Zoom Settings

Some of today's digital SLR cameras have a quick zoom option, where you can set a particular amount you want your zoom to zoom in to. Check your owner's manual to see if your digital camera has a custom quick zoom setting.

Sharpening After the Fact in Photoshop

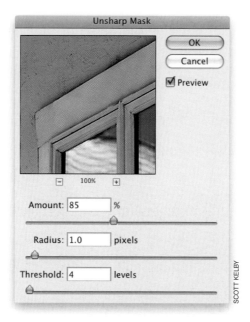

SCOTT KELBY

If you've followed all the tips in this chapter thus far, and you've got some nice crisp photos, you can still make your photos look even that much sharper by adding sharpening in either Adobe Photoshop (the software darkroom tool the pros use) or Adobe Photoshop Elements (the semi-pro version). Now, which photos need to be sharpened using Photoshop? All of them. We sharpen every single photo we shoot using Photoshop's Unsharp Mask filter. Okay, it sounds like something named "unsharp" would make your photos blurry, but it doesn't—the name is a holdover from traditional darkroom techniques, so don't let that throw you. Using it is easy. Just open your photo in Photoshop, then go under Photoshop's Filter menu, under Sharpen, and choose Unsharp Mask. When the dialog appears, there are three sliders for applying different sharpening parameters, but rather than going through all that technical stuff, I'm going to give you three sets of settings that I've found work wonders.

(1) For people: Amount 150%, Radius 1, Threshold 10
(2) For cityscapes, urban photography, or travel: Amount 65%, Radius 3, Threshold 2
(3) For general everyday use: Amount 85%, Radius 1, Threshold 4

Pro Sharpening

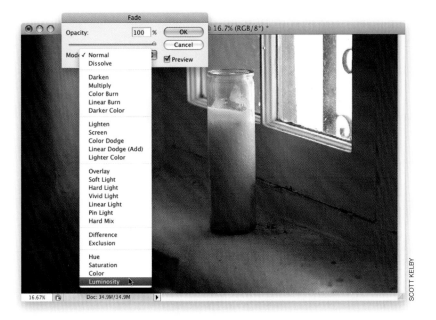

If you have Photoshop or Photoshop Elements, try this sharpening technique. This is the method most widely used by pros, because it lets you sharpen more without creating nasty halos and color artifacts which might otherwise occur when you use lots of sharpening. Here's how it's done:

(1) Open the photo you want to sharpen and apply Unsharp Mask using the settings shown on the previous page.

(2) Now, before you do anything else, go under the Edit menu and choose Fade Unsharp Mask.

(3) The only thing you're going to do here is change the Fade dialog's pop-up menu from Normal to Luminosity.

That's it! Your sharpening is applied to just the luminosity areas of your photo, and not the color areas, and by doing this it helps avoid color halos and other pitfalls of sharpening a color image. Pretty easy stuff once you know the secret, eh?

Hand–Held Sharpness Trick

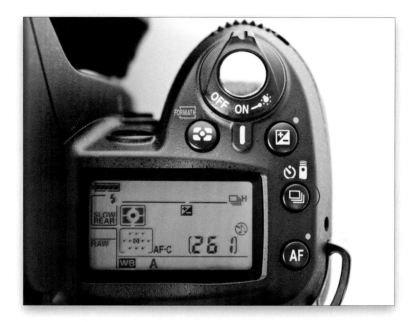

Anytime you're hand-holding your camera in anything but nice direct sunlight, you're taking your chances on getting a sharply focused photo because of camera shake, right? Well, the next time you're hand-holding in less than optimal light, and you're concerned that you might not get a tack-sharp image, try a trick the pros use in this sticky situation— switch to continuous shooting (burst) mode and hold down the shutter release to take a burst of photos instead of just one or two. Chances are at least one of those dozen or so photos is going to be tack sharp, and if it's an important shot, it can often save the day. I've used this on numerous occasions and it's saved my butt more than once. (Nikon's continuous shooting mode button is pictured above. See Chapter 5 for more on shooting in continuous [burst] mode with both Nikon and Canon cameras.)

Getting Steadier Hand–Held Shots

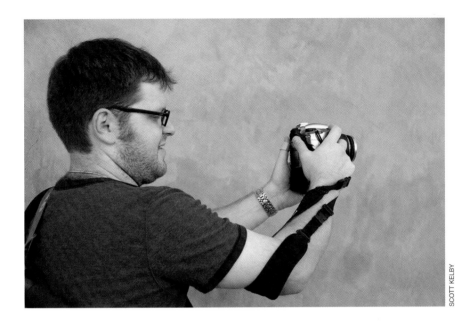

SCOTT KELBY

I picked up this trick from photographer Joel Lipovetsky (pictured here) when we were out on a shoot and I saw him hand-holding his camera with his camera strap twisted into what he called "The Death Grip." It's designed to give you extra stability and sharper shots while hand-holding your camera by wrapping your camera strap around your arm (just above the elbow), then wrapping it around the outside of your wrist (as shown above) and pulling the strap pretty tight, which makes your camera more stable in your hand. You can see how it wraps in the photo above, but the pose is just for illustrative purposes—you still would hold the camera up to your eye and look through the viewfinder as always. Thanks to Joel for sharing this surprisingly cool tip.

Lean on Me!

Another trick the pros use (when they're in situations where they can't use a tripod) is to either: (a) lean themselves against a wall to help keep themselves steady—if they're steady, then the camera's more steady, or (b) lean or lay their lens on a railing, a fence, or any other already stationary object as kind of a makeshift tripod. Keep an eye out for these tripod substitutes whenever you're without yours—it can make a big difference.

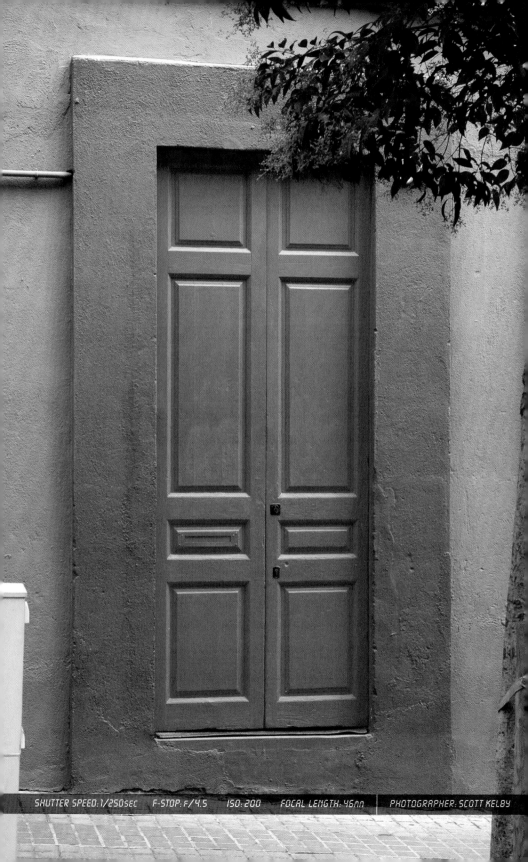

SHUTTER SPEED:1/250sec F-STOP: f/4.5 ISO: 200 FOCAL LENGTH: 46mm PHOTOGRAPHER: SCOTT KELBY

Chapter Two

Shooting Flowers Like a Pro

There's More to It Than You'd Think

You're probably surprised to see a chapter in here about shooting flowers because flowers seem like they'd be easy to shoot, right? I mean, they're just sitting there—not moving. They're colorful. They're already interesting, and people love looking at them. It should be a total no-brainer to get a good flower shot. But ya know what? It's not. It's a brainer. It's a total brainer. Ya know why? It's because of pollination. That's right, it's the pollination that naturally occurs in nature that puts a thin reflective film over flowers that can't normally be seen with the naked eye, but today's sensitive CMOS and CCD digital camera sensors capture this reflectance and it appears as a gray tint over our images. Not only does it turn the photos somewhat gray (which causes flowers to lose much of their vibrant color), you also lose sharpness as well. Now, there is a special photographic filter (called the Flora 61B from PhotoDynamics) that can help reduce the effects of this pollination and both bring back the sharpness and reduce the graying effect, but because of U.S. trade sanctions imposed by the Federal Trade Commission, we can no longer buy this filter direct. Especially because I totally made this whole thing up. I can't believe you fell for this two chapters in a row. Seriously, how are you going to get good flower photos if you're falling for the old Flora 61B trick? Okay, I'm just teasing you, but seriously, getting good flower shots is an art, and if you follow the tips I'm laying out in this chapter, the very next flower shots you take will be that much better (especially if you don't mind the graying and loss of sharpness caused by pollination). See, there I go again. It's a sickness.

Don't Shoot Down on Flowers

On an average day, if you were to walk by some wildflowers in a field, or along a path in a garden, you'd be looking down at these flowers growing out of the ground, right? That's why, if you shoot flowers from a standing position, looking down at them like we always do, your flower shots will look very, well…average. If you want to create flower shots with some serious visual interest, you have to shoot them from an angle we don't see every day. That usually means not shooting down on them, and instead getting down low and shooting them from their level. This is another one of those things the pros routinely do and most amateurs miss. Hey, if you're going to shoot some great flower shots, you're going to have to get your hands dirty (well, at least your knees anyway). The shots above show the difference: on the left, the typical "shooting down on flowers" shot; on the right, the same flowers in the same light using the same focal length lens shot 30 seconds later, but I shot them from the side (down on one knee) instead of shooting down on them. You can see the difference shooting a non-typical angle makes. So, to get great flower shots, start by not shooting down on them. By the way, while you're down there, try getting really low (down below the flowers) and shoot up at them for a fascinating angle you rarely see!

Shooting Flowers with a Zoom Lens

SCOTT KELBY

You don't have to have a macro (close-up) lens to take great flower shots—zoom lenses work just great for shooting flowers for two reasons: (1) you can often zoom in tight enough to have the flower nearly fill the frame, and (2) it's easy to put the background out of focus with a zoom lens, so the focus is just on the flower. Start by shooting in aperture priority mode (set your mode dial to A), then use the smallest aperture number your lens will allow (in other words, if you have an f/5.6 lens, use f/5.6). Then try to isolate one flower, or a small group of flowers that are close together, and focus on just that flower. When you do this, it puts the background out of focus, which keeps the background from distracting the eye and makes a stronger visual composition.

Save Your Knees When Shooting Flowers

If you're going to be shooting a lot of flowers, there's an inexpensive accessory that doesn't come from the camera store, but you'll want it just the same—knee pads. They will become your best friend. Find them at Home Depot, Lowe's, or any good gardening store.

Use a Macro Lens to Get Really Close

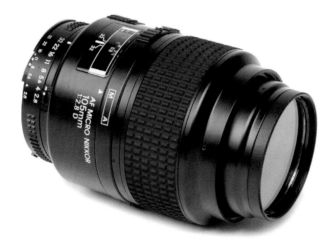

If you've ever wondered how the pros get those incredibly close-up shots (usually only seen by bees during their pollination duties), it's with a macro lens. A macro lens (just called "macro" for short) lets you get a 1:1 view of your subject and reveal flowers in a way that only macros can. A macro lens has a very shallow depth of field—so much so that when photographing a rose, the petals in the front can be in focus and the petals at the back of the rose can be out of focus. I'm not talking about an arrangement of roses in a vase—I'm talking about one single rose. By the way, you *must* (see how that's set off in italics?), must, must shoot macro on a tripod. When you're really in tight on a flower, any tiny bit of movement will ruin your photo, so use every sharpening technique in Chapter 1 to capture this amazing new world of macro flower photography.

Turn Your Zoom Lens into a Macro Zoom

It's easy—just add a close-up lens (like we talk about on the next page) onto your regular zoom lens. As I mention, these close-up lenses (also called two-element close-up diopters) are cheaper than buying a full-blown macro lens, plus adding it to your zoom gives you zoom capability, as well. You can buy single-element close-up filters, but they're generally not as sharp at the edges, but for flowers the edges usually aren't as important anyway.

Can't Afford a Macro? How 'bout a Close-Up?

I learned about this from my buddy (and famous wildlife and nature photographer) Moose Peterson, and what it lets you do is turn your telephoto zoom lens into a macro lens for 1/4 of the price, and 1/10 the weight and size. It looks just like a thick filter (it's about 1" thick), and it screws onto both Canon and Nikon lenses just like a traditional filter, but it turns your zoom lens into a macro zoom. What's great about this little close-up lens is that:

(1) it takes up so little room in your camera bag;
(2) it weighs just a few ounces;
(3) and best of all—it's pretty inexpensive (well, compared to buying a decent macro lens, which would run you at least $500).

It's called the Canon Close-Up Lens (even though it's from Canon, you can get a version that screws onto a Nikon lens. It's the only thing I know of from Canon that's designed for Nikon cameras. I use the Canon Close-Up Lens 500D to attach to my 70–200mm Nikon VR lens [it's 77mm], and it works wonders). So, how much is this little wizard? Depending on the size of the lens you're going to attach it to, they run anywhere from about $70 to $150. That ain't bad!

When to Shoot Flowers

There are three ideal times to shoot flowers:

(1) On cloudy, overcast days. The shadows are soft as the sun is hidden behind the clouds, and the rich colors of the flowers aren't washed out by the harsh direct rays of the sun. That's why overcast days are a flower photographer's best friend. In fact, there's probably only one other time that's better than shooting on an overcast day, and that is…

(2) Just after a rain. This is a magical time to shoot flowers. Shoot while the sky is still overcast and the raindrops are still on the petals (but of course, to protect your digital camera [and yourself], don't actually shoot in the rain). If you've got a macro lens, this is an amazing time to use it. While you're shooting macro, don't forget to shoot the raindrops on leaves and stems as well, while they're reflecting the colors of the flowers (of course, don't forget to shoot on a tripod if you're shooting macro).

(3) If you shoot on sunny days, try to shoot in the morning and late afternoon. To make the most of this light, shoot with a long zoom lens and position yourself so the flowers are backlit, and you'll get some spectacular (but controlled) back lighting.

Don't Wait for Rain—Fake it!

SCOTT KELBY

This one may sound cheesy at first, but you'll be shocked at how well this works. Instead of waiting for a rainy day to shoot, take a little spray bottle with you, fill it with water, and spray the flowers with water yourself. I found a nice little spray bottle in Walgreens' beauty section (I know what you're thinking, "Walgreens has a beauty section?" Believe it or not, they do) for a couple of bucks, and it works wonders. Just a couple of quick spritzes with the spray bottle and you've got some lovely drops of water on your petals, and no one will ever know you didn't wait patiently for Mother Nature to intervene. Get a small enough bottle and you can carry it in your camera bag (empty, of course). By the way, I've used this spray bottle technique to shoot some yellow roses I bought for my wife, and by using a macro lens you'd swear I was shooting on the White House lawn after a spring shower. Try this once—you'll become a believer.

Tip That Doesn't Belong in This Book

There's another hidden benefit of carrying a small spray bottle in your camera bag: getting wrinkles out of clothes. Just give your shirt, sport coat, photographer's vest, etc., a couple of spritzes before bed and when you wake up in the morning, the wrinkles are gone. I know, this has little to do with photography, but I had this empty space at the bottom here, so I figured I'd pass this on.

Flowers on a Black Background

SCOTT KELBY

One of the most dramatic compositions for shooting flowers is to position a single flower on a black background. You can add a black background in Photoshop, but in most cases that is just way too much work. Instead, do what the pros do—put a black background behind your flower when you shoot it. My buddy Vincent Versace, one of the leading nature photographers (and instructors) in the business, told me his trick— he wears a black jacket while out shooting flowers, and if he sees a flower he wants on a black background, he has his assistant (or a friend, or his wife, or a passerby, etc.) hold the back of his jacket behind the flower. I know, it sounds crazy—until you try it yourself. If you're shooting flowers indoors (I shoot nearly every arrangement I buy for my wife, or that we receive from friends), buy a yard of either black velvet or black velour (velvet runs around $10–15 per yard; velour runs around $5–10 per yard) and literally put it behind your flowers. You can prop it up on just about anything (I hate to admit it, but I've even propped up my velour background by draping it over a box of my son's Cookie Crisp cereal). Leave a few feet between your flowers and the black background (so the light falls off and the black looks really black) and then shoot away. Now, what kind of light works best? Keep reading to find out.

Shooting on a White Background

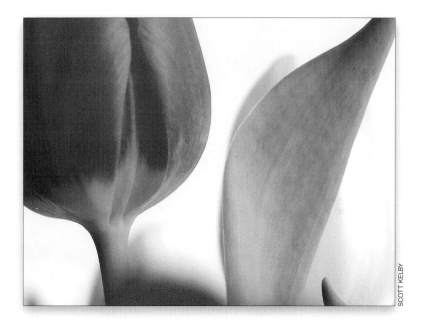

SCOTT KELBY

Another popular look for a flower photographer is to shoot on a white background. You could buy a seamless roll of paper from your local camera store (it's pretty cheap), but it's usually much wider than you need. Plus, unless you're shooting flowers for a florist, you're usually not going to want to see the vase. That's why I go to Office Depot and buy two or three 20x30" sheets of white mounting board (it looks like poster board, but it's much thicker and stiffer). I usually position one behind the flowers (in a vase), and then use the other to reflect natural light (from a window with indirect sunlight) back onto the white background so it doesn't look gray. Again, put about 3 feet between your flowers and the background, and use that natural light to capture your flowers on what appears to be a solid white background you added in Photoshop, but it was even easier because you did it in the camera.

Put That Shower Curtain to Work

If you buy the white shower curtain mentioned in the tip on the next page, here's another way to stretch your shopping dollar—use it as your white background. As long as you're using a shallow depth of field, you'll never know that white background is a shower curtain. Just don't shoot at f/11 or f/16 or people will say things like, "Hey, nice shower curtain," or, "Did you shoot that in the bathroom?"

The Perfect Light for Indoor Flower Shots

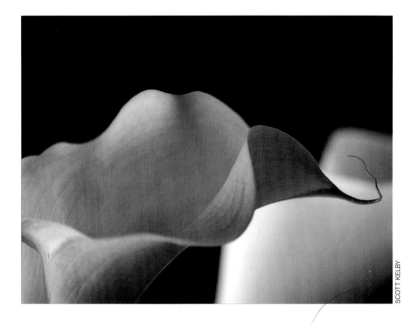

SCOTT KELBY

If you're shooting flowers indoors, you don't have to buy an expensive lighting rig (finally, something you don't have to spend a bunch of money on), because flowers love diffused natural light. By diffused, I mean that it's not getting direct sunlight, so any soft light coming in from a window works just great. If your window is really, really dirty, that's even better because it makes the light even more diffuse. So look for a window in your house, studio, office, etc., that has non-direct sunlight coming in. Then set your flowers near that window, and position them so you're getting side lighting (if the natural light hits the flowers head on, they'll look kind of flat—you need that extra dimension that side lighting brings). Now set up your tripod so you're shooting the flowers at eye level (remember, don't shoot down on flowers). Now you're ready to shoot in some beautiful, soft light, and you didn't spend a dime (at least on lighting, anyway).

How to Create the Perfect Natural Light by Cheating

If you're faced with nothing but harsh direct sunlight through your open window, you can cheat—just go to Wal-Mart, Kmart, or Target and buy two things: (1) a frosted white shower curtain (or shower curtain liner), and (2) some tacks or push pins. Go back to your harsh light window, tack up your frosted shower curtain, and enjoy the best diffused natural light you've seen. Don't worry—I won't tell anybody.

Where to Get Great Flowers to Shoot

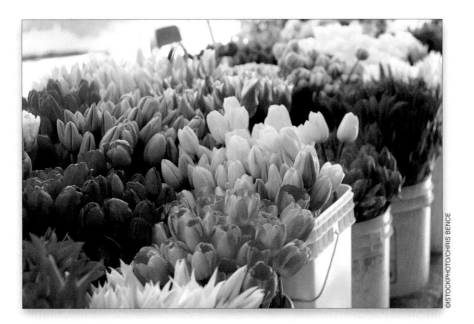

©ISTOCKPHOTO/CHRIS BENCE

This may sound like the "Duh" tip of the book, but I can't tell you how many times I've told a photographer about this and they say, "Gee, I never thought of that." To get some really great flowers to shoot, just go to a local florist and buy them (see, there's that "duh" part). You can pick exactly which individual flowers you want (I like shooting roses, calla lilies, and daisies myself), and chances are the flowers you're getting are in great shape (they're fresh). You can reject any flower they pull out that has brown spots or is misshapen (I love that word, "misshapen"), and you don't have to pay to have them arranged. You can often walk out for less than 10 bucks with some amazing-looking subjects to shoot at the height of their freshness (though sometimes you have to wait a day or so until your roses are in full bloom).

Stopping the Wind

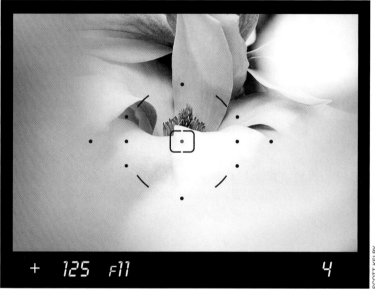

If you're shooting flowers outdoors, you're bound to run into the natural enemy of flower photography—wind. There's nothing more frustrating than standing there, tripod set, camera aimed and focused, and you're waiting for the wind to die down enough to get the shot. This is especially bad if you're shooting macro, where the slightest movement spells disaster (well, not disaster, but a really blurry photo). You can try the old use-your-body-to-block-the-wind trick (which rarely works by the way), but you're actually better off letting the camera fix the problem. Switch to shutter priority mode (where you control the shutter speed and your camera takes care of adjusting the rest to give you a proper exposure), then increase the shutter speed to at least 1/250 of a second or higher. This will generally freeze the motion caused by wind (unless it's hurricane season). If the higher shutter speed doesn't do the trick, then you have to go to Plan B, which is making the wind the subject. That's right, if you can't beat 'em, join 'em—use a very slow shutter speed so you see the movement of the flowers (you'll actually see trails as the flower moves while your shutter is open), and in effect you'll "see" the wind, creating an entirely different look. Give this seeing-the-wind trick a try, and you might be surprised how many times you'll be hoping the wind picks up after you've got your regular close-ups already done.

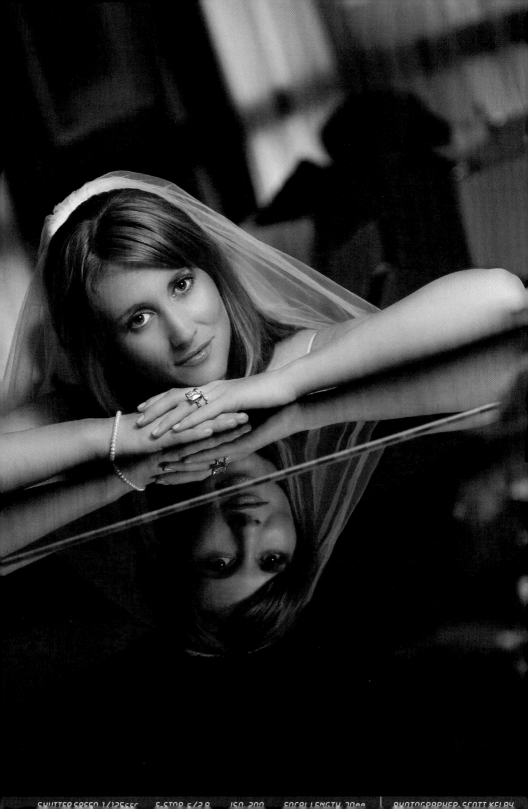

Chapter Three

Shooting Weddings Like a Pro

There Is No Retaking Wedding Photos. It's Got to Be Right the First Time!

If you're living your life and you think to yourself, "Ya know, I've got it pretty easy," then it's time to shoot a wedding. Don't worry—this isn't something you're going to have to go looking for—if you've got even one long lens (200mm or longer), it will find you. That's because in a lot of people's minds, if you have a long lens, you're a serious photographer. It's true. Seriously, try this: show up at an event with a 200mm to 400mm lens on your camera and people will literally get out of your way. They assume you've been hired by the event and that you're on official photography business, and they will stand aside to let you shoot. It's the equivalent of walking into a factory with a clipboard—people assume you're legit and they let you go about your business. Add a photographer's vest and it's like having an official press pass to anything (try this one—you'll be amazed). Anyway, if you have a long lens, before long someone you know will get married but they won't have a budget for a professional photographer (like your cousin Earl). He'll ask, "Can you shoot our wedding photos?" Of course, you're a nice person and you say, "Why sure." Big mistake. You're going to work your butt off, miss all the food, drinks, and fun, and you'll experience stress at a level only NORAD radar operators monitoring North Korea ever achieve. A wedding ceremony happens once in real time. There are no second takes, no room for mess-ups, no excuses. Don't make Earl's bride really mad—read this chapter first.

The Trick for Low–Light Shooting in a Church

Although you usually should use a tripod when shooting the formals (the group shots after the ceremony with the bride, groom, family members, etc.), when shooting the wedding ceremony in a low-light situation like a church, you'll often need to hand-hold your shots. This is a problem because hand-holding in low-light situations is almost a guarantee of having blurry photos (because of the slow shutter speeds of low-light situations). So, how do the pros get those crisp low-light shots in a setting like a church? Two things: (1) They increase their digital camera's ISO (the digital film speed). Today's digital SLR cameras (in particular, the Nikons and Canons) let you shoot at very high ISOs with little visible noise. So how high can you go? At least ISO 800, but you can usually get away with as high as ISO 1600 in most situations (or even higher, depending on your camera). This lets you get away with hand-holding in the low light of a church, while avoiding the camera shake you'd get at ISO 100 or 200. (2) They shoot with their fastest lens (your lens with the largest available f-stop, like f/1.4, f/2.8, or f/3.5), which lets in more available light, allowing you to shoot in lower light without blurring your images.

Way Cool Tip
If you're shooting in very high ISOs, you'll want to know about a popular Photoshop plug-in for wedding photographers called Dfine 2 (from NikSoftware.com). Besides reducing noise, a happy side effect is that it also smoothes skin.

Getting Soft, Diffused Light with Flash, Part 1

If you're shooting your weddings with a flash indoors, you're likely to get harsh shadows and unflattering, flat light, but it doesn't have to be that way. The trick for getting soft, diffused light from your built-in flash without those harsh, hard shadows is to get a flash diffuser (a translucent sheet that fits over your flash to make the light softer and diffused). If you have a built-in pop-up flash on your digital camera, you can use something like LumiQuest's Soft Screen Diffuser (which runs around $13), or if you have an external flash unit, take a look at the Westcott Micro Apollo Softbox, which sells for around $36, attaches over your flash unit, and does a great job of softening the light and dispersing it evenly. This will make a big difference in the quality of the light that falls on your bride, groom, and bridal party, and you'll get much more professional results for a very small investment.

Getting Soft, Diffused Light with Flash, Part 2

The other method of getting soft, diffused, and better yet, directional light using a flash (the key word here is directional, because it keeps your flash shots from looking flat) works if you're using an external flash unit (and not the built-in flash on your camera, which is pretty limited, as you'll soon see). The advantage of an external flash unit is that you can change the angle and direction of the flash. The reason this is cool is that instead of aiming your flash right into your subject's face (which gives the most harsh, flat light you can imagine), you can bounce the light off one of two places: (1) the ceiling. If the room you're shooting in has a white ceiling (and chances are the ceiling is white), then you can aim your flash head up at the ceiling at a 45° angle (as shown above, and provided that the ceiling isn't more than 10 feet tall) and the ceiling will absorb the harsh light, and what will fall on your subject is much softer, smoother light and, best of all, it won't cast hard shadows behind your subject. Instead, your soft shadows will cast on the ground (and out of your frame). Now, want to take this up another notch? Then instead of aiming at the ceiling, (2) have an assistant (a friend, relative, etc.) hold a reflector on your left or right side, slightly above shoulder height, then angle your flash head into that. So now, the reflector eats up the harsh light, but better yet, since the reflector is at an angle, it casts soft directional light on an angle, too. This puts soft shadows on one side of the bride's (groom's, bridesmaid's, etc.) face, giving a more pleasing and less flat lighting effect (think of it as side lighting).

Use Your Flash at Outdoor Weddings

MATT KLOSKOWSKI

One trick that wedding photographers have been using for years is to use fill flash outdoors on sunny days. I know, it sounds crazy to use a flash when the sun is bright in the sky, but wedding photographers add flash to these daylight shots to help eliminate those hard, harsh shadows in their subjects' faces, and make the bride and groom look more natural under these undesirable lighting conditions (plus it will usually add nice catchlights in the eyes of your subjects, as well). Always check the results in your LCD monitor to make sure your light is properly balanced. Here's a shot of me taken while shooting a recent wedding. Notice the flash doesn't fire straight into the wedding party's faces. Instead, the head is rotated to the right (or left) and tilted 45°, so the flash fills in the shadows yet doesn't have that harsh look you'd get by aiming the flash straight at your subjects. As long as you're not more than 8 or 10 feet away from your subject, don't worry—the flash will still be effective, even though it's not aiming straight on.

Another Cool Flash Tip

Here's another tip that will make your flash seem less "flashy" when shooting outdoors: use your camera's flash exposure compensation button and change the flash exposure compensation to –1 (it works the same way regular exposure compensation works, but for flash exposures). Your flash will still help lift out the shadows, but now without being so obvious.

Keep Backup Memory Cards on You

It's not unusual for a pro wedding photographer to shoot 750 shots in one wedding, covering the four major parts of a wedding (the pre-wedding shots, the ceremony, the formals, and the reception), so it's likely you'll be shooting a similar amount (maybe less, maybe more, but it will be literally hundreds of shots). The last thing you want to happen is to run out of film (in other words—you don't want to fill up your digital camera's memory card unless you have an empty backup card ready to step right in so you can keep shooting). The trick here is to keep a spare backup memory card physically on you at all times. Keep one right there in your pocket (or purse) so the moment your card reads full, you're just seconds away from continuing your shoot. It's a natural law of wedding photography that your memory card will become full at the most crucial moment of the ceremony, and if you have to stop to go find your backup card (in your camera bag across the room, in the car, or in the reception hall), you're going to miss the most important shot of the day (I learned this the hard way). So always keep a backup physically on you, so you're only 10 seconds away from shooting again.

 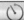
Formals: Who to Shoot First

©ISTOCKPHOTO

After the ceremony, in most cases you'll shoot the formal portraits of the bride and groom posed with everyone from bridesmaids to grandparents. The hard part is rounding up all the people you'll need to shoot with the bride and groom at the exact time you need them. This can take 30 minutes or three hours—it's up to you and how organized you are. Here's a tip to make things move as quickly as possible: gather everyone that will appear in any shot together right from the start. While they're all sitting there, shoot the formal bride and groom portraits first (you'll see why in just a moment). Once you've got those out of the way, shoot the largest groups of people (the huge family portraits), and then once you're done with a group (like the grandparents for example), send them off to the reception. So, in short—start with everyone, and then as you shoot them, release them to go to the reception until you're left with just the bride and groom again. If you don't do it this way, you'll wind up standing around for long periods of time waiting for Uncle Arnie, who's somewhere in the reception hall. The reason you shoot the bride and groom first is that the pressure to get the bride and groom to the reception hall increases exponentially as time goes by, because generally they hold the meal until the bride and groom have arrived. So, everyone is sitting in the reception hall waiting on you—the photographer. You then wind up rushing the most important portraits of them all (the ones the couple will actually buy—their formal portraits). Make your life easy—start big, then get small.

Formals: Where to Aim

When shooting large groups for the formal portraits, you'll want to make sure that you use an aperture setting that keeps everyone in focus. Try f/11 for a reasonable depth of field for groups. Now, where do you focus? If you have more than one row of people deep, the old rule (which still stands true today) is to focus on the eyes of the people in the front row. You have more depth behind than in front, so make sure you focus on them, and the rest should be okay, but if that front row is out of focus, the whole shot is a bust.

The Trick to Keeping Them from Blinking

©ISTOCKPHOTO/NICK SCHLAX

If you shoot a group of five people or more, it's almost guaranteed that one or more people will have their eyes shut. It's another natural law of wedding photography, but you're not going to have to worry about that very much, because you're about to learn a great trick that will eliminate most, if not all, instances of people blinking or having their eyes closed. When you're ready to shoot the shot, have everybody close their eyes, and then on the count of three have them all open their eyes and smile. Then, wait one more count before you take your shot. When I'm shooting these groups, here's what I say, "Okay, everybody close your eyes. Now open them on 3-2-1...open!" Then I wait one count after they open their eyes before I take the shot. It works wonders.

Reception Photos: Making Them Dance

SCOTT KELBY

There's a problem with taking photos of people dancing. If you shoot them with a flash (and most likely you will), it will freeze their movement, so they'll look like they're just standing still, but in somewhat awkward poses. It still amazes me how people doing a line dance can be pictured as people in a police lineup—the camera just doesn't capture motion—unless you tell it to. There are really two techniques: the first is in the camera. It's called panning, where you take the camera and follow the movement of one of the people dancing (usually the bride, groom, a bridesmaid, or a groomsman), while using a slow shutter speed so the rest of the people have a motion blur, which makes them look like (you guessed it) they're dancing. If you didn't remember to employ this technique during your reception shoot, then you can add this motion blur in Photoshop. The first step is to duplicate the Background layer. Then go under the Filter menu, under Blur, and choose Motion Blur. Set the Angle to 0°, then increase the Distance until things look like they're really moving. The last step is to get the Eraser tool, choose a really big soft-edged brush (like the soft round 200-pixel brush) and erase over the person you're focusing on (like the bride, etc.) so that person appears in focus, while everyone else is dancing and moving around having a good time.

Your Main Job: Follow the Bride

©ISTOCKPHOTO/ELIANET ORTIZ

The main focus at any wedding is the bride, so make darn sure your main focus at the pre-wedding, the ceremony, the formals, and the reception is the bride. Follow the bride just you would follow the quarterback if you were shooting a football game. Especially if you're going to be selling these photos as it will be the bride (either directly or indirectly) that will be buying the prints. So make darn sure that she's the clear star of the show (photos of Uncle Arnie at the reception don't sell well, if you get my drift).

Formals: How High to Position Your Camera

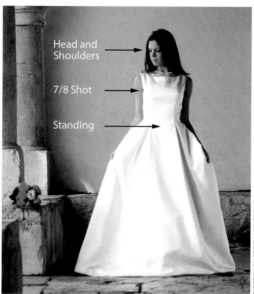

When you're shooting your formal shots, the height that you position the camera is actually very important, because if it's not positioned correctly, your subject's body can look distorted or some parts can look larger than normal (in general, this is just not good stuff). So, finding the right height for professional portraits is critical. Here are a few guidelines to help you get the pro look:

Standing, Full-Length Portrait: Position your camera (on your tripod) at the bride's waist height (yes, you'll have to squat down/bend over, etc., but the final result will be worth it). Keep your lens straight (don't aim up towards the bride's face).

7/8 Shots (from the Calf Up): Position your camera (on your tripod) at the bride's chest level and shoot with your lens straight from there.

Head and Shoulders Shots: Position your camera (on your tripod) either at the bride's eye level or slightly above.

Formals: Don't Cut Off Joints

When you're framing your formals in your viewfinder, for a more professional look, be careful not to cut off anyone at the joints (in other words, don't let the bottom of the frame cut anyone off at the elbow or knee. On the side of the frame, don't cut anyone off at the wrist or elbow either). Basically, stay away from the joints. If you have to crop an arm or leg off, try to do it as close to the middle of the arm or leg as possible, staying clear of the joints. 'Nuf said.

Formals: Build Off the Bride and Groom

©ISTOCKPHOTO/KEVIN RUSS

There's a popular format for creating all your formals—have the bride and groom in the center, and have them stay put. They don't move—instead you have groups of other people (bridesmaids, groomsmen, the best man, maid of honor, parents, grandparents, etc.) move in and out around them. Use the bride and groom as building blocks and everything will be much easier (well, as far as posing your large groups goes anyway).

Formals: The Trick to Great Backgrounds

©ISTOCKPHOTO/PHIL DATE

In formal portraits, the backgrounds are just that—backgrounds. And the key to a great background is using a very simple one. The simpler, the better. So don't look for an outdoor shot with a waterfall, 36 different kinds of plant life, and flowers blossoming from hanging vines, etc. Look for simplicity or it will greatly distract from your portraits, and give your formals an uncomfortable look (yet nobody will know why). Plus, if for any reason you have to retouch the background later in Photoshop, the less busy the background, the easier your retouch will be.

Background Tip

Here's another good tip: vary your background for your formals. It may not seem like a big deal at the time, but when you see the same background over and over and over again in the final wedding album, it can become really tedious. Once you've shot a few sets on one background, if there's another simple background nearby, try it in order to keep the album from looking like a cookie cutter.

Shooting the Details (& Which Ones to Shoot)

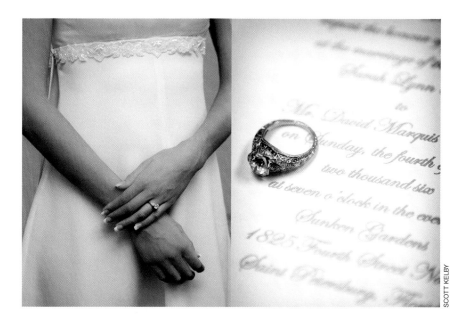

SCOTT KELBY

The photojournalism style of wedding photography is very big right now (where you tell the story of the wedding in photos as if you were covering it for a newspaper or magazine). One of the cornerstone elements of this technique is to make sure to photographically capture the tiny details of the wedding, especially behind the scenes before the wedding. Here's a list of things you might want to capture (shoot), which can either stand alone in the wedding album or be used as backgrounds for other photos:

- The bride's shoes
- The bride's dress hanging on a hanger
- The bride's tiara, necklace, etc.
- The wedding invitation
- The sheet music played at the wedding
- The guestbook (once a few people have signed it)
- Their champagne glasses
- Name cards at the reception
- Their wedding rings (perhaps posed on the invitation with some rose petals casually placed nearby)
- The airline tickets for their honeymoon
- The sheet music, or CD jewel case, to the music for their first dance
- The groom's boutonniere
- The bride's bouquet
- Any fine detail in her dress

Change Your Vantage Point to Add Interest

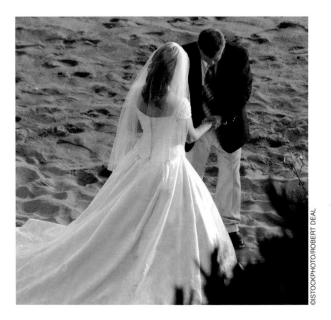

©ISTOCKPHOTO/ROBERT DEAL

Want to create a shot everyone will remember? Shoot it from a high vantage point (look for a second story window you can shoot down from, or a balcony on the second floor, a bridge, etc.). If you can't find an existing high vantage point, then you can always create your own by bringing (or borrowing) a ladder to shoot from. Of course, be careful, because being on a ladder with expensive camera equipment is the stuff Hollywood comedies are made of. This high vantage point trick is ideal for shooting bridesmaids, groomsmen, and even the bride and groom, as shown here.

Finding That Perfect Bridal Light

SCOTT KELBY

At most weddings there is a spot with really spectacular light just waiting for you to walk over and find it, but once you find it, you have to know how to use it. That light, of course, is natural light coming in through a window (it's hard to make a photo look bad in that light). Look for a window that doesn't have direct sunlight (a window facing north usually works well to provide some soft, diffused light). So, once you find this wonderful natural side light coming in from a window, where do you place the bride? Ideally, about 6 to 8 feet from the window, so the light falls evenly and softly upon her (almost sounds like a song, doesn't it?). This is a great spot for shooting some pre-wedding shots of the bride alone, the bride with her mother, and the bride with her father.

How to Pose the Bride with Other People

SCOTT KELBY

When you're posing other people with the bride, including the groom, to create the level of closeness you'll want in your photos, be sure to position the heads of the bride and the other person very close to each other. This doesn't sound like it would be a problem, until you actually start posing people. When they fall into what feels like a natural pose, they leave way too much room between their head and the bride's head. While this may look perfectly natural in person, the photos will lack a closeness that will be really obvious. I've seen this again and again, and I constantly have to remind people, even the groom, to move their head in very close to the bride. To them, it just feels unnatural being that close while posing, but if they don't do it, your shots will look stiff and unnatural. Keep an eye out for this on your next wedding shoot and you'll be amazed at how the level of closeness between your subjects goes up, giving you much more powerful images.

What to Shoot with a Wide-Angle Lens

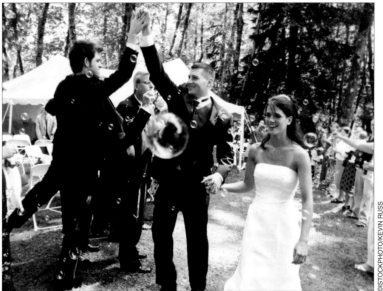

©ISTOCKPHOTO/KEVIN RUSS

At weddings, there are three things you're definitely going to want to shoot with a wide-angle lens. One is the rice throwing (of course, they don't actually throw rice anymore). You'll want to shoot this with a wide-angle lens so you get the bride, groom, and—just as important—the crowd throwing the rice (or rice byproduct) behind and around them. The other thing you'll want a wide-angle lens for is shooting the interior of the church. The bride is going to expect a photo that takes it all in and your wide-angle lens will be your Get Out of Jail Free card when it comes to covering this all-important shot. Lastly, you'll want your wide-angle lens for shooting the bouquet toss and garter toss, so you can get both the tosser and the anxious crowd waiting to capture the prize (so to speak). Go wide, shoot from in front of the bride, and you'll get it all in one shot (but don't just take one shot—this is where a burst of shots will pay off).

Back Up Your Photos Onsite

A wedding happens once. You don't get a redo, so make sure that backing up your photos on location is a part of your workflow. If you fill a memory card, and pop in a new one, the next thing you should be doing is backing up that full card to a hard drive. I recommend either the Epson P-6000 or P-7000 (shown above), both of which enable you to pop a CompactFlash card directly into the unit and back up your photos onto it without having a computer nearby. I keep a P-7000 in my camera bag, and as soon as I fill a card, I pop it into the P-7000 and hit the copy button. In just a few minutes, my memory card (with those irreplaceable photos) is backed up. Also, as soon as I return to my studio, I immediately copy all the photos onto a removable hard drive, so now I have two back-ups of the wedding photos. This backing up is so important—without a backup, you're placing a lot of faith in those memory cards. Imagine how you'd feel having to tell a bride and groom that your memory card somehow became corrupted and you lost the shots of their ceremony. You can sidestep that crisis by making one or two simple backups.

Scott's Gear Finder

The Epson P-6000 (80-GB hard drive) sells for around $600.

The Epson P-7000 (160-GB hard drive) sells for around $800.

If Shooting JPEGs, Use a Preset White Balance

If you're shooting with your digital camera set to RAW format, you don't need to worry about the white balance (leave it set at Auto White Balance, you can always change it later, in Photoshop), but if you're like many pro wedding photographers, you're shooting in JPEG Fine format (so you can take more shots and write to the memory card faster). If that's the case, then you're better off choosing a preset white balance in the camera that matches the lighting situation you're shooting in (that way, the overall color of your photo looks balanced for the light). If you don't set the right white balance, your photos can look too yellow or too blue. Luckily, choosing a white balance is easier than you'd think, and it will save you loads of time later when you're processing your photos in Photoshop. Just go to the menu on your digital camera, scroll to the white balance control and choose Incandescent if you're shooting in a standard reception hall, or Daylight if you're shooting an outdoor wedding. If you're using a flash, set your white balance to Flash. It's that easy to get your color in line.

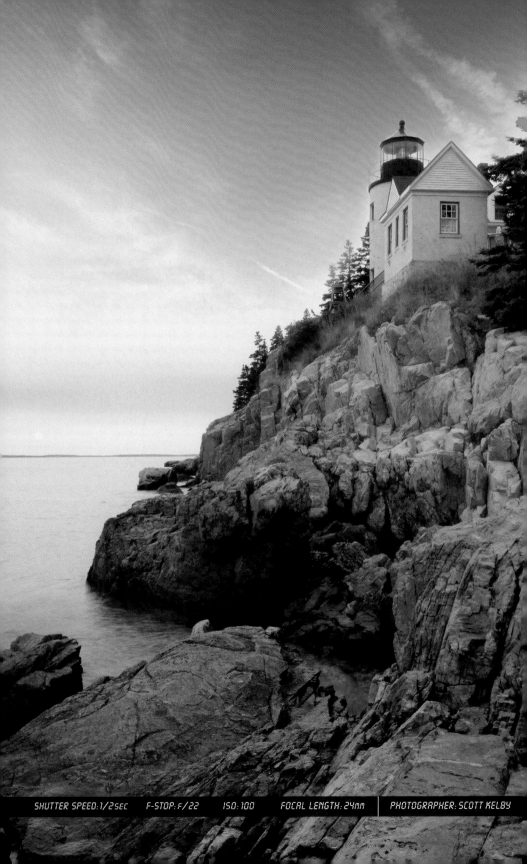

SHUTTER SPEED: 1/2 SEC F-STOP: F/22 ISO: 100 FOCAL LENGTH: 24mm PHOTOGRAPHER: SCOTT KELBY

Chapter Four

Shooting Landscapes Like a Pro

Pro Tips for Capturing the Wonder of Nature

If you ever get to shoot in some truly amazing outdoor locations, like the Grand Canyon or Yosemite National Park, it's really a very humbling photographic experience. The reason why is you're looking at this amazing vista, at the sheer grandeur of it all, and it looks so awe inspiring you'd figure a chimp could even take a great photo of it. I mean, it's just so spectacular, how could you mess it up? Then you set up your tripod, look in your viewfinder, and it happens—you begin to silently sob. You're sobbing because you bought all this expensive camera gear, with multiple camera bodies and lenses that cost more than a Toyota Prius hybrid, you've got more filters than a Ritz Camera store, and your camera bag weighs approximately 54 lbs. You saved all year, took your two-week vacation from work, bought round-trip airfare, and rented a huge SUV big enough to haul you, your family, and all your expensive gear out into the sweltering summer heat of the canyon. Now you're looking through your viewfinder and what you see doesn't look half as good as the stinkin' postcards in the park's gift shop that sell for $1.25 each. Tears begin to stream down your face as you realize that you're not going to get the shot you came for. And whose fault is all this? Ansel Adams—that's who. He screwed up the Grand Canyon, Yosemite, and a dozen other locations for us all. But even though we're not Ansel Adams, we can surely get better photos than the ones in the gift shop, right? Well, it starts with reading this chapter. Hey, it's a start.

The Golden Rule of Landscape Photography

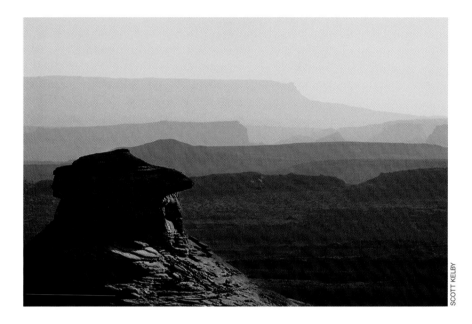

SCOTT KELBY

There's a golden rule of landscape photography, and you can follow every tip in this chapter, but without *strictly* following this rule, you'll never get the results the top pros do. As a landscape photographer, you can only shoot two times a day: (1) dawn. You can shoot about 15 to 30 minutes before sunrise, and then from 30 minutes to an hour (depending on how harsh the light becomes) afterward. The only other time you can shoot is: (2) dusk. You can shoot from 15 to 30 minutes before sunset, and up to 30 minutes afterward. Why only these two times? Because that's the rule. Okay, there's more to it than that. These are the only times of day when you get the soft, warm light and soft shadows that give professional quality lighting for landscapes. How stringent is this rule? I'll never forget the time I was doing a Q&A session for professional photographers. The other instructor was legendary *National Geographic* photographer Joe McNally. A man in the crowd asked Joe, "Can you really only shoot at dawn and dusk?" Joe quietly took his tripod and beat that man to death. Okay, that's an exaggeration, but what Joe said has always stuck with me. He said that today's photo editors (at the big magazines) feel so strongly about this that they won't even consider looking at any of his, or any other photographer's, landscape work if it's not shot at dawn or dusk. He also said that if he takes them a shot and says, "Look, it wasn't taken during those magic hours, but the shot is amazing," they'll still refuse to even look at it. The point is, professional landscape photographers shoot at those two times of day, and only those two times. If you want pro results, those are the only times you'll be shooting, too.

Become Married to Your Tripod

BARNEY STREIT

Okay, so now you know that as a pro landscape shooter your life is going to be like this: you get up before dawn, and you miss dinner about every evening (remember, there's no shame in coming to dinner late). If you're okay with all that, then it's time to tell you the other harsh reality—since you'll be shooting in low light all the time, you'll be shooting on a tripod all the time. Every time. Always. There is no hand-holding in the professional landscape photography world. Now, I must warn you, you will sometimes find landscape photographers out there at dawn some mornings shooting the same thing you are, and they're hand-holding their cameras. They don't know it yet, but once they open their photos in Photoshop, they are going to have the blurriest, best-lit, out-of-focus shots you've ever seen. Now, what can you do to help these poor hapless souls? Quietly, take your tripod and beat them to death. Hey, it's what Joe McNally would do. (Kidding. Kind of.)

Tripods: The Carbon Fiber Advantage

The hottest thing right now in tripods is carbon fiber. Tripods made with carbon fiber have two distinct advantages: (1) they're much lighter in weight than conventional metal tripods without giving up any strength or stability, and (2) carbon fiber doesn't resonate like metal, so you have less chance of vibration. However, there's a downside: as you might expect, they're not cheap.

Shoot in Aperture Priority Mode

Nikon

Canon

The shooting mode of pro outdoor photographers is aperture priority mode (that's the little A or Av on your digital camera's mode dial). The reason why this mode is so popular is that it lets you decide how to creatively present the photo. Here's what I mean: Let's say you're shooting a tiger with a telephoto zoom lens and you decide you want the tiger (who's in the foreground of the shot) to be in focus, but you want the background out of focus. With aperture priority mode, it's easy—set your aperture to the smallest number your lens will allow (for example, f/2.8, f/4, f/5.6, etc.) and then focus on the tiger. That's it. The camera (and the telephoto lens) does the rest—you get a sharp photo of the tiger and the background is totally out of focus. So, you just learned one of the three aperture tricks—low numbers (and a zoom lens) leave your subject in the foreground in focus, while the background goes out of focus. Now, what do you do if you want the tiger and the background to both be in focus (you want to see the tiger and his surroundings clearly)? You can move your aperture to either f/8 or f/11. These two settings work great when you just want to capture the scene as your eye sees it (without the creative touch of putting the background majorly out of focus). Far away backgrounds (way behind the tiger) will be a little bit out of focus, but not much. That's the second trick of aperture priority mode. The third trick is which aperture to use when you want as much as possible in focus (the foreground, the middle, the background—everything): just choose the highest number your lens will allow (f/22, f/36, etc.).

Composing Great Landscapes

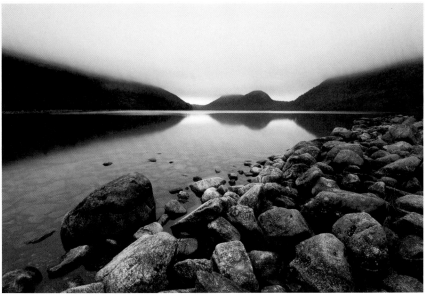

SCOTT KELBY

The next time you pick up a great travel magazine that features landscape photography or look at some of the work from the masters in digital landscape photography, like David Muench, Moose Peterson, Stephen Johnson, and John Shaw, take a moment to study some of their wonderful, sweeping images. One thing you'll find that most have in common is that these landscape shots have three distinct things: (1) a foreground. If shooting a sunset, the shot doesn't start in the water—it starts on the beach. The beach is the foreground. (2) They have a middle ground. In the case of a sunset shot, this would be either the ocean reflecting the sun, or in some cases it can be the sun itself. And lastly, (3) it has a background. In the sunset case, the clouds and the sky. All three elements are there, and you need all three to make a really compelling landscape shot. The next time you're out shooting, ask yourself, "Where's my foreground?" (because that's the one most amateurs seem to forget— their shots are all middle and background). Keeping all three in mind when shooting will help you tell your story, lead the eye, and give your landscape shots more depth.

Another Advantage of Shooting at Dawn

Another advantage of shooting at dawn (rather than at sunset) is that water (in ponds, lakes, bays, etc.) is more still at dawn because there's usually less wind in the morning than in the late afternoon. So, if you're looking for that glassy mirror-like reflection in the lake, you've got a much better shot at getting that effect at dawn than you do at dusk.

The Trick to Shooting Waterfalls

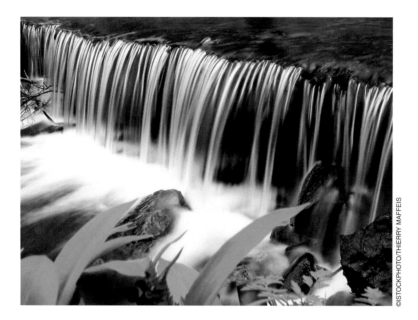

©ISTOCKPHOTO/THIERRY MAFFEIS

Want to get that silky waterfall or that stream effect you see in those pro photos? The secret is leaving your shutter open (for at least a second or two), so the water moves while everything else (the rocks and trees around the waterfall or stream) remains still. Here's what you do: switch your digital camera to shutter priority mode (the S or Tv on your camera's mode dial), and set the shutter speed to 1 or 2 full seconds. Now, even if you're shooting this waterfall on a bit of an overcast day, leaving your shutter open for a few seconds will let way too much light in, and all you'll get is a solid white, completely blown-out photo. That's why the pros do one of two things: (1) they shoot these waterfalls at or before sunrise, or just after sunset, when there is much less light. Or they (2) use a stop-down filter. This is a special darkening filter that screws onto your lens that is so dark it shuts out most of the light coming into your camera. That way, you can leave the shutter open for a few seconds. Such little light comes in that it doesn't totally blow out your photo, and you wind up with a properly exposed photo with lots of glorious silky water. Now, if you don't have a stop-down filter and you run across a waterfall or stream that's deep in the woods (and deep in the shade), you can still get the effect by trying this: put your camera on a tripod, go to aperture priority mode, and set your aperture to the biggest number your lens will allow (probably either f/22 or f/36). This leaves your shutter open longer than usual (but that's okay, you're in deep shade, right?), and you'll get that same silky-looking water.

A Tip for Shooting Forests

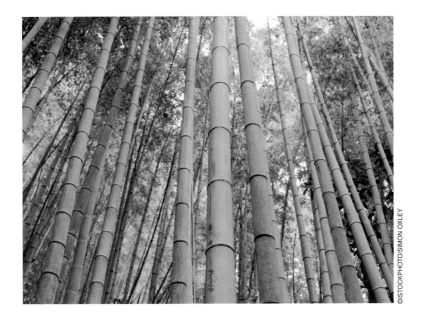
©ISTOCKPHOTO/SIMON OXLEY

Want a great tip for shooting forest scenes? Don't include the ground in your shots. That's right, the ground in the forest is often surprisingly messy (with dead branches, and leaves, and a real cluttered look) and that's why so many pro forest shots don't include the ground—it distracts from the beauty of the trees. So, easy enough—frame your shots so they don't include the ground, and you're shooting better forest shots right off the bat. Now, if the ground looks good, then by all means include it, but if it's a mess, you've got a way to save the shot. Here's another forest shooting tip: overcast days are great for shooting forests because it's difficult to get a decent forest shot in bright, harsh sun. However, there is one exception to this rule: if there's "atmosphere" (fog or mist) in the forest on bright days, the sun rays cutting through the fog or mist can be spectacular.

This Isn't a Forest Tip. It's for Waterfalls

So why is this tip here instead of on the waterfalls page? I ran out of room on that page. The tip is this: when shooting waterfalls, if you don't have a stop-down filter, then you can try putting your polarizing filter on instead. This serves two purposes: (1) it cuts the reflections in the waterfall and on the rocks, and (2) since it darkens, it can eat up about two stops of light for you, so you can shoot longer exposures with it than you could without it. Also, choosing slower shutter speeds exaggerates the silky water effect, so try a few different shutter speeds (4 seconds, 6 seconds, 10 seconds, etc.) and see which one gives you the best effect for what you're currently shooting.

Where to Put the Horizon Line

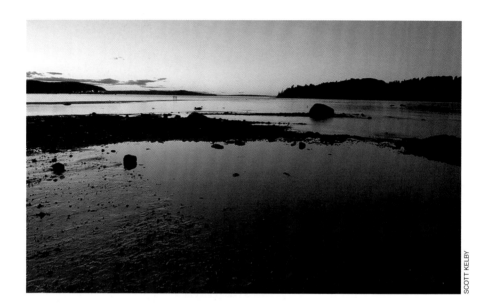

SCOTT KELBY

When it comes to the question of "Where do I place the horizon?" the answer is pretty easy. Don't take the amateur route and always place the horizon in the dead center of the photo, or your landscape shots will always look like snapshots. Instead, decide which thing you want to emphasize—the sky or the ground. If you have a great-looking sky, then put your horizon at the bottom third of your photo (which will give you much more emphasis on the sky). If the ground looks interesting, then make that the star of your photo and place the horizon at the top third of your photo. This puts the emphasis on the ground, and most importantly, either one of these methods will keep your horizon out of the center, which will give your shots more depth and interest.

Really Boring Sky? Break the Rule

If you're shooting a landscape shot with a sky where nothing's really happening, you can break the 1/3 from the top horizon line rule and eliminate as much of the sky from view as possible. Make it 7/8 ground and 1/8 sky, so the attention is totally off the sky, and onto the more interesting foreground.

Getting More Interesting Mountain Shots

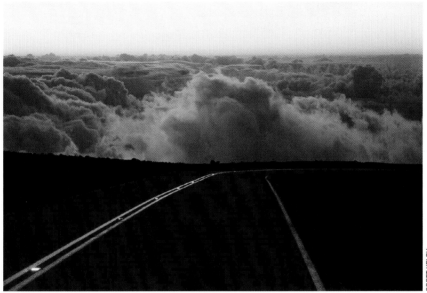

SCOTT KELBY

One theme you'll see again and again throughout this book is to shoot from angles we don't see every day. For example, if your subject is mountains, don't shoot them from the road at the bottom of the mountain. This is exactly how we see mountains every day when we drive by them on the interstate, so if you shoot them like that (from the ground looking up), you'll create shots that look very normal and average. If you want to create mountain shots that have real interest, give people a view they don't normally see—shoot from up high. Either drive up as high as you can on the mountain, or hike up as high as is safe, then set up your camera and shoot down on or across the mountains. (This is the same theory as not shooting down on flowers. We don't shoot down on flowers because that's the view we normally have of them. In turn, we don't shoot up at mountains, because we always see them from that same view. It's boring, regular, and doesn't show your viewer something they haven't seen a hundred times before.)

The Trick for Warmer Sunrises and Sunsets

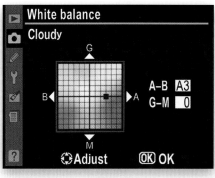

Nikon

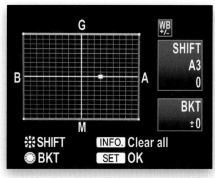

Canon

Here's a trick I picked up from Bill Fortney for getting even warmer sunrises and sunsets. For Nikon shooters, go to your camera's menu and choose Cloudy as your white balance. Press the right arrow button to get the White Balance Cloudy submenu, and move the dot in the middle of the grid to the right three spots (to A3), and then click OK. This does an amazing job of warming these types of photos. If you're a Canon shooter, go to your camera's menu and choose Cloudy as your white balance. Go back to the menu, select WB SHIFT/BKT, move the dot in the middle of the grid to the right three spots (to A3), and then press the Set button. *Note*: Don't forget to turn this setting off when you're not shooting sunrises or sunsets. Okay, it wouldn't be the worst thing in the world (it won't ruin all your subsequent shots), but your world will be a little warmer.

Turn on "The Blinkies" to Keep More Detail

Okay, they're technically not called "the blinkies" (that's our nickname for them), they're actually called highlight warnings (or highlight alerts) and having this turned on, and adjusting for it, is a critical part of getting properly exposed landscape shots. This warning shows exactly which parts of your photo have been overexposed to the point that there's no detail in those areas at all. You'll be amazed at how often this happens. For example, even on an overcast day, clouds can blow out (turn solid white with no detail) easily, so we keep our camera's highlight warning turned on. Here's how it works: When the highlight warning is turned on and you look at the shot in your LCD monitor, those blown out areas will start to blink like a slow strobe light. Now, these blinkies aren't always bad—if you shoot a shot where the sun is clearly visible, it's going to have the blinkies (I don't mean sunlight, I mean the red ball of the sun). There's not much detail on the suface of the sun, so I'd let that go. However, if your clouds have the blinkies, that's a different story. Probably the quickest way to adjust for this is to use your camera's exposure compensation control (covered on the next page). For now, let's focus on making sure your highlight warning (blinkies) is turned on. If you have a Nikon camera, press the playback button so you can see the photos on your memory card. Now, push the down arrow button to see file information, then the right arrow button until the word Highlights appears below your photo on the LCD monitor. If you have a Canon camera (like a 40D, 50D, or a Rebel XTI), press the playback button to view your images and then press the Info button to see the blinkies.

How to Avoid the Dreaded Blinkies

If you look on your camera's LCD monitor and you see the blinkies appearing in an area that's important to you (like in the clouds, or in someone's white shirt, or in the snow, etc.), then you can use your digital camera's exposure compensation control. Basically, you're going to lower the exposure until the blinkies go away. It usually takes a few test shots (trial and error) to find out how much you have to back down, but normally this only takes a few seconds. Here's how it works:

Nikon: Press the exposure compensation button that appears just behind your shutter button (as shown above). Then move the command dial until your exposure compensation reads –1/3 (that's minus 1/3 of a stop). Now take the same shot again and see if the blinkies are gone. If they're not, do the same thing, but lower the amount another 1/3, so it reads –2/3 of a stop, and so on, until the blinkies are gone.

Canon: Turn the mode dial to any creative zone mode except manual, turn the power switch to the quick control dial setting, then set the exposure compensation by turning the quick control dial on the back of the camera and using the settings mentioned above.

How to Show Size

©ISTOCKPHOTO/JAN PAUL SCHRAGE

If you've ever had a chance to photograph something like the California redwood trees or a huge rock formation out in Utah's Monument Valley, you've probably been disappointed that when you looked at those photos later, you lost all sense of their size. In person, those redwoods were wider around than a truck. In your photos, they could've been the regular pines in your backyard, because they lost their sense of size. That's why, when trying to show the size of an object, you need something in that shot to give the object a sense of scale. That's why many photographers prefer to shoot mountains with people in the scene (hikers, climbers, etc.) because it instantly gives you a frame of reference— a sense of scale that lets the viewer immediately have a visual gauge as to how large a mountain, or a redwood, or the world's largest pine cone really is. So, the next time you want to show the sheer size of something, simply add a person to your shot and you've got an instant frame of reference everyone can identify with. It'll make your shots that much stronger. (*Note*: By the way, this also works for things that are very small. Put the object in someone's hands, and it instantly tells the story.)

Don't Set Up Your Tripod. Not Yet

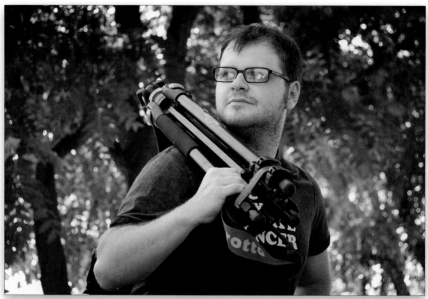

SCOTT KELBY

Okay, so you walk up on a scene (a landscape, a mountain range, a waterfall, etc.) and you set up your tripod and start shooting. What are the chances that you just happened to walk up on the perfect angle to shoot your subject? Pretty slim. But that's what most people do—they walk up on a scene, set up their tripod right where they're stand-ing, and they start shooting. It's no big surprise that they wind up with the same shot everybody else got—the "walk up" shot. Don't fall into this trap—before you set up your tripod, take a moment and simply walk around. View your subject from different angles, and chances are (in fact, it's almost guaranteed) that you'll find a more interest-ing perspective in just a minute or two. Also, hand-hold your camera and look through the viewfinder to test your angle out. Once you've found the perfect angle (and not just the most convenient one), you can then set up your tripod and start shooting. Now the odds are in your favor for getting a better than average take on your subject. This is one of the big secrets the pros use every day (legendary landscape photographer John Shaw has been teaching this concept for years)—they don't take the walk-up shot. They first survey the scene, look for the best angle, the best view, the interesting vantage point, and then (and only then) they set up their tripod. It sounds like a little thing (survey-ing the scene before you set up), but it's the little things that set the pros apart.

The Trick to Getting Richer Colors

One tool the pros use to get richer, more vivid colors is the polarizing filter. Of all the add-ons used by landscape pros, the polarizing filter is probably the most essential. This filter screws onto the end of your lens and it basically does two things: (1) it cuts the reflections in your photo big time (especially in water, on rocks, or on any reflective surface), and (2) it can often add more rich blues into your skies by darkening them and generally giving you more saturated colors throughout (and who doesn't want that?). Two tips: (1) polarizers have the most effect when you're shooting at a 90° angle from the sun, so if the sun is in front of you or behind you, they don't work all that well, and (2) you'll use the rotating ring on the filter to vary the amount (and angle) of polarization (it's also helpful so you can choose to remove reflections from either your sky or the ground). Once you see for yourself the difference a polarizing filter makes, you'll say something along the lines of, "Ahhhh, so that's how they do it."

Polarizing Tip

If there's a lens the polarizing filter doesn't love, it's the super-wide-angle lens (like a 12mm or 10.5mm, etc.). Because the field of view is so wide, the sky winds up having uneven shades of blue, and because of that, many pros avoid using polarizers with super-wide-angle lenses. Also, when it comes to polarizers, it pays to buy a good one—that way it will be truly color balanced. It doesn't pay to scrimp here.

What to Shoot in Bad Weather

©ISTOCKPHOTO/DUNCAN WALKER

Okay, so you're thinking that it's an overcast or drizzly day, and you're going to spend the day inside working on your photos in Photoshop. That's not the worst idea in the world, but you'll miss some great shooting opportunities, like:

(1) Right after a rain, while it's still cloudy and dark, is the perfect time to shoot foliage, forests (the green leaves look more saturated and alive, even leaves on the ground look good, plus the water droplets on the leaves and flowers add interest), mossy rivers, and waterfalls (you can use slower shutter speeds while the sun is buried behind the overcast rain clouds).

(2) If it's storming, there's a good chance that right after the rain stops, and the clouds break, and the sun peeks through, there's a very dramatic shot coming. It may only last a couple of minutes, and it will either start storming again or clear up and just get really sunny (an outdoor photographer's enemy), so be ready for those few magical moments between storms. They're worth waiting for.

(3) Before the storm "lets loose," you can get some really amazing skies, with angry clouds and sometimes colorful light or strong light beams. Most people miss these shots, so be ready (just don't shoot in the rain, to protect you and your gear).

Atmosphere Is Your Friend

©ISTOCKPHOTO/FRED DE GROOT

Besides just keeping us here on earth, the atmosphere (low-hanging clouds or fog) can make for some really interesting landscape photos (we're talking soft, diffused light heaven). In fact, some of my personal favorite shots are taken when the fog rolls in between mountains (but of course, you need to shoot this from above the fog on a higher mountaintop). I've shot horses on the beach with the fog rolling in and it creates almost a Hollywood fantasy effect that looks great on film (digital film, anyway). Also, beams of light in the forest, beaming through moisture in the air, or through thick fog, can be just amazing. Get up early (or miss dinner) to make the most of these atmospheric effects.

Protect Your Gear Tip

Fog and moisture are fancy names for water, and digital cameras flat out do not like water, so make sure your gear is not getting silently soaked. You can buy rain gear for your camera from B&H, but in a pinch, use the shower cap from your hotel room and put it around your camera—it's not pretty, but it works.

Getting Rid of Lens Flare—The Manual Way

MATT KLOSKOWSKI

Another great reason to wear a baseball cap when you shoot (besides the two obvious reasons: [1] it protects you from the harmful rays of the sun, and [2] it looks cool) is to help eliminate (or at the very least, reduce) lens flare. If you're using a lens hood on your camera, that can certainly help, but I've found that often it alone is not enough. That's where your ballcap comes in—just take it off and position it above the right or left top side of your lens (depending on where the sun is positioned). Then look through your camera's viewfinder to see (1) right where to position your ballcap so it blocks the lens flare from the sun (it's easier than you think), and (2) to make sure your ballcap doesn't show up in your photo (I've had more than one photo with the edge of a ballcap in the frame. I guess that's why they make Photoshop—to remove silly stuff like that). I'm still surprised how well this totally manual technique for removing lens flare works.

The Landscape Photographer's Secret Weapon

So, earlier you learned about the polarizer and how essential that filter is. This filter, the neutral density gradient filter, isn't necessarily essential but it is the secret weapon of professional landscape photographers. It lets them balance the exposure between the ground and the sky to capture a range of exposure which, without it, their camera could never pull off (it's either going to expose for the ground or for the sky, but not both at the same time). For example, let's say you're shooting a landscape at sunset. If you expose for the sky, the sky will look great but the ground will be way too dark. If you expose for the ground, then the sky will be way too light. So, how do you get both the sky and the ground to look right? With a neutral density gradient filter (a filter that's dark at the top and smoothly graduates down to transparent at the bottom). What this essentially does is darken the sky (which would have been overexposed), while leaving the ground untouched, but the brilliance of it is the gradient—it moves from darkening (at the top of the filter) and then graduates smoothly down to trans-parent (on the ground). That way it only darkens the sky, but it does so in a way that makes the top of the sky darker, and then your sky gradually becomes lighter until the filter has no effect at all by the time it reaches the ground. The result is a photo where both the sky and ground look properly exposed.

Keeping Your Horizons Straight

Nikon

Canon

There is nothing that looks worse than a crooked horizon line. It's like when you don't get the fleshtone color right in a photo—it just jumps out at people (and people can't resist pointing this out. It doesn't matter if you've taken a photo with composition that would make Ansel Adams proud, they'll immediately say, "Your photo's crooked"). A great way to avoid this is by using the Virtual Horizon feature on your camera (if your camera has this feature, like the Nikon D3 shown above on the left) or with a double level—a simple little gizmo that slides into your flash hot shoe (that little bracket on the top of your camera where you'd attach an external flash). This double level gizmo has a mini-version of the bubble level you'd find at Home Depot and it lets you clearly see, in an instant, if your camera is level (and thus, your horizon line). The double level version works whether your camera is shooting in portrait or landscape orientation and is worth its weight in gold (of course, that's not saying very much, because I doubt the thing weighs even one ounce, but you get my drift). As luck would have it, they're more expensive than they should be—between $25 and $50—but still very worth it.

Shooting on Cloudy Days

SCOTT KELBY

This is another one of those things that may initially elicit a "Duh" response, but I've been out shooting with more photographers than I can think of who didn't think of this simple concept when shooting on gray, overcast days—shoot to avoid the sky. I know, it sounds silly when you're reading it here, but I've heard it time and time again, "Ah, the sky is so gray today, I'm not going to shoot." Baloney. Just take shots that limit the amount of visible sky. That way, if you make a tonal adjustment later in Photoshop (that's a fancy way of saying, "I'm going to make the sky look bluer than it really was on that gray, overcast day"), you won't have to work very hard. This just happened on my last shoot, where we'd have 20 minutes of blue sky and then an hour and a half of gray, overcast sky. I just really limited the amount of sky in my photos (I was shooting urban city photos), and then it took just seconds to fix in Photoshop. Here's what I did:

Step One: I opened one of the photos where the sky looked nice and blue, then took the Eyedropper tool (I), and clicked on the blue sky to make that my Foreground color.

Step Two: I then opened a photo with small amounts of gray, overcast sky and with the Magic Wand tool (W) clicked in the sky to select it (which took all of two seconds).

Step Three: I added a new blank layer above my Background layer and filled the selection with my Foreground color. That's it—my gray sky was blue.

Tips for Shooting Panoramas, Part 1

RANDY HUFFORD

There is something so fascinating about what happens when you stitch together five or six (or more) landscape photos into one long, single image. It's as close as you can get (with a photograph anyway) to recreating the experience of being there. Now, although this will take more than one page to describe, shooting panos right is easy, so if you're serious about panos, follow these rules. However, if you have Photoshop CS4, Photomerge is so vastly improved, you can simply just overlap each shot by 20% when you shoot your pano.

(1) Shoot your pano on a tripod.
(2) Shoot vertically (in portrait orientation) rather than horizontally (in landscape orientation). It'll take more shots to cover the same area, but you'll have less edge distortion and a better looking pano for your extra effort.
(3) Switch your camera's white balance to Cloudy. If you leave it set to Auto, your white balance may (will) change between segments, which is bad, bad, bad.
(4) There's more—go to the next page...

Tips for Shooting Panoramas, Part 2

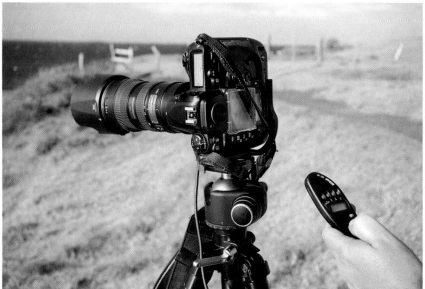

RANDY HUFFORD

(5) Press your shutter button halfway down to set your exposure, then look in your viewfinder and make note of the f-stop and shutter speed. Now switch your camera to manual mode and dial in that f-stop and shutter speed. If you don't, and you shoot in an auto exposure mode of any kind, your exposure may (will) change for one or more of the segments.

(6) Once you focus on the first segment, turn off auto focus for your lens. That way, your camera doesn't refocus as you shoot the different segments.

(7) Before you shoot your first segment, shoot one shot with your finger in front of the lens—that way you'll know where your pano starts. Do it again after the last shot.

(8) Overlap each segment by 20–25%. That's right, make sure that about 1/4 of your first shot appears in the second shot. Each segment needs to overlap by at least 20% so Photoshop's stitching software can match things up. This is very important.

(9) Shoot fairly quickly—especially if clouds are moving behind your landscape. Don't be lollygagging for two minutes between each shot. Git 'er done, or something could change (lighting, clouds, etc.) in your pano, which will really mess things up.

(10) Use a shutter release, or at the very least a self timer, so you don't have any camera movement as you're shooting each segment. Nothing's worse than one segment that is blurry.

Tips for Shooting Panoramas, Part 3

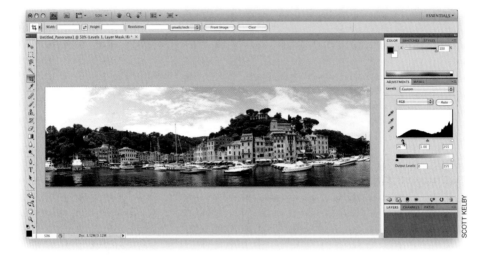

SCOTT KELBY

Now, if you followed the rules set out on the previous two pages, the rest is easy:

Step One: Open Photoshop and then open all the photo segments (so all the photo segments are open at the same time).

Step Two: Go under Photoshop's File menu, under Automate, and choose Photomerge.

Step Three: In the resulting dialog, from the Use pop-up menu, choose Files, then click the Add Open Files button. Make sure the Blend Images Together checkbox is turned on, and then click OK.

Step Four: Photoshop will then stitch the photos together into one seamless panorama (you may need to crop off any transparent areas). If you see a small seam at the top, between two segments, use the Clone Stamp tool (S) to cover it by pressing-and-holding the Option key (PC: Alt key) and clicking nearby in an area of sky that looks similar to sample that area. Then, choose a soft-edged brush from the Brush Picker and clone (paint) over the little seam to hide it.

Faking Panoramas

If you have Photoshop or Photoshop Elements, there's a great way to create a fake panorama—crop the photo so it becomes a panorama. Just get the Crop tool (C) and click-and-drag so it selects just the center of your photo (as shown above), cropping off the top and bottom. Then press Return (PC: Enter) and the top and bottom are cropped away, leaving you with a wide panoramic crop of your original photo. Hey, don't knock it until you've tried it.

Why You Need a Wide-Angle Lens

If you're shooting landscapes, you've probably come back from a shoot more than once and been disappointed that the incredible vista you saw in person didn't transfer to your photos. It's really tough to create a 2D photo (which is what still photos are—two-dimensional) that has the depth and feeling of being there. That's why I recommend one of two things:

(1) Don't try to capture it all. That's right, use a zoom lens and deliberately capture just a portion of the scene that suggests the whole. These can often be much more powerful than trying to fit everything into one photo, which often can lead to a photo without a clear subject, and with distracting images and backgrounds. This is why I often shoot with a 70–200mm lens—to get in tight on a portion of the scene.

(2) Buy a super-wide-angle lens. Not a fish-eye lens—a super-wide-angle lens (like a 12mm). If you're trying to capture it all, a super-wide-angle (sometimes called ultra-wide-angle) lens is often just the trick you need to take in the big picture. My favorite outdoor lens is my 14–24mm zoom lens (which is also a good sports shooting lens by the way). I must admit, I rarely use the 24mm end, because I use this lens when I'm trying to get "the big picture," so I use the 14mm end most of the time. You'll love what it does to clouds, almost giving them a sense of movement along the edges.

Shooting Wildlife? Aim at Their Eyes

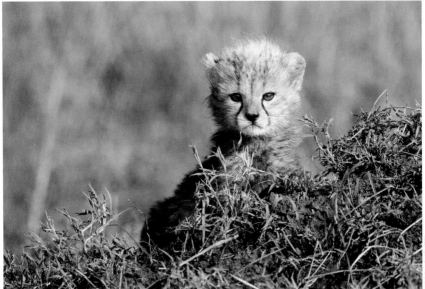

PEGGY GUENZEL

Okay, that headline doesn't sound great when you say it out loud (it sounds like we're actually shooting wildlife with a gun, rather than taking photos), but it's right on the money. When you're shooting wildlife photography, your point of focus needs to be the animal's eyes. If they're not in focus, it doesn't matter what else is. Oftentimes you'll be capturing wildlife in motion (or in flight, as the case may be), and that's where it's especially important to make certain the eyes are in focus. If you're using a panning technique (where you follow the moving animal with your lens), make sure your focal point is the eyes. Everything else can be blurred, but keep those eyes tack sharp and you'll have a winner.

Don't Crop Wildlife in Motion Too Close

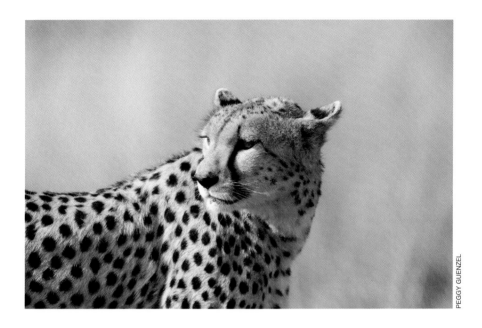

PEGGY GUENZEL

If you're shooting wildlife, when you're composing the image, don't frame it so close that the animal has nowhere to go. In other words, give the animal some space in front of the direction it's going for a much stronger composition—one that tells a story. If you crop in too tight and don't leave room for the animal to exit the frame, it's almost like trapping them in your shot, and the photo will look uncomfortable to the viewer. When you're composing in the viewfinder, leave some extra space to "run" in front of your subject, and your photo will be that much stronger for it.

Shooting Wildlife? Get in Really Tight

There is a phenomenon that happens when shooting wildlife that doesn't seem to happen when shooting anything else. However close your subject looks in your view-finder, when you see the actual photo it seems only half as close as you remember. It's crazy, but it's consistent—it always looks much farther away than you hoped. So, when it comes to shooting wildlife, you want to get in incredibly tight. That's why the pros shoot with those giant 400mm and larger lenses. But if your budget doesn't allow for that (I know mine doesn't), you can cheat and use a teleconverter (also sometimes called a tele-extender). These basically extend the reach of your current telephoto (or zoom) lens by magnifying them. So if you have a 200mm telephoto (or zoom) lens (which is already equivalent to around a 300mm thanks to digital), and add a 1.4x or 2x teleconverter, you instantly have the equivalent of a 450mm or 600mm traditional telephoto lens. A Canon 1.4x teleconverter runs around $290, and a Nikon 2x teleconverter runs around $400 (make sure you check to see that the teleconverter you buy works with your current lens—get it to match your make and model).

What to Shoot at Sunset

©ISTOCKPHOTO/ANDRZEJ BURAK

Besides just shooting the sunset itself, another great subject to shoot at sunset is silhouettes. There are two basic rules to shooting silhouettes: (1) make sure the subject (or the object) you're silhouetting is easily recognizable. I see lots of silhouette snapshots where my first thought is, "What is that thing?" Keep the object simple, and it will work much better. (2) Position your subject directly in front of the setting sun, so the sun is covered and helps outline your silhouette, then expose for the sky (this will pretty much make certain that your subject will appear in a black silhouette).

Silhouette Tip

Keep an eye on lens flare when you're shooting silhouettes because you're basically shooting into the sun. You'll see a lot of classic silhouettes where the sun is peeking around the subject just a tiny bit, and that's okay if you like that effect, but make sure it doesn't reveal too much detail in your subject—they should remain black.

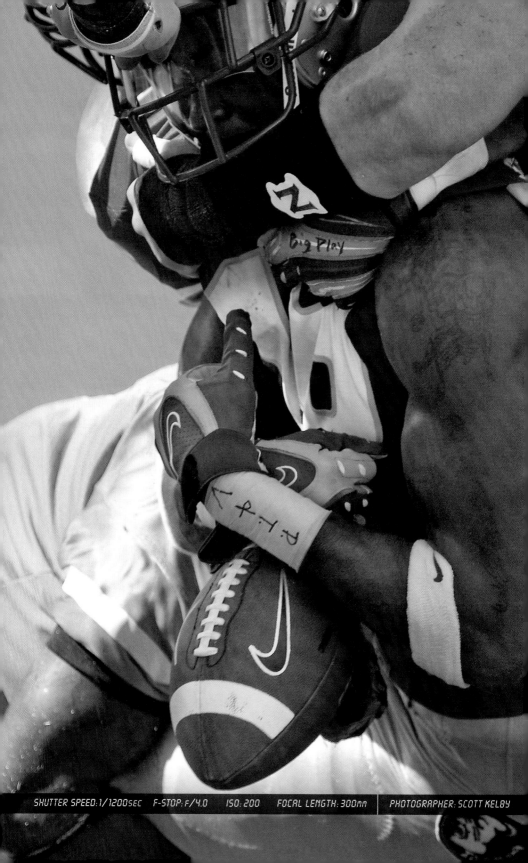

Big Play

SHUTTER SPEED: 1/1200SEC F-STOP: F/4.0 ISO: 200 FOCAL LENGTH: 300MM PHOTOGRAPHER: SCOTT KELBY

Chapter Five

Shooting Sports Like a Pro

Better Bring Your Checkbook

This is the one chapter in the book where you have a choice. Do you want to get much better at shooting sports using the tips the pros use, but pretty much use your own existing gear? Or, do you want to seriously shoot sports for a living? Here's why I mention this: we're going to conduct a brief, totally scientific test which will quickly determine which path you should take. Ready? Let's begin. Question 1: This book retails for $24.99. When you turned the book over to look at the price, how did you react? You thought: (a) $24.99, that's cheap enough— I think I'll buy it; (b) I dunno, it's $24.99—I hope this is worth it; (c) $24.99, that's pretty steep, but I really need to learn this stuff; or (d) $24.99! $24.99! I can't believe they're charging $24.99! Well, I'm not happy about it, but I have to have this book. Answer: If you answered a, b, c, or d, you're not ready to enter the world of professional sports photography, because professional sports photographers spend so much on their equipment that they would never even think of looking at the price of anything. Ever. They see something they want and they just take it to the checkout counter and buy it, never questioning its price, because they figure they've spent so much on their photography equipment, there's no way any book, or flat screen TV, or luxury car could ever cost anything close. So what are we mere mortals to do? We use the tricks in this chapter to get better shots with what we've got. Of course, a few accessories wouldn't hurt, right?

Set Your White Balance for Indoor Sports

If you're going to be shooting sports indoors, you can count on your photos having a yellow or green tint, caused by the indoor lighting used at most indoor events. You can save yourself a lot of Photoshop editing down the road if you change your white balance to either Fluorescent or Tungsten/Incandescent now, in the camera. (Set it at Fluorescent and do a test shot, then take a look at your test shot in your LCD monitor. If the overall color looks too yellow or green, then try Tungsten/Incandescent. See the Nikon menu above.) By doing this, you're offsetting the yellow or green tint you would have had, which will keep you from pulling your hair out later. If you're shooting in RAW format, you can always reset the white balance later in your RAW processing software. But by setting the correct white balance in the camera, at least you'll see your photos in the proper color temperature when you view them in the LCD monitor on the back of your camera.

Don't Use Color Filters

Your first thought might be to add a screw-on color balance filter to your lens to offset the indoor color cast, but don't do it. When you're shooting sports, you're already going to be challenged by lower than ideal lighting situations, and adding a filter takes away even more light. You're better off using a custom white balance setting because it only affects the color of light, not the amount.

Shoot at a 1/640 Sec. Shutter Speed or Faster

SCOTT KELBY

With sports photography, most of the time you're going to want to stop the action, and to do that you'll have to switch to shutter priority mode (or manual mode if you're comfortable with it), and then shoot at a speed of at least 1/640 of a second (or faster—an ideal setting of 1/1000 will freeze any sport) to stop the motion and keep your image sharp. The slowest you can generally get away with is 1/500 of a second, but that's iffy. Go with 1/640 or higher for better results (there are times when you're going to intentionally want to shoot at slower speeds so you can blur parts of the photo to exaggerate the movement and speed, but for most situations, you'll want to freeze the motion with a faster shutter speed like we're using here).

Pro Sports Shooting Is Dang Expensive

Of all the photographic professions, professional sports photography is probably the most expensive, so if you think you want to go this route, better bring your checkbook. The main reason it's so expensive is because many sporting events are held indoors (or in domed stadiums) or at night, so you'll need the most expensive (fastest) lenses money can buy (well, only if you want to compete at a professional level). For example, you're going to need some long telephoto lenses (ideally 400mm or 600mm) and since you'll generally be shooting in lower-light situations, they'll need to be f/2.8 to f/4 lenses. If you haven't priced quality 400mm f/2.8 lenses, they're around $6,600. Each. You'll also need more than one camera body, and more than one external flash. Plus a couple of monopods—one or two to hold your long heavy lenses, and one to strap your flash units (which cost $200 and up apiece) to. Also, to be competitive (with the pro shooters), you're going to need a camera body that shoots around 8 frames per second (which means as a Canon shooter, you're going to spend around $3,700 for an EOS-1D Mark III or for a Nikon shooter, you're going to spend around $4,300 for a D3). By the time you add up two camera bodies, a handful of flashes, some long, expensive lenses, monopods, teleconverters, lots of very fast memory cards (plan on shooting around 900 photos for a typical baseball or football game), you're in the $30,000 and up range, just for starters. It helps if you were a doctor or lawyer first (it doesn't make you a better sports photographer, but it helps you pay for your gear).

Don't Plan on Changing Lenses

©ISTOCKPHOTO/ANTONIO HARRISON

Now, don't read this headline to mean you only need one lens for sports photography. It means just what it says, don't plan on changing lenses—plan on changing cameras. That's right, if you're really into sports photography, you'll miss "the shot" if you have to change lenses. That's why the pros have multiple camera bodies hanging around their necks—so they can change from a wide-angle lens to a 400mm telephoto in an instant. If they didn't do this, while they were changing lenses, the guy next to them would be getting "the shot" (which winds up on the cover of the magazine). If you want to compete with the big boys, you'll be hanging more than one camera body around your neck so you're ready to catch the shot with a moment's notice. I told you this digital sports photography thing was expensive.

Which Lenses to Use

©ISTOCKPHOTO/TAN KIAN KHOON

When you're shooting sports, carrying a load of lenses and a big camera bag (even a camera backpack) will strain your back and just add to your frustration. Instead, go light with just two lenses:

(1) A wide-angle lens (like a 14–24mm zoom). You'll need these wide angles to capture full stadium shots, full court shots, close-up group shots, etc.

(2) A 300mm or 400mm telephoto lens (or a 200–400mm zoom). You'll be better off if you can spring for a VR (Vibration Reduction for Nikon cameras) or an IS (Image Stabilization for Canon cameras) lens, because you'll be able to hand-hold more shots in the lower lights of indoor events or nighttime events.

Again, you're not going to want to change lenses, so ideally you'd put one lens on one camera body, and one lens on the other. The only other thing you'll need to carry (besides extra memory cards and a backup battery) is a 1.4x teleconverter to get you even closer to the action (these magnify the amount of zoom, turning a 300mm telephoto into a 450mm). Note: Some pros advise against 2x teleconverters because they feel 2x photos are not as sharp and you lose up to two f-stops of light, making it harder to get the fast shutter speeds you need. To move all this stuff around with the greatest of ease, try a Tenba or Domke photo vest, or at the very least, keep your extra gear in a photo waist pack rather than a camera bag or backpack. You'll thank me later.

Pre-Focus to Get the Shot

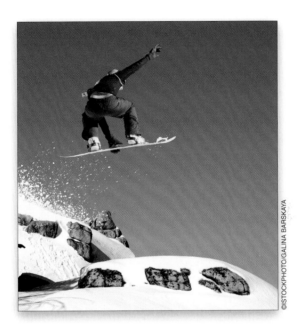

©ISTOCKPHOTO/GALINA BARSKAYA

If you're covering an event where you have a pretty good idea where the action is going to happen (for example, you're covering baseball and you know the runner on second base is headed to third, or you're covering snowboarding and you know approximately where the snowboarder is going to land), pre-focus on that spot, so when it happens, all you have to do is press the shutter button. You can start by leaving auto focus on, and then focus on the spot where you expect the action to occur, then switch your lens to manual focus and leave the focus alone (it's set). Now you can pretty much relax and watch the event unfold. When the runner (jumper, skier, etc.) gets near your pre-focused point, just aim back to that area and fire—knowing the focus is locked onto that point. No waiting for auto focus to either get, or miss, the focus. You're good to go—just fire away.

Raise Your ISO to Get the Speed You Need

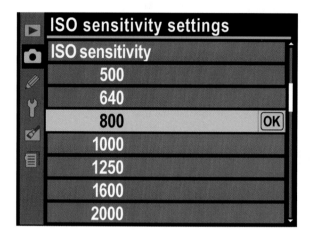

Ideally, you'd have a super-fast long lens (like an f/2.8 or f/4, right?) for your sports shooting, but those cost a bundle. So, how are you going to shoot sports with your f/5.6 zoom lens? By raising the ISO, that's how (see Nikon menu above). You can get away with 800 for most decent quality digital SLRs these days (the Canons, Nikons, etc.). That should give you the 1/640 sec. or higher speed you need to freeze the motion of sports without too much visible noise. Now, if there's enough light where you're shooting so you don't need to raise the ISO—don't do it. Preferably, you'll leave your ISO at 100 or 200 (or whatever the lowest ISO is that your camera allows), but in situations where your lens just isn't fast enough (which will probably be the case when shooting indoors with f/5.6 lenses, which are fairly common), you'll have no choice but to raise the ISO. You do that in the menu on the back of your camera (as shown here). Luckily, you can usually get away with an f/5.6 lens when shooting in daylight, but as soon as you move indoors, you're probably going to have to raise your ISO to get enough shutter speed to freeze the action. That's why fast lenses (f/2.8 and f/4) are so important to pro sports shooters.

The Pros Know the Game

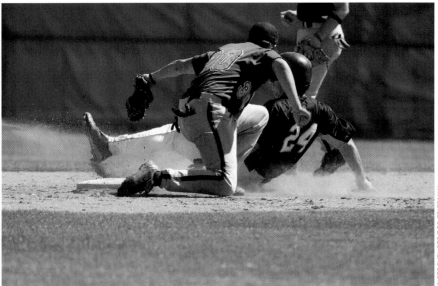

©ISTOCKPHOTO/ROB FRIEDMAN

If you know the game you're shooting (for example, if you're a baseball fanatic and you're shooting a baseball game), you're going to get better shots than the next guy because you're going to know where the next play is likely to unfold. This is a huge advantage in sports shooting, and being able to anticipate when and where the big moment will unfold can make all the difference in getting "the shot." The key is you have to watch the game while you're shooting, so you can see the play unfolding and be ready to aim where you feel the action will take place. You won't always be right, but you'll be right enough that you'll get the shot more often than not. So, what if you're assigned to shoot a game you don't know well? Go to Blockbuster and rent some videos, go to the magazine store and buy some magazines on the topic, and study how the pros that cover that sport are shooting it—find out who the stars are in that sport and make sure you follow them (after all, the stars are most likely to be involved in the big plays, right?). It basically comes down to this: if you know the game, you're putting yourself in the best position to get "the shot." If you don't know the game, the only way you'll get "the shot" is by sheer luck. That's not a good career strategy.

Don't Always Focus on the Winner

©ISTOCKPHOTO/JAMES BOULETTE

In sports photography (and in sports in general), it's only natural to follow the winner. If someone scores a critical point, you'll be capturing shots of the athlete that made the big score, right? If a team wins, you'll be shooting shots of the winning team celebrating. But if you follow that tradition of covering only the winner, you might miss some of the most dramatic shots with the most powerful story-telling angle, which are the expressions and reactions of the loser or the losing team. This is especially important if you just missed the action play—quickly switch to the reaction of the guy who missed the ball, or didn't block the shot, or missed the goal, etc. Sometimes their reactions are more fascinating than those of the person who makes the shot. Next time, try catching the expression of the golfer who missed the putt (or the golfer who lost because her opponent just sank a 40-footer), and see if it doesn't elicit as much or more emotion as a shot of the winner.

Shooting in Burst Mode

Nikon

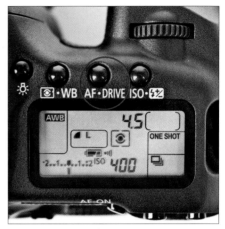

Canon

Much of the shooting you'll be doing in sports photography will require you to take bursts of shots (four or more shots per second) in order to make sure you get the shot while a play is in motion. So, you'll need to set your camera to shoot multiple shots while you hold down the shutter button (this is called burst mode on some digital cameras). By default, most cameras shoot one frame at a time, so you'll have to switch this burst mode on.

On Nikon cameras, you can switch the camera's mode to continuous (where holding down the shutter release takes multiple photos) by holding down the release mode button (found to the right of the control panel) and rotating the main command dial until you see an icon of a stack of photos in the top right of the camera's LCD monitor.

On Canon cameras, press the Drive•ISO or AF•Drive button (which appears just in front of the LCD panel on the top-right side of the camera), then rotate the quick control dial (to the right of the LCD monitor) until you see an icon that looks like a stack of photos with an H at the bottom right on the right side of the LCD panel.

Now, you can simply hold down the shutter button to fire multiple shots.

Stability for Shooting Sports

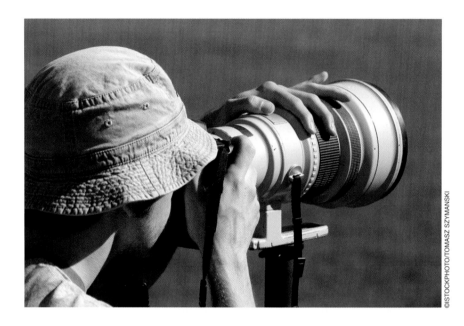

©ISTOCKPHOTO/TOMASZ SZYMANSKI

Sports photographers don't generally use tripods for a number of reasons: (1) they're not mobile enough for the fast-action shooting that typifies sports photography, (2) many professional sports won't allow the use of tripods, and (3) having a tripod set up near the playing field (in football, basketball, etc.) has the potential to injure a player. That's why sports shooters, especially those shooting with long lenses, use monopods instead. These one-legged versions of tripods generally wind up supporting those long lenses (the lens attaches directly to the monopod itself for support and to keep the lens and camera still during the low-light situations many sporting events are played under). Monopods are easy to move (or to quickly move out of the way if need be), and many professional sports that ban tripods allow monopods. Carbon fiber monopods are the most popular because, while they can hold a lot of weight, they are surprisingly lightweight. Now, not surprisingly, they're not cheap (nothing in sports photography is).

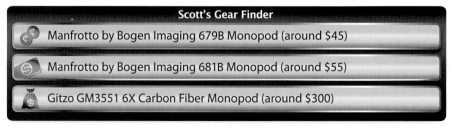

Scott's Gear Finder

Manfrotto by Bogen Imaging 679B Monopod (around $45)

Manfrotto by Bogen Imaging 681B Monopod (around $55)

Gitzo GM3551 6X Carbon Fiber Monopod (around $300)

Shoot Vertically for More Impact

Much of pro sports photography is shot vertically because it's easier to fill the frame with your subject (plus, it's ideal for magazine covers, ads, etc.). Just turn the camera sideways, get in tight (with your long lens) and make the magic happen (so to speak). This particularly holds true if you're shooting a single athlete, rather than two or more, where a horizontal shot might work best, but when it comes to shooting a single subject, your best bet is to go vertical. That being said, if you want to really cover your bases (like the way I worked that sports metaphor in there), shoot both as much as possible. As my tech editor Bill Fortney says, "The editor will always ask for the orientation you didn't shoot."

Pan to Show Motion

©ISTOCKPHOTO/ANDREA LEONE

For this entire chapter we've been talking about using super-fast shutter speeds to freeze the motion of sporting events, but there are times when it's more dramatic to emphasize the motion and let parts of the photo become intentionally blurry from movement. There are three keys to this technique:

(1) Use a slow shutter speed—ideally, either 1/30 of a second or 1/60 of a second. So, switch to shutter priority mode (using the mode dial on the top of your digital camera) and set the shutter speed accordingly.

(2) Pan right along with your subject—following them with your camera. Believe it or not, it's the camera's motion that creates the blurring background, because you're trying to move (pan) right along with the athlete so they remain sharp while everything around them appears blurred.

(3) Use continuous shooting (burst) mode for your best chance to capture a sharp shot—capturing multiple shots per second really pays off here.

One important thing to remember: Don't stop panning when the athlete leaves your frame—continue panning for a couple of seconds afterwards to get a smooth release.

Shoot Wide Open

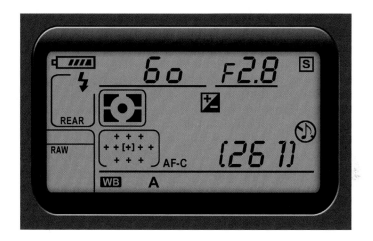

By shooting wide open, I mean shoot as close to your wide open aperture as possible (so if you have an f/2.8 lens, shoot at f/2.8 or one stop up). This will pay off in two ways:

(1) This will blur the background, creating a more dramatic, dynamic, and uncluttered photo of your subject. Busy backgrounds are a problem when shooting sports, and shooting with a telephoto lens at such a wide open aperture gives you a very shallow depth of field (meaning your subject in the foreground is in focus, while the background is out of focus).

(2) You'll be able to shoot at faster shutter speeds, which will greatly help when shooting indoors under artificial low-light situations.

Go for the Face

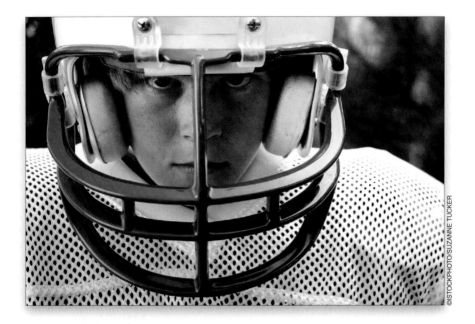

When you're shooting athletes, what's the most important thing to capture? Generally, it's their face. It's their facial expressions that tell the story, and it's their faces that people want to see. So if you're not capturing that, you're missing "the shot." Don't worry about shooting close-ups of their hands, or the ball, or their feet kicking up dirt, etc. Want a photo that's going to capture the imagination of your viewer? Then go for the face. It's the "money shot"!

RAW or JPEG for Sports Shooters?

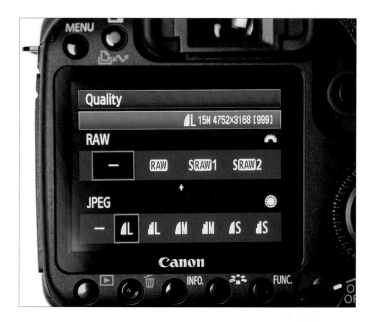

Because of the fact that much of sports photography is taken in burst mode (see page 103) and the fact that you only have so much memory space in your camera's multiple-shot buffer, the larger the photos you take, the quicker that buffer will become full. When it's full, you're done shootin' (well, at least until it has time to write the shots to your memory card, which empties the buffer again). That's why many pro sports photographers choose to shoot in JPEG format rather than RAW. It's because JPEG files are considerably smaller in file size so more of them fit in the buffer (plus, since they're smaller, they write to your memory card faster, so you can effectively shoot more uninterrupted shots in JPEG format vs. RAW format). Now, there are some purists who feel so strongly about shooting in RAW for every occasion (including shots of their kid's birthday party at Chuck E. Cheese) that reading about anyone advocating any file format other than RAW sends them scrambling into a tower with a high-powered rifle to pick off pedestrians. To them, I just say, "Remember, RAW is a file format. Not a religion." (By the way, I know a popular *Sports Illustrated* magazine shooter who now sets his cameras to shoot RAW+JPEG, which captures both file formats at the same time. Just thought you'd like to know.)

Composing for Sports

©ISTOCKPHOTO/GLENN JENKINSON

When composing your sports images, use the same technique we talked about earlier in shooting wildlife (Chapter 4)—give your athlete somewhere to go. Don't compose the shot so your athlete is running out of the frame, compose it so there's room in front of the athlete to move to continue his visual story, so the athlete (like the wildlife) doesn't look boxed in. It's as uncomfortable a look for sports as it is for wildlife, so when you're composing, be sure to leave some running room (i.e., for a shot of an athlete running left, compose the shot with him on the far right side of the frame. That way, he visually has room to run). This simple compositional trick will make a big difference on the impact of the final image.

SHUTTER SPEED: 1/60SEC F-STOP: F/2.8 ISO: 200 FOCAL LENGTH: 102mm PHOTOGRAPHER: SCOTT KELBY

Chapter Six

Shooting People Like a Pro

Tips for Making People Look Their Very Best

Now, the subhead above says this chapter is how to make people look their very best, and that is kind of misleading because it's really about making your photos of people look better. If you've got some really ugly looking people in your photos, there's not much you or I can do to help these poor souls. They've been hit with the ugly stick, and they don't make a digital camera that will make these people, who didn't have a date for the prom, suddenly look like Halle Berry or Hugh Jackman (who, not coincidentally, were chosen as the Sexiest Woman Alive by *Esquire* magazine and Sexiest Man Alive by *People* magazine, just in case you cared). By the way, although I did not make this year's cut, if you read my bio at the beginning of this book, you learned that I was among *People* magazine's top 50 sexiest picks back in 2004. This surprises many people, including my wife, as she has no recollection of this whatsoever, but I'm actually thankful for that because she has also completely erased any memory of my brief but highly publicized affair with Angelina Jolie while we were filming the movie *Taking Lives* in Toronto. But I digress. Now this chapter isn't so much about studio portrait techniques, because if you're shooting in a studio, then you're a professional photographer and, honestly, this chapter (and this book for that matter) really isn't for you. This is really for getting better outdoor, or candid, or posed shots that are supposed to look candid, but really aren't, but you can tell they are because they're posed. Are you taking all this down?

The Best Lens for Portrait Photography

There are not many aspects of photography that have a specific focal length you should try to shoot with, but luckily portrait photography is one of them. Most pros shoot portraits with a short zoom lens, and one of their favorite focal lengths is the 85–100mm range. In fact, telephoto lenses in the 85–100mm range are often called portrait lenses because they let you shoot from a good working distance (10 to 12 feet from your subject, giving you and your subject some breathing room, while letting you still fill the frame with your subject), but more importantly, shooting with focal lengths between 85mm and 100mm eliminates the unflattering facial distortion wide-angle lenses are notorious for, while avoiding the compression long telephoto lenses give. Some portrait pros swear that the 85mm focal length is the portrait sweet spot, and others swear by 100mm, but that's the kind of thing pros debate in online forums all day long (and you can try both with your zoom lens and choose the one you like best, because they both give a pleasing perspective for portraits), so I won't take up that battle here. (*Note:* Both Nikon's 18–105mm zoom and Canon's 28–105mm zoom are ideal for portraits because you can choose 85mm, 100mm, or anything between the two.) Another reason these short zoom lenses are ideal is because you won't have to pick up your tripod and move it (or your model) each time you need to slightly recompose the shot. So, get yourself a zoom lens that covers the 85–100mm range, and you're good to go. By the way, the lens shown here is a 24–120mm zoom, so this lens would do the trick because with it you can choose any zoom focal length between 85mm and 100mm (the sweet spots for portraits).

Which Aperture to Use

SCOTT KELBY

One thing I love about portrait photography is that a lot of the decisions are made for you (like which lens/focal length to use), so you can focus on the harder parts of portrait photography—ensuring that you have great light and capturing the personality of your subject. So, now that you know which lens to use, believe it or not (and this is very rare), there is a special aperture (f-stop) that seems to work best for most portrait photography. When it comes to portraits, f/11 is the ticket because it provides great sharpness and depth on the face (and isn't that what portraits are all about?), which gives you a great overall look for most portrait photography (now, I say "most" because there are some artistic reasons why you might want to try a different aperture if you're trying to get a special effect, but for the most part you can choose aperture priority mode, set your aperture at f/11, and then worry about the really important stuff—the lighting, capturing your subject's personality, how much to bill your client, etc.).

Using Seamless Backgrounds

©ISTOCKPHOTO/TOBIAS LAUCHENAUER

Backgrounds provide quite a challenge for portrait photographers because they generally get in the way of the portrait photographer's goal—capturing the personality, the drama, the soul (if you will) of the person they're shooting. That's why so many portrait photographers shoot their subjects on as plain a background as possible. In the studio, perhaps the least expensive option is to use a seamless background—these are very inexpensive because they're made of paper. That's right, it's just a big giant roll of paper, and a standard size (53"x36') will only run you about $25. That ain't bad for a professional studio background (you can find these backgrounds at your local camera store). Some photographers tape it to the wall, others nail it to the wall, but the best option is probably to buy an inexpensive stand that holds the roll up for you (you can get a decent one for around $100). Now, which colors should you use? For starters, stick with black (for dramatic portraits) or white (for everything else). The nice thing about a white seamless background is that it usually appears as a shade of gray. To make it really appear white like the one above, you'll have to aim one or more lights at the background or the light from your flashes will fall enough, giving you a gray backround. Gray is not a bad background color (in fact, it's very popular), but if you're really going for white, make sure to position one or two lights behind your subject, aiming at the background itself. If you go with a black seamless background, you may need an extra light to backlight your subject (especially if they have dark hair), so they stand out against the black.

Using Canvas or Muslin Backgrounds

©ISTOCKPHOTO/FLOYD ANDERSON

Canvas or muslin backgrounds aren't quite as cheap—I mean as inexpensive—as seam-less rolls, but they're inexpensive enough that you should consider using one as a formal background, as well (a decent canvas background only runs around $185). These back-grounds are seamless too, and I'd recommend buying one (at least to start) that's kind of neutral, like one that's mostly gray or mostly brown. These backgrounds add texture to your photo without distracting from the subject, and they're very popular for use in everything from formal business portraits to engagement photos. Again, an inexpensive stand will pay for itself in no time (they start at around $100), and you'll be amazed at how quickly you can change the look of your background by repositioning your lighting.

The Right Background Outdoors

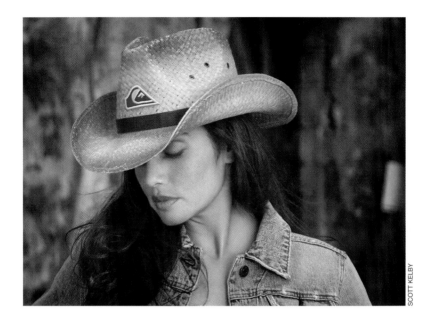

SCOTT KELBY

When shooting portraits outdoors, you're not going to be able to use a muslin background or seamless paper (did I even have to say that?), and because of that you have to think about your background even more. The background rule for shooting portraits outdoors is to keep the background as simple as possible. The simpler the background, the stronger your portrait will be, so position your subject where the least possible amount of activity is going on behind them. Here's where you might want to break the f/11 rule, so you can throw the background out of focus by using an aperture like f/2.8 or f/4 with the portrait focal length you like best. Remember, when it comes to portrait backgrounds outdoors, less is more.

The Background Lighting Rule

When it comes to backgrounds, there's another simple rule you can follow that will keep you out of trouble. When you're choosing a simple background to shoot on, make sure your background is no brighter than your subject (in fact, darker is better because a dark subject on a bright background rarely works).

Where to Focus

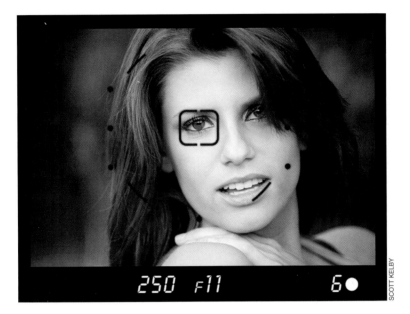

250 ғ11 6●

SCOTT KELBY

Over the years, there have been conflicting thoughts as to where the optimal place is to focus your camera when shooting portraits (the cheek, the tip of the nose, the hairline, etc.). Luckily, today the consensus is fairly clear (you'll still find some cheek holdouts here and there, but don't let them throw you): focus directly on the subject's eyes. By shooting at f/11 and focusing on the eyes, this will give you a nice level of sharpness throughout the face (and most importantly, the eyes will be tack sharp, and in portraits that is absolutely critical).

Where to Position Your Camera

BRAD MOORE

Portraits generally look best when you position your camera at the subject's eye level, so set your tripod up so you're shooting level with their eyes. (*Note:* Here, I'm not using a tripod because the speed of the flash will freeze any motion.) This is particularly important when shooting children—don't shoot down on children (just like you don't shoot down on flowers), or you'll wind up with some very disappointing shots. So, with kids, you're either going to raise them up to your eye level (on a tall seat) or you're going to lower your tripod down to their eye level and shoot on your knees (I know—the indignities we have to suffer for our craft and all that…). Also, now that you're at the right height, about how far back should you position your tripod from your subject? Your focal length will pretty much dictate that for you, but if you're about 6 to10 feet from your subject, depending on your lens, you'll be in good shape.

 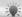

Positioning Your Subject in the Frame

If you're shooting portraits outdoors, especially candid portraits or editorial style shots, there's a rule that many pros use about where to position the subject's eyes in the frame—position them 1/3 of the way down from the top of the frame. This is another one of those tricks that gives your portraits more visual interest, and it's easy enough to do since you just compose the shot so your subject's eyes are 1/3 of the way down from the top.

Tip for Framing Portraits

SCOTT KELBY

If you're looking for another tip for great portrait shots, try zooming in close so your subject's face fills the entire frame. Also try zooming in close enough so that either the top of the head or the sides (the ears) actually extend outside the frame.

Getting Great Light Outdoors

SCOTT KELBY

Although there's plenty of light for shooting portraits outdoors in the middle of the day, most of that light is very direct and will wind up casting hard, unflattering shadows on your subject's face (not to mention that your subject will usually be squinting, sweating, or both). So, how do you get great outdoor portraits at two o'clock in the afternoon? It's easy—move your subject into the shade, where the light is softer, and the shadows are less prominent and much softer. Now, don't move into a cave—just move to a shady area near the direct sunlight (typical places include under a large tree, under the overhang of a building or house, on the porch of a house, under an umbrella, etc.). Just find a place you'd normally go to get out of the sun on a hot day, and you're ready to get portraits where your subject isn't squinting, and the light is soft and flattering. The photos above perfectly demonstrate the advantage of doing this. The shot on the left was taken in direct sunlight and the shot on the right, of the same model in a similar pose, was taken one minute later less than 30 feet away but in open shade. Notice how much softer and warmer the light is, how vibrant the color is, and how much better the same model looks. All I did was move her into the shade. It makes that big a difference.

Getting Great Light Indoors

SCOTT KELBY

What's the pros' trick for getting great portrait light indoors without setting up some extensive studio lighting? Use the best light ever created—natural light. This is such wonderful light that many pros insist on using nothing but natural light for their portraits. To take advantage of this wonderful light source, just position your subject beside a window in your house, office, studio, etc., that doesn't get direct light. The most ideal window light is a north-facing window, but any window getting nice, soft, non-direct sunlight will work. If the window is dirty, that's even better because it helps diffuse the light and makes it even softer. If the only window you have gets direct light, try using sheers (thin curtains that are almost see-through—you find these in hotel rooms quite often, and they make great light diffusers). You can position your subject standing or sitting, but to keep the light from looking flat, make sure your subject is getting side light from the window—not direct light. The soft shadows on the other side of the face will enhance the portrait and give it depth and interest.

Don't Forget the Shower Curtain Trick

That's it—don't forget the frosted shower curtain trick you learned in Chapter 2. It can work wonderfully well here too, and although your subject may think you're a little lame for pinning up a frosted shower curtain, the people who look at their portrait will only think, "What soft, magical lighting—your photographer must be a genius" (or something along those lines).

Taking Great Photos of Newborn Babies

SCOTT KELBY

By now you've probably heard how hard it is to photograph babies. That may be true, but newborn babies usually have a distinct advantage—they're asleep. That's right, newborns spend most of their days sleeping, so getting great shots of them is easier than you'd think—but you have to put them in the right setting or everyone who looks at the photos will say something along the lines of, "Aw, too bad she was asleep." Generally, people like babies to be wide awake and smiling in photos, but there's a very popular brand of newborn photography where the baby and mom (or dad) are sharing a quiet moment, and it really sets the stage for a touching portrait. I saw this first-hand when David Ziser (the world-class wedding and portrait photographer) spent one evening photographing my newborn daughter, Kira. Now, David had a huge advantage because my daughter just happened to be the cutest little baby in the whole wide world, but he did stack the deck in his favor with a simple, but extremely effective, technique—he had my wife and I both wear long-sleeved black turtleneck shirts (you can find these at Target). Then, he photographed Kira as my wife held her in her arms (I took a turn as well). David shot very tight (zoomed in), so what you basically got was a sweet little baby resting peacefully in her mother's (and father's) arms. You can use a diffused flash (more on this in Chapter 3), or you can use soft natural light from a side window.

Great Sunset Portraits

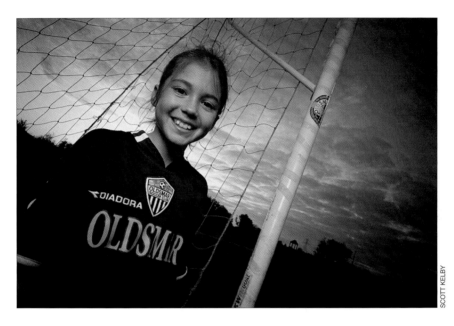

SCOTT KELBY

Everyone wants to shoot portraits at sunset because the sky is so gorgeous, but the problem generally is that (a) your subject either comes out as a silhouette because the sunset is behind them, or (b) you use a flash and your subject looks washed out. Here's how to get great portraits at sunset without washing out your subject: start by turning off your flash and aim at the sky. Then hold your shutter button halfway down to take an exposure reading from the sky, and while still holding the shutter button halfway down (or you can turn on the exposure lock button on your digital camera), recompose the shot by aiming at your subject, but now turn the flash on and reveal your subject with the light of the flash. This way, your subject gets fill flash, but the sky behind them still looks great. It's an old trick, but it's still around because it works so well.

Better Natural-Light Portraits with Reflectors

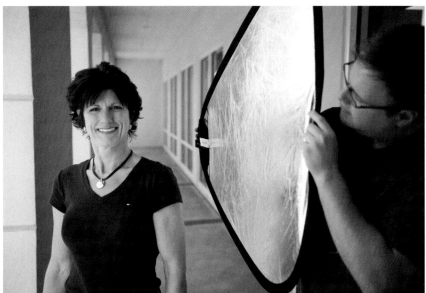

SCOTT KELBY

If you're going to be shooting portraits using glorious, wonderful natural light, there's something you probably ought to pick up that will make your portraits that much better—one (preferably two) collapsible reflectors (I choose collapsible reflectors because they take up virtually no storage space when you're not using them). These aren't just for big-time pros because they just don't cost that much, but they do wonders for opening up the shadows in your portraits and making the most of that marvelous natural light. You simply use these to reflect (or bounce) the natural light from the window back into the shadow areas in your subject.

I use the Lastolite 20" circular collapsible reflectors with gold on one side (if you want the light you reflect to look warmer) and silver on the other side (for a cooler reflected light). They sell for around $24 each. I told you they didn't cost much, but the results are golden (or silver, as the case may be).

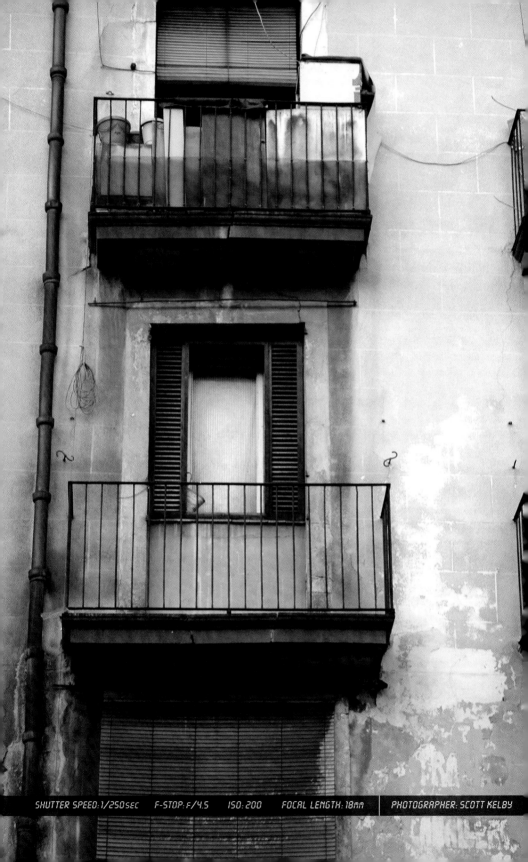

Chapter Seven

Avoiding Problems Like a Pro

How to Avoid Digital Headaches

Pros are out shooting every day. And when I say out, if they're studio photographers they're actually usually shooting indoors, so in that case, of course I mean they're out shooting in the studio. Stick with me here, will ya? Anyway, these pros are out shooting every day, while most of the rest of us only get to shoot when our wives let us. I mean, we only get to shoot on certain occasions (like when our wives are out of town), so although we run across digital problems when we're shooting, since we won't have to deal with them again until our wives fly to Minnesota to visit their parents, we just let them slide. The pros don't because they have to deal with these things every day (meaning their in-laws live in the same town they do), so the way they keep from having migraine headaches the size of the Shuttle's booster rockets is by figuring out clever ways to deal with them on the spot. So, this chapter is kind of a shortcut because you're going to get the benefits of years of other people's headaches, but you're going to get to fix them right now, sidestepping one of the real downsides of shooting digital, and that primarily is having to shoot your cousin Earl's wedding (see, you should have listened to your wife when she told you not to get that long lens). Now, you may have noticed that I've been referring to wives as if all photographers were men, and clearly that's not the case. It's just that I am a man (a masculine, mannish, manly man) and therefore it would be silly for me to say, "My husband didn't want me to go shooting that day," when you know darn well he wouldn't mind. Wait—that's not what I meant.

Pro Tips to Avoid White Balance Problems

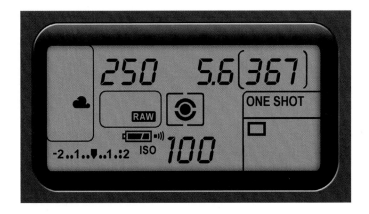

White balance problems often happen when you shoot indoors under fluorescent, incan-
descent, or just "them regular ol' light bulbs." Of course, you don't generally find out about
them until you open the photos later on your computer and all the shots have either a
yellowish, or greenish, or blueish color cast. By default, your camera is set to Auto White
Balance, which works pretty well outdoors, but generally doesn't work worth a darn indoors.
The pros use three methods to avoid white balance problems when they shoot: (1) they go
into the camera and choose a preset white balance setting that matches the lighting they're
shooting in (it's easier than you think—just go to your camera's white balance section, and
choose either Incandescent [for regular indoor lighting] or Fluorescent [for typical office
lighting]). You can choose preset white balance settings for outdoor shots as well, and you'll
get more realistic colors there too. (2) They create a custom white balance. Luckily, your
camera will do most of the work for you if you just put a neutral gray card (you can find
these at any camera store or B&H Photo) about 8 to 10 inches in front of your lens, and
zoom in/out so the card fills your frame. Then go to your camera's custom white balance
menu and set it up to measure what it sees to create a custom white balance (it's easier
than it sounds—just take a peek in your camera's manual). And, (3) They shoot in RAW
format, so they don't worry about white balance, because they can choose the white
balance after the fact, either in Adobe Photoshop's Camera Raw or in their RAW process-
ing software (if they don't use Photoshop's RAW processor). This is just one advantage of
shooting in RAW (see Chapter 10 for more on why RAW rocks).

Cold Weather Shooting Means Extra Batteries

Another thing the pros have learned is that digital camera batteries don't last nearly as long in cold weather. So if you're going out shooting in the snow, you'd better bring at least one or two backup batteries for your camera or it could turn into a very short shoot.

Extra Batteries Are a Shoot Saver

I go out of my way to avoid using flash (I'm one of those natural light freaks), so my batteries last a good long time, and I seldom have to change batteries during a shoot. However, I have at least one backup battery for both of my cameras, and although I don't use them that often, when I have needed them, they've been a shoot saver big time. If there's a must-have accessory, it's an extra battery.

Don't Change Lenses in Dusty Weather

SCOTT KELBY

If you're shooting outdoors, take a tip from the pros and don't change lenses if you're in a dusty environment. That's the last thing you want getting down inside your digital camera, and although you can't sometimes see the dust swirling around you, your camera's sensors will see it, and then so will you (when you open the photos on your computer). If you must change lenses, try to go back to your car, or some indoor location, and switch lenses there. Remember, it doesn't take a whole lotta dust to make your camera really miserable—it's worth the extra effort to either plan carefully for shoots in desert or sandy conditions and go with just one lens, or to keep your car nearby so you can go inside, shut the door, and change the lens without fear of fouling your gear.

Protect Your Gear Tip

You can buy protective gear for your camera for shooting in harsh or rainy weather conditions. But, if you find yourself in that kind of situation without that protection, you can do what my buddy Bill Fortney does and take a clear plastic shower cap from the hotel you're staying at, and use it to cover your camera and lens. It balls up right in your pocket, and it does a better job than you'd think.

Apply for Permits to Shoot with Your Tripod

Many indoor locations (including museums, aquariums, public buildings, etc.) don't allow you to shoot on a tripod, even though these locations generally have very low "museum-like" lighting. However, in some cases you can apply for a free permit to shoot on a tripod—such as the one shown above from New York's Metropolitan Museum of Art—you just have to ask in advance. I've had a number of instances where, by asking in advance, they would let me come in before or after hours to shoot when nobody's there (alleviating their fear that someone might trip on my tripod and sue them). Sometimes government buildings or museums will let you apply for a permit so you can shoot during their regular open hours, but often they'll have you come before or after hours, which I actually prefer. So, usually it's just me and a security guard shooting at five o'clock in the morning or nine o'clock at night, but at least I've got a stable shooting platform, I'm getting sharp shots because I'm on a tripod, and I don't have to worry about anyone tripping over my tripod, shooting their flash while I'm trying to shoot, or rushing me to get out of the way.

Be Careful What You Shoot

Especially since September 11th in the U.S., people can sometimes get freaky when they see someone shooting photos outside their building (which is common in downtown areas), and they're particularly touchy outside state and federal buildings. Recently, a photographer I know was shooting in a downtown area, and when he pulled his eye away from his viewfinder he was surrounded by three security guards. He didn't realize the building he was shooting was a federal building (it just looked like a fascinating old building to him), and the guards wanted to confiscate his camera's memory card. Luckily, he was able to convince the guards to let him just delete the photos from his card right in front of them, but if he hadn't, the police would have been involved within minutes (it was a federal building, after all). However, building security for corporations can be very aggressive as well (I've heard stories there, too), so just take a little care when shooting in downtown areas and be prepared to delete shots off your card if necessary. Also, as a general rule, in the U.S. and in other countries, you're taking your chances any time you shoot government buildings, airports, military bases, terrorist training camps, nuclear missile silos, Russian sub bases, etc.

A Tip for Shooting on an Incline

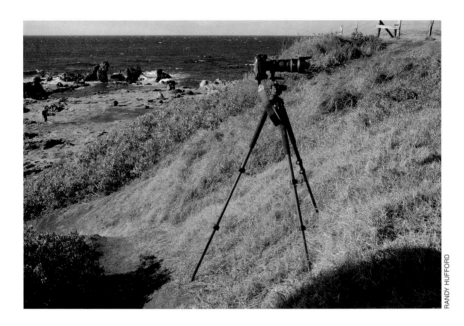

RANDY HUFFORD

If you find yourself shooting on an incline with your tripod, here's a tip that can save your camera from instant death. Let's say you're shooting on a rock or on the side of a hill. Your tripod has three legs—place only one facing you. That way, if the camera starts to tip back, the single leg acts like an anchor and keeps it from falling. If the two-legged side is on the ground, with a single leg on the rock or hillside, your camera will topple right over.

Tip for More Stable Shooting on a Tripod

When you're shooting on a tripod, depending on the terrain, you don't always wind up extending your tripod's legs all the way—sometimes you just extend one set of legs and not both. If that's the case, the pros extend the top ones (the legs nearest the camera) first, because they're thicker and provide more stability and balance than the thinner lower legs.

The Other Reason Pros Use a Lens Hood

The lens hood that comes with most good-quality lenses these days is designed to reduce or eliminate the lens flare that can creep into your lens when shooting outdoors in daylight, but pros keep a lens hood on even indoors (basically they keep it on all the time) for another reason—it protects the lens. Think about it—the glass end of your lens is pretty much flush to the end of the lens barrel, and if it comes in contact with anything that's not really, really soft, it can get scratched, cracked, or just fingerprinted or dirty. However, when you put a lens hood on the end, it puts a buffer between the glass and the scary world around it. It can save your lens if you drop it or knock it into someone or something.

Keeping Your Lens Out of Trouble

If you're going to be using good-quality lenses with your digital camera, then I highly recommend buying a UV filter for each lens. Although the UV part doesn't do all that much (it filters out UV rays to some extent, which makes your photos look better to some small extent), the real reason to use one is to protect your lens (specifically, the glass on your lens, which can get scratched easily or break if you drop it). Although this "buy a UV filter/don't buy one" controversy is heavily debated on the Web, I can tell you from personal experience it saved one of my lenses from certain death. I was out on location, and while changing lenses I somehow lost my grip and my lens crashed to the ground, glass first. My filter was severely damaged, but once I unscrewed it and took a look at my lens, it was totally unscathed. The filter took all the damage, and it's *much* cheaper to buy a new filter than it is to replace an expensive lens. So, while a UV filter might not do all that much for your photos, it does a lot for your peace of mind.

Back Up Your Photos in the Field

SCOTT KELBY

When you're out shooting, as soon as you fill up a memory card, back it up to a portable external hard drive (ideally, you'd like a portable drive that lets you pop in your memory card and copy it onto the drive without having to be connected to a computer). That way, you've backed up your digital negatives right there on the spot. Here's how I use this workflow: let's say I do an early morning shoot (the 5:00 a.m. sort). As soon as I'm done with my shoot (around 7:00 a.m.), when I get back to my car, I pop my memory card out of the camera, pop it into my Epson P-7000, and start copying the card over. Then, while it's still copying, I put the P-7000 back into its carrying case, and then back into my camera bag. By the time I get to the breakfast restaurant (a yummy breakfast is a critical part of the early morning shoot), the photos are copied onto the hard drive. Right after I place my breakfast order with the server, I break out my P-7000 and start seeing if the morning shoot yielded any "keepers" in the P-7000's huge LCD window. That way, not only do I have a solid backup, but I also get a preview of how my morning shoot went.

Limit Your LCD Time to Save Battery Life

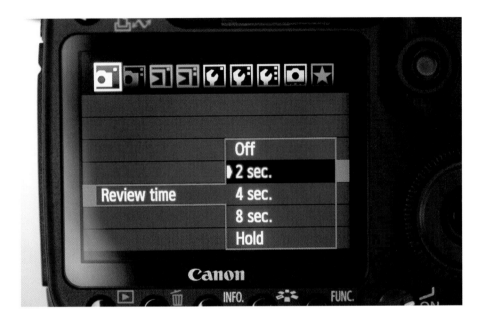

One of the biggest drains on battery life is the color LCD monitor on the back of your digital camera. Although it's a very important part of digital photography, using it too often can really drain your battery, but here's something that can help—lower the number of seconds that your LCD displays right after you take the shot. After all, if you need to see a shot you just took again, you can just press the playback button on the back of your camera and it will reappear. Also, limit your chimping (admiring your photos on the LCD monitor or showing them off to others while making "Oooh! Oooh!" sounds).

Be Careful When Throwing Out CDs/DVDs

Be careful when throwing away old CDs or DVDs with photos on them. One thing the pros have learned (some the hard way) is that if you just throw a CD or DVD of photos away, there's a chance those photos might "come back from the grave" and reappear where you least expect them, like on the Web, or on a stock photo site, or…wherever. These days, old CDs often attract unwelcome attention in a landfill because trollers are looking for credit card numbers, personal information, etc., and if they find anything of value (including your photos), they may find a way to use (or abuse) them. How do you protect yourself against this? Buy a serious shredder—one that will shred CDs/DVDs (like the Fellowes Intellishred PS-79Ci, which will shred just about anything on earth)—and shred your CDs so they're unusable by just about anybody. It doesn't seem like a big threat until you see someone else selling your work.

Bracket If You're Not Sure About Exposure

In a tricky lighting situation, or a situation where you've just got to get the correct exposure for the shot, the pros make use of the camera's built-in exposure bracketing feature. This basically sets up your camera to shoot multiple versions (as many as five, if you like) of your current scene using different exposures (some lighter, some darker) with the idea that one of them will be just right. It starts by using the suggested exposure reading taken by your camera (which your camera believes is the correct exposure, by the way, but it can sometimes be fooled in tricky lighting situations), then it creates another image that is slightly underexposed, and another slightly overexposed (so you've bracketed both ends of the original exposure). This greatly increases your odds of getting the perfect exposure, and since digital film is free—hey, why not, right? You turn on bracketing right on the camera itself. For Nikon digital cameras, there's a bracketing button to the left of the viewfinder (it says "BKT" on the button). On Canons (like the 40D or 50D), you have to turn on bracketing from the menu itself.

Bracketing Tip

If you're shooting in RAW, bracketing becomes much less important because you have so much control after the fact (in your RAW conversion software), and because you can make as many copies, with different exposures, as you'd like.

Avoid Red Eye

SCOTT KELBY

Without going into all the technical (and physiological) reasons why people in our photos often get "red eye" when we use a flash, let's just look at how to avoid it. The main culprit is your camera's pop-up flash, which sits right above your lens and is an almost automatic recipe for red eye. The easy fix (the one the pros use anyway) is to either get that flash (ideally) off the camera and hold it a couple of feet away from the lens, or at the very least up much higher away from the lens, to reduce the chance for red eye. Another method is to bounce your flash off the ceiling, which is a great cure for red eye. Of course, all of these require you to have a separate external flash unit (and not just your camera's built-in pop-up flash). If you can't spring for an external flash, there are a few other popular strategies when you have no choice but to use your built-in pop-up flash: (1) turn on some room lights, if possible. It lets your subject's pupils contract, and that causes less red eye than shooting in complete darkness. (2) If your camera has a red-eye reduction mode (where it sends a preemptive flash, which causes your subject's pupils to quickly contract, before it fires the main flash), that sometimes reduces red eye. (3) Ask your subject to look slightly away from the lens and that will certainly help, plus (4) moving your camera closer to your subject can also help reduce the dreaded red eye.

Remove Red Eye

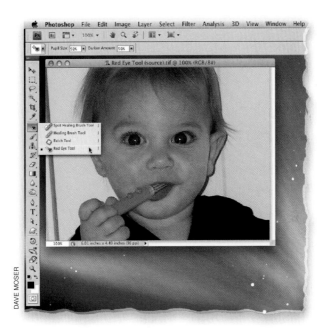

DAVE MOSER

Okay, let's say you forgot to try one of the strategies on the previous page and you wind up with an important photo that has red eye. Luckily, it's easier than ever to get rid of red eye. Whether you're using Adobe Photoshop or Photoshop Elements (the consumer version of Photoshop), you can use the Red Eye tool to quickly get rid of red eye. Here's how they work: open the photo in Photoshop (or Photoshop Elements), then get the Red Eye tool (it's in the Toolbox on the left side), and simply click directly on the red area in one of the eyes. That's it—it does the rest. Then do the other eye. Not too shabby, eh? If clicking directly on the red part of the eye is too hard (the person is standing kind of far away so their eyes are kind of a small target), then just take the tool and click-and-drag a rectangle around the whole eye area, and when you release the mouse button, it will do its thing. Either way you do it, that red eye is going to be gone in seconds. Just another reason why I love Photoshop.

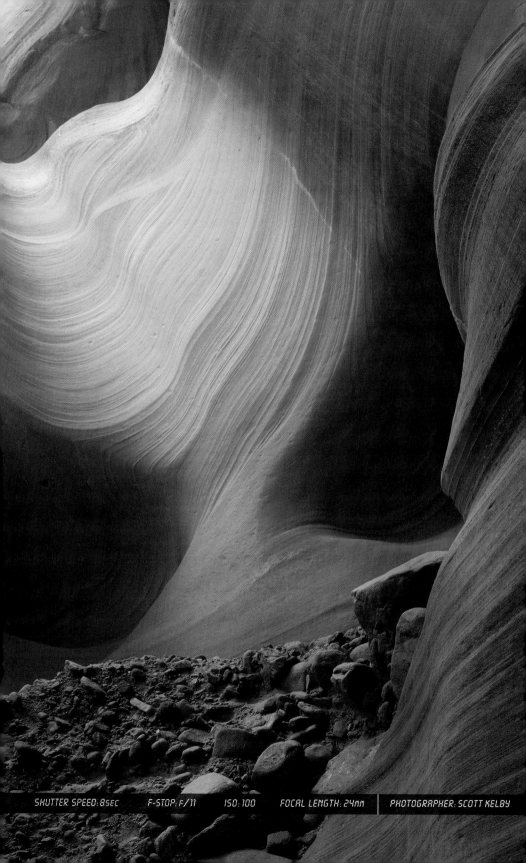

SHUTTER SPEED: 8SEC F-STOP: F/11 ISO: 100 FOCAL LENGTH: 24mm PHOTOGRAPHER: SCOTT KELBY

Chapter Eight

Taking Advantage of Digital Like a Pro

It's More Than Just a Replacement for Film

I added this chapter to the book for a very important reason—I constantly run into people who treat their digital camera like a film camera that comes with free film. These people (freaks) don't realize that digital is much more than just a new type of "free-film camera" and digital cameras offer advantages that we (they, them, us, etc.) never had in film cameras. So, that's what I tried to do in this chapter—show how the pros take advantage of digital cameras to get the most out of their investment. Now, these pros have to squeeze every advantage out of their cameras for two reasons: (1) they have to monetize the results. They paid a lot of money for these tools for their business, and they have to have a verifiable means of tracking their ROI (return on investment). And (2) they have to be able to make enough money to pay both alimony and child support, because their spouses left them shortly after they went digital, because now they spend all their free time playing around with their photos in Adobe Photoshop. Hey, it's an easy trap to fall into, and I've been known to spend an hour or two in Photoshop myself. But that doesn't mean I've turned my back on my wife and child. I mean, wife and two children. My two boys. I mean, my son and daughter, right? Little what's-her-name? And of course, my son Gerald. Er, Jordan. That's it—Jordan. Great little boy, too. What's he now, six? Nine! No kidding, he's nine already? Boy, they sure do grow up fast.

Level the Playing Field: Press That Button

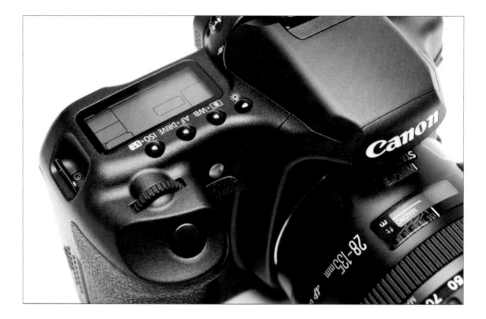

Will digital photography really get you better photos? Absolutely. There are two huge advantages digital brings (if you take advantage of them), so I'm covering both of them on these first two pages. The first is—film is free. In the days of traditional film cameras, every time I pressed the shutter, I heard in my head "22¢." Each time I clicked off a shot, it cost me around 22¢. So whenever I considered taking a shot, I would consciously (or subconsciously) think, "Is this shot worth 22¢?" Of course, I wouldn't know for days (when the film came back from the processing lab), but it always made me pause. Now I can push the shutter again and again and again, and in my head I just see a smiley face instead. Why? Because I'm insane. But besides that, it's because once you've bought your memory card, film is free. This really levels the playing field with professional photographers, because this has always been a huge advantage they had over the amateurs. The pros had a budget for film, so if they were shooting a portrait, they'd shoot literally hundreds of photos to get "the shot." Amateurs would shoot, maybe, a roll of 24. Maybe 36. So, here's a pro photographer shooting hundreds of shots vs. an amateur shooting 36. Who had the best chance of getting the shot? Exactly. Now, jump ahead to digital. It's portrait time—the pro will shoot hundreds of shots, right? Now, so can you, and it doesn't cost you a dime. When you shoot "with wild abandon" (as my friend Vincent Versace always says), you level the playing field. Your chances of getting "the shot" go way, way up, so fire away.

Put the LCD Monitor to Work

SCOTT KELBY

The second thing that levels the playing field is that now, with the LCD monitor on the back of your camera, you can see if you "got the shot." And by "got the shot," I mean you can tell if your color is in the ballpark, if your subject blinked when the photo was taken, if your flash actually fired—that sort of thing (I'm not trying to trivialize them—these are huge advantages). But because the LCD monitor is so small, it can also fool you. Everything looks in focus when it's 2" tall on the monitor. When you open that photo later in Photoshop, you might find out that the key shot from your shoot is horribly out of focus (or your camera focused on the wrong object, so the background is in sharp focus, but your subject is blurry). This actually happens quite often because (all together now) everything looks in focus on an LCD monitor. To really take advantage of the LCD monitor for focus, you'll need to zoom in and see if it's really in focus (see page 17 for how to zoom in).

The LCD Monitor Challenge

Another way the LCD monitor will make you a better photographer is through instant creative feedback. If you take your shot, look at the LCD, and what you see disappoints you, then it challenges you to come up with something better. It makes you work the shot, try new angles, get more creative, and experiment until you finally see on the monitor what you set out to capture in the first place.

Edit as You Shoot to Get More Keepers

One of the tricks the pros use to keep an efficient workflow, and to keep from unnecessarily filling up their memory cards, is to edit out the bad shots as they go. If they take a shot and look on the LCD monitor and see that it's grossly underexposed, overexposed, has tons of blinkies, is clearly out of focus, or is just plain badly composed, they delete it right there on the spot. If you do this as well, later, when you download your photos into your computer, you're only looking at shots that actually have a chance of being a keeper. Plus, you can take more shots per card, because the bad ones have been erased to make room for more potential good shots.

The Hidden "Edit as You Go" Advantage

You may think this is silly (at first), but if you edit out all the really bad shots, when you finally do download and start looking at them, you'll feel better as a photographer. That's because you'll be looking at a better group of photos from the very start. The really bad shots have already been deleted, so when you start looking at the day's take, you'll think to yourself, "Hey, these aren't too bad."

Take Advantage of the Blinkies

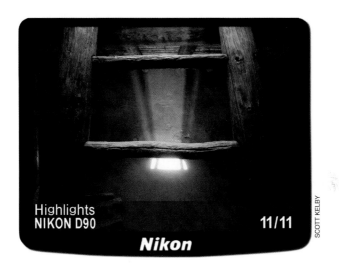

I know I mentioned this earlier, but it bears repeating. Turning on your highlight warning (or highlight alert, the strobe-like flashing you see on your LCD monitor which shows the parts of your photo that are totally blown out and have no detail) and looking for the "blinkies" will yield you more keepers—no doubt. So, what do you do when you see the blinkies? Use your camera's exposure compensation control to back down the exposure a 1/3 stop and shoot the same photo again. If you still see the blinkies, take it down another 1/3 stop and shoot it again. Keep shooting until the blinkies go away. *Note*: Some things will always have blinkies—like the sun—and that's okay. What you want to be concerned about is specifically "blinkies that matter" (blinkies in parts of the photo that you care about). A reflection of the sun on the chrome bumper of a car is an okay situation to let blinkies live. However, blinkies blinking on the forehead of your subject is not acceptable. Also, when looking at the LCD monitor, keep an eye on the overall exposure of the photo—don't let it get way underexposed just to stop a tiny blinky somewhere. Here's how to adjust using exposure compensation:

Nikon: Press the exposure compensation button just behind the shutter button, then move the command dial to the left until it reads –1/3 in the viewfinder readout.

Canon: Turn the mode dial to any creative zone mode except manual, turn the power switch to the quick control dial setting, then set the exposure compensation by turning the quick control dial on the back of the camera.

Change Your ISO on the Fly

A huge advantage of digital is that you can change the ISO anytime the scene dic-
tates it. With traditional film, that was impossible. Well, it wasn't impossible, it was
just incredibly expensive, because to change the ISO (film speed) you actually had to
change film. So, for example, let's say you're shooting the outside of a church with a
brand new roll of ISO 200 film (36 exposures), and you crank out four or five shots. You
walk inside, and it's very dark, and they won't allow you to set up a tripod (which isn't
unusual for a church). If you needed to switch to ISO 800 film, you'd need to pop out
the 36-exposure roll (basically sacrificing 31 unexposed shots to the film gods), as you
pop in a new roll of ISO 800. So you crank off 17 shots, and then you're back outside.
Whoops—you've got ISO 800 film in, and it's a sunshiny day. Time to switch film again
(and sacrifice 19 more shots). See where this is going? But with digital, you can take
advantage of on-the-fly ISO switching. You shoot at ISO 200 outside, then walk inside,
change the ISO on your camera to 800, and crank out a few more. Maybe try a few
at ISO 400 to see if you can get away with it. Maybe a few shots at 1600 just for kicks,
then you walk out the door and change the ISO back to 200. All without ever changing
film (because, after all, there is no film—we're digital). Take advantage of this power to
shoot hand-held in low-light situations where a tripod is off limits. For the least noise
possible, we try to shoot at the lowest ISO possible, but when the right situation pres-
ents itself, take advantage of this big digital advantage to "get the shot."

No Penalty Fee for Experimenting

In the days of traditional film, the only people who could really afford to experiment were pros (or wealthy amateurs), because both the film and processing cost money, and experimenting was just that—taking a chance with money. Now, with digital, not only can you see the results of your experiment instantly (on your LCD monitor), but you can see the full-size results on your computer, and best of all—it doesn't cost a dime. Got a crazy idea? Try it. Want to shoot a subject from a really wild angle? Do it. Want to try something that's never been done before? Go for it. Now there's nothing holding you back from trying something new (except, of course, the intense humiliation that comes with experiencing utter and complete failure, but there's nothing digital can do to help you deal with that. Well, not yet anyway).

Don't Cram Too Much on One Card

One thing a lot of pros do to help avoid disaster is to not try to cram all their photos on one huge memory card, especially when shooting for a paying client. Here's why: Let's say you're shooting a wedding and you want to capture everything on one 8-GB card, so you don't have to switch cards. That's cool, as long as the card doesn't go bad (but sadly my friend, cards do go bad—not often, but it happens. It's a sobering fact of digital photography, but remember that traditional film can go bad as well—there is no "never fails" film). So, if you get back to your studio and find that your 8-gig card took a fatal dive, every photo from that wedding may be gone forever. You might as well just sit by the phone and wait for their lawyer to call. That's why many pros avoid the huge-capacity cards, and instead of using one huge 8-GB card, they use four 2-GB cards. That way, if the unthinkable happens, they only lose one card, and just one set of photos. With any luck, you can save the job with the 6 GB of photos you have on the other three cards, and avoid a really harrowing conversation with "the attorney representing the bride and groom."

Shooting RAW? Leave a Little Room on That Memory Card

A word of warning: If you're shooting in RAW format, don't use up every shot on your memory card (leave one or two unshot) because you could potentially corrupt the entire card and lose all your shots. It happens because some RAW shots take more room on the card than others, but your camera calculates how many shots are left based on an average size, not actual size. So, don't chance it—leave one or two unshot.

Take Advantage of Poster–Sized Printing

You don't have to have a large-format printer to get large poster-sized prints, because today there are pro photo labs online (like Mpix.com, the photo lab I use—they're fantastic). You just upload your photo, choose your size (anything from wallet-size up to 24x36" full poster-sized prints), and they'll output your files, and ship right to your door, crisp, wonderful poster-sized prints for as little as $25 (for a 20x30" poster). I love it, because they do all the work (they'll even color correct your image for free), and before you know it, you're holding some amazingly large prints at amazingly low prices. By the way, the process is so much easier than most people think—once you do it, you'll get hooked. So will your clients.

You Can Make One Film Fit All

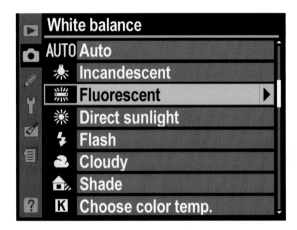

Here's another advantage digital has over traditional film, and if you take advantage of it, you'll save yourself loads of time later in Photoshop, and that is to set the right white balance. In the old days, with traditional film, if you ran into a problem lighting situation (like shooting under indoor fluorescent lights in an office or retail environment), you had to either switch to film that was balanced for shooting under fluorescent light or you had to add a special filter to your lens to offset the color cast created by those lights. Even though today's digital cameras let you choose a preset white balance for the lighting you're shooting in, most amateurs just leave their cameras set to Auto White Balance because it's easier. But the pros know that although they can fix it later in Photoshop, it's easier for them to get the shot right by changing just one little setting.

Is It Better to Underexpose or Overexpose?

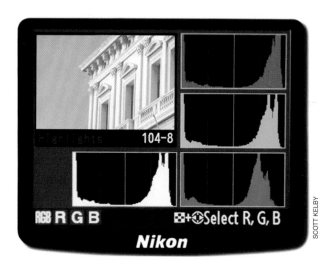

There have been some theories bouncing around a few of the photography forums on the Web that claim that you should underexpose by a stop for digital photography. First off, let me say this: your goal (my goal, our common goal) is to get the proper exposure. That's our goal. Always. But if that's not possible, if given a choice between overexposing (a photo that's a bit too light) and underexposing (a photo that's a bit too dark), go with overexposing—you'll have less noise. That's because noise is most prevalent in the shadows, and if you have to lighten an underexposed photo, in Photoshop (see tip below) you're lightening (increasing) the noise in the photo. That's why it's better to shoot lighter (overexposed), because darkening a photo doesn't increase noise the way lightening it does. So, if you'd rather have one than the other—overexpose (but again, or goal is to do neither. That's why we bought these fancy cameras with their highly advanced metering systems).

What to Use Photoshop For

If you're shooting in RAW, then you're going to use Photoshop to process your RAW photos, but once you leave Camera Raw and you're in the regular part of Photoshop, the idea is to use Photoshop to finish your photos—not fix them. You want to spend your Photoshop time being creative and having fun, not fixing things you should have done correctly in the camera.

Keep from Accidentally Erasing Memory Cards

This is a small tip, but one that can save your hide when you're out shooting in the field. If you keep your spare memory cards in a card holder (and for the sake of your cards, I hope you do), there's a simple routine the pros use to keep track of which cards are full and which cards are empty and available for quick use. They turn the full cards backwards in the case (with the labels facing inward), so they can instantly tell which cards are available for use (the ones with the labels visible) and which ones are full. The next time you're shooting in a fast-paced environment (like a wedding shoot or a sporting event), you'll be glad you adopted this system.

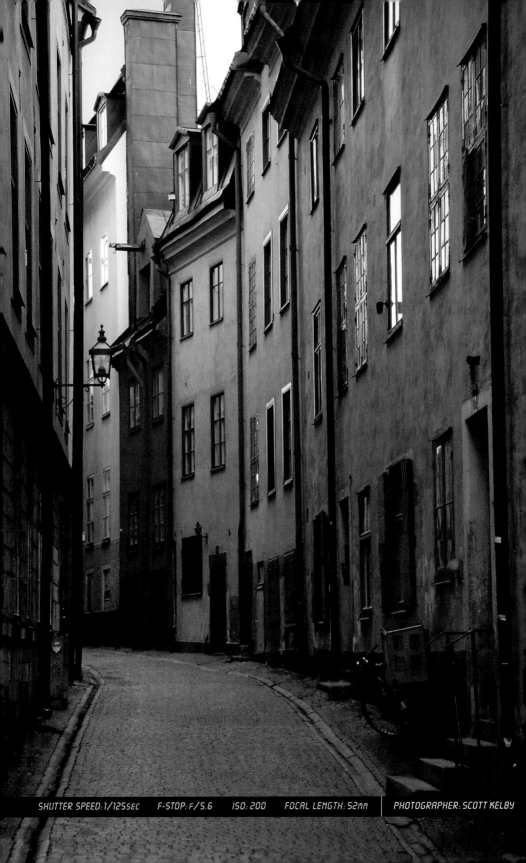

SHUTTER SPEED: 1/125SEC F-STOP: F/5.6 ISO: 200 FOCAL LENGTH: 52mm PHOTOGRAPHER: SCOTT KELBY

Chapter Nine

Taking Travel & City Life Shots Like a Pro

Tips for Urban Shooting

Ya know what there's not a whole lot of? Professional travel photographers. Ya know why? It's because there are not a whole lot of travel magazines. I mean there's *Condé Nast Traveler*, and *National Geographic Traveler* (one of my personal favorites), and *Travel & Leisure*, and well...I'm sure there are a couple more, but the thing is, there's not like a whole bunch of them. But just because the market's tight for jobs in the professional travel photographer market, that doesn't mean we don't want to take travel and city life shots like we're trying to compete, right? Well, that's what this chapter is all about—tips on beating the living crap out of a couple of those pro travel photographers, so they're in the hospital for a while so we can snag some of their assignments. It's the law of the jungle, and shooting in the jungle sounds like fun, except for the fact that some smug pro travel photographer already has the gig. Or did he just fall (was pushed?) off the side of a mountain in Trinidad and all his expensive gear went right along with him? What a shame. I wonder who'll cover that assignment to shoot the sand dunes in Namibia? Hey, what the heck—I'll do it (see, that's the spirit behind this chapter— jumping in and taking over when one of your photographic comrades has a series of unexplained accidents while shooting on location). Hey look, I'm obviously kidding here, and I'm not actually recommending on any level that you learn the techniques in this chapter so you'll be ready for a last-minute pro assignment, but hey—accidents do happen, right?

How to Be Ready for "The Shot"

Nikon

Canon

When you're shooting urban (city) or travel photography, you're looking for "the shot." My buddy Dave calls it "the money shot." You know, that shot where you turn the corner and something fascinating, amazing, or [insert your own adjective here] happens and you just happen to be there with a camera to record it. It happened to me in Barcelona when I walked by an alley and saw a man sitting in the dead center of the alley, facing the alley wall, reading a book. It was an incredibly compelling photo (so much so that many people have asked me if it was posed). So, how do you stay ready to catch a photo that just appears on the scene (or maybe drives by in a car)? You shoot in a mode that lets you concentrate on one thing—getting the shot. That's right, when you're walking the city streets, you shoot in program mode. I know, I know, this goes against all sacred rules of professional photog-raphy, except the one that says getting the shot is more important than the mode you shoot it in. So, switch your digital camera's mode dial to program mode (which sets both the aperture and shutter speed for you, without popping up the annoying on-camera flash every two seconds like auto mode does) and get the shot. Now, if you get to a scene that isn't changing for a few minutes, you can always switch back to aperture priority (or manual) mode and take creative control of your shot, but for quickly getting the shot as you roam through the city, there's no more practical mode than program. *Note:* Nikon's program mode has a feature called Flexible Program Mode, which lets you change either the shutter speed or aperture setting while the camera automatically changes the opposite setting to keep the same exposure. If you don't touch either dial, it does all the work for you. Sweet!

Shoot Kids and Old People. It Can't Miss

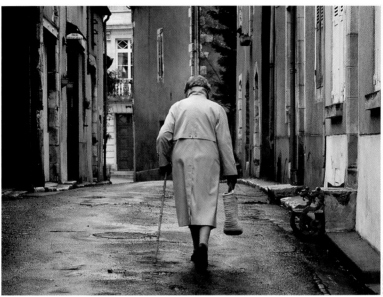

SCOTT KELBY

The next time you pick up a travel magazine, take a look at what's in the photos they publish. I can save you the trouble. Their travel photos have two main people themes: old people and children. Now, when I say old people, I don't mean people in their late 50s. I mean really old people, and by that I specifically mean old, wrinkly, craggy-looking women whose skin looks like shoe leather, and old, hobbly, crusty men with a cane wearing hats that haven't been washed since the Korean War. As for kids, the younger the better (but skip the babies). As long as you shoot them on uncomplicated, simple backgrounds, kids make incredibly compelling additions to your urban and travel pics (that's why the magazines love them). Also, if you get either age group to pose for you, make sure you spend some time talking with them before you start shooting—it can go a long way toward loosening them up, which will give you more natural looking poses and expressions (plus, they'll probably let you shoot longer after you've built up a little rapport).

What Not to Shoot

Okay, so kids and old people are "in." What's out? Crowd shots. They're just about useless (you won't even put 'em in your own travel album). Shoot an empty street first thing in the morning, or shoot two people together, but skip the crowds.

Hire a Model (It's Cheaper Than You'd Think)

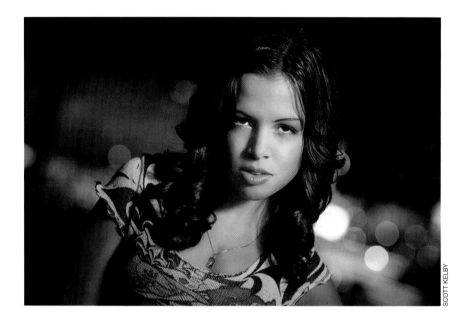

SCOTT KELBY

How do the pros get those amazing shots of people in exotic locales? One of their tricks is to hire a local model (especially if they're shooting to sell the photos to a stock photo agency). Now, before you turn the page because you think hiring a model is out of your budget, it's usually cheaper than you'd think (well, unless you were thinking it's really, really cheap). Here's a real world example: I hired a professional model recently for a shoot out in New Mexico, and the going rate was $15 per hour, plus I had to provide her prints from the shoot for her portfolio. Some models new to the business will work for free in exchange for you making prints for their portfolio (the term for this in the business is TFP, which stands for "Time For Prints," [they are trading their time for your prints]), so ask your prospective model if they do TFP. If they look at you and ask, "Does that mean Tampa Free Press?" you should probably find another model.

Get That Model Release!

If you've hired a model, make absolutely certain that you get your model to sign a model release, which enables you to use those shots for commercial work. You can find some sample model releases online (I believe the PPA [Professional Photographers of America] has downloadable release forms available for its members), and having one could make all the difference in the world.

What Time to Shoot

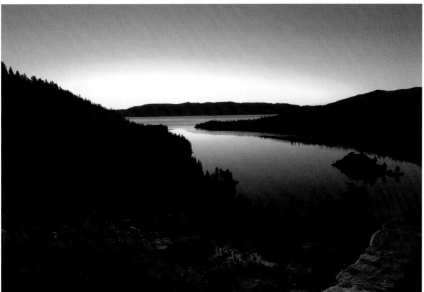

SCOTT KELBY

Many pros prefer to shoot urban and travel shots at dawn for a couple of reasons: (1) the light is perfect. That's right, the same golden, magical light that looks great for landscape shots looks great for shooting in the city, too. And (2) the streets are usually empty, so there's little distraction for your architecture shots, cathedral shots, or charming little streets and alleys. You only have a limited time to shoot before the sun gets too light in the sky (and the lighting turns harsh) and the streets start to fill with traffic, so get set up before sunup and, of course, shoot on a tripod. Another great time to shoot is at dusk. The lighting will once again be golden, and the only major downside is that the streets won't be empty. There are still some decent opportunities to shoot urban and people shots during the day, because cities often have lots of open shade (sometimes courtesy of the tall buildings in downtown areas). So unlike the landscape photographer, you can often get away with shooting all day, especially if it's an overcast or cloudy day (remember, if the sky is gray, try to avoid including much sky in your photos). Afternoon is a perfect time to shoot charming doorways (in the shade), windows, kids playing in the park—pretty much anything you can find in decent open shade. So, to recap: the best time is probably morning. Second best is dusk, but you can still get away with shooting in open shade during the day, and there's often plenty of it, so fire away (so to speak).

Look for Bold, Vivid Colors

SCOTT KELBY

SCOTT KELBY

One of the things to keep an eye out for when you're shooting urban and travel shots are the bold, vivid colors of the city. You'll often find brilliantly colored walls, doors, (shots with a bold-color wall with a contrasting colored door), shops, signs, cars, and bikes. One of my favorite urban shots was of a bright red Vespa scooter parked directly behind a bright yellow Lotus sports car. It almost looked set up for me, and I took dozens of shots of it because the colors were just so vivid, and so perfectly matched. Keep your eyes peeled for brightly painted walls (especially wonderful if you find someone working in front of the wall, or waiting patiently for a bus with the colorful wall in the background, or a bright yellow car parked in front of a bright blue wall). If you're looking for these colorful combinations while you're out exploring, you'll be surprised at how often they'll reveal themselves to you. By the way, I know I'm beating a dead horse here, but these colors will look richer and have more depth in (you guessed it) great light, which generally occurs (you know it) around dawn and dusk. Just remember, the next best thing to those two is open shade.

Shooting Travel? Visit
WhereTheProsShoot.com First

If you're looking to find the shots everybody else misses (in other words, you don't want shots that are too touristy), before you leave on your trip visit WhereTheProsShoot.com. This site is run by photographer Brad Moore (who shot most of the product shots you see here in the book). Once you get there, just type in the place you want to shoot (the city, a landmark, etc.), and it gives you a list of cool nearby shooting locations, including a map of how to get there, GPS coordinates, sample photos taken in the area, best times to shoot, and all the stuff you'd want to know about where to take great photos.

Don't Try to Capture It All: Shoot the Details

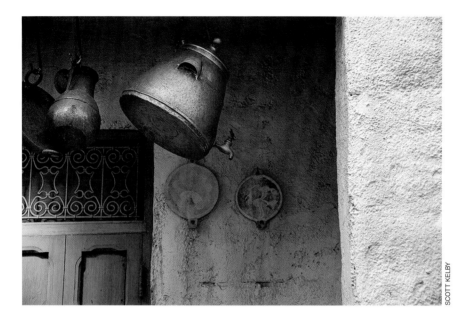

SCOTT KELBY

I've heard a lot of photographers complain about the results of their urban shoot-
ing, and much of the time it's because they try to capture too much. What I mean by
that is that they try to capture the entirety of a majestic building or the grandeur of a
magnificent cathedral, but even with an ultra-wide-angle lens this is very, very hard to
pull off. That's why the pros shoot details instead. For example, instead of shooting to
capture the entire cathedral at Notre Dame in Paris, instead capture details that sug-
gest the whole—shoot the doors, a window, a spire, a gargoyle, the pigeons gathered
on the steps, or an interesting architectural element of the church, rather than trying
to capture the entire structure at once. Let your photo suggest the height, or suggest
the craftsmanship, and the mind's eye will fill in the blanks. By shooting just the details,
you can engage in some very compelling storytelling, where a piece is often stronger
than the whole. After all, if you want a photo of the entire cathedral, you can just buy
one from the dozen or so gift shops just steps away. Instead, show your impression,
your view, and your take on Notre Dame. Give this a try the next time you're out shoot-
ing in a city and see if you're not infinitely more pleased with your results.

The Best Shot May Be Just Three Feet Away

SCOTT KELBY

My good friend Bill Fortney said it best, "The biggest impediment to photographers getting great shots is the fact that they don't move. The best shot, the best view, and the best angle is sometimes just 3 feet from where they're standing—but they just don't move—they walk up, set up, and start shooting." It's so true (that's why I also made reference to this non-moving phenomenon in the landscape chapter). Once you find that fascinating detail, that vividly colored wall, that unique scene—walk around. Be on the lookout for other more interesting views of your subject and shoot it from there as well. Besides just moving left and right, you can present a different view by simply changing your shooting height: stand on a chair, squat down, lie on the ground and shoot up, climb up a flight of stairs and shoot down on the scene, etc. Remember, the best shot of your entire trip may be waiting there just 3 feet to your left (or 3 feet up). *Note:* The shot shown above is proof of this concept. It was taken in Morocco. Well, Disney's version of it anyway (at Disney's Epcot Center in Florida). If you were to walk 3 feet to the left (which is the shot I saw first), you'd see an outdoor courtyard full of park visitors eating dinner. But when I stepped 3 feet to the right, it hid the baskets of food and Coca-Cola cups and gave me this more authentic-looking view. By the way, that orange light through the open window is coming from a Disney gift shop. Another few feet to the right, and you'd see some stuffed Mickey Mouse dolls.

Shoot the Signs. You'll Thank Yourself Later

Want to save yourself from a lot of headaches? When you're out shooting a cathedral, or a stadium, or a building, etc., take one extra shot—shoot the sign. That's right, later on you may be scrambling to find out the name of that amazing church you shot, and without a lot of research, you may be out of luck. That is, unless you took a shot of the sign that has the name of the church (or building, bridge, etc.). This has saved me on more than one occasion, and if you ever wind up selling the photos, you will absolutely need this info (stock agencies generally won't accept "Pretty Church in Cologne" as a saleable name for an image). Shoot the sign and you'll thank yourself later.

Tripod Wisdom

When it comes to tripods, it's like my buddy Bill Fortney says, "There are two types of tripods: those that are easy to carry and good ones." Even with the advent of carbon fiber, if your tripod feels really lightweight, it's a lightweight. Spend the extra money and get a kick-butt tripod—you'll never regret it.

Showing Movement in the City

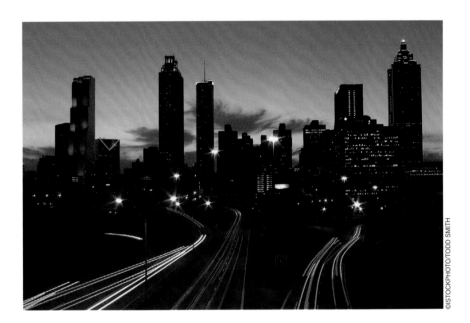

©ISTOCKPHOTO/TODD SMITH

If you want to show the hustle and bustle of a busy city, there's a simple trick that will do just that—slow down your shutter speed and let the people and traffic create motion trails within your image. It's easy (as long as you've got a tripod, which is absolutely required for this effect)—just switch your camera's mode to shutter priority and set the shutter speed at either 1/16, 1/8, or 1/4 of a second (you can go longer if you have low enough light that it doesn't blow the highlights out in your photo). Then press the shutter, stand back, and in less than a second the motion of the city will reveal itself as the buildings, statues, lights, and signs stay still, but everything else has motion trails around it. If you're shooting at night, you can really have a blast with motion. Try to find a high vantage point (like from a hotel room window, or on a bridge, etc.) where you have a good view of traffic. Then put your camera on a tripod (an absolute must for this effect to work), go to shutter priority mode, set your exposure to 30 seconds, and take a shot. Thirty seconds later, you'll see long laser-like streaks of red lines (taillights and brake lights) and white lines (from the headlights), and you'll have an amazingly cool image that most folks won't get.

Use an Aperture That Takes It All In

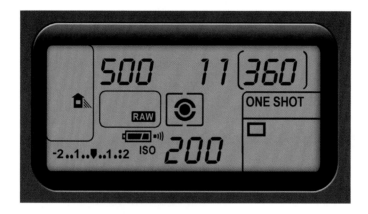

When you're shooting in a city, unless you're shooting an object close up (where you intentionally want the background out of focus), chances are you want as much of the city in focus as possible, right? That's why an f-stop like f/11 works great in a city. It keeps pretty much everything in focus, as long as you don't set your focus on the closest thing in the frame—the rule of thumb is to focus on something about 1/3 of the way into the scene you're trying to capture.

For Maximum Impact, Look for Simplicity

SCOTT KELBY

The single thing that probably kills more properly exposed city life photographs than anything else is clutter—all the distracting background items, foreground items, and just general stuff that gets in the way. So, one of the big secrets to creating powerful and dramatic urban and travel shots is to strive for simplicity. Look for simplicity in your backgrounds, in your people shots, in your architectural elements, in every aspect—the simpler the surroundings, the more powerful the impact. Go out shooting with that very goal in mind. Look for the absence of distraction. Look for the absence of clutter and noise, watch for distracting elements that sneak into the top and sides of your frame, and create some photos that have great impact—not because of what they have, but because of what they don't have—lots of junk.

The Monopod Scam

SCOTT KELBY

Now, a lot of places simply won't let you set up a tripod indoors (for example, try to set up a tripod in someplace like Grand Central Station. You can count the seconds before security arrives). However, here's the weird thing: while many places have a strict policy on tripods, they don't have a policy on monopods (a one-legged version of a tripod, often used for long-lens sports photography. Although they're not quite as stable as a good tripod, they're way more stable than hand-holding). So, the scam is this: if they say anything to you about shooting on a monopod, you can always counter with, "Hey, this isn't a tripod." It often stops them dead in their tracks. One reason they let you get away with a monopod is simply because they don't take up much space, and since there are no extended legs, there's nothing really for anyone to trip on (a concern for many building interiors, museums, etc.). So, if you know the indoor environment you're planning to shoot doesn't allow tripods, see if you can pull the old monopod scam. My guess is—you'll float right by 'em.

What to Do When It's Been "Shot to Death"

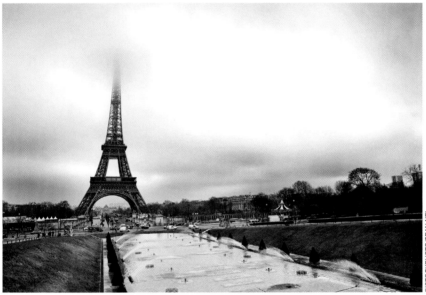

©ISTOCKPHOTO/SEAN NEL

So, you're standing in front of the Eiffel Tower (or the Lincoln Memorial, or the Golden Gate Bridge, etc.—any touristy landmark that's been shot to death). You know you have to shoot it (if you go to Paris and don't come back with at least one shot of the Eiffel Tower, friends and family members may beat you within an inch of your life with their bare hands), but you know it's been shot to death. There are a million postcards with the shot you're about to take. So what do you do to show your touristy landmark in a different way? Of course, the obvious thing (you'll find in every photography book) is to shoot it from a different angle. Frankly, I'd like to see an angle of the Eiffel Tower that hasn't been shot. But since, in many cases, that angle just doesn't exist, what do you do next? Try this—shoot the landmark in weather it's not normally seen in. That's right—shoot it when nobody else would want to shoot it. Shoot it in a storm, shoot it when it's covered in snow, shoot it when a storm is clearing, shoot it when the sky is just plain weird. Since the landmark doesn't change, shoot it when its surroundings are changing to get that shot that you just don't see every day. Here's another idea: Try shooting it from a difficult place to shoot from (in other words, shoot it from some view or vantage point that would be too much bother for most folks to consider. Find that "pain in the butt" viewpoint, and chances are you'll pretty much be shooting it there alone). Hey, it's worth a shot. (Get it? Worth a shot? Ah, forget it.)

Including the Moon and Keeping Detail

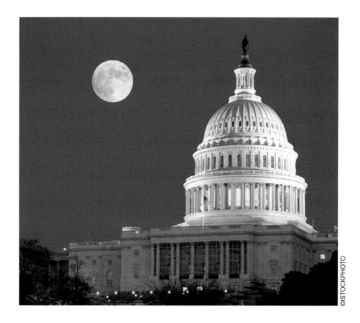

©ISTOCKPHOTO

This sounds like it would be easy—a nighttime city skyline with a crisp detailed moon in the background, but most people wind up with a totally overexposed bright white circle, rather than the detailed moon shot they were hoping for. That's because it's just about impossible to get both the city (which takes a long exposure) and a detailed shot of the moon (which takes a very short exposure because it's actually quite bright) in the same shot. So, what photographers have been doing for years is creating multiple exposures (two images captured in the same frame). Now, there are some digital cameras today that let you create double exposures, but it's just as easy to take two separate photos—one of the city, one of the moon—and combine them later in Photoshop. First, start with your nighttime city skyline. Use a wide-angle lens (maybe an 18mm or 24mm), put your camera on a tripod (an absolute must), set your camera to aperture priority mode, choose f/11 as your f-stop, and your camera will choose the shutter speed for you (which may be as little as 20 or 30 seconds or as long as several minutes, depending on how dark the city is), then take the city skyline shot. Now switch to your longest telephoto (or zoom) lens (ideally 200mm or more). Switch to full manual mode, and set your aperture to f/11 and your shutter speed to 1/250 of a second. Zoom in as tight as you can get on the moon, so there's nothing but black sky and moon in your shot (this is critical—no clouds, buildings, etc.), then take the shot. Now add the moon to your city skyline in Adobe Photoshop (visit www.scottkelbybooks.com/moon to see my step-by-step Photoshop tutorial on how to do this).

Shooting Fireworks

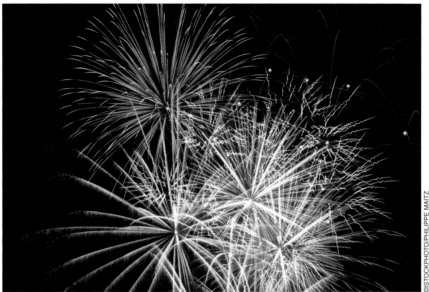

©ISTOCKPHOTO/PHILIPPE MAITZ

This is another one that throws a lot of people (one of my best friends, who didn't get a single crisp fireworks shot on the Fourth of July, made me include this tip just for him and the thousands of other digital shooters that share his pain). For starters, you'll need to shoot fireworks with your camera on a tripod, because you're going to need a slow enough shutter speed to capture the falling light trails, which is what you're really after. Also, this is where using a cable release really pays off, because you'll need to see the rocket's trajectory to know when to push the shutter button—if you're looking in the viewfinder instead, it will be more of a hit or miss proposition. Next, use a zoom lens (ideally a 200mm or more) so you can get in tight and capture just the fireworks themselves. If you want fireworks and the background (like fireworks over Cinderella's Castle at Disney World), then use a wider lens. Now, I recommend shooting in full manual mode, because you just set two settings and you're good to go: (1) set the shutter speed to 4 seconds, and (2) set the aperture to f/11. Fire a test shot and look in the LCD monitor to see if you like the results. If it overexposes, lower the shutter speed to 3 seconds, then check the results again. *Tip:* If your camera has bulb mode (where the shutter stays open as long as you hold the shutter release button down), this works great—hold the shutter button down when the rocket bursts, then release when the light trails start to fade. (By the way, most Canon and Nikon digital SLRs have bulb mode.) The rest is timing—because now you've got the exposure and sharpness covered.

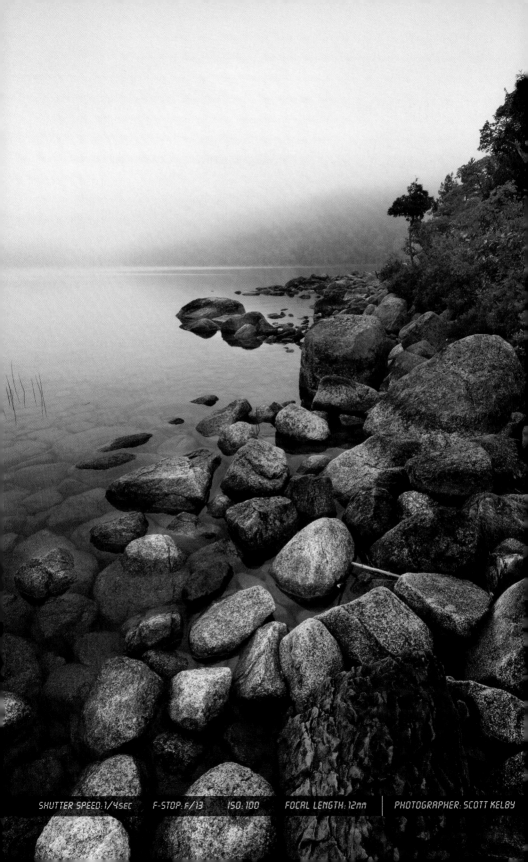

Chapter Ten

How to Print Like a Pro and Other Cool Stuff

After All, It's All About the Print!

This is a great chapter to read if you're a doctor, because you're going to want a great printer, and you're going to want big prints (at least 13x19", right?), and that means you're probably going to need to spend some money, and nobody spends money like doctors. Ya know why? It's because people always get sick or get hurt. Why just the other day this photographer was in Trinidad shooting and the next thing you know he tumbles down this hillside and winds up in the hospital (I know that last sentence made it sound like he finally stopped tumbling when he hit the wall of the hospital, but that was misleading—he actually was stopped by hitting a large llama grazing at the bottom of the hill, but luckily it was a pretty sharp llama, and she was able to summon an ambulance for him, but not before the llama put all his camera gear on eBay. Hey, I said she was pretty sharp). Anyway, who do you think is going to show up at the hospital to help this unfortunate accident victim? That's right—a doctor. And is this doctor going to fix this photographer for free? I doubt it. The doctor is going to get paid handsomely from the insurance carrier that covers the travel photographer. So what's this doctor going to do with the money? He's going to go on eBay and get a great deal on some camera gear. He'll probably save thousands. Now, what's he going to do with the savings? Buy a 13x19" printer. See, this is the wonder of market-driven economies and why we should all sell our camera equipment and go to medical school, because within a few years we'll all be able to buy some really nice gear.

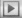 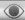

The Advantages of Shooting in RAW

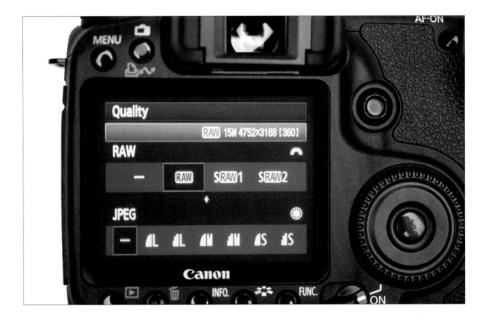

I've mentioned shooting in RAW several times in the book, but I haven't talked that much about it. RAW is an image quality mode, and most professionals today agree that RAW gives you two big advantages over the JPEG-quality images: (1) it provides the highest possible image quality because the photos are not compressed (JPEG files are compressed to a smaller file size by throwing away some of the original data), and (2) the images are just as they were captured by your camera's sensors, and no in-camera processing is done (when you shoot JPEGs your camera actually does some color correction, sharpening, etc., to make the JPEGs look good). When you shoot in RAW, your camera doesn't do any of this automatic correction—you get to do it yourself (including making white balance, exposure, shadow, and other decisions after the shot has been taken) either in Adobe Photoshop or in your camera manufacturer's RAW processing software. Pros love the control this gives them because they can process (and experiment with) RAW images themselves, and best of all, they never damage the original (the RAW digital negative).

The Downside of Shooting in RAW

There are really only two: (1) RAW files are larger in size, so you'll fit about 1/3 fewer photos on your memory card, and (2) since RAW files are much larger in file size, it takes longer to do any editing with them in Photoshop.

 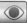

How to Process RAW Photos in Photoshop

Once you import RAW photos onto your computer, if you open them in Adobe Photoshop, a totally different window appears (like the one shown above). This is a RAW processing window called Adobe Camera Raw, and it was developed by Thomas Knoll, the same man who originally developed Adobe Photoshop in the first place. Adobe Camera Raw is pretty brilliantly designed. It lets you simply and easily process your RAW photo by choosing whichever white balance setting you'd like, and by choosing your exposure, shadow, and midtone settings, along with about a dozen or more other adjustments, so you can tweak your photo just the way you want to (and even fix exposure and lens problems) before you enter regular Photoshop for retouching and finishing touches. And best of all—it never changes your original RAW photo, so you can always create new prints from your digital negative anytime you want.

> **Where to Learn More About RAW**
>
> If you want to learn more about processing your RAW photos, I've created three different resources for learning: (1) my book, *The Adobe Photoshop CS4 book for Digital Photographers* (from New Riders publishing), which has three entire chapters dedicated to learning Camera Raw; (2) I have a training DVD called *Mastering Camera Raw in Photoshop CS4*; and (3) I have an online training course by the same name. You can find out about all this stuff at www.kelbytraining.com.

Compare Your LCD to Your Computer Monitor

Once you've filled up a memory card with photos from your latest shoot, go ahead and open them on your computer in whatever software package you use to view and organize your photos (I use Adobe Lightroom, which is a software application from Adobe especially designed for professional photographers. You can find out more at www.adobe.com), and then keep your camera nearby. Once you've got your photos opened on your computer, grab your camera and start comparing how the photos on your camera's LCD monitor look compared to the photos you're now seeing on your computer screen. This will give you a quick idea of how close your digital camera's LCD monitor is to what reality is, and that can be a big help when you're out shooting. For example, if you learn that your LCD makes everything look cooler than it really is on your computer screen (where you'll ultimately be editing your photos), then you know you don't have to worry about adding a warming filter to your lens to warm up your photos. If the LCD is too dark (compared to your computer screen and/or printer), then you know you need to shoot a little lighter for reality. Try this and you'll be amazed at how knowing how "true" your LCD is can improve your photography.

Organizing Your Photos with Lightroom

Although I use Adobe Photoshop for all the serious retouching and high-end tweaking of my photographic work, I use a product from Adobe called Adobe Lightroom for managing and organizing my thousands of digital photos, processing my RAW photos, creating onscreen slide shows, and printing out multi-photo spreads. This is an application designed from the ground up for photographers, is available for both Macintosh and Windows users, and it only costs a fraction of what Photoshop costs. Now, it certainly doesn't replace Photoshop, because it doesn't create the amazing special effects, cool layouts, and the myriad of things that only Photoshop can do, but then Lightroom isn't supposed to do all those things—it's for organizing and viewing your photos, and it does that pretty brilliantly I might add. If you get serious about this whole digital photography thing (and if you bought this book, you're getting serious), I recommend you check out Lightroom—especially because if you actually go and buy it, I get a cash kickback from Adobe. I'm kidding of course, but I wish I weren't.

How Many More Megapixels Do You Need?

3 megapixel = 5x7"

4 megapixel = 8x10"

5 megapixel = 11x14"

6 megapixel = 13x19"

8 megapixel = 16x20"

10 – 12 megapixel = 24x36"

There's a ton of confusion (also known as marketing hype) around megapixels, and many people truly believe that megapixels have to do with image quality—the higher the number of megapixels, the better the quality. Unfortunately, that's not true. So, if you were using that as an excuse to buy a new camera, that's not going to float with me (although your spouse may buy that line). Here's what megapixels really mean: how large can I print my final photograph? That's it. If you're not going to print anything larger than 8x10", then a 5-megapixel camera is absolutely all you need. In fact, it's really more than you need, but since 5 megapixels is about as few megapixels as you can buy these days, we'll leave it at that. If you want to routinely print 13x19" color prints, then you only need a 6-megapixel camera (I know, this is hard to swallow after years of thinking you needed 10 megapixels or more). So, what are today's 10- and 12-megapixel cameras for? Suckers. (Okay, not really, but you knew I was going to say that.) Actually, 10- and 12-megapixel cameras are for pros who need to print 24x36" poster-sized prints. If that's you, then it's time to pony up, but if you're not routinely printing poster-sized prints, a 6-megapixel camera is all most people will really ever need, so put away your checkbook. Hey, don't blame me. I'm trying to save you some money so you can buy some decent lenses and a fancy tripod.

Printing Lab–Quality 8x10s

At some point, after putting all these techniques to use, you're going to want prints, and today many pro photographers create their own prints. Personally, I only use Epson printers, and about every other pro I know uses Epson printers as well, because they've become the standard for professional quality color and black-and-white inkjet printing. Now, before I start making recommendations as to which Epson printer to buy, I want you to know up front that the only reason I'm telling you this is because it's exactly what I'd tell any friend who asked. I don't get a kickback or cut from Epson. They have no idea I'm telling you this, so if you tell them, "Hey, Scott said I should buy an Epson," they'll say something along the lines of, "Scott who?" I personally have three Epson printers, and I love them dearly for three main reasons:

(1) They work pretty flawlessly most of the time, but if I do run into a bump along the way, they have live 24-hour tech support, which is actually quite good.
(2) They not only sell the printers, but the paper as well, and I love their paper.
(3) The output is absolutely stunning. The quality prints that come out of my Epson printers still amaze me.

For printing borderless 4x6s, 5x7s, and 8x10s, I use (and highly recommend) the Epson Stylus Photo R1900. It costs about $550. Worth every penny.

Printing Lab-Quality 13x19" Prints

A popular print size with pro photographers is the 13x19" large print, and the Epson Stylus Photo R2880 is the king of this realm. I've never seen another printer even touch it, except for maybe the R2400 it replaced. Its color output is really stunning, but where the R2880 really kills is when you print black-and-white prints. You'll lose your mind. Plus, the R2880 uses Epson's UltraChrome K3 archival-quality inks, so your prints are going to last longer than you will by a long shot. Of course, besides the 13x19" prints, it also does all of the smaller sizes, as well. This is as in love with a printer as I've ever become. It costs around $800, which, for what it does, is a bargain.

Printing 17x22s—The Pros' Top Choice

Pros who sell their prints know that the bigger the print, the bigger the paycheck, and maybe that's why so many favor the 17x22" large print format, and the printer for that is Epson's Stylus Pro 3800. Although it technically prints 17" by as wide as you want to go, the size everybody's trying to hit is that 17x22" sweet spot, and the 3800 does it wonderfully well. It's a dream machine.

Which Paper Should You Print On?

If you're getting an Epson printer, then you definitely want to print on Epson paper. Epson paper not only works best on Epson printers, sometimes it's the only paper that will work (for example, one time when I was in a bind, I tried some HP paper. It didn't work at all—the paper went through the printer and ink came out, but it looked like… well, let's just say it didn't work and leave it at that). So, which papers do I recommend? Here they are:

Epson Velvet Fine Art Paper: This is a cotton paper with a matte coating that looks like watercolor paper and has a wonderful texture that gives your photos almost a painted feel. Clients love the feel of this paper and it's usually the first thing they notice.

Epson Ultra Premium Photo Paper Luster: This is probably my all-around favorite paper (and a favorite with many pros) because, although it definitely has a sheen to it, it does so without being overly glossy. It's that perfect paper between glossy and matte.

If you're really serious about your prints, I think the best paper on earth is Epson's Exhibition Fiber Paper, which is literally gallery-quality paper, and looks as amazing for B&W images as it does color images. I've never seen a paper I liked better—it's the "real deal" (and not surprisingly, it's a bit pricey).

All of these papers are available directly from Epson.com, but I also often find these at bhphotovideo.com in sizes up to 17x22".

What Determines Which Paper You Use?

PREMIUM LUSTER

SCOTT KELBY

VELVET FINE ART

SCOTT KELBY

So, how do you know which paper to use? Believe it or not, there's an easy way—the paper you choose to print on is determined by one thing: the subject matter of your photo.

For example, if you're printing things of a softer nature, like flowers, birds, landscapes, water-falls, or any type of image where you want a softer feel, try a textured paper like Epson's Velvet Fine Art Paper (provided you are printing to an Epson printer), which works wonderfully well for these types of images. This is your choice any time you want that "artsy" feel to your pho-tography, and it also works well when your photo isn't tack sharp. Try it for black-and-white photography, too (especially on Epson's R2880), when you want extra texture and depth.

For serious portrait work, architecture, city life, travel, and finely detailed landscape shots, try Epson's Ultra Premium Photo Paper Luster. Anything with lots of detail looks great on this paper, and it really makes your colors vivid. So, when the shot has lots of detail and sharpness, lots of color, and you need it to "pop," this is the ticket for sharp, crisp prints.

I use the Exhibition Fiber Paper for all my serious B&W prints—it just rocks. A weird thing you'll find out about this paper is that when you hand somebody one of your prints, they'll always comment about how the paper feels. It just has a particular feel that makes photog-raphers "oooh" and "aaah" (I know it sounds silly, but how things feel matters). Anyway, it's expensive, so I don't use it for every print, but when you've got that killer shot, this is the stuff to use.

Getting Your Monitor to Match Your Printer

Color management (the art of getting your color inkjet prints to match what you see on your monitor) has gotten dramatically easier in recent years, but the key to getting a color management system to work is getting your monitor color calibrated. A few years ago, this was a costly and time-consuming process usually only undertaken by paid consultants, but now anybody can do it because (1) it's very affordable now, and (2) it pretty much does all the calibrating work automatically while you just sit there and munch on a donut (you don't have to eat a donut, but it doesn't hurt). Probably the most popular monitor calibrator in use by pros these days is the i1 Display 2 from X-Rite. It sells for around $200, and that's pretty much all that stands in the way of having your monitor match your prints. Well, that and downloading the free color profiles for the paper you're printing on (more on that on the next page).

Download the Color Profiles for Your Paper

If you buy Epson papers (or any of the major name-brand professional inkjet papers), you'll definitely want to go to Epson's (or your paper manufacturer's) website, go to their downloads page for your particular inkjet printer, and download their free color profiles for the exact paper you'll be printing to. Once you install these free color profiles (they install with just a double-click), when you go to Photoshop to print your photo, you can choose the exact printer and paper combination you'll be printing to. This gives you the best possible results (and color fidelity) for your particular paper and printer. The pros do this every time and it makes a huge difference in the quality of their prints.

Tip for More Predictable Color

Your printer has a color management system, and Photoshop has one, too. Having two color management systems going at the same time is a guaranteed recipe for bad color. So, if you're printing from Photoshop, you should definitely turn *off* the color management system for your printer and use Photoshop's instead (in other words, let Photoshop determine the right colors).

Selling Your Photos as "Stock" Online

Selling photos to a stock agency is a dream of many photographers (pros included), but generally only the best of the best get this opportunity. Until now. Now you can start selling royalty-free stock photography today thanks to iStockphoto.com, which is a community of photographers all around the world who sell their photos online as stock (which means you give the rights to other people to buy, download, and use your photos in brochures, ads, websites, flyers, and other collateral material graphic designers and Web designers create for their clients). The great thing is anybody that follows their guidelines can upload their own photos and start selling them right away as part of iStock-photo's huge database of images. Now, you only get paid on how many people actually buy your photo, and since the photos sell for $1 (for extra small size), $3 (for small size), $6 (for medium size), $12 (for large size), and $18–27 (for full-page), you're going to need to move a lot of photos to make this a business. But let me tell you this, there are photographers who make their living (and their Porsche payments) strictly from what they sell on iStockphoto.com, because iStockphoto is used by about a bazillion people around the world. Needless to say, the better quality your work is, and the more popular the subjects are, the more your images will get downloaded. How popular is iStockphoto.com? Well, Getty Images, one of the world's leading and most respected providers of high-quality stock images, bought them out—if that gives you any idea.

A Quick Peek at My Gear

For those interested in what kind of photo gear I use, here's a quick look: my main camera is a Nikon D3 and my backup camera body is a Nikon D300. I carry four lenses with me when I'm shooting: a Nikon 14–24mm f/2.8 wide-angle zoom, a 70–200mm VR f/2.8 zoom, a 24–70mm f/2.8 zoom, and a 200mm f/2. I also have a 70–180mm f/4.5 macro zoom lens. I use polarizers, split neutral gradient filters, and UV filters. That's it.

I use Nikon SB800 and SB900 external flashes and I have an Epson P-7000, and two OWC 160-GB On-The-Go hard drives (as my second backup drive).

I use a Gitzo carbon fiber tripod and a Gitzo monopod, and a Really Right Stuff BH-55 ballhead (the mother of all ballheads, if you ask me). I use four Hoodman RAW UDMA 300X CompactFlash memory cards. Lastly, I lug all this gear around in two ways: on most days I pull (it rolls) a Lowepro Pro Roller 1, but when I want to travel light I use a Lowepro Stealth Reporter D200 AW Shoulder Bag, which works great!

Some Books I Personally Recommend

I hope this book has ignited your passion to learn more about the craft of photography, and if that's the case, here are some books I recommend (in no particular order):

(1) *Understanding Exposure: How to Shoot Great Photographs with a Film or Digital Camera* by Bryan Peterson
(2) *The Moment It Clicks: Photography Secrets from One of the World's Top Shooters* by Joe McNally
(3) *The Digital Photography Book,* volume 2 by Scott Kelby
(4) *Footprints Travel Photography*, by Steve Davey
(5) *Rick Sammon's Complete Guide to Digital Photography: 107 Lessons on Taking, Making, Editing, Storing, Printing, and Sharing Better Digital Images* by Rick Sammon

If you just love great photography, here are some photo books I recommend:

(1) *America From 500 Feet II* by Bill Fortney and Mark Kettenhofen
(2) *Golden Poppies of California: In Celebration of Our State Flower* by George Lepp
(3) *Flying Flowers* by Rick Sammon
(4) *Window Seat: The Art of Digital Photography and Creative Thinking* by Julieanne Kost

Learn from Me on *Photoshop® User TV*

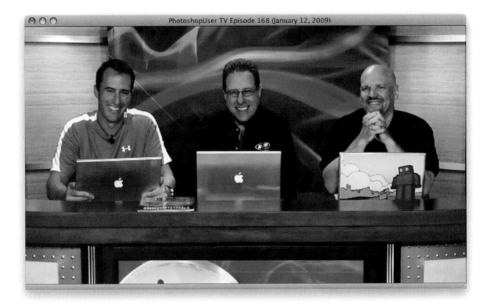

PhotoshopUser TV Episode 168 (January 12, 2009)

If you want to learn more about Adobe Photoshop and how to process and edit your digital photos, then check out *Photoshop® User TV* (www.photoshopusertv.com). It's a 30-minute weekly video show that I co-host with my friends (and fellow Photoshop gurus), Dave Cross and Matt Kloskowski. Each week we give you the latest tips, step-by-step tutorials, Photoshop news, and lots of other cool stuff (like prizes and contests). *Photoshop® User TV* is free, and you can watch it right there on our website or you can download it and watch it on your computer or your iPod (as a video podcast). In fact, you can subscribe to the show for free, and each Monday the show will be automatically downloaded to your computer, so you can watch it at your leisure. Here's how to subscribe:

(1) Whether you're running Windows or Mac OSX, launch Apple's iTunes software (it's free for Mac or PC) and go to the iTunes Store.
(2) Click on the Podcasts link on the left side of the iTunes Store homepage.
(3) In the Search field at the top right of the iTunes window, type in "Photoshop" and press the Return (PC: Enter) key on your keyboard.
(4) In a couple of seconds, you'll find *Photoshop User TV*. Click on it, and then click on the Subscribe button. That's it—you're subscribed. Now you can watch it from right within the iTunes window (at any size you'd like), or you can download it to your video iPod and watch it there.

SHUTTER SPEED: 1/400SEC F-STOP: F/10 ISO: 200 FOCAL LENGTH: 50mm PHOTOGRAPHER: SCOTT KELBY

Chapter Eleven

Photo Recipes to Help You Get "The Shot"

The Simple Ingredients That Make It All Come Together

Hey, it's the end of the book, and now is as good a time as any to let you in on a secret. There's really no way in hell we're going to get those really magical shots (like you see in magazines such as *Outdoor Photographer* or *Shutterbug*). That's because when we get out to that prime shooting location at the crack of dawn to hopefully capture one of these once-in-a-lifetime shots, carrying so much gear that our chiropractors are on speed dial, we'll soon find that it's too late—there are already a dozen or so photographers set up there waiting for that magical light, too. Since they were there first, the only spot left on that tiny plateau is behind them, and every shot you take is going to have some, if not all, of their camera gear fully in your frame ruining any possible chance of you getting "the shot." But this chapter is all about recipes for getting the shot, and I've got a special recipe for this very situation. Just as the golden light appears over the horizon, you quietly slide your foot inside one of their tripod legs, then quickly pull your foot back, toppling over their entire rig, and as their thousands of dollars of gear begins to crash violently to the ground, you deftly press the cable release on your camera and capture that amazing vista as the sound of broken glass echoes off the canyon walls. Ahh, that my friends is the magical sound of you getting "the shot." If you hear the faint sound of sobbing in the distance, it all becomes that much sweeter. Enjoy.

 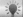
The Recipe for Getting This Type of Shot

SCOTT KELBY

Characteristics of this type of shot: the water is very still; you can see through the water because there's very little reflection; the overall tone is blueish; the lighting and shadows are very soft; you get a full sweeping view.

(1) This type of light doesn't happen at 5:30 p.m.—you have to get up early and be in place ready to shoot at 5:30 a.m., right before the sun comes up.

(2) To get really still water, you also have to shoot at dawn. If you shoot this same scene at sunset, the winds will have picked up and the water won't be as smooth.

(3) Set up your tripod without extending the legs, so your lens is close to the rocks for a low, more interesting angle (remember, most point-and-shooters would have shot it standing up—the average viewpoint we usually see, which would be boring).

(4) To remove some of the reflection from the water and see some of those rocks, you'll need to screw on a polarizing filter and rotate the filter around until, like magic, the reflection disappears (that's right—polarizing filters are not just for skies).

(5) Use a wide-angle lens to give the shot its "vastness." If you have an 18–80mm zoom, set it at 18mm (the widest setting for that lens).

(6) Use aperture priority mode and choose an f-stop like f/22 to give you good sharpness throughout the entire photo, from the rocks to the mountains.

(7) To further enhance that "blue morning" effect, if you're shooting in JPEG, change your white balance to Fluorescent, take a test shot, then look at the results in your LCD monitor. If you're shooting RAW, you can choose your white balance later in Photoshop.

 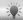
The Recipe for Getting This Type of Shot

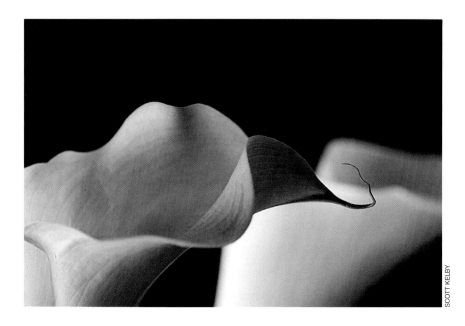

SCOTT KELBY

Characteristics of this type of shot: soft, natural light; shot on a black background, very close to the subject. This type of shot is easier than it looks.

(1) You need a black background behind your flowers. These were sitting in a vase, with black poster board placed about 3 feet behind them. You can use black velvet (which works even better than what was used here) that you buy from the local fabric store.
(2) You have to set up your tripod's height so it's level with the flowers. You don't want to shoot down on them—you want to shoot them at eye level, so put the vase on a table so they're up high enough, then position your tripod at the same height.
(3) Use natural light. These were positioned about 4 feet from an open window that wasn't getting direct light. Don't shoot straight into the window, shoot from the side so your flowers are getting side lighting.
(4) Use a macro or close-up lens to get this close to the flowers. When you use a macro (or close-up lens), the depth of field is very shallow automatically, so the flower(s) in the background will already be blurry, and that's what you want.
(5) The f-stop was f/5.6, which again gives you maximum sharpness on the object closest to the camera, and everything behind will be blurry. It was shot in aperture priority mode (which is an ideal mode for controlling your depth of field). When shooting with a macro lens, the depth of field is much more shallow.
(6) To get super sharp, you need to be super still; use the mirror lock-up trick in Chapter 1.

The Recipe for Getting This Type of Shot

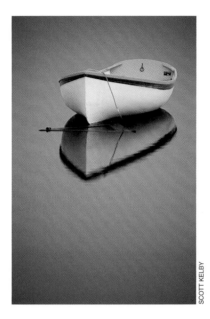

SCOTT KELBY

Characteristics of this type of shot: your subject fills the frame from side-to-side; no visible sky; great contrast of color; interesting placement of subject.

(1) The star of this shot is really the contrasting colors—otherwise it would just be another "rowboat in the water" shot. There were dozens of boats in the harbor that day, but this one was the only one with such great contrasting colors. The white and salmon color against that blue water creates lots of visual interest through color.
(2) To get this wonderful light and the soft shadows, there are only two times of day you can shoot—either at dawn or dusk. This was taken at dusk, and that's why the colors are so vivid (the colors are vivid because the sun isn't washing them out).
(3) To get this close to the boat, you either have to be in another boat or on the dock with a long lens, which is the case here. Put on your longest zoom lens and zoom in so that the boat almost fills the width of the frame.
(4) You must use a tripod to get a shot like this for two reasons: (a) it's dusk so the light is low and you really can't hand-hold and get a sharp photo, and (b) you're using a long lens. The further you're zoomed in, the more any tiny vibration will be exaggerated and your photos will be blurry. You've gotta use a tripod for shots in low light with a zoom.
(5) The other key to getting a shot like this is composition. By putting the boat up top, rather than dead center, it creates loads of visual interest and draws your eye right to the subject.

The Recipe for Getting This Type of Shot

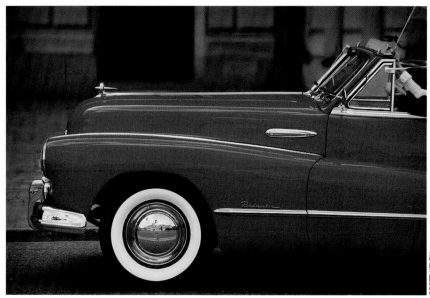

SCOTT KELBY

Characteristics of this type of shot: fascinating color; high contrast between the car and the background; the composition of the shot tells a story.

(1) This is one of those city life shots, and the best way to get them is to be ready for them to happen. As I mentioned in Chapter 9, when you're in a city, be ready for any shot by shooting in program mode. The flash won't pop up on you (ruining the shot), but you can basically point and shoot. This unexpected shot happened when I was walking back to my hotel in Stockholm, Sweden. It was graduation day for Stockholm's high school students, and many were riding around town in convertibles and open bed trucks cheering, waving Swedish flags, and celebrating their achievement. I had my camera over my shoulder and some incredibly delicious fries in my hands (it's a long story). Anyway, while carefully balancing my fries (so as not to lose a single delicious strand), this car pulled up beside me. My camera was in program mode, so with my one free hand I held up the camera—click—and got the shot. Had I been in aperture priority mode (my usual shooting mode), I would have missed it while setting the aperture because a split-second later the car drove away.

(2) By including just a little of the driver's arm, passenger's arm, and flag, the photo tells a story: What were they doing? Why were they carrying flags? Where are they going? However, an even better composition would have a little more room showing on the left side, in front of the car, so the car had somewhere to go.

 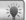

The Recipe for Getting This Type of Shot

SCOTT KELBY

Characteristics of this type of shot: still water; close-up shot of the flower, but obviously not a macro shot; fairly soft light, but well-defined shadows.

(1) This type of shot is taken in open shade (by that, I mean the water was in the shadows, under some sort of cover). That's why the shadows are pretty well defined—enough light was getting under the shade that the shadows were maintained. Look for open shade (or cloudy days where white puffy clouds act as your softbox, diffusing the light) to get shots like this, where the colors are vibrant and the light is still soft. (2) Use as long a zoom lens as you have to get the flowers to fill the frame as much as possible. In this case, I used a 300mm zoom, but this was a rare instance when I didn't have a tripod with me, and you generally can't hand-hold a 300mm lens steady enough to get a sharp photo, so I improvised. I shot this from a bridge overlooking a small pond, so I rested the lens on the handrail of the bridge to steady the camera and lens and it worked perfectly. In a pinch, rest your camera (or lens) on anything stable. (3) Everything in the shot is at the same depth (there is really no foreground or background—it's all at the same distance from the camera), so an f-stop like f/11 works well for shots like this when you want everything at the same distance in focus.

 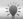

The Recipe for Getting This Type of Shot

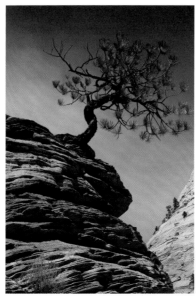

SCOTT KELBY

Characteristics of this type of shot: you're shooting a well-known subject (this lone tree in Zion National Park) in harsh direct light; it has surprisingly warm colors for a shot taken in noon-day sun.

(1) Sometimes you have to take the shot in less than ideal lighting situations (I was passing through Zion on my way to another shoot, so I could either take the shot in bad light or not take it at all). In cases like this, pull out your polarizing filter and rotate until it adds more blue to the lifeless sky.

(2) Make a composition decision that will make the shot interesting. Point-and-shooters would center the tree. You want to either: (a) make the rock below the tree have the most emphasis in the frame, or (b) make the sky above the tree have the most emphasis. (In the shot shown here, I made the rocks below the tree have more importance in the frame, but I shot it both ways—some with lots of blue sky above the tree, with the tree way down low in the frame, and then some like this, with the tree near the top, with lots of rock below it. I went with the rock shot, because I felt it was more interesting than the blue, cloudless sky.)

(3) Shoot in aperture priority mode and set your f-stop to f/11, which is a great f-stop when you want a really sharp shot and you're not trying to put any part of the photo visibly out of focus. It's kind of the no-brainer f-stop. So is f/8.

The Recipe for Getting This Type of Shot

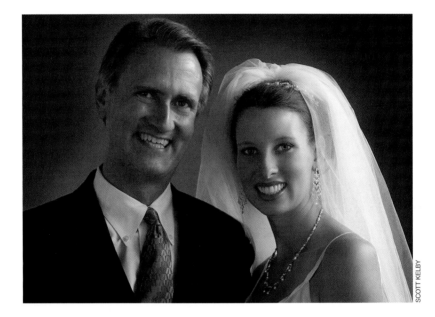

SCOTT KELBY

Characteristics of this type of shot: soft, directional light; visual interest through the composition; no flash used so skin tones look natural.

(1) Set your subjects up about 6 to 8 feet from an open window with natural light coming in. The key is to make sure the light coming in through that window isn't direct sunlight, so the light is soft—not harsh beams of light. Don't use flash. Let the natural light do all the work.

(2) Put your camera on a tripod. Although there is natural light, the light is lower than you'd think, and for maximum sharpness you want your camera on a tripod.

(3) Position your subjects so the light comes in from one side (in the photo above, the light is coming from a window to the right of the bride).

(4) Focus on the subject's eyes (in this case, the bride) because if her eyes aren't in focus, the shot goes in the trash.

(5) Shoot in aperture priority mode with your f-stop at f/11, which is great for portraits.

(6) By not positioning the father and bride in the dead center of the photo, it makes the portrait that much stronger and more visually appealing. Kick them over to the left or right a little bit, so they don't look dead center.

(7) The glow around them was added in Photoshop. To see this Photoshop technique step-by-step, visit www.scottkelbybooks.com/glow.

The Recipe for Getting This Type of Shot

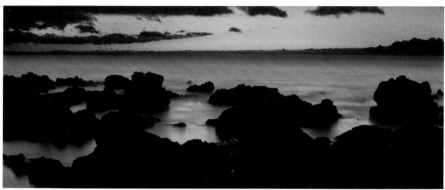

SCOTT KELBY

Characteristics of this type of shot: smooth, silky water; dramatic skies; sharp detail from front to back; contrast of color in the sky and the water.

(1) To get a shot like this, with the silky water look, requires a number of things. First among them is you have to shoot it in very, very low light (before the sun comes up or well after it goes down—this shot was taken more than one hour after sunset) because you have to leave the shutter open long enough (10 seconds or more) so the waves can wash in and out while your shutter is open—that's what gives it the silky look. Normally, leaving your shutter open for 10 or more seconds will totally blow out your sky. That's why you do it well after sunset—so there's little light in the sky—but don't worry, the long exposure will capture what little light is there, giving you a shot like the one above. If you have a neutral density gradient filter, you can also use this so you don't have to wait quite as late to shoot, because it darkens just the sky for you.
(2) Set your camera to shutter priority mode, set your exposure to 10 seconds, and try a test shot to see if the ground is light enough (the sky won't be the problem). Your camera will automatically choose your f-stop in shutter priority mode.
(3) If your camera has a feature called long exposure noise reduction, turn it on before you take your shot and it will help reduce noise in your shadow areas.
(4) Shoot low by setting up your tripod very low to the ground (don't extend the legs), and use either a cable release or your camera's self timer to reduce camera shake.

The Recipe for Getting This Type of Shot

SCOTT KELBY

Characteristics of this type of shot: flower fills the frame; the background is out of focus; contrasting colors; visual interest through composition.

(1) Shoot with a zoom lens—use your longest zoom to get in tight and get the flower to fill the frame. This was shot with a 200mm lens, and the flower was actually a few feet away in a garden.

(2) Shoot at flower level. Set up your tripod so you are level with the flower (remember, don't shoot down on flowers), which requires you to squat down (knee pads are great for getting shots like this—I wish I had remembered mine that day).

(3) Shoot in aperture priority mode and use the smallest number f-stop your lens will allow (in this case, on this particular lens, it was f/5.6) to keep the flower in focus but the background out of focus.

(4) Now, bee patient (okay, that was lame). Actually, I saw bees flying around from flower to flower, so I sat there with my camera focused on the flower until a bee actually landed on the flower. Then all I had to do was press the shutter button.

(5) The shot was taken in natural light, but it looks fairly soft because the sun had tucked behind some white fluffy clouds, which are great for flower shots because it diffuses the harsh direct light. I didn't set up my tripod until the sun actually went into a large bank of clouds, so patience (for the right light, and for the bee to land) pays off.

The Recipe for Getting This Type of Shot

SCOTT KELBY

Characteristics of this type of shot: nice light; vivid colors; soft shadows; motion, which adds excitement and interest to the photo.

(1) To get motion in the shot, you have to shoot with a slower shutter speed. Set your mode to shutter priority and choose 1/8 of a second or slower, so your shutter is open long enough to capture any movement as a blur. With this slow of a shutter speed, you'll need to be on a tripod so the rest of the photo remains sharp.

(2) To get the rich, vivid colors and soft light, you'll need to shoot a shot like this in the late afternoon when the sun is low in the sky, or in open shade, and this shot had a little of both. If you look closely, you'll see the sunlight is coming from the right (as seen on the singer's face) and that adds some dramatic lighting, but because this was taken downtown on the side of a building that was already mostly in the shade, the light is very soft. By the way, you'd think direct sunlight would make the colors more vivid, but it usually does just the opposite—it washes the colors out.

(3) You can shoot a shot like this in aperture priority mode, choose a play-it-safe f-stop like f/11, and in the low light of the late afternoon/early evening your camera will automatically choose a slow enough shutter speed for you that will exaggerate any motion in the shot.

The Recipe for Getting This Type of Shot

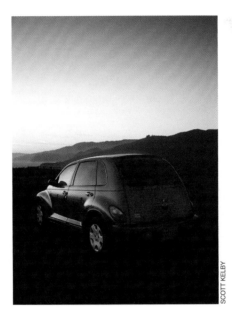

Characteristics of this type of shot: perfect light reflected on the side of the car; beautiful color in the sky; it's a sunset shot that's not just about the sunset.

(1) Shoot with a wide-angle lens, and turn your camera vertical (portrait orientation) to capture both the subject (in this case, a car) and enough of the sky to make the shot visually appealing. This was taken with a 24–120mm wide-angle lens, with the lens length at 24mm.

(2) To get a shot like this, once again you have two choices: (a) shoot at dawn, or (b) shoot at dusk (this particular shot was taken at dusk, just after the sun dipped into the ocean in the Marin Headlands overlooking San Francisco).

(3) In lighting this low, you'll have to shoot on a tripod to get a sharp photo.

(4) Compose the shot with your subject (the car) at the bottom of the frame to add visual interest, rather than centering the car in the frame which would give this more of a snapshot feel.

(5) The rest is just positioning your camera to make the most of the reflection on the side of the car. The beautiful light is really doing all the work—you're just waiting for the right moment to press the shutter release (actually, you're better off in this low light either using a cable release or your camera's self timer to reduce camera shake and give you a sharper photo).

The Recipe for Getting This Type of Shot

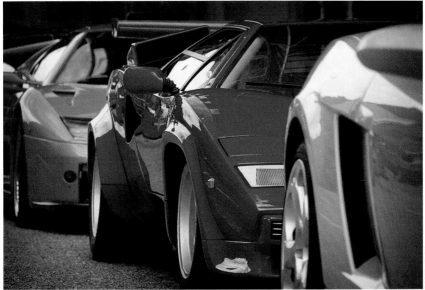

SCOTT KELBY

Characteristics of this type of shot: interesting point of view; great contrast of colors; interesting composition.

(1) To get a shot like this, you need a very low angle to shoot from, and that's what really makes the shot interesting—the angle isn't one you'd see very often because your average photographer would take the shot standing up (in fact, I was surrounded by photographers doing just that. Just in case you were wondering, this shot was taken outside a Lamborghini dealer located in a downtown area). To get this shot, which was hand-held, I sat in the middle of the street while my buddy looked out for cars. (2) To get the red car in the center in sharp focus and make the other cars softer in focus, shoot in aperture priority mode, choose a low number f-stop (in this case, it was f/5.6), and shoot with a zoom lens (this was taken with an 18–200mm zoom, with the lens at 180mm). The reason the yellow car in front is out of focus is because of how depth of field works: 1/3 of the area in front of your focus area (the red car) will be out of focus, and 2/3 of the area behind your focus area will be out of focus. (3) Another thing that makes this photo work (besides the interesting angle of view) is the close-up view of the cars, leaving more of the story (the rest of the cars) out of view. (4) The rest is just the luck of coming across a row of brightly-colored Lamborghinis on an overcast day.

The Recipe for Getting This Type of Shot

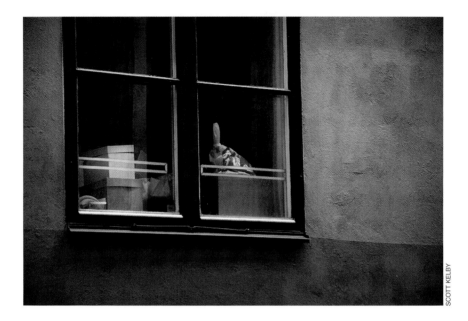

Characteristics of this type of shot: colors; visual interest inside the window; composition that shows details.

(1) The key to this shot is composition in the viewfinder. Don't try to capture the whole building or the entire wall. What makes this shot interesting is that you're not trying to capture everything—you're just showing one detail of the building, which suggests the whole. Plus, by getting in close, it begs the question: "What's inside that window? Who put those things there? What's in those blue boxes?" It makes the viewer think. Also, the window isn't dead center—it's off to the left, which adds to the visual interest. (2) To capture a window in a city life shot like this, you're going to need a zoom lens (this was shot with an 18–200mm zoom, with the length around 100mm). (3) You can shoot this in program mode and have the camera do all the work (as I mentioned earlier in the book, I often shoot in program mode while shooting city life so I can quickly get the shot without having to make any adjustments to the camera). (4) A polarizing filter will help you see through the glass by reducing glare. (5) City life is usually hard to capture with a tripod, because the shooting is often spontaneous and if you set up a tripod in a downtown area, the only spontaneous thing that will probably happen these days is the response of the security guards, so it's often best to hand-hold your shots.

The Recipe for Getting This Type of Shot

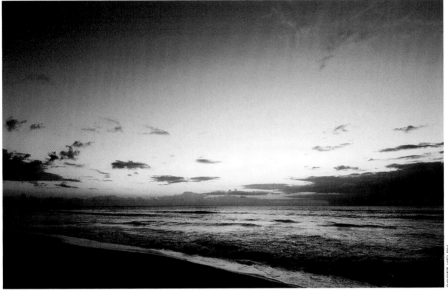

SCOTT KELBY

Characteristics of this type of shot: the classic sunset shot, but not shot in the classic snapshot way.

(1) Use the widest wide-angle lens you've got (this was taken with a 12–24mm zoom, with the length set at 12mm for maximum wideness).

(2) What makes this work is the fact that the horizon line isn't dead center (and sadly, dead center is where amateurs work so hard to get the horizon line). When shooting a shot like this, make your choice between these two: (a) you want to emphasize the beach, or (b) you want to emphasize the sky. In most cases, since you're shooting a sunset after all, make the sky the star of the show by putting the horizon line in the lower third of the frame (as shown above). Now, most people shooting sunsets don't include the beach at all—they're attracted to the sun and the horizon, so their sunset shots are usually made up of just sea and sky, but by including a little bit of beach, it helps lead the eye and tell the story.

(3) It doesn't much matter which shooting mode you use, because there's no important object to focus on—you pretty much want it all in focus, so you can use program mode or aperture priority mode with your f-stop set to anything from f/8 to f/16 and everything will look sharp from front to back.

(4) I know I've beat this to death, but you're shooting in low light; it's tripod time.

Index

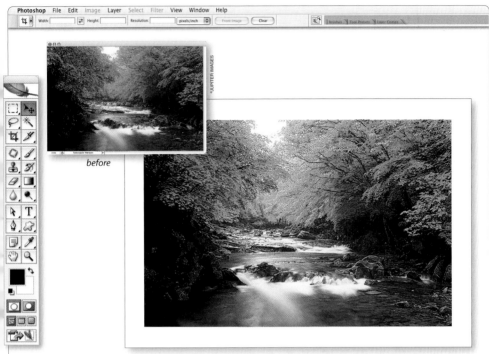

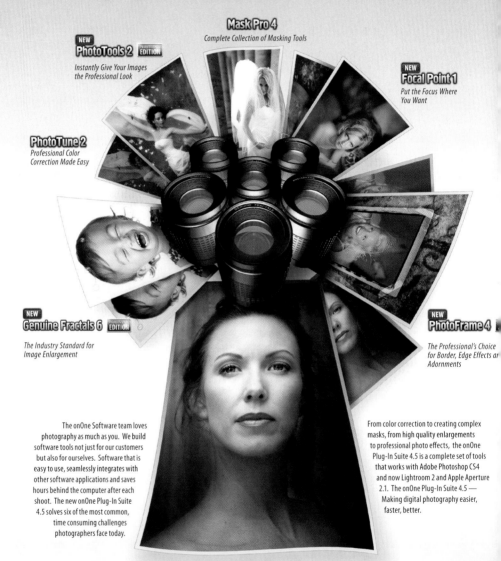

NEW
Plug-In Suite 4.5
Making Digital Photography Easier, Faster, Better

Mask Pro 4
Complete Collection of Masking Tools

NEW PhotoTools 2 PROFESSIONAL EDITION
Instantly Give Your Images the Professional Look

NEW Focal Point 1
Put the Focus Where You Want

PhotoTune 2
Professional Color Correction Made Easy

NEW Genuine Fractals 6 PHOTOSHOP EDITION
The Industry Standard for Image Enlargement

NEW PhotoFrame 4
The Professional's Choice for Border, Edge Effects and Adornments

The onOne Software team loves photography as much as you. We build software tools not just for our customers but also for ourselves. Software that is easy to use, seamlessly integrates with other software applications and saves hours behind the computer after each shoot. The new onOne Plug-In Suite 4.5 solves six of the most common, time consuming challenges photographers face today.

From color correction to creating complex masks, from high quality enlargements to professional photo effects, the onOne Plug-In Suite 4.5 is a complete set of tools that works with Adobe Photoshop CS4 and now Lightroom 2 and Apple Aperture 2.1. The onOne Plug-In Suite 4.5 — Making digital photography easier, faster, better.

onOne software

"The new Plug-In Suite 4.5 is a "must-have" for every photographer . Common editing tasks that are complicated & time-consuming can be done easier, faster and better with professional quality."

—Jim DiVitale, Master Photographer & Photoshop World Dream Team Instructor

Learn more and download a free demo at **www.ononesoftware.com**

Never take your eyes off your work.
Never memorize another keyboard shortcut.
Never waste a second screen on palettes.

**Always be
in control.**

Introducing the **NuLOOQ**™ professional series.

The revolutionary NuLOOQ navigator™ input device and NuLOOQ tooldial™ software
streamline the time-intensive elements of workflow: navigating images, adjusting
option values, and accessing menus. For users of Adobe® Creative Suite 2.

Take the NuLOOQ interactive product tour at www.logitech.com/nulooq.

The
Digital
Photography
The step-by-step secrets for how to
make your photos look like the pros'!
Book

VOLUME 2

Scott Kelby

The Digital Photography Book, Volume 2

The Digital Photography Book, Volume 2 Team

TECHNICAL EDITORS
Cindy Snyder
Jennifer Concepcion

EDITORIAL CONSULTANTS
David Hobby
David Ziser
Steve Dantzig

TRAFFIC DIRECTOR
Kim Gabriel

PRODUCTION MANAGER
Dave Damstra

GRAPHIC DESIGN
Jessica Maldonado

COVER DESIGNED BY
Jessica Maldonado

STUDIO SHOTS
Rafael "RC" Concepcion
Brad Moore

PUBLISHED BY
Peachpit Press

Copyright ©2008, 2011 by Scott Kelby

FIRST EDITION: December 2007

Composed in Myriad Pro (Adobe Systems Incorporated) and Lucida Grande (Bigelow & Holmes Inc.) by Kelby Media Group.

Trademarks
All terms mentioned in this book that are known to be trademarks or service marks have been appropriately capitalized. Peachpit Press cannot attest to the accuracy of this information. Use of a term in the book should not be regarded as affecting the validity of any trademark or service mark.

Photoshop, Elements, and Lightroom are registered trademarks of Adobe Systems Incorporated.
Nikon is a registered trademark of Nikon Corporation.
Canon is a registered trademark of Canon Inc.

Warning and Disclaimer
This book is designed to provide information about digital photography. Every effort has been made to make this book as complete and as accurate as possible, but no warranty of fitness is implied.

The information is provided on an as-is basis. The author and Peachpit Press shall have neither the liability nor responsibility to any person or entity with respect to any loss or damages arising from the information contained in this book or from the use of the discs or programs that may accompany it.

THIS PRODUCT IS NOT ENDORSED OR SPONSORED BY ADOBE SYSTEMS INCORPORATED, PUBLISHER OF ADOBE PHOTOSHOP, PHOTOSHOP ELEMENTS, AND PHOTOSHOP LIGHTROOM.

ISBN 10: 0-321-52476-4
ISBN 13: 978-0-321-52476-8

16

Printed and bound in the United States of America

www.kelbytraining.com
www.peachpit.com

To Jean A. Kendra
for coming along with us
on this crazy ride, and for
being such a great friend
to our family for all these years.
We love you!

Acknowledgments

Although only one name appears on the spine of this book, it takes a team of dedicated and talented people to pull a project like this together. I'm not only delighted to be working with them, but I also get the honor and privilege of thanking them here.

To my amazing wife Kalebra: I don't know how you do it, but each year you somehow get more beautiful, more compassionate, more generous, more fun, and you get me to fall even more madly in love with you than the year before (and so far, you've done this 18 years in a row)! They don't make words to express how I feel about you, and how thankful and blessed I am to have you as my wife, but since all I have here are words—thank you for making me the luckiest man in the world.

To my wonderful, crazy, fun-filled, little buddy Jordan: You are, hands-down, the coolest little boy any dad could ever ask for, and although I know you don't read these acknowledgments, it means so much to me that I can write it, just to tell you how proud I am of you, how thrilled I am to be your dad, and what a great big brother you've become to your little sister. Your mom and I were truly blessed the day you were born.

To my beautiful baby daughter Kira: You are a little clone of your mom, and that's the best compliment I could ever give you. You already have your mom's sweet nature, her beautiful smile, and like her, you always have a song in your heart. You're already starting to realize that your mom is someone incredibly special, and take it from Dad, you're in for a really fun, exciting, hug-filled, and adventure-filled life.

To my big brother Jeff: A lot of younger brothers look up to their older brother because, well… they're older. But I look up to you because you've been much more than a brother to me. It's like you've been my "other dad" in the way you always looked out for me, gave me wise and thoughtful council, and always put me first—just like Dad put us first. Your boundless generosity, kindness, positive attitude, and humility have been an inspiration to me my entire life, and I'm just so honored to be your brother and lifelong friend.

To my in-house team at Kelby Media Group: You make coming into work an awful lot of fun for me, and each time I walk in the door, I can feel that infectious buzz of creativity you put out that makes me enjoy what we do so much. I'm still amazed to this day at how we all come together to hit our often impossible deadlines, and as always, you do it with class, poise, and a can-do attitude that is truly inspiring. You guys rock!

To my editor Cindy Snyder: I can't thank you enough for stepping up to the plate and knocking one out of the park while our "Mommy of the Year" Kim Doty was off having the cutest little baby boy in the whole wide world. You did just a great job of keeping the train on the track, keeping me focused, and making sure that volume 2 kept the same voice and vision as the original. I am very grateful to have worked on this with you. Way to go!

To Dave Damstra and his amazing crew: You guys give my books such a spot-on, clean, to-the-point look, and although I don't know how you do it, I sure am glad that you do!

To Jessica Maldonado: I can't thank you enough for all your hard work on the cover, and on the look of this and all my books. We got very lucky when you joined our team.

To my friend and Creative Director Felix Nelson: You're the glue that keeps this whole thing together, and not only could I not do this without you—I wouldn't want to. Keep doin' that Felix thing you do!

To Kim Gabriel: You're the unsung hero behind the scenes, and I'm sure I don't say this enough, but—thank you so much for everything you do to make this all come together. I know it's not easy, but you somehow make it look like it is.

To my best buddy Dave Moser: Besides being the driving force behind all our books, I just want you to know how touched and honored I was that you chose me to be the Best Man at your wedding. It meant more than you know.

To my dear friend and business partner Jean A. Kendra: Thanks for putting up with me all these years, and for your support for all my crazy ideas. It really means a lot.

To my Executive Assistant and general Wonder Woman Kathy Siler: I'm writing this right before my Bucs play your Redskins, so at this point, while we're still talking: thank you, thank you, thank you! All the mini-miracles you pull off each day enable me to continue to write books, take photos, and still have a family to come home to. I am indebted (not so much that I want the Redskins to win, but indebted nonetheless).

To my publisher Nancy Ruenzel, marketing maverick Scott Cowlin, production hound Ted Waitt, and all the incredibly dedicated team at Peachpit Press: It's a real honor to get to work with people who really just want to make great books.

To David Ziser, David Hobby, and Steve Dantzig who acted as tech editors on three very important chapters: the wedding photography chapter, the off-camera flash chapter, and the studio chapter, respectively. I asked for your help because I knew you were the best, and the book is far better because of your input, suggestions, and ideas. I am so very grateful to you all.

To all the talented and gifted photographers who've taught me so much over the years: Moose Peterson, Vincent Versace, Bill Fortney, David Ziser, Jim DiVitale, Helene Glassman, Joe McNally, Anne Cahill, George Lepp, Kevin Ames, and Eddie Tapp. I give you sincere and heartfelt thanks for sharing your passion, ideas, and techniques with me and my students. As you know—I couldn't have done it without you.

To my mentors John Graden, Jack Lee, Dave Gales, Judy Farmer, and Douglas Poole: Your wisdom and whip-cracking have helped me immeasurably throughout my life, and I will always be in your debt, and grateful for your friendship and guidance.

Most importantly, I want to thank God, and His son Jesus Christ, for leading me to the woman of my dreams, for blessing us with such amazing children, for allowing me to make a living doing something I truly love, for always being there when I need Him, for blessing me with a wonderful, fulfilling, and happy life, and such a warm, loving family to share it with.

Other Books by Scott Kelby

Scott Kelby's 7-Point System for Adobe Photoshop CS3

The Adobe Photoshop Lightroom Book for Digital Photographers

The Photoshop CS5 Book for Digital Photographers

The Photoshop Channels Book

Photoshop Down & Dirty Tricks

Photoshop Killer Tips

Photoshop Classic Effects

The iPod Book

InDesign Killer Tips

The Digital Photography Book

Mac OS X Tiger Killer Tips

Getting Started with Your Mac and Mac OS X Tiger

The Elements 8 Book for Digital Photographers

The iPhone Book

About the Author

Scott Kelby

Scott is Editor, Publisher, and co-founder of *Photoshop User* magazine, Editor-in-Chief of *Layers* magazine (the how-to magazine for everything Adobe), and is the host of the top-rated weekly videocast *Photoshop User TV* and the co-host of *D-Town TV*, the weekly videocast for DSLR shooters.

He is President of the National Association of Photoshop Professionals (NAPP), the trade association for Adobe® Photoshop® users, and he's President of the software training, education, and publishing firm, Kelby Media Group, Inc.

Scott is a photographer, designer, and award-winning author of more than 50 books, including *The Photoshop CS5 Book for Digital Photographers*, *Photoshop Down & Dirty Tricks*, *The Adobe Photoshop Lightroom Book for Digital Photographers*, *The Photoshop Channels Book*, *Photoshop Classic Effects*, *The iPhone Book*, *The iPod Book*, and *The Digital Photography Book*, volumes 1, 2 & 3.

For six years straight, Scott has been honored with the distinction of being the world's #1 best-selling author of all computer and technology books, across all categories. His books have been translated into dozens of different languages, including Chinese, Russian, Spanish, Korean, Polish, Taiwanese, French, German, Italian, Japanese, Dutch, Swedish, Turkish, and Portuguese, among others, and he is a recipient of the prestigious Benjamin Franklin Award.

Scott is Training Director for the Adobe Photoshop Seminar Tour, and Conference Technical Chair for the Photoshop World Conference & Expo. He's featured in a series of Adobe Photoshop training DVDs and has been training Adobe Photoshop users since 1993.

For more information on Scott, visit his daily blog at www.scottkelby.com

Table of Contents

Table of Contents

Table of Contents

Table of Contents

Table of Contents

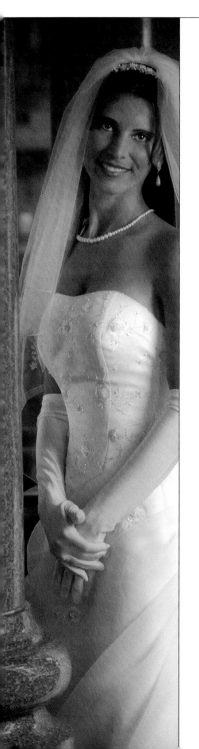

Table of Contents

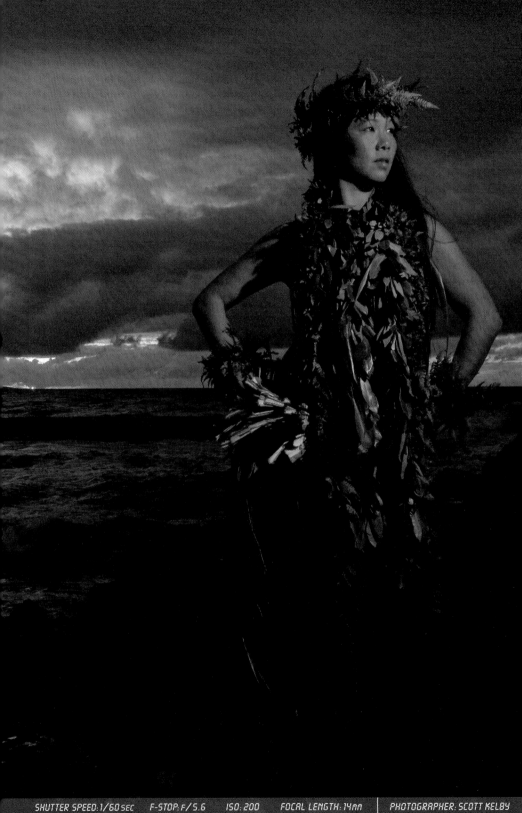

SHUTTER SPEED: 1/60 SEC F-STOP: F/5.6 ISO: 200 FOCAL LENGTH: 14mm PHOTOGRAPHER: SCOTT KELBY

Chapter One

Using Flash Like a Pro

If You Hate the Way Photos Look with Flash, You're Not Alone

If you've taken a photo with your camera's pop-up flash, you're probably wondering how camera manufacturers list pop-up flash as a feature and keep a straight face. It's probably because the term "pop-up flash" is actually a marketing phrase dreamed up by a high-powered PR agency, because its original, more descriptive, and more accurate name is actually "the ugly-maker." You'd usually have to go to the Driver's License Bureau to experience this quality of photographic light, but luckily for us, it's just one simple push of a button, and BAM—harsh, unflattering, annoying, blinding light fires right into your subject's face. Seriously, does it get any better than that? Actually, it does. You just have to get your flash off your camera. Now, the first time you actually use pop-up flash and you see the quality of light it creates (and by "quality" I mean "a total lack thereof"), you'll be tempted to do just that—rip that tiny little flash right off the top of your camera (I'm not the only one who did that, right?). I have to figure that camera manufacturers include a pop-up flash on most camera models to do one thing and one thing only: spur sales of dedicated off-camera flash units (which are actually fantastic). Because as soon as you see the results from your pop-up flash, you think, "There has just got to be something better than this!" or maybe "I must be doing something wrong," or "My camera must be broken," or "This camera must have been stolen from the Driver's License Bureau." Anyway, this chapter is for people who figured there must be something better, and if someone would just show them how to use it, they could love flash again (not pop-up flash, mind you, but off-camera flash, which is a gas, gas, gas!).

1

10 Things You'll Wish You Had Known...

Okay, there aren't really 10, there are just eight, but "Eight Things" sounded kinda lame.

(1) First, go right now to www.kelbytraining.com/books/digphotogv2 and watch the short video I made to explain these points in more detail. It's short, it's quick, and it will help you read this book in half the time (that "half the time" thing is marketing hype, but you'll get a lot out of the video, so head over there first. I'll make it worth your while).

(2) Here's how this book works: Basically, it's you and me together at a shoot, and I'm giving you the same tips, the same advice, and sharing the same techniques I've learned over the years from some of the top working pros. When I'm with a friend, I skip all the technical stuff, so for example, if you turned to me and said, "Hey Scott, I want the light to look really soft and flattering. How far back should I put this softbox?" I wouldn't give you a lecture about lighting ratios or flash modifiers. In real life, I'd just turn to you and say, "Move it in as close as you can to your subject without it actually showing up in the shot. The closer you get, the softer and more wrapping the light gets." I'd tell you short and right to the point. Like that. So that's what I do.

(3) Sometimes you have to buy stuff. This is not a book to sell you stuff, but before you move forward, understand that to get pro results, sometimes you have to use some accessories that the pros use. I don't get a kickback or promo fee from any companies whose products I recommend. I'm just giving you the exact same advice I'd give a friend.

...Before Reading This Book!

(4) We don't all have budgets like the pros, so wherever possible I break my suggestions down into three categories:

 If you see this symbol, it means this is gear for people on a tight budget.

 If you see this symbol, it means photography is your passion, and you're willing to spend a bit more to have some pretty nice gear.

 If you see this symbol, it means this gear is for people who don't really have a budget, like doctors, lawyers, venture capitalists, pro ball players, U.S. senators, etc.

To make this stuff easier to find, I've put up a webpage with links to all this gear, and you can find it at www.kelbytraining.com/books/vol2gear.

(5) If you're shooting with a Sony or Olympus or a Sigma digital camera, don't let it throw you that a Nikon or Canon camera is pictured. Since most people are shooting with a Nikon or Canon, I usually show one or the other, but don't sweat it if you're not—most of the techniques in this book apply to any digital SLR camera, and many of the point-and-shoot digital cameras as well.

Here Are Those Last Three Things

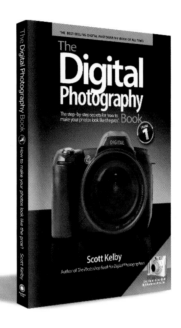

(6) The intro page at the beginning of each chapter is designed to give you a quick mental break, and honestly, they have little to do with the chapter. In fact, they have little to do with anything, but writing these off-the-wall chapter intros is kind of a tradition of mine (I do this in all my books), but if you're one of those really "serious" types, you can skip them because they'll just get on your nerves.

(7) This is volume 2 of *The Digital Photography Book* and it picks up where the last book left off (so it's not an update of that book, it's new stuff that people who bought the first book asked me to write about next). If you didn't buy volume 1, now would be a really good time to do that (just think of it as a "prequel." Hey, it worked for George Lucas).

(8) Keep this in mind: This is a "show me how to do it" book. I'm telling you these tips just like I'd tell a shooting buddy, and that means, oftentimes, it's just which button to push, which setting to change, where to put the light, and not a whole lot of reasons why. I figure that once you start getting amazing results from your camera, you'll go out and buy one of those "tell me all about it" digital camera or lighting books. Okay, it's almost time to get to work. I do truly hope this book ignites your passion for photography by helping you get the kind of results you always hoped you'd get from your digital photography. Now pack up your gear, it's time to head out for our first shoot.

Pop-Up Flash: Use It as a Weapon

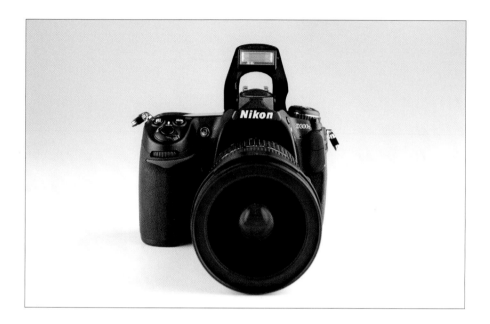

The pop-up flash built into your digital camera is designed to do one thing: give you the flattest, harshest, most unflattering light modern-day man has ever created. If you have a grudge against someone, shoot them with your camera's pop-up flash and it will even the score. Here are just some of the reasons why you want to avoid using that flash at all costs: (1) The face of the pop-up flash itself (where the light comes out) is very, very tiny and the smaller the light source, the harsher the light it produces. (2) Since the flash is positioned right above your camera's lens, you get the same quality of light and angle that a coal miner gets from the light mounted on the front of his helmet. (3) Using a pop-up flash is almost a 100% guarantee that your subject will have red eye, because the flash is mounted so close to, and directly above, the lens. (4) Because the flash hits your subject straight on, right square in the face, your subject tends to look very flat and lack dimension all around. (5) You have little control over the light, where it goes, or how it lands. It's like a lighting grenade. These are the reasons why so many people are so disappointed with how their shots look using their camera's flash, and it's exactly why using your pop-up flash should be absolutely, positively, a last resort and only done in the most desperate of situations (okay, actually it can do a somewhat decent job if you're shooting outdoors, your subject has the sun behind them, and you need a little bit of light so they're not just a silhouette. Then, maybe, but other than that…). So, what should you use instead? That's on the next page.

The Advantages of a Dedicated Flash

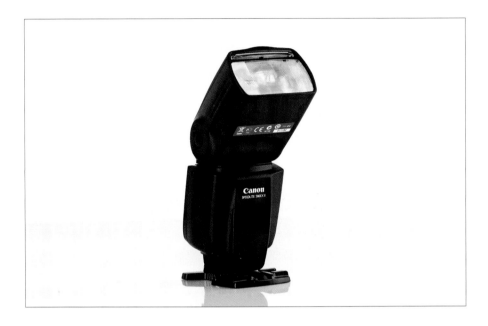

If you want to get pro-quality results from using flash, you're going to need to get a dedicated flash unit (like the one shown above or the ones listed below). What makes these dedicated flashes so great is:

(a) You can aim the flash in different directions (a pop-up flash just blasts straight ahead);
(b) You can angle the flash upward (this is huge—you'll see why later in this chapter);
(c) You can take this flash off your camera to create directional light;
(d) Even when mounted on your camera, because it's higher, you'll get less red eye;
(e) You get control, a more powerful flash, and most importantly, a better quality of light.

Best of all—today's dedicated flashes do almost all the work for you. Here are three I like:

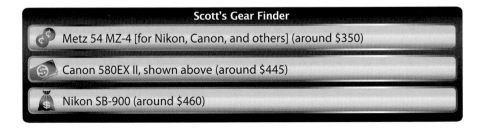

Scott's Gear Finder

Metz 54 MZ-4 [for Nikon, Canon, and others] (around $350)

Canon 580EX II, shown above (around $445)

Nikon SB-900 (around $460)

Get Your Flash Off Your Camera

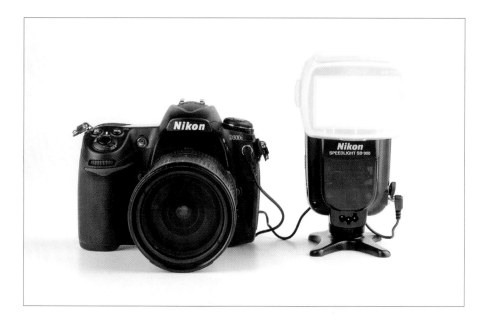

One of the best things you can do to get better results from your dedicated flash is to literally get it off the camera. That way, you can create directional light—light that comes from the side of your subject or above (or both), rather than the flat, straight-on light you get when your flash is mounted on your camera. Directional light is much more flattering, more professional looking, and it adds dimension and depth to your photos. One way to get your flash off your camera is to use a flash sync cord (a short cable that connects your flash to your camera). You just attach one end of the flash sync cord to the flash sync connector on your camera, and the other end plugs into the same place on your flash unit, and well—that's it. You can now hold your flash unit in your left hand—up high, and out away from your body. Then, aim it down at your subject and you've got directional side lighting (by holding it up high and aiming it down at your subject, it kind of approximates how sunlight would hit your subject). This little change alone makes a huge difference (it's bigger than you'd think), because having that directional light is really what it's all about. Getting that dedicated flash unit "off-camera" is one of the first steps to getting pro-quality results, and all that's standing between you and having more professional-looking directional light is that sync cord (which only costs around $35 for a 5' sync cord. Worth every penny).

Making Your Flash Wireless

JEFF REVELL

If you've got a recent Nikon or Canon digital SLR (anything from a Nikon D90 on up, or a Canon 50D or later), it has a feature that lets you avoid having to use a sync cable at all—you can get off-camera wirelessly instead. Once you turn this feature on, it acts just like there's a sync cable in place—when you press the shutter button on your camera, it fires the flash wirelessly. So, you save money because you don't have to buy a sync cable, you don't have to worry about your sync cable breaking or getting lost—in fact, you don't have to worry about dealing with cables at all. It's really quite brilliant. However, Nikons and Canons go about this whole wireless off-camera flash thing in a different way, so they're covered separately on the next couple of pages.

High-Powered Off-Camera Flash for Any Brand of Digital SLR

Quantum makes some serious high-end pro flash units that are very popular with pro photographers (they're higher powered flashes, almost like mini-studio strobes, are packed with pro features, and come with a number of flash accessories). I use the Quantum Qflash T5d-R, which works with most brands of digital SLR cameras, and can even be used wirelessly—you just need a wireless transmitter (attached to your camera) and a receiver (connected to the flash unit). You can find out more about the Qflash T5d-R at www.qtm.com.

Going Wireless (Nikon), Part I

If your Nikon camera has a built-in pop-up flash (you have a Nikon D90, D300s, or D700), you can make a Nikon SB-600 or SB-900 flash go wireless. (*Note:* If you have the Nikon D3, D3s, or D3X models, they don't have pop-up flash, so you'll have to buy Nikon's SU-800 transmitter, which slides into the hot shoe on the top of your camera so you can control the power of your wireless flash.) This is a two-part setup and the first part (on this page) is what you change on the flash unit itself. Here's what to do: On the Nikon SB-900, just turn the ON/OFF switch to Remote and your flash is now wireless. On the Nikon SB-600, press-and-hold the Zoom and – (minus sign) buttons until the Custom Settings menu appears. You should see the word "OFF" and a squiggly line with an arrow beneath it. Press the Mode button to turn the wireless function On, then press the ON/OFF button, and your flash is now wireless.

Going Wireless (Nikon), Part II

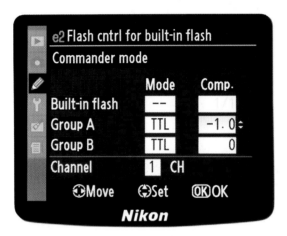

Okay, here's what we need to set up on the camera itself: (1) First, pop up your camera's built-in pop-up flash (it actually triggers the wireless flash, so if you don't have your built-in flash popped up, it won't work).

(2) Now, you need to switch your camera's pop-up flash into Commander mode, so instead of firing its flash, it only sends a small light pulse to your wireless off-camera flash unit to trigger it. To do this, press the Menu button on the back of your camera, go to the Custom Settings menu, and choose Bracketing/Flash. When the Bracketing/Flash menu appears, choose Built-in Flash, then choose Commander Mode (as shown above). Highlight the Built-in Flash field, and use the dial on the back of your camera to toggle the setting until it reads just "--" (as shown above), which means the pop-up flash is off (except for that little light pulse, of course).

(3) Now when you fire your shutter, as long as your flash unit's sensor can see the little light pulse (it's that small red circle on the side), it will fire when you press the shutter button. You control the brightness of your wireless flash from this same menu—just scroll down to Group A and over to the last field on the right. To lower the brightness (power output), use a negative number (like –1.0, for one stop less power) or a positive number to make the flash brighter. I've put together a short video clip just to show how to set this all up at www.kelbytraining.com/books/digphotogv2.

Going Wireless (Canon), Part I

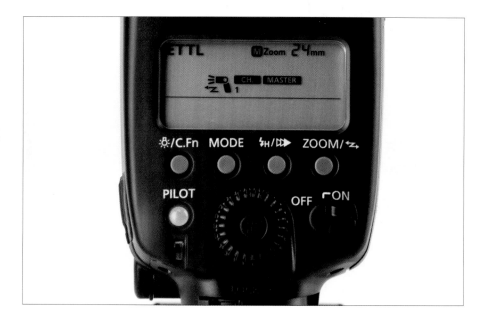

With Canon flashes, to go wireless you'll need either of the following:

(1) A Canon Speedlite Transmitter ST-E2 (around $230 at B&H Photo), which sits right on your camera's flash hot shoe, and not only triggers the wireless flash, but lets you control its brightness (power output), which is a key part of this process.

(2) You can use another Canon Speedlite flash (like a second 580EX II) as your transmitter. This second flash sits on the hot shoe on top of your camera, doing basically the same job that the Speedlite Transmitter ST-E2 does, which is to send a tiny light pulse from your camera to the wireless flash unit to tell it when to flash, and it lets you control the brightness of the wireless flash, as well.

Either way, the process is pretty similar: If you're using the ST-E2 transmitter, it's already set up as your wireless controller, and it has no flash of its own to turn off, so just put it into your camera's hot shoe and it's ready to go—you can jump over to the next page and pick up there. If you're using a Canon 580EX II Speedlite, put it in your camera's hot shoe, then hold the Zoom button on the back of the flash until the display starts flashing. Then turn the Select dial until the screen reads Master and press the center Select button. Now go to Part 2 on the next page. (*Note:* If you're using an older flash, like the 580EX, move the switch on the bottom of the flash over to Master, and you're set.)

Going Wireless (Canon), Part II

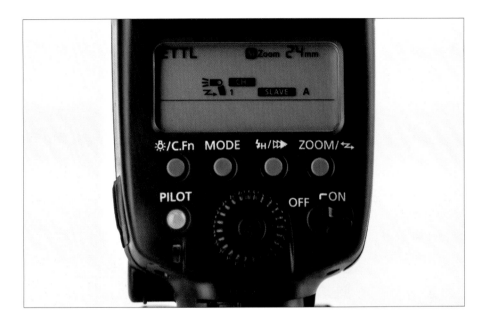

Now that you have a master flash mounted on your camera's hot shoe, you have to set up the other flash (the one you want to be wireless). (1) If you're using a Canon 580EX II Speedlite, hold the Zoom button on the back of the flash until the display starts flashing. Then turn the Select dial until the screen reads Slave and press the center Select button. (*Note:* If you're using an older Canon flash, like the 580EX, move the switch on the bottom of the flash unit itself over to Slave.) Now, to recap: The flash unit on top of your camera is set to be the master unit (the controller), and the other flash is set to be the wireless unit (the slave). (2) Turn off the flash on the master unit so it just emits a pulse of light, which triggers the wireless flash (you don't actually want it to light your subject). To do this, press the Zoom button once on the back of the flash until the display starts flashing. Then turn the Select dial until the screen reads OFF right above the word Master, and press the center Select button. I've put together a video to show you exactly how this all is done, and you can watch it at www.kelbytraining.com/books/digphotogv2.

If Your Wireless Flash Doesn't Fire

If your wireless flash isn't firing, make sure your master unit and slave unit are both on the same channel (channel 1, for example). If not, press the Zoom button twice and then use the Select dial to set them both on the same channel.

"Drag the Shutter" to See More Background

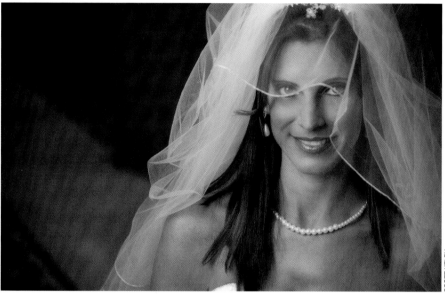

SCOTT KELBY

There are four big secrets the pros use to get beautiful quality light (and professional-looking images) from their dedicated flash units. One, you've already learned, is getting the flash off the camera so you can create directional light. The second is to set up your flash so it blends in with the available light already in the room, so the background behind your subjects looks natural. Without using this technique, you'll get what everybody else gets—the background behind your subjects turns black, they look harsh, and the shot will look pretty awful, which is why most people hate flash shots. The technique is called "dragging the shutter," and what you're doing is slowing down your camera's shutter speed so it allows in the existing light, then your flash fires to light your subject. Although this sounds complicated, it's incredibly simple. First, set your camera to shoot in program mode. Then, aim at your subject and hold the shutter button down halfway so your camera takes a meter reading of the scene. Look in your viewfinder and see the f-stop and shutter speed your camera chose to properly expose your subject, and remember those two numbers. Now, switch to manual mode and dial in those same two numbers. If the camera showed a shutter speed of 1/60 of a second, to drag the shutter you'd need to use a slower shutter speed, right? So try lowering the shutter speed to 1/15 of a second and take the shot. Don't worry—your subject won't be blurry, because when the flash fires it will freeze your subject. You'll be amazed at what just lowering the shutter speed like this will do to the quality of your flash photos.

How to Soften the Light from Your Flash

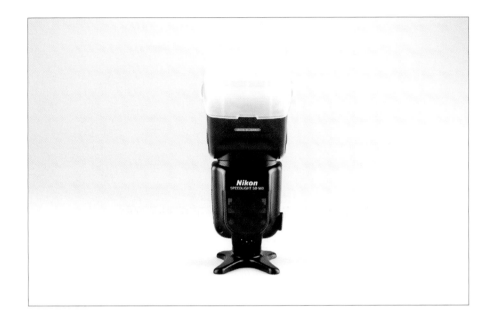

Okay, so you've used all the tricks we've covered so far, and your flash photos are already looking better—but there's still a problem. The light is still harsh because the flash itself is very small, and the smaller the light source, the harsher the light. So, to get softer, more flattering light, you need to make your light source larger, right? Right! There are a number of different tricks for doing this, and each pro does it differently, but I will tell you this—they *all* do it. They all use tricks to soften and diffuse the light from their flash (it's the third secret for getting professional-looking light from your dedicated flash). Probably the quickest and easiest way to soften the light from your flash is to snap a diffusion dome cap over the end of your flash (like the one shown above), which softens and diffuses your light. Considering how small and light it is, it does a pretty decent job. Once this cap is on, you aim your flash head upward at a 45° angle and it takes care of the rest. If you're a Nikon user and buy a Nikon SB-900 flash, it comes with the diffusion dome you see above right in the box (if you've lost your SW-13H dome, you can buy a replacement from B&H Photo). If you have a Canon flash, you can buy a diffusion dome separately, and the one I recommend is the Sto-Fen Omni-Bounce, which does a great job and is a favorite with pro wedding and event photographers (it sells for around $9.75 at B&H Photo). One thing to note: Adding this diffusion dome works great indoors, but outdoors where there's really nothing much for the light to bounce off of, it doesn't do much at all. Hey, I thought you should know.

Softer Light by Bouncing It

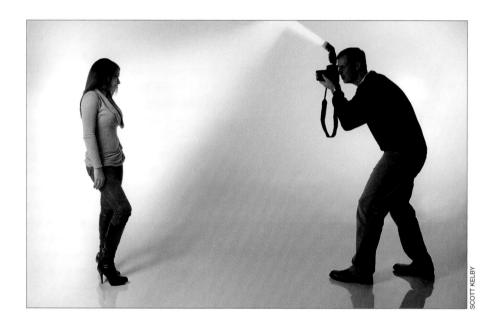

SCOTT KELBY

Another popular way to soften the quality of your light is to bounce your light off a ceiling. This does three wonderful things: (1) When your small, direct flash of light hits the large ceiling, it spreads out big time, so the quality of the light that falls back onto your subject is much wider and much softer. It immediately takes the harshness out of your flash, and gives you better quality light. (2) Because the light is now coming from above, it's no longer that one-dimensional, straight-on flash—now it's directional flash, which creates nice shadows and lots of dimension for your subject's face, and as a bonus (3) it keeps you from having harsh shadows on the wall behind your subject. Because the light is coming from above (down from the ceiling), the shadows appear on the floor behind your subject, not on the wall behind them. Plus, because the light is softer, the shadows are softer, too. So, if this bouncing off the ceiling technique is so great, why don't we use it all the time? Well, there are a number of reasons: (1) There's not always a ceiling you can bounce off. Sometimes you're outdoors, or (2) the ceiling is too high to bounce off of (like in a church). If the ceiling is much higher than about 10 feet, the bounce trick really doesn't work because the light has too far to travel up and back, and your subject doesn't get properly lit. Of course there's also (3) the fact that light picks up the color of what it hits, so if the ceiling is yellowish, your light becomes yellowish, and your subject will now appear (come on, say it with me) yellow-ish! However, if it's an 8'or 9' white ceiling—you're set.

Softbox–Quality Light from Your Flash

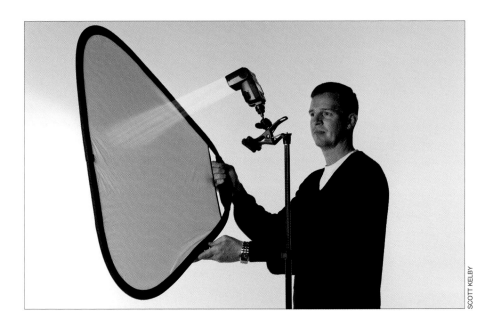

SCOTT KELBY

If you want to take this whole softening thing to the next level (qualitywise), you could buy a softbox that mounts over your flash, but the problem is they're small softboxes, so the light doesn't spread and soften as much as you'd probably like. So, what I do on location to spread and soften my light is to shoot my flash directly through a large diffusion panel, which is a large white translucent piece of fabric that spreads and diffuses the light. The one I use is a Lastolite TriGrip 30" 1 Stop Diffuser (seen above), which is very lightweight, not too expensive (it's around $66.95 at B&H Photo), and it collapses down into a very small, circular carrying case, so it's easy to take with you. To use this diffuser, have an assistant (or a friend, spouse, etc.) hold the panel about 1 foot or more in front of your flash. That way, when the tiny light from the flash hits the panel, it causes the light to spread out dramatically, which gives you much softer, smoother, more flattering light. If you don't have an assistant or a friend nearby, you can clamp your diffuser on a second light stand using a Bogen/Manfrotto mini-clamp for around $17.50.

Tip for Shooting Through a Diffuser

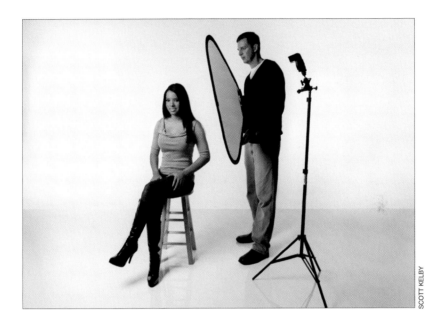

SCOTT KELBY

If you're shooting your flash through a diffuser (like the TriGrip diffuser I just mentioned), here's a tip: position the diffuser as close to your subject as possible without it actually being seen in the photo. This gives you the best quality wraparound light that is the softest and most flattering (think "closer is better"). Then position your flash so it's aimed at your subject, but still firing through the diffuser (set it at least 1 foot back from the diffuser, or even farther if you'd like softer, smoother light, but just know that the farther away you move the flash, the lower the power the light will become). From this point on, don't move the flash itself—instead just move the diffusion panel to get the light to fall where you want it to on your subject.

Where to Learn More About Off-Camera Flash

If this chapter ignites your passion for off-camera flash, and you want to take things to the next level, you'll definitely want to check out *Strobist*, which is the #1 site on the Web for flash enthusiasts (both amateurs and pros). It's run by David Hobby, a tremendous photographer and teacher who has built an entire worldwide community of flash users, and there's really nothing like it anywhere on the Web. Highly recommended (you'll find it at www.strobist.blogspot.com).

Putting That Nice Twinkle of Light in the Eyes

If you're using bounce flash and you want to add a little bit of life and sparkle into your subject's eyes, then simply pull out and raise the little white bounce card that's tucked into your flash head (well, at least it is if you're using a Nikon or Canon flash), as shown above. When you put that little white bounce card up, it redirects just enough of that light heading toward the ceiling back onto your subject to add a nice little catch light in their eyes, and the bonus is this also often removes some of the shadows that appear under their eyes. The key to making this work is that your flash head is aiming up at a 45° angle and the card is fully extended.

What to Do If You Don't Have a Bounce Card or Yours Breaks

If your bounce card is broken, or if your flash doesn't have a bounce card (hey, it's possible), then try this: use your hand. That's right—shoot with your camera in one hand, and then put your other hand up at the same position and angle a bounce card would be. It will send some of that light forward (like a bounce card), and because light picks up the color of whatever it reflects off of, your light will be nice and warm (thanks to your skin tone).

Why You Might Want a Stand for Your Flash

Most of us don't have the luxury of having an assistant to hold and position our wire-less flash for us, so we either wind up holding the flash in our left hand (so our right hand is still free to press the shutter button), or we put our flash on a lightweight light stand and position it where we'd like it. You can buy a standard light stand, like the 7.75' Bogen/Manfrotto 1052BAC light stand, for around $70, and then you'd need a flash shoe mount (about $13 from B&H Photo), which lets you mount your flash on a light stand like the Bogen/Manfrotto. This mount has a little plastic hot shoe on it, and your flash slides right into that hot shoe to hold your flash securely on top of the light stand. That $13 flash shoe mount is surely the inexpensive route, but the down-side is you can't angle your flash head downward—only upward, and that's why the Justin Clamp, while more expensive, is really the way to go. So, once you've got your flash on this light stand, where do you put it? There's no single right answer, but I'll give you a good starting point—put it to the left, and in front, of your camera, up about a foot or so higher than your subject. That way, if you have your flash mounted on a Justin Clamp, you can aim the flash head back down at your subject, so the light is more like studio light (or window light) and helps to create that all-important directional light.

Mounting Flashes Anywhere

If you're going to wind up putting your flash on a light stand, I recommend buying a Bogen/Manfrotto Spring Clamp with Flash Shoe (better known in the industry as simply a "Justin Clamp"). This is just the handiest little gizmo and you'll love it for three reasons: (1) Your flash slides into a little plastic hot shoe on the top of the clamp, and that clamp is connected to a miniature ballhead that lets you easily and instantly position your flash in any direction or at any angle. So, instead of moving the light stand every time you want to change the angle of the flash, you just move that little ballhead. (2) It has a large clamp on one end, so if setting up a light stand isn't practical (or isn't allowed), you can clamp it onto just about anything, from a railing, to a tree branch, to a ceiling tile. These sell for around $56.50 (at B&H Photo, anyway), and it's one of those accessories that once you use it, you'll never go anywhere without it.

Rear Sync Rocks (& Why You Should Use It)

SCOTT KELBY

There's a setting on your camera that will help you get better-quality photos using flash. In fact, your flash shots will get so much better that you'll wonder why this feature isn't turned on by default (but it's not—you'll have to go and turn it on yourself). It's called Rear Sync, and what it basically does is changes when the flash actually fires. Usually, your flash fires the moment you press the shutter button, right? So it does freeze any action in the scene, but it also generally makes everything solid black behind your subject (like you see in most snapshots). Changing to Rear Sync makes the flash fire at the end of the exposure (rather than the beginning), which lets the camera expose for the natural background light in the room first, and then at the very last second, it fires the flash to freeze your subject. Now your background isn't black—instead, it has color, depth, and detail (as seen above right), and this gives you a much more professional look all the way around. In the example above, the shot on the left is using the normal default flash setting (notice how dark the background is, and how washed out the flash makes him look). For the shot on the right, I only changed one single thing—I switched the flash to Rear Sync. Give it a try and you'll see what I mean (just remember to keep the camera still when shooting in Rear Sync mode, because the shutter stays open longer—enough to expose for the background. This can create some cool effects if your subject is moving while your shutter is open, or it can create some irritating effects if they're moving and you don't want them to).

The Fourth Secret to Pro Flash Results

SCOTT KELBY

I saved the best trick for last (the fourth of the four pro flash tricks), and this one you can use to make your flash look like natural light. In fact, this trick works so well that if you do it right, most folks won't be able to tell that you used a flash at all—you'll just have glorious-looking, soft, natural light whenever and wherever you want it. Your goal is to create light from your flash that matches, and blends in with, the current lighting in the scene (the ambient light) and doesn't overpower it. Here's the trick: don't change your f-stop or shutter speed—instead, just lower the power output of the flash until it matches the available light. To do that, first get the flash off the camera for directional light, and diffuse the light, then take a test shot. Chances are, your flash will overpower the existing light. Now, go to your flash unit itself, lower the flash output power by one stop, and take another test shot. Look at the LCD panel on the back of your camera, and see if the light from your flash still looks obvious—like light from a flash. If it does, lower the power of your flash another ½-stop and shoot another test shot. Keep doing this (lowering the power and shooting a test shot) until you're getting just enough flash to light your subject, and nothing more. That way, it looks real, directional, and natural, instead of looking like flash (like the shot above, lit with a Nikon SB-800). It might take you five or six test shots to dial in the right amount of power, but that's the beauty of digital cameras: it doesn't cost anything to do test shots—as many as you need—until you strike that perfect balance between ambient light and the light from your flash.

Using Gels (& Why You Need Them)

The light from your flash is always the same color—white. It's nice, bright, white light, which is great in most circumstances, but what if you're doing a portrait of someone in an office, or you're shooting in a locker room, or in a meeting room? Well, that's a problem, because the color of the light from your flash won't match the color of the lighting in the room, which is exactly why some flashes (like the Nikon SB-900) actually come with pre-cut gels that slide right onto the flash to let you change the color of your flash's light, so it matches the rest of the lighting in the room. (*Note:* If you have a Canon flash, you can buy a large sheet of Rosco CTO gel for around $6.50 from B&H Photo. You'll have to cut it down in size so it fits over your flash head, but at least you'll have a huge supply of them, whereas Nikon only gives you one.) Amateurs don't worry about this, because they're going to just overpower the light in the room, right? But since you now know the pro tricks of how to balance the light from your flash with the ambient light already existing in the room, you'll need to do this next step, but believe me, for the 20 seconds it takes to slide that gel into place—it's worth it. You'd use a yellow gel for balancing your flash color with incandescent light (the standard light found in homes), and a green gel for balancing the light if you're shooting under fluorescent lights, like the ones found in most office interiors (Rosco makes those, too). Just pop that tiny gel into your diffusion dome, and you're ready to go!

Using Gels to Get That *SI* Look

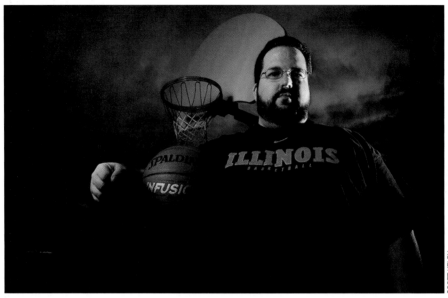

SCOTT KELBY

There's a very cool trick you can do using just a yellow gel that I learned from *Sports Illustrated* photographer Dave Black when he and I were teaching a class out in San Francisco. When you try it, you'll see it has that *SI* look you see in a lot of outdoor sports portraits. It actually requires you to do two things: (1) First, you set the white balance on your camera to Tungsten (it's one of your camera's built-in white balance presets, and it makes your whole photo look very blue—well, at least it does if you're shooting outdoors), then (2) pop a yellow gel onto your flash (see the tip on the previous page to find out if you already have them or where to get them). That's it. Now, you want to shoot this near dusk, so the background sky is dark and moody. The Tungsten white balance setting makes the sky look moody and blue, but the yellow light (from the gel on your flash) hits your subject with a warm light. It's a very clever combo that is easy to achieve, and lots of pros are using this style today because, well…it's really cool (no pun intended, but I wish it had been).

If You Have to Use Pop-Up Flash, Do This

If you can't get around it, and you are in a situation where you must use your camera's pop-up flash, then at least do these two things: (1) set your flash to Rear Sync first, so you'll pick up some of the ambient light in the room, and (2) do something—anything—to soften the harshness of the flash, and that can be as simple as shooting your pop-up flash through a white table napkin or cutting a rectangle-shaped diffuser out of the side of a plastic gallon of milk and shooting through that. If you know in advance that you might have to shoot with your pop-up flash, then check out LumiQuest's Soft Screen (shown above), which is designed to fit over your pop-up flash to spread and diffuse the light. Luckily, it's very inexpensive (around $9.95), and well…if you have to use pop-up flash, this will at least make it bearable.

Two Tips for Getting Better Results from Your Pop-Up Flash

Another thing that will help you get better-looking images from your pop-up flash is to reduce the flash's brightness (lower its power) or lower your flash exposure (using flash exposure compensation). Most DSLRs have a setting where you can lower the brightness of the flash, and that helps to not blow out your subject with harsh white light. You might also try taping a small warming gel (like a ¼-cut CTO gel from B&H Photo) over your flash and leaving it there all the time. This gives the cold flash a much warmer, more pleasing look. Thanks to flash guru David Hobby for sharing these tips.

Using a Second Flash

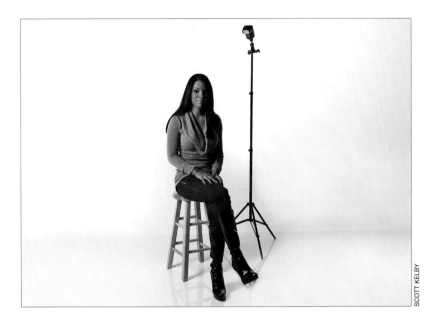

SCOTT KELBY

If you want to add a second wireless flash (maybe you want to use it as a hair light, or to light the background, or…whatever), it's easy. When your first flash fires, it automatically triggers the second flash so they both fire at exactly the same time. Let's say you want to add a flash to light your subject's hair. First, position the flash behind your subject, but off to the right (if you're holding your other flash in your left hand while you're shooting), as shown here. This is a perfect time to use one of those Justin Clamps I mentioned earlier, so you can clamp your second wireless flash to anything nearby, or you can position your second flash on a light stand—just make sure you don't see the stand, or the flash unit itself, when you look through your camera's viewfinder. Set your second flash to wireless mode (look back on page 9 for Nikon flashes or page 11 for Canon flashes). Best of all, you can control the brightness of this second flash wirelessly from on your camera (see the next page to find out how).

Controlling Your Second Flash (Nikon)

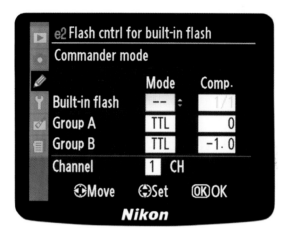

You will want to be able to control the brightness of each flash individually, so that way if the second flash is too bright, you can lower it without affecting the first flash or you can turn it off altogether. However, you want to be able to do all this right from your camera itself—without running around behind your subject, or running from flash unit to flash unit. On a Nikon camera, here's how it's done: On the back of the flash, set this second flash to Group B. That's all you do on the flash itself. Now, you control the brightness of each flash by pressing the Menu button on the back of your camera, going to the Custom Settings menu, and choosing Bracketing/Flash. When the Bracketing/Flash menu appears, choose Built-in Flash, then scroll down and choose Commander Mode. Your first flash (the one you hold in your left hand, or near you on a light stand) is in Group A. You set your second flash to Group B, so the brightness control for your second flash is found in the Comp field to the far right of Group B. Scroll over to that field, and to lower the brightness by one stop, dial in –1.0 (as shown above). Now shoot a test shot, and if that second flash appears too bright, try lowering it to –1.3 and shoot another test shot, etc., until it looks right. To turn if off altogether, toggle over to the Mode field, and change the setting until it reads "--" which turns off your second flash. To control the brightness of your main off-camera flash, it's controlled the same way, but in Group A. Just remember, for all of this to work, you have to have your pop-up flash up, because it triggers the flash (or you can use an SU-800 transmitter if your camera doesn't have pop-up flash).

Controlling Your Second Flash (Canon)

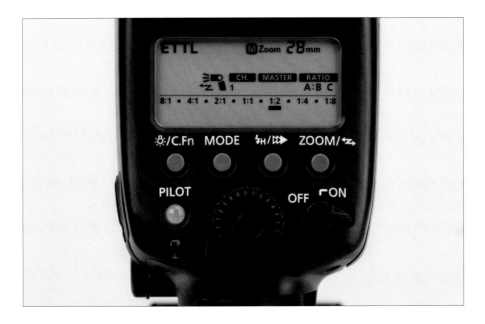

To add a second Canon Speedlite flash (one you'll use for a hair light or to light the background), hold the Zoom button on the back of the flash until the display starts blinking, then use the Select dial to switch the flash to Slave mode, and press the center Select button. Now your first wireless flash and this second flash will fire simultaneously, which is good, but you want to be able to control the brightness of each flash individually, right from your camera (so you're not running back behind your subject just to lower the brightness of the second flash. After all, what's the good of wireless if you have to keep running over to the flash every time you need to make a small change, eh?). To do that, you'll want to assign this second flash to a separate control group (Group B). To assign the second flash to Group B, press-and-hold the Zoom button on the back of your Speedlite, and then use the Select dial to move over to Group B. Now you can put this flash into place (behind the subject), and do a test shot. Both flashes should fire, but if the second flash (the one behind your subject) is too bright, then press the Zoom button until Ratio highlights (the ratio amount controls the brightness). Now, set the ratio to 1:2 (one stop less bright), then do a test shot. If the second flash still looks too bright (when you look at the shot in your LCD monitor), then lower the brightness to 1:4 or 1:8 and shoot another test shot, and keep this up until the second flash looks balanced. If you want to control the brightness of the first flash, make sure it's on Group A, and you can lower and raise its ratio the same way.

How Far Back Can You Stand Using Flash?

SCOTT KELBY

So, how far back can you stand from your subjects and still get pro-quality results from your flash? Well, if you're using a flash with a diffusion dome, or you're bouncing your flash, or you're using some type of diffuser to soften the light (and you should be), as a general rule, you really don't want to stand farther than about 10 feet back from your subjects. Unfortunately, any further than that and your dedicated flash won't have enough power to get the right amount of light all the way over to your subjects to light them properly.

How to Stand Back Even Farther

If you absolutely need to stand back more than 10 feet from your subject, then you can use this trick to extend the power and range of your flash: just raise your digital camera's ISO (making the camera more sensitive to light). So, if you're shooting at 100 ISO (it's always our goal to shoot at the lowest possible ISO—more on this later), then if you increase your ISO to 200, you effectively double the power (and range) of your flash. So, if you need to be 20 feet back, try increasing your camera's ISO to 200 or 400, and that should do the trick. Okay, well, there is one more thing you can try: if you don't want to raise your ISO and you have to be back farther than 10 feet from your subject, then you'll need to (gasp!) remove the diffuser cap from your flash, so your light has more power and reach (personally, I'd raise the ISO, but hey—that's just me).

How to Get More Power from Your Flash at Long Distances

If you find yourself having to shoot pretty far back (maybe you do a lot of large group shots), you might want to buy another diffusion dome cap and cut out a little section of the top so some of that light reaches a bit farther.

Controlling Your Light to Add Drama

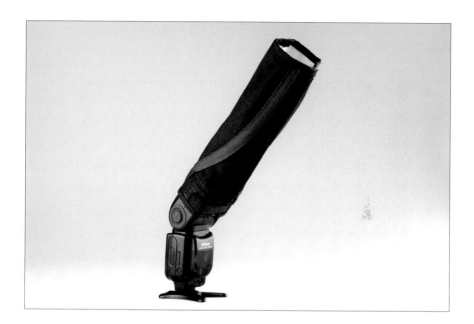

If you want to add some serious drama and interest to your flash images, one of the quickest ways to get there is to limit the amount and shape of the light that hits your subject. By lighting only part of your subject, it puts part of your subject into the shadows, and although this is a fairly common technique using full-blown studio lighting, ExpoImaging has come up with their own inexpensive, lightweight light modifiers for shoe-mount flashes like the Nikon SB-900 and Canon 580EX. They're called Rogue FlashBenders and I just love 'em. They've got a 10" snoot that acts like a funnel for light—concentrating it in just one area—it fits right over your flash head (as seen above) and is secured with a little ring of velcro. The snoot sells for around $39.95 at B&H Photo.

Shooting Sunset Portraits with Flash

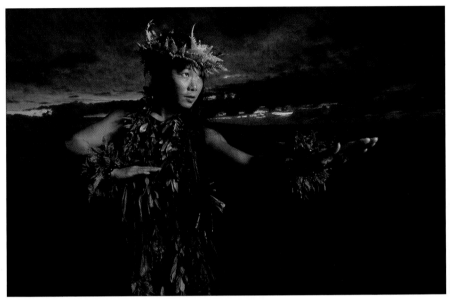

SCOTT KELBY

Like a lot of shots taken with flash, this one is a formula, and if you follow it, you'll get the look you want. First, turn off your flash, switch your camera to program mode, aim at the sky (but not at the sun itself), and hold your shutter button halfway down. This tells your camera to take a meter reading of the sky, so while that button is still held down, look in your viewfinder to see the f-stop and shutter speed, and remember what they're reading (in the example above, it read f/5.6 at 1/60 of a second). Now, switch your camera to manual mode and dial in f/5.6 for your f-stop and 1/60 of a second for your shutter speed (even if you've never used manual mode before, this is a no-brainer—usually the front dial on your camera controls the f-stop, and the back dial controls the shutter speed, so just move those two dials until you see f/5.6 and 1/60 as the settings when you look through the viewfinder). Now your sunset sky will look perfect, but your subject will be almost, if not totally, a silhouette. So, turn your flash back on, but lower the brightness (power output) of the flash by around two stops, so just a little bit of flash fires—not enough to overpower the existing light, just enough to light the head and shoulders of your subject. You'll have to fire a couple of test shots to get this just right, but remember: don't change the camera settings—they're perfect as is—just lower (or raise, as the case may be) the brightness of your flash. That's it—that's how to get great-looking flash portraits at sunset. (*Note:* If the shutter speed suggested by your camera is faster than 1/250 of a second, you're hosed, as many cameras/flashes won't sync at faster than 1/250 of a second. Not all, but many.)

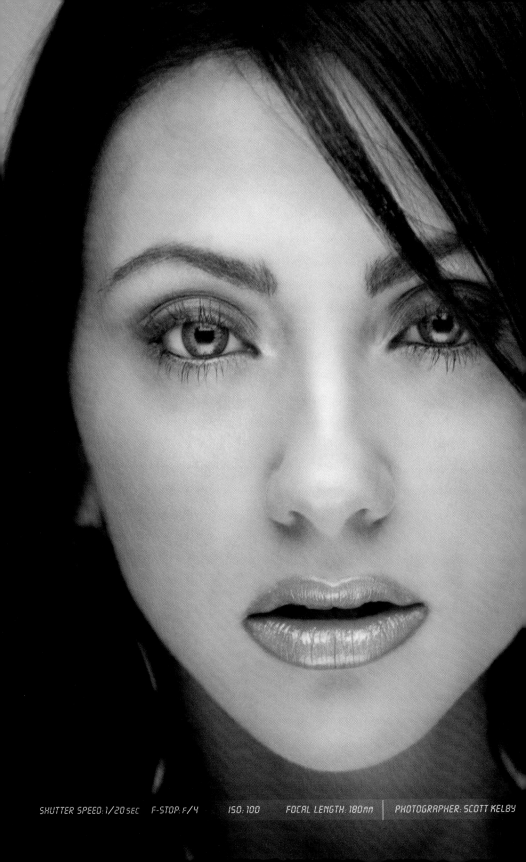

Chapter Two

Building a Studio from Scratch

It's Much Easier and Less Expensive Than You'd Think

It used to be that only full-time working professionals could afford to put together a studio, but these days the prices of studio gear have come down so much, and the equipment is so much easier to use, that anyone (well, anyone with a platinum American Express card) can now build a studio of their own. Of course, I'm joking, you don't have to have a platinum card (a gold card will do just fine). Actually, the main reason why building a studio from scratch is within most folks' reach today is that you can do so much with just one light. In fact, nearly this entire chapter is to show you how to get professional results using just one light. Now, in the studio we don't always refer to lights as simply "lights," because then people would know what they do (we call them "strobes," because it sounds much cooler). Studio photography is intentionally shrouded in mystery to make the process appear more complicated than it really is. In fact, there is a special committee, The Council for Creation of Complex-Sounding Studio Gear Names (the CCCSSGN, for short), whose charter is to create confusing insider lingo to throw beginners off track. For example, when we talk about the color of light, we don't use the term "indoor lighting." Nope, people would realize what that is, because they've been indoors before. Instead, we assign a color temperature measured in Kelvin, so to throw beginners off, we might say to one another, "It looks like that strobe is throwing 5500 Kelvin." And the other person might say, "It looks a bit warmer to me. More like 5900," then the other person might say, "Ya know, you might be right—it is more like 5900 Kelvin." It's amazing that either of these people ever get a date. Anyway, this chapter is designed to cut through the Kelvin and show you the light.

Studio Backgrounds

One of the least expensive, and most popular, studio backgrounds is seamless background paper. This paper comes in long rolls, and the two most popular widths are just over 4 feet wide (53") and nearly 9 feet wide (107"). The nice things about seamless paper are: (1) It's cheap. A 53-inch-wide white roll that's 12 yards long goes for around $25 (at B&H Photo), and if you want the 9-foot-wide roll, it's only around $40. (2) It's seamless. There's no visible seam where the paper folds as it reaches the floor (or a tabletop), so the background looks continuous. (3) The stands to support seamless paper backgrounds are pretty cheap, too. For example, the Savage Economy Background Stand Support System, which supports both the 53" and 107" rolls, only costs around $65. That ain't bad. And, (4) this paper comes in a wide variety of colors, from solid white to solid black, to blue, green, and everything in between (hey, that rhymes). If you're building your first studio, this is a great way to start, because you can get your background and the supports to hold it up for around $100.

So Which Should I Get, the 53" or the 107" Seamless?

If you're planning on shooting products on a table, or strictly just head-and-shoulder shots of people, you can get away with the 53" width. If you need to see more of your subjects, go with the 107".

Using Studio Flash (Called Strobes)

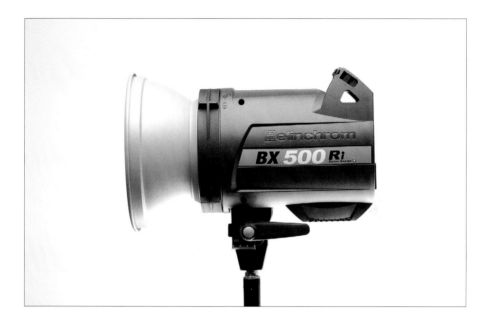

A lot of people are intimidated by studio lighting, thinking it's complicated or too technical for them, but in reality, most studio lights are just bigger versions of the off-camera flash you're already used to (in fact, they are flashes, but in the industry they're usually called "studio strobes" or just "strobes"). The two main differences between off-camera flashes (like a Nikon SB-900 AF Speedlight or a Canon Speedlite 580EX II) and studio strobes are: (1) studio strobes usually plug into the wall rather than running on batteries, and (2) studio strobes are more powerful (they put out more light) than the flash that's on (or off) your camera. That's about it. (Well, studio strobes are usually mounted on light stands, but since we sometimes mount off-camera flashes on light stands, too, I think this goes in the "more in common" column.)

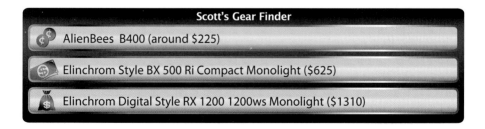

Scott's Gear Finder

AlienBees B400 (around $225)

Elinchrom Style BX 500 Ri Compact Monolight ($625)

Elinchrom Digital Style RX 1200 1200ws Monolight ($1310)

Softening Harsh Studio Strobes

So, if the light from your regular off-camera flash is harsh, imagine how harsh the light will be from a brighter, more powerful flash (your studio strobe). Right, it's harsh city. To diffuse that light and make it softer, you have to make the light that comes from your strobe larger, because the rule is: the larger the light source, the softer the light. So, we have to put something big between our studio strobe and our subject to spread and soften that light, and for that I recommend a softbox. They're aptly named because they soften the light from your strobe big time, and they are very popular with professional studio photographers (in fact, it's the softening device of choice for most top pros). They fit right over your studio strobe (they have a hole in one end) and your flash fires through the white diffusion material at the large end of the softbox. This spreads the light, so when it hits your subject, it's a bigger source of light, and that means it's a much more flattering, softer light. But this softer light isn't just for lighting people—even if your subject is a product, you still want nice, soft shadows throughout your image, and a softbox is your key to getting just that.

Why I Prefer Softboxes to Umbrellas

Besides softboxes, another way to spread and soften your light is to use a lighting umbrella. Surprisingly, you don't generally put the umbrella between your strobe and the subject (although you could). Instead, you turn the strobe so it's aiming 180° away from your subject—in the opposite direction. Then you put the umbrella in front of the flash (strobe) itself, so that your strobe fires into the underside of the umbrella. When the light hits the umbrella, it spreads out and travels back in the opposite direction, back toward your subject. Because the light spreads out when it hits that umbrella, the light from your strobe is much softer. So, why don't I like, or recommend, using an umbrella? It's because with a softbox your light is pretty much contained within a box—it doesn't spill out, so your light is more directional. You aim it in a direction and it pretty much goes right there. But with an umbrella, you have less control over what happens once the light leaves your umbrella. I think of it more like a lighting grenade—you throw it in the general direction of what you're trying to light, and it'll probably light it. So, while an umbrella does take the harsh light from your strobe and create soft, pretty light from it, it kind of goes everywhere. Whereas, a softbox is more contained, more directional, and you can add other accessories to narrow the throw of your softbox light even more.

What a Speed Ring Does (& Why You Need It)

So, you need: (1) a strobe, (2) a light stand to hold it up, (3) a softbox to spread and soften the light, and (4) you're also gonna need a speed ring. A speed ring is generally made of a light metal, and has four holes on the edge where you insert the ends of the four thin metal poles on each corner of your softbox. Once you insert those poles into the speed ring, it gives your softbox its form (it creates the shape of a box), and then you attach this whole rig (the speed ring with your softbox attached) to your strobe. I use an Elinchrom Rotalux softbox, which has an Elinchrom speed ring built right in, with an Elinchrom BXRi 500. However, most softboxes don't come with a speed ring built in, so if you have to order one, make sure you order one designed to fit your brand of strobe. By the way, most speed rings are rotating (meaning you can rotate the softbox from tall to wide while it's mounted on the strobe), and if that's important to you (and I would think it would be), then make sure the one you have or order does rotate.

Using a Modeling Light

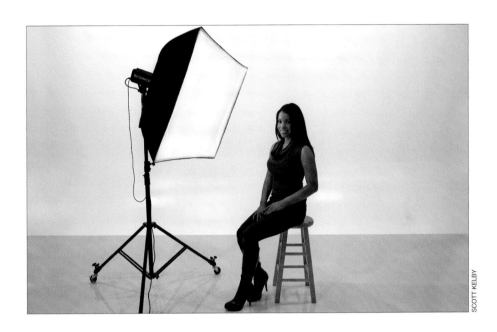

SCOTT KELBY

Usually, when you're shooting in a studio environment, the only lights you want to light your subject are the studio strobes themselves. Otherwise, the other lights in the room can affect your exposure, so studios are generally pretty dark once the shooting starts. This creates a problem, because the auto-focus on the camera needs some light to lock its focus onto. That's one reason why studio strobes usually come with a built-in modeling light, which is a fairly dim, continuous light that stays on between flashes to let your camera's auto-focus do its thing. Another advantage of using a modeling light is that it gives you an idea where your shadows are going to fall on your subject (it's not exact, but it does give you an idea). I leave the modeling light on all the time during a shoot, but you'll find an on/off switch on the back of your strobe unit itself (or on a separate power pack or battery pack, if you're using one).

Scott's Pro-Speak

TRANSLATOR

When you're talking about studio strobes, there are basically two kinds: (1) A monolight, which is what we've been talking about here in the book, is a self-contained unit (with the power pack, flash bulb, and power controls all in one) that plugs directly into a standard wall outlet, and (2) a flash head, which is just the flash itself, and all controls are in a separate power pack or battery pack, which you plug the flash head into.

Firing Your Studio Strobe

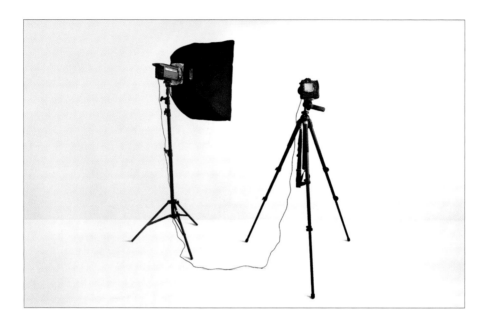

To get your strobe to fire when you press the shutter button, you'll need to sync your camera with your flash unit, and you can do that the same way you would with your standard off-camera flash, and that's by using a sync cord. One end plugs into your camera's sync cord input, and the other end plugs into your strobe. That's it—now when you press your shutter button, your studio strobe fires. To stop the strobe from firing each time, unplug the cable.

Sometimes You Have to Buy Gear

Just so you know, I don't get a kickback, bonus, or promotional fee from any of the companies whose products I recommend. I'm just giving you the same advice I'd give a friend if we were out shooting (which is the theme behind this entire book). This is not a book to sell you stuff, but before you move forward, understand that to get pro results, sometimes you have to use (and that means buy) some of what the pros use.

Firing Your Studio Strobe Wirelessly

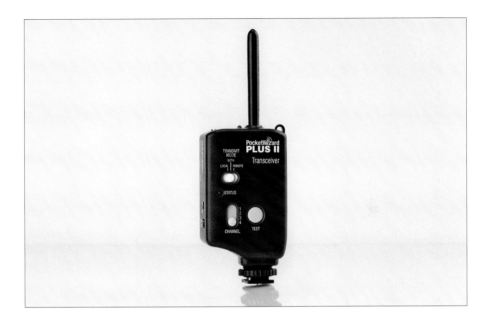

While sync cords are fairly inexpensive (I found the cheapest 15-foot sync cord for around $10 at B&H Photo), you're now tied to your flash unit, so there's not much freedom of movement in your studio. To get around that, you can use a wireless flash trigger, and then you can move about freely, completely untethered, unencumbered, unfettered (insert your own "un" word here), and once you shoot wirelessly like that, going back to a sync cord feels like being put on a leash. Here's how it works: to start, you need two of these wireless devices—one sits on your camera's hot shoe and transmits the wireless signal, and the other plugs into the sync input on your strobe. What I love about them is you just plug them in, turn them on, and they do their thing. There's no real configuring or messing around for this simple setup. Now when you press your shutter button, it instantly fires your strobe, even if it's across the room. As for make and model, I use the ever-popular PocketWizard PLUS II, which is a small, very lightweight, wireless triggering system that works incredibly well, is extremely reliable, very well made, and about every studio photographer I know uses a PocketWizard. They're not cheap, at around $170 each (and remember, you need two), but they totally rock.

Using Continuous Light Instead

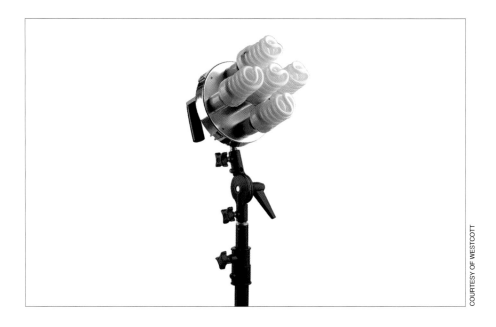

COURTESY OF WESTCOTT

A fast-growing alternative to studio strobes is continuous lights, and with these lights there is no "flash of light"—instead, the lights just stay on continuously. This makes studio lighting incredibly easy, because what you see is what you get. I use these continuous lights in my studio (I have three of them) and on the road with my Adobe Photoshop Lightroom Live Tour, where they have nearly created a sensation, because no matter what I tell you about them here in this book, it doesn't have the impact of seeing them used live, and people just go nuts over them. The ones I use are Westcott Spiderlite TD5s (as shown above), which use daylight-balanced fluorescent light (since they're fluorescent, they produce hardly any heat—they stay nice and cool the entire time you're shooting with them, and your subjects stay cool, too). These lights are naturally softer than the studio strobes, but of course I still use them with a softbox attached, and the nice thing is the speed ring is built right into the light itself, so you don't have to buy a speed ring. Best of all—they're fairly inexpensive, and you can buy a kit, which includes a light stand, the Spiderlite TD5 fixture, a tilter bracket, and a 24x32" softbox, for around $600 at B&H Photo. Hard to beat. So, what's the downside with these lights? There's one: since there's no flash to freeze things, things need to be fairly still, because the fluorescent lights aren't as bright as the light from a strobe, so as long as your subjects don't move a whole bunch—they're awesome.

Choosing the Size for Your Softbox

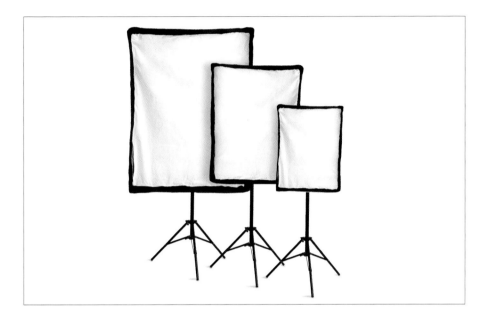

When you're trying to decide which size to choose for your softbox, there are a couple of considerations: the first being, what are you planning to shoot, and the second being, how soft do you want your light? We'll tackle the "What are you planning to shoot?" question first. If you're shooting product shots on a table, you can get away with a smaller softbox, like one that's 2x3', yet it would still be big enough to also work for head-and-shoulders portraits. If you're going to be shooting people, and doing more than just head-and-shoulder-type stuff, then you'll need to go with a larger softbox. I mentioned before that the larger the light source, the softer the light, so if you buy a very large softbox (like one that's 3x4'), you're going to get very soft light, and you're going to be able to light a larger area. I use three sizes in my studio: a 2x3', a 3x4' for people shots, and a 7' (74") Elinchrom Octabank when I want really, really, wonderfully soft wraparound light.

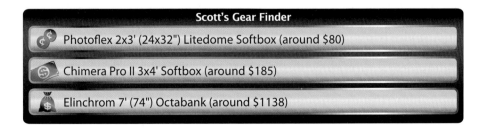

Scott's Gear Finder

Photoflex 2x3' (24x32") Litedome Softbox (around $80)

Chimera Pro II 3x4' Softbox (around $185)

Elinchrom 7' (74") Octabank (around $1138)

Why You Really Need to Use a Light Meter

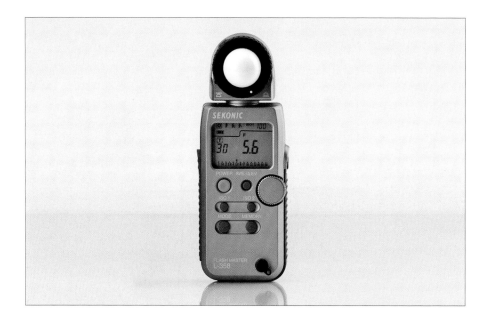

Shooting in the studio, with more and more lights and reflectors, can make it tricky to get the right exposure (especially when you're trying to measure light that happens in 1/250 of a second), but the pros don't sweat it because they use a light meter. They use a handheld light meter because they've already learned that their camera's built-in meter, while great for most things, just doesn't cut it in studio lighting conditions. Besides, who wouldn't want a simple-to-use device that tells you exactly how to set your exposure every time? Today's light meters are so simple to use that it's much harder not to use it than it is to use it. If you want to be a success with your studio lighting, if you want to make your life easier, and you don't want to spend all day in Photoshop trying to fix your exposure mistakes after the fact, then buy a handheld light meter. This is an absolute must (by the way, I use the Sekonic L-358 shown above and listed below).

Scott's Gear Finder

Gossen Digiflash Light Meter (around $189)

Sekonic L-358 Flash Master Light Meter (around $279)

Sekonic L-758DR DigitalMaster Flash Meter ($569)

How to Use a Light Meter

SCOTT KELBY

Before you get started, there are two simple things you do before you measure the light from your flash: (1) You enter the ISO that your camera is set to into your light meter (so if you're shooting at 200 ISO, you enter 200 ISO). And, (2) make sure the round white plastic dome on the meter is extended (turn the wheel so it extends out). That's it—you're ready to put it to use. Most people aim the light meter at the light itself, but today's meters are actually designed so they work with that white plastic dome aiming back directly at your camera's lens. If you're metering a person for a portrait, position the meter directly under their chin, with the dome aiming back directly at the camera. Now, push the button on the side of the meter, and then fire the flash (you might have to have your subject hold the meter under their chin and push the button on the side. That way, you can take a test shot to fire the flash). Once the flash fires, it instantly tells you the exact shutter speed and aperture settings you need to dial in for a perfect exposure. So you go over to your camera, make sure you're in manual mode, set your f-stop to what it said, set the shutter speed to what is listed on the meter, and you've got it—perfect exposure. As long as you don't move the light or change the power of the flash, you can continue to use those settings. If anything does change, just take a new meter reading the same way, and change your f-stop and shutter speed to match those readings.

Adding a Hair Light

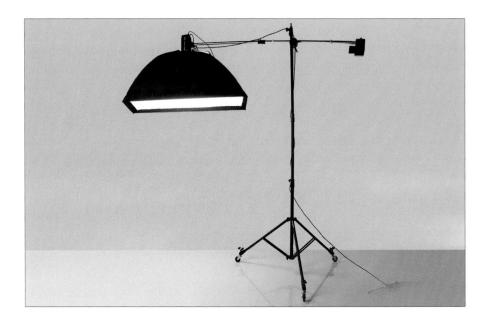

If you're thinking of adding a second light to your studio, it should probably be a hair light. A hair light is just another strobe, but it's aimed directly at your subject's hair (did I even have to say that?), which helps to separate your subject from the background and give your portraits a more professional look all around. You want the light from your hair light to be pretty directional (you want it aiming right at their hair, and a little on their shoulders, and that's about it). That's why you want to buy either a very small softbox (like a 16x22" softbox—where the light, once it spreads, is just big enough to cover their head and shoulders) or a long, thin, rectangular softbox (sometimes called a strip bank) whose shallow width (no larger than 12" wide) helps to keep your hair light more directional. Also, I usually set the power on my flash unit so it's around one stop brighter than my front light, so the light from my front light doesn't overpower it.

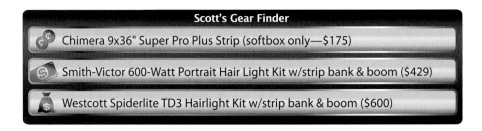

Scott's Gear Finder

Chimera 9x36" Super Pro Plus Strip (softbox only—$175)

Smith-Victor 600-Watt Portrait Hair Light Kit w/strip bank & boom ($429)

Westcott Spiderlite TD3 Hairlight Kit w/strip bank & boom ($600)

Where to Position Your Hair Light

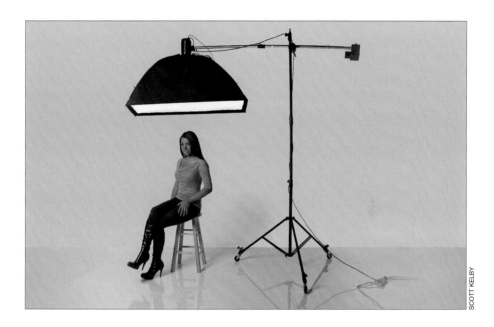

SCOTT KELBY

If you're going to buy a hair light, make sure you get one that either comes with a boom stand, or you'll definitely want to buy a separate boom stand for it. That's because arguably the ideal place for a hair light is to have it positioned directly over your subject's head. That way, it's easy to direct the light down exactly where you want without causing any lens flare issues from the light spilling back into your camera's lens (this is a bigger problem than you might think). When the light is aiming straight downward, it's not going to spill back into the lens, so that boom stand really makes your life easy. If you don't have a boom stand, you can still theoretically place the light straight above your subject, but you're going to see the light stand in nearly every shot, so to keep from pulling your hair out—just spring for the boom stand. Now, that being said, how far above your subject do you place the hair light? I put mine about two to three feet above the top of my subject's head, but make sure you don't position it directly over their head—it should actually be back just a little bit, so absolutely none of the hair light spills onto their face or nose.

Testing Your Hair Light's Position

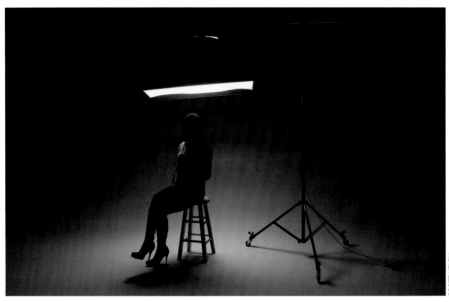

A trick for checking the position of your hair light, to make sure none of the light from it is spilling onto your subject's face, is to turn off your main strobe (your front light), so nothing but the hair light is turned on. Your subject should be in complete silhouette, with no light on their nose, cheeks, or face whatsoever. If you see any light now, you'll need to either move your subject forward or your hair light back a little bit, until you only see light on their head and shoulders—none on the face. A trick my buddy Andy Greenwell uses is to leave all the modeling lights on, but put your hand flat out over their forehead (like you're shielding them from the light). Move your hand in toward their forehead and back out. If your hair light is in the right position, you shouldn't see any change of light on their nose while you move your hand in and out. If the light changes, then light is spilling onto their nose, so you need to move the light back just a bit.

Keeping Your Hair Light from Spilling

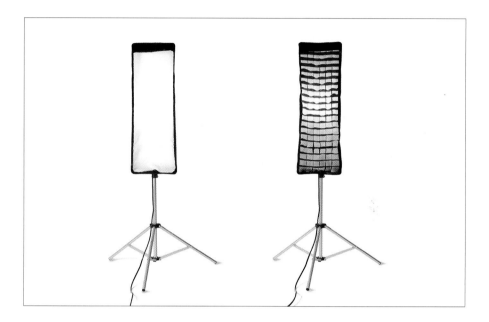

Probably the most popular accessory for hair lights (besides a boom stand) is an egg crate grid. This is a fabric grid that Velcros over the front of your strip bank. It narrowly focuses the light from your hair light so it doesn't spill out the sides, and it really does a wonderful job of focusing your light just where you want it. They come in different sizes, and there's one to match the exact size and shape of your strip light, but no matter what size you get—they're expensive. There must be some sort of "egg crate cartel" that controls the price of these puppies, because when you see one in person, you'd figure that it probably costs around 30 bucks, but it doesn't. An egg crate grid for a small 12x36" strip bank costs around $173, and they go up from there. Yeouch! But, once you use one, you'll always use one, because for hair lights they're absolutely ideal.

Which Mode Should You Shoot In

Technically, you can shoot in aperture priority (Av) mode in your studio, but if you want to make your life easier, this is the one time I would absolutely suggest that you shoot in manual mode. When it comes to using 100% flash (as we do in the studio), it's very important to be able to set both the f-stop and shutter speed independently, and manual mode lets you do just that. Your trusty light meter (the one we talked about just a few pages ago) will tell you exactly where to set those dials. Now, if you don't have a light meter (yet), and you want some settings as a starting place, try an f-stop of f/5.6 and a shutter speed of 1/60 of a second. Take a shot and see how it looks on your camera's LCD monitor. Then, don't change the settings—instead, just raise or lower the power of your main strobe until the lighting looks right to you.

A "Show Me How to Do It" Book

This is a "show me how to do it" book. I'm telling you these tips just like I'd tell a shooting buddy, and that means, oftentimes, it's just which button to push, which setting to change, where to put the light, and not a whole lot of reasons why. I figure that once you start getting amazing results from your camera, you'll go out and buy one of those "tell me all about it" digital camera or lighting books.

Where to Position Your Main Light

There is no absolute "right" place to position your lights (light position can be argued until late into the night), so it really comes down to how you want the shadows to look in your photo. Personally, when shooting portraits I like a "loop" lighting pattern, which is probably the most popular lighting pattern used today. To get a loop lighting pattern, you place your strobe (with a softbox attached, of course) either to your camera's left or right at about a 45° angle (or more) from you. This directional light produces a small, soft shadow on the opposite side of your subject's nose, and a triangle of light on their opposite cheek, which has a very flattering effect on most people. How high do you place this light? Ideally, you'd like it to come from above their eye level, around 3 feet higher than your lens height, so the light is casting down a little on your subject (like sunlight). How close should your softbox be to your subject? The closer it is, the softer and more wrapping your light will become, so I usually place it so close that if it were any closer it would be visible in the shot (just remember that as you move it closer, the light will be brighter. It won't get harsher—it will actually get softer, but it will get brighter). These are just the basics to get you started in the right direction— lighting is an art, and we haven't gone into broad lighting, short lighting, Rembrandt lighting, or any of the other classic styles or reasons why you place lights where you do (often depending on the shape of your subject's face), so my goal here is to give you some insights into how I light a subject, and if you came by my studio, this is the exact stuff I would show you first. Then we'd go get a beer (I mean, a Diet Coke).

Using a Fan for Windblown Effects

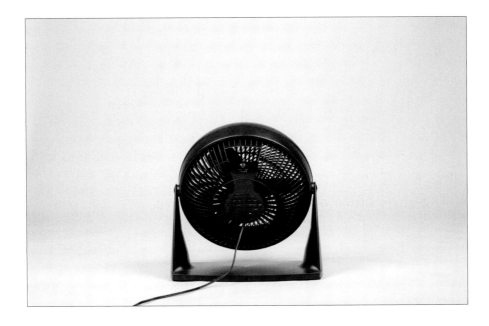

If you're shooting portraits of women, this is going to sound silly at first, but you want to buy a fan. Not just a fan, a powerful, hurricane-force commercial fan that would put most of your lighting equipment in jeopardy if you were to ever turn it on to its highest possible setting (which I believe, on most fans, is marked "Category Five"). Anyway, a fan with a nice kick to it (like the Air King 9212 12" Industrial Grade Electric Floor Fan, for around $65) creates a windblown hair effect that can add energy and excitement to your portraits (besides making the subject's hair look full and glamorous). The fan should be positioned on the ground, aiming upward at your subject, and once the fan is in place and turned on, there's not much else to do but shoot. If you really want to "blow people away," take a look at Buffalo Tools' 42" Industrial Fan (it sells for $366), which was designed for use in factories and sports arenas, and features high-performance, belt-driven motion with a two-speed capacitor and a thermal cut-off (whatever that means). In short, it's guaranteed to relocate anything in your studio that's not bolted to the foundation.

Want to Impress the Folks at *Vogue*? Buy This Fan!

If you get a huge, paying, fashion cover shot gig and you want to really impress your new clients, buy the only fan I've found that is made for shooting fashion—the Bowens Jet Stream Wind Machine. With its 2500-rpm blast and a wireless remote, it'll be knocking your clients off their feet (and it should—it sells for around $920). B&H Photo has 'em in stock. What the heck—buy two!

Want Softer, More Even Light? Feather It!

SCOTT KELBY

If you're already using a large softbox (one that's around 36x48" or larger), and you want softer, more even light than it delivers, then you can use a technique called feathering, which puts your subject in the softest and most even light your softbox can deliver. Feathering just means that you turn the light away from your subject, so they are now lit by just the edges of the light. They won't be getting the full intensity of the light when you feather it, so you might have to adjust your exposure so it's not too dark (use a lower number f-stop on your lens—like f/4 or f/3.5, etc.—or better yet, use your light meter and it will tell you exactly which settings to use when feathering your light). This light out at the edges of your softbox is very even, very soft, and very flattering (since the light in the center of the softbox is usually brighter and less even), so when you really need that super-soft, even light—now you know where to get it. This technique looks great on portraits of young children, a mother/daughter shot, or when you want a very soft, glamorous look to your lighting.

What That Extra Panel in Your Softbox Does

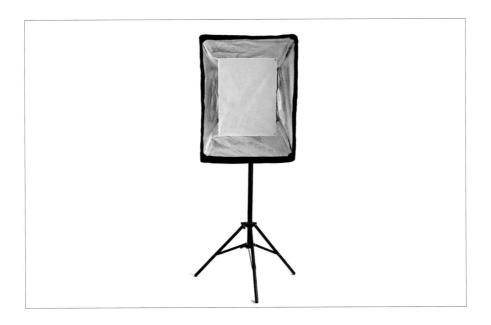

When you buy your first softbox, it may come with a second smaller diffusion panel, which you place inside the softbox (and then you place the larger outer diffusion panel on the inside edge of the softbox, to cover the front). That internal diffusion panel really serves one purpose: to try to even out the light, so you don't get a hot spot in the center of your light where the flash bulb is. This internal panel does make the light a tiny bit softer, but that's not its main job—it's to hide that hot spot. Of course, by adding this internal panel, your light has to pass through that diffusion material first, so you lose a little bit of light in the process. As a general rule, if I'm using continuous light (like the Westcott Spiderlites), I always take this extra internal diffusion panel out. That's because those daylight fluorescent bulbs are already soft (by their very nature), and the panel doesn't really soften them significantly, it just eats up light, so I especially want them out when using continuous lights, because I need all the brightness I can get. Otherwise, if I'm using strobes, I leave them in place.

Using a Pop-Up Collapsible Background

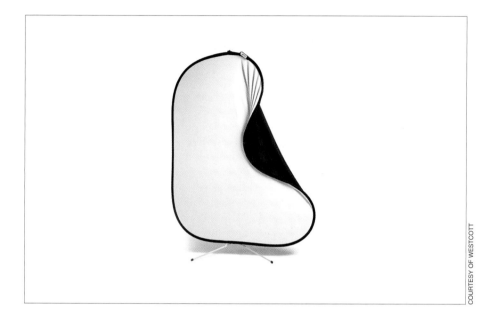

COURTESY OF WESTCOTT

Another quick and flexible studio background is a pop-up collapsible background that instantly folds up into a small, flat circle, but expands to be a full studio background in a matter of seconds. The one I use is a 6x7' Westcott Masterpiece 2-in-1 Collapsible Illuminator Background with white on one side and black on the other. It sells for around $215, and I also recommend buying the Illuminator stand to hold it up, which is another $67, but unless you can stand there and hold it up (or have somebody else hold it up), it's worth its weight in gold. So, with this background, anytime you want to shoot, you just open the round plastic case it comes in, pull it out, and it pops up, ready to go. You put it on the Illuminator background stand, and you're ready to go. Another advantage of this particular background (over the seamless paper route) is that it's very portable, lightweight, and you can set it up in literally seconds—by yourself. The only downside is it doesn't go all the way to the floor seamlessly, so it's fine for ¾-body shots, but not full-body shots. One more thing: although I use the black/white version, these collapsible backgrounds come in all sorts of patterns, looks, sizes, and colors.

The Least Expensive Extra Light

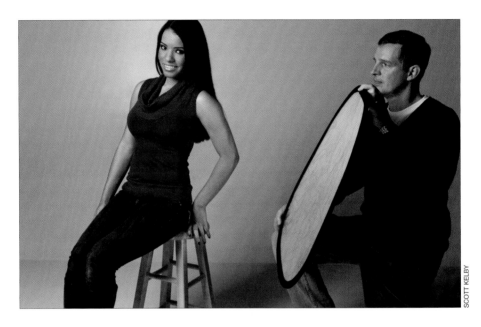

SCOTT KELBY

If you're thinking of buying an extra light, I hope it's a hair light, because if you think you need a second strobe just to fill in shadows, you really don't need one. That's because for around $36 you can pick up a silver 30" reflector, which will act as your second light by bouncing light from your first light back toward your subject to fill in any dark shadow areas. If you use the silver side of your reflector, it will throw a tremendous amount of light back at your subject (the white side reflects or bounces much less light than silver, and works best just to add a little sparkle and fill in close-up portraits). If you want a serious second-light alternative, go with a round silver reflector.

Three Backgrounds for the Price of One

One of the advantages of shooting on a white background is that you can get three different looks from it, depending on how you light it. For example, if you put two bright strobes (or continuous lights, for that matter) aiming at the background behind your subject (or product), the background will look bright white. If you dim those lights, or remove one, then the background looks like a light gray. If you leave the background lights off altogether, your white background will now look medium gray. So, with white you get three separate looks: bright white, light gray, and dark gray—all based on whether, and how, you light the background.

Using Off–Camera Flash to Light Backgrounds

If you want to add a light to your background (aiming back at your seamless paper), but you don't want to go through the extra expense of adding a second studio strobe, if you have a standard off-camera flash (like a Nikon SB-900 or a Canon 580EX), you're in luck. You can set either of these off-camera flashes to become wireless slave flashes, meaning that when your studio strobe fires to light your subject, it automatically triggers your off-camera flash to light your background. You only have to do two things to make this happen: (1) Put your flash on a light stand. (*Note:* If you have a Nikon SB-900 flash, it actually comes with wonderful little flash stand that lets you set your flash on the floor. Then you aim the head back up at your background, and this will work in a pinch.) So, the first thing (once again) is to put your flash on a light stand, and position it directly behind your subject so your subject's body hides the flash from view. Then, (2) set your off-camera flash to Slave, so it fires when it senses the light from your studio strobe. For example, on a Nikon SB-900, turn the ON/OFF switch to Remote, press-and-hold the OK button, and scroll down to SU-4 (as shown above). Select ON, press the OK button, then select Exit, and you're ready to go.

The Advantage of Shooting Tethered

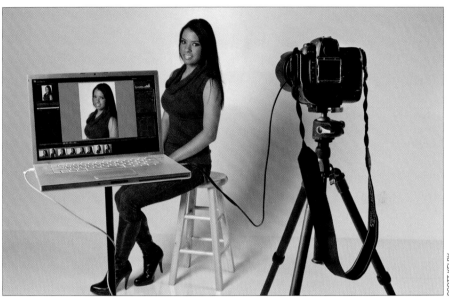

SCOTT KELBY

If I'm shooting in a studio, I'm shooting tethered. This means I've attached a USB cable to my camera, and the shots I take don't go onto my camera's memory card—instead they go from my camera straight onto my laptop. That way, I can see each image appear at a very large size right on my computer screen while I'm shooting. At this large size, you can really see what's going on in your photo (and how your lighting looks), and you can make adjustments based on a larger-sized 8x10" image, which makes it hard to look at that tiny 2 ½" or 3" LCD display anymore. When you're shooting tethered, you see every-thing (including lots of things you might have missed). I highly recommend giving this a try. You just plug one end of your USB camera cable into the USB slot on your computer, then the other end plugs into the USB slot on your camera. But, to shoot tethered, you'll need some software. If you use Photoshop Lightroom 3, you can shoot tethered right into your computer without any other software. If you don't have Lightroom and you're a Canon shooter, you already have the software you'll need—it's that EOS Utility soft-ware you got when you bought your camera (if you can't find it, don't worry—you can download it free from Canon's website). If you're a Nikon shooter, then you'll need Nikon Camera Control Pro 2 to shoot tethered. It's $145.95, but you can download a working 30-day trial from Nikon's website.

Getting Super–Saturated Background Color

SCOTT KELBY

If you want some really vivid, punchy colors as your background, here's a recipe to get just that: Start on a background of black seamless paper (I know, it sounds weird that we start creating vivid colors with a black background, but believe it or not, this is the easiest way), and then position a light on the background. Now, for a background light you can use another of the same strobes you already have (so, basically, you're going to need a second strobe if you want to light the background, or there's a trick you can pull to use your off-camera flash as a background light that we talked about a couple pages ago). Once you've got your black seamless paper in place and a second strobe (or off-camera flash) positioned behind your subject, aiming at the background, the trick is to put a vivid-colored gel (a translucent piece of plastic) over the front of your flash, and when your background flash fires, the color it produces is rich, vivid, and surprisingly colorful. You can get these gels (made by Lee or Rosco) from B&H Photo for around $6.50 for a 20x24" sheet (choose really vivid colors—reds, yellows, greens, etc.).

Lighting a White Background

When you shoot on a white seamless-paper background, you'll probably be surprised to find out that most of the time it doesn't look white—it looks light gray. To get it to look solid white (that nice bright white you're used to seeing in portraits and product shots), you have to light the background. It doesn't take a bunch of lights—usually just one or two will do the trick, and they don't have to be very high-powered strobes either (see the off-camera trick a few pages back), so it's not a bad idea to buy a lower-powered, less expensive strobe just for lighting the background. But beyond just having a background light aimed at your white seamless background, there's a little trick you'll want to use to make sure that the light does make the background look that nice solid white, but without blowing out the background so much that the back light starts to wash out the edges of your subject (this happens more than you might think). The pros' trick to getting around this is (you guessed it) to use their light meter. They hold the meter up against the background, aim the white dome back towards the camera position, and check the reading. You want the background to be around one stop brighter than the light on your subject. So if your meter showed f/11 for your subject, you want the background to read one stop brighter (like f/16). You get that background brighter by increasing the power (brightness) of the strobe itself. Try increasing a bit, then recheck the background with your meter again, and keep adjusting the power of the background light until it reads that one stop (or slightly more) than your subject. That's the formula.

Which Color Reflector to Use

Outdoor Studio Both

Reflectors come in a variety of colors (white, black, silver, gold, etc.), and if you're wondering which color does what, well, here ya go:

- **Silver** reflects the most amount of light, and doesn't change the color of the studio light that hits it, so you see a lot of portrait pros using silver.
- **White** reflectors don't bounce nearly as much light, but they're still used in portraits, and work both indoors and outdoors. White reflectors are also a good choice if you're doing product photography.
- **Gold** reflectors are for outdoor portraits to match the warm color of sunlight. They don't work well in a studio, because when the white light from your strobe hits the gold reflector, it becomes very yellow (so one side of your subject's face looks studio white, and the shadow side looks overly yellow).
- A **Black** reflector actually absorbs light, so it's used to cut reflections when you're shooting anything that's reflective, like glass, or jewelry, or tableware, or anything that's clear, etc.

For my studio portraits, I use a reflector that is silver on one side and white on the other, and I use the silver side around 80% of the time.

Where to Position a Reflector

RAFAEL "RC" CONCEPCION

Reflectors are a key part of a studio setup, because they keep you from having to use a second light. Luckily, they're pretty inexpensive (the Westcott 30" Silver/White Illuminator square reflector I use costs only around $36), but once you've got one, where do you put it? There is no one "right" place to position your reflector, but since its job is to bounce some of the light from your studio strobe back into the shadow areas of your subject, you'll need to position it where it can do its job, right? The first thing to remember is that the reflector normally should be placed a little forward of your subject, so the light can bounce back onto them. One popular method is to place the reflector directly beside your subject (and just a little bit forward) on the opposite side of your strobe (softbox), so it catches the light and fills in the shadows. So, if your light is positioned to the left of your subject, then the reflector would be positioned on the right side of the subject, aiming directly at them (as shown above). Another popular place to position a reflector is below your subject, aiming back at them, so the light bounces back to light their face, in particular the eyes and the shadows under the eyes. You can have your subject hold the reflector, you can position it on a stand, or even lay it on the floor in front of them. The key thing to remember with reflectors is: if the light isn't hitting the reflector fairly directly, it's got nothing to bounce, so make sure that wherever you position it, the light from your strobe is hitting it directly.

Reflectors Without an Assistant

If you don't have an assistant to hold your reflector in the studio, then it pays to buy a light stand with a reflector boom arm, so you can position (and tilt) your reflector just the way you want it. The one I use is made by Impact, and you can buy it in a kit that comes with a 32" 5-in-1 reflector (silver, white, gold, soft gold, and translucent) for around $95 at B&H Photo. The boom arm has two clips on it that hold your reflector, and because it's on a boom, you can easily tilt it to an angle you'd like. This is incredibly handy to have around (and much less expensive than hiring an assistant to hold your reflector).

Visit B&H Photo's New York Superstore

If you're ever in New York City, make it a point to drop by the B&H Photo store. It is absolutely amazing. It's like Disneyland for photographers. I could spend a day there (and I have). Anyway, they're good people.

Seeing the Light from Your Reflector

SCOTT KELBY

So, you're standing there holding a reflector. How do you know if it's really hitting your subject? Here's a quick trick for helping you position the angle of your reflector so you know the light is hitting where you want it to. Hold the reflector by its side and tilt it up and down a few times as you're facing your subject, and you'll see the reflected light move across their face. By tilting the reflector up and down a few times, you'll locate that "sweet spot"—where the light is hitting and fully bouncing from—and then you can tilt the reflector to right where you want it.

Where to Go to Learn More About Studio Lighting

If this chapter gets you excited about what can be done with just one strobe (or one strobe and a hair light), and you want to learn more (and learn how and when to add more lights), then check out the book *Softbox Lighting Techniques for Professional Photographers* from Stephen Dantzig (published by Amherst Media).

Keep Light from Hitting the Background

SCOTT KELBY

If you want to create a portrait with dramatic lighting, the key is to control where the light goes, so only a small portion of it actually hits your subject (and little or none winds up lighting the background). The problem is that even with a softbox (which is fairly directional compared to an umbrella), the light aiming back at your subject can spread too much, so we use "black flags" to block the light from hitting our background (or anything else we don't want it to hit). These flags are really just tall, or wide, black rectangular reflectors that absorb and block light, so you put one between your strobe (softbox) and the background, and voilà—it stops the light from spilling (as shown above). So, if you have more than one, you can really keep your light pretty much directed just where you want it, by putting these black flags up to block any extra light. I use two Mathews 24x36" black flags (around $41 each). If you're not ready to plunk down that kind of change, you could always get two large black pieces of poster board or foam core, and that will do the trick.

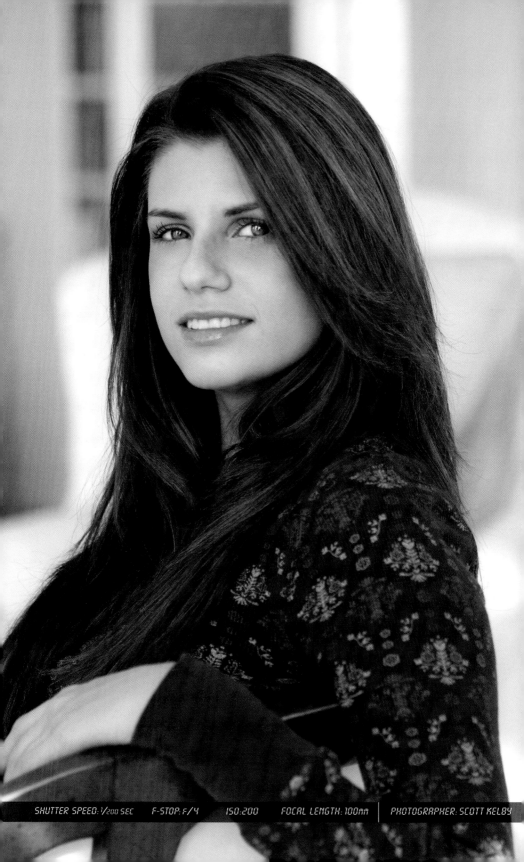

Chapter Three

Shooting Portraits Like a Pro

More Tips to Make People Look Their Very Best

Getting professional-looking shots of people is harder than you might think, for one simple reason: the pros hire really good-looking models, and as you know, models are models for one simple reason—they forget to eat. I'm joking, of course. They're models because they photograph really, really well. So, what makes our job so hard is that we're not surrounded by fabulous-looking models who just happen to be standing around not eating. Nope, we usually wind up shooting portraits of our friends, many of whom (on a looks scale) fall somewhere between Mr. Bean and Jabba the Hut. This is why our job, as portrait photographers, is actually substantially more challenging than that of a seasoned professional—we've got to make magic from some seriously un-model-like people. This is precisely why we're often so disappointed with our portraits (when it's really not our fault). So, in this chapter we'll look at two proven strategies to get better, more professional-looking portraits every time, including: (1) how to make friends with better-looking people (it helps if you're rich), and (2) learning to control your light and pose your subjects so that no one gets a really good look at them. The key to this is to use dramatic light, and by "dramatic light" I mean—virtually none at all. The less you light these "un-model-like" subjects, the better your final images will be. In fact, think silhouette or long distance night photography, where your subjects are 100 to 200 yards away—anybody looks good from that distance (that's why long distance relationships work so well). Anyway, what this chapter will give you is a strategy for photographing people, and a list of places where good-looking people hang out and wear jeans that cost more than the gross national product of Luxembourg.

71

Don't Leave Too Much Headroom

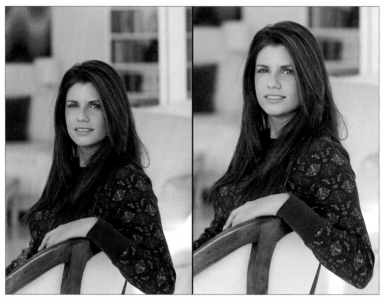

SCOTT KELBY

When your average person takes a snapshot of someone, they almost always leave way too much space above their subject's head (as you see on the left here). It's a classic mistake most amateurs make, but luckily it's one that's really easy to fix. Just don't do that—don't leave too much space. If you remember my portrait composition tip from volume 1 of this book (position your subject's eyes at the top one-third of the frame), then you'll usually avoid this "too much headroom" problem altogether.

Shoot in Portrait Orientation

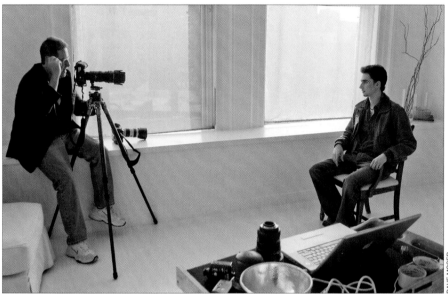

DAVE MOSER

Most photos are taken in horizontal (landscape) orientation, and that makes perfect sense, since cameras are designed that way—to be held horizontally—and that's why the shutter button is on the top right, right where your finger would naturally be. However, professional portraits are generally taken using a vertical orientation (that's why it's referred to as "portrait orientation," but that term is most often seen when you go to print something on your computer—you'll see a button for Landscape [wide] or Portrait [tall]). So, if you want more professional-looking portraits, turn your camera vertically and shoot in portrait orientation (of course, like any rule, there are exceptions, some of which you'll learn later in this chapter).

Shooting Portraits? Get a Battery Grip!

SCOTT KELBY

If you shoot a lot of portraits, you're going to be spending a lot of time with your camera flipped vertically, and before long you'll get tired of reaching over the top of your camera to press the shutter button. When that happens, you'll want to get a vertical battery grip. Besides enabling you to use two batteries, so you can shoot longer without recharging your batteries, there's another huge advantage to battery grips, and that is that most include a vertical orientation shutter button and dials for setting your aperture and shutter speed, so you're as comfortable shooting vertically as when you're shooting horizontally. Besides those advantages, most of the photographers I know swear that it makes the whole camera feel better and more substantial in their hands, even when shooting horizontally (and how a camera feels in your hands is very important). The best news is these battery grips are available for most DSLRs, and for all the advantages they offer, they cost less than you'd think (starting at around $100). Just one thing to look for when ordering yours: not all battery grips have the vertical shutter button, so check to make sure the one you order does.

Most High–End Cameras Already Come with a Vertical Shutter Button

If you've got a high-end digital camera, like a Canon 1Ds Mark III or 1D Mark IV, or a Nikon D3s or D3X, they already come with a vertical shutter button built right in. Hey, ya pay that type of money, they oughta come with one, right?

The "Sun Over Your Shoulder" Rule Is Bogus

©ISTOCKPHOTO/IZABELA HABUR

You may have heard of the "Sun Over Your Shoulder" rule, which basically states that when you're shooting people outdoors, you put the sun behind you (over your shoulder), so your subjects' faces are lit. This is a perfectly fine rule for people taking snapshots, but it is the worst thing you can do for your group portrait (besides the "tall people in the back" thing). If you want more professional-looking shots of people outdoors, the last thing you want is the bright sun blasting them straight in their faces (although that's exactly what your average person does), so everyone is squinting, trying to shield their eyes, and turning away from the camera. Worse, it puts harsh, direct, unflattering light on them. Instead, position your subjects with the sun behind them (not behind you), so it puts a nice rim light effect around them (outlining their hair), and then use just a tiny bit of flash (keep the brightness of your flash low) to put just enough light into their faces to make them blend in with the natural light that surrounds them.

Shoot Wide and Push in Tight

SCOTT KELBY

This is a concept—shooting on-location portraits with a wide-angle lens—that I hadn't considered for many years because of the time-honored rule that states: "Don't shoot people with a wide-angle lens because they look all distorted and weird." But it was one of the world's top shooters, the brilliant Joe McNally, who totally busted that myth and totally changed the way I shoot environmental portraits by turning me on to "shoot wide and push in tight." When you're shooting wide-angle and you get really close to your subjects (you're pushing in tight), they don't look distorted—only the stuff at the very edges of the frame looks a little "wide," but it's that stuff at the edge of the frame that shows the environment where the shot is taken. I was skeptical until Joe challenged me to pick up a *People* magazine and look at what most of the shots are—taken in tight with a wide-angle lens. I was shocked, but it's not just *People*, it's just about everywhere—from magazines to billboards to prints ads to the Web. The pros are shooting wide and pushing in tight. You can, too!

Name–Dropping Disclaimer

Throughout this book, I wind up mentioning names of some famous photographers. The reason I do this isn't to drop names; instead, it's to give credit where credit is due. If I learned a tip or technique and I can remember who taught it to me, I think it's only right to give them the proper credit.

Shoot Profile Shots in Horizontal

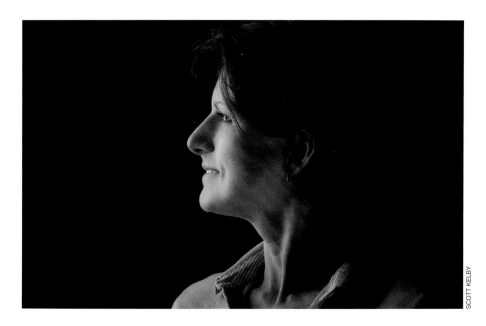

SCOTT KELBY

So, now that we've learned the Shoot Portraits Vertically rule, let's break it! (That's the great thing about the photographic rules—once you learn 'em, you can break 'em, then it's cool. It's only uncool when you break the rules by accident because you didn't know any better.) Anyway, one place where we intentionally break this rule is when we're shooting a profile view of our subject. The reason is this: because your subject is facing the edge of the frame, if you shoot your subject vertically, they look boxed-in, and that's uncomfortable for your viewer. So, by breaking the vertical rule and shooting profiles horizontally, it gives your subject some visual breathing room and makes your subject look more comfortable within the frame.

Shoot Long for More Flattering Portraits

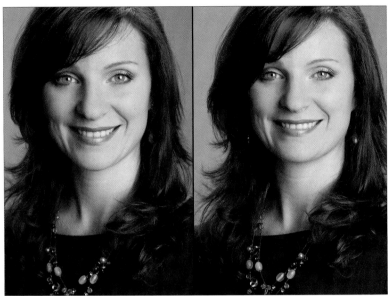

SCOTT KELBY

Have you ever seen a high-end photo shoot on TV (maybe a fashion or celebrity shoot), and have you noticed how far back the photographer is from their subject? That's because they're taking advantage of "lens compression" offered by a longer zoom lens (which is very flattering to portraits). The shots above really tell the story—the one on the left was shot with a 50mm lens, and the one on the right with a 70–200mm lens zoomed out to 190mm. Even though all the camera settings and lighting are identical (they were taken just seconds apart), her features in the shot on the right look much more pleasing. That's why you'll see many pro photographers shooting portraits at the far range of their zoom. By that I mean they shoot with the lens extended out as far as it can go. So, if they're shooting a 28–135mm lens, they're shooting out in the 100mm to 135mm range to get the best, most flattering look for portraits.

Scott's Pro-Speak TRANSLATOR

The phrase we use for shooting all the way out at the longest end of a telephoto lens (for example, shooting at 200mm on a 70–200mm lens) is "racked out." So, you might hear a photographer say, "I shot racked out to 200," which means he shot with his lens extended out as far as it can go—to the far end of its range (in this case, 200mm).

Why Diffusers Rock for Outdoor Portraits

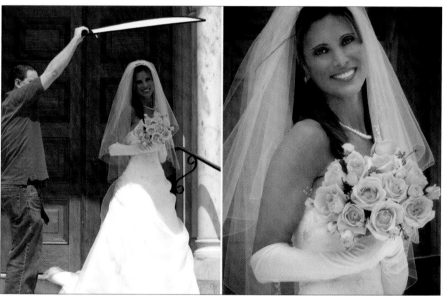

SCOTT KELBY

When it comes to really harsh, unflattering light for portraits, it's a toss-up between which is worse: your camera's built-in pop-up flash or direct sunlight. Luckily, as you learned in volume 1, if you're shooting portraits outdoors and there's an area with some shade nearby, you can shoot there. But what if you're out at the beach, or in the desert, or one of a thousand other places that doesn't have a shady tree nearby? Then you'll want to own one of these—a 30" Lastolite TriGrip 1 Stop Diffuser (the same one I mentioned in the flash chapter for diffusing harsh light from an off-camera flash—so it does double-duty here). Just have a friend hold this diffuser between the sun and your subject (as shown above), and instantly you have soft, beautiful, natural light on location. It sells for around $67 at B&H Photo, and you'll want this lightweight lifesaver with you every time you leave the studio.

 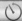

Making a Better Background for Portraits

SCOTT KELBY

The key to great backgrounds for portraits is "less is more." If you're shooting an environmental portrait (a photo taken on location in someone's home, office, etc.), to get that pro look, it's not what you do to the background—it's what you take away from the background that makes it work. You want to have as few distracting elements in the background as you can, so either position your subject on a very simple, uncluttered background to begin with, or if that's not possible, remove as many distracting elements (or knicknacks) as your subject will let you get away with as I did in the image on the right here. Don't take this lightly—to create a really great environmental portrait, it can't just be the foreground that works. The whole photo has to work together, and by choosing (or creating) a sparse, uncluttered background, your chances of having a winner go way up.

 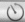

Trendy Composition Tip

SCOTT KELBY

Since most photos you see are either horizontal or vertical, doing something different looks…well…different! And right now, a very popular technique for portrait photography is to turn the camera at an angle, which puts your subject kind of up in the corner. The technique couldn't be simpler—just rotate your camera to the left or right a little bit and then take the shot. It may take you a couple of tries to get your subject positioned right where you want them in the frame, but this look (which has been around for years) is getting very popular once again.

Cropping Off the Top of Their Head

SCOTT KELBY

This is the next step past "Don't leave too much room above your subject's head" in portraits. In this composition technique, you actually cut off the top of your subject's head, and while that probably sounds weird reading it here, it's a very popular pro technique that fills your frame with your subject's head. Getting in tight like this makes for a very compelling look, as you see above, and now that it's been brought to your attention, you'll see this composition technique is everywhere and has become the mainstay of many top fashion, beauty, and portrait shooters. (*Note:* Although it's perfectly fine to cut off the top of their head, or side of their arms, shoulders, hair, etc., you shouldn't cut off their chin. People are actually very used to seeing the top cut off and it looks natural, but seeing a shot where the chin is cropped off makes for a very uncomfortable composition.)

Group Photos Are Easier Outdoors

©ISTOCKPHOTO/ALDO MURILLO

Lighting a group shot, and getting a consistent amount of light on each person, can be pretty challenging, which is why, when it comes to group shots, you'll usually get better results by moving the group outside. It's easier to light the group using available outdoor light, especially if you can get them in the shade (not deep in the shade, just on the edge of the shade, but without letting any dapples of light appear on them through tree branches or gaps between windows or buildings). If you're lucky enough to wind up shooting a group portrait on an overcast day, then your job will be pretty easy—just get them outside and the overcast sky will take care of your lighting woes, so you can focus on getting them posed. (By the way, professional-looking group shots never start with the photographer saying, "Okay, all the tall people in the back row.")

Tip for Posing Group Portraits

SCOTT KELBY

The next time you're shooting a group portrait, rather than lining everybody up in rows (which you already know doesn't look good), instead try to get them to rally around something—some object—and they'll arrange themselves naturally around it. For example, try posing people in and around a couch, a column, a chair, a car, a desk, or any object that can pull them together into a group that isn't just a bunch of people standing in straight lines.

Great Tip for Casual Group Shots

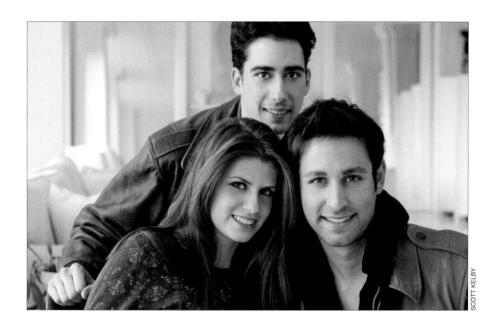

Want to make a more compelling look for a casual group shot? Put your subjects in a very tight pyramid shape (a triangle), but by tight I mean so tight that they're all touching—arms around one another, their heads very close together, with one person at the top of your frame, and one on either side of the bottom of the pyramid shape (as shown above), with the others all scrunched in the middle. Also, you'll notice their bodies are not in a straight line—they're kind of staggered, but they're all leaning into the shot, which gives the shot more energy and a sense of fun. I wouldn't try this for an executive group portrait, but if you've got a fun-loving casual group, this is a great way to visually say that about them.

Don't Use Rows—Use Clusters

If you're shooting a large group, instead of posing everyone in those tired rows, group people together in small clusters—like a mini-triangle within the group, with three or four people in each triangle. These little mini-clusters add closeness and energy, and then when you've got two or three groups put together, slide them all a little closer together to visually make one big group. (These mini-clusters don't have to touch each other—small gaps between them are okay.)

Don't Light Your Entire Subject Evenly

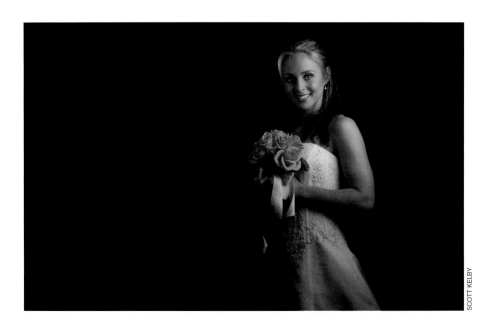

SCOTT KELBY

When people look at a photo, their eye is first drawn to the brightest thing in the photo, so you only want the brightest light falling where you want them to look, right? Right. So, if you're shooting a portrait, do you want the person viewing the portrait to look at your subject's face or their folded arms? Right. But most people light the entire portrait with the same exact light throughout, where the subject's hands at their sides have the same approximate light as the subject's face. If you want to create portraits that really lead the viewer to where you want them to focus, light your subject so the light is brightest on their face, and it gradually falls off the lower down their body it goes. This adds interest, drama, and a visual focus that you'll find so often in high-end portraits. By the way, this is another case for feathering your light, so that the edges of the light are what light your subject's face, and below that the light falls off pretty rapidly (but don't let it get too dark—it should still have light, and detail, just not as much as their face).

Don't Let Too Much Light Fall on Their Ears

If there's a part of your subject that doesn't need to be well-lit, it's their ears. Ears are often distracting because they're poking out of what is usually a darker area (a person's hair), so they catch enough light to draw your attention. Since a person's ears are rarely their best feature, you don't want your viewer's eyes stopping on them first, so just be careful to not have some really bright ears in your portraits.

Want Better Portraits? Don't Count Down!

If you want that really posed look, then count 1-2-3 right before you press the shutter button. It's almost a guarantee that you won't have any natural expressions in your portraits. It's your job as photographer to find that moment when your subject looks natural, and capture that moment in time. Anyone can stand there and say "1-2-3" and push the shutter button at "4," and if you do that, you'll wind up with images that anyone can take. If you want something special, something more natural—a genuine smile or expression—then ditch the 1-2-3 cliché and instead just talk to your subject. Engage them, get them talking, laughing, smiling naturally in the course of a conversation, or even goofing around, and then when the moment is right—capture that moment. Then you'll be giving them more than a well-lit, totally posed photo. You'll give them something special.

Shoot Before the Shoot and Between Shoots for More Natural-Looking Portraits

A number of pros swear by this technique for getting more natural shots: they tell the subject not to pose yet, because they're just taking "test shots" to check the lighting. Since you're not really shooting, they're not really posing, and you're just talking to them, firing away the whole time. Once you tell the subject, "Okay, here we go," they change their demeanor, and begin "posing," so make sure you get lots of these candid, non-posed shots before the official shoot and between shoots, because they will probably be the most natural, un-posed shots of the day.

Window Light: Where to Position the Subject

DAVE MOSER

Window light, especially light from a north-facing window, is among the most beautiful light for portraits anywhere (in fact, some pros insist on only using natural window light for all their portraits—period!). The window diffuses the light streaming in, and the larger the window, the more soft and diffuse the light. So, if you've got some nice window light, where do you position your subject to make the most of this beautiful light? You want to position your subject with their shoulder facing the window (so the light comes across your subject, creating soft shadows on the far side of their face). Then, place them about 6 feet from the window, so the light is very soft and wraps around your subject (if you get them any closer, that soft light could turn very contrasty fast). Also, position your subject a little bit back behind the window, so they catch the edge of the window light and not the direct sunlight. This edge light is very soft and gives you that wonderful, almost magical light that so many pros swear by.

Window Light: Where You Should Shoot From

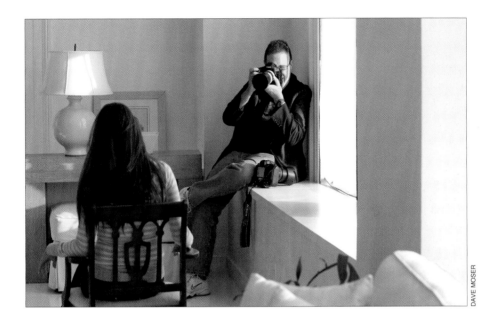

DAVE MOSER

When shooting a window-light portrait, you want to set up your camera right near the window, with your shoulder facing the window. Then, you'll aim back a little toward your subject, who should be positioned just past the window, about 6 feet from it (so basically, you're up against the window, shooting at a slight angle back toward your subject).

Window Light: Where to Position the Reflector

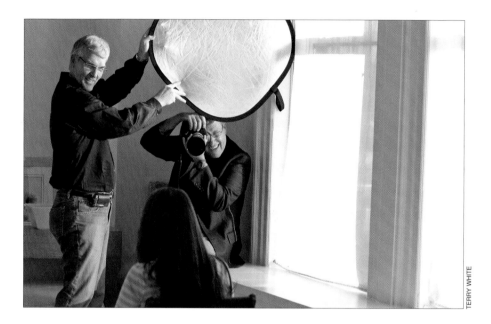

TERRY WHITE

Since we generally use a reflector to bounce light into the shadow side of our subject's face, you might think that with window light you'd put the reflector on the shadow side of your subject's face. It makes sense, right? Right. And you can do that, but with window-light portraits, try this technique I learned from legendary portrait and wedding photographer Monte Zucker: bounce the light from the camera position (near the window) above your head, bouncing the window light down onto the dark side of your subject's face to open up those shadow areas.

Six Quick Tips for Fixing Facial Challenges

©ISTOCKPHOTO/EDUARDO JOSE

You can hide or greatly reduce many typical facial problems (like a big nose, round face, wrinkles, big ears, etc.) by how you pose and light your subject. Here are seven quick posing tips to help you make your subjects look their very best: (1) If your subject is balding, shoot from a lower angle, and don't use any hair light whatsoever. (2) If your subject has lots of wrinkles, try lighting them straight on, because side lighting tends to accentuate the shadows and make the wrinkles more prominent. (3) If your subject has large ears, pose them so they're only showing one ear, then light them so that ear appears on the shadow side of their face (so basically, only one ear is showing, and that one is kind of hidden in the shadow). (4) If they have a big honkin' nose (that's a technical term, by the way), then have them turn their head straight toward the camera, have them raise their chin a bit, and shoot from a little lower angle, which will take much of the emphasis off their schnozz. (5) If your subject has a double chin, have them look straight at the camera, and extend their head forward toward the camera a bit. This stretches and tightens the skin under their chin. Also, if you light them straight on (with the light positioned directly above where you're shooting from), this puts a shadow under their chin and helps to hide the double chin. (6) If your subject has a round or fat face, make fun of them, and tell them to lose a few pounds. Then, when they burst into tears, you'll have some of the most natural-looking expressions of the day. Or, you can have them turn their face to the left or right, giving a ¾-view of their face, which will make their face look less round, but really—it's your call.

Don't Shoot with Their Shoulders Straight On

SCOTT KELBY

Everybody—women, men, kids—looks better when posed with their shoulders angled toward the camera. If their shoulders are straight toward the camera, it makes your subjects look very wide and flat, and even somewhat confrontational. But by simply having them turn one shoulder away from the camera, it makes them look thinner and generally gives them a more pleasing look by lessening the width of their shoulders, and focusing more attention on their head. Remember: Their head can still face the camera—you're just turning their shoulders.

Making Your Subject Look Slimmer

SCOTT KELBY

If you want to make someone's body look slimmer, keep their arms from touching their body—leave a little gap between their arms and their body, so their arms don't add to their body mass and make their whole figure look larger. You'll see this trick used often in celebrity and fashion shots, and you'll be surprised what a difference this little gap between the arms and waist can make (as seen in the before/after above). Another trick is to have your subject face their body away from the camera at an angle, and then just twist the upper half of their body toward the camera (leaving their lower half still facing away). Again, this is one of those little tricks that makes a big difference.

Using a Posing Chair

SCOTT KELBY

One of the best reasons to pose your subjects in a chair is that people often feel more comfortable in a chair, and if they're comfortable, your chances of getting a relaxed, natural portrait go way up. If you have your subject standing alone in the middle of a studio, with all sorts of lights aimed at them, you're giving your subject every opportunity to be uncomfortable, and that usually translates to less-than-natural, uncomfortable-looking portraits. By the way, if you do shoot your subject seated, here's a tip to help get better-looking poses: have them sit near the end of the chair (being that far from the back of the chair almost ensures that they won't slouch or lean back), and it helps the overall look to have them lean a little forward, into the camera. So, the next time your subject looks really uncomfortable, offer them a seat, and watch them instantly become more comfortable, which usually results in better, more natural-looking portraits.

Keeping Your Subject "In the Zone"

DAVE MOSER

When you're shooting a person's portrait, it's a very vulnerable, and often uncomfortable, position to be in, and in most cases the person you're shooting wants you, the photographer, to be happy with what you see and what's going on with the shoot. If they feel things aren't going well, they start to think it's their fault. You want them feeling great—you want them confident and happy, enjoying their time in front of the lens as much as possible, because that translates into better portraits. One way to keep them "in the zone" and engaged is to keep talking to them. All the time. The entire time. Talk about what you're doing, why you're doing it, talk about the weather—anything to keep them engaged. Anytime there's a period of silence, they start to get worried something's wrong, and that it may be their fault. They have no idea what you're seeing through the viewfinder, and if things get quiet, they start to get concerned and they start to get edgy, and within a minute or two they're totally out of the zone. When I'm shooting a portrait, I'm talking to them the whole time. If I stop to move a light, I tell them why (I know they don't care, but I'm keeping them engaged in the shoot). I keep giving them constant verbal encouragement ("That looks great. Fantastic! Right on the money! What a great smile," etc.) the whole time, and it makes them more comfortable and confident.

Avoid Dappled Light

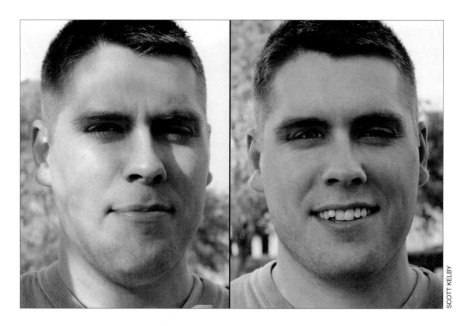

SCOTT KELBY

If you read volume 1 of this book, then you already know about putting your subjects in the shade to get better portraits outdoors (ideally, out near the edge of the shady area for the best light), but when you do this, there's something to watch out for—the dreaded "dappled light." That's those small areas of bright sunlight that break through the trees, causing uneven hot spots of light on your subject, which pretty much ruin the portrait (even if the dapples don't fall directly on their face). Luckily, the fix is amazingly easy—just reposition your subject in an area of the shade that doesn't have any of this distracting dappled light shining through. You can see how much better this looks in the image on the right here. Now, there are certain instances where dappled light works when you're shooting landscape photography, but when it comes to shooting people, dapples pretty much ruin any hope of a professional look, so be on the lookout for them anytime you're shooting under trees, or in a barn (where sunbeams can come through the cracks in the wood), or anyplace where small beams of sunlight can fall directly on your subject.

Get Couples Really, Really Close

SCOTT KELBY

When you pose a couple and tell them to get in nice and close to each other (which you definitely should), they never get nearly close enough to look "close" in a photo. When you put your eye up to the viewfinder, you'll see the gap I'm talking about, so you tell them to "get even closer" and they move in all of about 2 inches, but I've got a trick that fixes this every time. Go ahead and take a quick shot—with the gap between them—then take it right over and show them the gap on your LCD monitor. Once they see it (and how big the gap that they thought wasn't there actually looks), they'll really get in close, and it literally makes the shot. I've done this again and again, and it always works like a charm.

Which Color Reflector to Use

One of the most popular color combinations for reflectors is silver on one side and gold on the other. The silver side is usually used when shooting indoors or inside a studio. The gold side is usually used outdoors, and since it's gold (and light picks up the color of whatever it hits), the light it throws will be very warm—like sunlight. So why wouldn't you use this warm reflected light in the studio? Because the light in your studio is usually very white balanced, probably from a flash, and you don't generally want to have white-balanced light from a flash on one side of their face and warm, golden light on the other side.

Shoot Outdoor Portraits Shallow

SCOTT KELBY

If you're shooting a portrait outdoors, for a more professional look, you want to direct the attention to your subject, minimize distracting backgrounds, and you want to put some visual separation between your subject and the background. The easiest way to do all of this is by creating a shallow depth of field. To do that, switch your digital camera to aperture priority mode, and then set your camera's f-stop to either the lowest or next-to-lowest f-stop you can. (So, if the lowest number you can go is f/2.8, you'd use f/2.8 or the next highest number, f/3.5.) Using these low numbers throws the background out of focus, which puts all the focus on your subject. This out-of-focus background look is a very popular technique used by portrait professionals when shooting outdoor portraits.

Minimizing Shadows Under the Eyes

If your subject starts to get shadows under their eyes (from overhead lighting indoors or outdoors), one way to reduce those is to put a silver or white reflector directly in front of them at their chest (or as high up as right under their chin), aiming up at them and reflecting some of the light back up into their eyes.

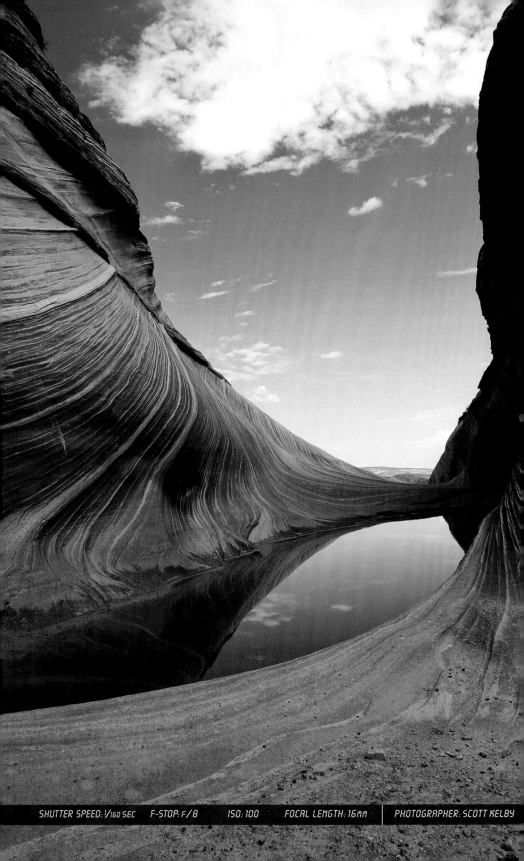

SHUTTER SPEED: 1/160 SEC F-STOP: F/8 ISO: 100 FOCAL LENGTH: 16mm PHOTOGRAPHER: SCOTT KELBY

Chapter Four

Shooting Landscapes Like a Pro

More Tips for Creating Stunning Scenic Images

In volume 1 of this book, I had a chapter on shooting landscapes, and it turned out to be one of the most popular chapters in the book. So, when I started on volume 2, I knew right then I would have to include another chapter with even more landscape techniques. And the only way to come up with new landscape techniques is to (you guessed it) shoot more landscapes, and what better place to shoot landscapes than at a landscape photography workshop? So, since I published the last edition of this book, I've taught at photography workshops in beautiful locations like Yosemite National Park, Cape Cod, Great Smoky Mountains National Park, and Glacier National Park, and then I just did some shooting in Maine this summer, and some other amazing places like Utah's Monument Valley, and the Grand Canyon, and a half-dozen other incredibly scenic spots. But when it's all said and done, do you know what all these places really meant to me? Tax deductions. That's right, because I went to these locations on business (the images will be used by me to teach photography), I get some really juicy write-offs for these trips. For example, you see that photo on the facing page? That's The Wave, which is just outside Page, Arizona, and not only is access to The Wave tightly restricted by the Bureau of Land Management, it was a grueling two-hour hike in scorching 112° desert heat over rocky mountains and hot desert sand, lugging all my camera gear, tripod (and bottles of water), and I have to be honest with you—there were times when I almost gave up, but you know what kept me going? It was the fact that if I didn't get there, and get a decent enough shot to make it into this book, I couldn't write my trip off as a tax deduction. See, I really do care.

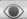

The Secret to Shooting Sunsets

SCOTT KELBY

Because you're shooting into the sun, it can really throw your camera's built-in light meter way off, and what looked so beautiful when you were standing there comes out…well…pretty lame. Luckily, there's a simple trick to getting perfect sunset shots every time. The trick is to aim just above the setting sun itself (but make sure you can't see the sun itself through your viewfinder), then hold your shutter button halfway down, which tells the camera to set the exposure for just what it sees in the viewfinder right now. This gives you a perfect sunset exposure, but don't let go of that shutter button quite yet (keep it held down), then you can move your camera and recompose the shot as you'd like it to look. By keeping that button held down, you've locked in that perfect exposure, and once everything looks good to you, just press the shutter button down the rest of the way and take the shot. You will have nailed the exposure and captured the scene perfectly.

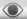

Cutting Reflections in Water

SCOTT KELBY

If you're shooting streams or lakes, or really anything with water, there's a filter you're going to want to use that does something very important—it removes the reflection of the sky from the water and lets you see through the water. That way, things like rocks below the shore or in a stream, fish in a koi pond, etc., all suddenly appear crystal clear, and that can make for some very compelling images. The thing that surprises most folks is that it's a filter that most photographers use to get bluer skies—a circular polarizer. As I mentioned in volume 1 of this book, a polarizer is indispensable for getting those blue skies, but it's just as important for this overlooked double-duty of cutting reflections. Here's how it works: screw the filter onto your lens, aim at the water in front of you, and then rotate the circular ring at the end of the filter, and as you do, you'll almost magically cut through the reflections and see right through the water, as seen on the right here. It's one of those things you really just have to try to appreciate it, but believe me—you'll love it.

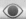

For Landscapes, You Need a Clear Subject

SCOTT KELBY

One of the things that kills a lot of landscape shots is that there's no clear subject, and for a landscape shot to really work, you have to be able to look at it and explain what you shot in one simple sentence. It's a lighthouse. It's that seagull on the rocks. It's that old barn. It's the palm trees on the beach. If you can't explain your landscape shot in a short sentence like that, you don't know what the subject is, and if you don't know, people viewing your image won't know either, and if that happens, the photo just isn't working. Keep this in mind when you're composing your landscape shots, and ask yourself the question, "What's my subject?" If you can't come up with a solid answer immediately, it's time to recompose your shot and find a clear subject. It makes all the difference in the world.

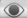

Using Your LCD Monitor Outdoors

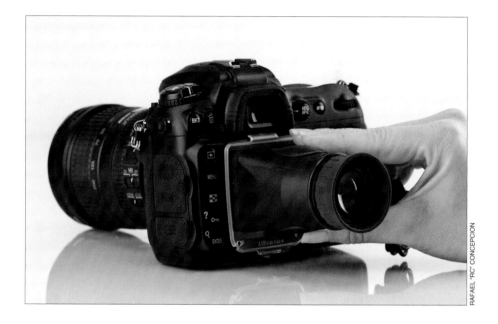

RAFAEL "RC" CONCEPCION

If it's bright outside, you're going to quickly run into one of the biggest challenges of shooting outdoors, and that is you can't see anything on your LCD monitor—the sunlight washes everything out. In fact, it's often so hard to see anything that you might as well turn off your monitor and save your battery, but then your LCD monitor becomes about useless. That's why I've fallen in love with the Hoodman HoodLoupe Professional. You wear this around your neck (when you're shooting outdoors), then you simply hold it up over your LCD monitor and its soft rubber enclosure blocks out the sun and gives you a crystal clear view of your monitor. I carry this with me to all my outdoor shoots, and after you use it even once, you won't want to be without it. (*Note:* Even though it's called a "loupe," it doesn't really magnify your image like a traditional loupe—it just blocks the sun out, but really, that's all we need.) It sells for around $79 at B&H Photo.

How to Shoot a Panorama That Works

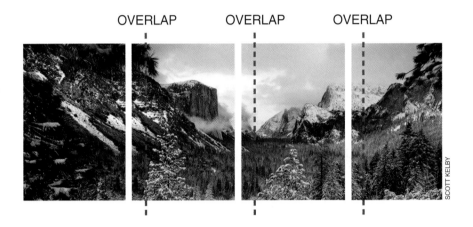

OVERLAP OVERLAP OVERLAP

SCOTT KELBY

In volume 1 of this book, I told you some things you needed to do to shoot a wide panoramic image that would actually stitch together seamlessly inside Photoshop. But, that's all changed, because Photoshop's built-in panorama stitching feature (called Photomerge) has reached a point where it's so good that you can toss out half the old rules and loops we used to have to jump through to make a panorama. Now you can handhold your shots (no problem), use program mode or aperture priority (or whatever mode you like), you can leave your white balance set to Auto (or whatever you like), and you can pretty much just point-and-shoot, as long as you do just one thing: overlap each shot by around 20%. So, for example, if you're shooting a wide panorama, you'd start from left to right, taking one shot—let's say there's a tree on the far right side of your frame when you take that shot—then, when you move your camera over to take the next shot, that same tree should now be in the far left of your frame (so you're overlapping by at least 20%, as shown above). That's the key—overlapping—so I take a shot, move to the right, take another, and another (I've shot as few as three photos to make a pano and as many as 22), and Photoshop will put them together into one nice, wide pano for me (simply because I overlapped by around 20%).

How to Have Photoshop Put It Together

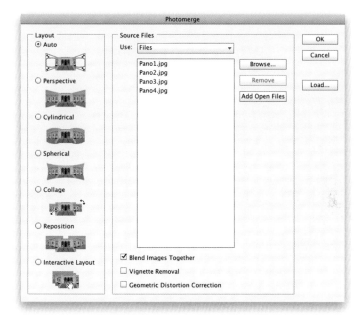

As long as you overlapped each frame of your panorama by 20% or more, Photoshop will not only stitch the photo together seamlessly, it will blend the color of the photos so they're consistent through the whole pano. Once you've taken your overlapping shots, open those images in Photoshop. Then go under the File menu, under Automate, and choose Photomerge. When the dialog above appears, click on the Add Open Files button, leave the Layout (on the left side of the dialog) set to Auto, then click OK. That's it. Sit back and relax because Photoshop will do the rest, and before you know it, you'll see a stunning, wide, perfectly stitched panoramic image.

Shoot Fast When Shooting Landscape Panos

©ISTOCKPHOTO/MARK EVANS

If there are any clouds in your scene when you're shooting your pano, then you'll want to shoot fairly quickly (with only a second or two between shots), because the clouds may be moving, and if you let them move too much (by taking too long between shots), they won't line up exactly, and then you'll have to spend a bunch of time retouching and cloning them to make it look right. Basically, if you're shooting a seven-photo pano, it should take you only around 10 to 12 seconds to shoot it. It should go like this: shoot, move to the right, shoot, move to the right, shoot, etc. As soon as your camera gets in place for the next frame—shoot. It sounds hard on paper, but it's simple to do in person, and because it takes so little time, you'll wind up shooting more panos, which is a good thing.

A Timesaving Pano Trick

SCOTT KELBY

When you come back in from your shoot, if your shoot included some panos, you're going to quickly find out one of the hidden challenges of shooting panos: finding them. For example, when you open your images in Adobe Photoshop Lightroom, or Adobe Bridge, or in iPhoto, etc., you're looking at thumbnails of perhaps hundreds of images from your shoot, and it's a bit of a challenge to figure out where your panos start and end. In fact, numerous times I've been looking through thumbnails from a shoot, and I look at a shot and think, "What I was thinking when I took this one?" Only to find out later it was one frame from a 10-frame pano. Worse yet, if I'm shooting on vacation, it might be a week or more before I get home to look at the images, and I completely forget that there's even a pano included in a particular shoot, because they just don't jump out at you. Luckily, there's a simple trick that makes finding your panos a two-second job: Before you shoot the first frame of your pano, hold your finger up in front of your lens and take a shot (as you see in the first frame above). Now start shooting your pano. Once you finish shooting the last shot of your pano, hold two fingers in front of the camera and take another shot (as seen in the last frame). Now, when you're looking at your photos in a photo browser and you see one finger in your shot, you know there's a pano starting there. So, select all the photos that appear between your one-finger shot and your two-finger shot—that's your pano. Open those in Photoshop and let it stitch them together for you.

The Trick for Using a Fisheye Lens

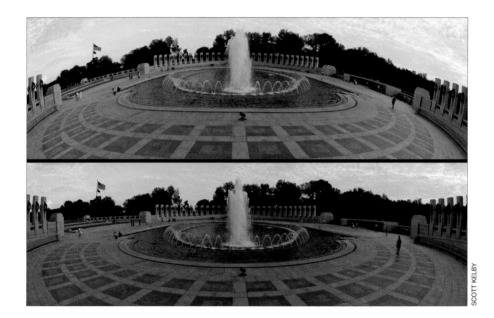

SCOTT KELBY

Fisheye lenses are making a big comeback, and they actually can be very cool for a variety of landscape shots—you just don't want your final image to look rounded and distorted, like many fisheye shots you see. You only want a very wide field of view. The trick to doing that is to simply keep the horizon line in the center of your image. This limits the amount of fisheye-like distortion and makes a huge difference in the final look. The best way to test this is to actually tip your camera downward, then back up towards the sky, all while looking through the viewfinder. You'll see the edges of your image distort as you move up and down (as seen in the top image), but you'll notice that as your horizon line gets centered in the image, the fisheye distortion is at its very minimum (like in the bottom image), and it just looks like a really, really wide-angle lens. Give it a try—you'll see what I mean (by the way, this is the only time you really want the horizon line in the center of your image, as you learned in volume 1).

When to Shoot Streams

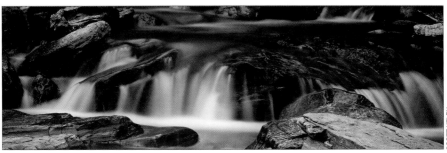

SCOTT KELBY

If it's a gray, cloudy, rainy day (I don't mean pouring rain—a light drizzle or soft rain), then head to a local stream, because you're about to make some magic. The overcast, cloudy, rainy sky does two things that make it ideal for shooting streams: (1) it makes the rocks, leaves, and everything sticking out of the stream nice and wet, which looks great in stream photographs, and (2) it makes the scene much darker (and the darker it is while still daylight, the better), which lets you use long shutter speeds, and it's those longer shutter speeds that give the stream that wonderful silky-water effect. Try shooting in aperture priority mode, and set your aperture (f-stop) to f/22 (or a higher number if your lens has it). With this darker sky, f/22 will leave your shutter open long enough to give you that silky-water look. The shot above was taken on a drizzly afternoon where there was literally nothing else to shoot, and shooting at f/22 in the forest, under that dark, cloudy sky, left my shutter open for 13 seconds (in aperture priority mode, you pick the f-stop and then your camera will leave the shutter open for however long it takes to get the right exposure—in this case, I stood there in the gentle rain for 13 seconds. How do you like the way that phrase "gentle rain" made the experience sound? Actually, I was cold and wet, but cold, annoying rain just doesn't paint a pretty picture—but the camera sure captured one).

Don't Stop Shooting at Sunset

SCOTT KELBY

More and more people have totally embraced the golden rule of landscape photogra-
phy, which is to only shoot when that wonderful, magical light is available, and that only
happens just before and during dawn, and just before and during sunset. However, a lot
of folks pack up their gear just a few minutes after the sun has gone down, and the sad
part is, they're about to miss what is often the most magical light of all. Around 20 to 30
minutes after sunset, sometimes the clouds turn bright orange, or deep red, or purple, or
if you're lucky, a combination of all three, and some of my all-time best shots have been
taken after everyone else has gone to dinner. Wait even longer (30 to 45 minutes or more
after sunset), and the sky will often turn a vibrant, deep blue (not black, like the night—
I'm talking blue—and it happens right before night). It only lasts for a few minutes (10 or
12 minutes usually), but what wonderful twilight photos you can get then. Try this blue
twilight-hour shooting when you have a cityscape, or bridge, or other lit object in the
background—it makes for a wonderful scene.

Remember, Your Camera Has Similar Settings

If I'm talking about white balance, and I'm showing the Canon white balance menu,
but you're not shooting with a Canon, simply breathe deeply and say to yourself,
"It's okay, my [insert your camera name here] also has a white balance setting and it
works pretty much like this one." Remember, it's about choosing the right white bal-
ance, not exactly which buttons to push on your camera.

How to Shoot Fog

SCOTT KELBY

I love the look of fog or mist in images. To me, it adds mystery and intrigue to the scene, but one unfortunate side effect is that it also is very hard for your camera's built-in light meter to read properly, so you get what you're seeing with your naked eye. Of course, like so many things, there's a trick of the trade that helps you get a good exposure that keeps that foggy look. Start by aiming at the fog itself, and then hold your shutter button halfway down (which tells your camera to take a reading of that area). Now, go to your camera's exposure compensation control and increase the amount of exposure by one stop (basically, what you're doing is disagreeing with what the camera read for the fog, and overriding it by increasing the exposure by one stop). On Nikon cameras, you do this by holding down the exposure compensation button on the top right of the camera (just behind the shutter button), and while you're holding that button down, turn the command dial on the top back of the camera to the right until you see +1 in your camera's viewfinder. On Canon cameras, you'll hold the same button (it's in the same place—behind the shutter button), and then you'll spin the quick control dial (the big one on the back of the camera) to the right until you see +1 in the camera's viewfinder. Just one reminder: when you're done shooting your fog shots, set your exposure compensation back to zero, or you'll be shooting the rest of the day with every shot overexposed by one stop.

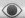

Getting Shots of Lightning (Manually)

©ISTOCKPHOTO/MORITZ VON HACHT

Shots of lightning can be very dramatic, because usually we only see lightning for a fraction of a second. If you can freeze that moment, it makes for a fascinating photo, but like many landscape shots, it requires a certain amount of timing (and luck). Now, before I share how to capture lightning with your camera, I want to make sure you don't capture lightning with your body. Don't stand in the rain, or under a tree, etc. Shoot from a very safe distance (because lightning will see you as a portable lightning rod) and exercise the same caution you would if you weren't a distracted photographer. Now, on to the technique. First, put your camera on a tripod (this is a must). Then, set your mode to bulb (the B setting on some cameras), which leaves the camera's shutter open for as long as you hold down the shutter button. Now, you can't actually press the button on your camera—for this to work properly you need to use either a shutter release cable (a cable that attaches to your camera with a shutter button you hold in your hand) or a wireless shutter release (you can find these for most camera makes and models at B&H Photo). The reason is: any minor vibration while your shutter is open, and the shot will be so blurry, it will be unusable. So, set up on a tripod, compose your shot (aim your camera in an area where you've been seeing lightning), use f/8 as a starting place, make sure your camera is set to bulb mode, then when you see a strike of lightning, press-and-hold the shutter release cable (or wireless) shutter button down and when you see a second strike, wait just a moment and then release the shutter button. It may take you a few tries at first, but you'll get it (hopefully the shot, not the lightning itself).

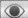

Getting Shots of Lightning (Automatically)

©ISTOCKPHOTO/ALLEN JOHNSON

If you try some lightning shots and fall in love with this type of photography, you might want to consider buying a Lightning Trigger (they're not cheap—so make sure you're truly "in love" first). This unit sits on your camera and it has a sensor that detects the bright flash of light from lightning, so it opens the shutter at exactly the right moment and gets the shot for you. In fact, you can pretty much set up your camera, set your camera to shutter priority mode (with your shutter speed anywhere from $1/8$ to $1/4$ of a second), aim in the right direction, sit back with a cool drink, and wait for the magic to happen, knowing that your camera is doing all the hard work for you. Later, when you're showing off your amazing work, there is no obligation (from the manufacturer's point of view) for you to tell the people viewing your work that you used a Lightning Trigger. Hey, it's just another tool in your bag of tricks. Go to www.lightningtrigger.com for a model that works with most cameras (it runs around $329 direct from the manufacturer. Hey, I told you it wasn't cheap).

A Trick for Shooting Great Rainbows

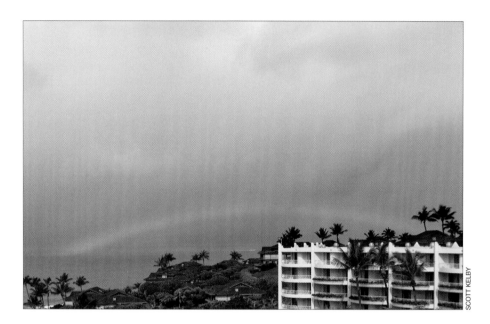

SCOTT KELBY

Want to really bring out the vibrance and color of your shots that have a rainbow in them? Then use a circular polarizer (now we've got three reasons to have a polarizer: [1] bluer skies, [2] cutting the reflections in water, and [3] making your rainbows "pop!"). Just turn the circular end of the filter while you're aimed at the rainbow and stop when the colors look their most vibrant. Easy enough to do, and the results are worth it. Now, beyond that, there's a wonderful tip I learned from my buddy, and renowned landscape photographer, Bill Fortney. Bill says, "If you see a rainbow, drive like the devil until you find something interesting for the rainbow to come down in." He doesn't mean drive until you come to the end of the rainbow, or all you'll get is a shot of that pot of gold. Just drive until you can find a gorge, or a water source, or something—anything interesting—for it to end with. Do those two things and you'll wind up with a remarkable shot.

Removing Distracting Junk

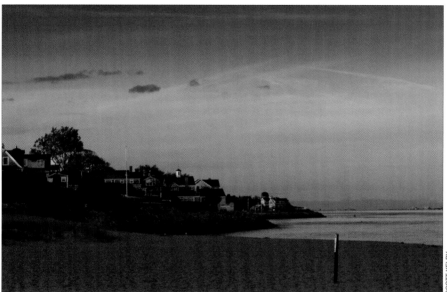

SCOTT KELBY

In some of my landscape photo workshops, we do a class critique of shots from the participants in the workshop (the person who took the image always remains anonymous during the critique, unless we all really love the shot, then they usually stand up and shout, "Hey, I took that!"). Anyway, one thing that always stands out as a spoiler of some otherwise great images is that the image has a distracting element (also known as "some distracting junk") in the photo. It can be a road sign, a sign on the beach (as you see above), an empty beer can, some telephone wires, or even a tree branch extending into the photo, and I've always felt if it doesn't add to the photo, it takes away from it. There are three different ways you can deal with this "junk" that creeps into your photos: (1) Compose around it. When you're shooting, be very aware of what's in your shot, especially in the background. Check all four sides of the frame (top, left side, right side, and bottom) for anything that you'll wish later wasn't there, and if you see something, change your composition to eliminate it. (2) Physically remove the distracting element (as long as you're not a photojournalist). If there's a beer can, a twig, some trash, etc., pick it up and move it out of the frame (be careful not to damage anything in nature—period!). Or, (3) remove it later in Adobe Photoshop using either the Healing Brush tool, Patch tool, or the Clone Stamp tool. I've done a quick video clip for readers of this book to show you how to use these three tools, and you can watch it at www.kelbytraining .com/books/digphotogv2.

Where to Focus for Landscape Shots

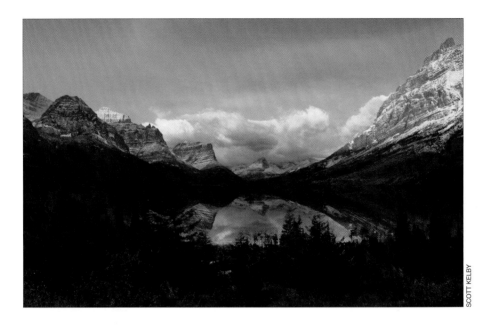

SCOTT KELBY

When you're taking a landscape shot, where do you focus your camera's focal point (that red dot in the center of your viewfinder. Well, its default spot is in the center, but you can move that spot, so if you moved yours, get it back to the middle for this)? With landscape shots, the rule is: you want to focus about one-third of the way into the image. This gives you the widest possible range of focus throughout the image. Also, another trick you can use is to shoot big, sweeping landscape shots at f/22, which gives you the most focus from front to back in your shot.

Getting the Clearest Landscapes Possible

Have you ever seen a landscape photo that just has incredible clarity throughout the image? I'm not talking about sharpness—I'm talking clarity (like a total lack of haze, or fog, or any other atmospheric effect). Well, there's a technique for getting that amazing clarity, and it's simple: shoot in winter. The air is the clearest during winter time, and it's the perfect time of year to get those amazingly clear shots that you just can't get any other time of year.

Find the Great Light First

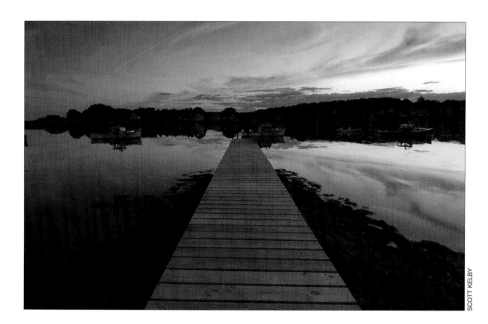

SCOTT KELBY

A few years ago, my friend, and landscape photography hero, Bill Fortney said something that really had an impact on my photography and I'm going to pass it on to you. Bill feels that the single most important thing in a shot of any kind is the quality of light, and that the quality of light is so important that he'll search for great light first, and then once he finds that great light, he'll find a subject—something or somebody to shoot in that wonderful light. Essentially, if the light is great, you'll find a subject, but if you've found a great subject, you have to be very, very lucky for great light to just magically appear. In short: "It's all about the light." Once you get that, everything else falls into place. It's deeper than it sounds.

How to Shoot on a Gray, Overcast Day

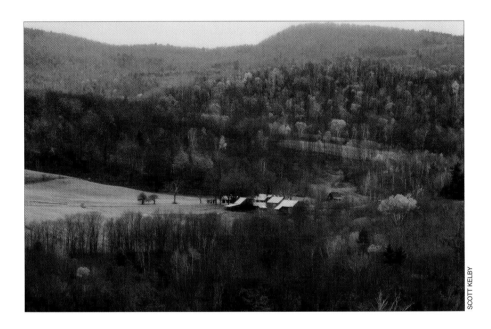

SCOTT KELBY

This one might sound kind of obvious when I say it, but I can't tell you how many times I've been out shooting with a group and one or more people in the group has come up and said, "Well, the sky is totally messing up our shoot today." While a gray sky definitely stinks, there is something you can employ for shooting on gray-sky days, and that is simply to compose so little (or none) of that gray sky winds up in your shots. If you go into the shoot knowing that you're going to do your best to avoid seeing the sky in any of your shots, you can then get all of the benefits that a gray sky usually brings, which are colors that are actually fairly saturated and softer shadows throughout your images. You probably won't be able to fully eliminate the sky from your photos, so just compose your shots so the amount of sky you do see is kept to a minimum. This simple technique has saved many a shoot.

A Trick for Great-Looking Flower Shots

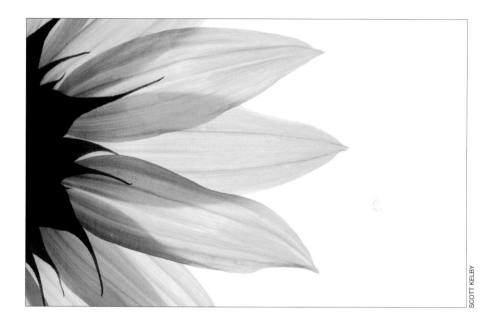

SCOTT KELBY

Want a great quick trick for some interesting-looking flower shots? Get down low, and shoot the flowers so they're backlit, with the sun behind them. The sunlight shining through the translucent petals creates a beautiful effect, and this is a popular trick employed by serious flower shooters that works every time. Don't forget to get down low (so low that you're either shooting straight on or up at the flowers) to get the most from this effect.

The Full-Frame Camera Advantage

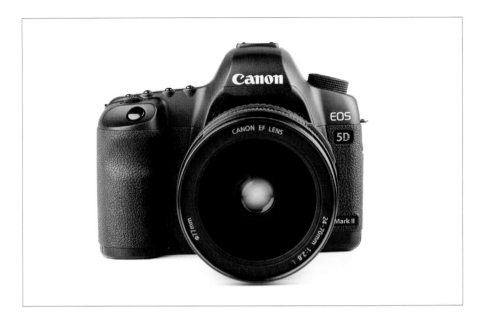

The vast majority of today's digital cameras have a built-in magnification factor because of the size of the sensors in the camera. For example, most Nikon cameras have a 1.4x magnification factor, and what that means is if you put a 100mm lens on a Nikon digital camera (like a D3000, D5000, D90, or D300s), that 100mm lens becomes a 140mm lens because of the sensor's magnification factor. Most Canon cameras have a 1.6x magnification (like the Rebel XS, Rebel XSi, Rebel T1i, Rebel T2i, 50D, and 7D), which makes a 200mm lens more like a 320mm lens. Many sports shooters, birders, and a host of other photographers who routinely use zoom and telephoto lenses love this added reach from digital sensors, but when it comes to the wide-angle lenses landscape photographers use, it can somewhat work against us. For example, a 12mm wide-angle Nikon lens becomes a less-wide 16mm lens. For Canon shooters, a 14mm wide-angle lens becomes a 22mm equivalent. That's why some landscape photographers are drooling over the new full-frame digital cameras, like Nikon's D3s or Canon's 5D Mark II (shown above), both of which are full-frame, and when you put a 12mm on the Nikon, it's that same, beautifully wide 12mm aspect ratio we used to enjoy back in the film days. When you put a 14mm on a Canon 5D Mark II, it's the same thing—a real 14mm with no extra magnification. I'm not saying you need to switch, or that you bought the wrong camera, I just want you to know what all the fuss is about for landscape photographers and other people who "go wide."

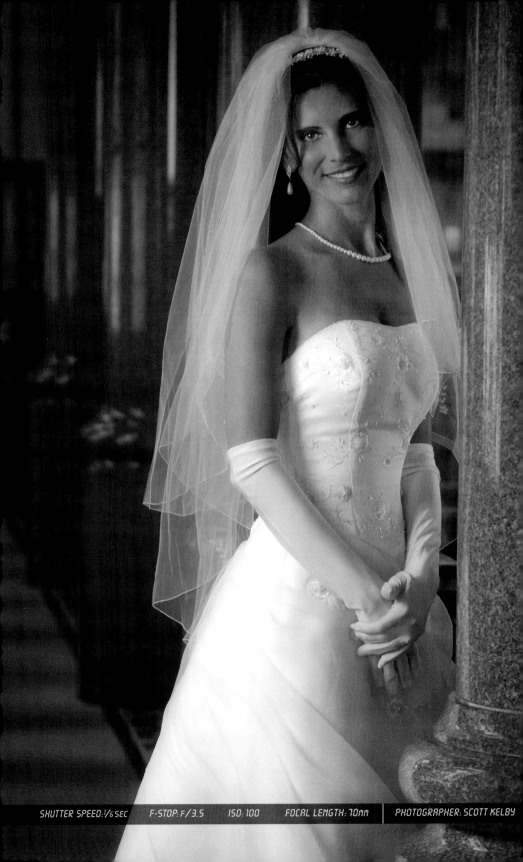

SHUTTER SPEED: 1/6 SEC F-STOP: F/3.5 ISO: 100 FOCAL LENGTH: 70mm PHOTOGRAPHER: SCOTT KELBY

Chapter Five

Shooting Weddings Like a Pro

How to Get Professional Results from Your Next Shoot

Shooting a wedding is tricky business, and if you have friends (and they know you have a nice camera), it's only a matter of time before you're standing in a church yelling things like, "Okay, next I need the groom's grandmother and grandfather." Once you've said that line aloud in a church, you are officially ordained as a temporary wedding photographer. Now, just because you took the gig for free, as a favor to that guy you know over in accounting, don't think for a minute that the bride is expecting anything less than absolute pro-quality images. Worse yet, the nicer gear you have, the better they expect those images to be, and if, up until this day, you've been a sports shooter or a landscape photographer, all that goes out the window, because today you are a wedding photographer, which is arguably the single hardest photography job in the known world. The reason is simple: there is no reshoot. This particular wedding, the one you are responsible for shooting, only happens once. There is no, "Oh, my camera broke" or "I didn't bring enough memory cards" or "I forgot my charger for my flash," because if the bride hears anything even approaching one of those excuses, she will take her bare hands and squeeze your neck until either your lifeless body falls to the floor like a wet bag of cement, or a pack of AAA alkaline batteries pops out of you like a Pez dispenser. That's because regardless of whether you're getting paid or not, she has waited, dreamed about, meticulously planned, agonized over, and micro-managed this special day to death, and if you miss any one of those critical moments (the ring, kissing the bride, walking down the aisle as man and wife for the first time, cutting the cake, the first dance, etc.), then it's time for you to die. That's why this chapter is all about one thing: increasing your life expectancy.

127

Create a Shot List

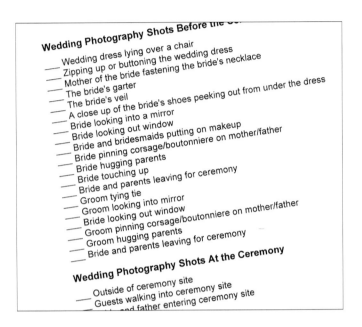

Before you even leave your office to head to the wedding, you should put together a shot list of photos you'll need to take for the wedding album, prints, etc. There are no redos at weddings, so you'd better be sure you leave with a list in hand of which shots you need, from bride and groom formals, to detail shots (the invitations, the rings, the bouquet, the bride's shoes, etc.), to reception shots like cutting the cake, receiving lines, place cards, and more. Without a written shot list, you're winging it, and it's almost an absolute lock that you'll miss one or more critical shots that your clients (the bride and groom) are going to expect to be in their album, so don't take a chance—this little bit of preparation can make a world of difference. Luckily, you can find wedding photography shot lists online for free at places like http://weddings.about.com/od/photographer/a/Photogchecklist.htm or this article and shot list from Amazon.com at www.amazon.com/b?ie=UTF8&node=13876911 (actually, there are literally hundreds of different shot lists available for downloading—just Google "wedding shot list" and you'll have a wide range of choices). Find a shot list that makes sense to you, and although you can get creative and do far beyond what it suggests, at least you'll have the most critical shots covered. Also, make sure you talk to the bride and groom before you finalize your shot list to ensure the specific shots they want are included (they may want shots with old friends from high school or college, or a special relative, and the only way to find out about these is to talk with the bride and groom in advance).

Have Backups for Everything!

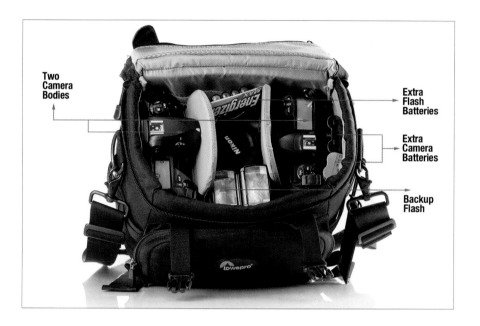

Two Camera Bodies

Extra Flash Batteries

Extra Camera Batteries

Backup Flash

If anything can go wrong at the wedding you're shooting, it will. That's why the pros always take backups for everything, because there are no retakes, no redos, no "do overs." Go through each piece of your gear and ask yourself what you would do if it wound up missing or broke. I can tell you this, at the very minimum you need to have two camera bodies—one main and one backup (a friend of mine was shooting a wedding, his camera slipped out of his hands, and the shoot was over. He was lucky enough to have a friend race him a replacement camera, but if his friend wasn't available, or was shooting a wedding himself that day, or was at the movies, etc., he probably would have wound up in court). You also need backup batteries for your flash, and even a backup flash unit. You need extra memory cards and a backup lens (I recently saw a photographer pick up his camera bag, which he thought was zipped, and we all cringed at the sound of breaking glass). Also, don't forget to bring backup batteries for both of your cameras. It comes down to this: you don't want to put yourself in a situation where one piece of equipment fails, one piece gets dropped, or your battery dies, and your job is in jeopardy (not to mention the loss of future wedding gigs from the fallout of having a large public event like a wedding day shoot go belly up).

Silencing Your Camera's Beep

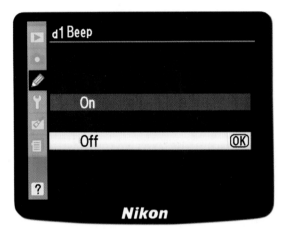

The last thing the wedding couple (or the clergy, or the guests) wants to hear during the ceremony is the distracting sound of your camera beeping as it locks focus. Before the wedding begins, go to your camera's menu and disable the audible beep sound. From that point on, use the focus symbol that appears in your camera's viewfinder to let you know when the auto-focus has locked on. Once the ceremony is over, you can always switch back.

Backlighting Your Bride

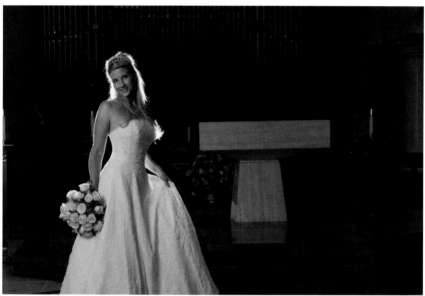

SCOTT KELBY

A popular effect with wedding photographers is to backlight the bride—where a bright light rims the outline of the bride—and then add in just a little bit of flash to light the front of the bride, so she's not a silhouette (as shown above). This takes two flash units: one in front of the bride (in this case, I used an off-camera flash on a light stand, positioned to the left of the camera at a 45° angle), and a second flash on a light stand directly behind the bride (so the bride's dress covers the light stand and flash). The flash of light from the front flash triggers the second flash behind the bride. The key is to make sure the flash behind the bride is much brighter than the flash in front of the bride (in the shot above, I lowered the power of the front flash as low as I could, but kept it bright enough so it would still trigger the flash behind her. It took a couple of test flashes to find out just how low that front flash could go). Another nice look (which is very dramatic) is to go ahead and let her just be lit with a flash behind her, then turn the flash in front off, so she actually is mostly a silhouette. If you do this, you'll have to set your flash so it doesn't fire the full flash, but only a very low light pulse—just enough to trigger the wireless flash behind her, but so it doesn't throw any measurable light on the bride (Nikon's DSLRs with pop-up flash have this feature built in).

Don't Changes Lenses, Change Cameras

DAVE CROSS

Once a wedding starts, things happen very quickly and you're not going to have a lot of chances (read as: none) to change lenses. So, if you're shooting with your zoom lens, and you suddenly need to switch to a wide angle, take a tip from professional sports shooters and don't switch lenses—switch camera bodies instead. That's right—keep two camera bodies around your neck (or one around your neck, one in your hand), and put a wide-angle lens on one body, and a zoom lens on the other. That way, switching lenses takes two seconds, not two minutes, and because of that, now you "get the shot."

Another Two-Camera Strategy

Besides the zoom and wide-angle double-camera technique above, here's another one to consider: have one camera with a flash mounted on your hot shoe for when you need flash, and have your second camera with a really fast lens, like a 50mm f/1.8 or f/1.4 (see page 137) for when you can't use flash (or don't want to use it), so you can capture those intimate moments without being obtrusive.

Bring a Stepladder for a Higher Vantage Point

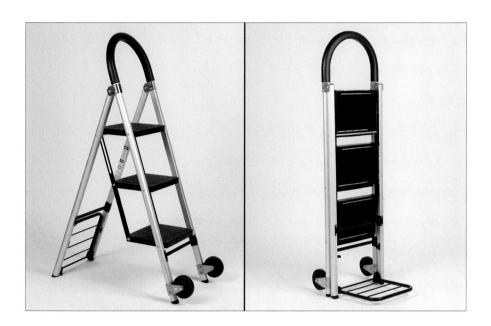

At weddings, you're going to be posing and shooting large groups (for your formals), and one trick the pros use is to carry a small, lightweight, collapsible aluminum ladder, like the Conair Travel Smart LadderKart, which doubles as a hand truck to help you move your gear (when you're not standing on it). It holds up to 300 lbs., and sells for around $70, but I've found similar ladders online for as low as $60. Being able to shoot the formal group portraits from a higher angle is a big help, because it enables you to see more faces and arrange your groups more easily. Also, it's great for shots during the reception, where a higher angle gives you a better view of the bride and groom on the crowded dance floor. Actually, you can put it to use anytime you want a different perspective, plus you can even use it as a posing stool in a pinch. You'll find this to be an indispensable tool (even if you only wind up using it for lugging your gear).

Why You Want a Second Shooter

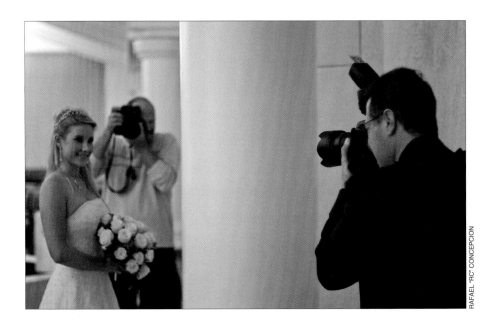

RAFAEL "RC" CONCEPCION

Many pro wedding photographers bring a second shooter to their jobs (sometimes even a third shooter) as an insurance policy to make sure they cover all the most important shots, and the bigger the wedding, the more you need a second shooter. After all, you can't be everywhere, and if any little thing goes wrong (equipmentwise or otherwise), there's someone else to either keep shooting, or to deal with the problem so you can keep shooting. This second shooter also usually acts as an assistant, and in the fast pace of a wedding, this second shooter can be an absolute lifesaver, but beyond that—the second shooter may (will) have a different style than you and can bring a different dimension (they can shoot zoom while you're shooting wide), a different camera angle, they can shoot from a different location in the church and reception hall, plus there's a good chance that if you missed "the shot" your second shooter will have gotten it (or vice versa).

When to Shoot in RAW

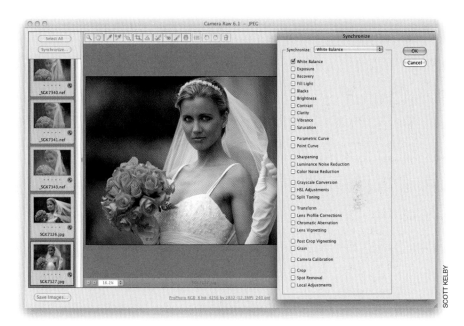

SCOTT KELBY

Although many wedding photographers choose to shoot exclusively in JPEG mode, when you get in a tricky lighting situation, your Get Out of Jail Free card is to switch to RAW mode. Here's why: when you shoot in JPEG mode, the white balance you set in the camera is embedded into the file. If you set it wrong (which can happen in tricky lighting situations), you've got a color correction nightmare. However, when you shoot in RAW mode, you have the option of changing the white balance to any one of the same white balance settings you could have chosen in the camera itself. Best of all, once you've fixed the white balance for one photo, you can apply that change to all the other images at once. If you use Adobe Photoshop, here's how: (1) Select all the RAW photos you want to adjust and open them in Photoshop's Camera Raw (it will open all your selected photos at once). (2) Choose the White Balance setting from the pop-up menu. (3) Click the Select All button at the top left. (4) Click the Synchronize button, and when the dialog appears, choose White Balance from the pop-up menu at the top, then click OK. Now the white balance you chose for the current RAW photo will be applied to all your other open RAW photos. If you use Adobe Lightroom, select the photos you want to adjust, then go to the Develop module and choose your new white balance. Click the Copy button on the bottom left. When the dialog appears, click the Check None button, turn on just the checkbox for White Balance, then click Copy. Now click the Paste button to paste that white balance setting to all your other selected photos. Also, if you want the best of both worlds, set your camera to Raw + JPEG, which captures a RAW image and a JPEG version at the same time.

Where to Aim Your Flash

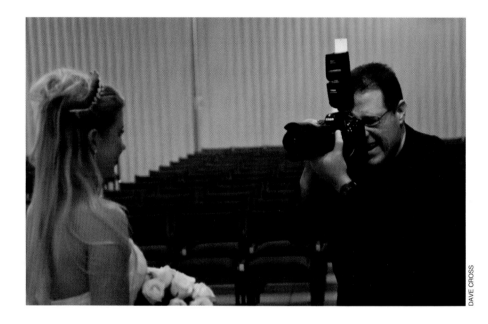

DAVE CROSS

Another one of the tricks the pros use to get just that little extra bit of light into their wedding photos (even ones taken in daylight) is to aim their flash head straight upward (as shown here). This works best if you're not standing too far from your subjects, and even if there's no ceiling to bounce the light from the flash off of, it still sends that little bit of light forward to light the face. This helps in adding catch lights in the eyes, but it does it without creating that "too much flash" look. To help make sure those catch lights appear, pull up your flash's bounce card to help direct more of that straight-up light forward (you can see the white bounce card pulled up in the photo above). So, if you've got a nice white ceiling to let the light from your flash bounce off of—great (but keep that bounce card extended either way). If not, still keep that flash aimed straight up most of the time, especially if there's already some existing room light, as the light from your flash will be subtle enough to nicely blend in.

Shoot in Lower Light Without Raising Your ISO

Since you'll be shooting on a regular basis in the low lighting of a church, there's a tool many of the top pros use that lets them get away with shooting perfectly exposed, sharp, handheld shots without using flash, or without pumping their ISO up to 1200. They buy an inexpensive 50mm f/1.8 lens (right around $100), or better yet, a 50mm f/1.4 lens (like the one shown above, which goes for around $285). These super-fast lenses let you shoot handheld in really low light, and you won't find a wedding pro that has one who doesn't swear by it. They're lightweight, surprisingly crisp (considering their low cost), and another tool in your bag of tricks to make sure you get the most important shots.

A Recipe for Balanced Flash in Church

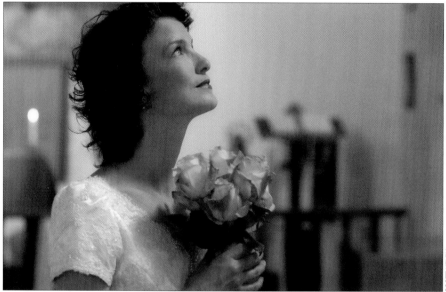

SCOTT KELBY

When you're shooting the formals in the church (before or after the ceremony), here is a recipe you can use to get a natural-looking light balance between your flash and the available light in the church: set your ISO to 800, set your shutter speed to 1/60 of a second, and set your f-stop to f/5.6, or a lower number if possible (like f/4, f/3.5, or even f/2.8). By using a relatively low shutter speed like 1/60 of a second, it's a slow enough speed that your camera can properly expose the background (you see it lit with the available light in the room), and then your flash comes in to freeze the action. Once you've got those two settings in place, now all you have to do is take a test shot with your flash, and if it overpowers the room light (the background looks black), then lower the brightness (power) of your flash unit, so although your subject will be mostly lit with flash, you'll still see some of the natural light in the church. This gives a nice balance between the natural light (which should be around 30% to 35% of the light in the photo) and your flash (which should be 60% to 65% of the light).

Compose to Include the Church

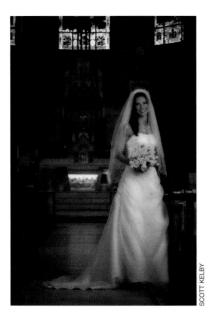

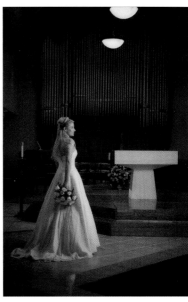

This is one of many tricks I learned from my friend, and wedding photography guru, David Ziser (a master wedding photographer and brilliant teacher): compose a decent number of the formal bride and groom portraits to include a lot of the interior of the church (as shown above). It's important to brides to see the church where the ceremony took place, and by composing it into the formals, it really gives the shots a sense of place (after all, if you compose them so tight that you don't see the church, you might as well have taken them the day before in the studio).

Don't Forget Your Business Cards

There is no better place to book new business than at the wedding you're shooting, and if you seem calm, in control, and confident, you may get inquiries right there on the spot (before your prospective client has even seen a single image). They assume if you got this gig, you must be good, so make sure you have some extra business cards on you. Writing your number on a napkin doesn't instill confidence.

Add B&W to the Album

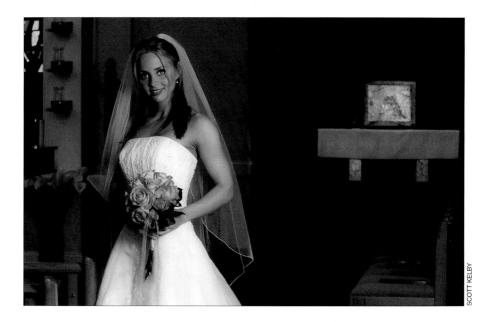

SCOTT KELBY

Another popular element in today's wedding albums is to include a number of black-and-white images. You'll still shoot these in color, and then you'll use Adobe Photoshop to convert some of your images into black and white. This enhances the "photojournalistic" look of the wedding album, it adds contrast to the album, and many wedding photos look just wonderful in black and white. If you have Photoshop, there is a Black & White conversion tool that does a pretty decent job of converting your color image into black and white (and it comes with some built-in presets—you just have to choose one you like). If you have Photoshop Elements, it can do the job, as well. I've created a short video clip to show you how to convert from color to black and white in Photoshop and Elements—you can find it on this book's download site at www.kelbytraining.com/books/digphotogv2.

Charge Everything the Day Before the Wedding

The day before the wedding, make sure you charge everything—including your cameras (both bodies). Make sure you have fresh batteries in all your flash units. If you're taking your laptop, make sure its batteries are charged. And just make certain that if a piece of your equipment has a battery, it's a fresh battery, or a freshly charged battery. Also, it's not a bad idea to fill your car up with gas now, too.

The Advantage of a Flash Bracket

DAVE CROSS

Another popular tool with wedding photographers is a flash bracket. These brackets get the flash off the camera and up high enough away from the lens that they nearly elimi-nate the red-eye problem caused by flash. But there's another huge advantage that be-comes clear the moment you go to shoot a shot in vertical (portrait) orientation. If your flash is sitting on top of your camera (in the flash hot shoe), and you turn the camera sideways for a tall shot, your flash winds up lying on its side to the side of your camera, so now you have a new set of problems. Well, a flash bracket lets you flip the flash back upright, so although the camera is turned sideways, the flash is still straight above your lens. The flash bracket I use is the WPF-QR Bracket from Really Right Stuff (it's $170 direct from www.reallyrightstuff.com). It's extremely well-built, lightweight, and it lets you flip your flash upright with just one simple move. (*Note:* When using a flash bracket, I always use a dome diffuser to soften and spread the light, and still try to bounce the light off the ceiling or nearby wall whenever possible. At the very least, I aim the flash straight upward as mentioned in "Where to Aim the Flash" a couple pages back.)

Tip for Posing the Bride

SCOTT KELBY

Another tip I picked up from David Ziser is a posing tip for formal shots of the bride that lowers the shoulder that's farthest from your light source, which creates a flattering diagonal line between her shoulders. To do this, have the bride stand with her feet in a staggered V-shape (as shown above), and then have her shift her weight to her back foot, which creates a much more dynamic look for your pose.

Dealing with the "Unofficial" Wedding Shooters

When you're hired as the official wedding photographer, these days you're probably going to have to deal with a number of "unofficial" photographers (friends of the bride/groom with digital SLRs) who want to shoot over your shoulder while you're doing the formals. Well-known photographer and author Derrick Story shared a tip with me that might help give you some breathing room so you can get your job done. Derrick goes over to the unofficial shooters and asks that they let him get his job done first, then he'll hold the group in place for a few a moments so they can step in and get their shots. He finds that this usually does the trick, and they stay out of his hair while he's getting the formals taken care of.

Keeping Detail in the Bridal Gown

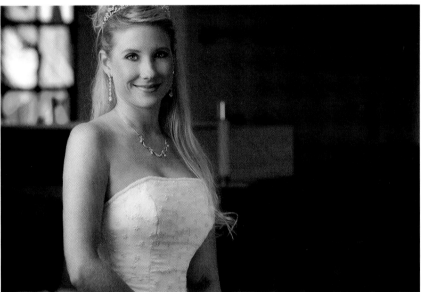

SCOTT KELBY

Since most bridal gowns are white, we have to be careful how we position the bride when shooting the formal bridal portraits, so we don't blow out the highlights on the gown and lose all the important detail of the dress (and that detail is *very* important to the bride). David Ziser taught me a great trick that works every time for keeping this critical detail, and it has to do with how you position the bride. You want the light from your flash (or from a window, if you're using window light) to cross the dress (so it accentuates the shadows and brings out detail), not hit it straight on and blow everything out. The easiest way to do this is simply to position your bride so her shoulder that is closest to the light source is angled toward the light source. That's it. This is important because if the shoulder closest to the light isn't in front, the flash hits the gown straight on and you lose the shadows and the detail. So, just make sure to angle the bride so her shoulder that's closest to the light is angled toward the light (as shown here, where you can see by looking at the bride, the flash is to the left of my camera, because she's much brighter on that side. The shoulder closest to the camera is aiming toward the light). Easy enough.

Getting More Flashes Per Wedding

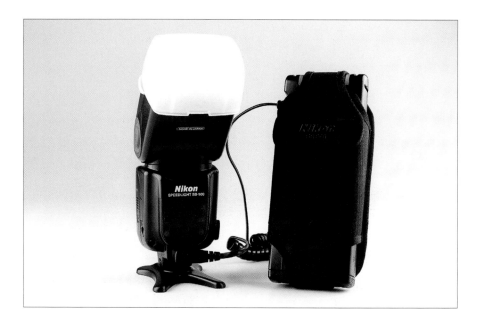

Your flash is going to get a workout at a wedding, and you're going to be stopping to pop in fresh batteries on a pretty regular basis. Batteries must sense fear, because they always seem to die during absolutely critical moments in the wedding, so you want to be changing batteries as little as possible. (Plus, as your batteries start to wear down, it starts to take longer and longer for your flash to recycle so it's ready to fire again.) That's why many pros use a small external battery pack to double how long they can shoot with flash before having to change batteries. Better yet, it greatly cuts the recycle time between flashes. These packs are a little larger than a deck of cards, and run on six or eight AA batteries (depending on the model). You just connect the pack's cable to your flash, pop the pack into your shirt or suit pocket, and fire away. If you don't have a battery pack and your battery's getting low, try shooting at a higher ISO—it cuts the flash output and extends your battery life considerably.

Scott's Gear Finder

Nikon SD-9 High Performance Battery Pack (around $195)

Canon Compact Battery Pack CP-E4 (around $150)

Quantum Slim & Compact Turbo Battery Packs (around $444 and up)

How to Lessen Noise in Your Photos

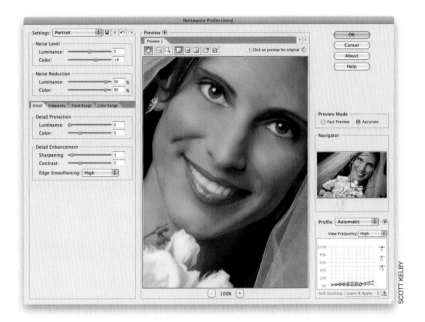

SCOTT KELBY

When you raise the ISO on your camera (so you can shoot in lower light), there is a tradeoff, and that is you increase the amount of noise (grain) in your shots. Depending on the make and model of your camera, this noise might be acceptable or it might be so visible that it kind of ruins the shot. If you have Photoshop CS5 or Lightroom 3, they both have excellent built-in noise reduction. However, I've found an inexpensive, easy-to-use Photoshop plug-in that does a brilliant job of removing high ISO noise from wedding photos, while maintaining as much of the important detail in the photo as possible. It's called Noiseware Professional (from www.imagenomic.com for $69.95), and it does a brilliant job of removing this type of noise (I just use the presets it comes with, rather than messing with the sliders and other controls. In fact, I've never used anything but the built-in presets). But beyond just removing noise, a happy side effect is that it usually also softens your bride's (and bridesmaids') skin. So, it removes noise and softens skin. What's not to like? (Two other popular noise plug-ins are Noise Ninja and Dfine 2.0.)

A Tip for Outdoor Weddings

If you go a day early to scope out the location where you'll be shooting an outdoor wedding, make sure you're there at the exact same time of day that you'll be actu-ally shooting the wedding. That way, you can see what the real lighting conditions will be when you're shooting the "real thing."

Tips for Shooting the Bride's Profile

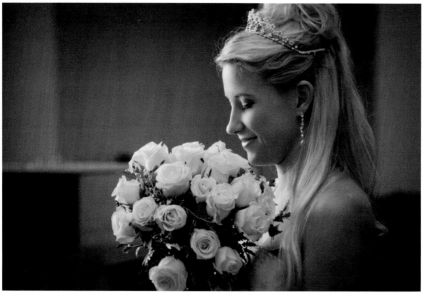

SCOTT KELBY

Here are a few more tips I picked up from David Ziser for making perfect profile portraits of your bride: (1) Shoot horizontal. As I mentioned in the portrait chapter, this puts some breathing room in front of your subject, so they don't look squeezed into the frame. (2) Position the bride so it's a full profile shot, where you don't see any of the eye on the other side of her head, or any of the other side of her face at all. (3) Don't position your flash (or softbox) directly in front of her face—position it slightly behind her so the light wraps around her face. (4) Don't have her look straight ahead, or you'll see too much of the whites of her eyes. Instead, have her look just a tiny bit back toward the camera (don't let her move her head—just her eyes). That way, you see more iris and less whites. (5) If the shadow side of her face (the side facing the camera) gets too dark, use a silver reflector to bounce some of that light into that dark side of her face.

Get to the Church Early and Scope Everything Out

The last thing you want during the wedding shoot is to frantically search for good light, good backgrounds to shoot in front of, or a power outlet to plug in your charger. Get there crazy early (or go a day before the wedding, if possible) and scope everything out in advance. That way, you're calm, prepared, and you have some great spots already picked out so the couple looks their best.

Wedding Zoom Effect Made Easy

SCOTT KELBY

Here's a popular effect for adding a sense of motion and energy to your reception shots (perfect for dance floor shots). It's a zoom effect that you create using your flash and zoom lens, and it's easier to get than it looks. First, set your camera to manual mode, and lower your shutter speed to around 1/8 of a second (or slower). Then, zoom in tight on the couple dancing, press the shutter button with your right hand, and then immediately zoom the lens out all the way to wide angle with your other hand. Because the shutter is open while you're moving the zoom lens, it creates that motion effect, and then your flash fires to freeze the motion. The key is to zoom out to wide just as soon as you press that shutter button. Try this just a few times and you'll "get it." (That's another benefit of digital photography—you can try the trick and look at the LCD on the back of your camera to see if you got the zoom effect or not. If you didn't, you can just try again.)

Throw Some Snacks in Your Camera Bag

While everybody else is eating, you're expected to be shooting, so make sure you throw a few small snacks (energy bars are ideal) and some bottled water in with your gear. Even if the bride and groom have offered to feed you while you're there, you probably won't get a chance (once a reception starts, there's no break—too much is happening), so keep some snacks and water handy.

Read David Ziser's *Digital ProTalk* Blog Daily

If you're serious about this stuff, do what I do: read David Ziser's *Digital ProTalk* blog every day. He is an absolute fountain of information for professional wedding photographers, and on his blog, he not only shares his tricks of the trade, and hard-earned techniques, he also shares some of his amazing photography (including some wonderful non-wedding imagery). Plus, David does a lot of live speaking gigs, and if you ever get to see him in person, he will just blow you away. David speaks for me each year at the Photoshop World Conference & Expo, and the first time I sat in on his class (which was an on-location wedding shoot at a local church, complete with professional bride and groom models), I was amazed. When I came back to the conference hall, one of my buddies asked me how his workshop was, and I described it this way: "He was teaching more than just lighting and posing. He was teaching them the business of today's wedding photography, in such a meaningful and straight-to-the-point way that it was like he was running around stuffing money in their pockets. It was that good!" I find his blog as inspirational as it is informative. Check it out at www.digitalprotalk.com. Also, David wrote what many consider to be the Bible on wedding photography—it's called *Captured by the Light* (shown above). I worked with David on this book and I think he did just a wonderful job sharing his techniques and photography.

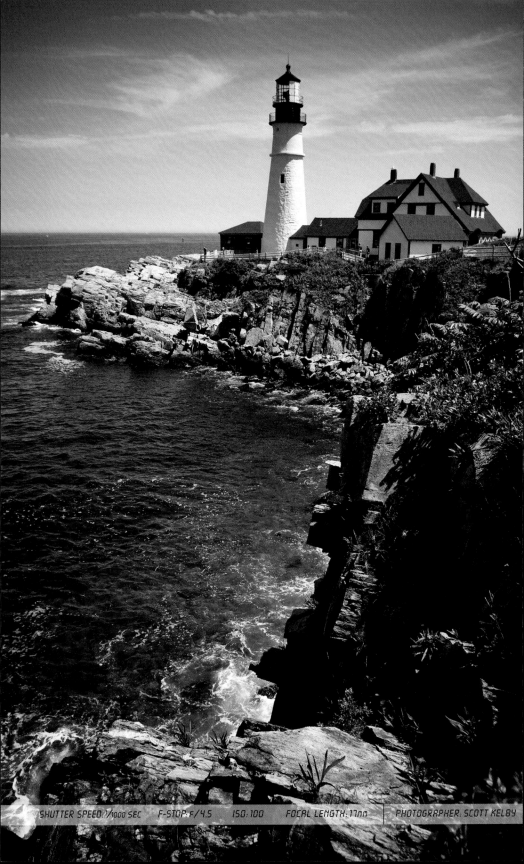

SHUTTER SPEED: 1/1000 SEC F-STOP: F/4.5 ISO: 100 FOCAL LENGTH: 17mm PHOTOGRAPHER: SCOTT KELBY

Chapter Six

Shooting Travel Like a Pro

How to Bring Back Photos That Really Make Them Wish They Were There

When you come home from a really amazing trip, it's not enough to chronicle your trip through photos and show factual images that detail where you were. You want to move people. You want to create images that are so powerful that they make the person viewing them want to go there so badly that they're willing to risk a series of white collar crimes (mostly embezzling) to pay for their trip to that very same place. Now, if you took good enough shots, it won't be long before your friends are overcome with emotion (jealousy) and will have to go to the exact same location to experience that same amazing feeling once again. Now, if either of your two friends have DSLR cameras, it's helpful to understand right up front that they're not going to that spot because they trust your judgment on travel. They're going there because they think they can get better photos from that spot than you did. Then, once they come back and show off their images, all your mutual friends will say something like, "Did you see Rick's photos from Machu Picchu? Wow, his were much better than Sandy's" and at that moment—you've been blinged. Actually, this is what is known as an IB, or an "Intentional Bling," and it gives you some insight into just how shallow your friends really are. But as shallow as they are, you can drain a little more water out of the pond by pulling this quick and easy stunt: when they see a really cool travel shot of yours, and they ask you where you took it (which means they don't already recognize the landmark)—lie. They'll never know. For example, if you shot the Portland Head lighthouse in Cape Elizabeth, Maine, tell 'em it's the Nauset lighthouse in North Eastham, Massachusetts. By the time they catch on, they'll already be back home, and you can feign a mysterious illness.

In This Case, Less Gear Is More

I'm a total gear freak, but the one time I definitely don't want to lug around a lot of gear is when I'm doing travel photography. You're going to be lugging your gear all day long, hopping on and off of all sorts of transportation, and as the day goes on, your gear seems to get heavier and bulkier, and by the end of the day, you've all but stopped digging around in your camera bag. To get around that, take as little with you as possible—one or two lenses, tops. For example, Nikon makes a reasonably priced 18–200mm lens with built-in VR (vibration reduction; as shown above) that lets you leave your camera bag back in the hotel because you've got everything covered from wide angle to long telephoto in just one lens. Canon makes an affordable 28–200mm lens that doesn't go quite as wide as the Nikon, but is amazingly small and lightweight. Also, there are some incredibly lightweight travel tripods available today, ranging from the Slik Sprint Pro for around $90 to what is probably the best travel tripod on the planet, the Gitzo GT1550T Traveler carbon-fiber tripod (for around $750). When it comes to lugging around lots of gear in an unfamiliar city, travel photography is definitely a case of "less is more." Do yourself a favor and travel light—you'll find yourself taking more shots, because you're changing lenses and messing with your equipment less.

Working People into Your Travel Shots

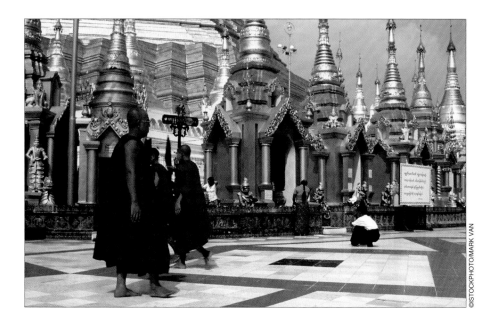

©ISTOCKPHOTO/MARK VAN

If you want to improve your travel photos, here's a simple trick: add more people to your shots. When you really want to capture the flavor of an area, don't just shoot build-ings, cathedrals, and monuments—show the people of that area. Nothing conveys the character and soul of a city more than its people, and that's why so many of the top travel photo pros work people into the majority of their shots. The next time you're feeling disappointed with your travel shots, it's probably because you're looking at cold buildings and empty streets. Add people and everything changes (for the better).

How to Know What to Shoot

Before you travel to a new city, do some research to see what other photogra-phers have shot there and where they shot it from. One great place to do this type of research is the websites of the big stock agencies (like Corbis or Getty Images), where you can do a search for the country or city you're going to. You'll see some amazing images, and you'll get lots of ideas for how the pros cover that area.

Getting People to Pose

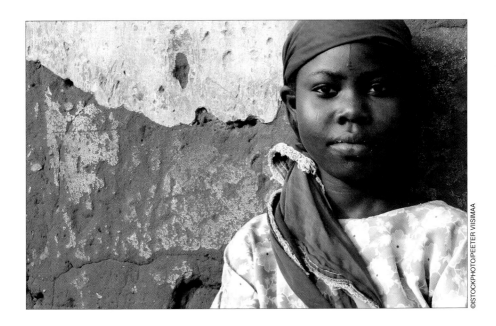

©ISTOCKPHOTO/PEETER VIISIMAA

Candid shots of some of the locals make a nice addition to your travel shots, but if you have too many of them, they start to look less like travel photos and more like surveillance photos. To get those close-up, fascinating personal shots, you'll need to get some of the locals to pose for you. One of the best tricks for getting people to stop what they're doing and pose for you is to get them to let you take the first shot. When they see that I have a camera, I smile at them, hold up the camera with my finger on the shutter, and nod my head as if to say, "Is it okay if I take your picture?" Most of the time, they smile and nod back, and pause just long enough to let me snap one photo. Then I immediately turn the camera around and show them the photo on the camera's LCD monitor. Once they see that photo on your LCD, it kind of breaks down a barrier, because everybody loves a photo (especially if they're the subject), and they're usually more than happy to pose for a few more.

A Surefire Way to Get Them to Pose (Buy Stuff)
If you're uncomfortable with the "lift-and-nod" technique I outlined above, here's one that can't miss—find somebody selling something and buy one. If you're in a market, and you buy something from a vendor, you can bet that they'll pose for a quick picture or two, because now you're not just some tourist with a camera, you're one of their customers. This one works like a charm.

What to Shoot on Overcast Days

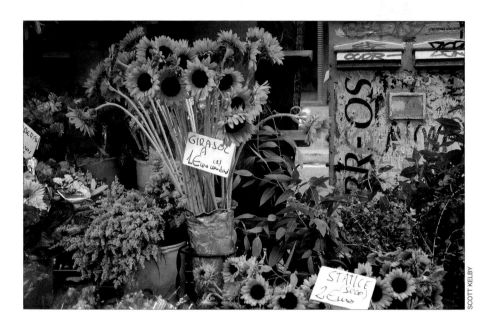

SCOTT KELBY

When the weather gets cloudy and overcast, don't pack up your gear—this is the time to shoot people on the street, open-air markets, stained glass windows (which look great under cloudy skies), and close-ups of architecture (as long as you do your best to avoid including any of that gray, cloudy sky). Cobblestone streets are great to shoot right after it has rained, and flowers photograph great under the shade that comes from a cloudy sky. Plus, if the sky gets really nasty, it may be a great time to shoot the sky itself. If it's just a flat gray, it's boring. But if a storm is on the way, the dark clouds can make an interesting subject, or add to a boring subject just with the shadows and mystery they bring.

What to Do If Your Room Doesn't Have a View

If you can't get a room with a view (see next page), try these: (1) See if there's a restaurant or lounge at the top of the hotel—you can bet it has plenty of great views, and they may let you shoot there at dusk, before they start serving dinner. (2) See if you can take a few shots from the rooftop. Strike up a rapport with the concierge (give him a big tip) and you'll be amazed at the doors that will open.

Shooting from Your Hotel Room

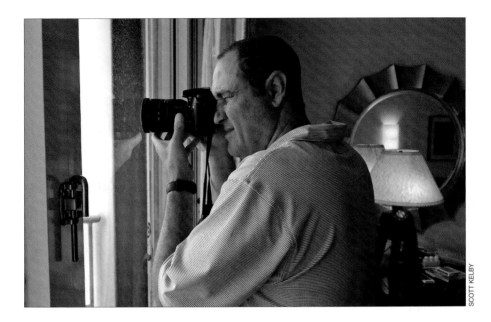

SCOTT KELBY

Everybody wants to have a "room with a view," and now you have even more motivation to ask for just that, because your hotel room can be a wonderful platform to shoot the city from. When you check in, ask for a room on the highest available floor and be prepared for some amazing opportunities to unfold right outside your window. If you don't have a balcony, or a window you can open, you can shoot right through the window if you follow these three rules: (1) Turn off any lights in your hotel room—they'll cause reflections in the glass that can show up in your photos—and (2) put your lens as close to the glass as possible (I keep a lens hood on my lenses, so I put the lens hood right on the glass itself. If you think you'll be doing this a lot, you can buy a rubber lens hood, which runs from around $5 on up). And, (3) you can often use a polarizing filter to cut the reflections in the glass, but since you lose some light, you might need to shoot on a tripod, which makes getting right against the glass that much trickier. (I'm not even going to count this last one as a rule, because I hope it goes without saying, but…don't use your flash.)

The Magic Time for Cityscapes

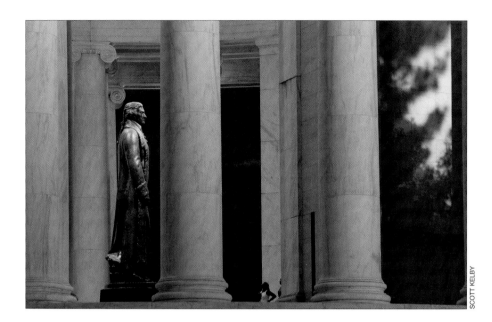

SCOTT KELBY

Great shots of cityscapes don't happen at 2:00 in the afternoon. If you want that killer shot of the city skyline, wait until about 30 minutes after sunset and shoot at twilight. The sky will usually be a rich, dark blue and the lights of the city will all be on, creating that magical photographic combination that creates the type of cityscapes you've always dreamed of taking. Now that you know what time to shoot, there's one more key to making this type of shot work, and that is you absolutely, positively must take this type of low-light shot with a tripod. Your shutter is going to have to stay open for a full second or more, and if you're not on a tripod, you're going to wind up with a blurry mess.

Taking the Cityscape Lights Shot Up a Notch

If the city you're shooting is near water, try to position yourself so that water comes between you and the city (for example, try shooting from a bridge). That way, you see reflections of the city lights in the water, which can add a tremendous amount of visual interest. This is another one of those "can't miss" travel shots, and what an impact it makes when friends, family, and even other photographers see your city-at-twilight-reflected-in-the-water shot.

Get These Shots Out of the Way First

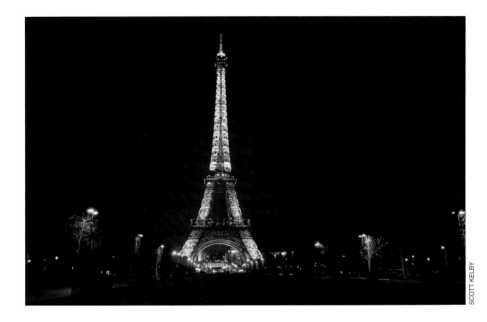

SCOTT KELBY

If you travel to a famous city, your friends and family back home will be expecting shots of that city's most famous landmarks. For example, if you go to Paris, you'd better come back with some Eiffel Tower shots (cliché as they may seem), because people expect it. If you don't come back with some Eiffel tower shots, they'll be so distracted by what you didn't shoot that they won't pay attention to what you did shoot. So, get those out of the way first—shoot those ones for the folks back home now and get them "in the bag." That way, you can spend the rest of your time showing the city your way—shooting the people, the local flavor, the customs, and taking shots that speak to the photographer in you. One more thing: When you get back home, and friends and relatives tell you some of your shots look like postcards (and they will), just smile and thank them. Although photographers sometimes tend to look down on travel postcards, your average person doesn't, so if they tell you your shots "look like postcards," they're actually paying you a huge compliment.

Shooting Famous Landmarks

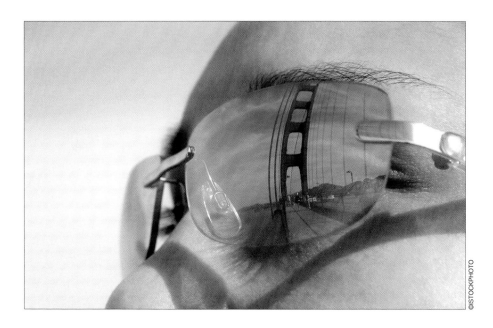

©ISTOCKPHOTO

If you're shooting a famous landmark, you can be sure it has already been shot a million times before, so it's incredibly hard to come back with a photo that hasn't been seen a million times (it's not impossible, just really hard). Here are a couple of ideas that might help you bring a fresh look to a landmark that has been shot to death: (1) Don't make the landmark the subject of your shot. For example, one of my favorite photos of Paris was taken by photographer Doug Merriam, and I love it because the subject is a French couple strolling along, holding hands, but the Eiffel Tower is clearly visible in the background. So, even though you can clearly see the landmark, it's not the subject, and that really made an impact with me. (2) Try showing the landmark as a reflection in water, or in a store window (picture the window of a Paris bistro with the Eiffel Tower reflecting in it), or the Arc de Triomphe reflecting in the chrome bumper of a French car, or better yet—in its side or rear view mirror. (3) Show only a small part of the landmark—just enough that it suggests the whole. The photo that I've taken of the Eiffel Tower that I like the best was taken 20 years ago (on Ektachrome 64 slide film), and it's of a nearby apartment building with one of the massive legs of the Eiffel Tower rising up behind it. You can't see anything but that one leg in the background, but you know it's the Eiffel Tower. It hung framed in my office for years.

Air Travel with Photo Gear

Earlier, I mentioned that you want to travel with as little gear as possible, and here's another reason—you absolutely, positively want to bring your gear on the plane as a carry-on. If your camera bag is too big and bulky, there's a good chance it won't fit in the overhead bin, especially if at some point in your trip you wind up in a smaller regional jet or turboprop with little, if any, overhead space. If you're thinking of buying a hard case and checking your gear, I'd reconsider. A photographer I know recently got *all* his checked gear stolen—lenses, camera bodies, flashes, the works! When he arrived at his destination and opened his case, it was completely empty. Keep your gear down to a minimum, take a small camera bag, and take it with you on the plane as a carry-on, and you'll avoid a lot of stress and complications, and possibly having to replace all of your gear. The camera bag shown above is the Airport International from Think Tank Photo. It's the best camera bag I've ever used.

Bring Extra Batteries

When you're in an unfamiliar city, the last thing you want to waste your time doing is searching for batteries (believe me, I learned this one the hard way), so make sure one thing you do bring with you is plenty of extra batteries for your flash unit and your camera (at the very least, recharge your camera battery every single night, because if your battery runs out, that's the end of the shoot).

Shoot the Food

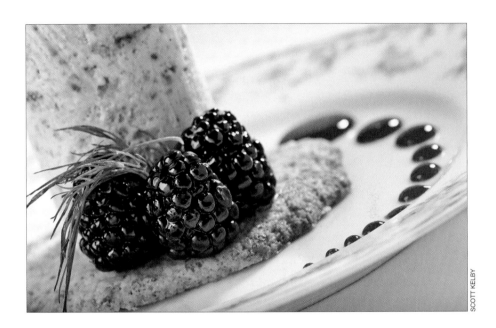

SCOTT KELBY

Take a look at any great travel magazine and in every feature about a charming city, you'll always find a photo of its food. Trying new dishes is one of the most fun things about traveling to a new destination, so why wouldn't you include it in your photographs? Watch the expressions of people who look at your album when they come across a photo of a great-looking dish—do that once, and you'll always "shoot the food." Your best opportunities will be during the day, especially if you ask to sit near a window (to catch some of that gorgeous natural window light) or outside (preferably under an umbrella or awning, so you can shoot in shade). If you've got a white tablecloth (which is likely), you've got a great background to shoot on—just remove distracting items from around the dish as much as possible. Also, the classic food shots you see in these magazines generally have two things in common: (1) They generally use a very shallow depth of field (where the front of the plate is in focus and the back is somewhat out of focus). To get this effect, use the lowest f-stop possible (f/4, f/2.8, or even lower if you can). And, (2) shoot plates that have great presentation (in other words, shoot food that's beautifully arranged on the plate, which usually comes from higher-end restaurants). Desserts often are presented nicely, as are appetizers and sushi, and keep an eye out for anything served in a unique-looking dish.

Get a GPS for Your Digital Camera

Today, you can buy small, incredibly lightweight GPS units that sit in your camera's hot shoe, and each time you take a photo, they embed the exact location (longitude and latitude) of where the shot was taken directly into the digital photo itself. Then, applications like Lightroom can display that information (it appears in Lightroom's Metadata panel), and you're then one click away from seeing that location plotted on a Google map, and better yet, you can even see a satellite photo of that exact location while you're there. I use Dawn Technology's tiny GPS unit called the di-GPS that works with most digital cameras. They start around $150.

Have Someone Else Shoot You

If you're the one behind the camera, nobody's getting any shots of you in these fascinating, exotic, wonderful places. That's why you need to make it a point to get a friend or acquaintance you meet in your travels (even if it winds up being the waiter who serves you at a restaurant) to get at least a few shots of you. Although it might not mean much to you that you're not in any of your photos, it does mean something to your family and friends that you are in the shots.

Shooting Where They Don't Allow Flash

If you plan on shooting in museums, cathedrals, and other places that generally don't allow you to set up a tripod or use your flash, then I recommend buying an inexpensive 50mm f/1.8 lens. This is an old trick pro wedding photographers use (see the wedding photography chapter), and these super-fast lenses let in so much light that you can handhold shots where others dare not tread. Both the Nikon and Canon 50mm f/1.8 lenses sell for around $100–120 each, they take up little room in your camera bag, and they add very little weight to your bag, as well. If you can spring for an even faster lens (like an f/1.4, shown above, or an f/1.2), they let in an amazing amount of light, so you can fire away in incredibly low light (like candlelight situations) without having to raise your camera's ISO to 800 or more (which can greatly increase the amount of noise in your images).

When They Won't Let You Set Up Your Tripod

If you're in a place where they just won't let you set up your tripod, but the light is so low that your camera is going to leave the shutter open for a few seconds, try using your camera bag as a tripod. Turn your camera bag on its side, position it on a ledge, a counter, or any tall surface, then rest your camera on top. Put some spare batteries under the lens to support it and use the self-timer to take the shot.

Look for High Vantage Points

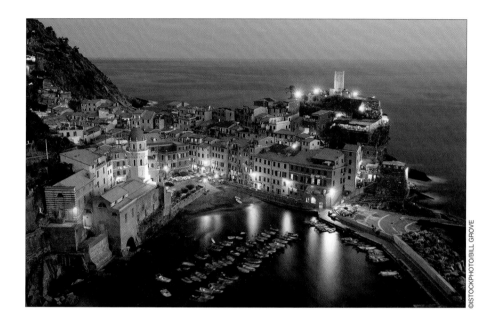

©ISTOCKPHOTO/BILL GROVE

Your average person's view of a city is going to be from the city streets (or from a tour bus on those streets), so if you want a more compelling place to shoot from, look for a different vantage point—one above the city. Look for towers, observation decks, tall hotels, church towers, cable cars, a bridge, an office building, or mountains overlooking the city, where you can show the city from a completely different view that your average photographer wouldn't get. It's just another thing that keeps your travel photos from looking average.

The Perfect Background Music for Travel Slide Shows

Want to find the perfect background music to put behind slides from your trip? Try this: buy the movie soundtrack from a movie that was filmed where you took your shots. For example, if your shots are from your trip to Italy, you can be sure you'll find instrumental background music that sounds very Italian in the movie *Under the Tuscan Sun*. If you shot in Paris, try the soundtrack from Disney's *Ratatouille*. If you shot in Russia, you can get some very dramatic Russian-sounding background music from the movie *The Sum of All Fears*. These all work so well because most movie scores are instrumental, which is ideal for your travel slide shows.

Give Yourself a Theme

BARCELONA

SCOTT KELBY

Once you've shot the classic local landmark photos, here is a great way to spark your creativity and show the city in a different light for a day: give yourself a mini-assignment. Pick a topic, spend part of the day focusing on that subject, and you'll be amazed at what you can come up with. For example, some of the mini–travel assignments I have given myself are: (1) shoot charming street numbers on the outsides of buildings, homes, and apartments; (2) shoot interesting doors and/or doorways; (3) shoot just things that are one vivid color; (4) shoot weather vanes; (5) shoot nothing but flowers; (6) shoot charming local barns; and (7) shoot close-ups of local architecture. Other ideas might be: shooting coffee cups; shooting those little food signs in local markets; shooting interesting columns, traffic signs or street signs, mailboxes, or things that are a particular shape (like only things that are round), or things of a particular color (only things that are red). You don't have to make one of these the only thing you do all day, just keep an eye out for it during your travels, and each time you see one of your assignment objects, make sure you get it. Then, you can present these all together in one print (an example is shown above).

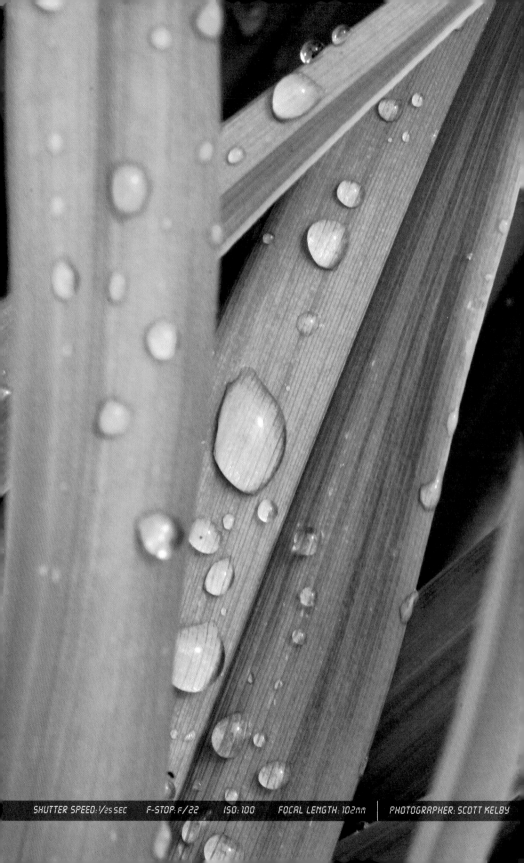

SHUTTER SPEED: 1/25 SEC F-STOP: F/22 ISO: 100 FOCAL LENGTH: 102mm PHOTOGRAPHER: SCOTT KELBY

Chapter Seven

Shooting Macro Like a Pro

How to Take Really Captivating Close-Up Photos

If you're one of those people who believes life is all about the little details, then have I got a style of shooting for you. It's called macro photography (macro is actually an acronym that stands for Man, Are Cows Really Obnoxious), and it's based on a special type of lens called a macro or close-up lens, which lets you focus on objects much closer than you'd normally be able to, and because of this close-up capability, you can often get close enough so that your subject completely fills your frame. Some of the most popular subjects for macro-loving photographers to shoot are flowers, leaves, ladybugs on leaves, bees on flowers, and other everyday things in nature that we're not used to seeing close up. That's one of the things that makes macro photography so captivating: you're often seeing images at a view or magnification we rarely, if ever, see with the naked eye. Now, because I was just able to work the word "naked" into the book, it's almost guaranteed that the book will be a bestseller. That's because, from now on, anytime someone goes to the Web and searches for the word "naked" (so basically, most of my friends), one of the results they get back will be this book. Now, thinking that my book will have lots of nudie nakedness, these people will often buy it sight unseen, because apparently people who search for the word "naked" are also very loose with money—they'll buy any product that they feel will get them closer to actually seeing nudie nakedness. However, once they receive the book, they will soon realize, as you have (with great disappointment), that there is no nudie nakedness in the book, but if it makes you feel any better, I'm totally naked under my underwear (see that? I got the word "underwear" in now, too). Cha-ching!

Maximize Your Depth of Field

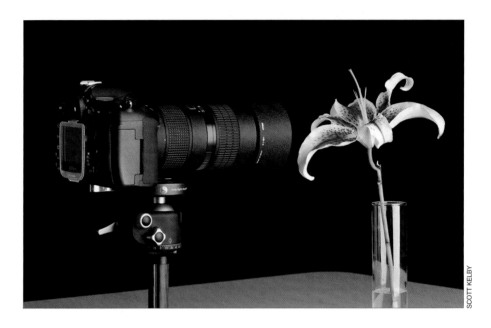

SCOTT KELBY

Macro lenses have a "sweet spot" where you get absolutely the most sharp results, and in macro photography, having tack-sharp images is critical. One trick to get the most sharpness out of your macro lens is to shoot with your lens aiming perfectly straight at the subject (in other words, don't angle your lens upward or downward toward your subject—try to shoot straight on for the best sharpness and clarity). So, for example, if you're shooting a bee on a flower, you'll need to lower your tripod to the point where you are aiming directly at the flower without having to tilt the lens, even a little bit (as shown above).

This Is Tripod Territory

Although there are now macro lenses that have built-in image stabilization (IS) or vibration reduction (VR), if you're serious about macro, you're going to be serious about how sharp your images are, which means you seriously need a tripod. This is absolutely tripod-land for sure, and a tripod may well be the single most important piece of your "making great macro shots" puzzle, so although you can cut a lot of corners in other areas, shooting on a tripod is one thing you absolutely, positively should do. They haven't yet come up with a built-in stabilization device that holds a camera as steady as even the cheapest tripod.

Why You Should Turn Auto-Focus Off

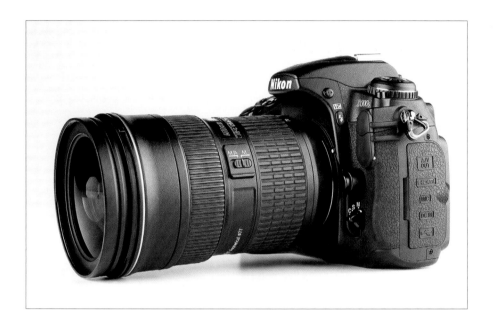

By now, you've learned that one of the big challenges of macro photography is getting things sharp and in focus. You're about to come to one of the things that can be the most frustrating, and this is using auto-focus when you're as close in on your subject as you are with macro shooting. If I can give you one tip that will lower your frustration level by a hundred, it's to turn off the auto-focus on your camera's lens and manually focus instead. I know, you hate to give up the auto-focus feature because, honestly, on today's cameras it's really amazingly accurate. That is, until you shoot macro. What will happen is your camera will try to find a focus point, and you'll hear the whirring of the lens as it tries to snap onto something, anything to focus on, and while it's getting frustrated—so are you. Just switch over to manual focus, and you'll both be better off.

Don't Touch That Shutter Button!

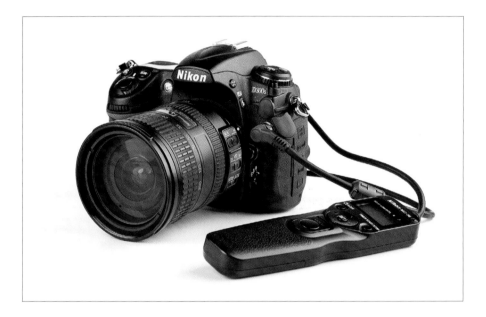

If you're going through the trouble of putting your camera on a tripod (and you abso-
lutely should), you can still get a "less-than-tack-sharp" photo from the vibration that
happens when you push the shutter button. That's why, when shooting macro, you
should either use a shutter release cable (a cord that attaches to your camera that lets
you take a shot without touching the shutter button on the camera itself) or use your
camera's self-timer, which takes the shot for you about 10 seconds after you press the
shutter button, so any vibration caused by your pressing the shutter button will be
long gone.

Focus on the Eyes

In portrait photography, we always focus on the eyes to get the sharpest image.
Same thing in wildlife photos. Same thing in macro shots of insects or butterflies,
or any little critters that wind up in your viewfinder.

Which f–Stop Works Best

Is there an f-stop that works best for macro shots? Well, yeah. It's f/22. Because the depth of field of macro lenses is so shallow (meaning, the front of that flower you're shooting can be perfectly in focus and the petal just one inch behind it can be totally out of focus), you need to get as broad a depth as possible, and that comes when your aperture setting is at something like f/22. You could get away with f/16, or maybe even f/11, but to get the maximum amount of your subject in focus, try f/22 (or higher if your lens will allow). The higher the number, the more of your photo will be in focus.

Point-and-Shoot Macro Photography

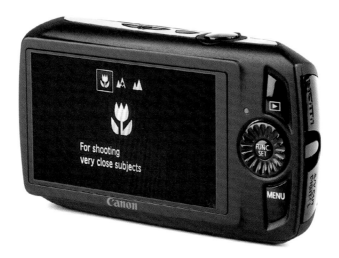

Most compact point-and-shoot cameras these days actually have a macro lens built right into them—you just have to know how to engage it (so to speak). You do that by switching your mode dial to macro (its icon is usually a little flower). This sets up your camera so you can get very close to your subject (like a flower, an insect, etc.) and still focus the camera (you can't get as close as you would with a dedicated macro lens on a DSLR, but you still can get surprisingly close for a compact digital camera). Once you've got this mode turned on, you can shoot using all the rest of the rules in this chapter, like shooting on a tripod, not shooting in even light wind, etc.

A Trick for Visualizing Macro

©ISTOCKPHOTO/CHRISTINE BALDERAS

When you're out shooting and you're looking at something and thinking, "I wonder if that would make a good macro shot?" you don't have to pull out all your gear and test it (especially because you probably won't). Instead, just carry a small magnifying glass (you can get thin plastic ones that fit in right in your wallet), then pull it out, go up to the object you're thinking about shooting, and you'll see right then and there whether it makes a good macro subject. Also, you can use this magnifier to try out different angles (think shooting flowers from way down low) before you go crawling around on your stomach with all your gear.

Simple Backgrounds Are Best

The same background rule we follow in portrait photography is also true in macro photography, and that is: keep the background simple. It may even be more important with macro than with portraits, because you're in so close your background will play a bigger role, so make sure your background is as simple as possible.

Why You Might Want to Shoot Indoors

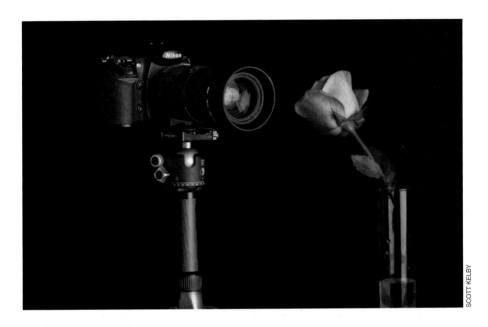

SCOTT KELBY

A lot of nature macro photography is actually done indoors, rather than outside (in most cases, you're going to be so close in, you don't have to worry much about anyone realizing that you're in a studio). One of the main advantages of shooting macro indoors is that there's no wind. This might not seem like a big deal at first, but when you set up your camera with a macro lens outdoors and look through the lens, you'll see firsthand that the tiniest bit of wind—wind that you don't really even notice is there—is moving your flower (leaf, twig, etc.) all over your frame, which means your photos are going to be soft and out of focus. It'll really throw you, because you'll back away from the lens, and you'll swear there's no wind, but then you'll look through the viewfinder and know right away—you're hosed. Another advantage of shooting indoors is that you can control the light (especially if you're shooting under studio strobes), and the key to lighting macro shots is to have nice even lighting across the entire image. You don't want drama and shadows—you want nice even light, and getting that in the studio is easier than it is outdoors by a long shot.

Buying a Macro Lens

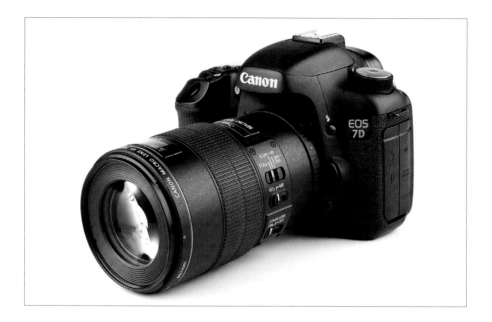

If this macro thing sounds really interesting, there are three ways you can dip your toe into the close-up shooting world: (1) Check to see if you already have a telephoto or zoom lens that has macro capability built right in. (2) Buy a macro lens—both Canon and Nikon make great macro lenses (that's a Canon lens above), and you can get a Sigma 105mm macro lens for around $479. And, (3) add a close-up lens attachment to one of your existing lenses. These screw on the end of your lens and turn any zoom lens into a macro lens (I have one of these, and it's small enough and lightweight enough that it goes with me everywhere I go). When it comes to macro lenses, the higher number the lens, the closer your subject will be in the frame (so a 65mm macro lens might get you the entire bee, but a 105mm will get so close you can get just the bee's head).

Create Your Own Water Drops

Use a tip from volume 1 of this book, and that is: don't wait for rain—bring a water bottle on your shoot and spray water on your flower petals (or leaves) to create the look of fresh raindrops, which look great in macro photography. Plus, if you get close enough, you'll be able to see reflections in the water drops themselves. Cool stuff.

Perfect, Even Light for Macro Shots

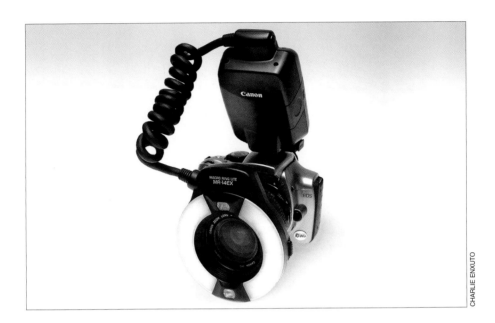

CHARLIE ENXUTO

When it comes to lighting close-up shots, your goal is to get as even lighting as possible, and there's actually a special flash, called a ring flash, that's designed to do exactly that. It's actually not one flash, it's a series of flashes attached to a ring that slides over your lens, and because these flashes light your subject from all sides, it creates that very even light you're looking for.

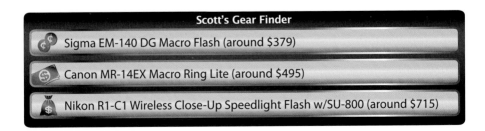

Scott's Gear Finder

Sigma EM-140 DG Macro Flash (around $379)

Canon MR-14EX Macro Ring Lite (around $495)

Nikon R1-C1 Wireless Close-Up Speedlight Flash w/SU-800 (around $715)

Making Your Lens into a Macro Lens

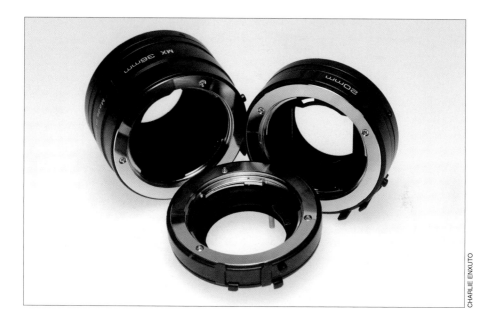

CHARLIE ENXUTO

The more space you put between your camera's sensor and your lens, the closer you'll be able to focus, and because of that, companies make extension tubes. These extension tubes attach between your lens and your camera (they look like a thin extra lens) to move the lens farther away from your camera's sensor, which cuts your minimum focus distance big time, so you can get in there and shoot nice and close (like you had a true macro lens). The advantage of these extension tubes is: they're much less expensive than a dedicated macro lens, starting around $83. (By the way, if you have a macro lens already, an extension tube can make your macro focus even closer. Sweet!)

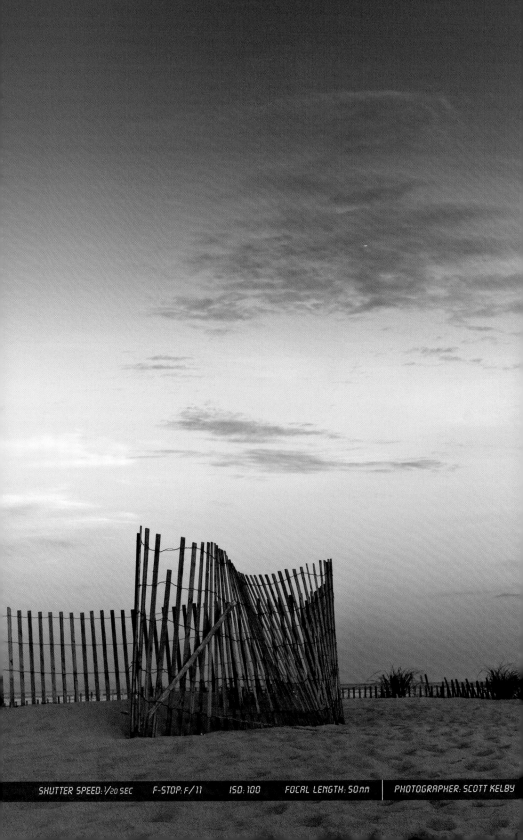

SHUTTER SPEED: 1/20 SEC F-STOP: F/11 ISO: 100 FOCAL LENGTH: 50mm PHOTOGRAPHER: SCOTT KELBY

Chapter Eight

Pro Tips for Getting Better Photos

Tricks of the Trade for Making All Your Shots Look Better

There are some tricks of the trade that just don't fit under any of the existing chapters, because they're not really just about getting better-looking portraits or more luscious-looking landscapes—they're about being a better photographer and getting better shots. And getting better shots is what it's all about, right? This is something we're all very passionate about, and if we get to the point where we're actually starting to sell our work (maybe as fine art prints, or through assignment work with a magazine), and are turning our passion into profits, then we're really living the dream—doing something we truly love for a living. Speaking of dreams, I haven't made a big deal about this on my daily blog (www.scottkelby.com) or in any of my live classes yet, because I don't want it to come off like bragging, but I recently signed a year-long contract with *National Geographic* that I'm pretty psyched about. In the terms of this agreement, I get 12 monthly issues for only $15, which is 74% off the newsstand price, so as you might imagine, I'm very excited. Anyway, in this chapter, we're going to focus on lots of those little tricks of the trade that you can apply to a wide range of photography to make everything you shoot look that much better. Now, one last thing: You might have heard I run with a dangerous crowd. We ain't too pretty, we ain't too proud. We might be laughing a bit too loud, but that never hurt no one. (I just wanted to see if you're still reading this after that whole *National Geographic* scam I pulled on you above. Come on, you have to admit, I had you going there for just a second or two, didn't I?)

179

Which Mode to Shoot In

Not sure which mode you should be shooting in? Here are some tips:

Aperture Priority (Av): I recommend this mode for both portrait photographers and landscape photographers, because it gives you control over your background. You get to choose whether you want your background out of focus (by choosing lower num-bered f-stops, like f/4 or f/2.8) or totally in focus (by choosing higher f-stop numbers, like f/11, f/16, and higher), and no matter your choice, your camera will automatically choose the right shutter speed to give you a good exposure.

Shutter Priority (S or Tv): I recommend this mode if you're shooting sports, where you generally need to freeze the action. This lets you choose to shoot with very high shutter speeds (provided you're shooting in bright enough light—like daylight), and then your camera will automatically choose the right f-stop for you to give you a good exposure.

Manual (M): If you're shooting with studio strobes, you need to shoot in manual mode, because in aperture priority or shutter priority, you won't get a proper exposure, as they won't take into account the fact that you're using strobes.

Program (P): Shoot in this mode when you want to be in point-and-shoot mode, but don't want the flash popping up. Perfect for when you need to quickly capture a moment and don't want to mess with any settings.

Choosing the Right ISO

Our goal is to shoot with our digital cameras set to the lowest possible ISO (ideally 100 ISO) for one simple reason—it offers the lowest amount of noise (grain) and gives us the sharpest, cleanest images possible. The only reason to raise your ISO is to be able to handhold your camera in low-light situations. So, for regular daylight or brightly lit situations, we shoot at 100 ISO. If you raise your camera's ISO setting to 200, it lets you handhold your camera in a little lower light and still get a sharp photo, but the trade- off is a tiny increase in visible noise. At 400 ISO, you can handhold in even lower light, but with more visible noise. At 800 ISO, you can handhold in the low light of a church, but with even more noise, and so on. It comes down to this: the higher the ISO, the lower light you can handhold your camera in, but the higher the ISO, the more noise you get, too. That's why we try to use tripods as much as possible. When our camera is on a tripod, it's perfectly still, so we can shoot at 100 ISO the whole time without worrying about getting blurry photos in low light.

Which Format to Shoot In (RAW, JPEG, or TIFF)

Most digital cameras these days (and all DSLRs) offer at least these three main file formats: RAW, JPEG, and TIFF. Here's when to use each:

JPEG: Shoot in JPEG if you're really good at nailing your exposure every time. If you're dead on (or really close) on your exposure and white balance, and don't think you'll need to tweak it much later (or at all) in Photoshop, then JPEG is for you. The file sizes are dramatically smaller, so you'll fit more on your memory card, and they'll take up less space on your computer.

RAW: Shoot in RAW mode if you don't nail the exposure and white balance most of the time, and think you might need to tweak your images later in Photoshop or Photoshop Lightroom. In RAW mode, you can control every aspect of the processing of your images, so if the image is underexposed, overexposed, or has a color problem—you can fix it easily. RAW offers the highest-quality original image, too, and offers maximum flexibility.

TIFF: Shoot in TIFF if you're loose with money. This is a great format for people who have money to burn, people who shoot to huge 16-GB memory cards and have plenty of 'em handy. TIFFs are also perfect for anyone who has lots of spare hard drive space and lots of spare time, because TIFF files are huge to deal with. Outside of that, I can't think of any real compelling (or remotely reasonable) reason to shoot in TIFF format.

Which JPEG Size to Shoot In

I recommend shooting at the largest size and highest quality setting that your camera will allow, so if you're shooting in JPEG format, make sure you choose JPEG Fine and a size of Large, so you get the best-quality JPEG image possible. If you choose a lower size, or JPEG Norm (normal), you're literally throwing away quality. The only trade-off is that JPEG Fine photos are a little larger in file size. Not staggeringly larger (those are TIFFs or RAW files)—they're a little larger, but the increase in quality is worth it. If you're serious about getting better-looking photos (and if you bought this book, you are), then set your image size to Large and your JPEG quality to Fine, and you'll be shooting the exact same format many of today's top pros swear by.

WHIMS Will Keep You Out of Trouble

Let's say you're going out shooting landscapes one morning. Do you know what your camera's settings are? They're whatever they were the last time you went shooting. So, if your last shoot was at night, chances are your ISO is set very high, and your white balance is set to whatever you used last. I've gotten burned by this so many times that I had to come up with an acronym to help me remember to check the critical settings on my camera, so I don't mess up an entire shoot (I spent a whole morning in Monument Valley, Utah, shooting at 1600 ISO because I had been shooting a local band the night before). The acronym is WHIMS, which stands for:

W: White balance check
H: Highlight warning turned on
I: ISO check (make sure you're using the right ISO for your surroundings)
M: Mode check (make sure you're in aperture priority, program, or manual mode)
S: Size (check to make sure your image size and quality are set correctly)

Before you take your first shot that day, take 30 seconds and check your WHIMS, and you won't wind up shooting important shots with your camera set to JPEG small (like I did when shooting one day in Taos, New Mexico).

How to Lock Focus

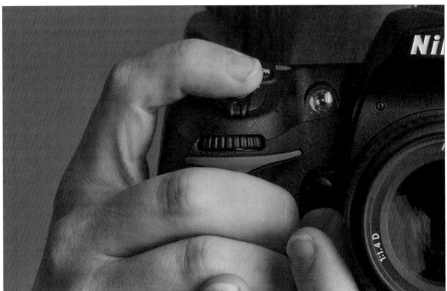

RAFAEL "RC" CONCEPCION

This is another one of those things that has snuck by a lot of people, and that is how to lock your focus. For example, let's say you're lying down, shooting a landscape through some tall grass, and you want the blades of grass in front of you to remain in focus, but when you lift the camera up to get the rest of the scene, the camera refocuses on the background. You can force the camera to keep its focus locked onto those blades of grass by simply holding the shutter button down halfway. While that shutter button is held down, your focus is locked, so now you can recompose the image without your camera trying to refocus on something else. I use this a lot on photos of people who may not be in the center of the frame (it keeps me from having to move the auto-focus dot— I just point at the person, hold the shutter button halfway down to lock the focus, then recompose the shot the way I want it. When it looks good, I just press the shutter button down the rest of the way to take the shot).

Moving Your Point of Focus

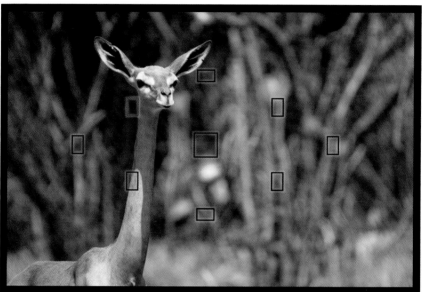

SCOTT KELBY

You know how you look through your viewfinder and, in the center of your viewfinder, there's a red circle or a red rectangle? That's your camera's auto-focus (AF) point, and what that point hits winds up being what's in focus. Well, something a lot of people don't realize is that most cameras let you move that focus point up or down, left or right. That way, if you've composed a shot where your subject is standing over to the right side of your frame, you can move the AF point over, right on them, so they wind up being perfectly in focus. On Canon cameras, you move your AF point by using the tiny multi-controller joystick or the dial on the back of the camera. On Nikon cameras, you move the AF point by using the multi-selector on the back of the camera.

 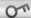

Zooming in Close? Use a High Shutter Speed

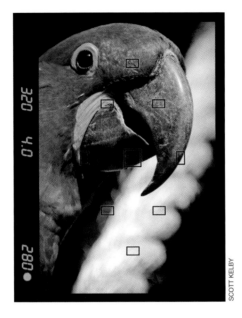

If you're using a long zoom lens, like a 200mm lens, there's something you should know to help you make sure you get sharp photos, and that is—the closer in you zoom, the more any tiny little movement of your lens is exaggerated. So, if you're handholding your camera, and you're shooting zoomed in to 200mm, any little movement on your part and you're going to have some blurry photos. Now, if it's a bright sunny day, you'll probably be shooting at some very fast shutter speeds, which will pretty much neutralize your movement, so you can sidestep that problem. However, if you're shooting in the shade, or really in anything where your shutter speed falls below 1/250 of a second, the best remedy is to put your camera on a tripod (even though it's during the day). That way, you can shoot out at 200mm all day long and not worry about some tiny movement on your part causing a serious loss of sharpness in your shots.

When It's Okay to Erase Your Memory Card

If you only have one memory card, it won't be long before you have to erase that memory card so you can get back to shooting. I have a pretty simple rule I use to know when it's actually okay to erase a memory card, and that is I erase it when I know I have two backup copies of the images that are on it. In other words, I have one set that I copied onto my computer, and then I copied that folder of images over to an external hard drive, so I have two copies. Then, and only then, I feel comfortable erasing that card and shooting again. Remember, when you have just one copy, you're working on the negatives. If your computer's hard drive crashes, those images are gone. Forever. That's why you gotta make a second backup copy, because I've seen people lose their work again and again, year after year, because they didn't make that second backup copy, but don't let that happen to you—back up twice, then erase that card!

Don't Just Delete Your Photos, Reformat the Card

You've probably heard horror stories of people who have done an entire shoot, only to have the memory card go bad and they lose all their shots (if you haven't heard this story—I've got dozens). Anyway, one thing you can do to avoid problems is to not just delete the images on the card (once you've backed up twice), but to format the card in the camera, which erases all the files in the process. Yes, it's that important.

Why You Need to Get in Really Close

SCOTT KELBY

This is probably the single simplest tip in the whole book, and the one that has the potential to make your photography the best, but it's also the one people will resist the most. The tip is: move in close to your subject. Really close. Way closer than you'd think. If you search the Internet, you'll find dozens of references and quotes about how much you can improve your photography by simply getting in closer to your subject. You'll find the famous quote (I'm not sure who it's attributed to) that says (I'm paraphrasing here), "Get your shot set up to where you think you're close enough—then take two steps closer." Or my favorite quote, which I think really sums it up nicely, from famous photographer Robert Capa, who once said, "If your pictures aren't good enough, you're not close enough." The pros know this, practice this, have embraced it, and have passed it on to their students for who knows how long, and yet your average photographer still tries to get "the big picture." Don't be an average photographer, who gets average shots. Take two steps closer, and you'll be two steps closer to better-looking photos.

What to Use Your Histogram For

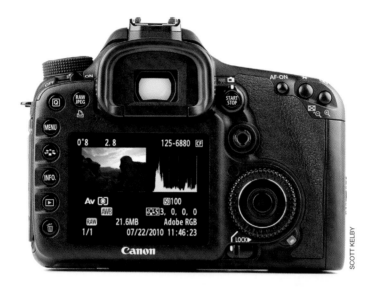

SCOTT KELBY

Today's DSLRs can display a histogram (which is a graphical reading of the tonal range of your photo) right there on the camera's LCD monitor, but if you don't know how to read one (or didn't know it's there), it doesn't do you much good. I only use my camera's histogram for one thing, and that's to make sure I haven't clipped off any important detail in my highlights. So, what am I looking for when I look at my histogram? Two things: (1) I don't want to see the histogram's graph touch the far right wall. If any of that graph hits the far right wall, I'm losing detail. So, what I'm really hoping to see is (2) a small gap between the end of the histogram and that far right wall (as shown above). If I see that gap, I know I'm okay, and that I'm not clipping any highlights. I can look at my histogram and immediately see if this has happened, and if I have clipped off important highlight information, I will generally use the exposure compensation control on my camera to override what my camera read, and lower the exposure by ¹/₃ of a stop, then I take the shot again and check my histogram. If I'm still clipping, I lower the exposure compensation to −0.7 and then shoot again, and check again. I keep doing that until my clipping problem goes away. Now, the histogram can only help so much, because what if there's a direct shot of the sun in my photo? That sun will clip big time, and there will be no gap, but that's okay, because the surface of the sun doesn't have any important detail (well, at least as far as I know). So the histogram can help, but it's not the bottom line—you still have to make the call if the area that's clipping is (here's the key phrase) *important detail*, so don't get hung up on histograms—at the end of the day, you have to make the call, and the histogram is just a helper, not your master.

Leave Your Lens Cap Off

My buddy Vinny calls your lens cap "The Never Ready Cap," because whenever that magical once-in-a-lifetime moment happens while you're out shooting, don't worry—it will be long gone by the time you stop and take your lens cap off. I definitely recommend putting your lens cap on when you're storing your gear back in your camera bag, but if your camera is out of that bag, your lens cap needs to be off your camera. If you're worried about scratching your lens, then buy a lens hood (or use the lens hood that came with your lens), but keep that cap off once that camera comes out of your bag.

Removing Spots and Specks After the Fact

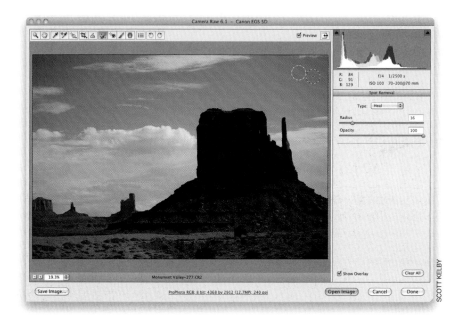

If you have a dust spot, smudge, or speck on either your lens or your camera's sensor, you're going to see that spot (or smudge or speck) again and again once you open your photos in Photoshop (or Lightroom, or Elements, etc.). If you want a quick way to get rid of that junk, try Photoshop's (or Elements') Spot Healing Brush tool. All you do is choose it from the Toolbox, then click it once over any spot or speck, and it's gone. That's all there is to it. Now, if you have Photoshop, you can fix a bunch of spots all at once (because, after all, if you have a spot on your lens, every shot from your shoot will have that same spot in that exact same location, right?). So, here's what you do: STEP ONE: Select all the photos that are in the same orientation (for example, select all your horizontal shots) and open them in Adobe Camera Raw. STEP TWO: Get Camera Raw's Spot Removal tool (from the toolbar up top) and click it once right over the spot. This removes that spot from your current photo. STEP THREE: Press the Select All button (on the top left) to select all your other photos, then click the Synchronize button. STEP FOUR: When the dialog appears, from the Synchronize pop-up menu up top, choose Spot Removal, and then click OK. This removes that spot from all your other selected photos automatically. Click Done to save your retouch. STEP FIVE: Open all the photos you took with a tall orientation and do the same thing. Now, all your spots are gone from all your photos in less than two minutes. If you shot 300 or 400 photos—that's sayin' something!

What Looks Good in Black & White

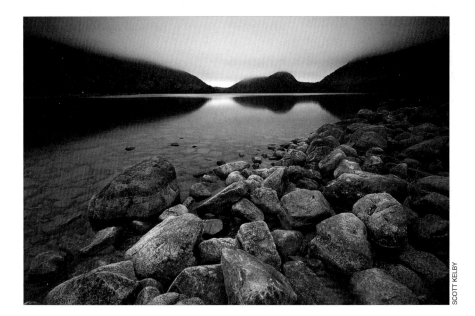

SCOTT KELBY

Some subjects just look great when you convert them from color to black and white, so when you're out shooting, keep an eye out for anything with lots of texture, like the peeling paint on the side of an old building, rusty old machinery, anything with an interesting shape or lots of contrast (because you don't have the crutch of color, you have to look for other things to lead the eye), objects with a lot of metal, old barns, old cars, old abandoned factories, and also consider cloudy days with dark menacing skies a perfect subject for black and white. In fact, any gray nasty day can wind up being a field day for black and white because you don't have to worry about avoiding the sky since it's not a nice, blue, sunny day. In black and white—it's all gray.

Recompose, Don't "Fix It" in Photoshop

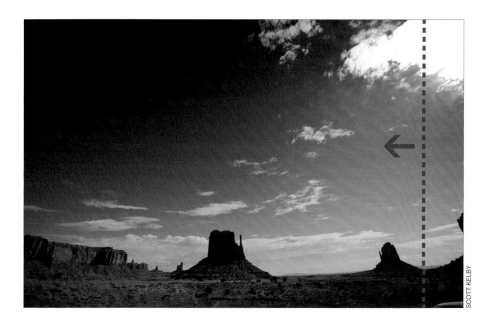

I love Photoshop. I think it totally rocks, and I've written around 35 books on Photoshop. That being said, it's much faster and easier to get it right in the camera, than it is to fix it later in Photoshop. If you see something distracting in your viewfinder, like a telephone line or a road sign, that's ruining your shot—you certainly could remove either one later in Photoshop. It probably wouldn't take you more than 10 minutes or so to remove that telephone line or road sign in Photoshop. But it probably wouldn't take you more than 10 seconds to move one foot in either direction to recompose your shot so you don't see the telephone wires (or the road sign) at all. Getting it right in the camera is just so much faster, and besides—you want to save your time in Photoshop for finishing your photos, not fixing them. Do yourself a favor, and compose so those distracting elements aren't in your frame, and you'll spend a lot more time shooting and having fun, and a lot less time on tedious cloning and repairing in Photoshop.

Want to Be Taken Seriously? Start Editing

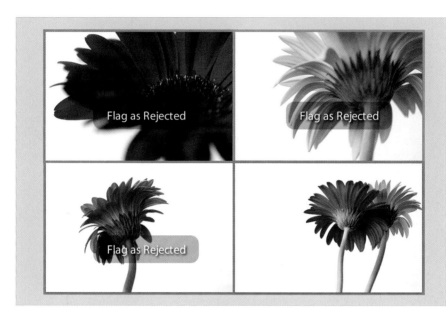

SCOTT KELBY

If you want to be taken seriously as a photographer and you want people to start to view you as a pro-quality photographer, then take a tip from the working pros, which is: only show your very best work. Period. One thing that makes a pro a pro is they're really good photo editors—they're really good at picking, and only showing, their very best stuff. You don't see their so-so shots or the shots that would have been great, if only…. You also don't see them showing seven or eight similar shots of the same subject. Only show your best of the best. That means if you went on a trip and you took 970 shots, you don't come home and show a slide show of 226 images. If you want people to think you're good, show your best 30. If you want people to think you're great, show just your best 10. Think about it: If you took 970 shots, maybe 400 are decent. Out of those decent shots, maybe 80 are pretty good. Out of those 80, maybe 30 are really good. Out of those 30, maybe 10 are outstanding. Now, just show those 10—and blow people away. (Just ask yourself what you would rather see—80 pretty good shots, or 10 outstanding shots.)

How to Be a Great Photo Editor of Your Own Work

Your shots have to stand on their own, without you telling a story about why you like the shot. If you have to explain to someone why you chose it or why you think it's special, it doesn't belong in your portfolio.

Label Your Memory Cards

This is another tip I picked up from Derrick Story, and he tells the true story of how he left a memory card in a taxi cab, but because he always puts a sticker on his cards with his name and address, he was able to get that card returned to him with all the photos still intact. That's right, he lost his memory card in a taxi and got it back. This obviously didn't happen in New York. (I'm totally kidding. You knew that—right?)

Go Square

SCOTT KELBY

Today's digital cameras all produce an image that is rectangular, so no matter whose photo you see, it's either a tall rectangle or a wide rectangle. Want to make your photo stand out from the pack and have more of a "fine art" look when you print it? Then "Go square!" That's right—just crop your photo to a perfect square (as seen above), and then position that perfect square with plenty of nice white space around it, for a nice fine art, gallery look, like the layout you see here. It's a simple little thing, but they're all little things, right?

Tip for Shooting at Night (Long Exposure Noise)

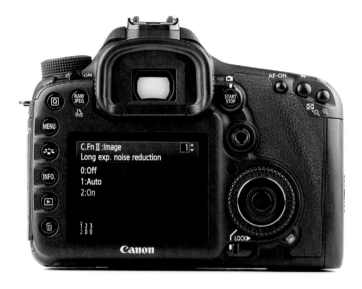

If you're shooting at night, your shutter is going to wind up staying open long enough for you to make a good exposure, and depending on how dark it is where you're shooting, it could open for 1/4 of a second, 4 seconds, or 40 seconds. If you start to have long exposures, like 40 seconds, chances are you're going to start to get some serious noise in your photo (even if you were shooting at ISO 100). One thing you can do to help is to turn on your camera's Long Exposure Noise Reduction feature (both Nikon and Canon DSLRs have this feature). This kicks in your camera's built-in noise reduction to combat the kind of noise that shows up in long exposures like these, and they actually do a surprisingly decent job, so they're worth turning on (just in these long exposure instances—this is *not* for everyday use).

The Very Next Book You Should Get

You've heard me mention legendary assignment photographer Joe McNally here in the book, and Joe has come out with a book that I truly believe is the most important photography book to come out in many years. It's called *The Moment It Clicks: Photography Secrets from One of the World's Top Shooters* (from New Riders), and what makes the book so unique is Joe's three-pronged "triangle of learning" where (1) Joe distills the concept down to one brief sentence (it usually starts with something along the lines of, "An editor at *National Geographic* once told me..." and then he shares one of those hard-earned tricks of the trade that you only get from spending a lifetime behind the lens). Then, (2) on the facing page is one of Joe's brilliant images that perfectly illustrates the technique (you'll recognize many of his photos from the covers of your favorite magazines), and (3) you get the inside story of how that shot was taken, including which equipment he used (lens, f-stop, lighting and accessories, etc.) and how to set up a shot like that of your own. There's just never been a book like it. The photography is so captivating, you could buy it just for the amazing images (think, coffee-table book), but his insights on equipment, technique, and the fascinating backstory behind the shot let the book totally stand on its own as a photographic education tool. This book combines those elements as it inspires, challenges, and informs, but perhaps most importantly, it will help you understand photography and the art of making great photos at a level you never thought possible. I worked as an editor on the book, and I have to tell you—it blew me away. It will blow you away, too!

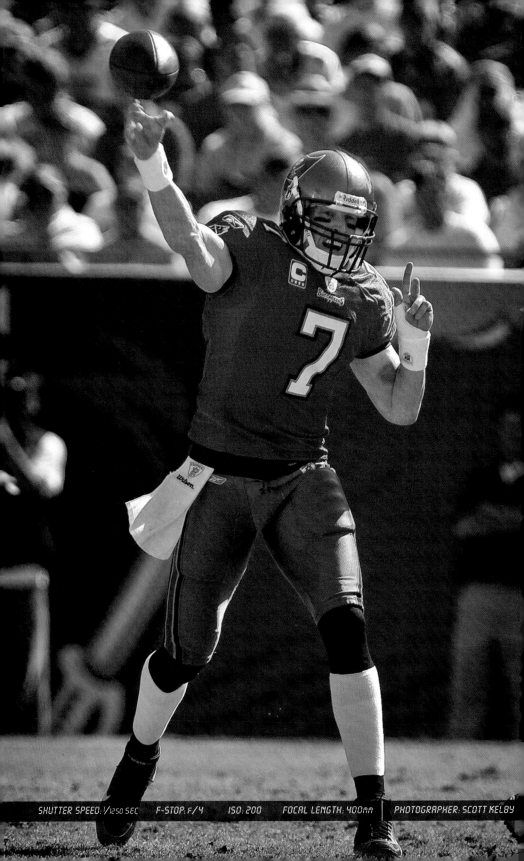

SHUTTER SPEED: 1/1250 SEC F-STOP: F/4 ISO: 200 FOCAL LENGTH: 400mm PHOTOGRAPHER: SCOTT KELBY

Chapter Nine

More Photo Recipes to Help You Get "The Shot"

The Simple Ingredients to Make It All Come Together

The chapter from volume 1 of this book that I probably got the most emails on was this last chapter—the photo recipe chapter. In this chapter, I show some of my shots, and then give the details for how to get a similar shot, including what kind of equipment you'd need, what time to shoot (if it's relevant), where to shoot it, where to set up your lights, tripod, etc., so it's kind of a photo recipe cookbook. Although there are a lot of shooters that do anything to get "the shot," you'll be happy to know—I'm not one of them. In fact, I've often toyed with the idea of starting a trade association for people like me and calling it "The International Society of Convenient Photographers" (or the ISCP, for short). Our credo would be, "Any shot worth getting, is worth driving to." Our ideal situation would be we drive up to a location, roll down the window, take the shot, and drive off. It doesn't get much more convenient than that. There would be special recognition for members who abide by our 50-ft. Cone of Convenience rule, which states: "If a once-in-a-lifetime photographic opportunity presents itself, the member may venture as far as 50 ft. from the member's vehicle, in any one direction, as long as they leave the car's engine running and the air conditioner turned on." But then I realized this was very limiting, because it would exclude most studio photographers. So, we added a special dispensation for them, in rule 153.45, Section B, which states: "A studio photographer should avoid changing their subject's pose, as doing such could force an inconvenient repositioning of the light, which breaks with the sacred tenets of our group." Sure, it's a small group, but we really get around.

The Recipe for Getting This Type of Shot

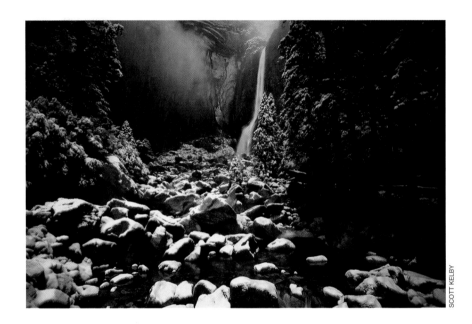

SCOTT KELBY

Characteristics of this type of shot: A sweeping shot with a silky waterfall effect, with lots of detail front-to-back and a real sense of depth. (*Note:* The location is Yosemite Falls.)

(1) To get this type of sweeping look, you need to use a very-wide-angle lens. This was shot with a 12mm wide-angle (it's not a fisheye lens—just a super-wide-angle).

(2) To get the detail from front to back, shoot in aperture priority (Av) mode and choose the highest number f-stop you can (this was shot at f/22, which keeps everything in focus from front to back).

(3) You absolutely need to shoot on a tripod for a shot like this because you're shooting at f/22, which means your shutter will be open long enough that even a tiny bit of movement will make the photo blurry.

(4) Another benefit of shooting at f/22 is that since your shutter stays open longer, the water in the waterfall looks silky (you might remember this trick from volume 1 of this book—how to get that smooth, silky water effect). You'll also want to use a cable release (or your camera's self-timer function), so you don't add any blur when pressing the shutter button (yes, it makes a difference).

(5) The final key to this shot is shooting it right around dawn. This does two things, the first being that since it's darker outside, your shutter will stay open longer and your water will look silkier. You couldn't get that silky water look at 1:00 in the afternoon. The second thing is even more important: the quality of the light and the nice soft shadows only happen like this around dawn (and around sunset), so get up early and get the shot!

The Recipe for Getting This Type of Shot

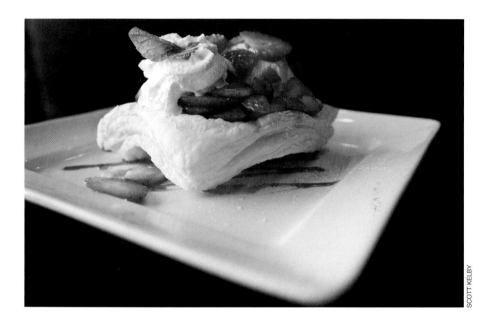

SCOTT KELBY

Characteristics of this type of shot: Very shallow depth of field (the front of the plate is out of focus, so is the back). The subject looks very sharp and the lighting is just great.

(1) Ask to sit near a window with natural light. This shot was taken in a restaurant, and before we were seated I asked the host to seat us near a window. There was a booth against a window, facing north, and as we passed it, I asked if we could have that booth. They were happy to oblige. Then, position the food so the light is hitting the food from the side (this helps to add depth and dimension to your shot).

(2) To capture food this close, you'll need a macro or close-up lens. I used a Canon Close-Up Lens screwed onto a Nikon 17–55mm f/2.8 lens (see Chapter 7 of this book or Chapter 2 of volume 1 for more on close-up lenses), but you can also use a regular macro lens or the macro setting on a zoom lens (if yours has one).

(3) Macro and close-up lenses already have a very shallow depth of field, but to get this look (with the plate out of focus in front and in back), shoot at the lowest number f-stop you can (like f/2.8 or f/4).

(4) When you're using a macro filter, you really need to use a tripod to keep your subject sharp like this, and in this case I used a very small Bogen tabletop tripod, barely big enough to hold my camera.

(5) To minimize any blur, use your camera's self-timer feature to take the shot for you (it might look especially weird to be using a cable release in a restaurant).

The Recipe for Getting This Type of Shot

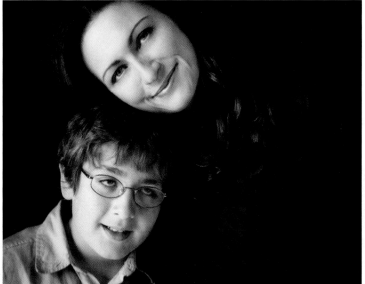

SCOTT KELBY

Characteristics of this type of shot: Soft, beautiful, natural light, very directional, and the shadows on the darker side of the face aren't too dark.

(1) The key to this shot is the light, and to get this gorgeous light, just position your subjects about 6 feet from a north-facing window. You also want to position them a little bit back behind the window, so they don't get the direct light, but only the edge of the light (that's where it's the softest and most flattering).

(2) To keep from having really dark shadows on the side of their faces that are facing away from the window, put a silver reflector just to the right of your subjects (from the camera view)—as close to them as possible without actually seeing it in the photo. You can position it straight up and down (like a wall beside them), and just a little in front of them (so the reflected light falls mostly on the front of them, not the back).

(3) This is a little bit of a low-light situation, so you're better off shooting this on a tripod for the maximum sharpness in the photo.

(4) To get this level of closeness from your subjects, use the trick I talked about in Chapter 3 for getting your subjects to pose closer than they normally would.

(5) Stand back at least 10 to 12 feet from your subjects and use a zoom lens to shoot somewhere around the 110mm to 140mm range, which looks great for portraits.

The Recipe for Getting This Type of Shot

SCOTT KELBY

Characteristics of this type of shot: Soft, natural-looking lighting, a bright background, sharp details in the features, and the whole photo seems to have energy.

(1) This was taken on a white seamless background (the model is my news anchor on *Photoshop User TV,* Stephanie Cross), and to make the background look nice and white, you need to aim a flash (or studio strobe) directly at the background. Place it behind your subject so their body covers the flash and stand. If you're using a flash meter, you'd like this background to read at least one stop brighter than your subject reads (so if you hold a light meter under her chin, aim it back at the camera, do a meter reading, and it shows f/11, when you walk back and take a reading from the background, it should read f/16. If it doesn't, turn up the power of the background flash and take another reading, and repeat this process until it reads f/16).

(2) This was shot with only one light and reflector (but it was one heck of a light). I used a 7' Elinchrom Octabank softbox, and it's positioned to her right, in front of her at a 45° angle. To get the extremely soft light you see here, you have to use a very large softbox and (this is key) position it as close to her as you possibly can.

(3) To keep the shadows from being too dark on the side of her face that is facing away from the light, use a silver reflector to bounce some of the light from that huge softbox back towards her.

(4) To get that movement in her hair, just turn on a fan and aim it at her. Easy enough.

The Recipe for Getting This Type of Shot

SCOTT KELBY

Characteristics of this type of shot: Dramatic portrait, suited for male subjects, with lots of drama to the lighting. Tight cropping gives the image impact.

(1) To get this type of shot, you need a dedicated flash, like a Nikon SB-900 (this shot was taken with a Nikon SB-800), or a Canon 580EX or EX II.

(2) To get the directional light, you have to get the flash off the camera, and to get it off the camera this far, you have to use either wireless flash or a really long sync cable.

(3) To get the softness and wrapping quality of the light from the flash, you'll need to fire the flash through a diffuser (this shot was taken with a flash fired through a Lasto-lite TriGrip 1 Stop Diffuser mounted on a light stand).

(4) Position the light to the right of the camera, at about a 45° angle toward your subject. Then put the diffusion panel as close as you can get it to your subject without actually seeing it in the photo. Put your flash about 1 foot behind the panel.

(5) No reflector is necessary and no tripod is necessary (the flash will freeze your subject).

The Recipe for Getting This Type of Shot

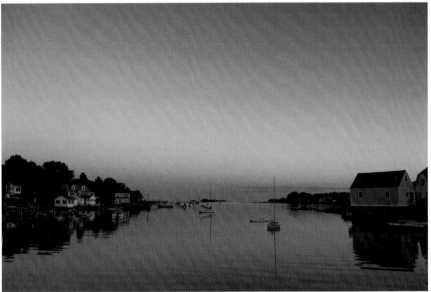

SCOTT KELBY

Characteristics of this type of shot: Glassy, still water, a beautiful sky, rich colors, and a wide vista.

(1) The key to this shot is (once again) when you shoot it. This type of shot needs to be taken about 30 minutes after sunset (everybody else will have already packed up by then, but sometimes the best light happens well after sunset). Also, composing so the horizon line is in the lower third of the frame really adds to its sweeping feel.

(2) In low light like this, of course, you need to shoot on a tripod and use a cable release or your camera's self-timer to minimize any camera shake. Because you're on a tripod, you can shoot at ISO 100, which will minimize any noise.

(3) You'll need to use a wide-angle lens to capture this wide a view (this was taken with a 12–24mm f/2.8 lens set at 19mm).

(4) This is another one of those shots where you want to use f/8 or a higher number to keep as much in focus as possible.

(5) There's only one way to get that smooth, glassy water, and that's to be lucky. This was taken at Cape Porpoise, Maine, and for three straight days there was just no wind, and the water in the cove you see above was just like glass. Sometimes you have to be patient and go back to a location a number of times, if you can, to finally shoot it when the sky looks great and the water is glassy. Once those two things come together, then follow steps 1–4 and you'll get a shot just like this.

The Recipe for Getting This Type of Shot

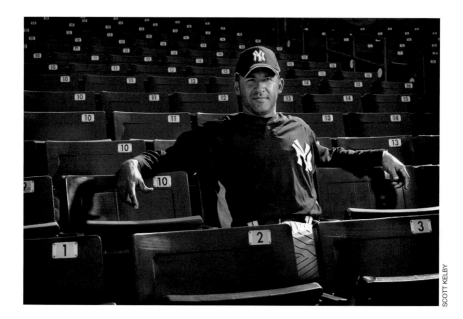

SCOTT KELBY

Characteristics of this type of shot: A daylight shot with the sun being overpowered with flash, and while the flash is bright, it's not harsh.

(1) This was taken at around 3:30 or 4:00 in the afternoon, in the middle of a major league ballpark (right after the game), and when the light is harsh like this, you can either put a diffuser (a translucent piece of fabric) between the sun and your subject (which puts them in the shade) or use a flash to overpower the sun, which is what I did here. The flash is actually positioned to his right (from the camera view) just outside the frame of the photo (in fact, it's on a light stand in front of seat 5 in the front row). (2) To keep the light from the flash from being harsh, place that diffuser between the flash and your subject. So, he's seated in seat 11. In his same row, in seat 13, is a Lastolite TriGrip diffuser connected to a light stand. It's literally just out of reach of his hand on the right side (from the camera view). Then, the flash (on a light stand) is one row in front of that, firing at him through that diffuser to make the light from the flash softer. (3) To capture your subject, and the surroundings, use a wide-angle lens (this was taken with a 17–55mm f/2.8 lens set at 44mm, so it's not too wide). To keep the fore-ground and background in focus, use f/8 or a higher number. (4) Since this was shot using flash, which freezes any motion, no tripod is necessary. (5) Since this was taken in daylight, using ISO 100 (for the least noise and maximum sharpness) was no problem.

The Recipe for Getting This Type of Shot

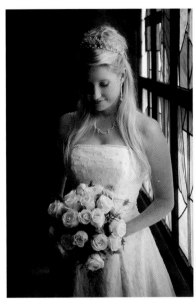

SCOTT KELBY

Characteristics of this type of shot: Beautiful, wrapping light, with a nice dramatic shadow on the far side of the face.

(1) This shot couldn't be easier, because it's mostly natural light coming in through a window. Usually, we'd place our subject farther away from the window to get softer light, but because the light was already heavily softened by the stained glass, we were able to position her closer to the window.

(2) If you want the stained glass to be an important part of the photo (which we did here), position yourself away from the window and shoot back towards the window.

(3) The only other thing you need to make this work is a silver reflector to the left of the subject (from the camera view), just far enough away that it's not in the photo. That helped to keep the shadow side of her face from being too dark.

The Recipe for Getting This Type of Shot

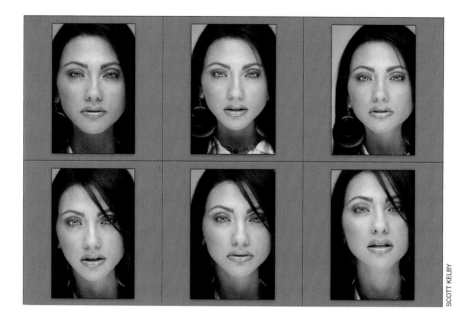

SCOTT KELBY

Characteristics of this type of shot: A bright, clean flash/beauty look with minimal shadows (mostly a small shadow under the nose), with bright, well-lit eyes that sparkle.

(1) Believe it or not, this is a one-light setup that is incredibly easy to use and gets wonderful results. You position the softbox directly in front of your subject, just a little higher than your subject's head, and tilted back down toward your subject (so the light is coming from slightly above her head). The key is to place this softbox absolutely as close as you can get it to your subject without being seen in the photo (so it may be only 8 or 10 inches from their face).

(2) Now, you take a silver reflector, hold it flat in front of your subject (like a dish), right at their chest level, so it reflects the light from the softbox just above their forehead and fills their face with this beautiful light. Put this as close as you can to your subject without it showing up in the frame.

(3) This setup is often referred to as clamshell lighting, because it looks like a giant clam that's about to eat your subject's face (strange as that may sound).

(4) There will be a little gap between the softbox and your reflector, and you position your camera to shoot between that gap, which gives you the look you see above, which has very little shadow, thanks to the light bouncing back into your subject's face.

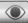

The Recipe for Getting This Type of Shot

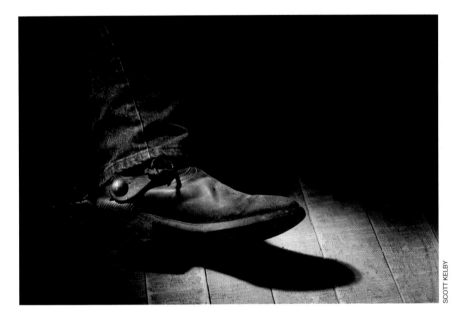

SCOTT KELBY

Characteristics of this type of shot: Dramatic light, lots of detail and depth.

(1) This shot is all about the light, because after all—it's just a shot of a boot. But it's a boot in really, really good light. This is natural light from a window with a very, very sheer drape in front of it, which helped soften the light.

(2) The key to making the light go where you want it is to block out the parts of the light you don't want. The top of his leg is darker because we blocked some of the light with the table the cowboy was sitting at, so it mostly fell right where we wanted it to—on the boot. You can block window light with pretty much anything you have handy (a jacket, a sweater, your camera bag, etc.).

(3) Although there are parts of this photo that are bright (like the floor behind his boot, and the highlights on his boot), this is definitely a low-light shot, and should be taken on a tripod for sure.

(4) The reason the photo has a yellowish look to it is because the white balance was set to something very warm (the Cloudy setting), which does a nice job of making everything just that little bit warmer, and is especially useful for outdoor shots (I leave my white balance set to Cloudy for all my outdoor shots. But then again, I shoot in RAW, so if I don't like the way Cloudy looks, I can always change the white balance later in Adobe Camera Raw).

The Recipe for Getting This Type of Shot

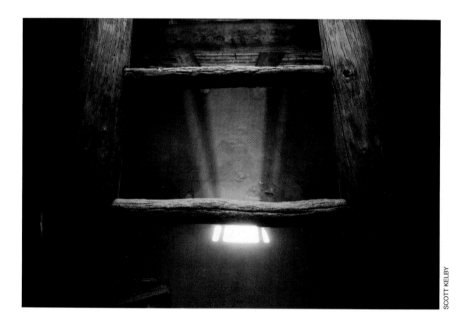

SCOTT KELBY

Characteristics of this type of shot: Dramatic beams of light, a photo with lots of depth and mystery.

(1) The trick to photographing beams of light is to take two handfuls of sand, toss them up into the air near the beams, and after a few seconds the beams will start to clearly appear as the sand starts to settle (this happens just after the sand hits the floor). I had a friend doing the sand tossing—he tossed it up, then quickly moved out of the frame. (2) For you to see beams of light, you're going to have to be in a place that's dark enough for beams to appear (in this case, I'm down in a small underground room [called a kiva] in New Mexico's Pecos National Historical Park). In low light like this, you'll have to be on a tripod to keep from having very blurry photos, because your shutter will have to stay open long enough to get a decent exposure (my shutter speed in this shot was 1/10 of a second). (3) To get the ladder in the foreground (which you use to climb down into the kiva) in focus, and have the back wall of the kiva in focus, you need to use an f-stop like f/8 or a higher number (the higher the number, the more of the photo will be in focus). (4) The last thing is this: with all that sand floating around, you can protect your camera from getting too dirty by wrapping it in a plastic shower cap (like the kind you'll find in your hotel room), so just the lens is sticking out. It works wonders to keep most of the dirt out.

The Recipe for Getting This Type of Shot

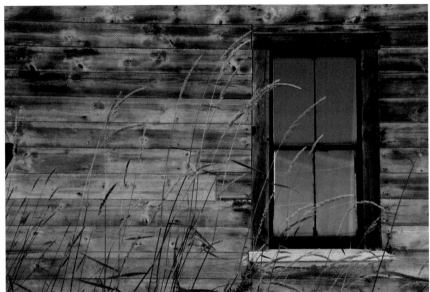

SCOTT KELBY

Characteristics of this type of shot: Great color and reflection in the window. A clear subject, and depth created by the grass being in front of the window.

(1) There are two keys to this shot, the first being composition. This was a window on the side of an old garage/barn, and you could try to capture the entire barn, but that's really tough. Instead, by closing in tight and focusing in on just one element of the large barn, it creates a very clear subject and a simple image with impact.

(2) The other key to this shot is positioning the camera so you see as much reflected sky as possible (I moved up and down the side of the building until I could find a spot where the reflection pretty much filled the window).

(3) This shot was taken very late in the day on the shady side of the barn, so that means lower light, which means you need to shoot it on a tripod (to keep from having a blurry photo). Also, to get the blades of grass in the shot, you have to position your camera at a very low angle, so you're basically down in the grass (I had to shoot this on my knees, with my camera aiming up a bit at the window, and the window was actually pretty low on the side of the barn). It was shot with a 17–55mm zoom lens, set at 40mm at f/11. Because of the low light, the shutter speed was 1/40 of a second (if the camera had read 1/60 of a second, I could have possibly gotten away with shooting handheld, but it still wouldn't be as sharp as taking it on a tripod, where there's no movement at all).

The Recipe for Getting This Type of Shot

SCOTT KELBY

Characteristics of this type of shot: This is one of the product shots for the book, which I lit to have lots of depth and detail, and the reflection below it is actually real.

(1) This was shot on a table on white seamless background paper. The way to get the reflection is to put a large sheet of clear plexiglass over the paper, and then anything you put on it creates a nice reflection. It's simple, but it works.

(2) To light a product like this so it doesn't look flat and boring, you'll need more than one light (in this case, three lights). One strobe with a softbox is placed to the camera's left, aiming back at the product about 2 feet in front of it. A second light is placed diagonally behind the product to the camera's right. The third light is actually a long strip bank we normally use as a hair light (like the one shown in Chapter 2), but a regular small softbox would have been perfect. So, why we did we use a strip bank? Honestly, it was because it was handy—it was already set up on a boom stand from a portrait shoot the day before, so we did the "lazy photographer" thing and used what was convenient. We placed the light directly above the product. Also, I used Westcott TD5 Spiderlites, which are those continuous daylight balanced fluorescent lights that are ideal for product photography (shot at ISO 200 at f/8 at 1/20 of a second).

(3) The goal when lighting a shot like this is to have areas that have lots of highlights and other areas with shadows. If it doesn't, the product looks flat.

(4) This was shot from far back with a 70–200mm lens all the way out at 200mm.

The Recipe for Getting This Type of Shot

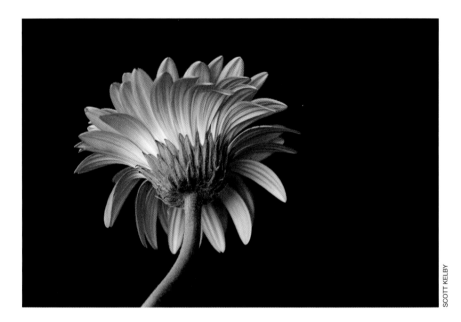

SCOTT KELBY

Characteristics of this type of shot: Close-up shot with a dramatic black background, and lots of detail and depth for a close-up shot like this.

(1) If you want a solid black background behind a flower, you have to put one there (I used a Westcott Collapsible Illuminator background, like the one in Chapter 2). The background is about 4 feet behind the flower.

(2) If you want beautiful flowers to shoot, buy 'em (I went to a local florist and ordered pink and yellow Gerbera daisies, which came in within two days. If the florist knows you're buying them to photograph them, they usually make sure you get really beautiful selections).

(3) This is taken with a macro lens, and to get this much depth of field you have to follow all three macro rules, including shooting at the highest aperture possible (f/22, in this case), shooting on a tripod, and shooting with the barrel of the lens aiming straight at the subject (not tipping up or down—perfectly horizontal).

(4) The light is nothing but beautiful, late afternoon, summer light. No reflectors, no flash—just natural light under the awning of a house (so it's not direct light).

(5) What makes this shot interesting is that you're showing a view of a daisy that's rarely seen—the underside of the back of the flower. To get this view, I had to place the vase on a tall side table, so I could get the camera low enough to be below the back of the flower.

The Recipe for Getting This Type of Shot

SCOTT KELBY

Characteristics of this type of shot: Golden, beautiful light, nice reflections in the windows, and a wide sweeping look.

(1) The key to getting this look is when you shoot it, you have to be in place and ready to shoot at dawn.

(2) For a sweeping look like this, you need to use a wide-angle zoom lens (this was shot with a 17–55mm zoom lens, set at 22mm). To keep a decent amount of focus throughout the shot, you should choose f/8 or a higher number (f/11, f/16, etc.).

(3) Since you're shooting just after dawn, the light will be low and your shutter will stay open longer (the shutter stayed open for 1/8 of a second), so you absolutely need to shoot this type of shot on a tripod or your shot will be blurry. Also, use a cable release or your camera's self-timer to minimize any camera shake.

(4) To get the reflections in the windows, you literally just have to walk around and position yourself at an angle where the reflections show up in the windows as much as possible.

(5) Since you're shooting on a tripod, shoot at 100 ISO for maximum quality and clarity.

(6) Because your subject has lots of white in it (the exterior walls), make sure your camera's highlight (clipping) warning is turned on, and if you get areas that are blinking when you view them in your LCD monitor, use your camera's exposure compensation control to lower the exposure by 1/3 of a stop or more, then shoot again.

The Recipe for Getting This Type of Shot

SCOTT KELBY

Characteristics of this type of shot: Dramatic portrait shot, ideal for shots of men due to the dark shadows on the right side of the face.

(1) The key to this shot is where you position the softbox. The camera is aiming straight forward, right at the subject, but you have the subject look to your left. The softbox isn't right in front of where he's looking—it's actually positioned a little bit past him, so the side of his face that is turned away from the camera is getting the direct light.

(2) Since you're on the other side of the light, it puts the camera side of his face in shadow, like you see here.

(3) Don't use a reflector to open up the shadows on the side of his face nearest the camera—you want that to be dark and fully in shadow, like you see here. That's it— one softbox—it's all in where you place it.

Index

THE WORLD'S MOST POPULAR PHOTOSHOP & PHOTOGRAPHY SEMINARS

With over 40,000 photographers and creatives attending our events each year, it's easy to see why Kelby Training LIVE is the most popular seminar tour in the world! Learn from the most gifted and talented photographers and creative gurus on the planet, all sharing their latest tips, tricks and advanced techniques for photography, Photoshop, InDesign, Lightroom, and more. **For locations, dates & tour info visit www.KelbyTrainingLIVE.com or call 800.201.7323**

$99 Full Day of Live Training!

$79 NAPP Members

100% Money Back Guarantee
See website or call for details.

COMING SOON TO A CITY NEAR YOU

Photoshop Lightroom 3 Live Tour *with Scott Kelby or Matt Kloskowski*

Photoshop Creativity Tour *with Bert Monroy*

Photoshop Maximum Tour *with Dave Cross*

Down & Dirty Tricks Tour *with Corey Barker, Dave Cross or Scott Kelby*

Location Lighting Tour *with Joe McNally*

Photoshop for Photographers Tour *with Ben Willmore*

Kelbytraining LIVE

WORLD'S MOST POPULAR SEMINARS FOR CREATIVES

Adobe, Lightroom, InDesign and Photoshop are registered trademarks of Adobe Systems Incorporated.

Kelbytraining.com
EDUCATION FOR CREATIVES

Learn Online with the Pros.

"I THINK WHAT WE ALL WANT IS A FRIEND WHO'LL JUST SIT DOWN WITH US AND SAY

'LOOK, HERE'S HOW YOU DO THIS STUFF.'

That's the way my classes are. It's just you and me, so I can skip all the formal techno-baloney.

I teach you the same way I would teach a friend so you learn way more in less time.

I'm Scott Kelby and I'm the Education Director and a teacher at Kelbytraining.com **"**

he Best Teachers n the Planet –Online– ll in One Place

stering digital photography, Adobe Photo-
p°, and Web design has never been easier
nore affordable. Subscribe today to receive
mited access to our online training catalog,
uring exclusive classes from the creative
ld's most talented and gifted teach-
. . .like Scott Kelby.

199^{USD} OR $24^{95 USD}

ER YEAR | **A MONTH**

PP Members $179 a year or $19⁹⁵ a month

Scott Kelby

Since 2004, Scott has been awarded the distinction of being the world's #1 best-selling author of all computer and technology books, across all categories. His books have been translated into dozens of different languages and he is a recipient of the prestigious Benjamin Franklin Award.

Subscribe or for More Information Visit
WWW.KELBYTRAINING.COM

a **Kelby**MediaGroup company
the force behind creatives

Adobe and Photoshop are registered trademarks of Adobe Systems Incorporated.

The
PART 3
Digital
Photography

The step-by-step secrets for how to
make your photos look like the pros'! Book

Scott Kelby

The Digital Photography Book, part 3

The Digital Photography Book, part 3 Team

TECHNICAL EDITORS
Kim Doty
Cindy Snyder

EDITORIAL CONSULTANT
Brad Moore

CREATIVE DIRECTOR
Felix Nelson

TRAFFIC DIRECTOR
Kim Gabriel

PRODUCTION MANAGER
Dave Damstra

GRAPHIC DESIGN
Jessica Maldonado

COVER DESIGNED BY
Jessica Maldonado

STUDIO AND
PRODUCTION SHOTS
Brad Moore
Rafael "RC" Concepcion

PUBLISHED BY
Peachpit Press

Copyright ©2010 by Scott Kelby

FIRST EDITION: July 2009

All rights reserved. No part of this book may be reproduced or transmitted in any form or by any means, electronic or mechanical, including photocopying, recording, or by any information storage and retrieval system, without written permission from the publisher, except for the inclusion of brief quotations in a review.

Composed in Myriad Pro (Adobe Systems Incorporated) and Lucida Grande (Bigelow & Holmes Inc.) by Kelby Media Group.

Trademarks
All terms mentioned in this book that are known to be trademarks or service marks have been appropriately capitalized. Peachpit Press cannot attest to the accuracy of this information. Use of a term in the book should not be regarded as affecting the validity of any trademark or service mark.

Photoshop, Elements, and Lightroom are registered trademarks of Adobe Systems Incorporated. Nikon is a registered trademark of Nikon Corporation. Canon is a registered trademark of Canon Inc.

Warning and Disclaimer
This book is designed to provide information about digital photography. Every effort has been made to make this book as complete and as accurate as possible, but no warranty of fitness is implied.

The information is provided on an as-is basis. The author and Peachpit Press shall have neither the liability nor responsibility to any person or entity with respect to any loss or damages arising from the information contained in this book or from the use of the discs or programs that may accompany it.

THIS PRODUCT IS NOT ENDORSED OR SPONSORED BY ADOBE SYSTEMS INCORPORATED, PUBLISHER OF ADOBE PHOTOSHOP, PHOTOSHOP ELEMENTS, AND PHOTOSHOP LIGHTROOM.

ISBN 10: 0-321-61765-7
ISBN 13: 978-0-321-61765-1

20 19 18 17 16 15 14 13 12

Printed and bound in the United States of America

www.kelbytraining.com
www.peachpit.com

For my in-house editor Kim Doty.
One of the best things that ever
happened to my books is you.

Acknowledgments

Although only one name appears on the spine of this book, it takes a team of dedicated and talented people to pull a project like this together. I'm not only delighted to be working with them, but I also get the honor and privilege of thanking them here.

To my amazing wife Kalebra: This year we're celebrating our 20th wedding anniversary, and I'm more in love, more crazy about you, and more thrilled that you're my wife than ever. Besides being a world-class mother, a gourmet chef, an artist, a singer, and a brilliant businesswoman, you're just about the coolest person I've ever known. I still can't believe that you chose me, and I'll spend the rest of my life working to make sure you always feel you made the right choice. I love you, sweetheart.

To my wonderful, crazy, fun-filled, little buddy Jordan: If there's any kid on the planet who knows how much their dad loves them, and how proud their dad is of them, it's you little buddy (even though, now that you're 12, I'm not supposed to call you "little buddy" anymore. Well, at least not in front of your friends). You were wired at the factory to be an incredibly fun, hilarious, creative, positive, sensitive, super-bright, yet totally crazy kid, and I love it. But I have to admit, as much fun as I have at our nightly *Halo 3* battles on Xbox LIVE, last week when I dragged my amp and guitar up to your room, you sat down at your drums, and we jammed on an extended version of Bon Jovi's "You Give Love a Bad Name," I knew at that moment that if it was possible to have become a luckier dad than I already was, it just happened. Dude (I mean, son), you rock!

To my beautiful "big girl" Kira: You're totally blessed with your mom's outer beauty, and also something that's even more important: her inner beauty, warmth, compassion, smarts, and charm, which will translate into the loving, fun- and adventure-filled, thrilling, drive-it-like-you-stole-it kind of life so many people dream of. You were born with a smile on your lips, a song in your heart, and a dad that is totally wrapped around your finger.

To my big brother Jeff: A lot of younger brothers look up to their older brothers because, well…they're older. But I look up to you because you've been much more than a brother to me. It's like you've been my "other dad" in the way you always looked out for me, gave me wise and thoughtful council, and always put me first—just like Dad put us first. Your boundless generosity, kindness, positive attitude, and humility have been an inspiration to me my entire life, and I'm just so honored to be your brother and lifelong friend.

To my best buddy Dave Moser: Do you know how great it is to get to work every day with your best buddy? I do. It's awesome. Thanks my friend—you are the best.

To my in-house team at Kelby Media Group: I am incredibly blessed to go to work each day with a group of uniquely dedicated, self-motivated, and incredibly creative people—people who mean much more to me than just employees, and everything they do says they feel the same way. My humble thanks to you all for allowing me to work with the very best every day.

To my editor Kim Doty: What can I say—this book is dedicated to you! Writing books is never easy, but you make my job so much easier by keeping me on track and organized, and for staying absolutely calm and positive in the face of every storm. One of the luckiest things that has ever happened to my books is that you came along to edit them, and I'm very honored and grateful to have you making my books so much better than what I turned in.

To Jessica Maldonado: You are, hands-down, the Diva of Design, and I owe much of the success of my books to the wonderful look and feel you give them. What you do brings my books to life, and helps them reach a wider audience than they ever would have, and I'm so thrilled that you're the person that works these miracles for us (signed, your biggest fan!).

To Cindy Snyder: A big, big thanks for helping tech and copyedit all the tips in the book and, as always, for catching lots of little things that others would have missed.

To Dave Damstra: You give my books such a spot-on, clean, to-the-point look, and although I don't know how you do it, I sure am glad that you do!

To my friend and longtime Creative Director Felix Nelson: We love you. We all do. We always have. We always will. You're Felix. There's only one.

To my Executive Assistant and general Wonder Woman Kathy Siler: You are one of the most important people in the building, not only for all the wonderful things you do for me, but for all the things you do for our entire business. Thanks for always looking out for me, for keeping me focused, and for making sure I have the time I need to write books, do seminars, and still have time with my family. You don't have an easy job, but you make it look easy.

To my photography assistant and digital tech Brad Moore: I don't know how I would have gotten through this book without your help, your work in the studio (shooting so many of the product shots), your advice and input, and your patience. You've only been here a short time and you're already having a big impact. I'm so grateful to have someone of your talent and character on our team.

To my buddy RC Concepcion: My personal thanks for reprising your gig from volume 2, and stepping in to help get the studio shots done for this volume. You are the Swiss Army knife of digital imaging and design.

To Kim Gabriel: You continue to be the unsung hero behind the scenes, and I'm sure I don't say this enough, but thank you so much for everything you do to make this all come together.

To my dear friend and business partner Jean A. Kendra: Thanks for putting up with me all these years, and for your support for all my crazy ideas. It really means a lot.

To my editor at Peachpit Press, Ted Waitt: Do you know what a joy it is to work on a photo book with an editor who's also a passionate and creative photographer? It makes a huge difference. You get it. You get me. I get you. It's a beautiful thing.

To my publisher Nancy Aldrich-Ruenzel, Scott Cowlin, Sarah Jane Todd, and the incredibly dedicated team at Peachpit Press: It's a real honor to get to work with people who really just want to make great books.

To all the talented and gifted photographers who've taught me so much over the years: Moose Peterson, Vincent Versace, Bill Fortney, David Ziser, Jim DiVitale, Helene Glassman, Joe McNally, Anne Cahill, George Lepp, Kevin Ames, Eddie Tapp, and Jay Maisel, my sincere and heartfelt thanks for sharing your passion, ideas, and techniques with me and my students.

To my mentors John Graden, Jack Lee, Dave Gales, Judy Farmer, and Douglas Poole: Your wisdom and whip-cracking have helped me immeasurably throughout my life, and I will always be in your debt, and grateful for your friendship and guidance.

Most importantly, I want to thank God, and His son Jesus Christ, for leading me to the woman of my dreams, for blessing us with such amazing children, for allowing me to make a living doing something I truly love, for always being there when I need Him, for blessing me with a wonderful, fulfilling, and happy life, and such a warm, loving family to share it with.

Other Books By Scott Kelby

Scott Kelby's 7-Point System for Adobe Photoshop CS3

The Digital Photography Book, vols. 1 & 2

The Photoshop Elements Book for Digital Photographers

The Adobe Photoshop Lightroom Book for Digital Photographers

The Photoshop Book for Digital Photographers

The Photoshop Channels Book

Photoshop Down & Dirty Tricks

Photoshop Killer Tips

Photoshop Classic Effects

The iPod Book

InDesign Killer Tips

Mac OS X Leopard Killer Tips

The iPhone Book

About the Author

Scott Kelby

Scott is Editor, Publisher, and co-founder of *Photoshop User* magazine, Editor-in-Chief of *Layers* magazine (the how-to magazine for everything Adobe), and is the co-host of the weekly video podcasts *DTown TV* (the weekly show for Nikon dSLR shooters) and *Photoshop User TV*.

He is President of the National Association of Photoshop Professionals (NAPP), the trade association for Adobe® Photoshop® users, and he's President of the software training, education, and publishing firm Kelby Media Group.

Scott is a photographer, designer, and award-winning author of more than 50 books, including *The Digital Photography Book*, volumes 1 and 2, *The Adobe Photoshop Book for Digital Photographers*, *Photoshop Down & Dirty Tricks*, *The Adobe Photoshop Lightroom Book for Digital Photographers*, *Photoshop Classic Effects*, *The iPod Book*, and *The iPhone Book*.

For five years straight, Scott has been honored with the distinction of being the world's #1 best-selling author of all computer and technology books, across all categories. His books have been translated into dozens of different languages, including Chinese, Russian, Spanish, Korean, Polish, Taiwanese, French, German, Italian, Japanese, Dutch, Swedish, Turkish, and Portuguese, among others, and he is a recipient of the prestigious Benjamin Franklin Award.

Scott is Training Director for the Adobe Photoshop Seminar Tour, and Conference Technical Chair for the Photoshop World Conference & Expo. He's featured in a series of training DVDs and online courses, and has been training photographers and Adobe Photoshop users since 1993.

For more information on Scott and his photography, visit his daily blog at www.scottkelby.com

Table of Contents

Table of Contents

Table of Contents

Table of Contents

Table of Contents

Table of Contents

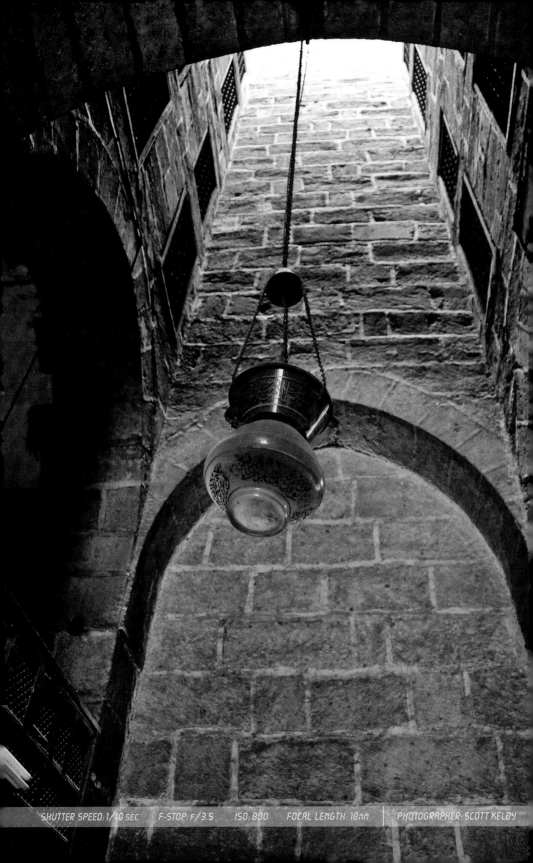

SHUTTER SPEED: 1/10 SEC | F-STOP: F/3.5 | ISO: 800 | FOCAL LENGTH: 18MM | PHOTOGRAPHER: SCOTT KELBY

Chapter One

Using Flash Like a Pro, Part 2

Picking Right Up Where the Last Book Left Off

I know what you're thinking: "If this is Part 2, where is Part 1?" Well, Part 1 is actually Chapter One back in volume 2. "Wait a darn minute—you're pulling that old 'bait and switch' scam, right?" No, a bait-and-switch scam is where you see an advertisement for a washer and dryer for a really low price (the bait), but then you go to the store and they tell you it's sold out, and then they try to talk you into buying a more expensive washer and dryer that they have in stock (that's the switch). My scam is totally different: (1) This book isn't about washers or dryers, and (2) I didn't offer a cheaper book, and then try to trick you into buying a more expensive book. Instead, my scam is called a "jump back," where I'm trying to get you to buy more books. Here's how it works: You've already bought volume 3 (the book you're holding in your hands right now), but on the first page of the book (this page), you realize that you should have bought volume 2 first, because it had a chapter with the most essential stuff about wireless flash. That way, you'd be ready for the stuff in this chapter, which is what people who read volume 2 told me they wanted to learn about next. So now, you have to "jump back" in your car (get it?) and head to the bookstore to buy volume 2. But, then, once you're home and you start reading volume 2, you soon realize that I assume if you're reading volume 2 that you have already read volume 1, so I skip over stuff that I figure you already learned in volume 1. Now you have to "jump back" in the car again and go buy volume 1, as well. It's a classic jump-back scam, but of course I would never admit that, especially here in the book. The whole thing is like the hit TV show *Lost*. If you didn't start watching it until Season 3, you'd realize it was aptly named.

9 Things You'll Wish You Had Known...

(1) **You don't have to read this part.** That's because I created a video that explains how to get the most out of this book. It's really short and to the point, but I promise you it will make using and learning from this book much more enjoyable (plus, then you can skip reading this section, because the video covers it all). You can find the video at **www.kelbytraining.com/books/digphotogv3**.

(2) **Here's how this book works:** Basically, it's you and me together at a shoot, and I'm giving you the same tips, the same advice, and sharing the same techniques I've learned over the years from some of the top working pros. But when I'm with a friend, I skip all the technical stuff. So, for example, if you turned to me and said, "Hey Scott, I want the light to look really soft and flattering. How far back should I put this softbox?" I wouldn't give you a lecture about lighting ratios or flash modifiers. In real life, I'd just turn to you and say, "Move it in as close as you can to your subject, without it actually showing up in the shot. The closer you get, the softer and more wrapping the light gets." I'd tell you short, and right to the point. Like that. So that's what I do here.

(3) **This picks up right where volume 2 left off,** and this stuff in this book is what people who bought volume 2 told me they wanted to learn next. So, for example, in the chapter on wireless flash, I don't show you how to set up your flash to be wireless, because all that type of stuff was already covered in the flash chapter in volume 2. Instead, it picks up right after that, with all new stuff. Now, should you have volumes 1 and 2 before...

...Before Reading This Book!

...you read this book? It's not absolutely necessary, but it certainly wouldn't bother me one bit if you did (like how I phrased that? A very subtle, soft-sell approach. Compelling, but yet not overbearing). All joking aside, if you're into off-camera flash or studio lighting, it is helpful to have read at least volume 2, because those chapters in this book figure you already learned the basics in volume 2.

(4) Sometimes you have to buy stuff. This is not a book to sell you stuff, but before you move forward, understand that to get pro results, sometimes you have to use some accessories that the pros use. I don't get a kickback or promo fee from any companies whose products I recommend. I'm just giving you the exact same advice I'd give a friend.

(5) Where do I find all this stuff? Since I didn't want to fill the book with a bunch of Web links (especially since webpages can change without notice), I put together a special page for you at my site with a link to any of the gear I mention here in the book. You can find this gear page at **www.kelbytraining.com/books/vol3gear**.

(6) The intro page at the beginning of each chapter is just designed to give you a quick mental break, and honestly, they have little to do with the chapter. In fact, they have little to do with anything, but writing these off-the-wall chapter intros is kind of a tradition of mine (I do this in all my books), so if you're one of those really "serious" types, please, I'm begging you—skip them, because they'll just get on your nerves.

That Was Only 6. Here Are the Last 3

(7) If you're shooting with a Sony or Olympus or a Sigma digital camera, don't let it throw you that a Nikon or Canon camera is pictured. Since most people are shooting with a Nikon or Canon, I usually show one or the other, but don't sweat it if you're not—most of the techniques in this book apply to any digital SLR camera, and many of the point-and-shoot digital cameras, as well.

(8) There are extra tips at the bottom of a lot of pages—sometimes they relate to the technique on that particular page, and sometimes I just had a tip and needed to fit it somewhere, so I put it on that page. So, you should probably at least take a quick glance anytime you see a tip box on the bottom of a page—ya know, just in case.

(9) Keep this in mind: This is a "show me how to do it" book. I'm telling you these tips just like I'd tell a shooting buddy, and that means oftentimes it's just which but- ton to push, which setting to change, where to put the light, and not a whole lot of reasons why. I figure that once you start getting amazing results from your camera, you'll go out and buy one of those "tell me all about it" digital camera or lighting books. I do truly hope this book ignites your passion for photography by helping you get the kind of results you always hoped you'd get from your digital photogra- phy. Now, pack up your gear, it's time to head out for our first shoot.

Soft Light on Location (the Budget Way)

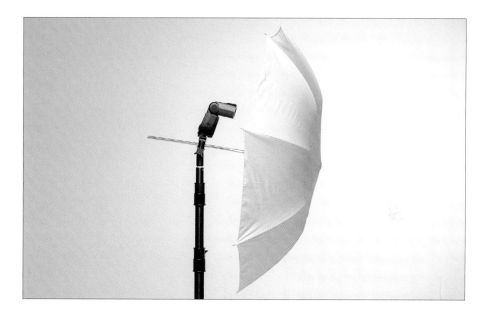

Back in *The Digital Photography Book*, volume 2, I went into great detail about how important it is to diffuse and soften the light from your small flash, so you get professional looking results. Although I usually have you firing through diffusers, here's another way to get the job done, which is particularly handy for people shooting without an assistant or anyone who can help wrangle the gear during the shoot: use a shoot-through umbrella setup. Now, before I get into this, I want to say up front that I just flat-out don't like reflective umbrellas, where you aim the umbrella and flash away from your subject, then the light from your flash hits the inside of the umbrella and travels back toward your subject like a lighting grenade. Yeech! However, in this case, you're actually aiming the flash at your subject, and you're using a special translucent shoot-through umbrella that's designed to let you fire your small flash directly through it and right at your subject, giving you a much more concentrated beam than a reflective umbrella does. The advantages are: (1) you can get softer wraparound light with it because you can put the umbrella very close to your subject, (2) it's an umbrella, so it's very compact, (3) you can control how large your light source actually is (see the next page), and (4) it's incredibly inexpensive for a pro setup (yes, a lot of working pros use a similar setup). To make this all work, you need three things (besides your flash unit, of course): a shoot-through umbrella (I use a Westcott 43" Optical White Satin Collapsible shoot-through umbrella, which sells for around $20); a tilting umbrella bracket, with a flash shoe to support the flash and a slot for the umbrella to slide through (I use a LumoPro LP633 Umbrella Swivel with Flash Shoe Adapter which sells for around $18); and a lightweight light stand (I use a Manfrotto lightweight 6'2" Nano Stand—around $60). So, the whole setup is just under $100.

Controlling Softness with an Umbrella

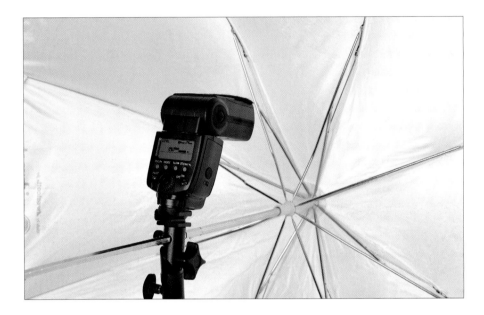

If you're using a shoot-through umbrella, you have to decide how soft you want the light to be that comes through that umbrella. Well, this is partially controlled by how far back you place the flash from the inside of the umbrella. I usually want really soft light for shooting things like brides, and portraits of families, etc., so I slide the umbrella out around two feet from the flash. That way, the light from the flash fills as much of the umbrella as possible, making my light source bigger, which makes my light softer (remember that from volume 2? The bigger the light source, the softer the light?). If you want sharper, edgier light, you know what to do—slide the umbrella in the adapter, so it's much closer to the flash. Now the flash has much less room to spread, and your light will be smaller, more direct, and less soft.

Get More Control Using a Portable Softbox

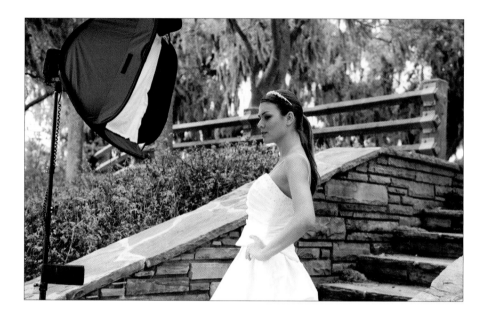

If you've got a few more bucks to spend, then you can move up to a small softbox designed for off-camera flash. I think there are two big advantages to using this over a shoot-through umbrella: (1) The light is more contained and directional than with a shoot-through umbrella, so it's easier to get more dramatic light, since it only goes where you aim it. (2) They don't seem to blow over as easy when using them outdoors. This is bigger than it sounds, because umbrellas catch the wind like you can't believe, and even the slightest wind can send the whole thing (umbrella, stand, and your flash) crashing over. The small-flash softbox I use is the Lastolite Ezybox. I like that it's so small and portable—it collapses down to a small round shape (like a reflector)—and it sets up without having to use steel rods, so it only takes two minutes. Plus, I love the quality of its soft, directional light. There are different sizes, but I use the 24x24" size.

Hand-Holding an Ezybox

You don't have to use a light stand to hold your flash and Ezybox. You can have a friend (or a bridesmaid, or an assistant, etc.) hold them using a special accessory, which is a small (24" tall), lightweight, hand-held stand with a handle on the bottom that lets your Ezybox pretty much go anywhere your friend can go, turning your friend into what has become known in flash circles as a VAL (the acronym for a voice-activated light stand).

What Your Flash's Groups Are For

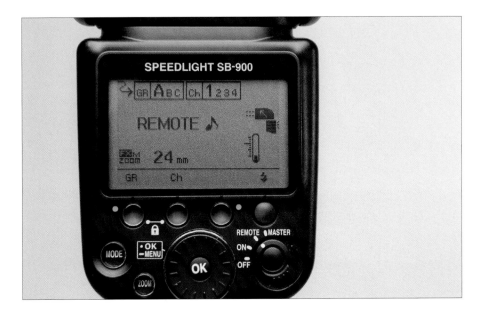

If you want to control your wireless flashes independently of each other, then you need groups. For example, let's say that you have one flash off to the left of your subject, and one flash behind the subject lighting a white seamless background. You'd want to be able to control the power of each flash individually, so if the background flash is too bright, you can turn it down without having the front flash power down, as well. You do that by assigning one flash to Group A, then the other flash (the background flash) to Group B. Now you can control the power of each one individually, without disturbing the other. Also, you can have more than one flash in each group. So, if you have two flashes on the background (one lighting the left side; one lighting the right), and you put them both on Group B, they would move up/down in power together, but your front flash (which is still on Group A) would be unaffected. Sweet! You assign a flash to a particular group right on the flash unit itself.

What Your Flash's Channels Are For

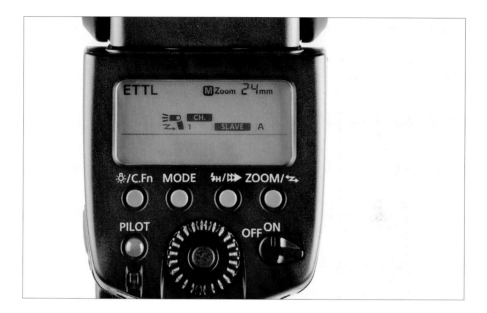

As long as you're by yourself, just you and your flash, things are good. But what happens if you're hired to shoot an event, like a wedding for example, and you have a second (or third) photographer shooting along with you (it's more and more common to have a second shooter at a wedding—especially weddings in Texas, where the ceremony is held on a grassy knoll. Sorry, that was lame)? The problem you'd probably face is that sometimes the second shooter's camera would trigger and fire your flash (and vice versa). That's why your flash has different channels. At the beginning of the wedding, you'd set your flash to Channel 1, and you'd tell your second shooter to set their flash to Channel 2. That way, your camera will only trigger your flash, and theirs will only trigger their flash. By the way, you have to set the channel in two places: (1) on the wireless flash unit itself, and (2) on whatever you're using to trigger your flash. For example, if you're shooting Nikon and the second shooter is using their camera's built-in Commander unit to control their wireless flash, you'd need to have them set their Commander to Channel 2. If you're shooting Canon, then you're probably using another flash mounted on your camera's hot shoe as your master flash, and in that case, you'd set that flash to Channel 2. If all of this "master" and "wireless" stuff sounds confusing, then you now know why I said you really need to read volume 2 of this book first, because it covers all the basics of wireless flash. Then all this would make more sense (and it would sell another book, which isn't a bad thing).

Using a Transmitter to Fire Your Flash

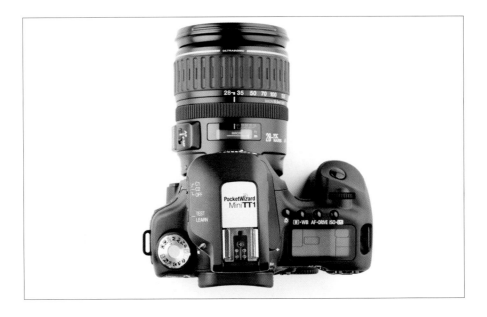

Back in volume 2 of this book, I showed you how to set up your small hot-shoe flash, so that your off-camera flash can be wireless, which is very cool (and makes your flash really usable). But there is a downside to using the built-in wireless system, and that is that the flashes have to be in the line of sight of whichever flash is your master flash (so, for example, if you're triggering your wireless flashes using the pop-up flash from your camera, the light sensor on the side of each of the wireless flashes has to be in the line of sight of the master flash [the pop-up flash], so they can sense the little light-pulse it emits as a signal for wireless flashes to fire. If they can't clearly see that light pulse, they won't fire). That's why many working pros use a dedicated wireless transmitter and receiver for firing their flashes—that way, the flashes fire 100% of the time, whether they can see the flash on your camera or not, because now the wire-less transmitter is doing the firing for you. PocketWizard (longtime maker of wireless gear for studio work) has come up with a special wireless system for small off-camera flash called the MiniTT1™ Radio Slave Transmitter, which fits right on your camera's hot shoe, and then your master flash goes on top of that. Of course, the downside to this is you need to buy a transmitter unit, and then a receiver unit for each flash, but then your flash-firing troubles simply go away.

How to See If All Your Flashes Will Really Fire

Let's say you've got four different flashes, and each one is assigned to a different group (just for the sake of this example, let's say we're shooting a studio portrait, and the main flash up front is on Group A, a hair light is assigned to Group B, and two background flashes are assigned to Group C). How can you tell if they're all going to fire? You can run a test! Just press the red test firing button on the back of your master flash unit, and each group will fire its flashes, in order, one after another, so you can see that they all work. (*Note:* It fires Group A's flashes first, then Group B's, and then the two background flashes on Group C last.) You'll visually see each one flash. If one doesn't fire, then you'll need to do some troubleshooting (make sure the non-firing flash is actually turned on, make sure it's assigned to the right group, make sure its sensor is seeing the flash from the master flash, etc.).

Shorten the Time Between Flashes

Each time your flash fires, since it's battery powered, it has to recycle before you can fire it again. When you first pop a fresh set of batteries into your flash, the recycle time is about as fast as it's going to get—probably just a few seconds between flashes. However, the more times your flash fires, the more your batteries wear down, and pretty soon a few seconds between flashes turns into five seconds, then 10 seconds, then 12 seconds, and then it just feels like an eternity, and you know it's time to change batteries. However, there's another way to shorten the recycle time, and that is to lower the power of your flash. That's right—the lower the power, the faster the flash will recycle. Of course, lowering the power of your flash will make your subject look darker, because now there's less light from your flash falling on your subject, so you'll have to adjust your f-stop so your image looks good. For example, if you're shooting at 1/64 power at f/5.6, you'll need to change your f-stop to at least f/4, if not f/2.8, to brighten the overall exposure, and make your flash balance out again.

Recycle Faster with an External Battery Pack

If you're doing some serious location flash work (like a wedding, on-location fashion shoot, etc.), or anything where you need the shortest possible recycle time with the longest battery life, then try using an external battery pack, like Nikon's SD-9 for the SB-900 (which holds eight AA batteries), or Canon's Compact Battery Pack CP-E4 (which also holds eight AA batteries). What these do is reassign how the batteries inside your flash work. Usually, those four batteries inside run both the recycling and all the software requirements of the flash unit. When you attach one of these external battery packs, it assigns all the recycling duties to those eight AA batteries, so you get longer battery life and much faster recycling times. Use one of these once, and you'll never be without one again.

Another Recycle–Faster Tip

If you use off-camera flash a lot, you're going to be going through a lot of batteries, and you'll probably want to get rechargeable ones, so you don't go broke buying batteries all the time. But beyond that, there's another advantage to using rechargeable batteries (which I learned from David Hobby of Strobist.com fame), as long as you buy nickel-metal hydride (NiMH) batteries. Because of their lower voltage, they recycle much faster (in flashes, anyway) than regular alkaline AA batteries. Plus, you can recharge a set of four in about 15 minutes (in fact, Energizer sells what they call their 15-Minute Charger for nickel-metal hydride batteries). I would buy two sets of AA nickel-metal hydrides—one set in the flash, and another set as your backup on location. If you need to switch to the backup set, you could always throw the first set in the charger, so they'll be ready if you need 'em again (and if that's the case, you're really poppin' a lot of flashes!).

Charge 'em Right Before You Use 'em

Nickel-metal hydride batteries discharge around 10% of their battery life per week if they're just sitting around doing nothing, so don't charge up your batteries until you need 'em for a job—that way they'll be at full capacity.

Typical Power Settings for Your Flash

If you're using your flash indoors, or outdoors in anything other than bright daylight, you'll be running your flash 99% of the time at less than half-power. In fact, you'll probably be often running it at 25% power (I'm sometimes at 1/8 or 1/16 power during a typical shoot). Why so low? Because the idea is to balance the light from your flash with the existing light already in the room (or already available outside), so you usually want just a little bit of flash (or your flash will look like flash). The goal is to make your flash look like natural light, so your power setting will probably stay real darn low.

Firing a Second Flash in Another Room

Let's say you're shooting the interior of a home and lighting it with off-camera flash. Nothing looks worse than seeing an adjoining room (maybe the dining room in the background) looking all dark, so you put a second flash in there and aim it at the ceiling to light that room. So far so good. Now, of course, in that dining room you don't want to actually see the flash unit itself, so you hide it from view, right? Here comes the problem: these flashes work on "line of sight" (meaning your second flash has to have an unobstructed view of the master flash. If it doesn't, it won't fire). So, here's the trick to get around that: you set your flash to Remote (or Slave) mode (depending of which brand of flash you own), and then it doesn't have to be in the line of sight anymore—if it detects even a tiny hint of light from the flash in the main room, that puppy fires! Keep this in mind the next time you need to hide a second flash, or put it where the whole line-of-sight thing won't work.

Overpowering the Sun

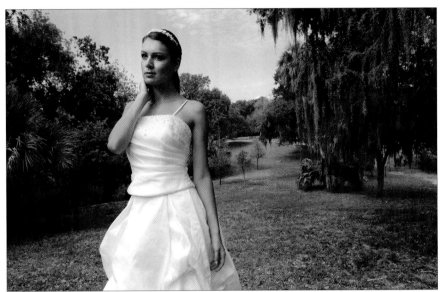

SCOTT KELBY

This technique is very popular with wedding photographers who shoot outdoors. It uses your flash on your subject, who is in broad daylight. They call this "overpowering the sun," but what you're really going to do is set your exposure for a regular daylight shot, then intentionally underexpose the shot by a stop or two, so the photo looks a little dark. Then, you'll turn on your flash, and let it light your subject instead of the sun, which produces a very commercial look. So, first switch your camera to program mode, then hold the shutter button halfway down and look at the settings your camera chose to properly expose this daylight shot. Let's say it's 1/80 of a second at f/11. Switch to manual mode, and dial in 1/80 of a second at f/11. Now, to make the scene darker (underexposed), you'd just change the f-stop to f/16. Take a test shot and see if it's dark enough. If not, drop it down to f/22 and make another test shot. Once it's obviously underexposed, now you turn on your flash, and use it to light your subject. Outdoors, I usually start at full power, and if it looks too bright, I try lowering the power of my flash a bit and then take another test shot. Keep lowering the flash power until the image looks balanced (like the shot above, taken in the middle of the afternoon in direct sunlight).

Getting the Ring Flash Look Using Small Flash

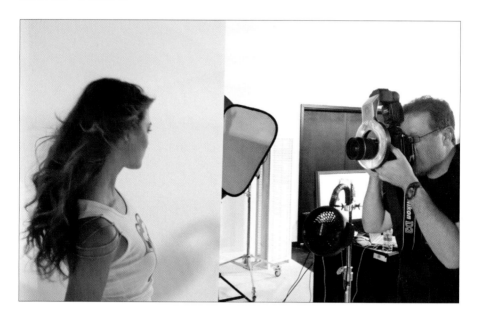

It's one of those looks you either love or you just can't stand (with its flat, bright look and hard-edged shadow behind the subject), and you're probably better off if you don't like it, because ring flashes are big, bulky, and fairly expensive. However, there is a ring flash adapter that fits over your off-camera flash that does a surprisingly good job of giving you the ring flash look (which has become incredibly popular in high-end fashion photography these days) without the ring flash price, weight, or size. It's called the Ray Flash—it slides right over your flash head, and your lens extends through the center of the flash (as seen above). It basically redirects the light from your existing flash into a ring shape and it's really lightweight and doesn't require batteries or anything else.

If You Long for a Real Ring Flash...

I did find a reasonably priced real ring flash from AlienBees that attaches to your camera, and while it is bulkier, heavier, and more expensive than the Ray Flash ring flash adapter shown above, it's not as bulky, heavy, or expensive as any of the other real ring flashes I've seen. I cover it on page 47 in Chapter 2.

What If Your Flash at Full Power Isn't Enough?

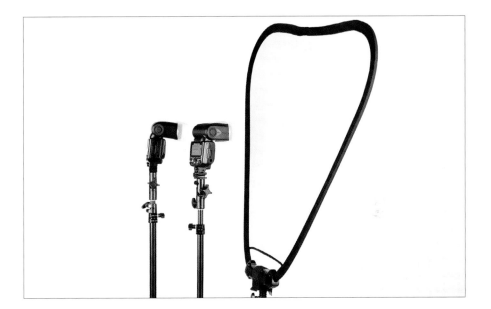

If you're lighting your subject, and your flash is at full power, but it's just not bright enough to do what you want it to do, just add another flash. That's right—pop another flash up there, right beside your other flash, but just make sure you put them both on the same group (so they'd both be assigned to Group A, or both assigned to Group B), so they both fire at the same time. Just like turning on another light in your home adds more light, adding another flash adds more light, too! By the way, adding another flash doesn't double your light output, it just adds about an extra stop of light. To add another stop of light, just add another two flashes, and so on.

Lowering the Power of Your Pop-Up Flash

Nikon

Canon

Some photographers use their camera's built-in pop-up flash as a fill flash when they're not trying to fully light the person they're shooting with flash, and they just want a little bit of flash to help fill in the shadows. The problem is your camera doesn't always know that you only want a little fill, and it usually sends more flash than you actually want, and the photo looks, well…it looks like you used a pop-up flash. However, most cameras actually have a setting that lets you lower the power of your pop-up flash, so if you try the ol' fill flash route and find that it looks more like regular flash, you can dial down the power of your pop-up and try again. On Nikon cameras, you do this by holding down the flash mode button (the one on the front side of your camera, right by the lens—it has a lightning bolt on it), then looking at the control panel on top, and turning the sub-command dial in front so you see a negative number. On Canon cameras, you press the ISO/flash exposure compensation button, look at the top LCD or viewfinder, and turn the quick control dial until you see a negative number. Then take a test shot, look at the results, and see if you need to lower the power some more.

When Not to Use a Diffusion Dome

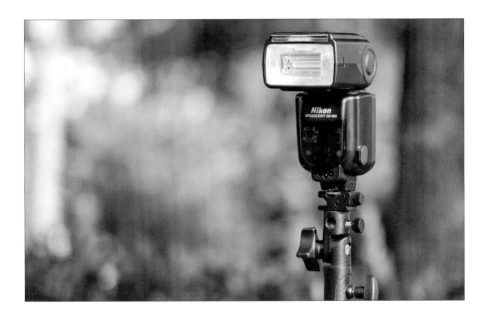

I leave my diffusion dome on my flash almost all the time (I'm usually looking to spread the light and make it softer), but there are a few instances where you don't want that dome on, and it's not just when you want hard, edgy light. For example, if your flash is far away from your subject, take the dome off, because when you're back that far, it will drain your batteries much faster, and since the light is far back, it's going to spread and soften a bit anyway. Another time you'd want to remove the dome is when you're outdoors using it as fill flash.

The Pro Trick for Better-Looking People Shots

One inside tip a lot of big pros use when they're shooting portraits with small off-camera flash is to put a very light orange gel over the flash. It doesn't matter what time of day it is, that orange gel is over the front of their flash. The type of gel is called a ¼-cut of CTO (Color Temperature Orange). If you shoot people, I'd keep this on there all the time for better, more natural-looking color from your flash shots.

Two Other Gels You Really Need

If you want natural-looking color from your flash (in other words, you want the light from your flash to blend in with the light already in the room), there are two colors of gels you're going to need to keep with you, which you put over your flash head: (1) an orange gel, for when you're shooting indoors under regular lighting (usually incandescent lighting), and (2) a green gel, for when you're shooting in an office or building under fluorescent lights.

You May Not Have to Buy These Gels

If you bought a Nikon SB-800, or the SB-900, both come with a set of gels (including the orange and green) right in the box.

Sticky Filters

Gels, for some reason, seem to freak people out who are new to off-camera flash, and even mentioning gels in a live session brings up a host of questions like, "Where do I get them? How do I know if I'm getting the right ones? What colors should I get? How and where do I attach them to my flash? Do I need to cut them down to size?" Well, I guess a company named Midsouth Photographic Specialties heard this so many times, they finally went out and created a set of gels for off-camera flashes in the most requested colors, pre-cut to size, and ready to go. They're called Sticky Filters—just slap 'em on and you're set!

Tips for Lighting Your Background with Flash

Here's a simple little rule that will help you when using your small off-camera flash to light a background wall or seamless background behind your subject. If you want to light the entire background fairly evenly, put your diffusion dome cap on the flash. This spreads the light out wide, and makes it appear smoother and more even (as shown here on the left). Then, back the flash itself away from the wall—the farther it is away, the more the light will spread. If, instead, you want a more defined "spotlight" look behind your subject, just move the flash in closer to the wall behind them and remove the diffusion dome (as shown here on the right).

Using That Little Flash Stand in the Box

If you buy a Nikon or Canon flash, take a look inside the box it came in and you'll find a little black plastic stand (I call it a "foot," but Nikon calls it a "Speedlight stand" and Canon calls theirs a "mini stand"). Anyway, your flash slides right into this little stand, and now you can put your flash on the floor behind your subject, or on a table, and it stands right up. It's like a free mini-light-stand. However, it has a feature a lot of folks miss: the bottom is threaded, so you can screw it directly onto either a tripod, or a standard light stand, and it will hold your flash up higher. Hey, it saves you from having to buy a special adapter just to hold up your flash (though if you mount your flash on a stand a lot, and need a little more control [like tilt], then I'd use my tip from back in volume 2 and buy a Manfrotto Justin Spring Clamp with Flash Shoe for around $57, and then you can mount a flash just about anywhere).

Where You Focus Affects Your Flash Exposure

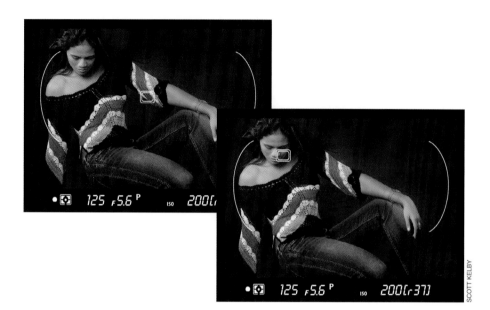

Today's small off-camera flashes do such a great job, partially because they adjust their power output based on the exposure for the shot (Canon calls this TTL for through-the-lens metering and Nikon calls this i-TTL for intelligent-through-the-lens metering, but they mean the same thing). So, why do you care? Well, your flash is going to help make the exposure based on exactly what you focus on in the photo. So, if you focus on your subject, it's going to try to give you a proper exposure for your subject, and vary the amount of flash power based on making your subject look good. However, if you focus on something else, like the background behind your subject, your flash is going to try to light that area instead. This is why, when using small off-camera flash, you need to make sure you're careful about focusing on the area you want to look best. If you do, your flash results will look that much better.

The Paid-Gig Flash Insurance Policy

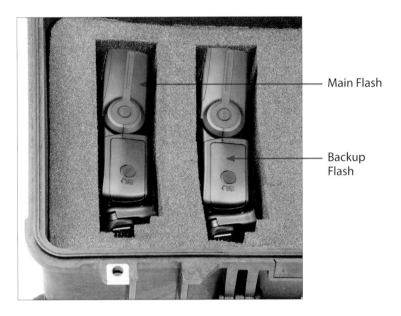

— Main Flash

— Backup
Flash

If you're hired to do a paid gig (like a wedding, or a portrait session, etc.), you want to make darn sure you have a backup flash, because if, for whatever reason, your first flash dies (you drop it, the wind knocks your flash over and it dies, there's some weird problem with the flash unit itself, etc.), at least you can grab the backup. That's not the tip, though. Having a backup for a paying job is an absolute necessity. Here's the tip: make sure the flash you use as a backup is the same make and model as your main flash. That way, if you suddenly have to switch flashes in the middle of the shoot, you're not trying to figure out how it works, or what the settings should be for a flash that doesn't have the same power output, or anything else that might freak you out (in front of the client), because you're not used to working with that model of flash. If you use the same make and model as your backup, and then you swap out flashes, it's just business as usual.

How High to Position Your Flash

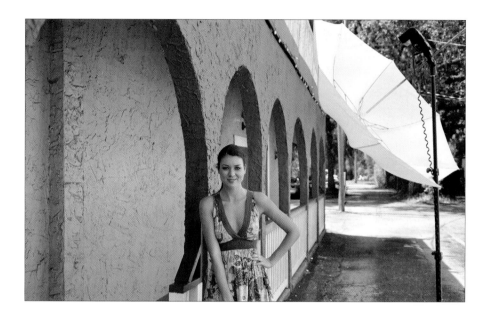

So, you've got your wireless flash all set up, your flash is on a light stand (or a friend is holding the flash for you), and now you're wondering, "How high up do I put this thing and where do I aim it?" Here's a simple way to think about it: position the flash where the sun would be. The sun is usually up in the sky, aiming down at us here on earth, so put your flash up high on a light stand, and angle it so it's aiming down at your subject. If you're inside, pretend there's no roof. You can see the resulting image from this shoot on the book's website at www.kelbytraining.com/books/digphotogv3.

Which Side Should Your Flash Go On?

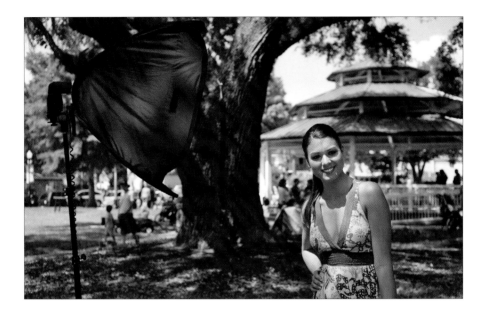

I once heard a famous portrait photographer say he always positions his light on his left side, because back in his days as a news photographer, he used to hold his flash in his outstretched left hand, so he could hold the camera and press the shutter button with his right hand. He's so used to seeing his light from the left, that now, even in the studio, he puts his studio strobe on the left side. I usually light subjects from the left side, too (but I have no idea why—I guess I'm just used to it that way). However, if I'm on location and can't light from the left side, I just move the light to the right side. Not everything to do with lighting has to be complicated. (See page 220 for the final image and recipe for the shoot shown here.)

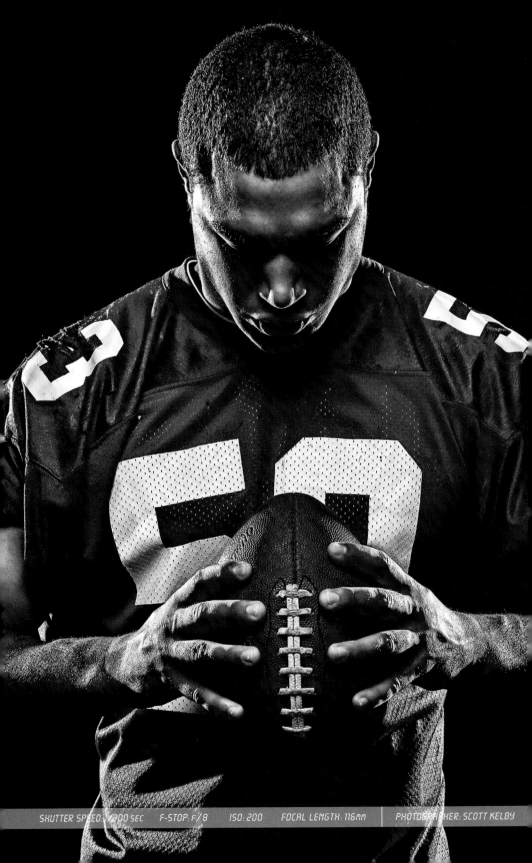

SHUTTER SPEED: 1/200 SEC F-STOP: F/8 ISO: 200 FOCAL LENGTH: 116mm PHOTOGRAPHER: SCOTT KELBY

Chapter Two

Using Your Studio Like a Pro

In Volume 2, We Built It From Scratch. Now, Let's Pimp It!

Back in volume 2, I showed you how, using just a simple, thin piece of plastic that fits easily in your wallet, you can completely and fully outfit a one-light studio from scratch. Well, after I wrote that chapter, people who read it wrote me and asked some really thought-provoking and soul-searching questions like, "What if we want to use two lights?" or "What if we want to add a second light?" and even "What if we have one light, but think we might need another?" I'm not gonna lie to you. I was pretty freaked out. I thought we covered so much in volume 2 that there was no way anyone would want to learn more, so when I originally wrote the outline for this book, volume 3, not only did I not have a chapter on more studio techniques, I specifically didn't mention the word studio, or techniques, or use any words with either an "s" or "t" in them, just in case. But then I realized writing a book without an "s" or "t" in it would preclude me from using my first name, and if that happened, I wouldn't be able to refer to myself in the third person (like, "Scott doesn't want to share more studio techniques" or "Scott made bail"). So, I really had to revisit the whole concept with a fresh set of eyes, and once I did, I realized that not only would I have to include a studio chapter that picks up where volume 2 left off, but I would actually have to rebuild my original studio from scratch, because after volume 2 was complete, and the chapter was done, I built a huge bonfire and destroyed all my gear. That's how "done" I thought I was with studio techniques, but apparently, that's not the case. Scott doesn't like to have to rebuild everything. Scott doesn't like to pull out the thin piece of plastic from his wallet. Scott needs a second job.

The Easy Way to a Pure White Background

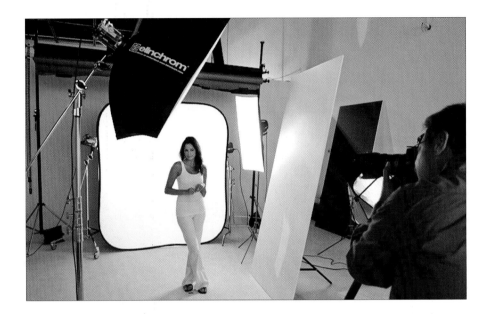

Getting a solid white background (ideal for shooting kids or fashion) can be challenging, because you'll usually need two lights to light it evenly, and you have to worry about balancing the light so there's not a "hot spot," where one side looks brighter. That's why I switched to using Lastolite's HiLite Illuminated Background. Now I have perfect, solid white backgrounds every time (even on location). The HiLite is collapsible, and when you pop it up, you just put a single flash head inside, on either side (or both), and aim it toward the back wall. Then, lower the power of your flash to around ¼-power. Now when you fire your strobe, the light hits the back of the HiLite and evenly spreads out for perfect coverage. There are slots for lights on both sides, but I've used it with one strobe, and it works perfectly—just remember to keep a reflector on the front of your strobe, so it doesn't get too hot. Plus, you can take it on location easily, because it folds up like a large reflector. It takes about three minutes to set up, and is lightweight enough to hold in one hand. To see the final image from this shoot, go to www.kelbytraining.com/books/digphotogv3.

Increase Your Chances of Success With A Shot List

If you're preparing for a studio shoot, take two minutes now and make a shot list—a written list of the types of images you want to create during the shoot. List everything from the lighting setups you want to use, to the poses you want to try, to any props you want to incorporate. When you have a plan, your chances for success go way up!

Strobes with Built-In Wireless Rock!

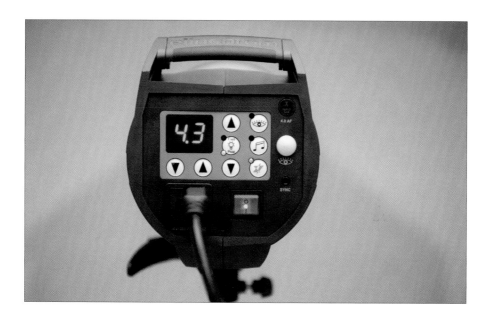

As you can see from the previous page, I'm always looking for an easy way to do…
well…pretty much everything (after all, the simpler it is, the more time you can spend
shooting, right?). Well, Elinchrom's new BXRi strobes come with a Skyport EL wireless
trigger built right in—all you need is the transmitter that slides into the hot shoe on the
top of your camera. Besides the fact that the wireless capability is built right into the
strobes, there's something I think is even more helpful: you can now control the power
of all your strobes from right at your camera using the transmitter. That means if you
have a strobe as a hair light up on a boom, and it's too bright, you can just turn down
the power while you're right there at your camera—no pulling the boom stand down
(or climbing up on a ladder) to change the power on the back of the strobe. It controls
up to four different groups of strobes, so you can have one assigned to your main light,
one to a hair light, and one to a background light, and control them all without ever
leaving your camera. I know—pretty sweet. You can get a kit from B&H Photo with two
of the 500-watt BXRi strobes, two 26" softboxes, two light stands, two cases, and the
wireless transmitter you need to make it all wireless, and the whole thing is around
$1,550, which I think is a steal for this quality of a rig (I have one myself).

Using a Set Background

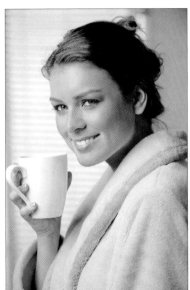

SCOTT KELBY

If you're shooting in the studio a lot, it won't be long before you get bored with shooting on white, gray, and black seamless paper, and the easy way to leverage those is to create your own sets (don't worry—it's much easier than you'd think). Notice I didn't say "build your own sets" (that's too much work). So, to make this work, you'll need to: (1) Go to your local Salvation Army, Goodwill, or thrift store (or keep an eye out at garage sales) for things like room dividers with shutters, large frames, coffee tables, an old couch, lamps on stands, basically just "stuff" to go in the background. It really doesn't matter that much what it is because of #2 and #3. Now, (2) you need to create some depth between your white, gray, or black seamless and your subject, then put your set pieces in between them (so it goes: seamless, a few feet of empty space, then your set pieces, a few more feet, then your subject—to see the setup for the shot on the right above, go to www.kelbytraining.com/books/digphotogv3). Then (and this is key), (3) you need to shoot at a pretty wide open aperture like f/4, or f/2.8, so the background elements are thrown so far out of focus that you can't tell if your shot was taken in a large mansion, or in a bedroom, or in a studio. I'm consistently amazed at how well just putting a few simple things in the background can look when you follow rules #2 and #3. Also, if you find anything you can hang off a boom stand—so it looks like it's hanging from a ceiling in the background—that will help sell the effect big time. Remember, what makes this work is the depth between your background, your set pieces, and your subject, and the very shallow depth of field. You'll be amazed at the results.

You've Got to Have Music During the Shoot

Ask any pro who shoots people for a living, and they'll tell you that they have music on during the shoot. Having that music playing in the background goes a long way toward making the people you're shooting more relaxed and comfortable, which usually translates into better looking images (if they're relaxed and having fun, the photos will look that way, too). All you need is an iPod (or any other portable media player)—go download some songs, get a small iPod-compatible speaker, and you're set. Now, here's the thing: for this really to make a difference, don't just play your favorite music (that will only make you feel relaxed and comfortable), you want to play your subject's favorite type of music. The type that will have them on the set saying, "Oh man, I love this song!" For this book, I shot with a number of professional male and female models, and I'd always ask them what type of music they liked. Sadly, they never choose old school funk or '80s big hair rock, or I would have had them covered. Instead, they wanted the same music they listen to at home and in their car: R&B, hip hop, rock, rap, and alternative. So, I called another photographer I know (my buddy, Terry White) who always has great music playing during his shoots, and I asked him where he got his music. Well, no surprise, he had one of his models pick it out, and he said, almost without exception, he gets raves from models in the studio about his musical taste. He made an iTunes iMix of his collection for me to download, and he was nice enough to let me share that iMix with you. Just go to www.kelbytraining.com/books/digphotogv3 and click on the link, which will launch iTunes and take you to that playlist, where you can buy one or all of the songs with just a click.

The Beauty Dish Look

If you want a look that isn't as soft as one with a softbox, but isn't as hard-edged as a bare-bulb strobe, you should try a beauty dish. The light it produces is kind of in between the two, giving you more punchy contrast without getting too harsh or edgy. A beauty dish attaches to the front of your strobe (like a softbox), but it looks more like a giant metal reflector. The light it produces has more "kick," which creates a very nice look for close-up face and headshots (because of the way it defines the face and skin tones), and it's great for anything you want to have that beauty look you see so often in makeup and beauty product print ads. You can also get a "sock" for your beauty dish, which covers the front to give you a little softer look. When you use the dish, it's usually positioned directly in front of your subject, up high, and tilted down at them at a 45° angle (as shown here). You have to kind of shoot under it. You may also want to put a reflector flat at your subject's chest level to fill in the shadows under their eyes (see page 50). Also, depending on which brand you buy (I use a 17" Elinchrom beauty dish), you'll probably have to choose between a white dish interior and a silver one. I chose the white because it's a little softer (the silver is more reflective and contrasty).

Using Grid Spots

If you took your softbox off your strobe, the light from the flash bulb would pretty much just go everywhere. That's one of the reasons we use softboxes in the first place—to help us put the light where we want it and greatly soften it, of course, but softboxes are, by nature, soft. That's where grid spots come in. These attach right over your strobe's reflector (the kind I use actually snap right into the reflector), and they have a metal honeycomb pattern that gives you a narrow, focused beam for very dramatic effects (the light will be hard-edged, because there's no softbox—it's a bare bulb with a metal reflector and a grid spot). Right now, you see these grid spots used big time as back-edge lights in portraits (in fact, I'm not sure you can find a magazine editorial-style cover shot in the past year that doesn't use at least one, if not two, rear grid spots, putting a white highlight on either side of the subject). These come in different degrees (like a 10° grid, a 20°, and so on), and the lower the number, the tighter the beam (I usually use a 20° or 30° grid). There's not much to using them. You just snap them into place and that's it—your beam is greatly narrowed. Put one on either side of your subject, aim them at the sides of their face, then use a strobe up front to put some fill light into their face, and—voilá—you've got the look. Well, there is a little more to it—make sure you see the last chapter of the book for more on this look—but it all starts with a grid spot.

Shooting Tethered Directly to a TV Monitor

SCOTT KELBY AND JVC

If you want to see a much larger view of what you would normally see on the tiny LCD on the back of your camera, try tethering your camera to a television monitor. Most newer dSLRs have some sort of video output (the newer, high-end Canon and Nikon bodies even have HDMI outputs), so you can take the video cable from your camera, go straight to the input on the television monitor, and see your LCD at a huge size. This is different than tethering your camera to a desktop computer or a laptop, because the images are still being burned onto your memory card (rather than being imported into a computer), and with this type of tethering, the TV monitor does actually take the place of, and do all the same functions as, your camera's LCD screen. So, you can see highlight warnings, see your camera's settings, and everything you would normally see on your camera's LCD, but now you see it huge! I can't tell you how helpful it is to see your images at this large a size, because you can see exactly what the light looks like, you can see exactly how sharp your images are, you'll catch mistakes you'd miss looking at a 2.5" or 3" LCD, and your subjects will love being able to see themselves at this size. I find it really gets them excited when they like what they see onscreen, and that turns into much better images all around. So, what do you need to make this happen (besides the TV, of course)? You'll need whichever cable your particular camera uses as a video out (many dSLRs come with this cable right in the box). That's all it takes.

Getting Your Laptop Nearby for Tethering

SCOTT KELBY

If you decide you want to tether directly to your laptop, where your images are downloaded into your computer, so you can sort and tweak them as you shoot (I showed how to do this in volume 2), then having your laptop in a convenient spot is real a time saver, and this rig (shown above) is about the easiest and most stable way to get there. It's a metal platform called the Gitzo G-065 Monitor Platform, which screws right into a standard tripod, and it's just the right size for a 15" laptop. If you often shoot using a tripod, then you can have this one tripod do double-duty by adding a Manfrotto 131DD Tripod Accessory Arm for Four Heads. This is a horizontal bar that screws onto your tripod, then you can attach the Gitzo Monitor Platform with your laptop on one end, and on the other end, you can put the ballhead that would normally be alone on your tripod. This way, one tripod holds them both, and they're right there together. Pretty sweet!

Judging Your Image Quality Onscreen

Here's something to keep an eye out for: when you open your image on a large-screen computer monitor (24" or larger) and view it at 100%, chances are it's not going to look tack sharp, but keep in mind that you're seeing it at a "larger than life" size. Zoom out until the size you see onscreen is approximately the physical size you plan to print the image. If you plan to print the image at a large poster size, make sure you back up at least six feet from the monitor to see the image at the same view everybody else views large images.

The Most Useful Inexpensive Accessories

If you don't have a roll of gaffer's tape in your studio, put down this book, go online, and order a few rolls right now. Not duct tape. Not electrical tape. Gaffer's tape! It's one of those things that once you have it, you'll wonder how you got through a shoot without it (ask any studio photographer). You'll use it for everything from holding grid spots in place, to fixing a gap in a softbox, to keeping things together when doing product shots, to...I could go on and on. The other thing you need about six, or so, of are A-clamps. They're another one of those things that should be in every studio, and you'll use them for everything from hanging things from a boom stand, to pinning back clothing on your subject to get rid of wrinkles (which is why you need small ones and large ones). You'll find these at your local hardware store (or go online) and you'll find a hundred uses for them. Keep these two inexpensive accessories around, and you'll keep from pulling your hair out—and it'll keep the shoot moving ahead (instead of coming to a halt while you run to the store).

Why You'll Love Rolling Light Stands

At some point, you're going to wind up buying light stands for your studio, so here's a bit of advice that will make life in your studio much easier: buy light stands with wheels. There are two big reasons you'll want to do this: One is pretty obvious—you'll be moving your lights a lot, and it's much faster and easier to roll them around than pick them up and move them. Plus, I've found (and I've seen firsthand with other photographers) that you're more likely to move your lights, and experiment, if they're on wheels. The second advantage is safety. Lights are top-heavy, and all the weight—the strobe, the softbox, and any accessories—is at the top of the stand. When you pick one up to move it, it's easier to bang it into something, or lose balance and topple the whole rig over, than you'd imagine (believe me—I've seen it). Whatever it costs you for wheels, you'll make back quickly by avoiding repair bills, potential injuries on the set, and visits to the chiropractor.

Why You Need Sandbags

I don't care how sturdy a boom stand you buy, one day (probably soon), it's going to go crashing over. The best-case scenario is that it just breaks your strobe's bulb, or the strobe itself, or maybe just tears your softbox. The worst-case scenario is that it falls on your subject, your client, a makeup artist, or a friend. It's not a matter of *if* it happens—it's like a hard drive crash—it's a matter of *when* it happens. That's why you ab-solutely need to have some sandbags, and to use them religiously when you've got any-thing on a boom or if you take anything outside on a shoot (where the wind can blow it over). B&H Photo sells empty sandbags—when they arrive you just fill them with sand (you can also find some pre-filled bags, but prepare to pay for shipping them). You can find them at your local hardware store, as well. Once you get them, put them on the legs of your boom stand to balance the weight, or hang them off the boom arm to add a counterweight (as shown above), or both, and take a big worry off your big worry list. Another thing to watch out for: be careful when removing your sandbags, because if the weight of them is keeping the boom from tipping over, when you remove the sandbag, your boom could topple right over. So, just keep an eye (or a hand) on things when you're taking them off.

Monolight vs. Battery Pack

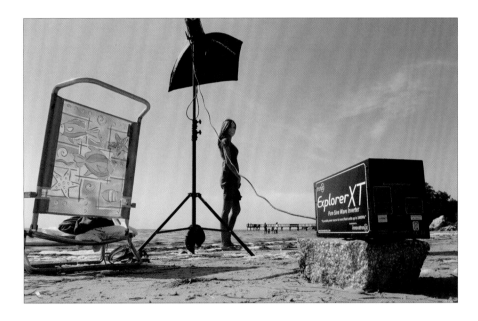

A monolight (also sometimes called a monoblock) is just a regular studio strobe that you plug right into a wall socket like a regular lamp. If you want to take studio strobes out on location, instead you use a battery pack and special strobe heads made to run off batteries (for example, I use an Elinchrom Ranger kit, which is a battery pack and strobe head). The advantage of something like a Ranger kit is you can take your studio lighting outdoors (to the beach, in the desert, out on a boat, etc.), but the disadvantage is you have to use special "made for the battery" strobe heads. However, now more and more companies are selling battery packs that let you plug your regular studio strobes right into them (for example, I've been using a battery pack called an Explorer XT, from Innovatronix, that lets me plug in up to two of my regular studio strobes, and it was fairly affordable compared to dedicated packs—around less than half the price). So, instead of having to buy strobe heads and a battery pack, if you already own studio strobes, all you have to buy is the battery pack. Sweet!

One Background, Three Different Looks

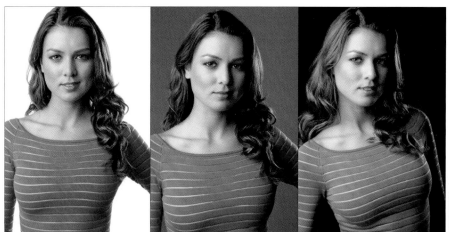

SCOTT KELBY

One nice thing about buying a white seamless background is, depending on how you light it (and what shutter speed you use), you can get three different looks. Here's how:

(1) To have a white background, you have to light it, so position a light (or ideally one on each side) down low, aiming up a bit to light the background. That gives you white.

(2) To have a gray background, just turn the background light(s) off. White paper needs light not to look gray, so when you turn those lights off, it gives you gray—your second color from the same white background.

(3) To get a black background, leave the lights off, and increase your shutter speed to as high as your camera will allow (your maximum sync speed), which is probably 1/200 or 1/250 of a second. This makes your background go even darker—to at least a very dark gray or a solid black—just by changing the shutter speed. What you're essentially doing is, by raising the shutter speed, you're eliminating any light already in the room (called "ambient light").

Using a Ring Flash

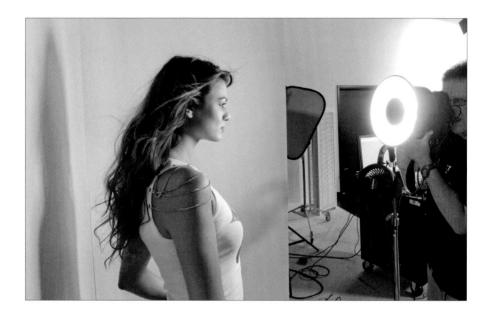

The hot look right now for fashion photography is to use a ring flash, which is a series of small flashes that form a circle around your lens, and give a very flat look with a fairly hard shadow behind your subject. In the chapter on flash (Chapter 1), I showed an adapter you put on your small off-camera flash to imitate a ring flash look, because ring flashes can be pretty expensive. However, I found one that's reasonably priced for someone who's not going to be making their living as a fashion photographer, but sometimes wants that flat, ring flash look. It's the AlienBees ABR800, and it's not terribly heavy (as ring flashes go—they are fairly bulky and heavy by nature), but works surprisingly well considering its $399 price tag (you can spend over $1,000 on a ring flash pretty easily). You can check out page 223 for a photo taken with the AlienBees ring flash, so you can see the type of look you can expect from one.

Using V–Flats for Fashion

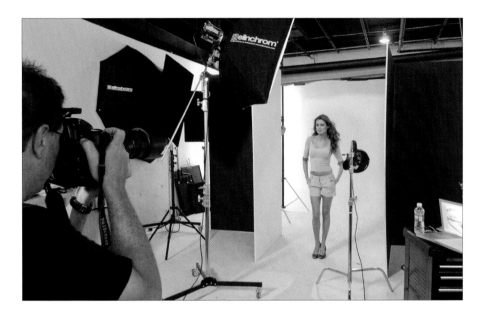

If you're shooting fashion, you're probably going to be shooting a lot of ¾-length and full-length shots, and if that's the case, you'll probably want to get some V-flats (these are actually large foam core sheets that are approximately eight feet tall by three or four feet wide, and you can usually find them with one side black and one side white). You'll use the white side as a giant full-body reflector, placed either directly to the side of your subject (on the opposite side of your main light), or in front and little bit to the side, leaning back a bit to throw some light back toward your subject. The reason these are called V-flats is because you take two of them, form a large V-shape, and tape them together on the seam. That way, you can stand them up and position them where you need them, without having to use a stand of any kind. Also, since one side is black, you can use the black side as a flag (to keep background lights aiming forward at your subject from spilling through to the camera and creating lens flare), or you can face the black side toward your subject, which subtracts light from the scene and gives a dramatic edge to your subject. To see the resulting image from the shoot above, go to the book's website at www.kelbytraining.com/books/digphotogv3.

Catch Lights and Why You Want Them

SCOTT KELBY

You know that reflection of your softboxes that appears in your subject's eyes? Those are called catch lights, and you want them. Badly. Without them, your subject's eyes won't have any sparkle to them and will look like dead, lifeless pools of despair (okay, that's pushing it a bit, but you get the idea). So, don't freak out, or as I've had people suggest in emails to me, try to remove them in Photoshop. Instead, make sure they're there, because they're supposed to be there. Now, that being said, the next time you see another studio photographer's work, take a good close look at the subject's eyes and you can usually not only tell which type of softbox they used (square, round, an umbrella, an octagonal softbox, a beauty dish, etc.), but you'll also be able to see the position of the light (if they had it right in front, over to the side, etc.). And, if you see another catch light at the bottom of the eye, you'll know the photographer used a reflector positioned down low to put some light back into the eyes. It's kind of a mini-lighting lesson each time you take a close look.

Reflectors: When to Use Silver or White

Reflectors come in different colors, but probably the most popular are white, silver, and gold (although gold is usually used outdoors, because adding warm yellow light in with white studio lights usually looks kinda weird). So, that leaves silver and white—which do you use when? Here's the general thinking on this: Silver reflects much more light, so you'll use silver when you position the reflector back away from your subject. If you need to get a reflector right up close, that's when I'd use white, because it doesn't reflect nearly as much light as silver. (See page 231 for the final image from this shoot.)

Reducing Glare in Glasses

If your subject wears glasses, seeing a reflection of the softboxes in their glasses is not uncommon, but you don't want such a strong reflection that it interferes with or covers their eyes. If that's the case, just move the main light to the side until the reflection goes away (it's easier than you'd think, because you'll see the modeling light reflecting in their glasses). However, what's important is that the glare is gone from the angle where your camera is set up, not from where you're standing moving the light. So this will go quicker if you have a friend or assistant move the light while you stand at the camera and tell them, "keep going…keep going…" until you see that the reflection is gone.

Using a Gray Card to Nail Your Color

SCOTT KELBY

If you're going to be post-processing your images using a program like Photoshop, or Photoshop Elements, here's a trick that will make the color correction process absolutely painless, and nearly automatic. Once you get your lighting in place, have your subject hold up a gray card target that has medium gray, light gray, black, and white on it (the one shown here is a target that comes free with my book, *The Adobe Photoshop Book for Digital Photographers*), then take a shot with it clearly in the frame. That's it—you need just one shot with the subject holding the card. Now, when you open your photos in Photoshop (or Elements), open the Levels dialog, click on the gray Eyedropper that lives in the dialog, and click it on the medium gray color swatch. Then click the black Eyedropper on the black swatch, the white Eyedropper on the white swatch, and that's it—you've color corrected that photo. Now you can open any other photo taken in that same lighting setup, and press Command-Option-L (PC: Ctrl-Alt-L) to apply that exact same color correction to this new photo. You can also use this same card for adjusting just the white balance of a RAW photo. Open that same photo in Photoshop's Camera Raw (or Photoshop Lightroom's Develop module) and get the White Balance tool from the Tool-box (or the Basic panel), then click it once on the light gray color swatch, and now your white balance is set. You can now apply that same white balance to all your RAW photos by copying-and-pasting just that white balance setting to as many photos as you want at once. A huge time saver.

Don't Light Your Whole Subject Evenly

SCOTT KELBY

The first two things the human eye naturally focuses on in a photo are the brightest part and the sharpest part of the photo. Keep this in mind when you're shooting in the studio or on location (even with small off-camera flash), because if you light your entire subject evenly, you won't be directing your viewers to look where you want them to, which in most portraits is the subject's face. For a more professional look, you want their face to be perfectly lit, and then the light should fade away as it moves down their body. How much it fades away is up to you (it can fade to black if you want, but again, that's your call), but when looking at your photo, it should be clear by the lighting where you want people viewing your image to look. One way you can control the light is to position it so it doesn't light all of your subject evenly, or to use a fabric grid, so the light doesn't spill everywhere, or even to use something to block the light from lighting the person's whole body evenly. I use a black flag (a 24x36" cloth flag) and position it under the light (usually on a boom stand), so the light is mostly concentrated on my subject's face. It doesn't have to block all of it—unless I want the person's body to fade to black—it just has to cut down the amount of light that falls on the rest of them. Take a look at your favorite portrait photographers, and you'll see this lighting technique used again and again to create interest, focus, and even drama in their images.

The Difference Between Main and Fill Light

SCOTT KELBY

When working with more than one flash, you've probably heard the terms main light (also called key light) and fill light. Here's what those mean: Whichever flash you choose to do most of the lighting of your subject is the main light. It's as simple as that. If you use another light that is not on the background, or on the subject's hair, *and* the flash isn't as bright as your main light, that's the fill light. The fill light is usually used to add just a little extra light to your scene. For example, let's say you're doing a profile shot of your subject. The profile light goes to their side, and a little behind them. Most of the light appears to come from behind and just a little bit of light falls on the side of their face that faces the camera. But what if it still looks a little too dark? Well, that's when you might add another flash in front (I'd put it opposite the flash behind them), but you'd lower the power of this flash way, way down, so just a little bit of light appears—just enough to fill in those shadows (to see the setup shot for this, go to www.kelbytraining.com/books/digphotogv3). That's a fill light, and now you know the difference between the main light and a fill light.

Avoiding the Flash Sync Speed Black Bar

SCOTT KELBY

If you're shooting in the studio, or with an off-camera flash, and you start seeing a black bar, or black gradient, across the bottom or either side of your photo, that's because you're shooting at too high a shutter speed for your camera to sync with your flash. Generally, the flash sync speed (the maximum shutter speed your camera will sync with a flash) is either 1/200 or 1/250 of a second (depending on the make and model of your camera). So, if you see that dreaded black bar, just lower your shutter speed to 1/250 of a second or slower, and that should take care of it.

Chapter Three

The Truth About Lenses

Which Lens to Use, When, and Why

One of the questions I get asked most is, "Which lens should I buy next?" Of course, I have to ask a question of my own before I can answer that question, and that is, "How stable is your marriage?" I ask that because if you have a really stable marriage—one that's based on trust, caring, compassion, and a healthy fear of handguns—it's entirely possible that it can endure having one of you become a serious photographer. Otherwise, I refuse to answer the lens question, because having a serious photographer in the family is going to seriously test the strength of your marriage. For example, there will come a day when you'll be faced with the decision of whether to get that new super-sharp, fast f/2.8 lens or to stay married. That's because, in most marriages, one spouse controls the funds, and it should never be the spouse that's into photography, because there will come a day, mark my words, where you'll be holding your mortgage payment book in one hand and the B&H Photo catalog in the other, and you're going to be faced with a moral dilemma that will test the very mettle of your commitment to your spouse, family, and friends. You'll start to ask yourself crazy questions like, "How would we do living on the streets?" and "Would our friends sneak us food?" and "I wonder if they'll throw in a free polarizing lens?" These are not the kinds of questions you want to be asking yourself at this stage of your life (by the way, the more expensive the lens, the more free stuff you should try to get thrown in). Anyway, if one day you're faced with one of these really tough decisions, I'll give you the same advice I gave my own daughter, "Honey, you can always find another husband, but a great sale on some really fast glass only comes along once in a lifetime." (I didn't say those exact words, but it was definitely implied.)

When to Use a Wide-Angle Lens

A regular wide-angle lens (as opposed to a "super wide") is around 24mm to 35mm, and it's just about a must if you're shooting landscapes, because the wide aspect takes in more of the scene (think of how much more wide-screen video takes in—it's kind of like that). Wide angle is also very popular for shooting environmental portraits (the type of images you see in magazines when they're doing a feature on a celebrity, politician, or a business exec, where the portrait takes in a lot of their surroundings). For example, if you're shooting a fireman in the fire station, with wide angle, you include a little, or a lot, of a fire truck in the shot, as well. They're also great anytime you want to create a view of something—just get in real close and things get interesting. You can buy wide-angle zooms (which are what I prefer) that zoom from wide-angle to normal (like a 24–70mm), or even a super-wide zoom that goes from 12–24mm. I GRAB THIS LENS FIRST WHEN...I'm going to shoot landscapes using a non-full-frame camera body.

Scott's Gear Finder

Wide-Angle AF Nikkor 24mm f/2.8D Autofocus Lens (around $360)

Canon Wide-Angle EF 24mm f/2.8 Autofocus Lens (around $310)

Sigma 28mm f/1.8 Lens (around $380) [for Nikon, Canon, and others]

When to Use a Fisheye Lens

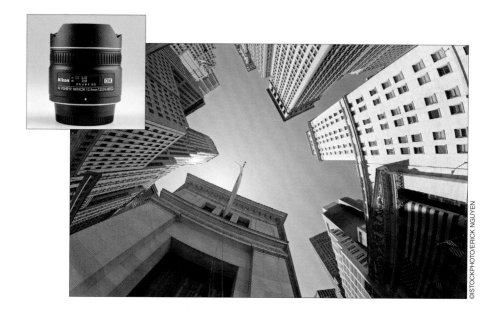

©ISTOCKPHOTO/ERICK NGUYEN

These are well named, because they give you an incredibly wide, almost circular view (and the lens itself bulges out like a fish's eye, but honestly I don't know if the lens was named for how the lens looks, or for how the photo it takes looks). This is definitely a special-effects lens that you want to use occasionally, because the fisheye look can get old fast if you use it too much. However, in the right circumstance, it looks really fascinating (try holding it up high over your head when you're in a crowd, or at dinner in a restaurant, and shooting straight down). One thing about fisheye lenses is that they do distort the horizon line quite a bit. For the minimum amount of distortion, try to keep the lens level in front of you, but if you want more creative looks, then all bets are off— just have fun with it. I GRAB THIS LENS FIRST WHEN…I'm going to be in a crowd, when I'm shooting up high in a sports stadium and want to take the whole thing in, or when I'm shooting skyscrapers and want to get them all.

Scott's Gear Finder

Nikkor AF 10.5mm f/2.8 Fisheye Lens (around $700)

Canon EF 15mm f/2.8 Fisheye Lens (around $660)

Sigma 10mm f/2.8 Fisheye Lens (around $700) [for Nikon, Canon, and others]

When to Use a Telephoto Zoom

When you want to get up close and in tight, this is the ticket. Now, you could just get a telephoto lens (one where the length is fixed, like a 200mm telephoto), and not a telephoto zoom (where you can zoom in from one length, like 80mm, all the way through to a really close view, like 300mm), but then if you hold the camera up and you're either too close, or too far away, your only option is to physically move up close, or back up. With a telephoto zoom, you can simply zoom in tighter, or zoom out if you're too close, which makes all the difference in how you'll compose your shots. I use telephoto zooms for everything from portraits to sporting events to architectural shots (I prefer to zoom in and focus on an interesting aspect or individual part of the building, rather than trying to show the whole thing at once). I GRAB THIS LENS FIRST WHEN...I'm shooting portraits or sports.

Jump Start Your Creativity By Using Just One Lens

The next time you're in a creative rut, try going out shooting and use just one lens the entire day (or if all you have is a zoom lens, try picking one end of the zoom [wide] or the other [telephoto] and shoot at that one focal length the whole day). Not having the lens you need for a particular shot forces you to get creative.

When to Use Super-Fast Lenses

If you want to shoot indoors without using flash (like in a church, museum, theater, or anywhere flash and/or tripods aren't allowed), then you need a really fast lens (which just means a lens whose f-stop goes to a very low number, like f/1.8 or, better yet, f/1.4. The lower the number, the lower light you'll be able to shoot in without using a tripod). Here's why this is so crucial: when you shoot in a dark place, the only way your camera can make a photograph is to slow down your shutter speed, so more light makes its way into your camera. That's not a problem if your camera is mounted on a tripod, because it's perfectly still, however, if you're hand-holding your camera (which is going to be the case in almost every church, museum, etc.), and your shutter speed falls below 1/60 of a second, you're going to have photos that look okay on the back of your camera, but when you open them later on your computer, or have them printed, they will be incredibly blurry and basically unusable. So, by setting your camera to f/1.8 or f/1.4, you'll be able to hand-hold in lots of places and have sharp, clear images where normally they'd be blurry as heck. In this case, less (a lower number) is more. I GRAB THIS LENS FIRST WHEN...I'm shooting a wedding.

If You're Really Serious About Getting Sharper Images, Try This Trick!

You can use the same technique sharpshooters (with rifles) use to minimize any movement while firing—they hold their breath. That's right. When hand-holding, some pro photographers only shoot after they exhale (or they take a deep breath and hold it, then shoot). This minimizes body movement, which minimizes camera shake.

When to Use an Ultra-Wide Zoom Lens

Although you see this lens used in creative ways for everything from portraits to travel photography, this is really a lens born for landscape photography. In fact, it's so wide it may be the ultimate lens for landscape photography (if you're a DVD or Blu-ray movie buff, think of a super-wide-angle lens like anamorphic wide screen). These lenses go as low as 12mm, and my favorite is my 14–24mm f/2.8 lens. If you find a lens below 12mm (like an 11mm, or 10.5mm), it usually means that it's a fisheye lens (see page 59), so I would stay away from that for most serious landscape work. Now, if you have a dSLR with a full-frame sensor, and you use a wide-angle zoom that's made for full-frame sensors (like a Nikkor 14–24mm f/2.8), it will capture a much wider image than it would if you used that same lens on any regular dSLR that isn't full frame (see page 72 for more on full-frame vs. regular), or if you used a regular lens on a non-full-frame camera. (This is where full-frame cameras really shine—when you want to go wide. In fact, when it comes to lenses, wide-angle is probably where you see the biggest improvement, because you get a really, really wide view with full-frame cameras.) I GRAB THIS LENS FIRST WHEN...I'm shooting landscapes.

When to Use a Super–Telephoto Lens

We call this "the long glass" (because the lens barrel itself is often very long), and it's designed to get you in really tight on whatever you're shooting. Typical focal lengths for these lenses would be from around 300mm up to around 600mm (or higher). They are mostly used for sports photography, aerial photography, and for shooting wildlife and birds. You can buy fixed focal lengths (like a Canon 400mm f/5.6), but they also make super-telephoto zoom lenses, as well (I use a Nikkor 200–400mm f/4 zoom myself). If you want a lens that will shoot in lower light (like an f/4 or an f/2.8), it can get really pricey (for example, the Canon 500mm f/4 lens runs around $5,800)—they're so expensive because the very low f-stop lets you shoot in lower light, like a night game, and still freeze motion. However, if you generally shoot sports in the middle of the day, in nice bright sunlight, then you can get away with buying a less expensive super-telephoto lens (like the Canon zoom telephoto EF 100–400mm f/4.5–5.6 for around $1,460). Also, if you buy a long lens, you're usually going to need a monopod to support it (your monopod screws into a hole on a bracket on the lens, and your camera is supported by being attached to the lens. It works much better than it sounds). I GRAB THIS LENS FIRST WHEN...I'm shooting sports.

Using a Teleconverter to Get Even Closer

I talked briefly about teleconverters back in volume 1, because they're such a handy and relatively inexpensive way to get you in tighter to the action. What these do is zoom your whole lens in a little closer, usually either 1.4x closer, 1.7x closer, or even 2x closer (though I only recommend the 1.4x teleconverter, because the quality doesn't change noticeably like it does with a 1.7x or 2x extender). As long as you buy a quality teleconverter (both Nikon and Canon make very good ones), there's only one potential downside, and that is you lose around one stop of light for a 1.4x (more for higher ones). So, if the lowest number your lens would go was f/2.8, when you add a teleconverter, now the lowest number is f/4. I say potential downside, because if you shoot in broad daylight, losing a stop of light isn't a big problem for you. But, if you shoot under stadium lighting at night, then it's a problem, because you can't afford to lose that stop of light—it might mean the difference between sharp shots and blurry movement. I GRAB A TELECONVERTER FIRST WHEN...I'm shooting sports or wildlife in bright daylight.

Teleconverters Don't Work with Every Lens

Before you buy a teleconverter, make sure it works with your lens—not every lens will work with a teleconverter. Look on the order page for the teleconverter and it will usually list the lenses that it either will or won't work with.

Lenses with VR or IS Built In

Nikon

Canon

Lens manufacturers know that people have a hard time hand-holding their cameras in low-light situations, so they started adding features that automatically help keep the lenses from moving, so you get sharper shots in low light. Nikon calls their brand of this "anti-movement" technology VR, for Vibration Reduction, and Canon calls theirs IS, for Image Stabilization. They're both well-named, because that's what they do—they hold your lens steady for you, so you get sharper shots, but it really only makes a difference when you are shooting at a slow shutter speed (you'll get no improvement when you're shooting in broad daylight, because your shutter speed will be so fast [which freezes any motion], that there's no reason for VR or IS to kick in). What VR and IS do is let you hand-hold in lower light situations, so if you wind up shooting a lot in churches, museums, theaters, and other low-light locations, you should probably keep an eye out for VR or IS lenses (they usually cost a little more). Also, you won't often find this feature in already very fast lenses, like an f/1.8 or f/1.4. One more thing: if you're shooting on a tripod, you should turn VR or IS off (there's a switch on the lens) to reduce any shake caused by the VR or IS searching for movement.

Using Active VR for Nikon Users

If you're a Nikon shooter, your VR lens may have a setting called Active, and that only needs to be turned on when what you're standing on is moving (if you're shooting from a boat, or a moving car, or a suspension bridge, etc.).

Using Filters with Your Lenses

There are literally hundreds of different filters you can slap on the end of your lens to either fix a problem (like to help you capture something your camera can't expose properly for) or create a look, but I only own three filters, and one of them I don't really use as a filter (more on that in a moment). They are:

(1) A Neutral Density Gradient Filter. This is mainly for people shooting landscapes, and it fixes a problem that happens when you expose for your foreground in a landscape shot and the sky gets totally washed out. You put this in front of your lens, and it darkens just the sky, so the sky looks right and the ground in front of you looks right (see Chapter 5 for more on this filter).

(2) A Circular Polarizer (shown above). Another landscape filter, and one no landscape photographer should be without. While it's designed to greatly reduce reflections in things like lakes and streams, which it does brilliantly, most folks use it to darken the sky. It's like putting a pair of sunglasses over your lens. The world looks less annoyingly bright.

(3) A UV Filter. Technically, this filters out unwanted UV rays from your lens, but what we all use it for is to protect our lens from getting scratches on it. Putting this filter on puts a thin piece of glass between your lens and anything that would scratch, or worse yet, break it. They're very cheap, so if one breaks or gets scratches, you just replace it. Life goes on. Get a scratch on one of your lenses, and they'll hear you weeping six blocks away. I buy a UV filter for every lens I own.

The Deal on Lens Hoods

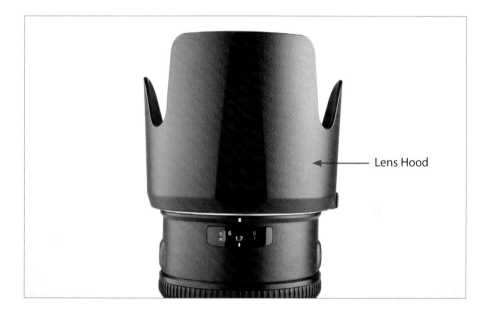

Lens Hood

Besides making your lens look longer and "more professional," a lens hood serves two very important roles (one advertised, one not as much). The first is that the lens hood helps keep lens flare from the sun, or from a flash, from getting to your lens and washing out your photos. Most good quality lenses these days come with a lens hood that is specifically engineered to work with that particular lens. The other, less publicized, use is to protect your lens from getting scratched or broken while it's slung over your shoulder as you walk around. I can't tell you how many times I've banged my lens against a chair, the end of a table, even a wall when coming around a corner, but all I ever hear is the sound of plastic, and it bouncing right off. If I didn't have a lens hood, I'm certain I would have had a number of scratched or broken lenses, but so far—not a one. I keep my lens hood on all the time. Besides, they look cool (don't tell anyone I said that). By the way, you can turn your lens hood around, facing back toward you, when storing it in your camera bag, or when it's not in use. I GRAB A LENS HOOD...anytime one comes with my lens, and I keep it on always.

When to Use a Macro Lens

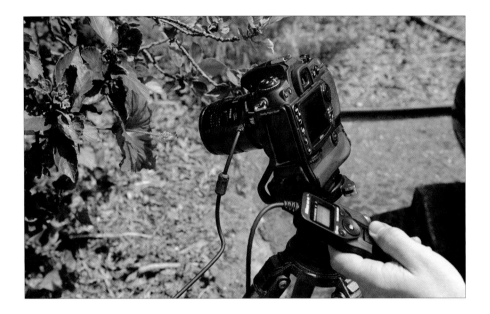

This is the lens you pull out when you want to shoot something really, really close up. Ever see those photos of bees really close up, or flowers, or ladybugs? That's macro. Dedicated macro lenses just do that one thing, but they do it really, really well. There are a few things you need to know about macro lenses:

(1) They have an amazingly shallow depth of field. So shallow that you can be shooting a flower, and the petal in the front will be sharp and in focus, and a petal on the other side of the flower will be so out of focus you can barely make out what it is. That shallow depth of field is one of the things that I love about macro lenses, but it's also a challenge when you're trying to get more things in focus (try shooting at f/22 to get as much in focus as possible. Also, try keeping your lens horizontal and not angling the lens up or down when you shoot for a little more depth).

(2) Any little movement or vibration will mean an out-of-focus photo, so I definitely recommend shooting on a tripod if at all possible. Using a cable release of some sort, so you don't actually have to touch the camera (possible vibration maker), will also help (see volume 1 for more on cable releases).

When to Use a Tilt-Shift Lens

This is a specialty lens if there ever was one! This is used primarily for shooting architecture, because you can shift part of the lens itself to keep your buildings from looking distorted as they climb upward. Serious architectural photographers swear by these, and many won't shoot architecture without them. Of course, like any specialty lens—they're not cheap.

If You Buy a Filter, Make Sure It's the Right Size for Your Lens

The filter you buy has to fit your particular size lens (some lenses are larger around in diameter than others, so you have to make sure the filter you order is the same size diameter [measured in millimeters] as your lens). For example, my 18–200mm lens takes a 72mm filter, but my 70–200mm lens takes a 77mm filter. Want a great way to quickly find out the right size? Go to B&H Photo's website (www.bhphotovideo.com), find your lens, and you'll see a bunch of filter accessories listed below it. They will display the size used for that lens. Also, if you bought one filter and want to use it on a slightly different sized lens, you can sometimes buy a step-up or step-down ring adapter that will let you do that, and it will still work just fine.

How to Clean a Lens

If you get some dust, a smudge, dirt, etc., on your lens, something really bad is going to happen—that dust, or smudge, etc., is going to appear on every single photo you take with that lens. All of them. Every one! That's why it's important to clean your lenses before you go shooting for the day, and anytime you see a little "junk" on your lens. Most of the time, you can use a simple lens cleaning cloth, but before you do that, it's best to first start by blowing any junk off the face of your lens (you can do that by just blowing with your mouth, but ideally you'd use a little hand-squeeze blower bulb), and then once any visible specks and dirt are blown away, you can clean the lens with the lens cloth by gently rubbing in a circular motion. You can get a lens cleaning kit for around $15, which includes a blower, a cleaning cloth, and particularly helpful is one that includes a LensPen, which has a little fine brush on one end, and a special cleaning tip on the other end. It works wonders.

Long Lenses Usually Come with Lens Collars

When you buy a long lens, they usually come with a special bracket on the bottom that lets you attach a monopod, but there's something else you'll love about these brackets that's not apparent at first: unscrew one little knob and you can instantly rotate your camera to a vertical shooting position, while the lens stays put. This lets you switch from shooting wide to shooting tall in all of two seconds.

When to Use the Manual Focus Ring

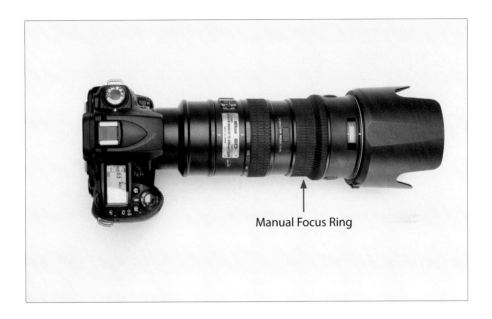

Manual Focus Ring

Most lenses let you turn off the autofocus feature and manually focus your lens, but a lot of today's lenses actually let you do both: start by letting autofocus set your initial focus, but then override it and tweak your focus using the manual focus ring (usually found at the far end of the lens). There are photographers who do this every time (start with autofocus and then tweak it), but most (like myself) just rely on today's excellent autofocus capabilities to do the work for them. If you want to tweak the focus yourself using the manual focus ring, just let autofocus do its thing first, and lock onto your subject before you start tweaking the manual focus ring.

Buying a Really Fast Lens for Studio Work

Over the years, I've run into so many photographers who have spent a ton on really fast lenses (like f/2.8 and f/4 lenses—usually the faster the lens, the more they cost), yet they either primarily, or only, shoot in the studio. This is just pretty much tossing money down the drain, because they probably rarely, if ever, shoot at f/2.8 or f/4 because they're not shooting in low-light situations (after all, they're in a studio—if they want things to be brighter, they just increase the power of their strobes). I guess the moral of this story is: if you don't shoot in low-light situations, you don't need expensive, really fast glass. Save your money for other studio gear and accessories (see, you thought I was just going to say, "Save your money," but I had already allocated your savings to other fun stuff, like studio strobes).

Zoomed vs. Full–Frame Lenses

Zoomed

Full-Frame

You've probably heard by now that most digital cameras (and dSLRs) have a zoom factor. What that means is that the number of millimeters you read listed on the lens used with a digital camera is different than what you used to get with a traditional 35mm film camera. For example, if you put an 85mm traditional lens on a digital camera, it's not really 85mm. On a Nikon, the lens is zoomed in by a factor of 1.5, so your 85mm lens is really giving you the results of a 127mm lens. On Canon cameras, it's zoomed in by 1.6, so an 85mm lens is really more like a 135mm lens. This drives photographers who have moved from film cameras to digital cameras a little nuts, because to them, an 85mm should be an 85mm, but that's just the way it's always been. However, now the big buzz is around full-frame cameras, and what that means is that with full-frame cameras, an 85mm is an 85mm once again. There is no zoom factor, no multiplication—the lens is finally really what it says it is. Ahhhh, but there's a gotcha! (Isn't there always?) If you put a lens that was made for a standard digital camera (and most digital lenses are just that) on a full-frame camera, it zooms it (basically, it crops your photo down to the zoomed dimensions). What that means to you and me is if you buy a full-frame digital camera, you won't get the advantage of a full-frame camera (at least when it comes to lenses), unless you buy lenses that are specially made for full-frame cameras. Now, that being said, some of the higher end, more expensive lenses do work fine with full-frame cameras and they don't crop down the image. So, how do you know which ones do and which ones don't? I put together a partial list for Nikon and Canon users at www.kelbytraining.com/books/digphotogv3.

Lens Vignetting and How to Remove It

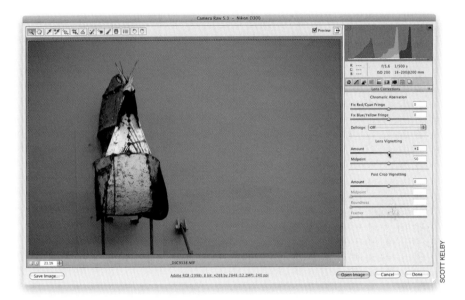

Have you ever taken a shot, and then when you look at the shot on your computer, you notice that the corners of your image seem darker than the rest of the photo? It's a fairly common thing, especially with some wide-angle lenses and some of the less expensive lenses. This is called "edge vignetting," and it is a problem caused by the lens itself that winds up on your photos. Luckily, you can remove edge vignetting (also known as lens vignetting) in most image editing programs, like Photoshop, Photoshop Lightroom, Photoshop Elements, etc. For example, in Photoshop's or Elements' Camera Raw window, you can click on the Lens Corrections tab and you'll see a section for removing lens vignetting. Drag the Amount slider to the right to lighten up the corners. The Midpoint slider below it determines how far into the photo the lightening extends, so if it's just right up in the corners, you can drag the slider quite a bit to the left. If the darkening extends pretty far out into your photo, then you'd drag to the right. In just a few seconds, your vignetting problem is gone! If you use Lightroom, you have the exact same controls, which work exactly the same way, in the Develop module. Just scroll down to the Vignettes panel. If all this sounds a bit confusing, don't worry—I made a quick little video just for you to show you what edge vignetting is and how to remove it. You can find it at www.kelbytraining.com/books/digphotogv3.

Why Some Lenses Have Two f-Stops (Like f/3.5–5.6)

When you see a zoom lens that has two different f-stops, what that means is that at the shorter range (let's say it's an 18–200mm lens, so we'd be talking about when you're at 18mm), the f-stop can go as low as f/3.5, but when you zoom it out to 200mm, the fastest it can go is f/5.6. When you're in between the two, the f-stop will gradually increase (so at 100mm, you might be at f/4). What this tells you is two things: (1) If you shoot at the wide-angle end (18mm), you'll be able to shoot in much lower light than you can zoomed in at 200mm (the lower the f-stop of the lens, the darker light you can hand-hold your camera in and still get sharp photos). This also means (2) that this is a less-expensive lens. Really "good glass" (as it's called) has a constant aperture (the same f-stop all the way through the zoom range), so the lens would be at, say f/2.8, whether you're out at wide angle or zoomed in tight (for example, Nikon's 70–200 f/2.8 VR lens can shoot at f/2.8 whether you're zoomed out at 70mm or zoomed in tight at 200mm).

When You Need to Focus Really Fast, Turn the Focus Limit Switch On

Each time you use autofocus, your lens searches everything it sees, from a few inches in front of you to miles in the distance, and then it locks on what it thinks you're aiming at. This takes just a second or two, but if what you're shooting is really far away (you're shooting sports or a bird up in a tree), you can switch your lens from Full focus to Limit, which tells it not to even try to focus on anything closer than around eight feet away. That way it focuses even faster, so you don't miss the shot.

Tips on Changing Lenses

If you have more than one lens, you'll probably be changing lenses in the field quite a bit, and if so, there are just a couple of things you should know. The first is that you generally don't have to turn the camera off to change lenses. Although you'll read some purists online who claim having the sensor still charged will attract dust and blah, blah, blah, I don't know any pros who actually turn their camera off to change lenses. However, when you do change your lens, to keep dust from actually falling into your camera itself, don't leave the open body of the camera facing straight up. That's just askin' for it. You're better off tilting the body down toward the ground. Also, if you're in a dusty or windy environment (let's say you're shooting in Arizona's Antelope Canyon slots, where dust is constantly trickling down from the above), don't change lenses at all—wait until you're in a clear area first, and then do it. And, ideally, you don't want to leave your camera body uncovered for long (again, to keep out dust), so don't take five minutes changing lenses—take one off, and pop on the other. You don't have to rush (you don't want to risk drop-ping anything), but don't dilly-dally either. (There's a term you don't hear every day.)

What to Do If Your Autofocus Suddenly Stops Working

First, check to see that you didn't turn off the autofocus on your lens, but if it's on, try this: just remove the lens, and then put it right back on again (called "reseating the lens"). This little trick has worked for me time and time again.

When to Use an "All-in-One" Zoom

The most popular Nikon and Canon lenses are their 18–200mm zooms, because they do it all. They go all the way from a nice wide angle to a tight telephoto and you never have to change lenses at all. Best of all, they're compact, pretty lightweight, and relatively inexpensive compared to some of the more expensive zooms with a smaller range. These are ideal lenses for travel photography (where you don't want to lug a camera bag around with you all day), or for photo walks, for city shooting, and even for landscapes you'll be shooting on a tripod. I have one of these 18–200mm lenses and, honestly, I love mine dearly. Now, you will see some photographers in forums online saying that these lenses are basically beneath them, because they're not as sharp as they could be, or they're not as rugged as the more expensive lenses, etc. Don't let that throw you. I don't know a single photographer that actually has one of these that doesn't love it, mostly because when it's on your camera, you're never going to say, "Oh, I missed that shot because I didn't have the right lens," because it does it all in one lens. As for quality, I have a 30x40" print of a photo I took with that lens while on vacation, framed, and hanging in my home. Everybody loves it, and it looks perfectly sharp and crisp all the way through. I GRAB THIS LENS FIRST WHEN...I'm going on vacation.

When to Use a Lensbaby Lens

Before I tell you about this lens, I have to warn you: people get hooked on Lensbaby lenses, and I can't tell you how many times a photographer friend I've known has bought a Lensbaby and then won't take it off their camera. They shoot everything, from the birth of their child to a space shuttle launch, with it, because these lenses (which you focus and aim with your thumbs and forefingers) are just plain addictive. So, you know that going in. Lensbaby lenses give you one small area of your photo that is sharp and in focus, and then all the other areas around that sharp area quickly go way out of focus and blurry, which results in a look that can have a lot of energy, movement and excitement to it. Of course, the look is only part of it, because what really gets people hooked on it is that whole "move it yourself" thing. It just feels like you're really "making a picture," rather than just taking a picture. I GRAB THIS LENS FIRST WHEN...I'm in the mood to shoot something really creative.

What Makes It a Portrait Lens?

There are certain lenses that have been referred to as portrait lenses, and I always get asked, "What's a good portrait lens?" That's a good question, and one that doesn't (like many things with lenses) have a single definitive answer. I would say that generally a portrait lens would be a fixed-length lens (so it doesn't zoom) that is between 85mm and 105mm. But, here's the problem (and where a lot of the mental fuzziness comes in): Back on page 72, I talked about the zoom factor and full-frame cameras. So, an 85mm fixed-length lens on a regular non-full-frame digital camera is actually more like a 120mm lens, right? See what I mean? That being said, you may remember that back in volume 2 I talked about how much better portraits look when shot with a longer lens because of the compression longer lenses give, which looks more flattering to the face (I showed a side-by-side comparison in the book). That's why you'll see so many fashion and portrait photographers shooting with 70–200mm lenses, and they're frequently out at the 200mm range for head or head-and-shoulders shots (especially if the model has dandruff. Sorry—I couldn't resist). I have shot with 85mm lenses on full-frame cameras, but I didn't like the look as well as I do an 85mm on a regular digital camera, so for my style, I like the 120mm range better. If you use a telephoto zoom, you can try both and see what you like. My point is you don't have to buy a portrait lens (whatever that means to you) to take pro portraits. Today's zooms do a beautiful job, and as long as you're over 100mm, I think you'll be pleased with the results.

Fixed-Length Prime Lenses vs. Zooms

You have to realize one thing about lenses—people get really "techie" about lenses, and they are a source of constant debate in online forums, where people get really condescending about which lenses they will or won't use. One current debate is prime lenses vs. zoom lenses. There are people who swear that fixed-length lenses (lenses that don't zoom—they are one particular length, and that's it—and are more commonly called a "prime lens") are visibly sharper than zoom lenses. I truly believe that at one point in time, this was absolutely the case. Zoom lenses were lesser quality, and primes were sharper (and generally they did, and still do, let you focus up closer). But I personally don't think that's the case with today's higher-quality zoom lenses (not just any zoom, but a high-quality zoom, like one that's f/2.8 all the way through). I think there are but a handful of photographers who, with the naked eye, can tell whether you took a particular shot with a zoom lens or a prime lens. I think it's more of a perceived difference, not an actual difference, but again, this is what creates these drawn out debates. This is going to send people who want to believe there's a big difference into a rage, but I've talked directly with manufacturers who make both the prime and zoom lenses themselves, and they've told me, point blank, that with today's higher-quality zoom lenses, there is no visible sharpness difference between zooms and primes. That being said, I do own two prime lenses. They are both very sharp. So are my good zooms. Either way, this isn't something to get hung up on. It's just a lens. Not a religion.

Shooting at Your Lens' Sharpest Aperture

I mentioned this in volume 1, in the chapter on getting really sharp photos, but I couldn't do a chapter on lenses and not include this really important technique. In short, each lens has a sweet spot—a particular aperture where the lens takes the sharpest image it can take. Where is that sweet spot? Usually, it's two stops above the lowest number your lens can go. So, for example, if you have an f/2.8 lens, then its sweet spot would be two stops above that, at f/5.6. Will your photo look sharper at f/5.6 than it will wide open at f/2.8? Yup.

When talking about lenses, if you hear the term "wide open," that means that you're shooting at the smallest number on your lens, like f/2.8 or f/4. Of course, you could just say, "I was shooting at f/4," but it doesn't sound nearly as cool as saying, "I was shooting wide open at f/4." Hey, you're snickering now, but wait until you're at one of those at-home lens parties, and you casually drop a "wide open" in there. You'll see the hostess drop her lens hood.

But My Friend Has That Lens and He Shoots...

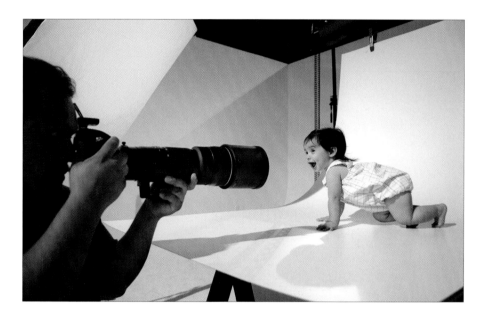

It's bound to happen. You're going to have a friend who's a serious photographer, and you'll hear that he's using a fisheye lens to shoot executive portraits or a 400mm super-telephoto lens to shoot baby photos. Then you're going to say, "But Scott said fisheyes aren't for portraits, and you should use a portrait lens for babies!" Here's the thing: if you buy any one of those lenses, you're going to try it out on other stuff. In fact, you should—it's your lens and you should try it on as many things as you'd like. That's half the fun of it. You may find yourself enjoying taking fisheye shots in a courtroom, and tilt-shift lens shots of your kid's high school graduation. In fact, your tilt-shift lens may become your go-to lens for shooting graduations, and there's nothing wrong with that. What I hoped to do in this chapter is send you in the right direction and give you a starting point for what type of lens is commonly used for what, but because it's a lens, it will take a photo of anything you aim it at when you press the shutter button. So, don't feel bad (or feel it's wrong) if you use a lens that's commonly used for one thing on something completely opposite. There's a name for doing stuff like that: creativity. Have fun with it, and don't get put aside by all the lens bullies. It's your lens. Fire away!

SHUTTER SPEED: 1/1000 SEC F-STOP: F/4.8 ISO: 200 FOCAL LENGTH: 50MM | PHOTOGRAPHER: SCOTT KELBY

Chapter Four

Shooting Products Like a Pro

How to Get Them to Look Like You've Always Wanted Them To

The first time you look at this chapter, you might think to yourself, "Why would I need to know how to make a great photo of a product?" There are tons of reasons (shooting products is surprisingly fun), but the most obvious might be having a great product shot is critical if you're selling stuff on eBay.com. Now, you might be thinking, "But I'm not selling any stuff on eBay," and if you just said that, that tells me one thing—that this is the first chapter of the book that you turned to, because although this book wasn't designed to make you want to buy new stuff, the sad truth is, to get the same results the pros get, sometimes you have to buy stuff (sometimes it's an accessory, or a light, or a filter, etc.). The stuff might not cost a lot, but still, it's stuff you have to buy. Okay, so if it's stuff you have to buy, some of it will probably be replacing stuff you already have, right? For example, if you bought a digital camera "kit" (where you got a camera body and a lens together), then when you read the chapter on lenses, you're undoubtedly going to see a lens you're going to want. But then you'll think to yourself, "I don't really need that lens. The lens I have is fine." But the more you think about it, the more you start to think, "If I sold my old lens, and some other camera gear I don't use anymore, I could probably buy that new lens," and then you figure that the easiest way to sell your old stuff is to sell it on eBay (which was practically invented for photographers), and so now you think, "I need to do a product shot," and it's at that moment that you realize you've been sucked into the whole photography equipment merry-go-round. Once you're on it, it's easier to come off drug addiction, because they actually have rehab centers for drug dependency, but there is no rehab clinic for photographers, which is why the best thing you can do is just skip this chapter and get on with your life. See? I care.

How to Create Real Reflections

In professional product photography, you'll often see a reflection appear below the product, and while you can add these reflections after the fact in Photoshop, it's easier to just have real reflections (plus, depending on the angle of the product, the job of creating fake reflections in Photoshop can range anywhere from quick and easy to a real pain in the %*$#, so you're better off doing it right up front). The easy way to get those reflections is to shoot your product on some plexiglass (either clear or white frosted). Just put a rectangular sheet of plexi right over your background (you can pick up these small sheets of plexiglass at your local Home Depot or Lowe's for around $15) and it does the rest. Plus, plexiglass is handy for all sorts of other stuff (you'll see it used again in a couple of pages, and another in Chapter 10. To see a production setup using plexiglass, go to page 93).

Faking Reflections in Adobe Photoshop

If you need to fake a reflection, here's how it's done: Make a selection around your product, then press Command-J (PC: Ctrl-J) to put that product up on its own separate layer. Go under the Edit menu, under Transform, and choose Flip Vertical. This turns your product upside down. Now press-and-hold the Shift key, and drag your product straight downward until the two "bottoms" touch, then in the Layers panel, lower the opacity of this layer to around 20%. That's it!

Mirrors for Those Hard-to-Light Places

When you're shooting products, it's very important to make sure the product is really well lit, and sometimes it's hard to get into little nooks and crannies with your light, which is why you'll love this trick: buy a few little tabletop mirrors (the kind they sell at the local pharmacy or Walmart, but make sure they tilt). Position a couple of these right outside your frame, aim them directly at the area you need to light, and they will reflect your studio light into those areas (if you're using continuous light for your product photography, like I talk about on page 88, then you'll be able to use these mirrors like little spotlights— as you tilt the mirror back and forth, you'll see a small beam of light that you can aim right where you want it. The first time you see this, you'll be amazed. If you're using strobes, it's a little trickier, but what you can do is turn up the power on your modeling lights and then use that light to aim the mirrors. Just know that when you fire your strobe, the amount of light you're putting into those shadow areas will be much brighter). The great thing about these mirrors is they're inexpensive, lightweight, and small enough to throw in your camera bag or lighting gear case.

Buying Your Little Mirrors

Make sure you don't buy too large a mirror, because you don't want to have to shoot around them, so keep them no larger than four inches around. Also, if you choose a mirror with a magnifier on one side, you'll have two different looks for your light.

Lighting From Underneath

A really popular technique for lighting products is to include a light coming from below the product. You see this look fairly often in product photography, and if you're shooting a product that has see-through areas (like glass), it really looks great. Okay, so you're probably wondering how you get that light through the table to your product. Plexi-glass! Instead of setting your product on a white background (and then putting the plexiglass on top of it), you remove the white background, and use your plexiglass as the tabletop (if you're going to be doing this often, make sure you buy thicker plexi from the hardware store). Just suspend the plexiglass between two light stands (or even between two sawhorses or two chair backs), and then position a light directly under the plexi-glass—on the floor—aiming upward through it.

Concentrating Your Below-Product Light

When you're lighting from underneath, you really don't want your light to spill out every-where—you want it concentrated straight upward. One way to help with that is to use a grid spot attachment (see page 39), which focuses your beam, but a lot of folks will just put foam core or black flags around all four sides of the light, so the light doesn't spill out. I've even seen DIY projects where you put the strobe on a short stand inside a cardboard box, and then you cut a little door out so you can reach in and adjust your strobe.

The Advantage of Shooting Inside a Tent

Product tents have become more popular than ever, because they allow you to easily wrap balanced soft light right around the product, while avoiding lots of nasty shadow problems you're likely to run into using multiple lights. Shadows are really a problem and soft light is a problem, so having a self-contained tent like this makes shooting the products crazy easy. The idea behind these is you put a light on both sides or either side of the tent (and perhaps one light below, aiming straight up, if you buy one that includes that feature, like the Studio Cubelite from Lastolite, shown above), and then the front of this is open for you to shoot. The light bounces around inside this box in a very wonderful way that lights the living daylights out of your product, and you come away with some surprisingly good results without having to be a master of lighting. If you're going to be doing a lot of this, and especially if you're trying to shoot things like watches or jewelry, you should definitely consider buying a light tent.

Using Continuous Lighting

Although I've used strobes many times over the years for product photography, today when I need to shoot a product, I usually use continuous lights like the Westcott TD5 Spiderlite. These aren't flashes, these are lights that stay on all the time, and they give bright daylight-balanced light, but because they use fluorescent bulbs, they don't get hot, so you can even use them to light food (as I did in the restaurant shoot above). These work incredibly well for product photography, because you can see exactly what you're going to get—there's no shooting a few shots, and then tweaking the lights, and shooting again, and tweaking the lights, because exactly what you see is what you get. Outside of the fact that they stay on all the time, they're just like strobes, and have all the similar accessories, like softboxes in every size (including strip banks), and fabric grids, and all the other stuff, but since they're always on, you don't have to worry about a wireless trigger or flash cables. I always recommend these to my friends, and every-body I've recommended them to has fallen in love with them. You can pick up a one-light kit (which includes the fixture, a softbox, tilt bracket, and light stand—bulbs need to be ordered separately) from B&H Photo for around $530. You can also get the fixture on its own (for around $280), but again, the bulbs need to be ordered separately.

Mixing Daylight and Studio Lights

SCOTT KELBY

If you've got a lot of space with a lot of natural light, you can shoot just using the natural light, but the problem is going to be getting light to wrap all the way around your product. That's why adding one light, and mixing that with your natural light, can make a big difference. I do this a lot when shooting food, or wine bottles, where I use the natural light for the backlighting (so it's really the main light) and then I use a West-cott Spiderlite continuous light for a fill light in front (after all, if the light is coming from behind my product, the front of the product will be kind of a silhouette. Bringing a little light in from the front makes all the difference in the world). The advantage of the Spiderlite is that it's daylight-balanced, and mixes really well with natural daylight. (To see the final image from this shoot, just go to the book's companion website at www.kelbytraining.com/books/digphotogv3.)

Enhancing Highlights and Shadows in Post

Before

After

Although we always strive to get as much right in the camera as possible, product photography is one area where it usually pays to do a little tweaking in Photoshop after the fact (called "post-processing" or just "post" by people who can only use one word at a time). When I shoot a product, what I'm looking to do in Photoshop (besides removing any specks, dust, or other little junk on the background or the product itself) is to enhance the highlights (the brightest areas of the product) and the shadows (the darker areas). Basically, I make the highlights brighter and more obvious, and the shadow areas a bit darker and richer. Once you see the difference this makes, you'll want to be doing some "post" yourself. I did a little video for you (you can find it on the book's companion website at www.kelbytraining.com/books/digphotogv3) to show you exactly how the Photoshop post-processing was done for most of the product shots used here in the book. I think you'll be surprised at both how easy it is, and what an impact it has on the finished image.

What File Format to Save Your Photos In

Even though we shoot in RAW format, once you open and edit your photos in a program like Photoshop, at some point, you're going to have a duplicate of the same image (for uploading to a lab, or archiving, etc.), and that's when you have to decide which file format to save your images in. I choose JPEG mode with a quality setting of 10 (out of a possible 12) for all my final images (I think a setting of 10 gives an ideal balance between maintaining great quality and still compressing the file size quite a bit).

Making Your Own Product Table

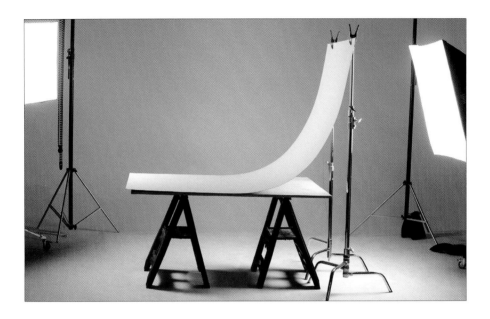

If you're looking for a great surface to shoot your product shots on, look no further than your local hardware store for a large panel of white formica. This stuff works great for a number of reasons: (1) When you put a product on white formica, its surface is already a little reflective, so it automatically gives your product a little bit of a natural reflection (not a sharp mirror reflection like acrylic, but kind of a subtle satin-like reflection). (2) It's very easy to keep clean—you can just wipe it lightly with a damp cloth—so you don't have to replace it often, like you do with white seamless paper, and (3) because it bends pretty easily, you can lie one end flat on a table, and then attach the other end to a couple of inexpensive light stands with some A-clamps (see page 42 for more on A-clamps), and this gives you a smooth, seamless curve behind your product, which makes it perfect for product photography. A full 8x4' sheet costs about $45–50 at my local hardware store, and believe it, it's worth every penny.

Special Wire for Hanging Products

SCOTT KELBY

Invisible thread. It's not just for repairing your clothes—this incredibly sturdy stuff can be used to suspend products in midair so you can shoot them (well, of course, it depends on the weight of the product. It's not going to hold a car battery, if that's what you're thinking). Just put a boom stand arm up high—just high enough so you can't see it in your viewfinder—then tie one end of the invisible thread to the boom, the other end to your product, and fire away. Now, you can also use fishing line if you can't get hold of some invisible thread, and while it's pretty unobtrusive, you're probably going to have to remove that line later in Photoshop. That's what I used in the shot you see above, and I did a video clip on how I removed the fishing line using Adobe Photoshop (the clip actually aired on *Photoshop User TV*, a weekly video podcast I've been co-hosting for the past few years), and you can see that clip on the book's companion website at www.kelbytraining.com/books/digphotogv3.

The Advantage of Using Strip Banks

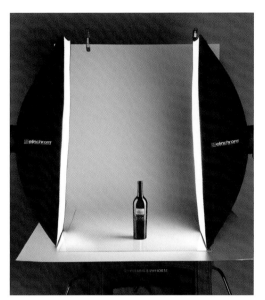

Have you ever seen a product shot of a wine bottle, or a piece of electronics, and reflected in the product you see a tall, thin, soft, rectangular reflection? Maybe even two of them? These wonderful highlight reflections are most likely from one of the mainstays of a lot of pro product shooters—a strip bank (also sometimes called a strip light). These are actually just tall, thin, rectangular softboxes (picture a softbox that's just 18" wide, but around 36" long), and they are very popular in product photography because of those wonderful tall reflections they create in products that reflect. (It's tough shooting products that are reflective, because you can see a reflection of everything in the product itself—even sometimes the photographer—so be careful when you're shooting reflective products.) You can buy strip banks for strobes, or even for the Westcott Spiderlite TD5 that I use for product photography, and the nice thing about them is that you can use them tall (vertically), or turn them on their side and use them horizontally for a really wide, wrapping light.

Using Foam Core

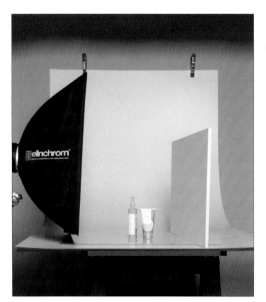

While you'll find portrait photographers using white reflectors a lot in the studio (usually to reflect or bounce light from the main light into the side of the face that's in the shadows), when it comes to product photography, more often than not, you'll find the pros using a large sheet of foam core instead. Form core tends to have a little more sheen to it than most reflectors and reflects more light. Plus, because you can cut a sheet of form core (found at most craft stores or office supply stores) down to pretty much any size you need, you can make these small enough to sit right on your product table and get right up close to your product (but just out of your viewfinder's frame).

A Dramatic Background for Products

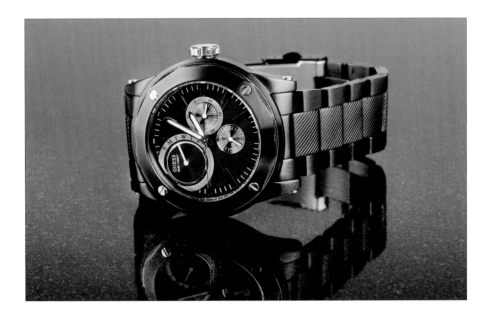

If you want to go for a dramatic look for your product shots, try this: go to your local home supply mega hardware store and buy a single tile of black granite. This stuff is incredibly reflective and just sitting your product on it makes it scream, "Shoot me!" It looks like this stuff was made for product shots, and yet it's fairly inexpensive (well, at least for one tile it is). Get as large a tile as they have in stock, but since it's unlikely to be very large, you'll use this for smaller items that you want to have a dark, dramatic look. Try this the next time you want to go a totally different direction from the standard white background that you see so often for products shots.

Use a Tripod

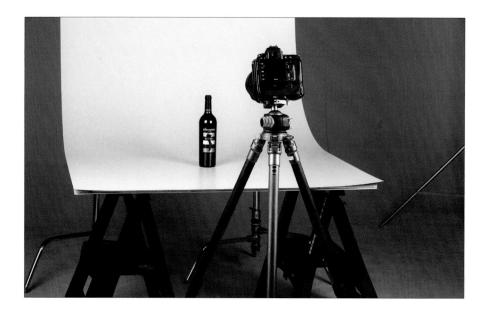

Product shots are one of those things that if they're not absolutely tack sharp, they just don't work, and that's why the pros use a tripod every time. Having that super-sharp focus is critical and, although I will hand-hold when shooting people (if I'm using studio strobes or flash to freeze any movement), when it comes to product shots, my camera goes right on a tripod and stays there. If you're looking for a way to take your product shots to the next level, this is absolutely the first step.

Hide Distracting Stuff

If you take a look at most professional product shots, you'll find that they go to great lengths to hide anything that would distract you from the presentation of the product, even if it's a part of the product itself. Perfect example? Headphones. You know and I know that there's a cord on headphones that plugs into our laptops, or our iPods, but in ads you rarely, if ever, see the cord—you just see the headphones (earbuds are an exception, but without the cords, they look like a couple of white peas). The photographer goes out of their way to hide things like cords, or cables, or anything else that would detract or take away from the product (like a camera strap on a camera. If you see Canons or Nikons, or, well....almost anybody's shot of their latest camera, you won't see a camera strap in the shot, even though in real life every dSLR we buy has one attached). Keep this in mind, and you'll wind up with cleaner looking shots. So, if you're shooting something with a cord that unplugs (like the headphones above), just unplug the cord and move it out of the image (as seen in the photo on the right). Otherwise, you'll have to remove the distracting object in Photoshop. I did a video for you on how to do this, and you can find it on the book's website at www.kelbytraining.com/books/digphotogv3.

Clean It Before You Shoot It

Before you shoot anything—clean it first. This is one of those things that, if you don't do it, I promise it will take you ten times longer to fix it in Photoshop than the 15 seconds it would have taken you to do it right in the studio. I can't tell you how many times in the past I've skipped this step, and I don't really notice all the fingerprints and little smudges, and specks of dust on the product until I actually open the shot later in Photoshop, and then I have to spend 10 minutes trying to retouch it all away. It's been so bad on a couple of occasions, that I actually went back, wiped down the product, and then reshot from scratch. You only have to do that a few times to learn the lesson—clean it thoroughly before you start shooting and save yourself a bunch of headaches after the shoot.

SHUTTER SPEED: 0.5 SEC F-STOP: F/22 ISO: 100 FOCAL LENGTH: 200mm PHOTOGRAPHER: SCOTT KELBY

Chapter Five

Shooting Outdoors Like a Pro

More Tips for Creating Stunning Scenic Images

If you're starting to see a pattern here, it's only because there's a pattern here. That pattern is what I talked about in the brief introduction to this book, which is this book "picks up right where volume 2 left off." Okay, if that's the case, then why isn't this chapter named "Shoot Landscapes Like a Pro, Part 2" like back in Chapter 1, Part 2? That's because not all of the tips in this chapter are about shooting landscapes. (That's why, Mr. Snoop Smarty Smart!) Hey, it's not my fault—you created these questions yourself. (Did not. Did too!) Anyway, this chapter is about getting better results from shooting outdoors, and luckily for us, it's easier to get better looking images outside because so many of the problems that we run into inside (like mall security) don't exist outside. Also, light is easier to find outside. I can't tell you how many times I've been walking down the street, I look down, and there's a perfectly good flash unit just lying there on the sidewalk. Okay, that's an exaggeration (it's only happened three or four times), but since the sun is usually found outside, our job is well-defined—we have to learn ways to control the sun to our advantage. For example, if you're handy with fabric and a readily available commercial grade lathe, you'll be able to assemble a rudimentary diffusion panel that's large enough to evenly illuminate a tour bus. This comes in incredibly handy if you get a call from a tour bus company wanting you to shoot a cover shot for their new fall catalog. However, if you get a call from a florist instead, I have to be honest with you, I'm not sure how much use you're going to get out of that 23x23' frame-mounted diffusion grid, but you know what they say, that's why God invented eBay. Anyway, no matter whether you're shooting buses outside or flowers, this chapter will fully and completely avoid both of those individual topics.

Make a Packing List So You Don't Forget Anything

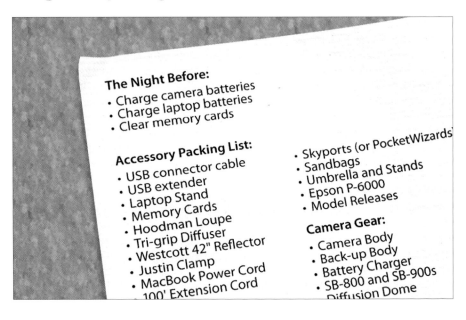

The Night Before:
- Charge camera batteries
- Charge laptop batteries
- Clear memory cards

Accessory Packing List:
- USB connector cable
- USB extender
- Laptop Stand
- Memory Cards
- Hoodman Loupe
- Tri-grip Diffuser
- Westcott 42" Reflector
- Justin Clamp
- MacBook Power Cord
- 100' Extension Cord

- Skyports (or PocketWizards)
- Sandbags
- Umbrella and Stands
- Epson P-6000
- Model Releases

Camera Gear:
- Camera Body
- Back-up Body
- Battery Charger
- SB-800 and SB-900s
- Diffusion Dome

There is nothing worse than getting out on location for a landscape shoot, or arriving in a foreign country where you hope to do some travel photography, and finding out that you forgot an important piece of gear. I've done it a dozen times. Well, at least I used to, until I started making separate gear packing lists for my landscape and travel photography trips (to see what I pack, go to Chapter 8). It doesn't have to be anything fancy, but pay particular attention to the little things you might forget, like a cleaning cloth, spare batteries, a polarizing filter, a cable release, etc. You're probably not going to forget your camera body (if you do, maybe improving your photography shouldn't be your biggest concern), so focus on those little things that you'd really miss once you're out on the shoot. One good way to do that is to mentally picture arriving on the scene, and put together your gear in your mind. At some point, you'll mentally reach into your bag for something that's not there. Add it to the list right then.

Show Movement in Your Shot

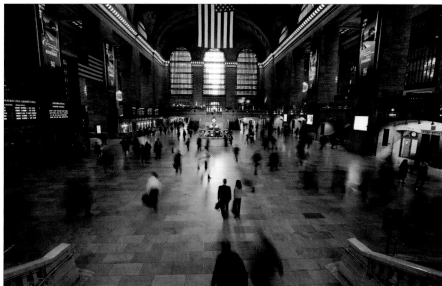

SCOTT KELBY

Showing movement is an easy way to add excitement to your photos, and it's easy to capture. The secret to showing movement is lowering your shutter speed. For example, in the shot shown above, in New York's Grand Central Station, two things have to happen for you to see the blur of people moving: (1) the station itself needs to stay sharp and crisp, so you shoot on a tripod; and (2) you use a long shutter speed, so when the shutter opens and people are walking, their movement is captured. If you're in kind of a dark setting (like the shot above), you can shoot in aperture priority mode, choose a safe all-around f-stop (like f/8), and press the shutter button. The shutter will stay open a second or two and everybody will be blurry. It's harder to get this movement effect in the middle of the day, because your shutter wants to stay open such a short time. So, what do photographers do? Probably the most popular trick is to use a screw-on darkening filter, like a neutral density filter (like those made by Singh-Ray Filters) to darken what your camera sees, so your shutter stays open longer.

Getting the Star Filter Effect

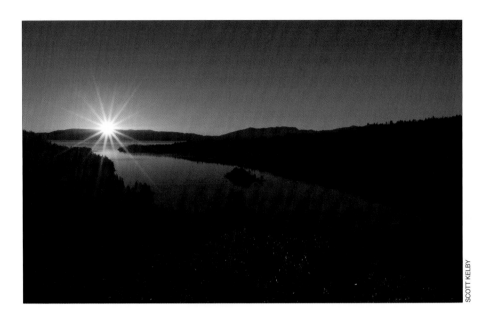

SCOTT KELBY

There are special lens filters you can buy that can turn bright lights captured in your dusk and nighttime images into starbrights. However, if you don't want to spring for the filter, you can get a similar effect right in-camera by just choosing an f-stop with the highest number you can, like f/22. This alone will usually give you that multi-point star effect without having to spend a dime.

Try Getting Creative with White Balance

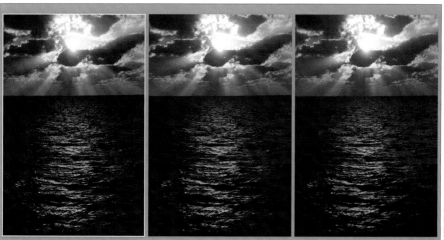

SCOTT KELBY

There are two ways to look at white balance: One is "proper" white balance, where the white balance is appropriate to the lighting situation you're shooting in. So, if you're shooting in the shade, and you've chosen a Shade setting for your white balance, your color looks normal and accurate. Then there's "creative" white balance (one of my favorites), where you choose a particular white balance because it will make the photo look the way you want it. For example, if you're up for a dawn landscape shoot, and it's a pretty flat look-ing, boring morning (lightwise), you could try changing your white balance to Tungsten, and now everything looks blue. That alone could turn a really boring daybreak into a very cool morning shoot. At dusk, changing your white balance to Shade suddenly makes everything very warm, like you had a much more exciting sunset than you did. In the example shown here, the image on the left was shot with the Auto white balance, the cen-ter one was changed to Fluorescent, and the one on the right was set to Tungsten. These aren't accurate white balances, they are you being creative in the camera by making the scene cooler (more blue) or warmer (more yellow) because regular white balance, while accurate, looks so…I dunno…regular. Give it a try the next time you're on location and the light doesn't cooperate.

Let Great Light Be Your Subject

SCOTT KELBY

Every once in a while, you get an amazing subject in front of you, and there just happens to be beautiful, amazing light on it. The problem is that this only happens every once in a while. However, beautiful light happens all around us, so instead of waiting for your subject to be bathed in beautiful light, start looking for beautiful light, and then once you find it, start looking for a subject that's in and around that light. Places I look for beautiful light are usually places with natural light, so when traveling, keep an eye out for great light in places like markets, little alleyways, old abandoned buildings, workshops, small churches, anywhere with skylights, or any building with really dirty windows (which create soft, diffused light). Outside, you can find great light around sunrise or sunset, but beyond that, keep an eye out for great light right after a rain storm. Sometimes, where the sun breaks through the clouds, you can have beautiful light appear, even if it's just for a few minutes. In short, when you come across some beautiful light, start looking for a subject, because just about whatever you shoot in it is going to be beautiful.

Watch for Bright Spots

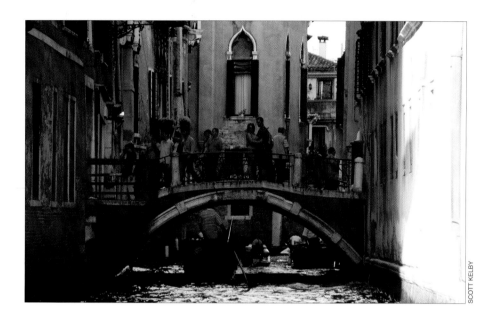

SCOTT KELBY

If you're on vacation shooting friends, family, or locals, keep this in mind: avoid taking shots where something bright is near your subject (a bright beam of sunlight, or an area lit brightly by the sun, while your subject is in the shade, etc.). By nature, the eye is drawn immediately to that bright spot first, not to your subject (in the image shown here, the bright wall on the right side of the image draws your eye away from the subjects on the bridge). So, when you see a bright area near your subject, change the position you're shooting from (move left or right) and compose that bright area right out of your shot.

Compose to Hide Modern-Day Objects

If you're shooting a travel photo, and you really want to emphasize the charm of the scene, try to compose the shot so you don't see modern day objects. For example, nothing kills that charming shot of the boat in the misty harbor like a 250-horsepower Evinrude motor hanging off the back. Look for a boat in the harbor that looks timeless, and try to exclude other boats around it that have modern looking engines, or radar dishes, or other modern day accessories to capture that charming look. Same thing in the city—exclude the new pay phone, mailbox, garbage can, posters, etc.

The Three Keys to Landscape Photography

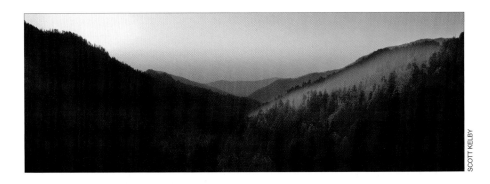

SCOTT KELBY

Successful landscape photography is made up of three things: (1) having the right equipment and knowing how to use it, (2) doing your homework and scouting your locations in advance, so when the light is great, you're in the right place at the right time, and (3) sheer unadulterated luck. Sadly, #3 plays a bigger role than you'd think, and here's why: You get up crazy early and get out to your location. You get your gear set up, and it's all ready to go. You know your equipment inside and out, and you're comfortable with your exposure, composition, and the whole nine yards. Then it starts pouring rain. Or a thick fog rolls in. Or it's perfectly clear, and it's just a blah sunrise with no clouds in the sky—it wasn't a majestic morning, it was dark one minute and then, a few minutes later, it got bright. Blah. It happens all the time. You're at the mercy of Mother Nature and dumb luck. It's a total roll of the dice whether you're going to get a spectacular sunrise or a murky mess, but you can tilt the odds in your favor big time by following one simple rule: return to that same location more than once. That's right, if you know it's a great location, and you were there on a blah morning, go back the next morning, and the next. If you're persistent, you're going to be there one morning when the light is just magical, the cloud pattern is just right, and you see colors you didn't know existed. You'll be there when the water in the lake is like glass, and the dawn light couldn't be more stunning. I've been on location on a few dawn shoots just like that. But just a few. More often than not, it's blah. So what do I do? I go back. The more I go back, the greater my chances are that I'll be there on a morning I'll talk about for years.

Look for Clouds to Hold the Color

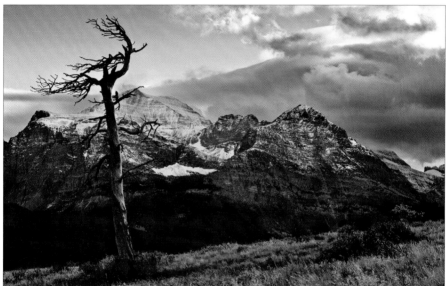

SCOTT KELBY

When it comes to shooting landscapes at sunrise or sunset, clouds are usually your friends. Not a blanket of clouds, mind you, but scattered clouds. The reason is you need something to hold the color in the sky. You need something for nature's gradients of color, that happen right around sunset, to play off of, and that something is clouds. If you've ever witnessed an empty, cloudless sky at sunset or sunrise, you know how lifeless they can be, so don't let a weather report that's calling for clouds the next day scare you off from your shoot. Sometimes, it's those clouds that turn the ordinary into the extraordinary.

Shoot Shadows

In the studio, we try to manage shadows—make them softer, smoother, or we even make them disappear altogether—but outside the studio, the shadows themselves make great subjects. So, make the shadows the subject—long shadows, hard shadows, distorted shadows. You can also let intentional shadows add to your location shots by putting objects between the light and a wall behind or beside your subject. This popular trick can add a lot of interest when you're shooting a blank, empty wall.

How to Shoot Underwater, Part 1

©ISTOCKPHOTO/BRYAN FAUST

If you're a travel photographer, you're probably doing a lot of your photography while you're on vacation, and if you're on vacation in a tropical place, at some point you're going to go snorkeling or diving, and at that point you'll be wondering, "How can I get shots of this coral reef?" It's easier than you'd think, but there are two parts to the equation: The first part is getting a waterproof housing for your camera, but before we go any further, when I say "your camera," I mean that small point-and-shoot camera that you also take with you when you're on vacation. The reason I say this is that underwater housings for dSLR cameras (shown here) often cost more than the camera (with a good lens) itself. I'm not exaggerating—it's amazing what they cost. So, unless you plan on making a career of underwater photography, take your point-and-shoot, and buy an underwater housing for somewhere around $150. In fact, it would be much, much cheaper for you to buy a brand new high-end point-and-shoot (like the excellent Canon G10) and an underwater housing for it, than it would be to buy just about any housing for your existing dSLR. I can't explain it, but sadly, that's the way it is. So, the first part of this is to buy your housing, and resign yourself to the fact that you're not taking your dSLR underwater, unless you're just incredibly loose with money. Part 2 is on the next page.

How to Shoot Underwater, Part 2

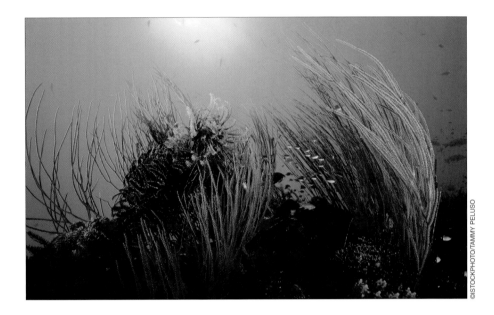

©ISTOCKPHOTO/TAMMY PELUSO

Once you've got your underwater housing, there are a couple of challenges you're going to face. First, there are things underwater that want to eat you. But that aside, one of your biggest issues will be light, or really the lack thereof. Ideally, when shooting in deeper water, having a flash or other light source is the only way to get good color in your photo. If you're shooting near the surface, you'll probably be able to keep a fairly low ISO, but once you start going down 30–40 feet, take a look at your shutter speed and you'll shudder (sorry, that was lame). The light down at this depth is low, and if you start getting shutter speeds of 1/30, 1/15, or below, what you're going to get is a bunch of incredibly blurry photos, but sadly, you won't know that until they're on your computer (or you've made prints), because (say it with me now, everybody) everything looks in focus on your tiny LCD screen. So, if you're buying a point-and-shoot for underwater photography, try to find one that has fairly low noise at higher ISO. Your other problem is going to be color casts, and a general murkiness or haze over your photos. The good news is that Photoshop can usually fix this automatically. I'm not a big fan of "Auto" settings in Photoshop, but this is one case where it works surprisingly well. Go under Photoshop's (or Photoshop Elements') Image menu, under Adjustments, and choose Auto Levels. That alone will usually do the trick.

It's What You Leave Out of the Frame

SCOTT KELBY SCOTT KELBY

I learned a great lesson one day from talking with David duChemin, a gifted travel and editorial photographer. I was in love with a photo he had taken of an old man sweeping inside an entryway, right in front of the Taj Mahal. It seemed like it must have been taken at dawn, because there was literally no one there but him, so I asked David how he got so lucky to be there when virtually no one else was there. He told me that actually there were tourists everywhere, and if he had shot a little wider I would have seen hundreds of people on either side of him. What he had done was make a conscious decision about what to leave out of his shot. He framed the shot so just that one man was in his frame, and it made it look like he and that man were the only two people there that day. In the example here, these two shots were taken seconds apart and the only difference is the framing. The shot on the left was taken from a standing position and you could see the gift shop, road, and other distracting stuff. Now, all I had to do to hide that stuff was kneel down behind the small sand dune in front of me and frame the shot so that only the tower was visible. The lesson: It's not always what you put in your frame—it's sometimes what you leave out.

Shoot the Reflections in Puddles

Here's another creative idea: shoot the reflections you find in puddles. I don't mean shoot a downtown with puddles in the foreground where you see a reflection, I mean shoot the puddles themselves. If you're in a city, there's something reflecting in those puddles—find the angle that looks best, and shoot it. Ya never know what you'll come up with.

Shoot at the Lowest ISO Possible

If you're shooting landscapes, you're probably shooting at around dusk and around dawn, and if that's the case, you're probably shooting on a tripod, and if that's the case (see how I'm stringing this whole case together?), then you need to be shooting at the lowest ISO your camera will allow (usually ISO 200 on most Nikon dSLRs, or ISO 100 on Canons). The reason why is you'll get the sharpest, most noise-free, best quality images at your lowest ISO, and because you're on a tripod, you don't need to raise your ISO above that sweet spot (remember, raising your ISO is usually for hand-holding in low light; you're not hand-holding, you're on a tripod, so go for the ultimate in quality).

The Noise You See Onscreen Sometimes Goes Away

If you shot at 400 or 800 ISO, chances are when you open that photo on your computer, you're going to see some noise (depending on how well your camera handles noise, you'll either see a little or a lot), but don't let that throw you—even though you see some noise onscreen, a lot of times that noise will disappear when you actually print the image.

Not Sure What to Shoot? Try This!

©ISTOCKPHOTO/FERRAN TRAITE SOLER AND SCOTT KELBY

If you've ever arrived in a city while on vacation and you don't have any idea where or what to shoot, your first stop should be a local gift shop to look at their postcards. If you see any interesting locations, it will usually tell you the name of them on the back of the postcard, or you can show the postcard to the shopkeeper and ask them where it's located. Okay, so why not just buy the postcard and head for the bar? Because we're photographers, that's why. Plus, we might be able to come back with some better images than the ones on the postcards they're selling (in fact, maybe next year they'll be selling your shots as their postcards, and hopefully, they're doing so with your permission and a commission).

Shoot Texture as Your Subject

A very popular subject to shoot, especially for travel photographers, is texture—anything from flaking paint on the wall of an old building, to the grain on the wood table at a café. Texture is everywhere, and can have great dimension if the light hitting it is from the side, because side lighting will enhance the texture as the shadows add interest and depth. Keep an eye out for texture when you're roaming city streets.

Keeping Unwanted Light Out

SCOTT KELBY

Here's a great tip I picked up, from renown wildlife and outdoor photographer Moose Peterson, for getting better exposure in your landscape photos when you're using a cable release to fire your camera (you use a cable release to minimize any camera shake that's caused by your finger pressing the shutter button). The problem is this: since you're using a cable release, your eye isn't right up to the viewfinder like it normally would be, so you're not blocking the light from coming in through the viewfinder and messing with your exposure. The solution is to cover your viewfinder. Some cameras, like Nikon's D3 and D3x, have a built-in viewfinder door you can close—the switch is to the left of the eyepiece itself—but most other Nikon dSLRs come with the DK-5 eyepiece cap (shown above) that snaps into place to keep light out of your viewfinder in cases like this. By the way, you can test to see if light is getting in through the viewfinder and affecting your exposure by covering and uncovering the viewfinder with your hand. If you see the shutter speed change at all, then light is getting in. If you don't have that little door, Moose recommends hanging your lens cap over the viewfinder to block the light. If you're a Canon shooter, most Canon dSLRs come with an eyepiece cover that covers the viewfinder and keeps outside light from affecting your exposure.

Using a Graduated Neutral Density Filter

If the polarizing filter is the most important filter for landscape photographers, then a graduated neutral density filter has to be the second most important. This filter is designed to help you do something your camera can't usually do on its own, and that is expose for the foreground without overexposing the sky. That's why this filter has become so popular—it darkens the sky, but it's how it does it that really creates a pleasing effect. This filter is graduated, so it's darkest at the top of the sky, and then it graduates down to full transparency (like a gradient), so the ground doesn't get darkened at all. The one I use is actually rectangular plastic, and I simply hold it up in front of my lens then take the shot. I don't use a lot of filters, in fact just a few (go to Chapter 3 to see the other ones I use), but this is one that makes a really big difference, and that's why it's with me on every landscape shoot.

Get Down Low

We shoot pretty much everything from a standing position. So, everything looks just like it would to anyone walking by that same spot. Try something from a different perspective—a view people wouldn't normally see. Get down low—really, really low. If you go down on one knee, you see things from a young child's perspective. Sit on the floor, and you've got a toddler's point of view. But if you really want to take it to the next level, lie on the floor and shoot, showing a perspective normally seen by squirrels (it gives you some idea why they're so nervous all the time).

How to Shoot for HDR

If you want to create HDR (High Dynamic Range) images (where you shoot multiple im-
ages, then combine and tone map them into a single image with a range of tones beyond
what your camera alone can capture), here are some tips to make the shooting part easier.
The first tip for HDR success is to shoot with your camera on a tripod (your software tweak-
ing later will be a lot easier). Next, you'll need to set up your camera to shoot in aperture
priority mode, then set your camera to take automatic bracketed exposures. Here's how:

Nikon: Press-and-hold the function (Fn) button on the bottom front of your camera (if
you have a D300, D700, D3, or D3x), then move the main command dial on the back of
your camera until you see bracketing turned on in your top LCD. Choose five bracketed
shots (so it takes one regular exposure, then one brighter, one way brighter, one darker,
and one way darker). Now switch your camera to continuous high-speed release mode,
then hold down the shutter button until your camera takes all five shots for you.

Canon: Press-and-hold the Mode and AF•Drive buttons to turn on auto exposure
bracketing (set the number of shots to 5 in the Custom Functions menu, so it takes one
regular exposure, then one brighter, one way brighter, one darker, and one way darker).
Now switch your camera to shoot in burst mode, then hold down the shutter button
until your camera takes all five shots for you.

What to Do with Your HDR Shots

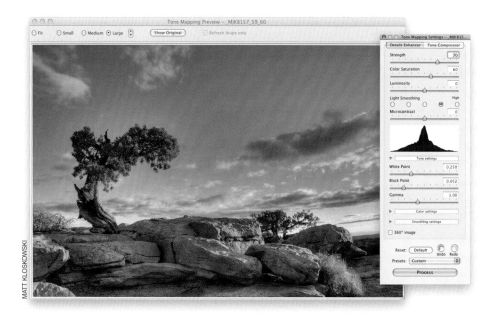

Shooting the bracketed shots is only one part of the equation, because all you've got is five shots, and four of them are either overexposed or underexposed. So, what you need now is a program to combine these into a single HDR image, which is what our goal is. The program that's the most widely used is called Photomatix Pro (from HDRsoft.com), and it runs $99. You can also download a fully working demo version for a Mac or PC (the trial never expires, but it does apply a watermark to your images). You open your five images in Photomatix Pro, and it does all the combining and tone mapping for you. I recorded a video tutorial just for you to show you how to use Photomatix Pro to create your first HDR image, and you can find it at www.kelbytraining.com/books/digphotogv3.

Scout Your Dawn Shoot Location

BARNEY STREIT

I'll never forget the first time I shot at Big Sur, along California's coast near Monterey and Carmel, a number of years ago. It was a mess. I had been in town earlier that day, but didn't think to go scout out a good shooting location, and the next morning, well before dawn, we headed out to the coast, where we found ourselves driving around in the dark trying to figure out where a good place to shoot was, but of course, we couldn't see anything—it was pitch black. Out of desperation, we pulled off at a "scenic" overlook (well, that's what the sign said anyway), and we set up our gear, waiting for sunrise, and then as the sun came up, I proceeded to capture some of the most unremarkable, bland, and forgettable images ever taken of Big Sur. In the dark, not surprisingly, we picked a totally blah spot. If I had done my homework and scouted a location, I would have at least had a shot of something really special. A lesson learned. Since then, I go out of my way to find a great shooting location first, and if I can, I take a test shot, even if it's during terrible light. That way, if the shot looks decent in bad light, all I have to do is come back and try for that same shot in great light. It's a recipe for success, and this little bit of homework up front will put you in the best position for something magical to happen.

Don't Always Shoot Wide Angle

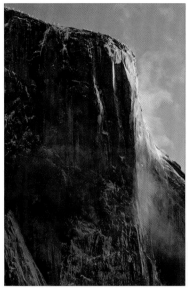

SCOTT KELBY

If you're into shooting landscapes, you're into shooting wide angle, and that totally makes sense, because most landscape photographers want to take in as much of a beautiful, sweeping landscape as possible. But the next time you're out in the field, try something different—take out a long telephoto lens and capture a totally different side of your location. Sometimes you can uncover amazing photo opportunities that are just outside the reach of your wide-angle lens. It lets you bring a totally different perspective to your landscape photography, and opens the door to a new way of shooting outdoors that you just might fall in love with. Give it a try the next time you're out shooting—you might be surprised at what's waiting just 100mm or so away.

Shoot Shapes (Circles, Squares)

I got this idea from my buddy and commercial photographer Joe Glyda, who gives himself specific shooting assignments for a specific amount of time. For example, he'll give himself a one-hour assignment in a downtown area to shoot nothing but things that are round. Or square. I'm constantly amazed at what he comes up with, and you'll be amazed at how a well-defined assignment like this will bring out your creativity. Just remember, no cheating—you have to give yourself the assignment before you arrive at the shooting locale.

Use Backlighting to Your Advantage

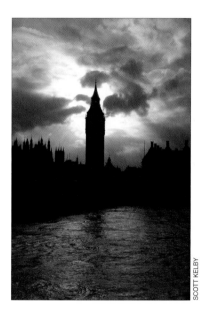

SCOTT KELBY

Although we often avoid backlighting when shooting travel portraits (unless we have a fill flash, of course), when it comes to shooting landscape photography, you can get some amazingly dramatic images when the sunlight is aiming right at you (rather than over your shoulder). You can even sometimes compose the shot with the sun right in the shot itself, and if you're shooting at a high f-stop number (like f/22), the sun will even get little light flares and starbursts that can look really captivating. Now, because you're shooting right into the sun, it can be a little trickier to come away with a killer shot, so don't be disappointed if, the first time out, you don't come home with something to frame for your wall. It takes a bit of practice—trial and error—to find the right exposure, and how to frame the shot so the sun actually isn't in every photo (just the backlighting effect), but believe me, when you nail it, you'll know.

Why We Get There Early

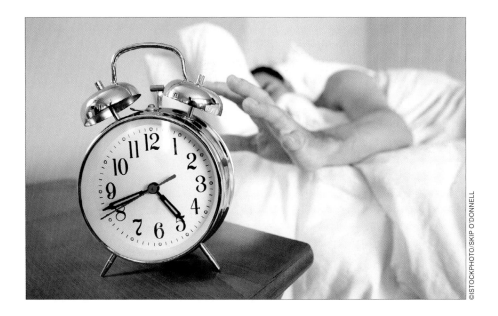

As I mentioned in volume 1, the two best times of the day to shoot landscapes are dawn and dusk, and if you choose to shoot at either one of these (and I hope you do), make sure you get to your shooting location plenty early. Earlier than you'd think. I can't tell you how many times I've seen photographers scrambling to get their gear out of the car, then they lug all their stuff out to the location, huffing and puffing, and all the while, those few minutes of incredible light are nearly gone, and you've never seen more stressed out, frustrated, and downright angry photographers than when that happens. Look, if you're getting up at 5:00 a.m. to catch sunrise nearby, instead get up at 4:45 a.m. and be on location, all set up, ready, composed, and relaxed, so you can not only get the shot, but you can enjoy the experience, too.

Shooting a Popular Landscape Destination? The Good Spots Go First!

If you're heading out to shoot a popular landscape destination, like the Arches National Park in Utah, keep in mind that the shooting locations you hike out to fill up very fast. So fast, that if you don't get there two hours before dawn, you might not get a place to set up your tripod at all. If you do get a spot, it may be behind 50 other photographers. These prime locations just don't have enough space, and the ideal shooting spot can sometimes only accommodate a handful of photographers, so if you plan a trip to shoot there, also plan to get there crazy early and be one of those handful with the ideal shooting position.

Why You Should Shoot Panos Vertically

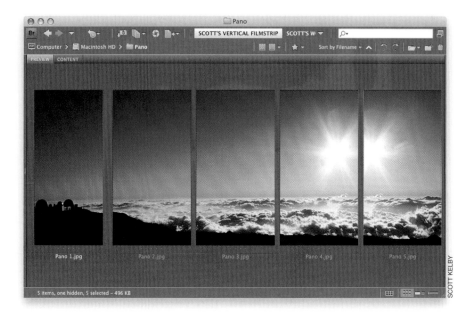

If you have Photoshop (at least version CS3 or higher), you absolutely should be shooting panoramas, because Photoshop will automatically stitch your individual images into a wide (or tall) panoramic image for you, and it does an absolutely amazing job. These days, you don't even have to pull a bunch of fancy tricks in the camera (you can even hand-hold your panos), you just have to follow one simple rule: make sure each photo overlaps by around 20%. Photoshop needs that overlap to do its thing. However, here's a tip that will keep you from having to crop off mountaintops or crop away something interesting in the foreground. Once Photoshop creates your pano, you'll always have to crop the photo a little bit because of the way it assembles your pano. Now, here's the tip: shoot your panos vertically. That way, when you crop your photo, you won't have to shear off the tip of a mountain, or part of a beautiful reflecting lake, because there will be a little "breathing room" left above your mountain range to crop in and still keep your mountains intact. Of course, if you compose so there's 1/16 of an inch above the tallest peak, the shooting vertical thing won't help, so I guess it's really two tips: shoot your panos in vertical orientation, and compositionally, leave a little breathing room above your subject in case you have to crop.

Getting More Vibrant Landscapes

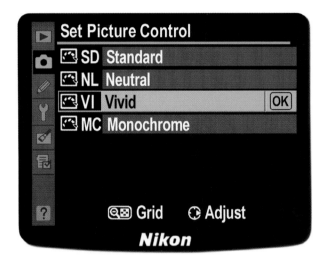

For years, traditional film photographers who shot landscapes used to be hooked on a brand of Fuji film called Velvia, because that film had a very vibrant, color-saturated look that landscape photographers just love. So much so that some simply wouldn't shoot without it. Today, with many digital cameras, we have something similar (which makes your images look more vibrant) right in the camera, but you can only take advantage of it if you're shooting in JPEG format. Nikon calls these "picture controls" and Canon calls them "picture styles," but they both do a similar thing: make your colors more vibrant. Here's how to turn this on:

Nikon: Go to the Shooting menu, and choose Set Picture Control. In the Set Picture Control menu, choose Vivid, then select OK to give you more vivid landscape photos when shooting in JPEG.

Canon: Go to the menus, to the Shooting menu, and choose Picture Style. Then choose Landscape to give you more vivid landscape photos when shooting in JPEG.

Delete Now Instead of Later

When I'm shooting travel photography, I make it a point to edit as I go—if I take a shot and see that it's blurry, or way overexposed, or just messed up in general, I delete it right there on the spot (after all, if I can see it's blurry or really bad on that tiny screen on the back of my camera, when I see it at full size it will be beyond unusable). There's no sense in carrying around these shots, which are just taking up space on your memory card, and soon they'll be just taking up space on your computer, when either way, they're destined to be deleted. So, why not save time, save space, and up the number of "keepers" from your shoot by deleting the obviously bad shots now? I usually do this in between shoots, so if I stop at a café for a snack, I'll take a look through the images I've captured, and delete the obviously really bad shots. There are some people who are hesitant to do this, because they're afraid that some blurry, overexposed shot is going to be "the one!" That's certainly never happened to me. I've seen shots that would have been great if they hadn't been blurry, or soft, or improperly exposed, but I've never used one of those for anything. You won't either. It'll just make you sigh and think, "Man, if that had only been in focus!"

SHUTTER SPEED: 1/200 SEC F-STOP: F/8 ISO: 200 FOCAL LENGTH: 200mm PHOTOGRAPHER: SCOTT KELBY

Chapter Six

Shooting People Like a Pro

Yet Even More Tips to Make People Look Their Very Best

How can there possibly be yet even more tips about how to make people look their very best? It's easy: have you ever looked at people? I mean, really looked at them. Up close. It's scary. I'm not talking about me or you, mind you. Other people. Let's take your average guy, for example. If he's above the age of 12 or so, most likely he has hair coming out of his nose, his ears, his underarms, and it's growing like ivy on his arms, legs—just about anywhere you wouldn't actually want hair growing. These are just the places you can see. I know. Gross. Anyway, what are we, as photographers, to do about shooting these grotesque human fur balls? We find ways to light them, using either natural light, studio light, or some twisted combination of the two, so that they're somewhat bearable to look at, as long we don't look very closely. This applies to all men, with the possible exception of George Clooney. Now, when I look at George Clooney, I see kind of a well-groomed, decent looking guy, but the women I know, including those who are photographers, see something entirely different in him. They don't see the hairy mass I described previously. They have the same reaction to him that they have to chocolate cake. They lose complete control of their faculties. So, based on this (my conclusions are strictly based on my own personal observations, and not scientific data, though I've never met a female scientist that didn't find George Clooney irresistible in a chocolate-molten-lava-cake kind of way), I decided to conduct an experiment. I went to my local bakery, had the woman who owns the bakery choose the hands-down yummiest chocolate cake she sells, and then I used a series of A-clamps and gaffer's tape to affix this to the head of my assistant Brad to see if this would bring about the "Clooney reaction," despite his having no Clooney-like resemblance. Well, it worked better than I had expected, and within two weeks he wound up marrying a supermodel from Prague, who to this day refers to herself as Mrs. Clooney. True story.

If They Look Uncomfortable, Hand Them a Prop

One of the things that makes some people so uncomfortable in front of the camera is that they don't know what to do with their hands—no matter what they do with them, they feel like they look dumb. If you can see that's the case with one of your subjects, give them something to hold (like a prop), and you'll instantly see their comfort level go up, and that will translate into more natural-looking photos. If you can give them a prop that they can relate to, all the better. (For example, if they're an artist, have them pick up a handful of paintbrushes. Shooting a nutritionist? Have her take a bite of an apple. Okay, it doesn't have to be quite as obvious as that, but you get the idea.) Once they have something in their hands they feel comfortable with, not only will they feel more comfortable, but your photos will have added visual interest, as well.

The Advantage of Having Your Subject Sit

SCOTT KELBY

Another situation where your subject will often feel awkward or uncomfortable is when they're standing. They feel so vulnerable just standing there alone in an empty space, and that's why some photographers choose to have their subjects sit down. Although you'll have to shoot from a lower position (which might make you a little uncomfortable), most people will be much more comfortable sitting vs. standing. Also, if you see your subject is still really uncomfortable, try putting a small table (like a posing table, for example) in front of them. Putting something in front of them like that will help them feel less vulnerable (think of how often public speakers like to hide behind a podium when giving their presentation—it's a comfort thing). Next time you're in one of those situations where you can tell your subject feels really awkward, have 'em take a seat and you'll usually see a world of difference.

Use a Posing Stool

You can have your subject sit on just a regular ol' chair, but if you want a chair specifically for photography (one without a back or arms), you can buy a posing stool, which is an adjustable-height stool that swivels, and they're pretty unobtrusive (which is good, as its job is to not draw attention to itself, and keep the focus on the subject). You can also buy an adjustable-height posing table, as well (B&H Photo sells them separately, or you can buy them together in a kit).

Shoot From Up Really High

SCOTT KELBY

Another perspective we don't get to see very often is a very high perspective, and by that I mean shooting down from a second floor walkway or shooting straight down on boats going under a bridge. These high vantage points offer a view we don't see every day (even though we may walk across a second floor walkway that's open to the lower level, we don't often see images taken from that vantage point). These work great for everything from shooting the bride encircled by her bridesmaids to shooting down on diners at an outdoor cafe. The shot above was taken straight down from my hotel room window while on vacation. Next time you want a totally different perspective on things, and don't feel like getting your pants dirty from sitting down, look up and see if there's a higher angle you could be shooting from.

Have Them Get a Leg Up!

Having your subject prop one of their legs up on a box does two things: (1) it helps their overall lines, improving their overall look, and (2) it usually makes them feel a little more comfortable (now that they're not just standing there). Many photographers use this trick whether their subject is sitting or standing. It doesn't have to be a very high box (in fact, it shouldn't be); it can just be six or eight inches tall—enough to give your subject that little extra something.

Shooting a ¾–View? Pick a Spot to Look At

SCOTT KELBY

One of the three most popular positions for formal portraits is the ¾-view, which shows about three-quarters of your subject's face—they're looking away from the camera at around a 45° angle (as if they're looking at something off to the side of where the photographer is standing, and because their head is turned slightly like this, you see both eyes, but you don't see the ear on the other side of their head). But this tip isn't how to pose a ¾-view, it's about how to get a more realistic-looking ¾-view without seeing too much of the whites of your subject's eye (if you get too much of the whites of the eyes, it looks kind of weird. Okay, it looks kind of creepy). The trick is: don't just have your subject look off to the left or right—choose a particular object in the room that they should focus on each time they do the ¾-view. Once you give your subject a spot to look at, take a test shot and see if you can see their irises clearly and there's not too much of the whites of the eyes showing. If you do see lots of white, they're looking too far away—have them turn their head a little more toward the camera and focus on a different object in the room (if there's nothing for them to focus on, put an extra light stand where you want them to look, and raise the top of the stand to where you want their eyes to go). Also, this picking-a-spot-for-the-¾-view technique is particularly helpful when working with professional models, because they'll be hitting a number of different poses during the shoot. If you give them a spot to look at each time they go for that ¾-view, they'll hit that same spot every time.

Get Everything Set Before They Arrive

If you're doing a studio shoot, you want to keep your subject as comfortable and relaxed as possible, and one way to do that is to not keep them waiting around—have everything set up, tested, and ready when they get there. You shouldn't be in the middle of setting up the lights, or adjusting your camera gear, or anything else when your subject arrives for the shoot. Have everything ready (test all the lighting—not only to make sure it works, but have it set up approximately where you want it, and have your exposure pretty well set) when they walk in the door. Don't have your subject sitting there for 20 minutes while you try to get the lighting right, or while you're trying to get your camera settings right. Besides looking unprofessional to your subject, they're going to be uncomfortable sitting there and not posing while you're testing everything (I have a subject who can't help but smile and pose, even when I'm just testing the lights, and then when it's time to actually start smiling, they've been doing it for 20 minutes already—they're "smiled out"). So, to increase your chances of success, to keep your subject relaxed, and to conduct your shoot like a pro, have everything ready when they walk in the door.

Super-Shallow Depth of Field for Portraits

SCOTT KELBY

Right now, one of the most popular looks for casual and location portraits is to use a very, very shallow depth of field, so everything is pretty much way out of focus except your subject. You get this look in two steps: (1) You have to have a lens that will allow you to shoot at a very low-numbered f-stop (like f/1.8 or f/1.4), so most folks use a fixed focal length lens (like a 50mm lens—it's not a zoom lens, it just shoots at a fixed length of 50mm, but that's okay, that's the depth we're going for), because they're not too terribly expensive (usually less than $100). And, (2) for a location portrait, to be able to shoot outdoors at such a wide-open f-stop, you have to shoot when it's really overcast, you're totally in dark shade (like in an alley), or it's nearly sunset. If not, shooting at that low of an f-stop number will totally overexpose your photos, and they'll be so bright they'll be unusable. So, pull this technique out of your bag on those cloudy, overcast, gray days—go to a downtown location, and do your best to compose so you don't see the sky. Also, make sure you're careful about your focus, because if you're off by even a little, they'll be out of focus. Focus directly on your subject's eyes, and understand that everything behind their eyes (like the back of their head or their earrings, as in the shot above) will either be a little, or a lot, out of focus.

Using a Triflector for Portraits

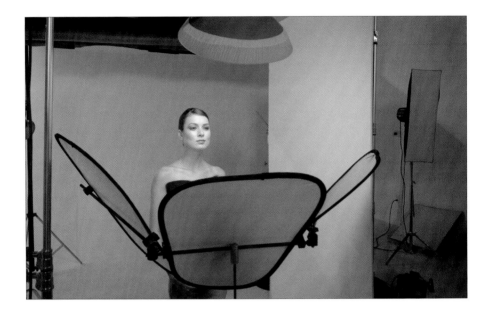

Another handy piece of gear for shooting fashion and beauty style portraits is a triflector, and what this is, is three small reflectors that mount on one thin horizontal bar. They're hinged so you can aim them right where you want them and create some amazing wraparound light (well, reflected light—they're reflecting light from a light positioned above your subject). Because you have three of these aimable reflectors, you can not only just reflect light on the center of your subject's face, you can aim the side reflectors up to put reflected light onto the sides of your subject's face, giving you a bright, clean look (which is why these have become so popular with beauty and fashion photographers). Another nice bonus of using these triflectors is the great catch lights they create in your subject's eyes. There are a number of companies that now make these and I've tried a few different ones, but the one I regularly use is the Trilite from Lastolite, with silver reflectors on one side and white on the other (I like how light-weight it is, and how easy it is to set up, but it doesn't feel cheap and chintzy).

Using Scrims for Shooting in Direct Sun

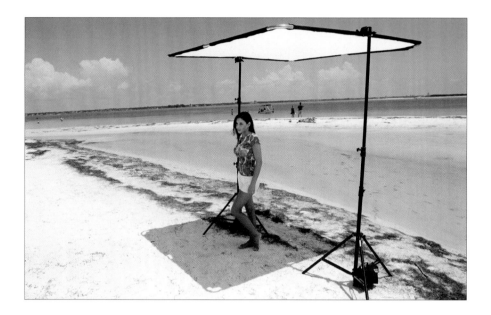

If you've ever wondered how the pros get those amazing portraits out in direct sunlight, like at the beach, or out in the middle of the day in a field, here's the trick: they don't. They're not shooting in direct daylight, because what you can't see, just outside the frame, is a large scrim positioned a few feet above the subject that diffuses and softens the light. Think of it kind of like a giant softbox that spreads the light from the sun. What's nice about scrims is they're very lightweight and portable (it's just fabric wrapped around, or attached to, a collapsible frame), and they're not crazy expensive (you can get a pretty decent-sized one, like 78x78" with frame and fabric, for around $375). Once you get your scrim, you're going to need to have a way to support it, because it has to go between the sun and your subject (they're usually put either directly over your subject, like a roof, or behind or beside them at a 45° angle). These are really lightweight, so you can have an assistant (or a couple of friends) support your scrim frame, or you can support them with light stands. If you go the stand route, you'll need to buy two little brackets that fit on top of your light stands to hold and tilt the frame, so don't forget to get those, too. Also, you'll probably want to bring a reflector, and maybe even a flash, depending on how late in the day you'll be shooting.

Shooting at the Beach

Besides just shooting in a really bright, direct sun environment (see the previous page for dealing with that), shooting at the beach presents its own set of challenges that you'll want to consider before doing a beach shoot. The first is sand—the natural enemy of camera gear. It doesn't take much wind for that fine sand to start blowing around, so if you're out on location and need to change your lens, your best bet is to go back to your car and change lenses there, or bring a changing bag that you can stick your camera body and lenses inside of to do the quick switch-a-roo. Also, once your shoot is done and you're back in the studio, don't forget to clean the outside of your camera and your lenses, especially if you were shooting near salt water. Outside of that, don't forget to bring the non-camera things like bottled water for everyone on the shoot, a fresh change of clothes (and towels) if you're going to be shooting in the water at all, and (I know this probably goes without saying, but I'm going to say it anyway) bring sunscreen and reapply it often.

Shooting on the Street

There are many famous photographers who specialize in capturing images of people on the street as they wander around, capturing real life as it happens around them. Unfortunately, these days people are much more aware, and wary, of people taking their photo on the street than ever, but I learned a couple of great tricks from a day I spent wandering the streets of New York City, with living legend Jay Maisel, that can really make a difference. The first was to shoot with a small lens. It can be a zoom lens, but the smaller and less obtrusive the better. Jay pointed out that with shooting on the street, the longer the lens you use, the higher the anxiety (and potential anger) of the people you'll be shooting. With a long lens on your camera, you go from being just another tourist on the street to what they might consider paparazzi, and then things can get ugly. Besides just shooting with a small zoom or fixed focal length lens, Jay told me to "leave the lens hood off," because anything that makes the rig look more pro means more resistance. Another tip was to not look people in the eye when you see the shot you want—don't lock eyes with your subject, just take the shot, and if they look right at you, just smile and move on. Now, of course we were shooting in New York City, where paparazzi are prevalent and people may be more guarded. In most other cities, and in foreign countries, I've found that a nice smile goes a long way and most folks will actually let you take their picture. If you show them the picture on the back of your camera, then they'll usually let you take a whole bunch of shots. The main thing is to respect everybody. If they don't want their photo taken, and they make that known by a facial expression (or a hand gesture, ahem), don't take it.

Get a Model Release

If you're shooting a subject for any commercial use, whether it's a friend or a professional model, make sure you get a signed model release from your subject while they're still in the studio. This release gives you, the photographer, the right to use their likeness in commercial projects like ads, brochures, websites, and promotions, or to resell their images for use in stock photography. You need your subject's written permission on a release to use their photos in this way, because without it you could open yourself up to lawsuits and an embarrassing situation with your client. So, you can avoid all that by getting one signed. Professional models are used to signing model releases (after all, what good would it be if you hired a professional model for a job, and then they wouldn't let you use the pictures for anything?), so that won't generally be a problem whatsoever, and there's no need to feel uncomfortable asking them to sign one. If the subject is a friend or co-worker, just let them know up front that you'll need them to sign a release giving you permission to use their image, and you shouldn't have a problem (I've never had someone I hired or set up an actual shoot with refuse to sign a release). So now that you know you need a release, where do you get one? You can find dozens of free downloadable releases online (just Google "model release"), or you can visit either the Professional Photographers of America (go to ppa.com and search for "model release") or visit the American Society of Media Photographers (ASMP) at http://asmp.org/commerce/legal/releases/ for a great article on releases. The laws regarding releases vary from state to state, and country to country, but having a signed release sure beats not having one.

They Don't Always Need to Be Smiling

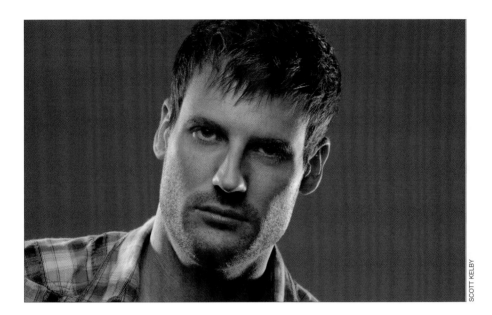

SCOTT KELBY

If we're shooting a portrait, it's our tendency to make sure our subjects are smiling in every shot (after all, you want them to look like they're happy and having a good time, right?). Smiles are great, and we definitely want those shots, but make sure you work some "real" shots in there, too. We're not always smiling in real life, and when we're smiling for a portrait, it's often a posed smile, so you're not capturing a real genuine emotion—you're capturing a fake smile that we've all been doing since we were little kids. If you want to capture portraits that have more depth, more emotion, and more realism, include some shots where your subject isn't smiling (as shown above). If you want your portraits to be more real, this is a great way to open that door.

They Don't All Have to Look at the Camera

Another thing we're programmed to do is always have our subjects facing the camera. While it's true that having your subject's eyes as the main focal point of an image adds interest, some of the most dramatic and captivating portraits ever taken have the subject looking elsewhere. Keep this in mind the next time you're shooting a location portrait, and you might be pleasantly surprised at what you'll come up with.

Overexpose on Purpose

Here's a different look to try: overexpose on purpose. This is great when you want a really bright look for portraits, because it hides detail and gives everything kind of a dreamy, morning-light look to it. Here's how you set this up: go ahead and take a regular shot (let your camera set your exposure), then add some positive exposure compensation, which means you're basically telling the camera, "Okay, I see you picked the right exposure for this photo, but I want to override your choice and make it even brighter." On Nikons, you'd do that by holding the exposure compensation button (the +/– button on top of the camera, right behind the shutter button), then rotating the command dial on the back of the camera until you can see +1 in the control panel on the top of the camera (meaning you just made the exposure one stop brighter than the camera thought it should be). On Canon cameras, first make sure the power switch is set in the top position (above On), then hold the shutter button halfway down, look at the LCD panel on top, and turn the quick control dial to the right to increase the amount of exposure compensation until it reads +1. Now, take a shot and see how the image looks on the LCD monitor on the back of your camera. If it doesn't look bright enough, try increasing the exposure compensation amount and take another test shot (and so on), until it has that dreamy, morning, window light look.

This Doesn't Work in Manual Mode

Exposure compensation works in all the standard modes except manual mode.

Put Multiple Photos Together to Tell a Story

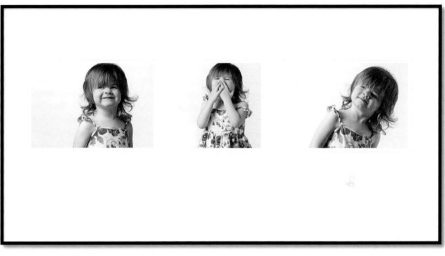

SCOTT KELBY

If you really want to capture a child's personality (and like me, you're not a big fan of the stiff, posed shots), then keep firing while your child is goofing around on the set. Then, take some of the best ones and put three or five together as a series in one frame, like the example shown above. By grouping a set of photos together like this, it instantly goes from a still frame to a story, and I can tell you from experience, clients (parents) just love it!

The Trick to Shooting Newborns and Having Their Faces Not Look So Flat

Newborn babies generally have very flat faces, and that's one reason why it's so hard to get great photos of newborns. The trick is to make their faces look rounder by positioning the baby, or your lighting, so one side of their face is in the shadows. That helps give some depth and dimension, and keeps their face from looking too flat.

Get Out From Behind the Camera for Kids

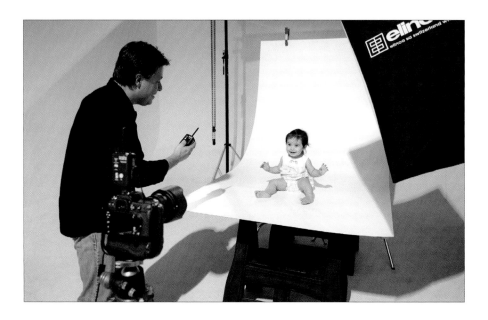

I learned a great trick from Jack Resnicki, a friend who shoots high-end commercial shots of children for print ads and displays in stores (and he's one of the absolute best out there). What Jack does is put the camera in position on a tripod, then rather than being stuck back behind the camera (and putting something between the child and the photographer), he comes right out in front, down on the floor, to get the child engaged. Now you can totally interact with the child, and focus on getting reactions and emotions that are usually so hard to create when your head is buried in the back of a camera. To make this happen, all you need is a wireless shutter release (B&H Photo carries these for all the major brands), and now it's just you and your subject—and you both can focus on the fun that makes such memorable shots.

Only Have One Person Focus the Child's Attention on the Camera

If mom, dad, and grandma are all on the set, they will all try, simultaneously, to get the baby to look at the camera. The problem is that they're usually standing in different areas behind you, so the baby is looking all over the place. Choose one person to be the "attention getter," and have them stand behind and to one side of the camera.

Don't Shoot Down on Kids

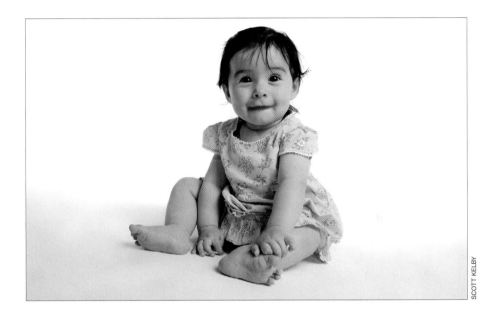

SCOTT KELBY

If you're unhappy with your shots of kids, it may be because you're shooting them like most people do—from a standing position, so basically you're shooting down at them. The problem with this is that, on an average day, that's how we see most children, with us in a standing position looking down at them, and if we photograph them from the same viewpoint, that's how the photos are going to look—average. The trick is to shoot from their level—get down on one knee, or sit (or even lay) on the floor, to capture them from a viewpoint we normally don't see, which honestly changes everything. It's one of the easiest things you can do that will have the greatest impact on your images.

The "Hand Them a Prop" Trick Works Even Better with Kids

If adults get intimidated and shy in front of a camera, imagine how intimidating a studio (with all the lights and stands, etc.) is to a child. To make them relaxed, make it fun by using the same trick you do with adults—give them an interesting or unusual toy or stuffed animal to get their mind off the camera and on the fun.

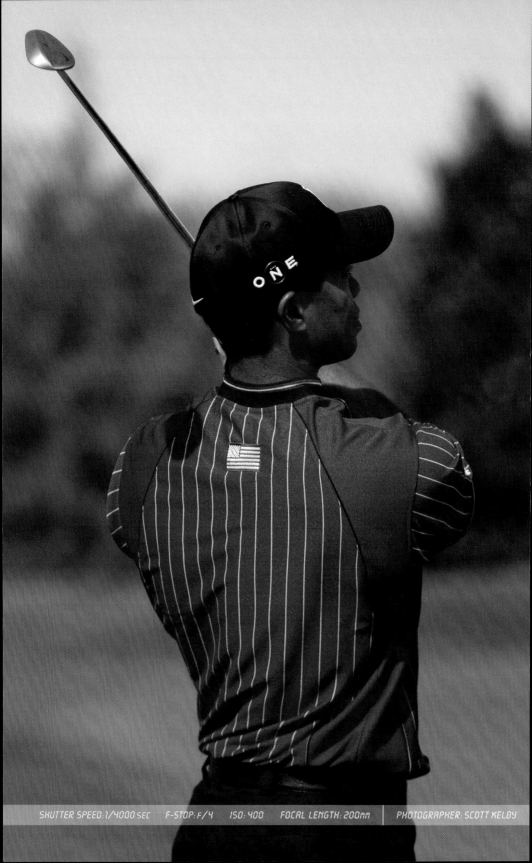

SHUTTER SPEED: 1/4000 SEC F-STOP: F/4 ISO: 400 FOCAL LENGTH: 200mm PHOTOGRAPHER: SCOTT KELBY

Chapter Seven

Shooting Sports Like a Pro

How to Get Professional Results From Your Next Sports Shoot

Shooting sports, especially if you have a family member who is one of the participants, is one of the most rewarding, thrilling, exciting, frustrating, maddening, emotionally draining, cuss-word emoting, expensive, laborious, and downright fun things you can do as a photographer. I rank it right up there with accidentally submerging your unprotected camera in saltwater—it's kind of like that. Now, I say this from experience, because these days I spend a good amount of my time shooting professional sports—everything from motorsports to American pro football, from horse racing to baseball—and let me tell you, it's one royal pain in the @$$! So, why do I do it? Because it's a blast! Wait, I just said it's a pain. It is a pain. Just ask any sports shooter. The day after a serious shoot, you're hobbling around like you were actually playing the game instead of just shooting it, but at the same time, there's just nothing like the thrill of shooting sports. Well, it's not all a thrill, there's a lot of what we call "hurry up and wait," because in all sports, there are lots of times where nothing is happening (like timeouts, penalties, breaks between periods or quarters, TV time outs, halftime, someone's hurt on the field, etc.), and you're just standing there talking to other sports photographers who are, by and large, kinda cranky, because it's in those downtime moments when they realize how much they've spent on the equipment required to really shoot sporting events right, and each time they pause to think about it, they die a little inside, because they know they could be driving nice cars, or living in comfortable homes, or they could have sent their kids to a great school, but instead, here they are waiting for the timeout to end, and then they turn to liquor to deaden the pain of a life spent on the road, and before you know it they're writing a volume 3 of their book, when all they really want is a hug, a decent monopod, and a bottle of ibuprofen.

Auto ISO Lets You Always Freeze the Action

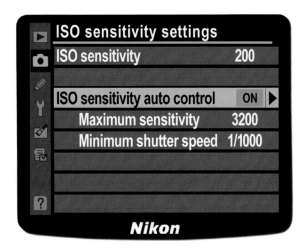

If you're shooting a sport where you need to freeze the action (like football, basketball, baseball, etc.), then you need to make sure you're shooting at a shutter speed that freezes action—around 1/1000 of a second. That's easy to do in broad daylight shooting at a wide open aperture like f/2.8 or f/4 like we would normally do with sports, but if it gets cloudy, or the light changes, or it gets later in the day, you run the risk of your shutter speed falling below 1/1000 and coming home with a bunch of blurry sports shots. That's why you'll fall in love with the Auto ISO feature, which makes sure you never fall below a certain shutter speed, because it will automatically increase the ISO without any input from you. What's especially slick about this is it won't just jump from 200 ISO to 400 ISO, it'll only move exactly as much as it needs, so it might go from 200 ISO to 273 ISO (something you couldn't even choose on your camera if you wanted to, right?). On Nikon cameras, you turn this on by going to the Shooting menu and choosing ISO Sensitivity Settings. Then you enter the Minimum Shutter Speed you want to maintain (I use 1/1000 of a second), and turn the ISO Sensitivity Auto Control on. Now, you get sharp shots every time, no matter how the light changes on the field. On Canon cameras, you need to set the ISO speed to A by looking at the LCD panel and turning the main dial on top of your camera.

Using the Extra Focus Buttons on Long Glass

If you're shooting sports with some "long glass" (200mm and on up), on most of these lenses you'll find a second (or multiple) focus button(s) right on the barrel of the lens, down toward the end. These let you use the hand that is steadying the lens to lock in your focus, so when the play happens, you can just press the shutter button quickly. However, there's a little known feature that, when coupled with back focusing, can really make a huge difference in "getting the shot." We'll use baseball as an example. Let's say there's a runner on first, so the play is going to be at second base. Go ahead and focus on second base itself, then turn on the Memory Set button on your long glass (if your lens has a memory lock). Now turn on your camera's back focus (AE Lock) feature, so instead of focusing when you press the shutter button, it focuses when you press the AE Lock button on the back of your camera. Then, swing your camera over to the batter, and press the back autofocus (AE Lock) button to focus on him. When he swings, go ahead and get the shot by pressing the shutter button (you can shoot fast because you don't have to wait for the autofocus to kick in—you already focused with the back autofocus [AE Lock] button). If he gets the hit, swing immediately over to second base, then with your other hand on the barrel, press the second focus button on the barrel of the lens, and it remembers the focus you locked in for second base, so all you have to do is wait for the runner and press the shutter button. Both areas, home plate and second base, will be in perfect focus, and you're right there, ready to capture the action.

Shooting Night Games with Super-High ISO

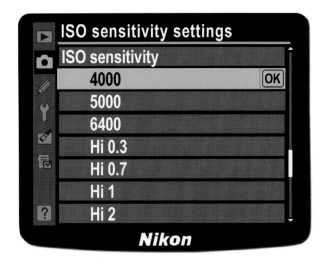

One of the most surprising things that new sports photographers learn is just how dark a playing field is at night. It may look bright from the stands, but for your camera, you might as well be shooting in a museum, because you have to maintain a high enough shutter speed to freeze the action (as I mentioned earlier, a good rule of thumb is 1/1000 of a second). So how big a problem is this? To give you an example, when shooting a Chicago Bears night game at Solider Field in Chicago, I had to shoot at 4000 ISO most of the night to get anywhere near 1/1000 of a second. From the stands, and even when down on the sidelines, it looks incredibly bright, until you look through your viewfinder and see the shutter speed. So, if it's that dim at Solider Field, you can imagine the challenge of shooting a high school football game. That's the reason why cameras capable of shooting at higher ISOs with minimal noise have become so popular (cameras like Canon's Mark III, and Nikon's D700 and D3, have such minimal noise that I'll often shoot at 6400 ISO and the noise is barely noticeable). If you try to shoot at high ISOs like that with lower-end cameras, the noise will be so distracting that you won't get the results you're after. I hate to tell you to rush out and buy an expensive high-ISO camera, but like I said in volume 1 of this book, shooting sports is expensive, so if you're going to do it, you'd better take a second job to pay for your gear.

The Advantage of Shooting From the End Zone

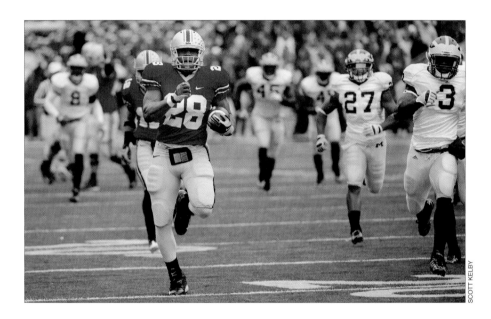

SCOTT KELBY

If you shoot football, you'll probably spend most of your time shooting from the sidelines, and if that's the case, you'll probably spend a lot of your time pulling your hair out as refs, game officials with the first down markers, and TV camera crews (including the guy holding the big parabolic mic dish) all walk into your shots, and block you from getting "the shot." That's why you'll see a lot of pros jockeying for space in the end zone and the corners of the end zone—they usually have a clear, unobstructed line of sight, and they're right in position if someone breaks loose to "take it to the house" (as shown above in this shot I took from the end zone of an Ohio State vs. Michigan game). The only "gotcha" is that if possession changes, you have to decide if you want to go to the opposite end zone, where the plays are now going towards (see, there's always a gotcha!).

The Two Most Popular Sports Shots

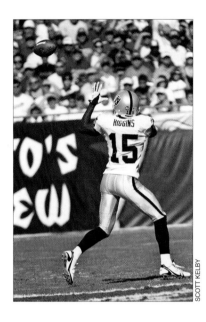

The "Holy Grail" for any serious sports photographer would be to have their work published in *Sports Illustrated* magazine. All the best shooters are there, the images are amazing, and getting to shoot for *SI*, as you'd expect, isn't easy (which is maybe why every sports photographer dreams of doing it). But what kind of images does a magazine like *Sports Illustrated* run the most? I was teaching a class on shooting football and I wanted to answer that question for my class, so I did a little research and I can tell you that, based on that research, they run two types of images: (1) Action images, where the ball (if there is one) is in the frame with the athlete (so if it's a shot of a quarterback or running back, they're holding the ball, or if it's the receiver, he's catching the ball, etc.). (2) Celebrations. Occasionally, it's an editorial shot of an athlete who just suffered a crushing defeat, but usually it's one or more players celebrating after a big win— it's Tiger Woods pumping his fist, a hockey team with their sticks in the air, a soccer player cheering on his knees, two football players bumping chests in midair. Almost invariably, those are the two types of shots that make it into *SI*. Also, they're usually in tight on the players, so you can see their facial expressions and the emotions of the game. So, how does this help you? Well, after all these years, you can imagine that *Sports Illustrated* has figured out exactly which types of sports photos people want to see, right? Right! Now you know which two types of shots you want to be sure to capture the next time you're shooting a game. Remember, if the ball's not in the shot or the players aren't celebrating, it doesn't make it into the magazine. There's a reason.

Once You've Got the Shot, Move On!

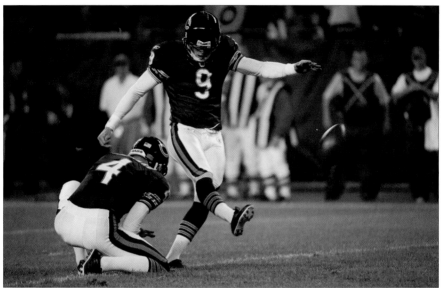

SCOTT KELBY

If you're shooting a game where you're not covering it on assignment, and you don't have a family member actually in the game, here's something to keep in mind: Let's say you're shooting football. Once you've got that great shot of the quarterback, where he's posed in the perfect position, and the ball has just left his hand for a perfect spiral pass, and you framed it just right, and you know you nailed it, or that shot of the kicker going for the extra point, and the ball has just left his foot, but it's still in the frame (as shown here)...move on. Don't keep shooting them doing those moves for the rest of the day expecting something different. I've seen so many times where a friend will shoot a game, and they'll have 200 shots of the quarterback doing essentially the same move. Sometimes they've nailed it in the first round of shots, but they stay on him the rest of the day, shooting literally hundreds of shots. Instead, once you've got "the shot" of that player (the receiver leaping to catch that ball over his head, with the corner's hands trying hopelessly to deflect it), you've got it. You got the shot. Move on to capturing another aspect of the game, another player in another position, or just stick to where the action is. When you get back, you won't just have "the shot." You'll have "the shots!"

Turning Off the Beep

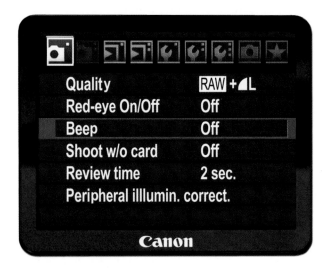

There are certain sports, like tennis or golf, where being quiet and unobtrusive is the name of the game for a photographer (yes, they sometimes will yell at you if you bring any undue attention to yourself), and one simple thing you can do so you don't stick out is to turn off your camera's autofocus beep—that little audible beep that lets you know your autofocus has locked on. Instead, turn that off, then just look in the viewfinder for the visible signal that your focus has locked on (on Nikon cameras, it's the Focus Indicator— the solid round circle on the bottom-left side of the viewfinder. On Canon cameras, it's called the Focus Confirmation Light, and it's found at the bottom right of the viewfinder). That way, the only sound they'll hear is your shutter. To turn off the beep on a Nikon camera, go to the Custom Setting menu, under Shooting/Display, choose Beep, and set it to Off. On Canon cameras, go under the Shooting 1 menu, choose Beep, and set it to Off, as shown above.

Having Your Focus Auto-Track the Action

If you're going to be shooting sports, there's a focus setting on your camera that you're going to want to change to help you track the action and stay in focus. Switch from the default focus, which is for non-moving objects, to a focus mode that tries to automatically track a moving object if it moves out of the focus area. On Nikon cameras, you'd switch from Single-Servo mode to Continuous-Servo focus mode, and you do that right on the front of the camera itself—it's that little switch on the front, right under the lens, marked M, S, and C. You want C (for Continuous-Servo). On Canon cameras, it's called AI Servo AF, and you turn it on by pressing the AF•Drive button on the top of the camera, and then turning the main dial until you see AI Servo in the top LCD panel.

Freezing Motion Doesn't Always Look Good

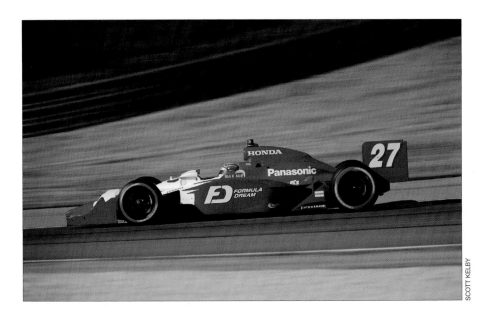

SCOTT KELBY

If you're shooting a sport like car racing, bike racing, or even an air show, freezing the action doesn't always look right. Take car racing, for example. If you completely freeze the action, you won't see the wheels of the car spinning—they'll be frozen like the car was parked on the track, rather than racing around it. Same thing with the wheels on a bike or motorcycle, or the propellers on a stunt plane—they'll all look like they're standing still. The way around this is to lower your shutter speed to around 1/250 to 1/360 of a second, and follow along with the moving object (called panning). That way, the shutter speed will be slow enough to show the wheels (or prop) spinning, and you'll get the sense of motion and speed that would be missing otherwise.

Avoid the Fence at All Costs

SCOTT KELBY

If you're shooting your kid's game, here's a tip to help you get more professional-looking images: try to set up the shot so instead of seeing a fence (very common), or cars in the parking lot, or the road near the field, you see the crowd (or the other parents, or the other players) in the background. This will look especially good if you're shooting wide open (using the lowest number f-stop your lens will allow, like f/2.8 or f/4), which puts the background out of focus.

Leveraging Daylight to Light Your Players

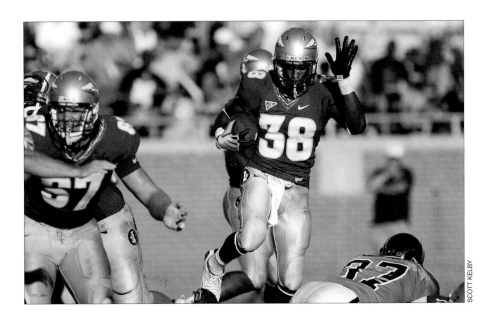

SCOTT KELBY

If you're shooting a game during the day, try to remember to position yourself so the sun is over your shoulder while you're shooting. That way, the players will be lit by the sun, and you'll be able to see their facial expressions. If not, they'll be mostly in the shadows, which is especially bad if they're wearing batting or football helmets. You might have to shoot from the opposite side of the field (which may well be the opposing team's side), but at the end of the day, you'll be able to clearly see all the players, and the emotions that make up the game.

Shoot From a Low Position

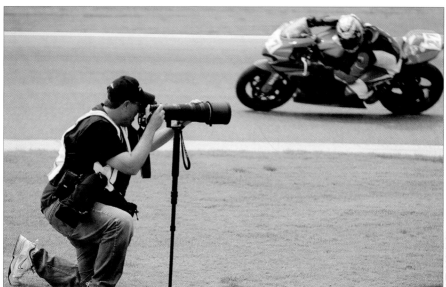

MATT KLOSKOWSKI

The next time you see a sporting event, take a look at the photographers shooting the event, and one thing you'll see again and again is that pros are often shooting down on one knee so they get a lower, and better, perspective for their shots. This goes for everything from motor racing to football—that lower perspective gives you the feeling of being right there, and helps to make the athletes (or their cars) look "bigger than life."

Save Your Knees (You'll Thank Me Later)

Mike Olivella, a pro-sports photographer, turned me on to one of his tricks for saving his knees when shooting at a low perspective: buy some gel-filled knee pads from the local home improvement store. I finally did that a year or so ago, and once I tried them, all I could think was "why did I wait so long?" They're inexpensive, very durable, and every time I wear them, at some point another sports photographer down on his knees looks at me, and through their grimace, says, "I've got to get some of those." Check out page 166 where I've got them on.

Isolate Your Subject for More Impact

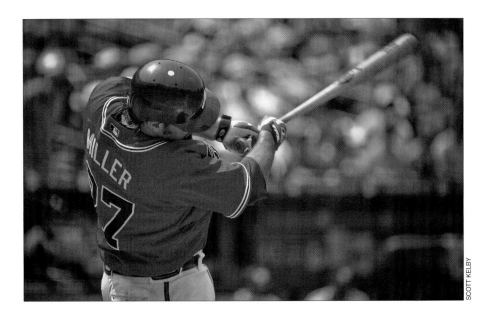

SCOTT KELBY

If you want your sports photos to have more impact, here's another tip to help: try to isolate your subject. There are two ways to do this, the first being simply to frame your shots so that only one or two people appear in the shot (if at all possible). When you get crowds of people in the shot, it's hard for the viewer to tell which person you want them to look at. The last thing you want to do is to make the viewer start searching your photo—trying to find the ball, or the puck. Look for those opportunities to shoot a player in a team sport all by themselves on the field, but during a moment of action. If you're shooting something like soccer or football, you can have more than one player in the frame, but try to make sure your composition makes it instantly clear which player they're supposed to look at, at first glance. The second method is to use a wide-open aperture (f/2.8 or f/4) to put everything in the background out of focus. F/11 is death for sports shots, and even an NFL game can look like a high school game without that shallow depth of field you're used to seeing from the pro shooters. Keep the idea of isolation in mind, and you'll have shots with much more impact your next time out.

Why You Want to Get in Tight

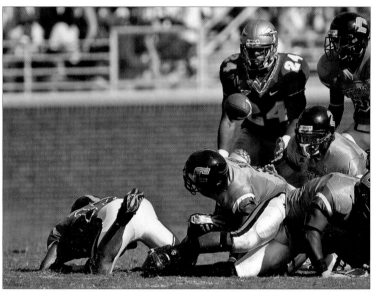

SCOTT KELBY

There's nothing more disappointing for a sports photographer than to have to shoot from the grandstands, and one of the main reasons why is that you'll come away with shots that are very similar to what everybody else in the stands saw that day. You're not bringing anything to them that they couldn't see with their own eyes. That's why it's so important to get in really, really tight when you're shooting sports. That way, you're bringing them something that they can't see with their naked eyes. You're bringing the emotion, the story of the game (not just the score), you're showing the sweat, the anger, the joy, and real things that make sports what it is—not just far off shots of faceless people running around in uniforms. That's why people react so positively to really close-up shots—you're showing them something they don't usually see. It's not just the ordinary view. We don't get that close to the athletes during a game, and seeing this new side of the game is fascinating to the viewer. You're revealing another side of the game by sharing this emotion. That's why we try so hard to get really great access to shoot sporting events. The great shots don't usually come from the stands (unless you've got a really, really long lens, and sadly most major stadiums, at least here in the U.S., are really cracking down on fans bringing pro camera gear to professional sporting events. Many stadiums now have a 4" rule—no lenses longer than 4").

Using a Second Camera Body? Get an R–Strap

Last year, I was turned on to BlackRapid's R-Strap, which for sports photographers using two camera bodies is a dream come true. (By the way, many pro sports shooters carry two full camera rigs during the event: one with a really long lens, and a second body with a short telephoto or wide-angle for when the action gets really close.) What I love about the R-Strap is that it straps across your chest, and it screws into the bottom of your camera, so your camera kind of hangs there like a gun in a holster (except there's no holster). When you need to take a quick shot with your second body ("quick" being the operative word here), you just reach your hand down to your side, and it falls right into place on your camera—you just pull your camera up to your face, and it slides right along the strap, giving you a fast, comfortable way to get the shot. When you're done, you just put it back down by your side. Being able to reach down and have my second body ready to shoot in a split second is a sports shooter's dream—I wouldn't want to shoot a sports event without it. You can watch a video demo of the R-Strap at www.blackrapid.com.

Tell a Story with Your Shots

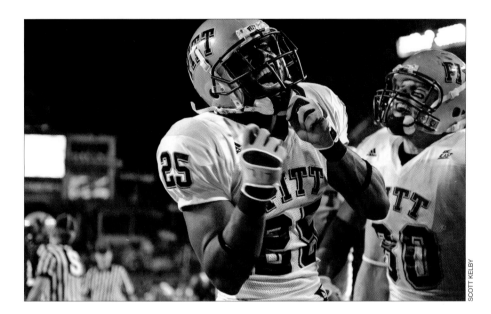

SCOTT KELBY

It's our natural reaction to put down the camera when the play is over, but that is precisely when you want to keep shooting—this is when you get to tell a story with your images. Imagine capturing the look on a quarterback's face when he realizes he's thrown an interception, or when a soccer player is given a red card. How about a coach when they're given what they think is a bad call. That's when the emotion pours out, and if you stop shooting at the end of the play, you'll miss some of the most dramatic, emotional, and even moving, moments in a game—the shots that tell a story.

Full-Frame vs. Standard Digital Chip

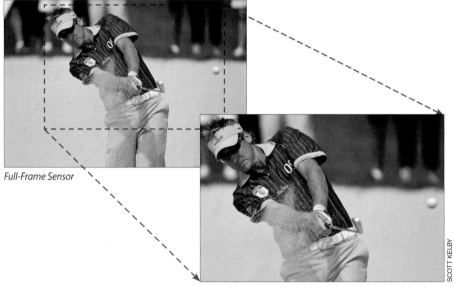

Full-Frame Sensor

Standard-Crop Sensor

SCOTT KELBY

Right now, full-frame sensor cameras are getting all the buzz, but for shooting sports, you might want to consider hanging onto that standard-crop sensor digital camera. Here's why: because of the zoom factor regular-crop sensor digital cameras have, they will get you much closer to the action. For example, a cropped-frame dSLR, like a Nikon D300, will get you 50% closer to the action, or for Canon shooters, an EOS 50D will get you 60% closer than the same lens on a full-frame camera. Here's how that works out: If you put a full-frame 200mm lens on a camera (like a Canon 5D Mark II), you get a real 200mm lens. But put that same 200mm lens on a Canon 50D, and it essentially becomes a 320mm lens. Add a 1.4x tele-converter on that 50D with that same lens, and now you've got nearly a 450mm lens (for the price of a 200mm lens). Landscape photographers make out like bandits with full-frame cameras, because the full-frame sensor lets their wide-angle lenses get much wider. But when it comes to sports, the "old school" 1.5x and 1.6x cropped sensor is very attractive.

> **High-Speed Crop on a D3 or D700 Is *Not* the Same!**
>
> When I talk about this topic, invariably someone asks, "Why don't you use the Nikon D3's built-in high-speed (Auto DX) crop, which switches you to the same cropped-sensor framing as a D300?" It's because using that feature cuts you down from 12-megapixel images to 6-megapixel images, and for sports, you sometimes need to be able to crop in tight after the fact (in Photoshop), and still have enough megapixels to make a high-resolution print, so it's not really an ideal option.

Don't Have "Long Glass?" Rent It for the Week!

If you have a special game or assignment coming up, and you don't have long enough glass to shoot the game the way you want to, then just rent it. I've done exactly that on a few different occasions from a company called LensProToGo.com. They have all the long glass for both Canon and Nikon shooters (they rent camera bodies, as well), and they ship directly to you overnight. What most people are surprised to find is how reasonably priced they are. For example, to rent a lens like a Nikon 300mm f/2.8 (a great, fast lens for shooting sports) for an entire week is just $230. If that seems like a lot, the alternative is buying that lens. B&H Photo has it in stock (as of this writing) for $4,899.95. So, even though you might not want to rent all the time, when you have a really important game, or a big assignment, they're a great resource (I've rented lenses from them a number of times, and they've always been great—never a problem once).

Still Players Are Boring

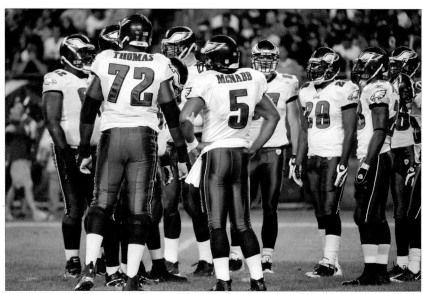

SCOTT KELBY

You'll be there at the game, and you'll see a player getting ready to dash down the field, and you've got a really great angle on them, and so you take the shot. As good as it might have looked in the viewfinder right then, when you open that photo later in Photoshop or Lightroom, you're going to look at that photo and wonder, "What was I thinking?" Don't shoot football players in the huddle or standing around. Don't shoot the runner standing with one foot on first base. Don't shoot the outfielder waiting for a pop fly—wait until the ball is there. Shoot the action, because when you start looking at your photos later, you're going to hate the shots that don't have it.

Another Reason to Keep Shooting After the Play

SCOTT KELBY

SCOTT KELBY

If you're shooting a team sport like football, it's easy to have the player you just shot carrying the ball, lost in a big pile of jerseys. Who was that player? Was it #22 or #37? If you keep shooting for a few moments after the play is whistled dead, you'll be able to see who finally comes up with the ball, and you'll have a reference photo with their number on it, so you can figure out later who the ball carrier on that play actually was. In the example shown here, when the player started getting up (shown on the right), I could see his number on the top of his shoulder pad (#34).

Add a Battery Grip for More Frames Per Second

You can get more frames per second with certain Nikon cameras (like the D300 or D700) by adding a battery grip. Adding one (and using the proper battery configuration) increases your fps rate, sometimes pretty significantly. For example, adding a battery grip to a Nikon D700 increases the fps from five frames per second to eight frames per second. That's a 60% increase in frame rate (not to mention that with a battery grip, you now have a shutter button on top for shooting vertical, which believe me, makes all the difference in the world).

You Don't Have to Drag Around a Camera Bag

BILL SMITH

With all the gear you'll be carrying around to shoot a sporting event, the last thing you want to have to do is lug around your camera bag. Worse yet, if you do bring it with you, you have to keep a close eye on it all day, because while you've got your eye in the view-finder, someone else could have their eye on your expensive gear. You get the shot, they get your other camera and lenses. That's one reason why a couple of years ago I switched to Think Tank Photo's Modular belt system, where my spare lenses, accessories, memory cards, water bottle, and even my cell phone are all just inches away, because they're right there wrapped around me, attached to a belt. Their system does an amazing job of distributing the weight, and like most sports shooters who use these (and there are a lot) will tell you, you completely forget you have it on. When you buy one of these, you can choose which types of lens pouches you want (they have sizes to fit all your regular lenses), which types of accessory pouches you want, and basically you just customize this belt system to your gear and your needs. I don't know a single sports shooter who has bought one of these that doesn't swear by it. Go to www.thinktankphoto.com to see what it's all about.

Start Shooting Right Before the Game

SCOTT KELBY

Right before a big game, the energy level is really high, and different athletes deal with this rush/stress/excitement in different ways. Some are all pumped up, and they're trying to fire up the other players, and some are very serious and quiet at moments like this, as they mentally prepare for the battle. This time, just a few minutes before the game, is a great time to catch some very emotional images right along the sidelines, or in the tunnel, or outside the locker room. Keep an eye out for capturing the different personalities and how they're reacting to what's about to happen, and you might come away with some killer shots before the opening whistle even blows.

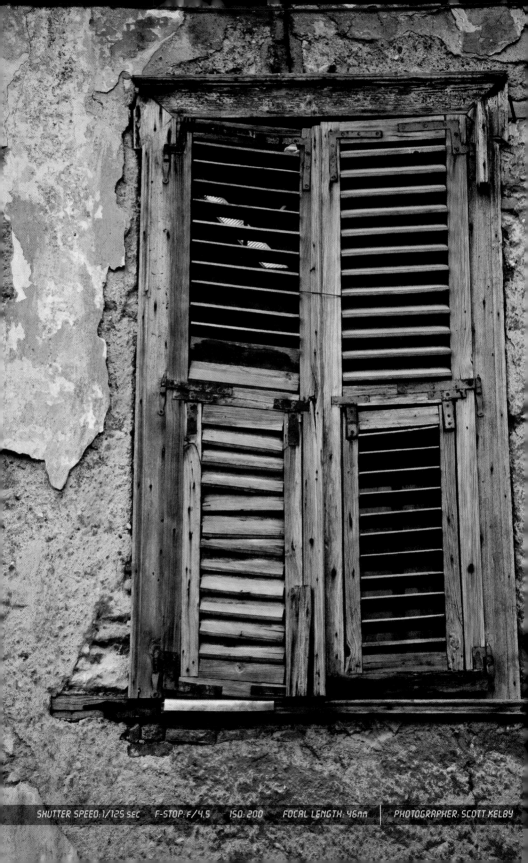

SHUTTER SPEED: 1/125 SEC F-STOP: F/4.5 ISO: 200 FOCAL LENGTH: 46mm | PHOTOGRAPHER: SCOTT KELBY

Chapter Eight

Pro Tips for Getting Better Photos

Tricks of the Trade for Making All Your Shots Look Better

Each of the other chapters in this book teaches you techniques that are pretty specific to a particular type of photography (like portraits, or shooting in the studio, etc.), but I wanted to once again include a collection of techniques that is just simply about getting better shots. At the end of the day, that's all we really want, right? We just want to take better photos. It's why we all work so hard to learn how to use our cameras—not so we can play around in the menus all day, it's because we know that once we really know the camera inside and out, then we can focus on getting the shots (and not the technology behind it all). Now, I know what you're probably thinking, "Scott, this all makes perfect sense, except for one thing: I'm reading this in one of the chapter introductions, and traditionally this is a part of the book that's not widely known for contributing to the chapter that lies ahead. What gives?" Well, here's the thing: my statement above would all make perfect sense if the chapter that follows was actually about making your photos look better, but sadly, it's not. What follows is actually a 22-page excerpt from my doctoral dissertation on neo-classical psychology patterns, which includes a non-apologetic look at man's inability to reconcile events from his pre-post-natal experiences and how those events have affected his non-verbal communication skills in the post-modern workplace. The reason I'm sharing this excerpt with you here is because I feel it deserves a wider audience than just my professor, who incidentally did not agree with several of the conclusions put forth in my well-documented, thoroughly researched, and flawlessly executed paper, which is why he will be referred to throughout the upcoming chapter as simply "Professor Big Poopie Head." Now, if you're thinking, "Dr. Kelby, I didn't know you had earned a doctorate," just remember this one underlying rule: I'm lying.

Using Live View to Set Your White Balance

There is a very cool new feature in some of the latest Nikon and Canon dSLRs that lets you use the LCD monitor on the back of the camera as a viewfinder, so you can compose and shoot your image using just it (just like a point-and-shoot camera). Now, it may not sound that appealing, but check this out: on some of these newer cameras, when you're view-ing the scene on your LCD, you can actually toggle through the different white balance settings and see right then and there how each white balance setting is going to look for that particular scene. This makes dialing in a great looking white balance absolutely simple—just scroll through the list, and when you see one that looks good, stop. Try it once, and you'll use it again and again (especially easy when you're on a tripod).

Spot Metering

Before *After*

Most folks keep their camera's metering set at the default, which is evaluative metering (on Canons) or matrix metering (on Nikons) and that just means it kind of looks at the entire frame and it tries to create an exposure that works for the entire image. These modes, on today's cameras, do a pretty amazing job most of the time. However, there's another type of metering—spot metering—you'll want to know about for those sticky exposures, like in the image above left, where I'm trying to capture both the light inside the little entryway and outside the building at the same time. In the default evaluative (or matrix) metering mode, it's going to make that entryway very dark. So, just switch to spot metering mode. This essentially tells the camera, "the part of the photo I want to look good is just this little tiny area right in the center of the frame." Then, you aim the center of the frame directly at that area, hold the shutter button down halfway to lock in that exposure reading, then reframe your photo to look how you want it (without releasing that shutter button), and take the photo. In the example above right, I just switched from matrix metering to spot, then aimed at the table inside that doorway. That's all it took (just remember to switch back to matrix, or evaluative, metering when you're done, because you generally only want to use spot metering in tricky exposure situations).

Shooting Concerts and Events

JOSH BRADLEY

One of the biggest mistakes people make when shooting concerts or events is to try to use their flash. A friend of mine shot a concert once and hated the results he got (he used flash). He emailed me some of the images, and I saw exactly why. I wrote him back, "So let me get this straight—there were around 275 of these huge 1,000-watt stage lights aiming right at the performers, but you thought there just needed to be one more?" We laughed about it, but there's a lot of truth to it. You want to see the color and vibrance of the stage lights, and you want the scene you photograph to look like what it looked like when you were there at the concert. Using flash wipes all that out (besides making the performers angry), and reveals all sorts of distracting things like cables, cords, plugs, duct tape, etc., that would never have been seen under normal stage lighting (in fact, if you shoot big name acts, they forbid the use of flash, and you generally only get to shoot for the first three songs of the concert, if that!). Since you absolutely shouldn't use flash, the key is to shoot at a high enough ISO that you can get your shutter speed around 1/125 of a second (to give you sharp shots in lower light—and yes, the stage is often very dramatically lit, and the lights are constantly changing, which is why shooting performances is so tricky). Since you may get some noise at these higher ISOs, be prepared to use a noise reduction plug-in (I've been using Nik Software's Dfine 2.0), and take along the fastest (lowest possible f-stop) lenses you've got (f/2.8, f/2, f/1.8, etc.). If you're close to the stage, take both a wide-angle lens and something like a 70–200mm f/2.8, or even an f/4 if you've got a good, low-noise camera.

Shooting Home Interiors

SCOTT KELBY

If you want better looking home interior shots, here are a few things to do that will make a big difference: First, turn on all the lights in the room (turn on every single light you can). This isn't to add light to the scene—this is to give the room some life (realtors have home-owners do the same thing when they're showing the house to prospective home buyers). Now, you have two jobs: (1) To make the room look big. Nobody wants to see a tiny little room, and one trick for doing that is to shoot down low, from a kneeling position, with a wide-angle lens. Then position your camera so you're aiming into one of the room's cor-ners. One of the biggest ideas to get your head around is what to do with bright window light coming into the room, because your camera isn't going to properly expose for what's inside the room and what's outside the window at the same time. So, here's what you need to consider: First, it's now fairly acceptable to let what's outside the window completely blow out to white (you even see this now in fine home magazines, so don't let it freak you out). If you feel that what's outside is as important as what's inside, then you need to take two shots with two separate exposures—one exposed for the room interior, then a sec-ond where you expose for what's visible through the window, and just ignore how dark the interior looks in this second shot. Then you put these two separate exposures together in Photoshop (yup, I did a video for you on that, too, at www.kelbytraining.com/books/digphotogv3). Now, (2) the final challenge (hey, I didn't say this was easy) is to evenly light the room. Most pros use one or more small off-camera flashes, hidden behind furniture (so you don't see them) and aimed straight up at the ceiling, to evenly light the room.

Shooting Time–Lapse Photography (Canon)

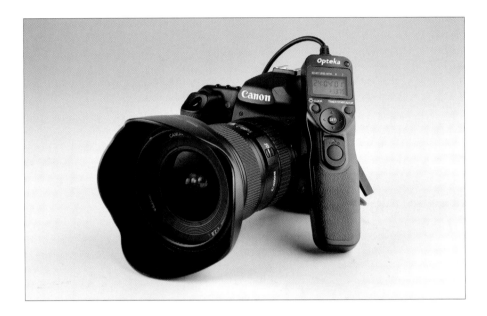

If you've ever watched a concert video, they always seem to have a video segment at the beginning where you see an empty venue, and then you watch while a giant stage, with tons of lights and speakers, is constructed right before your eyes—something that took an entire day or two to construct in real time, but here the whole experience lasts maybe 30 seconds total. This technique is called time-lapse photography (you've seen this used on TV to show a setting sun, outdoor events, a flower opening, etc.) and to do this, you set your camera on a tripod, and have the camera take a shot at a regular interval (like every 30 seconds, or every minute, etc.) over a certain period of time (like an hour, a day, two weeks, etc.), and then you combine all these images into a movie on your computer (I did a how-to video for you at www.kelbytraining.com/books/digphotogv3). Now, if you're doing this over a short period of time, you can just pull out a stopwatch, and every so many seconds or minutes, take a shot. However, for longer periods, if you're shooting a Canon camera, you'll need a separate timer accessory like Canon's TC80N3 Timer Remote Control, which costs around $140, which is why you probably want the Opteka Timer Remote Control instead (for around half the price). Either one connects to your camera's 10-pin input and lets you choose how many shots, how often, and over what length of time to capture your images. Now just start it, and walk away (well, walk away, providing of course, that your camera gear is safe and won't get stolen).

Shooting Time–Lapse Photography (Nikon)

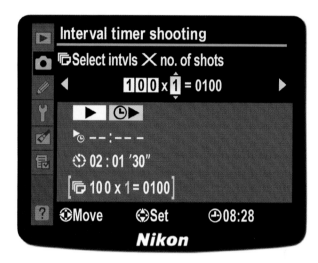

If you've ever watched a concert video, they always seem to have a video segment at the beginning where you see an empty venue, and then you watch while a giant stage, with tons of lights and speakers, is constructed right before your eyes—something that took an entire day or two to construct in real time, but here the whole experience lasts maybe 30 seconds total. This technique is called time-lapse photography (you've seen this used on TV to show a setting sun, outdoor events, a flower opening, etc.) and to do this, you set your camera on a tripod, and have the camera take a shot at a regular interval (like every 30 seconds, or every minute, etc.) over a certain period of time (like an hour, a day, two weeks, etc.), and then you combine all these images into a movie on your computer (I did a how-to video for you at www.kelbytraining.com/books/digphotogv3). A number of Nikon dSLRs have this feature built right in (like the D3, D300, and D700), so all you have to do is put your camera on a tripod, then go under the Shooting menu and choose Interval Timer Shooting. Press the right arrow, and choose when you want your interval timer (time-lapse) shooting to begin, how often you want a photo taken, the number of intervals, and the number of shots per interval. Now choose On and then OK, and you can walk away and the camera will record the images for you automatically (of course, don't just walk away if you feel like someone might walk up and take your camera).

Creating Multiple Exposures

If you want to combine two separate images into one single frame, there are two ways to do it: in-camera (if you own a Nikon dSLR) or in Photoshop, after the fact (for Canon or other dSLR users that don't have built-in multiple exposures). For the Nikon folks: You turn this feature on by going under the Shooting menu and choosing Multiple Exposure, then Number of Shots, and picking how many images you want to combine into one single image (in the example above, I just chose two), then choose OK. If you want a consistent background for both shots, put the camera on a tripod. Take the first shot, then have your subject move to a new position on the other side of the frame (don't let them move so far away that they're out of the frame), and take your second shot. That's it—both images will appear in the same frame (the advantage of doing it in-camera is that you have the two images combined as a single RAW file vs. doing this in Photoshop, where the end result will have to be a JPEG, TIFF, or PSD. If you're not shooting Nikon, I did a little video to show you how to combine two photos using Photoshop. You'd still have to start by taking two separate photos of your subject, and then we'll combine those in Photoshop. You can find this video at www.kelbytraining.com/books/digphotogv3.

Do You Really Need to Read Your Histogram?

This may be the most shocking thing you read in this book: not only do I not use the histogram on the back of the camera, but most of the pros I know don't either. With digital photography, our main concern is keeping detail in the highlight areas of our photo (so the brightest parts of our photo don't get so bright that there's nothing there but solid white), so instead of trying to evaluate the histogram, we just turn on our camera's highlight warning. It warns us if any part of our image is clipping (losing highlight detail), so then we can use exposure compensation to override the exposure our camera chose, and darken the exposure a bit until the detail comes back. That warning is telling us that the right side of the histogram is hitting the right wall of the graph (known as the "right wall of death" by…well…me). Anyway, here's why the highlight warning is better: the histogram only tells me if some part of the photo is hitting that right wall, it doesn't tell me if what's hitting the wall is something I care about, whereas the highlight warning shows me, right on the LCD monitor, exactly what part of my image is clipping, so I can quickly see if it's an area of important detail (like a white shirt) or something that doesn't have detail (like the sun. In the example shown above, you can see by all the black in the sky that these areas are clipping). So, if you're spending a lot of time worrying about your histogram, or worse yet, worrying that you don't know what the histogram even is, now you can get a good night's sleep. *Note:* Some people get really fanatical about technical stuff like histograms, so I just want to clarify this: I'm not telling you not to use your histogram, I'm just telling you that I don't use it. (Wink, wink.)

Using an Online Photo Lab

Back when I was shooting film, I used to send my most important shoots to a professional film lab for processing, but once digital photography (and great inexpensive printers) came along, I started doing all my own printing. Today, I do both. I still do some of my own printing, but I also often use an online lab for five reasons: (1) It's just so darn fast and easy. I upload the photos using my Web browser, and if I upload the images to the lab I use before lunch, they print and ship them the same day. (2) They'll color correct all my photos for free (I'm pretty handy in Photoshop, but sometimes it's just faster to let some-body else do it). (3) They can print in sizes that perfectly match the size digital cameras produce (so there's no cropping of my images to fit outdated sizes like 8x10" or 11x14". (4) You can have your prints mounted, matted, and framed (with glass), and (5) you can choose different types of paper (including metallic prints, matte finishes, etc.). This is one of those things that once you try it, you'll wonder why you waited so long. Plus, today's pricing for online labs is very competitive.

Mpix.com Is the Only Online Lab I Use

I've used Mpix.com since 2007, but had no idea how many Mpix freaks were out there until I mentioned them on my blog. People came out of the woodwork to tell me about their love affair with Mpix, and now I know why. They're not just for pros—anybody can use Mpix—but their quality makes you look like a pro. Try them once, and you'll see what I mean.

Shooting in Tricky Low–Light Situations

Although there are some tried and true techniques for shooting in tricky low-light situations (like shooting in a cave, or at your daughter's dance recital, or around a campfire), unfortunately there is no secret setting or magic button that suddenly makes it all work. However, here's what you can do: The #1 thing you can do is to find a way to steady your camera. Because you're in really low light, your shutter speed is going to drop way below 1/60 of a second (as low as most of us can hand-hold and still get a reasonably sharp photo), so ideally, you're going to need to put your camera on a tripod. If you can't use a tripod, how about a monopod? If you don't have either, rest your camera on something (I've been known to balance my camera on the seat back of an empty theater chair, or on a railing at a tourist attraction, or on the safety wall at the top of the Empire State Building in New York. I've even put the camera on a friend's or family member's shoulder to steady it). I do everything I can to steady it to avoid having to raise the ISO (which is our last resort, unless you have one of the new high-end cameras with great low-noise results at high ISOs). If there's just no way to steady your camera, then you have to resort to raising your ISO—keep raising it until you get your shutter speed to 1/60 of a second or higher, and then hold your camera as still as possible. If you raise your ISO up quite a bit, you're going to see noise in your photos, so you're going to need to run some noise reduction software (I've been using Nik Software's Dfine 2.0, a Photoshop and Lightroom plug-in, which does an amazing job of reducing the noise without blurring your photo too much).

Shooting Night Scenes Like Cityscapes

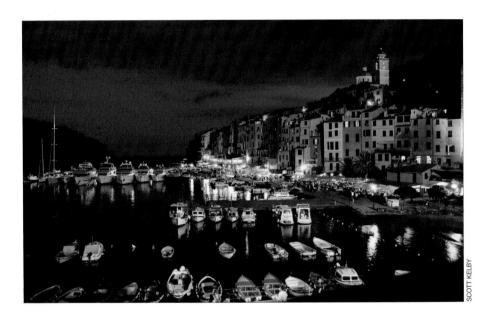

SCOTT KELBY

Shooting nighttime scenes is kinda tricky, because no two scenes are lit the same. However, here are some tips to help: The most important thing is getting the right exposure. Since everything is so dark, your first thought might be to aim at the lights, but if you do, your camera will think the whole scene is bright, and it will greatly underexpose your photo. Instead, try focusing just to the left or right of the lights. Take a shot and check your LCD monitor. If it still looks too dark, use exposure compensation to brighten the image by one stop, then take another test shot. It won't take long before you nail the exposure. Also, your exposure time will go anywhere from a few seconds to a few minutes (depending on how much light the scene you're shooting has), so you absolutely must be on a tripod to get a sharp shot. Since your shutter will be open for a long time, you'll also want to use a cable release or wireless shutter release, so you don't add any movement at all by pressing the shutter button with your finger. For getting a white balance that looks good, I use the Live View white balance trick on page 170. One last thing: the best time to shoot nighttime cityscapes is about a half-hour past sunset, so you get the perfect mix of natural light and city lights.

Remove Your UV Filter for Nighttime Shots

When it comes to shooting at night, this is the one time when the limited ultraviolet (UV) rays work against us (potentially giving us washed out images), and that's why many pros suggest removing your UV filter when shooting at night.

How My Camera Is Usually Set Up

I set up my camera pretty much the same way each time I shoot. First, I nearly always shoot in aperture priority mode, because I can choose whether I want the background behind my subject to be out of focus or sharp and in focus. This works whether I'm shooting sports, or a bee on a flower, or a sweeping landscape shot—I have total creative control over how the background looks. The only other shooting mode I use is manual, and then only when I'm in the studio using studio strobes. I try to shoot at ISO 200 as much as possible (it's always my starting place), and I only raise it if my shutter speed falls below 1/60 of a second (that's about as slow as I can go hand-holding my camera and still get a sharp shot. Some folks can go to 1/30, but not me). If I'm shooting out in daylight (like on a vacation trip or at an outdoor sporting event), I leave my white balance set on Auto. If I wander into the shade, I change it to Shade, and if I walk inside, I match the white balance to the lighting I'm shooting in (this keeps me from having to color correct my photos later). I leave my camera's flash setting at Rear-Curtain Sync (2nd Curtain for Canon users) all the time (that way, I get some movement around my subject, but then the flash fires to freeze them and make them sharp). I leave the highlight warning turned on all the time, and refer to it often (so I don't blow out my highlights). I never look at the histogram (sorry).

What I Pack for a Landscape Shoot

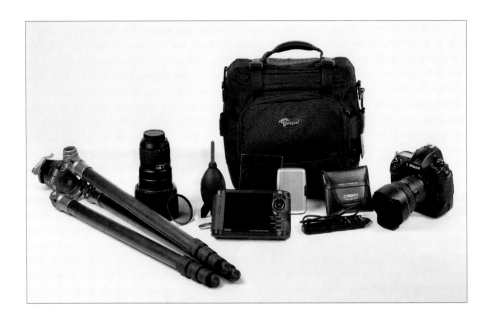

If I'm heading out for a landscape shoot, here's what I pack:

(1) One full-frame camera body (I take a full-frame body when shooting landscapes to get wider images)
(2) A 14–24mm f/2.8 ultra-wide-angle lens
(3) A good sturdy tripod with a ballhead
(4) One medium zoom lens, in case I want to shoot a panorama (I avoid wide-angle lenses when shooting panos)
(5) A cable release (either a wired release or, ideally, a wireless release)
(6) A polarizer (to cut reflections and darken the sky)
(7) A split neutral density gradient filter (to let me expose for the foreground and not have the sky get washed out)
(8) An Epson P-3000, -6000, or -7000 for backing up my images when out in the field
(9) A neutral density filter (to darken a waterfall or stream scene, so I can use a long enough shutter speed to make the water look silky)
(10) A backup battery, my battery charger, a cleaning cloth (in case I get water droplets on my lens), and a Rocket Air Blower (to blow any dust or specks off my lens)
(11) Multiple memory cards in a hard-sided memory card case
(12) It all goes in a LowePro Pro Mag 2 AW

What I Pack for a Sports Shoot

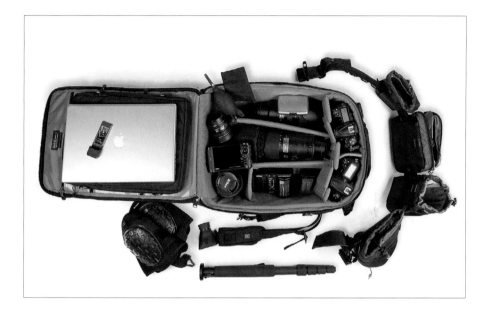

If I'm heading out for a sports shoot, here's what I pack:

(1) Two camera bodies

(2) A very long lens, like a fast 200–400mm f/4 zoom lens, or a 300mm fixed focal length lens

(3) A zoom lens, like a 70–200mm f/2.8, and one wide-angle zoom, like a 24–70mm

(4) A fisheye lens (in case I want to get a shot of the stadium, arena, etc.)

(5) A monopod to support my longest lens

(6) A BlackRapid R-Strap for my second camera body, so I can bring my second camera up to fire quickly if I need it

(7) An Epson P-3000, -6000, or -7000 for backing up my images when out in the field

(8) A laptop and a fast FireWire (or IEEE 1394) memory card reader

(9) A wireless PC card for uploading photos while the event is still underway

(10) Backup batteries for both bodies, battery chargers, a cleaning cloth, and a Rocket Air Blower to blow any dust or specks off my lens

(11) Gel kneepads (to save my knees when kneeling to get a low perspective for sports photography)

(12) A Think Tank modular belt system that holds my fisheye lens, backup memory cards, a water bottle, an energy bar, and my wide-angle lens

(13) A Hoodman HoodLoupe (which covers my LCD, so I can see it clearly in bright daylight)

(14) It all fits into a Think Tank Airport Security 2 rolling camera bag

What I Pack for a Location Portrait Shoot

If I'm heading out for a location portrait shoot, here's what I pack:

(1) A 70–200mm zoom lens

(2) A 24–70mm zoom lens

(3) Two off-camera wireless flashes with diffusion domes

(4) Two lightweight 7' light stands, two shoot-through umbrellas, and two tilt bracket adapters

(5) Two 8-packs of AA batteries (for the flash units)

(6) Two sets of gels for the flashes: one orange, one green

(7) A separate battery pack to get faster refreshes from the flash units

(8) An Epson P-3000, -6000, or -7000 for backing up my images when out in the field

(9) Multiple memory cards in a hard-sided memory card case

(10) One camera body, and a backup body if it's a paying gig

(11) A backup battery, my battery charger, a cleaning cloth, and a Rocket Air Blower to blow any dust or specks off my lens

What I Pack for a Travel Shoot

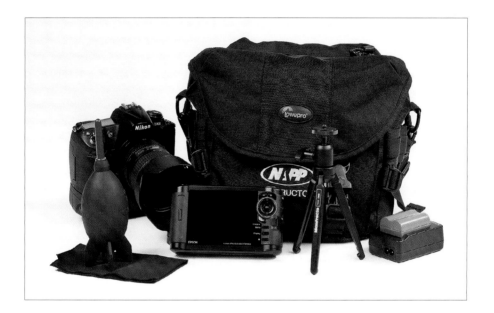

If I'm heading out for a travel shoot while I'm on vacation, here's what I pack:

(1) One camera body (a regular cropped-frame body)

(2) An 18–200mm zoom lens (I want one lens that does it all)

(3) An Epson P-3000, -6000, or -7000 for backing up my images when out in the field

(4) A backup battery, my battery charger, a cleaning cloth, and a Rocket Air Blower to blow any dust or specks off my lens

(5) A small tabletop tripod, so I can shoot food or sneak in a shot where full-sized tripods aren't usually allowed

What I Pack for a Wedding Shoot

If I'm heading out for a wedding shoot, here's what I pack:

(1) Two camera bodies (the extra one is a backup)
(2) A 14–24mm super-wide-angle lens, a 50mm f/1.4 lens (for shooting hand-held in low light), a 70–200mm f/2.8 VR zoom lens, a 10.5mm fisheye lens (great for capturing fun at the reception), and a 24–70mm f/2.8 lens
(3) An Epson P-3000, -6000, or -7000 for backing up on-site and four 8-GB memory cards
(4) A lens cleaning kit
(5) This all fits in a LowePro Pro Roller 1 Bag

Lighting Gear:
(1) Two off-camera flashes (like Nikon SB-900s)
(2) Diffusion domes for the flash units
(3) A Nikon SU-800 commander unit (to fire the flashes wirelessly)
(4) Two Bogen light stands with umbrella swivel brackets (the second one is a backup)
(5) Two Westcott 43" shoot-through white translucent umbrellas (the second is a backup)
(6) A Westcott white/silver reflector
(7) A tri-grip diffuser
(8) Four packs of AA batteries, AA battery charger, and a Nikon SD-9 battery pack (for longer battery life and faster refresh times)
(9) A ladder cart (to shoot up higher, and to lug the lighting gear around)
(10) I pack my flashes, stands, umbrellas, and brackets all in one Hakuba PSTC 100 Tripod Case

White Balance vs. Color Correction

If you're wondering why you hear so much these days about getting a proper white balance when you're shooting, here's why: if you get the white balance right in the camera, you won't have to do any color correction later in Photoshop (or Lightroom, or Aperture, or whatever). That's because, if the white balance is properly set, the color of the photo will look spot on. If the white balance is off, you're going to have to do some color correction later or your photo will look too blue, too yellow, too green, etc., so if you want to avoid the whole color correction process, just set your camera's white balance setting to the type of light you're shooting in (for example, if you're shooting in the shade, set your camera's white balance to Shade. Yes, it is that easy).

If You Want to Nail Your White Balance Every Time, Get an ExpoDisc

Switching your white balance in-camera to match the type of lighting you're shooting in will definitely get you closer than not doing it, but if you really want to nail the white balance every time, you need something like an ExpoDisc (from ExpoImaging). This is a translucent disc you hold over the end of your lens, aim at the light source, then take a photo, and it creates a custom white balance for you that is designed for the exact light you're shooting in. They do work wonders, and lots of pros swear by them.

How Many Great Shots to Expect From a Shoot

SCOTT KELBY

So, if you're a pretty serious photographer and you come back from a few hours of shooting (let's say you were on a photowalk, or wandering around a city while on vacation), and you took, say…240 shots, how many of those should you expect to be really killer shots—shots you would enlarge, frame, and hang on the wall? A lot of folks are surprised (actually shocked) to learn that even most pros would be happy to come away with one really great shot from that 240. Personally, if I can get two or three from that shoot that I really like, I am thrilled. Think of it this way: if you were hired to shoot the cover shot for *Vogue* magazine, and you hired a top model and assistants and a big New York or Paris studio, and you shot all day long and took thousands of shots, how many of those would wind up on the cover? One. Realistically, how many would the folks at *Vogue* really have to choose from, from your shoot? How many shots would you have captured that were "cover of *Vogue*" quality? Even a top pro might have 10 or 12 really great cover-quality shots for them to choose from. This is true for landscape photographers, travel photographers, commercial photographers—all of us. Talk to some of the top pros and you'll find that most of their shots go in the trash, but when they shoot 240 photos, there are usually a few really great ones in there, too—some killer shots—but how many of those will they actually frame and put on the wall? Maybe one. When you see a pro's work on display (in a gallery or a slide show presentation), you're seeing only their very best work. You're seeing nothing but that one killer shot from that day. They've just done a lot of those 240-image shoots.

If Your Camera Shoots Video....

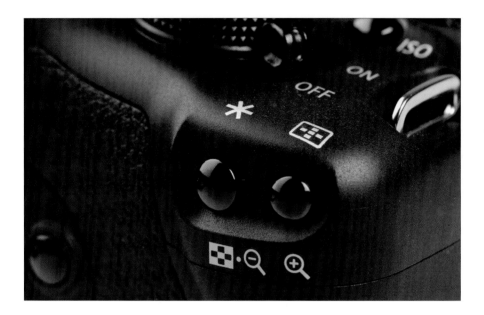

If your dSLR has the ability to shoot high-definition video, like a Canon 5D Mark II or a Nikon D90 or D5000 (by the way, more and more dSLR cameras are getting video these days), then there's a special setting that will help you get much better results from shooting video. You want to lock the Auto Exposure setting, or as you pan across a room or a scene, the exposure will keep trying to change as you pan, so during your pan the video starts glowing brighter then darker then brighter again (ugh!). On Nikon cameras, go under the Custom menu, to Controls, and choose Assign AE-L/AF-L Button (those acronyms stand for Auto Exposure Lock and Auto Focus Lock). Then, scroll down to AE Lock (Hold) and choose that. Now, when you're shooting video, once you start shooting, you'll press the AE-L/AF-L button on the back of the camera, and it will hold your exposure in place while you're panning the camera. Press it a second time to turn auto exposure lock off. On a Canon dSLR with video (other than the Canon 5D Mark II), when you're in video shooting mode, you can lock the exposure by holding down the AE Lock/FE Lock button, at the top right of the back of the camera, to keep the exposure from constantly changing as you pan or move the camera. In addition, if you have the Canon 5D Mark II, thanks to a recent firmware update, you can also manually control the exposure by switching to manual mode. This allows you to manually adjust the exposure controls, such as ISO, aperture, and shutter speed, while shooting video.

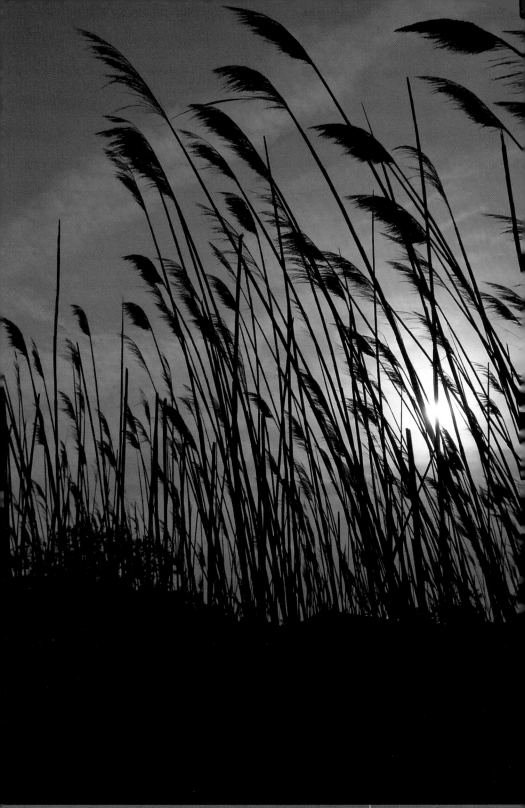

SHUTTER SPEED: 1/8000 SEC F-STOP: F/8 ISO: 200 FOCAL LENGTH: 24mm PHOTOGRAPHER: SCOTT KELBY

Chapter Nine

Avoiding Problems Like a Pro

How to Sidestep Those Things That Drive You Crazy

Today's digital cameras are amazingly sophisticated devices, and if you take a moment to really think about it, you're holding in your hands a lens, a shutter mechanism, a color TV monitor, and a computer. That's right, there actually is a computer inside every single digital camera. That's what those menus on the back are for—you're navigating the camera's software and turning on/off specific features, just like you do on your computer at work or at home. You're setting the preferences for how your computer works. So, at this point, you're not really taking a photo, you're tweaking your software to get a specific desired result. When you press the shutter button, it sends a signal to the software to briefly let some amount of light into the computer-controlled sensor, and that amount is determined through a mathematical calculation performed by (that's right) your onboard computer. So, is it any wonder that occasionally we make a mistake with this handheld computer, and a photo doesn't look how we wanted it to? No, it's not. So, technically, when the photo doesn't look the way we want it to, it's not our fault—it's that darn computer. Well, that's what this chapter is all about. Blame. You'll learn how to quickly and easily redirect the blame for any bad shot back to how the software behaved in your camera, and you'll be able to do it in such a convincing and logical way that there's no way you could ever be held personally responsible for taking any photo that is not literally Ansel Adams quality. Underexposed? "That stupid software!" Out of focus? "Darn autofocus got me again!" Took a shot of your foot as you were walking? "It fired without me pressing the button!" See? It's easier than you'd think. Let's try a few more: You hear, "Gee, the color looks off." You reply, "My stupid LCD isn't color balanced." (Oooh, good one!)

Can You Trust Your Camera's LCD Monitor?

SCOTT KELBY

You read a lot online about not being able to really trust what you see on the LCD screen on the back of your camera. Some of that is old outdated information, some of it depends on camera settings (which we'll cover in just a minute), and some of it is true. Here are my thoughts on it: If you shoot in JPEG mode using one of today's newer dSLR cameras (and the more expensive the camera, usually the better quality the LCD monitor), what you're seeing on the monitor is a JPEG preview, and it's pretty close to what you'll actually see when you open the photo on your computer (or get prints made). However, if you shoot in RAW mode, you're not seeing a preview of the RAW photo—you're seeing a preview of the JPEG image, and the JPEG image usually looks better than an unedited RAW photo. That's because JPEG images have been "processed" inside your camera, and they have sharpening applied, color correction, contrast, and basically your camera tries to make JPEGs look really good. But when you shoot in RAW, you're telling your camera, "Turn all that in-camera, make-it-look-good stuff off, and just give me the raw, untouched file, and then I'll do all that sharpening, color correction, and contrast stuff myself in Photoshop, or Lightroom, or whatever." However, you're still seeing that processed JPEG preview on your camera, so if you shoot in RAW mode, don't be startled when what you see on your computer doesn't look nearly as good as it did on the back of your camera. I'm not telling you on any level not to shoot in RAW mode, I'm just letting you know how what you see on your LCD relates to what you're going to see on your computer. Now ya know.

Resetting Your Camera to the Factory Defaults

If you've tweaked and played around with the menus in your camera and you feel like you've totally messed something up, and you just wish everything was back like it was when you bought the camera, then you'll be happy to learn that most cameras have a "return to default" setting that puts all the customizable settings back to their original factory-default settings. I use this when it just seems like my camera is all whacked out for some reason, and resetting to the defaults usually snaps it right out of its insanity. The only downside of doing this is when it returns to the defaults, any of the settings you changed in your camera are erased, too, so you have to go back and customize whatever settings you had customized again (which is why it helps to write those little changes down—that way you won't forget what your settings were). Anyway, here's how it's done: On a Canon camera, you press the Menu button, then go to the Set-Up 3 menu, and choose Clear Settings. Now choose Clear All Camera Settings and then select OK. If you're using a Nikon camera, press-and-hold the Qual (Quality) button and the +/– (Exposure Compensation button) down for more than two seconds, or you can press the Menu button, go to the Shooting menu, and choose Reset Shooting Menu, then go to the Custom Setting menu, and choose Reset Custom Settings. Doesn't matter which way you do it, it'll reset the camera to the factory fresh settings.

Instant JPEG From RAW

Most dSLRs these days will let you shoot RAW, or JPEG, and usually Raw + JPEG, which means it writes two separate files to your memory card—one is the untouched RAW file, and the other is a processed JPEG file. This is a big advantage for anyone who needs to quickly send a JPEG file to a client (like a pro sports photographer who needs to email shots to the magazine or wire service while the event is still going on. RAW files are much larger in file size, so they're a somewhat impractical for email, some clients don't have the software to read RAW files, and the files are unprocessed, unsharp-ened, and uncorrected, so having an already processed, compressed JPEG makes sense for some shooters). The downside is it takes up a lot more room on your memory card, and now you have two versions of every photo. Now, if you're one of those folks who shoots in Raw + JPEG, have I got a tip for you! Michael Tapes at RawWorkflow.com (the guy who makes the popular WhiBal white balance tool) created a free downloadable software utility that extracts the JPEG preview that's already embedded in every RAW image, and it does it incredibly, ludicrously (if that's even a word) fast! All you do is download the utility from www.rawworkflow.com and run the installer. Then, click on a folder of RAW photos, Control-click (PC: Right-click) on that folder, and choose Instant JPEG from RAW from the contextual menu that appears. You'll get to choose what size you'd like your JPEG (in case you need a smaller size for uploading to a website), and then click Extract and, literally in just seconds, it extracts those JPEGs for you and puts them in their own folder. I use this all the time, and I love it!

When to Shoot JPEG; When to Shoot RAW

I get asked on a regular basis, "When should I shoot in RAW and when should I shoot in JPEG mode?" This is one sticky question, because some photographers are so fanatical about shooting in RAW that there's no reason you could ever give them that makes sense not to shoot in RAW. If the photo you're going to take is of your wrecked car, and it's only going to be 3x4" in size, and the only person who would ever possibly see it is the insurance adjuster in a different state processing your repair claim, they would still shoot it in RAW. So, for those people (you know who you are), I'm going to save myself a lot of angry letters (not all, mind you, but a few), and state categorically that you should shoot all photos, no matter what the final intended use, in RAW format. There, I said it. It's been documented. Now, that being said, I've heard of some photographers who don't post-process their images—meaning they don't open the photos in Photoshop, or Elements, or Lightroom, or Capture, or whatever—they just take the shots, and then either put them on the Web, or put them on disc, or print them out as is. So, if you are one of those people who are pretty happy with how their photos look right out of the camera, and you do very little, if any, editing in a photo software application, and you enjoy fitting thousands of photos on a 4-GB memory card (rather than a few hundred), and you enjoy not having the hard drive on your laptop crammed full all the time, I guess in that situation, it's okay to shoot in JPEG Fine mode. Just don't ever tell anyone. Also, two other groups of people who often shoot in JPEG mode are pro sports photographers (who shoot thousands of shots per event), and many pro wedding photographers, as well, but hey—I'm not telling you it's okay (wink, wink).

Built-In Sensor Cleaning

The sensor on your digital camera collects dust like…like…well, like something that really collects a lot of dust (like that film camera up in your closet). The sensors in today's cameras are magnetized, and each time you change lenses, you're screwing a piece of metal into a metal mount, and not surprisingly, tiny metal shavings appear, and those can get sucked down onto your sensor, and before you know it, you've got tiny spots and specks on your sensor, which means you now have tiny spots and specks on every photo you're about to take. That's why we have to do our best to keep our sensors clean, and that's why more and more of the newer digital cameras now have built-in sensor cleaning capabilities. This basically demagnetizes your sensor for a moment to shake the sensor dust off, and it does a decent job. Not a great job, an okay job (it doesn't replace having your sensor fully cleaned), but if your camera has it built-in, you might as well use it. For example, on a Canon camera like the 50D, if you turn the power switch to the On higher position, this turns on the auto sensor cleaning feature, and it shakes the dust off your sensor right then and there. It cleans the sensor when it shuts down, too. With the power switch in the On position, you can also go to the Set-Up 2 menu, choose Sensor Cleaning, and then choose Clean Now. If you have a Nikon camera (like a D300), press the Menu button, go to the Setup menu, and choose Clean Image Sensor. In the next menu, choose Clean Now, and your sensor will be cleaned. If you want it to automatically clean the sensor each time you turn on the camera, choose Clean at Startup/Shutdown.

Shortcut for Formatting Your Memory Card

Many dSLRs have a shortcut which lets you quickly reformat (erase all your images on) your memory card without having to dig through all the menus on the back of the camera. On a Nikon, the shortcut actually appears in red beside the two buttons you need to hold down to reformat (you hold the Delete [trash can] button and the Mode button down together for two or three seconds, until you see the word "For" flashing in the LCD info window on top of the camera. Once "For" is flashing, release those buttons and press them again just once, and your card will format). On a Canon, there isn't a shortcut, but you can go under the Set-Up 1 menu, select Format, and then press the Set button. Select OK and your card will be formatted.

Don't Go Out Shooting with Just One Memory Card

If you shoot with just one memory card, it's going to catch up with you. Your card's going to be full, or you're going to have to wind up formatting the card without having two backups (or you'll have to stop shooting for the day), which is why you've got to have at least a second, if not a third, memory card with you on every shoot. I just checked and a 4-GB memory card is going for as little as $18.95. You can also find lots of cards with manufacturer's rebates (I recently bought a number of 8-GB memory cards for $69 with a $69 mail-in rebate. I kid you not. That's right—free cards. It happens).

Make Sure You Have the Latest Firmware

One huge advantage of having the brains of today's digital cameras run by software is that the camera manufacturer can release updates to your camera, which can range from fixing problems in the camera (bugs) to adding new features. These free camera updates are called "firmware" updates and you download them directly from the manufacturer's website. Once an update is downloaded, you just connect your camera to your computer (using that little USB cable that came with your camera), and run the firmware updater software (which usually has some simple instructions with it), and it updates your camera (by the way, it's not just cameras that get firmware updates— off-camera flash units can get them, too). The good news is they don't issue firmware updates very often—maybe only two or three times in the life of a camera, so this isn't something you'll have to be checking every week, but it doesn't hurt to stop by Google.com every once in a while and type in your camera's name plus firmware (so your search would be "Canon 50D" + "Firmware update" or "Nikon D700" + "Firmware update"), and you'll find a direct link to download the update from the manufacturer. Once you find the update online, check to see if the one available online is a higher number than the one currently installed on your camera (for example, on Nikon or Canon cameras, you go under the Setup menu and choose Firmware Version, and it will show you the version of your currently installed firmware [like version 1.01]). So, if you see that a more recent firmware update has been released (like firmware version 1.02 [or higher]), you'll want to download and install that firmware.

Don't Get Burned by Shooting Without a Memory Card

When camera manufacturers ship their cameras to camera stores, they want the sales people at the camera store to be able to open a camera box and hand the customer the camera to take a few shots and see how the camera feels (after all, how a camera feels in your hands is very important). So, at the factory, they set the camera up so you can take shots without actually having a memory card in the camera. The shutter fires just like usual, and you see the picture appear on the LCD on the back of the camera, just like always, except those photos vanish into thin air after, because they're not saved to a memory card. This is one thing you usually learn about the hard way. Well, at least I did when I did a photo shoot in a studio—I shot for 35 minutes—and when I popped the door on my camera open to back up my photos, I was shocked to find out there was no memory card, even though I had been looking at some of the shots on the camera's LCD monitor. Those shots were gone forever, so the first thing I do with any new camera is turn the memory card lock on, so it won't even take a shot without a memory card in the camera. On Canon cameras, go to the Shooting menu and choose Shoot Without Card, then set this function to Off. On Nikon cameras, go under the Custom Setting menu and choose No Memory Card. Change the setting from Enable Release to Release Locked. Now, the camera's shutter release will be locked, and it won't take a shot unless a memory card is in the camera.

You Need to Copyright Your Photos

With so many of us posting our images on the Web, you've got to protect yourself (and your images) by legally copyrighting your work. Luckily, the process (at least in the U.S.) is all now Web-based, so it's never been faster, easier, or more affordable than it is today. What copyrighting does is to legally define who owns the photo, and even though, technically, there is some very limited amount of protection afforded simply by the fact that you took the shot, if someone takes your photo off the Web and uses it in their brochure, or website, or print ad, etc., without actually having registered your work as copyrighted with the U.S. Copyright office, your chances of winning a judgment in court against the "photo thief" are virtually nil. Because this process has become so quick, easy, and inexpensive, there's no reason not to add this process as part of your photo workflow. To register your work online in the U.S., start by going to www.copyright.gov/eco/index.html (it only costs $35, and you can register literally thousands of photos at a time for that same fee). By the way, make sure you read the tip below.

Watch These Free, Short, Absolutely Fascinating Videos on Copyright

I did a series of video interviews with intellectual property attorney and noted photography copyright expert Ed Greenburg, and followed up with interviews with photographer rights advocate Jack Resnicki, in July 2008. These videos have been a huge hit with photographers, and I invite you to watch them on my blog: www.scottkelby.com. Once you're there, search for copyright and you'll find the videos.

Back Up Twice Before Formatting

There's a rule a lot of photographers (well, paranoid photographers anyway, like me) follow, and that is: we don't erase our memory cards until we absolutely know that we have two copies of our photos elsewhere. For example, when you download your photos to your computer, that's only one copy, and you shouldn't format your memory card with just this one copy (because when your hard drive crashes one day [notice that I said "when"] all those photos are gone forever). Now, once you back up those photos from your computer to a second drive (a backup hard drive), then you'll have two copies—one set on your computer and one set on your backup drive—and then it's safe to format (erase) your memory card and keep shooting with that card. Without two backups, it's just a matter of time before those photos are gone forever (I could tell you the saddest stories of people who have written me who have lost every photo of their kids for the past eight or 10 years, because they had them on their computer, and their computer died. I wish it was just one story, but I've got dozens and dozens).

My Personal Photo Backup Strategy

I wrote about my entire photography backup and archiving strategy in a very detailed article on my blog at www.scottkelby.com/blog/2008/archives/1410, and if you're paranoid about losing all your photos (and you should be), it's worth a read.

How You Press the Shutter Button Matters!

Want another tip for getting sharper images? Start gently squeezing the shutter button, rather than just pressing it. Actually, for the least vibration possible, you should kind of roll your finger over the shutter button from back to front. By doing this gentle pressing of the shutter button, you'll wind up with sharper photos every time.

Tuck in Your Elbows for Sharper Shots

Another technique for getting sharper photos when hand-holding your camera is to steady the camera by holding it with your elbows tucked in toward your body. This helps anchor the camera to your body, keeping it steadier, and giving you sharper photos. This is an easier change to make than you'd think, and once you see the results, you'll be glad you did it.

Don't Let the Small Screen Fool You!

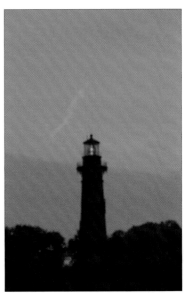

SCOTT KELBY

If you've ever taken a shot that looked great on your camera, only to open it later on your computer to find out that your killer shot was incredibly blurry, don't feel bad—everything looks sharp on a tiny 2.5" or 3" LCD screen, and every photographer has been burned by this (well, every photographer I know anyway). That's why it's so critical to check the sharpness right then and there—out in the field—while you still have a chance to reshoot the shot. When you see a shot that looks really great on the LCD, stop right there and make sure it's sharp by zooming in tight and checking the focus. Just press the Zoom In (on a Nikon) or Magnify (on a Canon) button on the back of the camera to zoom in. Once zoomed in, you move to view different parts of your zoomed-in photo using the multi selector (on a Nikon) or the multi-controller (on a Canon) on the back of the camera. Once you're done checking the sharpness, press the Zoom In (magnifying glass) button again (on a Nikon) or the Reduce button (on a Canon) to zoom back out. Keep your surprises to a minimum by checking the sharpness now, in camera, before it's too late.

Avoiding the Memory Card Moment of Doubt

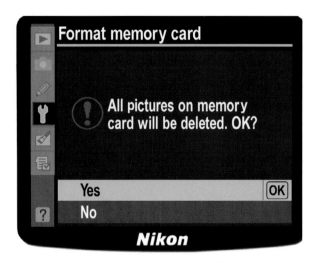

If you use more than one memory card (and I highly recommend that you do—see the tip at the bottom of page 197), you'll have experienced that "moment of doubt" when you go reaching for your second memory card, and you ask yourself, "What's on this card? Have I downloaded these? Is it okay to erase it?" I've had it happen to me more than once, but here's a way to avoid this moment of doubt altogether. Once you've download-ed the images to your computer, and then backed them up to a second hard drive (CDs and DVDs are a little too risky), right then and there, format your memory card. That way, if you see a memory card in your memory card case, you know it's formatted and ready to go, and that the images that were once on there are now safely backed up twice.

Shoot Multiple Shots in Low-Light Situations

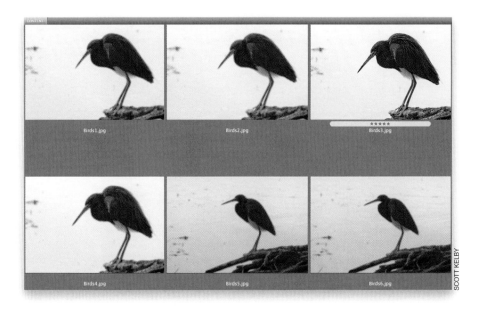

If you're in a situation where you're having to shoot in low light without a tripod (if your shutter speed gets under 1/60 of second, there's a pretty good chance your photo will be somewhat blurry if you're hand-holding), and you don't want to raise your ISO because your photo will get too noisy, here's a trick you can try that will usually get a sharp photo: shoot multiple shots in Burst or High-Speed Continuous mode. Chances are, if you take three or four shots in a quick burst, at least one of those shots will be in focus. I've done this numerous times and I'm always amazed at the results. You'll see a blurry one, blurry one, then all of a sudden there's a nice crisp shot (as shown here with the five-star image labeled yellow), and then right back to blurry. So, next time you're in one of those situations, crank off a few right in a row, and keep your fingers crossed that at least one of those will be in focus (hey, it's better than the alternative).

The High–Speed Memory Card Myth

If you upgrade to the latest high-speed Compact Flash or SD memory cards, is it going to really make a difference? Well, honestly, for most folks—probably not. These more expensive high-speed cards are designed for people like serious sports photographers, with higher-end dSLRs, who need to shoot long, continuous bursts of images. The reason high-speed cards matter to them is that they need any images temporarily stored in their camera's built-in memory buffer to be written to the memory card as quickly as possible to free that buffer for their next continuous burst of shots. If you're reading this and thinking, "I never shoot that many shots at once," then there's good news—you don't really need one of those expensive high-speed cards. This is good news, because regular-speed cards are much less expensive. For example, I just looked up what a regular 8-GB SD Lexar memory card costs at B&H Photo. It was $9.99. The 133x higher-speed 8-GB card sells for $61.95, but it did come with a mail-in rebate of $25 (however, retail statistics show only a very small percentage of consumers ever actually mail in these rebates, which is why mail-in rebates are so popular), but even with that, it's still $36.95—more than 3.5 times as much as the regular-speed card. So, why pay the difference if you won't experience a difference, eh?

Do This Before You Close Your Camera Bag

My friend Janine Smith shared this tip with me last year, and ever since she did, I've been using it and it's saved my bacon more than once. When you're packing your camera bag for a shoot, before you close the bag, pick up the camera and take a quick shot of anything. This will tell you instantly if you have a memory card with you, whether your battery is charged, and whether your camera is in basic working order. You don't want to learn about any of these problems once you're on location (or on vacation). You'd rather know now, while you still have time to grab a memory card, charge your battery, or fix a potential problem.

Why You Should Download Your User Manual

One of the biggest problems with camera user manuals is quickly finding what you're looking for. That's why I always download the free PDF electronic version of the user manual from the manufacturer's website, because the PDF versions have a search feature, and you can find what you're looking for in five seconds, rather than five minutes (of course, it's only five minutes if you're lucky. I've spent much more time looking for certain features). Once you use the free PDF version of the manual, you'll only reach for the printed manual in an emergency situation, when you're out in the field and you don't mind hauling the user manual around with you. By the way, I download the manuals for all my gear—flashes, cameras, wireless triggers, you name it. They're so small in file size, and so handy, there's no reason not to.

Where to Find Those Downloadable Manuals

If you're a Nikon user in the U.S., go to www.nikonusa.com/Service-And-Support/Download-Center.page, and if you're a Canon user in the U.S., go to www.usa.canon.com, click on the Download link in the menu bar across the top, and choose Consumer.

The Photoshop Trick for Finding Dust Spots

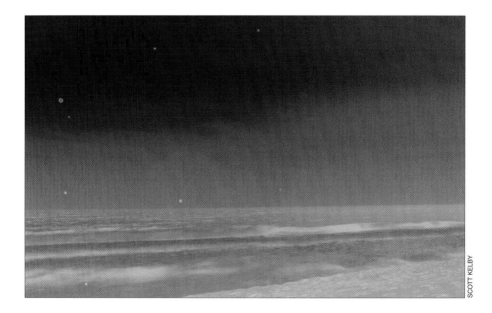

SCOTT KELBY

If you want to do a quick test to see if you've got "junk" on your camera's sensor, try this: aim at something like a solid gray wall, or a gray, cloudless sky, and take a shot. Import this photo into your computer, open it in Photoshop, and then press Command-I (PC: Ctrl-I). This inverts your photo, and any spots, specks, dust, or junk will stick out like a sore thumb, and you'll know right then if you need to clean your camera's sensor (by the way, although you can buy sensor cleaning kits, and cleaning your sensor is surprisingly easy, some folks just don't feel comfortable digging around inside their camera body, and in that case, you should stop by your local camera store and have one of their techs do a quick cleaning for you. They'll charge you a few bucks for it, but it beats having spots on all your shots). Make sure you do this before a big trip. (See page 196 for a tip on using your camera's built-in sensor cleaner.)

Shooting in Bad Weather

Sometimes the best images come from the worst weather, but if you're going to be shooting in this type of weather, you need to take a few precautions for your gear. Some cameras, like Nikon's D300, D700, and D3 line, have weather-sealed bodies that help keep moisture out, but your best bet is to buy rain covers for your gear that still allow you to hold your camera and operate the zooms on your lenses, while keeping the electronics inside your camera nice and dry. The set I use is the KT E-702 Elements Cover made by Kata (www.kata-bags.com), and it's got special sleeves on the side so you can reach inside the cover and adjust your camera settings and lens zoom. I don't have to use this often, but when I do, it's great not having to worry about my gear getting toasted. If you get caught in an unexpected rain situation, try using the shower cap from your hotel room to cover the entire back of your camera body (so just the lens sticks out).

What to Do When You Don't Have Protective Gear

If you get caught in the rain and don't have protective gear (hey, it happens), when you get back to a dry place, try patting dry the outside of your gear with a cleaning cloth, or a dry towel if a cleaning cloth isn't handy. Don't wipe it, or you risk moving water into places you don't want it, so just carefully pat it dry. I've heard of photographers using a blow dryer set on low to help dry things off, but luckily I haven't had to test that one out. Also, leave your camera off until the camera has had plenty of time to dry the inside on its own.

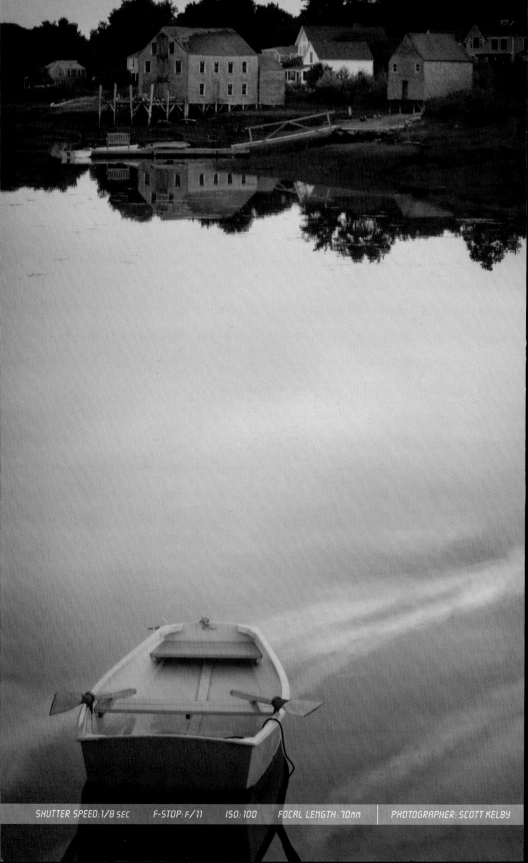

SHUTTER SPEED: 1/8 SEC F-STOP: F/11 ISO: 100 FOCAL LENGTH: 70mm | PHOTOGRAPHER: SCOTT KELBY

Chapter Ten

Yet Even More Photo Recipes to Help You Get "The Shot"

The Simple Ingredients to Make It All Come Together

Have you ever looked at a photo and thought, "I wonder how you get a shot like that?" Maybe it was a studio shot, or one taken out on location, and you're wondering where the light was positioned, or maybe if there was even a light at all. Maybe you could figure out that there was a flash of some sort used, but maybe you didn't know which type of softbox was used, or if there was more than one light. Has that ever happened to you? No? Really? Rats! That's going to make this chapter a hard sell for you, because like its two predecessors in volumes 1 and 2, this is more of those types of things, but if you're not into that, then we'll have to come up with a way to give this chapter real value for you. Wait…wait…I've got it! Let's make it a "photo treasure hunt." Yeah, I'll give you objects, and you look through the images in this chapter (being careful not to actually read any of the detailed step-by-step instructions on how to recreate those looks yourself), and then you find them. Now, once you find all these items, then go to the website www.ohyouhavetobekiddingme.com, and there you'll find a form with a broken link where you can fill in which page you found each object on, and then in a month or so, I'll forget to go to that site to choose a winner (from all the entries that didn't get submitted), and that lucky person (probably you, by the way) will win a free copy of one of my books (probably this book), and we'll ship that copy directly to you (probably sometime next year), but by then you'll have moved to a new address (you're probably running from the law), and delivery will be refused by the current occupant (your ex), and then I'll get the book back and send it to the next winner on the list (probably your parole officer). Or you could just read the chapter and see what you think. Really, it's your call.

The Recipe for Getting This Type of Shot

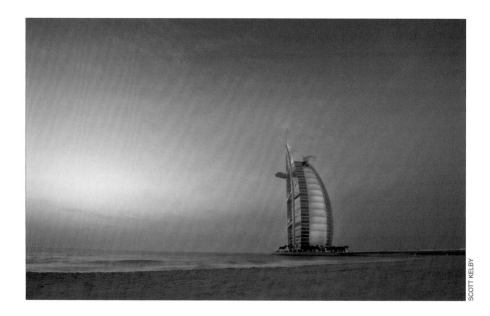

SCOTT KELBY

Characteristics of this type of shot: A sweeping shot that's both a landscape and travel shot in one, and with lots of detail all the way through and a clear focus on the hotel, there's no doubt what the subject is. (The location is the Burj Al Arab hotel, Dubai, UAE.)

(1) You need to use a very-wide-angle lens to capture this type of expanse. This was shot at 14mm with a 14–24mm wide-angle zoom lens on a full-frame camera, which makes the lens even wider than usual.

(2) To capture all the detail front to back, shoot in aperture priority (Av) mode, and choose the highest number f-stop you can (this was shot at f/22, which keeps everything in focus from front to back).

(3) This was taken right around sunset, so the light is low, which means you absolutely need to shoot on a tripod to keep the shot sharp and in focus. It also means the light is going to be gorgeous (even though the sun is tucked behind the clouds, the clouds are still great because they hold a lot of the color).

(4) To eliminate any camera shake, you can either shoot with a cable release or, at the very least, use the camera's built-in self-timer to take the shot, so your finger isn't even touching the camera when the shot is taken.

The Recipe for Getting This Type of Shot

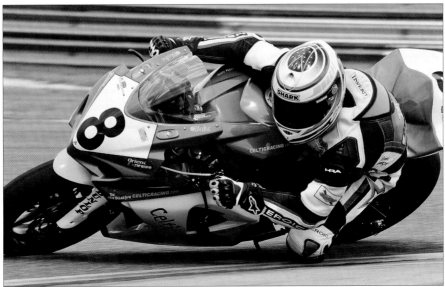

SCOTT KELBY

Characteristics of this type of shot: You're in really tight, which pulls you into the action, and the rotation of the wheels gives you a sense of movement, but without blurring the rest of the image.

(1) To get in really close like this, you need a long lens (this was taken with a 200mm lens with a 1.4x teleconverter to get in even closer).

(2) The key to this shot is finding a shutter speed that freezes the action enough for the bike and rider to remain sharp, yet keep some blur in the wheels, so it doesn't look like the bike is standing still. You can freeze most sports shots at 1/1000 of a second, so to see some wheel-spin, you know right off the bat it has to be slower than 1/1000. This was taken at 1/400 of a second.

(3) If you're shooting at a slow shutter speed like this (well, 1/400 of a second is slow for sports anyway), you'll need to pan (follow) along with the bike to keep the bike and rider sharp. You won't be shooting on a tripod, so keep your camera steady when panning (if you're using a long enough lens, you can try using a monopod).

(4) When panning like this, you need to be shooting in high-speed continuous (burst) mode to increase your chances of getting a sharp shot.

The Recipe for Getting This Type of Shot

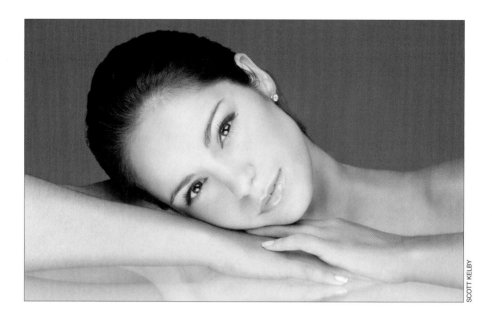

SCOTT KELBY

Characteristics of this type of shot: A "beauty-style" shot with soft, full lighting that wraps around your subject and gives you bright, flat, almost shadowless light.

(1) There are two keys to a beauty-style shot like this: The first is to have the subject put her hair back into a ponytail and hide as much of that behind her head as possible, leaving the face open and clean. The second is the lighting, which bathes the subject in light and gives the image the clean beauty look.

(2) There are just two lights used for this look: the main light is a beauty dish that's directly in front of the subject, but up about two feet above her face, aiming down at her at a 45° angle. The other light is under the plexiglass, aiming up at her at a 45° angle (this is sometimes called "clamshell" lighting, because it looks like you're shooting in between an open clamshell). Position the camera height right at her eye level.

(3) To keep everything in focus, from front to back, you'll need to use an f-stop that holds details, like f/11, and a long enough lens (like a 200mm) to give nice perspective.

(4) She's leaning on the same clear piece of plexiglass that I talked about in the product photography chapter (Chapter 4), which is held up by two people assisting in the studio. The background is a gray seamless paper background.

The Recipe for Getting This Type of Shot

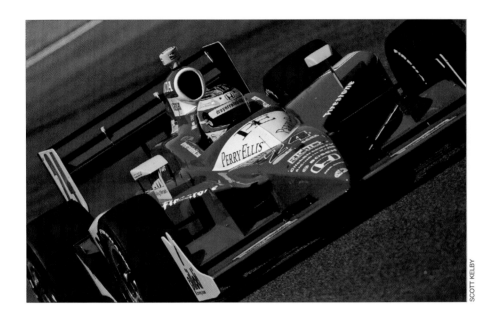

SCOTT KELBY

Characteristics of this type of shot: A tight-in shot, giving you an up-close view you don't usually see, and the shot has a lot of energy and vivid color.

(1) The key to this shot is using a very long lens (in this case, a 400mm lens) to get you really in tight to the action.

(2) Because you're shooting in direct sunlight during the middle of the day, getting a shutter speed greater than 1/1000 of a second won't be a problem at all (in fact, this was shot at 1/4000 of a second, which freezes everything).

(3) Because the car is coming almost straight at your shooting position, you hardly see the wheels like you do with a side or three-quarter view of the car, so you don't have to be as concerned about using a slow shutter speed to have the wheels blurred to show motion. Because of that, you can shoot with a much higher shutter speed and create a really crisp image.

(4) One thing that greatly adds to the energy of the shot is tilting the camera 45° to one side—a very popular angle for motorsports shots.

(5) You'll want to use a monopod to steady a lens 300mm or longer.

The Recipe for Getting This Type of Shot

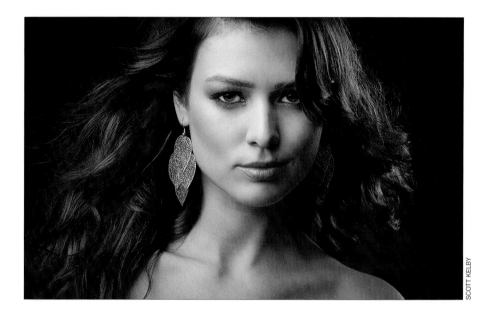

SCOTT KELBY

Characteristics of this type of shot: Dramatic lighting that doesn't evenly light the subject. Having a subject with dark hair on a dark background adds to the drama.

(1) To get this type of shot, you need just two lights: the main light is a large softbox positioned to the left (from our view) and slightly in front of the subject, but very close to the subject to create very soft light. The key is to keep this large softbox mostly to the side of the subject, so the light doesn't fully light her entire face—you want those shadows on the right side of her face to add drama. Keep the power on the main light down about as low as it will go, since it will be so close to the subject.

(2) The second light is a strip bank (a tall, thin softbox) positioned behind your subject on the right side (from our view), lighting her hair and shoulders (it's at a 45° angle about eight feet behind her to the right). The reason the light doesn't spill over every-where is that there's a fabric grid over the strip bank (I talked about these in volume 2).

(3) This was shot with the subject on a black seamless paper background. No reflector is necessary and no tripod is necessary (the flash will freeze your subject). It was taken at f/8 to keep everything from front to back in focus.

(4) To get a little movement in her hair, just add a fan (any old fan will do).

The Recipe for Getting This Type of Shot

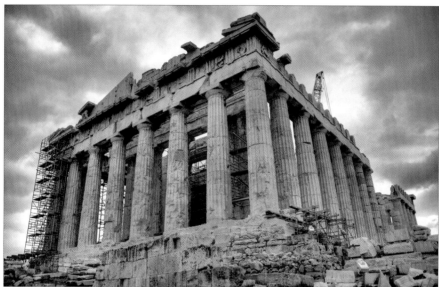

SCOTT KELBY

Characteristics of this type of shot: Lots of detail throughout the shot, including both highlight and shadow areas, and a surreal look in the sky.

(1) The key to this shot is shooting bracketed in your camera, so that later you can combine the bracketed shots into an HDR image using Photoshop and/or Photomatix Pro. (2) This was taken in the middle of the day, in direct sunlight (it wasn't as cloudy as it appears—the clouds are enhanced by the HDR effect), so there's enough light to use an f-stop of f/11 or higher, which keeps as much of the image in focus as possible from front to back. Set your camera to three- or five-image bracketing (see page 117 for how to do that). (3) To take all this in, you'll need a wide-angle lens (I used an 18–200mm lens, so I shot this at 18mm for the widest view possible). (4) Although I didn't use a tripod for this particular shot (I didn't have one with me), HDR shots work best when you can shoot on a tripod (although, obviously, you can get away with hand-holding an HDR shot if you have Photoshop CS3 or CS4, and can use the Auto-Align Layers feature to perfectly align the shots later, before you create the HDR image). I created a video just for you to show how to combine your bracketed shots into an HDR image like you see above. The link to it is on page 118.

The Recipe for Getting This Type of Shot

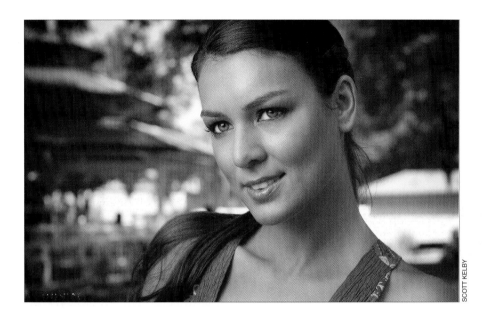

SCOTT KELBY

Characteristics of this type of shot: An outdoor portrait, taken at midday, with soft directional lighting (the opposite of what you'd get at midday).

(1) The first step is to get your subject out of the direct sunlight. If you look at the setup shot on page 30, the subject (above) is standing under a tree, but there's lots of light coming through the branches, so you'd have her move back a few feet, so there are no dapples of light falling on her—you want her completely in the shade.

(2) To light a shot like this, all you need is one single off-camera flash (in this case, a Nikon SB-800 flash) on a light stand, up high in front of her and to the left (from our view). You need something to soften the light—in this case, we used a Lastolite Ezybox (as seen back on page 7).

(3) To separate the subject from the background, you need to have the background blurry and out of focus, so you'll need to use a very low-numbered aperture. In this case, I used an f-stop of f/5.6 (the lower the number you use, the more out of focus the background will be).

(4) Set your flash at a very low power, so it blends in with the existing light. You don't need to shoot on a tripod, because the flash will freeze your subject.

The Recipe for Getting This Type of Shot

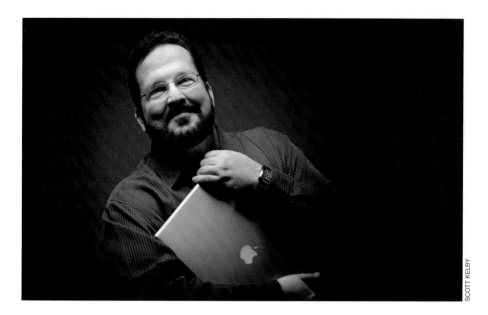

SCOTT KELBY

Characteristics of this type of shot: A dark, dramatic editorial-style shot.

(1) This is a simple one-light shot. It's a beauty dish (of all things) positioned directly above the subject's head, aiming straight down (like a street lamp).

(2) Because the light is aiming straight downward, some of the light is spilling onto the black seamless paper background, giving a little spotlight effect behind the subject.

(3) The subject is not a professional model, and didn't know what to do with his hands, so since he's kind of a Mac freak, we handed him a laptop. This is a great trick to use when your subject is uncomfortable in front of the camera—just hand them a prop, give them something to do, and then just capture the moment as they interact with the prop (which is what happened here, when he started jokingly hugging the laptop).

(4) The final key to this is having the light fall off, so his face is well lit, but then the light falls off as it moves down. This was done by placing a black flag (a 24x36" felt panel) just below the bottom edge of the beauty dish. That way, the light didn't spill too much onto his chest, and mostly concentrated on his face. This was shot with a 70–200mm f/2.8 lens (at 85mm) at f/6.3.

The Recipe for Getting This Type of Shot

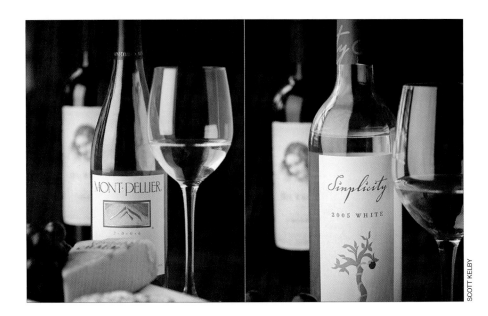

SCOTT KELBY

Characteristics of this type of shot: Soft daylight-looking light, with large, tall high-lights in the bottles and glasses, and a very shallow depth of field.

(1) These shots are a mixture of natural light and continuous daylight fluorescent studio lighting. The natural daylight was coming from a window behind and to the left (from our view) of the wine bottles.

(2) The main light (lighting the front of the wine bottles) is a Westcott Spiderlite (not a strobe, but a continuous light) using daylight fluorescent bulbs with a 24x36" softbox attached to soften the light. The light is just off to the left of the wine bottle, and in really close (just outside the left side of the camera frame). To get that nice tall reflection, just rotate the softbox so it's tall (rather than a wide).

(3) Both lights (the natural window light and the Spiderlite continuous light) are on the left side of the frame, so to bounce some light back into the dark area on the right side of the bottles is a white foam core reflector (you can buy these at your local office supply store), and it's standing straight up, to the right of the wine bottles, just outside the frame.

(4) This is a product shot, so shoot it on a tripod (especially in lower light like this).

The Recipe for Getting This Type of Shot

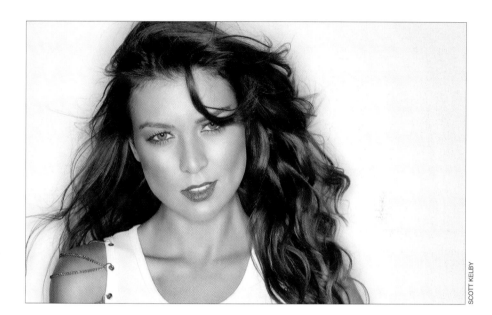

SCOTT KELBY

Characteristics of this type of shot: This is the bright, flat, shadowless look that's very popular right now in flash photography. However, with ring flash, you'll actually see a shadow halo outlining your subject, which is part of "the look."

(1) There's only one light—an AlienBees Ring Flash (seen on page 47), which is a circle of very small flashes, and your lens goes through the middle of this circle of flashes, so it's mounted right to the camera. You shoot from directly in front of your subject.
(2) Normally, you'd keep your subject about 10 feet away from the white seamless paper background, but to get that halo shadow behind her, you can reposition your subject so she's only around a foot or two from the background. That way, you can see the shadows created by the ring flash, but they're not too large.
(3) Since you're this close to the background, you don't need to light the background with a separate flash—the light from the ring flash is enough to light the background at the same time.
(4) A ring flash produces a harder light source than a strobe with a softbox, so to keep the shadows that outline your subject soft, make sure you shoot in close to your subject (this increases the relative size of your light source, which makes the light softer).

The Recipe for Getting This Type of Shot

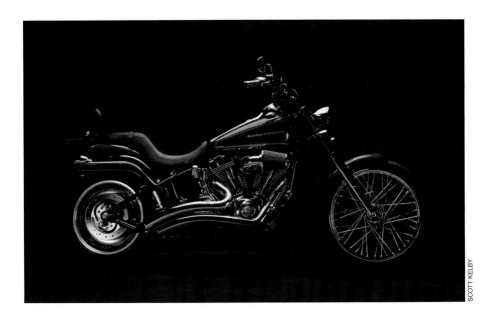

SCOTT KELBY

Characteristics of this type of shot: Dark, dramatic lighting that picks up the chrome and the lines of the bike.

(1) You only need one light to get a shot like this, but it has to be a big one (well, the strobe doesn't have to be big, but the softbox does—it has to almost be as long as the bike). Place the softbox directly over the motorcycle, on a large boom stand, aiming straight down at it.

(2) The reason you don't see the legs of the boom stand holding up the light is that I removed them using the Clone Stamp tool (found in Photoshop or Photoshop Elements). In the original, you could see part of the base of the rolling boom stand, and even part of the light stand itself, just to the right of the front tire.

(3) To keep the bike pretty sharp throughout, use an f-stop of at least f/8 or higher.

(4) This is essentially a product shot and since that's the case, you need to shoot it on a tripod to keep the image really sharp and crisp.

The Recipe for Getting This Type of Shot

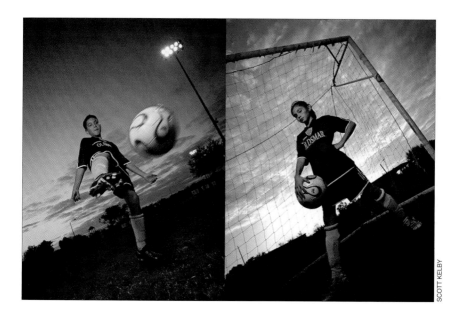

SCOTT KELBY

Characteristics of this type of shot: A great mix of sunset color and on-location flash, coupled with a shooting angle that makes these young kids look larger than life.

(1) There are two keys to the shot: The first being composition. To make the kids look big, you have to get down really low and shoot upward with a wide-angle lens (I used a 14–24mm ultra-wide-angle zoom on a full-frame camera). When I say to shoot really low, you actually need to be lying on the ground shooting upward to get this perspective. The other key to this shot is waiting until right around sunset to take it.

(2) The kids are lit using an off-camera flash (in this case, a Nikon SB-900 flash) mounted on a lightweight, portable light stand, with a small Ezybox softbox in front of it to soften and control the spill of the light. For both shots, the flash on the stand was on their right (from our view), just outside the frame.

(3) The key here is to switch to program mode, turn off the flash, aim at your subject, hold the shutter button halfway down, and then look to see the shutter speed and f-stop chosen by your camera. Then switch to manual mode, put in that f-stop and shutter speed, turn the flash on, and put the power really low—just enough to light your subject. Also, put an orange gel over the flash head, so the light from your flash doesn't look so white and artificial.

The Recipe for Getting This Type of Shot

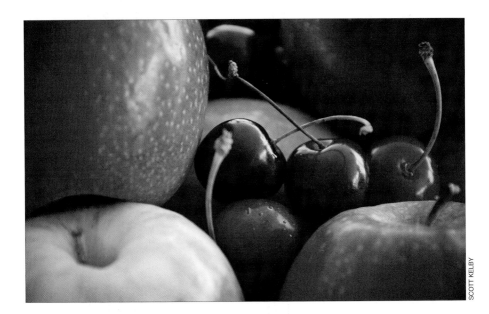

SCOTT KELBY

Characteristics of this type of shot: A cropped-in-tight shot with lots of detail, highlights, and shadows.

(1) It's a natural-light shot—a bowl of fruit, on a table, in the shade. All you have to do here is position yourself (or rotate the bowl), so the light is coming from one side, giving the photo depth and dimension.

(2) Shoot standing far back, and zoom all the way in to 200mm to get this tight composition. The shot was taken with my favorite all-around travel lens, an 18–200mm lens.

(3) When you're shooting in open shade like this, there's no direct light, so you're going to have to shoot at the lowest number your lens will allow (in this case, f/5.6) to be able to hand-hold the shot and still keep it in focus. This will give you a somewhat shallow depth of field (especially when you're zoomed-in tight like this, which is when the depth of field really kicks in). Notice how the apples in front are a bit out of focus, but the cherries are nice and sharp, and the apples behind the cherries are also out of focus. That's the f/5.6 at work for you. If I could have gone to a lower number f-stop (like f/4 or, ideally, f/2.8) the depth of field would have been even shallower.

(4) By shooting in aperture priority mode, all you do is choose the f-stop, and your camera will automatically choose the proper shutter speed for you.

The Recipe for Getting This Type of Shot

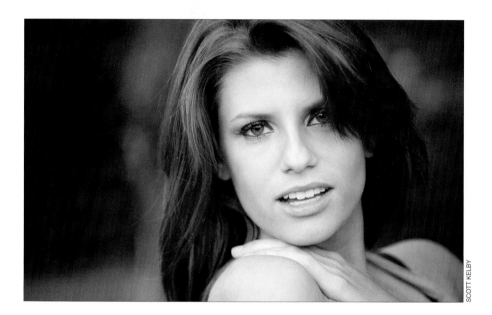

SCOTT KELBY

Characteristics of this type of shot: A soft, natural-light portrait where the subject has great separation from the background.

(1) There are four keys to this shot: The first is to shoot very late in the day (but before sunset). The sun is lower in the sky and the angle makes the shadows appear softer, and this late-day sun is generally a more flattering light.

(2) The second key is to position your subject so the sunlight is coming from one side. In this photo, the sunlight is coming from her left (from our view), and if you look at her hair, you'll see it's brighter on the left and more in the shadows on the right.

(3) The third key to this shot is to just make sure your subject is not in direct sunlight, but on the edge of a shady area (in this case, she's just below the thick branches of a tree high above). Because you're shooting in the shade, you'll have to increase the ISO a bit to make sure you have enough shutter speed (more than 1/60 of a second) to keep the image sharp if you're hand-holding your camera (this was taken at 800 ISO).

(4) To have such great separation between the subject and the background, you need a zoom lens so you can zoom in tight (here I'm zoomed in to 200mm), and you need the lowest number f-stop you can use (in this case, f/2.8 to get a nice shallow depth of field).

The Recipe for Getting This Type of Shot

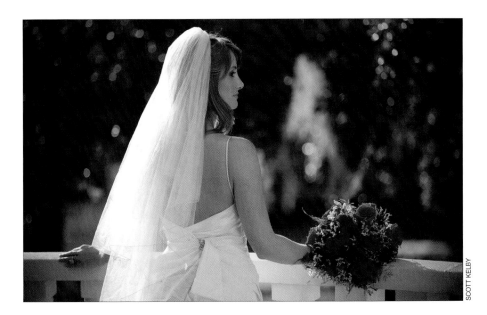

SCOTT KELBY

Characteristics of this type of shot: A bright backlight mixed with soft fill light, and a shallow depth of field to create separation of your subject from the background.

(1) One thing that gives the photo a dream-like quality is the very shallow depth of field, and you get that by using the smallest number f-stop (in this case, f/2.8), and by zooming in using a long lens (in this case, a 70–200mm lens, zoomed in to 150mm).
(2) To keep the sun from being harsh, you need to shoot a shot like this very late in the day (but at least one hour before sunset).
(3) The bride is backlit, with the sun behind her and to the left (from our view) lighting the back of her veil. To keep her face from appearing in shadow, position a white reflector to the right of the bride's bouquet to bounce some of that sunlight back onto her face. White reflectors aren't all that powerful, so she doesn't look washed in light, because the bounced light looks pretty natural.
(4) The thing to keep an eye out for is blowing out (clipping) the highlights in her veil. If you have your highlight warning turned on, and you see her veil blinking (warning you that the veil is blowing out), use your exposure compensation to lower the exposure by one-third of a stop, and take a test shot. If it's still blinking, lower it more, and test again, and so on.

The Recipe for Getting This Type of Shot

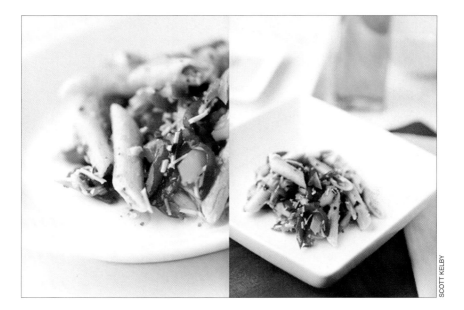

SCOTT KELBY

Characteristics of this type of shot: A bright, fresh look to the lighting, and a very shallow depth of field.

(1) The key to this type of shot is backlighting. Place the main (most powerful) light behind the food, and then use a lower-powered light in front.

(2) These shots were lit with a two Westcott Spiderlite daylight fluorescent lights (these are continuous lights—see page 88). The larger light is placed behind the food, on the left (from the camera view), and the second, smaller light is also on the left, with the power turned down a bit. To keep the shadows from being too dark on the right side of the food, place a large piece of white foam core standing to the right of the food (see page 94).

(3) If you don't have Spiderlites or strobes, you can use window light behind your food, and a white reflector in front and on the side.

(4) To get that really shallow depth of field, you need to use the lowest number f-stop your lens will allow (like f/4 or even lower, if your lens can go lower).

(5) This is essentially a product shot, so ideally you'd shoot this using a tripod.

The Recipe for Getting This Type of Shot

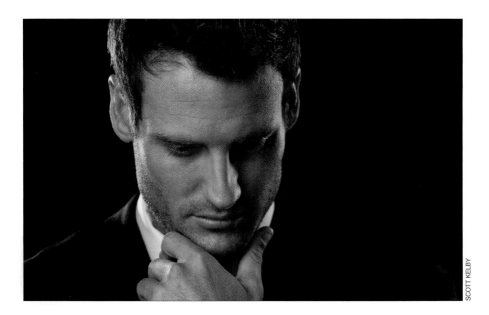

SCOTT KELBY

Characteristics of this type of shot: Hard, chiseled light on both sides of your subject's face, and a dark, dramatic, sharp look to the final image.

(1) This popular look takes three lights. You need two lights placed behind and on either side of your subject, aiming diagonally in at the sides of your subject's face.
(2) These two lights need to have a hard edge to them, so you're not going to use a softbox—just the standard metal reflectors and a bare flash bulb on each. To keep the light from spilling everywhere, use a 20° grid spot over each of the reflectors. They do a great job of aiming a beam of light right where you want it.
(3) To keep the light from these two back lights from creating lens flare (and washing out the photo), put a black flag (usually a 24x36" felt rectangle) in front of each light to block the light from entering your camera.
(4) The front light will be a large softbox, to the front and left side of your subject (from our view), which will be powered way down—just enough to add some fill light in his face. He's shot on a black seamless background. Shoot at f/8 to keep everything sharp and in focus, and use a long 200mm lens for a more pleasing look.

The Recipe for Getting This Type of Shot

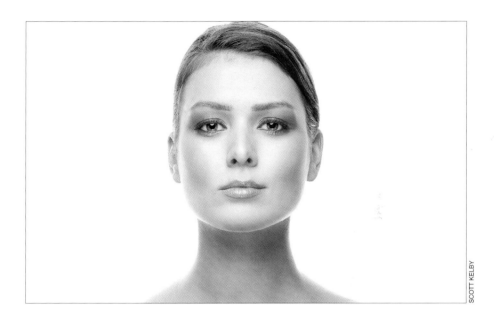

SCOTT KELBY

Characteristics of this type of shot: A clean, bright beauty shot with a wrapping light highlighting the side of your subject's face.

(1) Although you see light wrapping around the sides of her face from both sides, there are only two lights used for this look (which I think makes it even cooler). She is not standing in front of a white background, she's actually standing in front of a large softbox that's about one foot behind her, aiming upward at a 45° angle (just to help keep the flash from creating lens flare, since it would be aiming straight at the camera). So, what you're seeing is the light from that large softbox lighting both sides of her face, the underside of her chin, and the edge of her neck. (See page 50 for the setup shot for this shoot.)

(2) You put the second light, a beauty dish, directly in front of her, but up only about one foot above her head, aiming down at her at a 45° angle (it's almost right in her face—just outside the top of your frame). That lights the front of her face (you can keep the power down pretty darn low, like ¼-power or less).

(3) To keep from having lots of shadows under her eyes, put a large white reflector at her chest level, tilted up just a little bit toward her face. Put it up so high that it's almost in the frame, but not quite. This will reflect light from the beauty dish back onto her face to eliminate shadows and make her eyes nice and bright.

Index

A

about this book, 2–4
A-clamps, 42, 91
action shots, 150, 215, 217, 225
 See also **sports photography**
Adobe Photoshop. *See* Photoshop
Adobe Photoshop Book for Digital
 Photographers, The (**Kelby**), 51
AE Lock button, 147, 189
AlienBees Ring Flash, 47, 223
all-in-one zoom lenses, 76
ambient light, 46
American Society of Media
 Photographers (ASMP), 138
anti-movement technology, 65
aperture priority mode, 117, 181, 214, 226
aperture setting, 80, 158
architectural photography, 69
athletic events. *See* sports photography
Auto Exposure setting, 189
Auto ISO feature, 146
Auto white balance, 105, 181
autofocus feature, 71, 74, 75, 152

B

B&H Photo website, 69
babies
 focusing attention of, 142
 shooting newborn, 141
 See also **children**
backgrounds
 black granite, 95
 lighting, 25, 46
 sets used as, 36
 solid white, 34
backing up memory cards, 201
backlighting effect, 121
backup flash, 28
batteries, rechargeable, 14

battery grips, 165
battery packs
 external, 13
 studio strobes and, 45
beach portraits, 136
beauty dish, 38, 221, 231
beauty-style shots, 216, 231
black backgrounds, 46
black bar/gradient, 54
black granite, 95
BlackRapid R-Strap, 160
bracketing shots, 117, 219
breath holding, 61
bridal shots, 228
bright spots, 107
Burst mode, 206
BXRi strobes, 35

C

cable release, 68, 180
camera gear
 author's website on, 3
 downloading manuals for, 209
 lens gear finder, 58, 59
 modular belt system for, 166
 packing lists for, 102, 182–186
Camera Raw, 51
cameras. *See* digital cameras
Canon cameras, 4
 AI Servo mode, 153
 Auto ISO feature, 146
 exposure compensation on, 140
 external battery pack, 13
 eyepiece cover, 115
 firmware updates for, 198
 Focus Confirmation Light on, 152
 HDR bracketing on, 117
 IS lenses for, 65
 Live View white balance, 170
 memory card lock feature, 199

 sensor cleaning feature, 196
 Speedlight stand, 26
 time-lapse photography with, 175
 video capability on, 189
 viewfinder door, 115
 VR lenses for, 65
 zooming the LCD on, 204
NiMH batteries, 14
noise
 high ISO shots and, 148
 onscreen vs. print, 113
 software for reducing, 172, 179

O

Olivella, Mike, 157
online photo labs, 178
orange gel, 23
outdoor photography, 101–125
 arriving early for, 122
 backlighting effect in, 121
 bright spots avoided in, 107
 clouds included in, 109
 covering the viewfinder for, 115
 deleting bad shots during, 125
 framing shots in, 112
 graduated neural density filter for, 116
 HDR images from, 117–118
 hiding modern-day objects in, 107
 ISO setting for, 113
 lens selection for, 120
 light as the subject in, 106
 lower-level perspective for, 116
 movement effect and, 103
 overpowering the sun in, 17
 packing list for, 102, 182
 panoramas made from, 123
 portraits and, 17, 135, 136, 220
 postcard images and, 114
 puddle reflections in, 112
 scouting locations for, 119
 shadows included in, 109
 star filter effect in, 104
 texture shots in, 114

 three keys to, 108
 underwater shots in, 110–111
 vibrant color settings for, 124
 white balance and, 105
 See also landscape photography
overexposing portraits, 140
overpowering the sun, 17

P

packing lists
 importance of using, 102
 landscape photography, 182
 location portrait photography, 184
 sports photography, 183
 travel photography, 185
 wedding photography, 186
panning
 freezing motion by, 154, 215
 and shooting video, 189
panoramas, 123
people
 baby and child photos, 141–143
 high vantage point shots of, 130
 model releases for, 138
 props for shooting, 128, 143
 seating for comfort, 129
 street shots of, 137
 See also portraits
percentage of great shots, 188
perspective
 child-level, 143
 high vantage point, 130
 lower-level, 116, 157, 225
Peterson, Moose, 115
photo labs, 178
Photomatix Pro, 118
photos. *See* digital photos
Photoshop
 Auto Levels adjustment, 111
 Auto-Align Layers feature, 219
 combining images in, 173, 176
 faking reflections in, 84
 finding dust spots in, 210
 gray card color correction in, 51

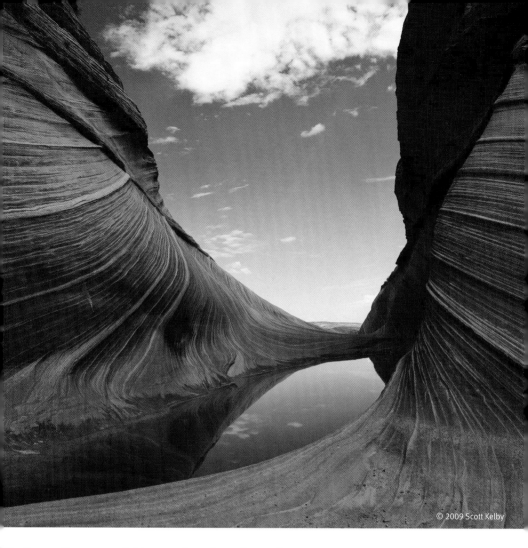

© 2009 Scott Kelby

Color Control Revolutionized

Nik Software
Viveza

Viveza offers the unprecedented ability to select precise areas of an image and adjust color and light without complicated selections or layer masks.

No other tool does a better job of controlling color and light naturally in your images. Spend more time behind the camera and less time at the computer.

Viveza is available for Photoshop®, Photoshop® Elements, Lightroom®, and Aperture™

"I find myself using Viveza more and more because I just want to get the job done as easy and as fast as possible."

– Scott Kelby
 President, National Assn. of Photoshop Professionals

Watch the video and try Viveza for free at **www.niksoftware.com/dpvol3**

The Digital Photography Book

The step-by-step secrets for how to make your photos look like the pros'! Book

PART 4

Scott Kelby

The Digital Photography Book, part 4

The Digital Photography Book, part 4 Team

TECHNICAL EDITORS
Kim Doty
Cindy Snyder

EDITORIAL CONSULTANT
Brad Moore

ASSOCIATE ART DIRECTOR
Jessica Maldonado

CREATIVE DIRECTOR
Felix Nelson

TRAFFIC DIRECTOR
Kim Gabriel

PRODUCTION MANAGER
Dave Damstra

PHOTOGRAPHY BY
Scott Kelby

STUDIO AND
PRODUCTION SHOTS
Brad Moore
Rafael "RC" Concepcion

PUBLISHED BY
Peachpit Press

Copyright ©2012 by Scott Kelby

Composed in Myriad Pro (Adobe Systems Incorporated) and LCD (Esselte Letraset, Ltd.) by Kelby Media Group.

Trademarks

All terms mentioned in this book that are known to be trademarks or service marks have been appropriately capitalized. Peachpit Press cannot attest to the accuracy of this information. Use of a term in the book should not be regarded as affecting the validity of any trademark or service mark.

Photoshop, Elements, and Lightroom are registered trademarks of Adobe Systems Incorporated. Nikon is a registered trademark of Nikon Corporation. Canon is a registered trademark of Canon Inc.

Warning and Disclaimer

This book is designed to provide information about digital photography. Every effort has been made to make this book as complete and as accurate as possible, but no warranty of fitness is implied.

The information is provided on an as-is basis. The author and Peachpit Press shall have neither the liability nor responsibility to any person or entity with respect to any loss or damages arising from the information contained in this book or from the use of the discs or programs that may accompany it.

THIS PRODUCT IS NOT ENDORSED OR SPONSORED BY ADOBE SYSTEMS INCORPORATED, PUBLISHER OF ADOBE PHOTOSHOP, PHOTOSHOP ELEMENTS, AND PHOTOSHOP LIGHTROOM.

ISBN 13: 978-0-321-77302-9
ISBN 10: 0-321-77302-0

9 8 7 6 5 4 3 2 1

Printed and bound in the United States of America

www.kelbytraining.com
www.peachpit.com

*This book is dedicated to the most
amazing woman I have ever known:
my wife, Kalebra.*

Acknowledgments

Although only one name appears on the spine of this book, it takes a team of dedicated and talented people to pull a project like this together. I'm not only delighted to be working with them, but I also get the honor and privilege of thanking them here.

To my remarkable wife Kalebra: This year we'll be celebrating our 23rd wedding anniversary, and you still continue to amaze me and everyone around you. I've never met anyone more compassionate, more loving, more hilarious, and more genuinely beautiful, and I'm so blessed to be going through life with you, and to have you as the mother of my children, my business partner, my private pilot, Chinese translator, gourmet cook, rock singer, and very best friend. You truly are the type of woman love songs are written for, and as anyone who knows me will quickly tell you, I am, without a doubt, the luckiest man alive to have you for my wife.

To my wonderful, crazy, fun-filled, son Jordan: If there's anything that makes a dad truly happy deep inside, it's seeing how truly happy deep inside his son is, and Jordan, if you were any happier you'd explode like a candy-filled piñata. As you've now entered your first year of high school, I can't imagine a kid being more on top of the world than you are, and I'm just so proud of the wonderful young man you have become, of the wonderful example you've created for your friends, of the compassion you display for complete strangers, and of your drive to help those in need. One day, when you have kids of your own, you'll understand exactly how I feel about you and why I feel so lucky to be your dad.

To my beautiful "big girl" Kira: You are a "mini-me" of your mom, and that is the biggest compliment I could possibly pay you. You're totally blessed with her outer beauty, and also something that's even more important: her inner beauty, warmth, compassion, smarts, and charm, which will translate into a loving, fun- and adventure-filled, thrilling, drive-it-like-you-stole-it kind of life so many people dream of. You were born with a smile on your lips, a song in your heart, the gift of dance, and a dad who absolutely adores you from the top of your tiara-wearing head to the bottom of your pink sparkly princess shoes.

To my big brother Jeff: A lot of younger brothers look up to their older brothers because, well…they're older. But I look up to you because you've been much more than a brother to me. It's like you've been my "other dad" in the way you always looked out for me, gave me wise and thoughtful council, and always put me first—just like Dad put us first. Your boundless generosity, kindness, positive attitude, and humility have been an inspiration to me my entire life, and I'm just so honored to be your brother and lifelong friend.

To my best buddy Dave Moser: Being able to work with somebody day in and day out, knowing that they are always looking out for you, always have your back, and are always trying to make sure you have everything you need to do your job at work and at home is a real blessing, and I feel like I have a real blessing in you, Dave. Thank you for everything you do for our company, for my family, and for me.

To my editor Kim Doty: Writing books is never easy, but you make my job so much easier by keeping me on track and organized, and by staying absolutely calm and positive in the face of every storm. One of the luckiest things that has ever happened to my books is that you came along to edit them, and I'm very honored and grateful to have you making my books so much better than what I turned in. You are this author's secret weapon.

To my photography assistant and digital tech Brad Moore: I don't know how I would have gotten through this book without your help, your work in the studio (shooting so many of the product shots), your advice and input, and your patience. I'm so grateful to have someone of your talent and character on our team.

To Jessica Maldonado: You are, hands-down, the Diva of Design, and I owe much of the success of my books to the wonderful look and feel you give them. What you do brings my books to life, and helps them reach a wider audience than they ever would have, and I'm so thrilled that you're the person that works these miracles for us (signed, your biggest fan!).

To Cindy Snyder: A big, big thanks for tech and copyediting all the tips in the book and, as always, for catching lots of little things that others would have missed.

To Dave Damstra: You give my books such a spot-on, clean, to-the-point look, and although I don't know how you do it, I sure am glad that you do!

To my friend and longtime Creative Director Felix Nelson: We love you. We all do. We always have. We always will. You're Felix. There's only one.

To my Executive Assistant and general Wonder Woman Kathy Siler: You are one of the most important people in the building, not only for all the wonderful things you do for me, but for all the things you do for our entire business. Thanks for always looking out for me, for keeping me focused, and for making sure I have the time I need to write books, do seminars, and still have time with my family. You don't have an easy job, but you make it look easy.

To Kim Gabriel: You continue to be the unsung hero behind the scenes, and I'm sure I don't say this enough, but thank you so much for everything you do to make this all come together.

To my in-house team at Kelby Media Group: I am incredibly blessed to go to work each day with a group of uniquely dedicated, self-motivated, and incredibly creative people—people who mean much more to me than just employees, and everything they do says they feel the same way. My humble thanks to you all for allowing me to work with the very best every day.

To my dear friend and business partner Jean A. Kendra: Thanks for putting up with me all these years and for your support for all my crazy ideas. It really means a lot.

To my editor at Peachpit Press, Ted Waitt: Do you know what a joy it is to work on a photo book with an editor who's also a passionate and creative photographer? It makes a huge difference. Be the love. Share the love. Make the love (whoops, scratch that last one).

To my publisher Nancy Aldrich-Ruenzel, Scott Cowlin, Sara Jane Todd, and the incredibly dedicated team at Peachpit Press: It's a real honor to get to work with people who really just want to make great books.

To all the talented and gifted photographers who've taught me so much over the years: Moose Peterson, Vincent Versace, Bill Fortney, David Ziser, Jim DiVitale, Helene Glassman, Joe McNally, Anne Cahill, George Lepp, Cliff Mautner, Kevin Ames, David Tejada, Frank Doorhof, Eddie Tapp, Jack Reznicki, and Jay Maisel, my sincere and heartfelt thanks for sharing your passion, ideas, and techniques with me and my students.

To my mentors John Graden, Jack Lee, Dave Gales, Judy Farmer, and Douglas Poole: Your wisdom and whip-cracking have helped me immeasurably throughout my life, and I will always be in your debt, and grateful for your friendship and guidance.

Most importantly, I want to thank God, and His Son Jesus Christ, for leading me to the woman of my dreams, for blessing us with such amazing children, for allowing me to make a living doing something I truly love, for always being there when I need Him, for blessing me with a wonderful, fulfilling, and happy life, and such a warm, loving family to share it with.

Other Books By Scott Kelby

The Digital Photography Book, vols. 1, 2 & 3

Professional Portrait Retouching Techniques for Photographers Using Photoshop

Light It, Shoot It, Retouch It: Learn Step by Step How to Go from Empty Studio to Finished Image

The Adobe Photoshop Lightroom Book for Digital Photographers

The Adobe Photoshop Book for Digital Photographers

The Photoshop Elements Book for Digital Photographers

Photoshop Down & Dirty Tricks

The iPhone Book

About the Author

Scott Kelby

Scott is Editor, Publisher, and co-founder of *Photoshop User* magazine, is Publisher of *Light it!* digital magazine, and is co-host of the weekly video-casts *The Grid* (the weekly photography talk show) and *Photoshop User TV*.

He is President of the National Association of Photoshop Professionals (NAPP), the trade association for Adobe® Photoshop® users, and he's President of the software training, education, and publishing firm Kelby Media Group.

Scott is a photographer, designer, and award-winning author of more than 50 books, including *The Digital Photography Book*, volumes 1, 2, and 3, *The Adobe Photoshop Book for Digital Photographers*, *Professional Portrait Retouching Techniques for Photographers Using Photoshop*, *The Adobe Photoshop Lightroom Book for Digital Photographers*, *Light It, Shoot It, Retouch It: Learn Step by Step How to Go from Empty Studio to Finished Image*, and *The iPhone Book*.

For the past two years, Scott has been honored with the distinction of being the world's #1 best-selling author of books on photography. His books have been translated into dozens of different languages, including Chinese, Russian, Spanish, Korean, Polish, Taiwanese, French, German, Italian, Japanese, Dutch, Swedish, Turkish, and Portuguese, among others.

Scott is Training Director for the Adobe Photoshop Seminar Tour, and Conference Technical Chair for the Photoshop World Conference & Expo. He's featured in a series of training DVDs and online courses, and has been training photographers and Adobe Photoshop users since 1993.

For more information on Scott, visit him at:

His daily blog: www.scottkelby.com
Twitter: http://twitter.com/@scottkelby
Facebook: www.facebook.com/skelby
Google+: Scottgplus.com

Table of Contents

Table of Contents

Table of Contents

Table of Contents

Table of Contents

Table of Contents

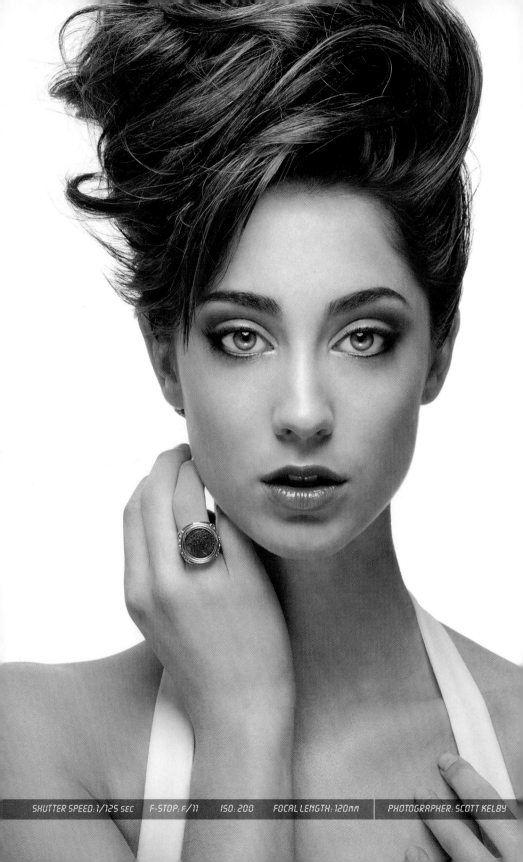

Chapter One

Shooting People Like a Pro

Yet Even More Tips to Make People Look Their Very Best

I think one of the most wonderful things about shooting people is that they're one of the few things that you'll ever shoot that will actually talk to you. Think about it—if you shoot landscapes, or HDR shots, or architecture, or cars, or home interiors, it's very unlikely that any of these will actually carry on a conversation with you, unless (and this is a big unless) you're on LSD. In that case, everything will talk to you. Bunnies. Rainbows. Mountains. Door handles. You name it. Now, you do run a serious risk when taking LSD and that is you may become annoyed at constantly hearing from these inanimate objects, because, like people, they don't always say exactly what you want them to say. For example, I remember this one time during the 1960s, when I was listening to this Jimi Hendrix song while crossing a rice paddy with my platoon (looking back, it may not have actually been a rice paddy, it may have been a small drainage ditch at the golf course behind my parents' house, and since I was probably about five years old, I guess I wasn't with my platoon, it was more likely the two neighbor kids that lived next door, and I imagine I wasn't listening to Jimi Hendrix, it was more likely "This is the way we wash our hands, wash our hands, wash our hands…" from the *Captain Kangaroo* show I watched that morning before heading off to kindergarten, but the '60s were such a blur for me). Anyway, when you shoot people, there are a few things you want to make sure of: (1) Hide the gun. This is the first thing the cops are going to go searching for. (2) Wipe everything clean of fingerprints. (3) When you hear, "It's the police. Open up!" don't freak out and accidentally flush your 70–200mm f/2.8 lens down the toilet. You cannot believe how long it takes for one of those to dry out.

9 Things You'll Wish You Had Known...

(1) **You don't have to read this part,** because I created a video that explains how to get the most out of this book. It's short and to the point, but I promise it'll make using and learning from this book much more enjoyable (plus, you can skip this section, because the video covers it). You can find it at **http://kelbytraining.com/books/digphotogv4**.

(2) **Here's how this book works:** Basically, it's you and me together at a shoot, and I'm giving you the same tips, the same advice, and sharing the same techniques I've learned over the years from some of the top working pros. But when I'm with a friend, I skip all the technical stuff. So, for example, if you turned to me and said, "Hey Scott, I want the light to look really soft and flattering. How far back should I put this softbox?" I wouldn't give you a lecture about lighting ratios or flash modifiers. In real life, I'd just turn to you and say, "Move it in as close as you can to your subject, without it actually showing up in the shot. The closer you get, the softer and more wrapping the light gets." I'd tell you short and right to the point. Like that. So that's what I do here.

(3) **This picks up right where volume 3 left off** (the previous books in this series should have been called parts 1, 2, and 3, instead of volumes 1, 2, and 3, so that's why I called this one part 4), and the stuff here is what people who bought volume 3 told me they wanted to learn next. So, for example, in the chapter on hot shoe flash, I don't tell you what your flash's groups are for, because all that was already covered in the flash chapter in volume 3. Instead, it picks up right after that, with all new stuff. Now, should you have volumes 1, 2, and 3 before...

...Before Reading This Book!

...you read this book? It's not absolutely necessary, but it certainly wouldn't bother me one bit if you did (like how I phrased that? A very subtle, soft-sell approach. Compelling, but yet not overbearing). All joking aside, if you're into off-camera flash or studio lighting, it is helpful to have read at least volumes 2 and 3, because I treat those chapters in this book as if you already learned the basics in volumes 2 and 3.

(4) Sometimes you have to buy stuff. This is *not* a book to sell you stuff, but before you move forward, understand that to get pro results, sometimes you have to use some accessories that the pros use. I don't get a kickback or promo fee from any companies whose products I recommend. I'm just giving you the exact same advice I'd give a friend.

(5) Where do you find all the gear I mention? Since I didn't want to fill the book with a bunch of web links (especially since webpages can change without notice), I put together a special page for you with a link to any of the gear I mention here in the book. You can find this gear page at **http://kelbytraining.com/books/vol4gear**.

(6) The intro page at the beginning of each chapter is just designed to give you a quick mental break, and honestly, they have little to do with the chapter. In fact, they have little to do with anything, but writing these off-the-wall chapter intros is kind of a tradition of mine (I do this in all my books), so if you're one of those really "serious" types, please, I'm begging you—skip them, because they'll just get on your nerves.

That Was Only 6. Here Are the Last 3

(7) If you're shooting with a Sony or Olympus or a Sigma digital camera, don't let it throw you that a Nikon or Canon camera is pictured. Since most people are shooting with a Nikon or Canon, I usually show one or the other, but don't sweat it if you're not—most of the techniques in this book apply to any digital SLR camera, and many of the point-and-shoot digital cameras, as well.

(8) There are extra tips at the bottom of a lot of pages—sometimes they relate to the technique on that particular page, and sometimes I just had a tip and needed to fit it somewhere, so I put it on that page. So, you should probably at least take a quick glance anytime you see a tip box on the bottom of a page—ya know, just in case.

(9) Keep this in mind: This is a "show me how to do it" book. I'm telling you these tips just like I'd tell a shooting buddy, and that means oftentimes it's just which button to push, which setting to change, where to put the light, and not a whole lot of reasons why. I figure that once you start getting amazing results from your camera, you'll go out and buy one of those "tell me all about it" digital camera or lighting books. I do truly hope this book ignites your passion for photography by helping you get the kind of results you always hoped you'd get from your digital photography. Now, pack up your gear, it's time to head out for our first shoot.

Getting Shallow Depth of Field with Studio Strobes

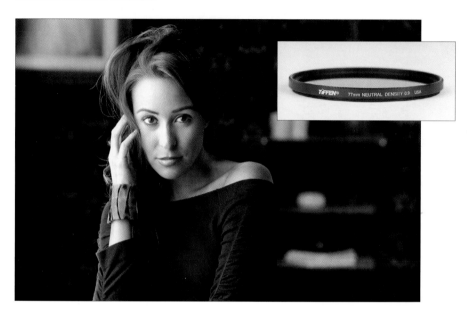

Generally, in the studio, everything's in focus (our subject, the background, you name it), because even at your strobe's lowest power setting, you still probably have to shoot at around f/8 to f/11, and that's great for most of the portraits you'll be shooting. But, what if you've built a set in the background, or you're using a scenic backdrop, or textured background, and you want it to be blurry and out-of-focus? You can't switch your f-stop to f/2.8 or f/4, because your shot would be way overexposed. So, what's the trick to getting soft, blurry backgrounds in the studio? It's using a filter that we would normally use outdoors to shoot waterfalls and streams—a neutral density filter (called an "ND filter"). This filter is totally see-through, but really dark, and basically it makes what your lens sees much darker. So dark that, to get a proper exposure, you actually have to lower the f-stop to around f/4 or f/2.8 (pretty tricky, eh?). You'll want to use either a 3- or 4-stop filter (these are made by B+W, Hoya, and Tiffen [shown above], among others) and they screw right onto the end of your lens (make sure you order one that fits your particular lens). That's it—pop the ND filter on your lens, and you're set to shoot at wide-open f-stops like f/2.8 or f/4.

Shooting Multiple Exposures In-Camera

Back in the film days, to shoot a multiple-exposure shot (one frame with two or more images in it), we used to have to take a shot, carefully rewind the film, and take another shot, and sometimes it actually worked! (Of course, back when I used to shoot film, I also couldn't make a call in my car, because cell phones hadn't been invented yet.) Anyway, while you can easily put two images together in Photoshop, you can actually do it in-camera pretty easily, too (a great example of this is Joe McNally's multiple-exposure shot of comedian Steve Martin). On Nikon DSLRs, go to the Shooting menu and choose Multiple Exposures. Press the right arrow on the multi-selector (on the back of your camera), choose Number of Shots, and press the right arrow again. Now, choose how many exposures you want (start with 2 the first time you try this) and press the OK button (also on the back of your camera). Next, make sure Auto Gain is turned On, then click the OK button (turn Auto Gain Off if the background you're shooting on is black). Now, take a shot, then have your subject move (or aim at something else), and shoot a second shot, and both images will appear in the same frame. Most Canon cameras don't have this function built-in, so you'll need to take two shots and blend them into one frame in Photoshop (or Photoshop Elements), so open both images in Photoshop. Step One: With the Move tool (V), press-and-hold the Shift key, and drag one image on top of the other. Step Two: Click on the Add Layer Mask icon at the bottom of the Layers panel. Get the Gradient tool (G), press the letter X on your keyboard to set your Foreground and Background colors to black/white, and then click-and-drag the Gradient tool through the top image, and it blends the two images together (it's easier than it sounds—give it a try).

One Person, Multiple Times, in the Same Shot

The trick to getting this look is amazingly simple in the studio, but you'll need to use Photoshop or Photoshop Elements to do the final step (it's really easy to pull off, even if you're fairly new to Photoshop). You start by putting your camera on a tripod (this is key, because the camera can't move, even a little, during your shoot. Well, it could, but it makes your job in Photoshop a whole lot harder). Anyway, once your camera is on a tripod, take your first shot. Now, have your subject take a few steps to the left or right of where they were just standing and take another shot. Repeat this two or three more times (you can have them dance around, jump around, etc., they just have to do it in a different place each time). Next, open the first photo you took in Photoshop (or Photoshop Elements), and then open the second photo. Step One: Get the Move tool (V), press-and-hold the Shift key, then drag the second photo on top of your first one (holding the Shift key perfectly aligns the two images together). Step Two: Click on the Add Layer Mask icon at the bottom of the Layers panel, then get the Brush tool (B), choose a small, soft-edged brush from the Brush Picker in the Options Bar, set your Foreground color to black, and paint away any edges or background that overlaps. Open another image and do the same thing (Shift-drag, add a layer mask, and paint away anything you don't want). If this sounds hard or funky or anything other than, "Oh man, is that all there is to it!?" then don't worry—I made a short video (you can find it on the book's companion website) that shows how I put the image you see above together. Then, you'll go, "Oh man, is that all there is to it!?"

How to Freeze Motion in Portraits

For the most part, if you're taking a portrait using a studio strobe, the flash of the strobe will freeze any movement (like hair blowing with a fan). But, if you're going to have your subject running through the image (like an action portrait of a runner or other athlete, or a ballerina spinning, or a contemporary dancer jumping on a trampoline), you're going to need a faster flash duration. In that case, the easiest thing to do is to turn off your studio strobes and switch to a hot shoe flash (like a Nikon SB-910 or a Canon 580EX II). These have a faster flash duration (that's one reason they're called "speedlights") and that short flash duration will freeze your subject in mid-air no problem, and the image will be sharp as a tack (also, the lower the power setting of a hot shoe flash, the shorter the flash duration). You can do this with studio strobes, as well, but there are a few things you'll need to do for this to work: (1) You'll need to shoot on a black background (it has to be really dark, so we're not doing this outside during the day, for the most part). (2) You need to set your shutter speed to its highest sync speed (generally ½₀₀ for studio lights, or ½₅₀ for hot shoe flash), because you want your flash to be the only light hitting your subject, and because of that, you want the existing light in the room (called "ambient light") to be as dark as possible (in fact, ideally, you don't want any room light at all, and that high shutter speed will help with that big time). And, (3) for most strobe brands, you want to keep your studio strobe's power setting as low as possible (the lower the power, the shorter the flash duration, and that shouldn't be a problem in a pitch black room— you'll only need a little flash power to fully light your subject).

Avoid Seeing Too Much "Whites of the Eyes"

Bad *Good*

One thing that ruins a lot of portraits where the subject isn't looking straight at the camera is when you see too much of the whites of the eyes. Luckily, once you're aware of the problem, there's a pretty easy fix: have them look just to the left (or right) of your camera position. I usually hold my hand all the way out to the side and tell my subject to look right where my hand is. If they stay looking right there, you'll see plenty of their iris and you won't have that creepy looking "white eye" effect.

More Tips for Great Group Shots

What's one of the biggest challenges with group shots (besides lighting them evenly, which is actually easy—just move the light way back)? It's seeing everyone's face. Invariably, someone's head is hiding behind someone else's (or their hair, or a hat, etc.). The trick? Take a stepladder and shoot from a higher perspective. That way, everybody's looking up, and there's less chance for anybody to be hidden. Another tip: Time is your enemy, because the longer this takes, the more disinterested the group becomes in the portrait. So, once you get everybody in place, take the darn photo (snap off seven or eight shots really quickly and be done). Lastly, before you assemble everybody, ask one or two people from the group to help out, and then direct them to move this person or that person. That way, you only need to know two people's names.

How to Keep a Group Portrait Shoot from Going Off the Rails

Remember that you're the director of this group portrait, and if you're buried behind the camera with your eye stuck to the viewfinder, you're going to lose the crowd. They'll start talking amongst themselves, and getting them to focus back on you is going to be tough. If you can, shoot your group shot on a tripod and use a cable release, so you're standing right in front of them, directing the whole time. Also, if you're talking to them, they won't have time to start chatting with each other, and you'll keep the train moving forward and on track. Don't mess around—make it quick!

Better Than the Self Timer for Group Shots

This technique for taking group shots where you need to actually be in the shot is much better than just using the self timer on your camera, because the self timer only takes one shot (and one group shot is never enough. In fact, two or three generally aren't enough, especially with a big group). Nope, instead, you're going to use an interval timer (also called an intervalometer), which makes your camera automatically take a series of shots at whatever time interval you choose (I generally go with one shot every three seconds). So, you start the interval timer, go get in place within the group, and the camera will start firing off shots for you. Some Nikon DSLRs have this feature built in (from the Nikon D200 on up), and in that case, you go under the Shooting menu and choose Interval Timer Shooting. In the menu that appears, you can choose when the shooting starts, how often it takes a shot, and so on. If you have a Canon DSLR, or a Nikon that doesn't have this interval timer feature built in, then you can buy an accessory that plugs right into your camera's remote shutter release port that will do it for you (like the Vello Wireless ShutterBoss Timer Remote shown above. I've seen some digital remote timers for as low as around $12 online).

Focus on the Subject's Eye, Then Recompose

If you want to absolutely nail the focus when you're shooting portraits, then your subject's eye needs to be in super-sharp focus. If the eye isn't in focus, the rest doesn't matter, so it's got to be right on the money. By the way, when I say "eye," I mean the eye closest to the camera (of course, if they're standing there with their shoulders and head facing directly toward the camera, both of their eyes should be the same distance from the camera. If not, they have an entirely different problem that's not going to be fixed with a camera). Anyway, here's the technique I use: (1) Aim the focus point on your LCD (usually a red dot or a red rectangle) directly at the eye closest to the camera (again, if their shoulders are square, straight toward the camera, just pick an eye), then (2) press the shutter button halfway down to "lock the focus" on their eye. Lastly, (3) with that shutter button still held halfway down, recompose the shot any way you'd like. Now, when you actually press the shutter button all the way to take the shot, your focus will be right on the money.

That Works Unless You're Shooting at f/1.4

The "lock focus and recompose" tip I just shared on the previous page works for almost every situation, with almost one exception: when you're shooting a portrait with your f-stop set to f/1.4, or maybe even f/1.8 (of course, you have to have a lens capable of shooting at that wide an f-stop, so if you don't have one of those, you can skip this tip altogether). The problem comes from the fact that when you're shooting at f/1.4 (for example) and you focus on the eye, then lock the focus and recompose the shot, the depth of field is so incredibly shallow that the recomposing part can actually put the eye a little bit out of focus (crazy, I know, but this is why you sometimes read in online forums people claiming that their $1,800 lens doesn't take crisp photos). So, when shooting at a super-wide-open f-stop like this (f/1.4, or even f/1.8), what you need to do is compose the shot the way you want it first, then manually move the focus point over the person's eye using the multi-selector (or multi-controller) on the back of your camera. That way, once it's aiming at their eye, it doesn't move. Now take the shot, and the sharpness of the eye will be right on the money. A big thanks to Cliff Mautner for this tip.

Creating the Blown-Out Look

I talk about doing this in the studio chapter, but if you don't have studio lighting, you're probably not going to read that chapter, so I wanted to include a version of it here for portraits. The "blown out" look (where you have really bright light behind your subject, so the photo almost looks blown out, or it has a big burst of light from the sun in it, or both) is really hot right now (this kind of cracks me up, because for years we've gone out of our way to avoid blowing out our photos, and now here I am writing a tip on how to actually blow them out). There are basically three tricks here, all of them simple: (1) Remove your lens hood (I know, that seems kind of obvious, but not everybody realizes the main job of a lens hood is to reduce lens flare, but now-a-days lens flare is cool, so if it flares, it's a win. Go figure). Then, (2) position your subject so the sun is behind them and you're kind of "shooting into the sun," and then (3) overexpose your shot a little bit by overriding what your camera says is a proper exposure. You do this using your camera's exposure compensation features (see page 80) by anywhere from 1 to 2 stops, depending on how "blown out" you like your images. However, exposure compensation doesn't work if you're shooting in manual mode (in which case, you have to overexpose manually, either by using a lower-numbered f-stop, or using a slower shutter speed, or both. Remember, when it looks really bad and really blown out…that's good!). One last thing: if you have your camera's Highlight Warning turned on, it should be blinkin' like a strobe at a disco— blown out look means blown out highlights (going to solid white in some or a lot of areas).

A Better Way to Direct Your Subject's Posing

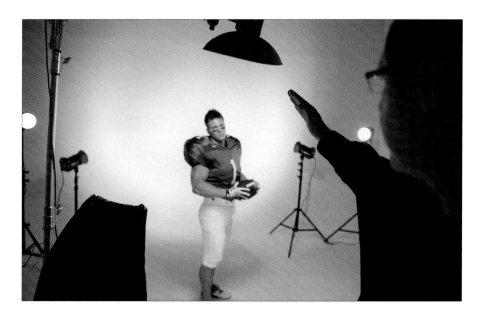

I've spent so many years shooting portraits and telling my subjects things like, "Move to your left a bit. No, my left. The other left. Uggh!" This stinks because your subject feels dumb for moving the wrong direction, you get frustrated because you just moved them the wrong direction, and the whole thing just doesn't have to happen if you use this great trick I learned from my buddy Jack Reznicki: stop giving them left/right directions. That's right, instead, just hold your hand up in front of you (as shown above) and then move your hand in the direction you want them to go, and by golly, they'll follow right along like a trained seal (so to speak). You can use this hand technique to move them forward, backward, to tilt their head one way or the other (no more "Tilt your head to the left. No, my left"), and so on.

Remembering Your Subject's Name

While we're talking about tips from Jack, here's another one I learned from him and I've been using it ever since, because I'm terrible at remembering people's names (although I never forget a face). At the beginning of the session, take a piece of white gaffer's tape and write your subject's name on it, and put that piece of tape right on the back of your camera. That way, it's always right there in front of you, and you can always refer to your subject by name (and you should. "Hey you" just falls kinda flat).

Only Photographers Care About the Characteristics of Catch Lights

Catch lights are those white reflections of the light source that appear in your subject's eyes (reflecting either the sun, or the softbox, or the reflector you used when you made the shot) and they're important, because they add life and sparkle to the eyes—without them the eyes kind of look dead. However, the fact that you do have catch lights in the eyes is really all you need to worry about, because the only people in the world that ever notice or care about the shape, size, or position of catch lights are other photographers. That's it. The public pays no attention whatsoever, so don't waste even two minutes worrying about how many catch lights you see in your subject's eye, or the shape of them, or if your reflectors can be seen in them. The only people that might ever care will never be hiring you to do a shot, since they're photographers already. So, thankfully, we can take the size, shape, position, and frequency of catch lights off our worry list.

Don't Worry About Your Softbox Reflecting in Sunglasses Either

Here's another thing not to sweat: softbox reflections in sunglasses. If you've been sweating this one, one trip to the local sunglass store in the mall should allay your concerns, as you'll see photo after photo with the softbox clearly reflected (you can walk around and see exactly what the photographer took each shot with—"Let's see…that one's a beauty dish. That's an umbrella. That one's an Octabank…").

What Not to Shoot with Your 50mm Lens

50mm

200mm

Don't shoot portraits of women. Well, certainly not close-up portraits anyway, and for one simple reason—it's just not flattering. When you shoot people with a 50mm lens up close, they generally look a bit distorted and that's the last thing you want in a portrait. That's why you see the pros shooting with longer lenses so often (I usually shoot with a 70–200mm lens out around the 150mm to 200mm end of the lens most of the time). These longer lengths create a compression that's very flattering in portraits, so people just plain look better (and why wouldn't you want your subjects to look better?). Now, can you shoot a full-length bridal portrait from the back of the room with a 50mm lens? Sure. Can you shoot group shots with a 50mm? Absolutely. Should you shoot a close-up head shot? Only if you don't care about working for that client again, because they're not going to be happy with the results. The 50mm is great for some instances, but when it comes to shooting portraits of women, almost any longer lens would probably be a better choice. By the way, I didn't need to mention the whole "don't shoot portraits of women with a fisheye lens," did I? (Kidding. I hope.)

Posing Tip to Make Her Eyes Look Bigger

Here's a quickie for larger, more flattering eyes: have your subject keep her chin down just a little bit. This puts a little extra "white" under the irises, and makes her eyes look bigger and better.

Getting Both What's in Front & Back in Focus

Subject in Focus

Object in Focus

If you're shooting a subject who's holding something out in front of them, like a football, flowers, etc., even at f/11 (where usually everything is in focus), something's going to be out of focus—either your subject or the object they're holding (and, of course, you want every-thing in focus). Luckily, there's a trick for this: First, it's easier if you shoot on a tripod, but you can absolutely hand-hold. Then, the trick is to take two shots, one right after the other—one where your subject is in focus, and one where the object is in focus—and merge them into one in Photoshop (it's simple). Compose your shot the way you want it and position your focus point (the red dot or rectangle) right over your subject's eye, so they'll be in sharp focus, and take the shot. Then, immediately move your focus point over onto the object your subject's holding and take another shot (the object will be in focus, but your subject will be a bit blurry). Open the first shot in Photoshop, then open the second one (the one where the object is in focus). Step One: Get the Move tool (V), press-and-hold the Shift key, and drag the second shot on top of the first one (holding the Shift key perfectly aligns the two together. However, if you hand-held, you'll need to select both layers in the Layers panel and choose Auto-Align Layers from the Edit menu). Step Two: Press-and-hold the Option (PC: Alt) key and click on the Add Layer Mask icon at the bottom of the Layers panel to hide the object layer behind a black layer mask. Now, get the Brush tool (B), choose a small, soft-edged brush from the Brush Picker in the Options Bar, set your Foreground color to white, and paint over the object. Voilà! It's in focus now, too!

Two Quick Composition Tips

When you're composing your portraits, if you're not shooting full-length, you're probably going to have to make some decisions about which body parts it's okay to cut off in the shot. In other words, if you're not shooting full-length, at some point, you're going to have to cut off your subject's legs, and if so, where is the "right" place to crop them? This is an easy one—crop them above the knee. If you compose it so you're cutting them off below the knee, they get that double-amputee look, so stay above the knee. You can apply that same rule if you're shooting in tighter—where is it okay to chop off their arms? I would do it above the elbows for the same reason. Any lower and it looks like they actually have had something chopped off. Take a look in any fashion magazine, and you'll see that while they do chop off a lot of things, they're usually above the elbow and above the knee.

When Do You Need Model Releases?

If you shoot people and you're not sure when you need to get a model release signed, you should pick up a brilliant book by photography copyright attorney Ed Greenberg and one of the leading advocates of copyright issues for photographers, Jack Reznicki. The book is called *Photographer's Survival Manual: A Legal Guide for Artists in the Digital Age*. It'll save your bacon.

How to Get Better Full-Length Photos

Shot Standing

Shot Sitting

I have so many photographers tell me they don't know what the problem is, but their full-length photos just don't look "right." That's probably because they're standing there shooting their full-length shots, but to get the right look and perspective, the trick is to shoot these from a really low perspective. I generally shoot from either a lying down position, or sitting down on the ground in a cross-legged position. This makes a huge difference (much bigger than you'd think)—the change in perspective makes your subject's legs look longer, it makes them look taller and thinner (who doesn't want to look taller and thinner?), and it even changes how the lighting looks on the background. So, you get all sorts of benefits from changing your shooting angle when it comes to full-length shots.

Controlling the Size of Your Subject

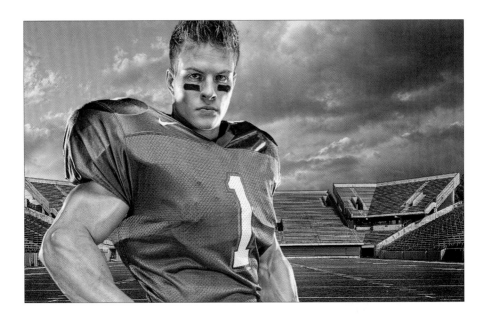

Sometimes, you want something in the foreground of your image to be the large, main focal point. For example, let's say you're shooting a high school football player in the team's stadium, and you want the player to appear huge, and the stadium to be somewhat smaller in the background. Your first inclination might be to zoom in on the player, but that only crops him in the photo—you need to change the perspective and zooming in won't do it. Instead, switch to a wide-angle lens, and then physically move in really tight to the player. That will give him a "larger than life" look, and if you really want to get the most bang for the buck from this look, get down on one knee and shoot up at the player, which exaggerates the effect even more.

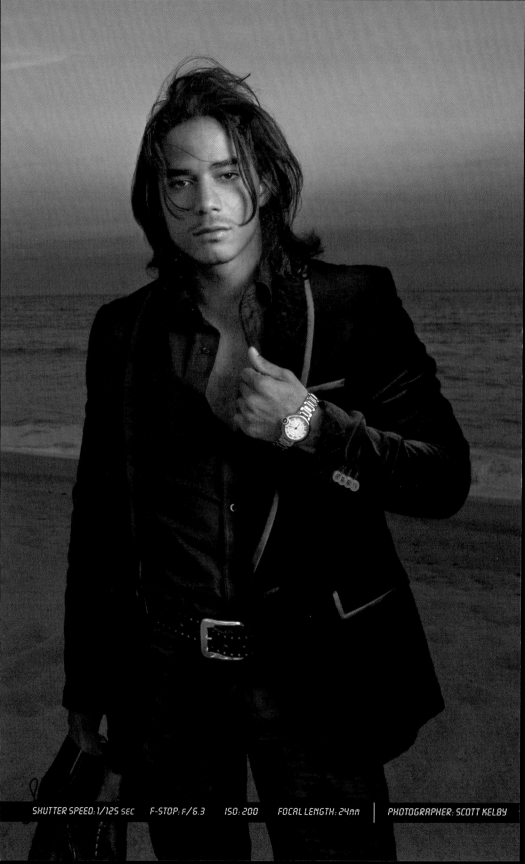

Chapter Two

Using Hot Shoe Flash Like a Pro, Part 3

Picking Right Up Where the Last Book Left Off

Did you ever see that movie *William and the Awkward Alterations Fitting* with Ethan Washington and John Trumann? If you didn't see it, I'm not surprised—it kind of flopped at the box office (it probably should have gone straight to DVD). Anyway, there's this pivotal scene in the movie where Sgt. Buck Logan (played sublimely by British actor Theodore Cowlin) hands his saucy one-armed lab assistant Christina (played by Tony-award-nominated actress Sara Jane Todd) a white 1-stop shoot-through umbrella and he tells her to take a tilter bracket and attach it, along with the shoot-through, to the end of a monopod for their location shoot later that day. Sounds pretty simple, but just as she starts to thread the bracket onto the monopod, "Mr. Fluffels," her precocious miniature labradoodle with a long-since diagnosed incontinence problem, suddenly jumps up from her doggie bed, perched up high on the window where Dr. Latisaw (Trumann) likes to watch the hummingbirds feed in the frosty morning air, and literally leaps right into the open shoot-through umbrella (which was lying nearby on the studio floor) and it was as if someone had opened a jar of peanut butter in there (Mr. Fluffels' favorite treat, revealed earlier in the movie). Well, it's just a calamity, and sure enough, her paw goes right through the thin diffusion fabric, and Mr. Fluffels starts running all over the studio with this umbrella attached to her leg, and well…I was laughing so hard I had tears in my eyes. Not only because this was such an over-used theatrical ploy, but because in plain sight, right on the rickety old wooden workbench behind Sgt. Logan, was a Lastolite EzyBox 21" softbox, which would have been the obvious choice, rather than a shoot-through umbrella, and anyway, the whole thing was just a hoot. You could instantly tell who the other hot shoe flash photographers in the theater were, because none of us could contain our laughter. We were all yelling "Use the EzyBox you idiot!" The usher had to come over and warn us twice.

Shooting Your Flash in Manual Mode

The flash manufacturers won't be thrilled to read this, but I'm not a big fan of TTL flash (Nikon's is called i-TTL and Canon's is called E-TTL, but they basically do the same thing—they use "through-the-lens" [TTL] metering to give you a better flash exposure automatically). When it works, it works really well. The problem is that it doesn't always work, and you don't always know why. That's why, when I work with hot shoe flash, I work in Manual mode on the flash (where I raise and lower the power manually, rather than having the flash make the decisions for me). For a location shoot, I set my flash to Manual mode, then I start with my power setting at ¼ power and do a test shot. If the flash is too dark, I crank it up to ½ power and take another test shot. If it's too bright, I drop it to ⅛ power and take a test shot. It normally takes me just a minute or two to find the right amount of flash to balance with the existing light in the location I'm shooting, so the light looks natural. I see more photographers frustrated with TTL than I do in love with it. Personally, I think, if anything, TTL usually makes the flash too bright and too obvious, so if I'm going to have to override it anyway, I might as well just control the power myself and leave all the frustration and aggravation behind. But hey, that's just me—there are people who love it. The cool thing is, you can try both methods and see which one fits your style (subliminal message: go Manual and you'll never go back).

The Trick to Keep from Lighting the Ground

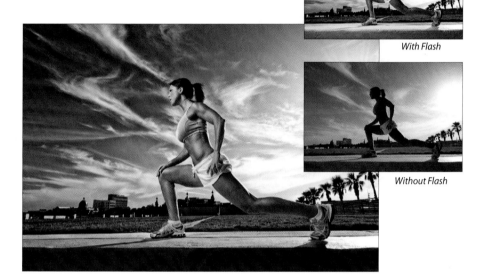

With Flash

Without Flash

When you're shooting a subject in sunlight, or in low light with flash, you want to light your subject, but you don't generally want to light the ground they're standing on (after all, the ground isn't the subject). It's often a bit cumbersome, though, to try to coax the light to only fall on your subject and then stop right there and not light the ground. That's why this tip, which I learned from David Hobby, rocks (it's ½ camera trick and ½ Photoshop trick). Here's how it works: When you take your shot, take two real quick shots in a row (you can use burst mode, if you like). On the first shot, your flash will fire, but it won't have time to recycle for the second shot, so the second shot is taken with just the available light at the scene. So, you have two shots now: one with the flash lighting your subject (and the ground) and one where the flash didn't fire and the ground looks normal. Open both photos in Photoshop (or Photoshop Elements). Press-and-hold the Shift key, get the Move tool (V), and drag the shot where the flash didn't fire on top of the one where it did, and it'll appear on its own separate layer (holding the Shift key down as you drag perfectly aligns the two images, one on top of the other). Now, press-and-hold the Option (PC: Alt) key and click on the Add Layer Mask icon at the bottom of the Layers panel. This puts a black mask over the top layer (the one where the flash didn't fire), which hides it from view. Get the Brush tool (B), choose a medium-sized, soft-edged brush from the Brush Picker in the Options Bar, set your Foreground color to white, and paint over where the flash lit the ground. As you paint, it reveals the ground from the shot where the flash didn't fire, which covers the spillover from the flash. (*Note:* I created a short video to show you how this works and how to create the finishing effect, which you can find on the book's companion website.)

Using Studio-Quality Softboxes with Your Flash

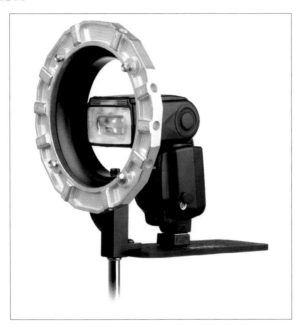

If you want to get real studio-quality lighting out of your off-camera flash, you'll need real studio softboxes, and one of the tricks to using them is an accessory called the Magic Slipper from F.J. Westcott (www.fjwestcott.com). The Magic Slipper lets you use nearly any studio softbox that Westcott makes (and they make a bunch) with your hot shoe flash. So, now you can use big octabanks, and strip lights, and huge rectangular softboxes—pretty much whatever you want from their collection of studio gear. There's also a company called Kacey Enterprises (www.kaceyenterprises.com) that has a speed-light adapter and ring that lets you use an Elinchrom softbox with your speedlights. You need both the Kacey Speedlight Bracket (you mount this on top of your light stand to hold either one or two Canon or Nikon flashes, depending on which model you order), and then you need the Kacey/Eli Adapter, which you attach to your Elinchrom softbox. Both the Westcott and Kacey solutions are about the same price (around $230 when this book was published). It's not cheap, but it opens up a new world of light modifiers (fancy word for softboxes) to you.

Mounting a Flash on a Monopod

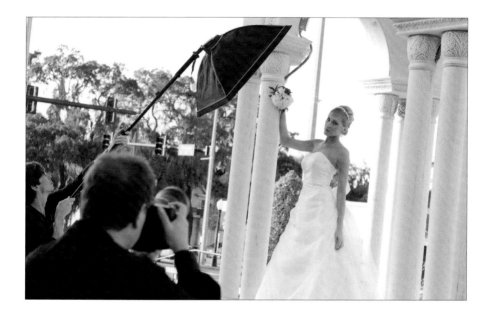

If you have someone that can help you during your shoot (a friend, a paid assistant, etc.), then you can use a rig that is becoming extremely popular, especially for shooting weddings and portraits on location, and that is your hot shoe flash mounted on a monopod (a single telescoping pole usually used to support large lenses for sports photographers). Then, to soften the light, you either add a shoot-through umbrella or, what I prefer, a small pop-up softbox (like Lastolite's EzyBox Hotshoe softbox). This rig really lets you "run and gun," because there's nothing to pick up and move—no stands or sandbags to haul around—and you can shoot in close quarters without having to worry about maneuvering the legs of your light stand (plus, you can shoot outdoors without having to worry about a gust of wind sending your lighting rig sailing!). The key to this rig is an adapter made to fit on the top of the monopod. Believe it or not, though, you might already have one that works with a softbox. That's right—you know that little plastic stand that comes in the box with Nikon and Canon flashes? If you turn it upside down, you'll find an opening for screwing this into a monopod. Just screw the stand into the top of the monopod, then put your flash on the stand. If you want something sturdier, that works with an umbrella, B&H Photo sells Impact's Umbrella Bracket with Adjustable Shoe, which also tilts, so it's perfect for using with a shoot-through umbrella. If you're using a hot shoe EzyBox, it already comes with an adapter that screws onto a monopod. Once your flash is on the monopod, and you have a wireless trigger attached to your flash, you or your helper can now move very quickly from location to location with no wires, stands, or other mess to slow you down.

How to Put the Background Out of Focus Using Flash

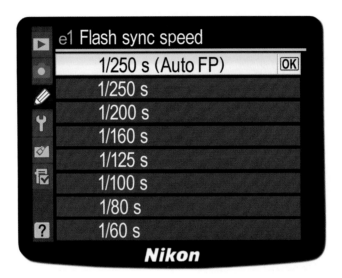

You'll notice that most images taken with flash have the background, along with pretty much everything else, in focus because, for a proper exposure, they're probably taken at f/8 or f/11. That's mostly because, with hot shoe flash, your shutter speed needs to stay at a maximum of 1/250 of a second or your camera and your flash won't stay in sync (called the maximum sync speed). If it goes above 1/250 of a second, you'll see a dark gray or black gradient appear across the top or bottom of your image (and the more you're over 1/250 of a second, the bigger that gradient will be). So, to shoot at wide-open apertures like f/4 or f/2.8 (f-stops that put the background out of focus), you'd need to have your shutter speed way above 1/250 of a second, especially if you're shooting in daylight. To be able to use the high shutter speeds, so you can shoot at those wide-open apertures like f/2.8, turn on High-Speed Sync. (Really, that's it? Well…yeah.) On a Nikon, go under the Custom Setting menu, under Bracketing/Flash, and choose Flash Sync Speed. From the list of sync speeds, choose 1/250 s (Auto FP)—the FP stands for Focal Plane. Now, if you look on the back of your flash, you'll see "FP" appear at the top of the LCD. You can now sync up to 1/8000 of a second, so with your camera in manual mode, you can dial in pretty much whatever shutter speed you need to get the wide-open f-stop you want. For a Canon, you turn this feature on right on the flash itself. Press the Mode button on the back of the flash, so that ETTL is displayed in the LCD, then press the High-Speed Sync button until you see its icon (a lightning bolt with an H) appear next to ETTL. That's it! There are downsides to shooting at high sync speeds like this, though: (1) it drains your batteries much faster, and (2) the power output from your flash goes down quite a bit.

Don't Have a Gel? Change Your White Balance

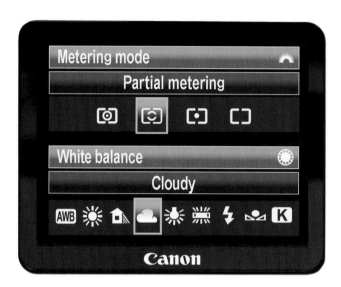

If you're shooting outdoors, and you don't have a gel to put over your flash head (to make the color of the light coming from the flash look more natural, instead of bright white, which looks like studio light outdoors and just looks weird), try this instead: change your camera's White Balance setting to Cloudy (on a Nikon, from the Shooting menu, choose White Balance, then choose Cloudy; on a Canon, press the White Balance Selection button, then turn the Quick Control Dial and select Cloudy). This gives your image an overall warm feel, and it helps make the light from your flash look warmer, too! Give it a try the next time you're stuck for a gel—it works better than you'd think.

Put Nikon's Commander Mode One Click Away

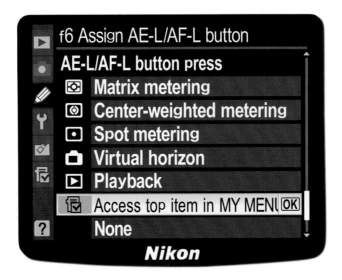

This is an incredibly handy tip I learned from David Tejada. It's for photographers who are triggering one or more Nikon hot shoe flashes using the built-in pop-up flash on their DSLR. (*Note:* If you have a Nikon D3 series camera, you don't have a pop-up flash, so you'll need to buy a Nikon SU-800 transmitter, which slides into the hot shoe on top of your camera, or an SB-910 hot shoe flash to trigger your other flash[es].) These folks are controlling the power of each flash using the camera's built-in Commander mode. The problem is getting to Commander mode is kind of a pain (you have to dig a few menus deep, and even if you put it in your My Menu options, it's still a few buttons away). That's why this tip rocks—you can have it so your Commander mode options appear instantly by pressing one button on the back of your camera. It just takes a one-time setup and here's what you do: press the Menu button on the back of your camera, choose My Menu (where you put your most frequently used menu items), then choose Add Items and add Commander mode to your menu (it's found under the Custom Setting Menu, under Bracketing/Flash, under Flash Cntrl for Built-In Flash). When you add Commander mode to your My Menu, it puts it at the top of your My Menu list. Now, go back to the Custom Setting menu, go down to Controls, and choose Assign AE-L/AF-L Button. Toggle over to the right (press the right side of the multi-selector on the back of your camera), select AE-L/AF-L Button Press, then choose Access Top Item in MY MENU, and click OK. Now, when you press the AE-L button on the back of your camera, the Commander mode settings appear on your LCD. How sweet is that!

Making Your Flash Fire Every Time

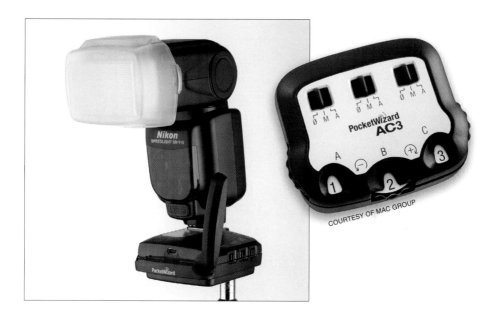

COURTESY OF MAC GROUP

I'm personally not a big fan of what they call "line of sight" methods for firing flash (where the only way your off-camera flash actually fires is if the sensor on the flash sees a pulse of light from one of your other flashes). The reason I don't like this method is because it doesn't work consistently. Well, it works fairly consistently if your flash has a clear, unobstructed view of the other flash, but in real life, that often isn't the case (now, if you're thinking, "But, I've seen Joe McNally do that," that's not a fair defense for two reasons: [1] we're not Joe McNally, and [2] Joe is a magical unicorn of off-camera flash, and I think his flashes fire simply out of respect, fear, or both). Anyway, to keep from pulling out your hair on location, I always recommend using a radio wireless remote, which pretty much always works (even if it's hidden from view, and even if it's 200 feet away from you). However, using just standard wireless units, like the PocketWizard Plus II, you can only wirelessly fire your hot shoe flash—you can't control the power settings (which is the one big advantage of the built-in, line-of-sight method—you can control each flash's power separately). PocketWizard, though, introduced a new, small, radio wireless controller called the AC3 ZoneController, which lets you not only fire, but control the power of up to three flashes individually (it's the dream baby—the dream!). Just so you know, you need the AC3 unit, which sits on the hot shoe mount on top of your camera and controls everything, and then you need a receiver (like the FlexTT5 Radio Slave Transmitter) on each wireless flash you want to use (I didn't say it was cheap, I said it was "the dream").

Creating a Tight Beam of Light

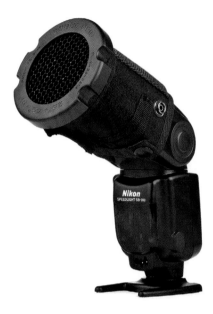

When we're using studio lights, and we want a tight beam of light (maybe we're doing something dramatic, with just a hint of light for our main light, or we want to have a crisp edge light behind or on the side of our subject), we don't use a softbox, we just use a reflector (like a beauty dish) and put a round metal grid over it and it creates a straight, focused beam of light aiming right at our subject. We can now do the same thing with hot shoe flash using a Rogue 3-in-1 Honeycomb Grid. You attach the included tube-shaped strap around your flash head with Velcro, then a round plastic grid holder inserts in the end (as seen above), and you get the same type of direct beam of light we get with studio lights. It works amazingly well. It's very lightweight, and since it comes with three different size grids (I generally use the 25° grid myself), you can choose precisely how tight of a beam you want (the lower the number, the tighter the beam, with 16° being the tightest one). They're from a company called ExpoImaging and they cost around $50 for the set of grid inserts, the tube-shaped strap, and the grid holder.

How Pros Deal with the Power Drop of High-Speed Sync

If you're going to be shooting in High-Speed Sync mode (see page 28), your flash power goes down, so its light won't travel nearly as far. That's why a lot of pros use a bracket that holds three (or more) flash heads (each flash only adds around 1 stop of light). Lastolite makes one, the TriFlash Shoe Mount Bracket, for around $80.

The Advantages of Using Flash in Daylight

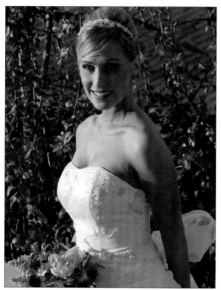

Without Flash

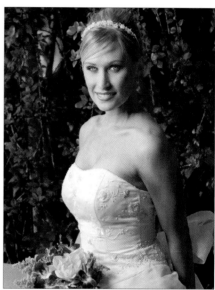

With Flash

A lot of people ask the question, "Why would I use a flash outdoors in the first place?" The simple answer is that it usually looks better, but there's more to it than that. First, you don't have much control over the position of the sun, and oftentimes it's in the worst place possible—right overhead. By using flashes outside, you get to create directional light, unless it's sunset, which is generally prettier light, although you may need flash to fill in a little. Plus, you get to use the sun as your backlight, lighting your subject's hair and giving you a beautiful rim light around them (just position your subject so the sun is behind them, if at all possible). Flash offers another benefit over using just a reflector outside, and that is your subject won't be squinting, like they usually do if you light them with a reflector and send a constant beam of sunlight back at their face.

Another Way to Deal with the Dark Gradient Shooting Higher Than 1/250

If you shoot at higher than 1/250 of a second and you see that dark gradient appear on your image, remember you can crop it away later in Photoshop. That way, you don't lose any power, and you don't drain the batteries as fast on your flash. Hey, I'm just sayin'.

How to Use Your Hot Shoe Flash's Modeling Light

Most studio strobes have a built-in modeling light—a continuous light that stays on when you turn your strobe on. It gives you a preview of how the light will look when the flash fires, and in a dark photo studio, gives your auto-focus lens enough light to lock on and focus on your subject. Most hot shoe flashes don't have a continuous modeling light, but to help you aim (preview) your light, they can create a temporary modeling light of sorts. On a Nikon flash, press the Menu button, then use the Selector dial to scroll down to Flash/Modeling (the icon looks like a lightning bolt and a person), and press the OK button. Scroll to Modeling and press OK again. You fire it (sending a series of very fast flashes, almost like a strobe, at your subject) by pressing the Test Firing button on the back of the flash unit. For Canon flashes, you turn it on by pressing-and-holding the custom function setting button until its icon shows on the flash's LCD. Then, turn the Select Dial and select the Modeling Flash (Fn 02) function.

A DIY Modeling Light for Hot Shoe Flash

You could buy a tiny LED flashlight and tape it to the top of your flash head with gaffer's tape. That way, you could illuminate your subject enough to let you focus in dark conditions and give you a preview of where your light is aiming. Energizer has a tiny 3-mode LED keychain light that's around $10 on Amazon.com.

Keep Your Flash from Powering Off

Because hot shoe flashes generally run on AA batteries, most of them automatically go to sleep, by default, after a certain number of seconds if they're not being fired, which is great for saving batteries, but not for saving face. Because when you go to shoot your next shot a few minutes later, your flash doesn't fire (because it's "asleep"), which doesn't make you, the photographer, look very good to…well…anybody. I'd rather swap out the batteries at some point rather than constantly have to wake up my flash after it doesn't fire. You can turn the battery-saver (embarrass maker) function, called the Standby function, off on Nikon flashes (like the SB-910) by going under the custom functions menu, choosing the Standby function, and then choosing --- (the Standby Function Canceled option, which is the three dashes) from the menu, which turns the feature off. On Canon flashes, like the 580EX II, go to your flash's custom function 01 (C.Fn-01), and turn off the Auto Power Off setting. Now, turning this off will definitely cause you to go through batteries faster, so you may not want this feature turned off all the time, but at least now you know that when you need those puppies to stay awake all the time, you know just how to do it.

How Far to Place the Flash from the Umbrella

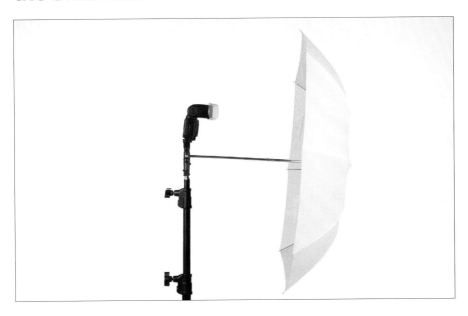

One question I get asked a lot by photographers using shoot-through umbrellas is, "How close do you put the flash to the umbrella?" This is a pretty reasonable question, because the umbrella's shaft can slide in/out of the swivel mount, and it's not really obvious where it goes. I always put my umbrella all the way out—as far away from the flash head as possible—for two reasons: (1) when it's far back like that, it will fill a larger amount of the umbrella with light, so my light source becomes larger, which makes the quality and softness of my light better, and (2) I don't get a big "hot spot" in the center of my shoot-through umbrella from the flash being too close to the umbrella. We want the light to spread out and get soft—not just concentrate in on the center.

How to Create a Broader Fill of Light with a Shoot-Through Umbrella

Once you have your flash in place, first make sure it's aimed at the center of the umbrella, but the tip is this: pull out the wide-angle diffuser (the clear one that pops out from the top edge of your flash) and put it over your flash head. This maximizes the spread of light from your flash to fill the umbrella, which gives you softer, better light.

Why Would Anyone Use Studio Strobes On Location?

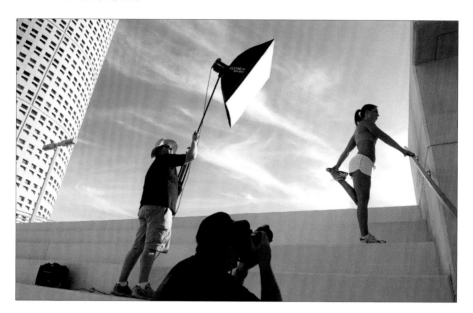

It's amazing what you can do with hot shoe flashes these days, and the accessories that you can buy these days give you near-studio-quality lighting on location. But if these hot shoe flashes are so great, why would anyone want to use studio strobes on location at all? Well, there are a couple of reasons, but one of the biggest is power. Believe it or not, these hot shoe flashes only put out around 50 watts of light, which is not a whole lot. They're ideal indoors, or at dawn or sunset, but when you need power, that's when you need studio strobes. For example, a low-powered studio strobe would put out at least 250 watts, with a standard strobe output at around 500 to 600 watts, so power is definitely an issue (especially if you're shooting outdoors in daylight, which is where many pros switch to studio strobes with battery packs). Another reason why studio strobes are popular on location is that you can take the same accessories you're used to working with in the studio out on location. The ability to have continuous modeling lights is a nice plus, but another big reason is the refresh rate—how fast your flash is ready to fire the next shot. Studio strobes with battery packs refresh very quickly— almost as quickly as they do in the studio—whereas you're often going to wait longer (sometimes much longer) with hot shoe flashes to refresh for the next shot. Of course, both have their pluses and minuses, but I wanted you to at least have an idea when it's time to rent a studio pack to go on location, rather than relying on your hot shoe flash for every situation.

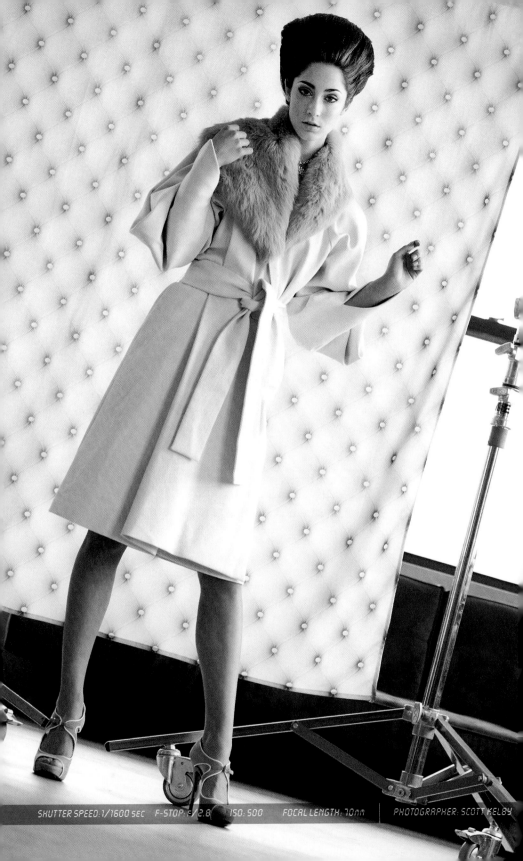

SHUTTER SPEED: 1/1600 SEC F-STOP: f/2.8 ISO: 500 FOCAL LENGTH: 70mm PHOTOGRAPHER: SCOTT KELBY

Chapter Three

More Tips on Using Your Studio Like a Pro

In Volume 3, We Took It Up a Notch. Now, Let's Do It Again!

If anybody had told me that, in this series of books, I would have three chapters dedicated to studio lighting, I would have told them that they needed to see a physicist. Now, you probably just read the last part of that line as "they needed to see a psychiatrist" (rather than a physicist, which is what I actually wrote) and that's probably because the human brain is pre-programmed to mentally insert words into sentences that reveal what we think we really need (a psychiatrist), rather than what I think you need (which is a really large softbox). For example, on some subliminal level, you must have repressed feelings of triggering inadequacies, but that's only because you have an unconscious desire to buy multiple wireless flash transmitters, which most likely stems from the fact that when you were a child your parents obviously denied you the right to assign your strobes to different groups and channels. This is surprisingly common these days, so I don't want you to think on any level that (a) you understand what all this is about, or (b) that I have any idea what this is all about, because clearly I don't know you well enough to be your therapist. But, I do know this: if you're still reading this chapter intro, you definitely need the professional help of a physicist. See, you did it again, you thought I said "psychiatrist." Maybe we should move straight to a word association exercise, which I think may reveal a lot about your inner psyche. When I say a word, you say the first word that pops into your head. Ready? *Pizza.* "20° round grid." *Salad bowl.* "Beauty dish." *Wide-screen TV.* "Strip bank!" *Savings & Loan.* "Octabank!" Hmmmm…I dunno, these seem pretty normal to me. But let's try one more just to be sure. *Declaration of Independence.* "Seamless paper." Yup, you're fine. Now tell me about your mother….

The Pro Trick for Creating Falloff

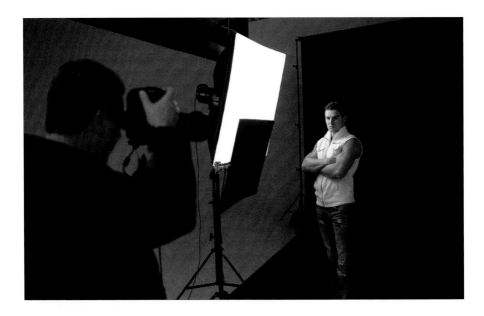

As you probably learned in one of the other books in this series, the human eye is drawn to the brightest thing in the image, and in portraits of people, the brightest thing should generally be their face, right? The problem is that your softbox doesn't know that, and it will light their face, shoulders, chest, stomach, and so on, all with pretty much the same brightness. So, what we need to create is falloff, where the light literally falls off in brightness, so their face is the brightest thing in the image, then their shoulders are a little less bright, then it gets darker and darker as it moves down their body (unless you're shooting fashion, where the clothes they're wearing are equally as important, and maybe more so, as the person's face). An easy way to create this falloff is to block the bottom ¼ to ⅓ of the softbox. You can do this with anything from a large black piece of posterboard you buy at any craft store to a photographic flag (I use the ones from Matthews, which can easily mount on a boom stand). You just put it in front of the bottom of the light (as shown here) to cut the spread of the light and create that falloff. (*Note:* You'll also hear a photographic flag referred to as a "gobo," which is a Hollywood movie lighting term that is short for "go between," as in you've put something between the light and your subject.) By the way, one of the biggest mistakes people new to studio lighting make is to light everything evenly or to over-light the subject, so by creating this simple falloff, your shots will already look more professional.

Getting a Different Look Without Moving the Lights

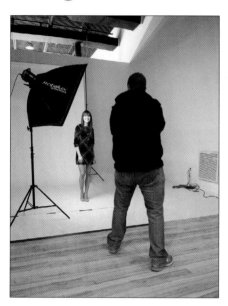

Once you've got your lights in place and you've got that first shot in the bag, try this: Don't move the lights. Don't move your subject. Instead, leave everything as is and move the photographer (kudos to Jeremy Cowart for this tip). If you were standing right in front of the subject, just move way over to one side or the other and take the shot again. You'll be amazed at how moving two or three feet in either direction can completely change the look of the lighting, even if you haven't touched a single light. Give this a try and you'll wind up with two or three lighting looks out of just one lighting setup.

Using Lens Flare as an Effect in the Studio

The blown-out, lens-flare look is really hot right now (it's that look where your image is intentionally overexposed and has a large lens flare visible in the shot). Luckily for us, it's fairly easy to nail this look—there are just a couple of tricks you need to know. The first is to take your lens hood off your camera. One of the reasons why we have a lens hood on in the first place is to eliminate lens flare, so we surely don't want that on our camera, eliminating the thing we actually want. Secondly, you're going to need a light behind your subject, and then you'll need to shoot from an angle that allows the beam from that back light to hit the face of your lens to some extent. (*Note:* If you have a fabric egg-crate grid on your softbox, or a metal grid on your strobe, make sure you take it off, because besides just focusing the beam, those grids actually help eliminate lens flare, so in this one case, they're working against you.) The key is finding the right position for your camera to maximize the effect coming from your strobe in the back, so it might take a few tries to get it to look right. By the way, today's higher-end lenses often have a special nano-coating on them designed to eliminate lens flare, so if you're struggling to get this look, try using one of your older lenses and that should do the trick.

How Far Should Your Subject Be from the Background?

As a general rule, I try to put my subject about 8 to 10 feet from the background (unless I'm using my main light to light the background). Here's why: by keeping them far away from the background, you avoid your front light spilling onto the background. That spill-over generally looks pretty bad, and a lot of times it's not real obvious what the problem is—your photo just doesn't look right—so it's best to avoid that problem altogether. Another advantage of keeping that distance between your subject and the background is this: if you do want to use a separate background light, the two lights will be very distinct in the final image (it won't all mush together), which will help create the separation and depth you want by lighting the background separately. One last advantage is you won't have to worry about your subject's shadow falling onto the background, and if your subject is far enough away from the background like this, you can have your white seamless paper turn black (if no light is hitting it at all, it'll go just about solid black, because it's that far away from the front light). Now, what if you're shooting in a tight space and you can't get your subject 8 to 10 feet from the background? In that case, move your main light in really close to your subject. As you move it in closer, the main light gets brighter (and the light falls off to black much faster), and you'll have to change your aperture, so your subject doesn't look like you just tossed a lighting grenade in their face. So, if you were at f/8, change it to maybe f/11 or f/14, and the front light won't affect your background very much, if at all.

Let Your Main Light Do Double Duty

I always talk about how much you can get out of one light, and if you only have one light, you can have it pull double duty by having it light your background, as well. The trick is to move your main light close enough to the background so that it actually lights it for you. I do this a lot when I'm shooting on a white seamless paper background. If you don't put a lot of light on the white paper, it looks dark gray in your photo. If I'm shooting fashion, I generally like a light gray, so to get that dark gray to turn to light gray, I just move my main light closer to the background and the spill from it winds up lighting the background quite a bit. Just be sure to position your light up high and have it aim down at your subject. That way, your subject's shadow will appear near the floor, instead of casting on the background. It's a handy tip to keep in mind when you're using just one light.

Frank Doorhof's Words of Wisdom About Using One Light

My friend, and studio lighting wizard, Frank Doorhof has a great saying he shares with his students. He tells them: "When you think you need two lights, use one light. If you think you need three lights, use one light. If you think you need four lights, maybe then you might consider a second light." He makes a really great point—if you can use just one light, chances are it's really all you need. The more lights you add, the more complicated things get, the longer it takes, and the more problems and challenges arise.

Rim-Light Profile Silhouettes Made Easy

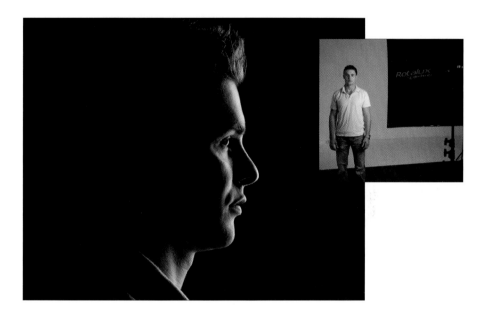

This is one of those super-quick, 30-second tricks that have a big impact. First, aim your softbox sideways and have your subject stand directly in front of the center of it (facing your camera). Now, have them turn sideways toward the softbox, so they're facing it directly. Next, have your subject take a step or two sideways, closer to you (while you're at your camera position). Have them step sideways toward you until they have actually moved past the edge of the softbox (so there's no softbox in front of them at all. It's actually a foot or so behind them, from your vantage point at the camera). Now take your shot. What you'll get is a strong rim light all the way around the profile of your subject, and the rest will appear as a black silhouette. If you want a little light to appear on the cheek facing the camera, have them move just a few inches back toward the light until you see that cheek lit just a tiny bit (this is where the modeling light comes in handy, because you can see a preview of how the light will fall).

Using a Ring Flash

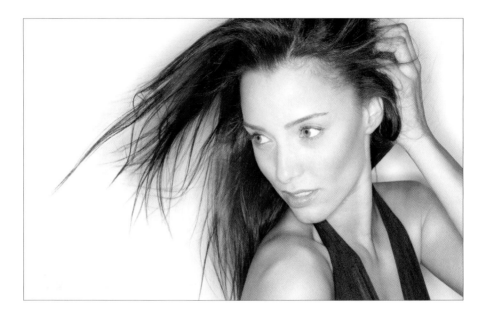

Part of the ring flash look is that you clearly see the black halo shadow it creates around your subject, but if you don't have your subject really close to your background (which breaks all of our other background rules), you won't see that halo. So, when you're shooting with a ring flash, the trick is to get your subject just a few inches from the background and that black halo shadow will appear (as seen above).

Charge 'em Right Before You Use 'em

Nickel-Metal Hydride (NiMH) batteries discharge around 10% of their battery life per week if they're just sitting around doing nothing, so don't charge up your batteries until you need 'em for a job. That way, they'll be at full capacity.

Use Almost Any Softbox You Want with Your Brand of Strobe

A lot of folks may not realize that if you have a particular brand of strobes, you don't have to buy the same brand of softboxes. That's because you can often buy an adapter that lets you use a different brand of softbox with your strobes. For example, F.J. Westcott sells adapters, so you can use Westcott softboxes with just about any strobe brand out there, and they're in the $30 range. If you have Profoto strobes, but want to use softboxes made by Elinchrom, you can buy an adapter ring from Elinchrom that lets you do just that. So, in short, you can probably use just about any softbox brand you want, with just about any strobe you want—you're just an adapter away.

The Tethering USB Cable That Came with Your Camera Is Too Short

Luckily, you can buy a 10-foot USB extension cable that lets you plug your short USB tether cable into this extension, so you can shoot without constantly worrying about yanking your cable right out of your computer. You can find these at B&H Photo, or on Amazon.com.

When It Comes to Softboxes, Bigger Really Is Better

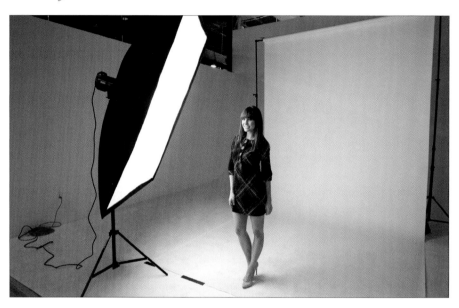

If I could give you just one tip about getting really beautiful light, it would be this: use the biggest softbox you can. Really big softboxes have gotten so popular lately because the bigger the softbox, the better the light, and today's lighting manufacturers have embraced this big time, so we have lots of choices. So, how big is big enough? My most-used softbox is an Elinchrom Rotalux 53" Midi Octa, because it's pretty big, but not so big that it dominates the room if I have to take it on location (which I often do). If you have a really high ceiling, you might look at something like the Elinchrom 74" Octa Light Bank (which is amazing!), but you don't have to spend a fortune to have a huge softbox these days. F.J. Westcott just introduced a series of huge 7' parabolic umbrellas— you can either fire a strobe into them (and the light gets huge and travels back toward your subject) or you can buy their shoot-through parabolic, where your flash fires through the umbrella (rather than reflecting off it). These are pretty darn affordable (well, in the context of lighting, anyway) at right around $100. If you want a more traditional softbox (the light is easier to control with softboxes versus umbrellas, so I tend to use them more often), then check out Westcott's 54x72" shallow softbox (it's huge and totally gorgeous and costs around $329). Are you seeing a pattern here? Yup. Big softboxes rule, and it makes getting beautiful portraits that much easier, and anything that makes getting great shots easier gets my vote.

What to Do When You Can't Turn Your Strobe Power Down Any Further

I mentioned on the previous page that the bigger the softbox, the softer and more beautiful the light. But what if you want even softer light? Well, the trick is to move that light as close as possible to your subject (without it actually appearing in the frame), because the closer the light, the bigger it becomes, which makes it even softer and more beautiful. One other thing happens when you move a light in this close: it gets much brighter (which makes sense, right? You move a light closer to something, and it gets brighter). So, as you move the light closer to your subject, you'll need to lower the power of your strobe so it's not so bright, right? Right. Now, what happens when you've lowered the power of your strobe as low as it can go (which is 2.3 on the BXRi 500 shown above), and it's still too bright (this happens to me quite often, because I usually position my softboxes very close to my subject)? When this happens to you, here's exactly what to do: raise your f-stop. That's right. If you were at f/8, raise it to f/11. If you started at f/11, raise it to f/14. This cuts the amount of light falling on your subject, so you get the best of both worlds—you're still getting super-soft light by moving it close to your subject, but you're not blowing them out with too much light because it's so close. You might even need to increase your f-stop by two stops or more, but if that's the case, don't sweat it—just do it.

How to Light a Couple or Small Group

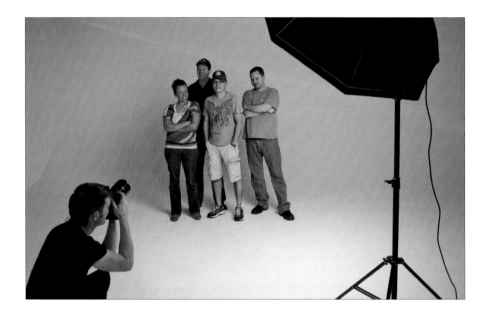

Lighting a couple or a small group is surprisingly easy, and you can do it with just one light and a large softbox, as long as you follow one simple rule: pull the light back fairly far from your subjects. If the light is too close, the person closest to the light will be brighter than the person standing next to them, and so on. Your goal is to have consistent, balanced light throughout the group, and the trick to that is to move your light way back. That way, the light pretty much hits the group at the same intensity, and the light looks balanced (just remember that moving the light farther away from your subjects makes the light darker, so you'll have to crank up the power on your strobe to make up for that). Another helpful tip is to position the light fairly near the camera position (not way off to the side) or you'll have shadows casting across people in the group. You will want the light off to the side a bit, just not way off to the side. You can even position the softbox directly behind you as you shoot (if your head sticks up a little in front of it, don't sweat it), and that will do the trick, too. (*Note:* If you're thinking, "Hey, won't moving the softbox back farther make the subjects smaller in relation to the size of the softbox, so the light won't be as soft?" you're right, which is why you want to use a very large softbox for shooting groups. That way, when you move it far away, it's still big, so the light is still soft.)

The Trick to Staying Out of Trouble

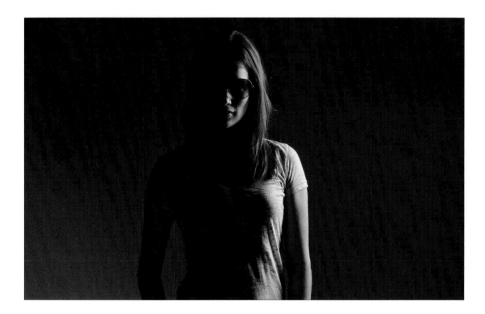

When I see photographers who are new to studio lighting really struggling, it's generally when they're using multiple lights and something looks wrong, but they don't know exactly what's wrong—but it's definitely something. No matter where they move the lights, it just gets worse. This is generally because they put the lights in position and turn them all on. This is a recipe for disaster. The trick to staying out of trouble is this: only turn on one light at a time. Get the brightness right (the power setting), get the light properly aimed, and get the position right. Once that one light looks right (here's the secret) turn *off* that light. Now, turn on another light (maybe a back light). Get just that one looking right (while no other lights are turned on), then once it looks good, turn that one off. If you're using a third light, turn only it on, and get it right. Now, turn them back on, one by one, starting with the back light. As you add a light, pause and take a look at how things look. Take a test shot with just the back light on, or just a hair light, or both, and see how it looks. If it doesn't look good by itself, turning on a bunch of other lights surely won't help. The secret to success with multiple lights is to get each individual light looking good by itself. That way, when you finally turn them all on, they will complement each other and work together, rather than just throwing a bunch of random lights everywhere. It takes a few more seconds up front to set each light and position it individually, but it will save you loads of frustration and aggravation along the way, plus you'll wind up with better lit photos, guaranteed.

Where to Put Your Softbox Demystified, Part I

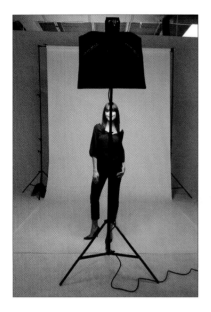

When I was on the road with my *Light It. Shoot It. Retouch It. LIVE!* seminar tour, one of the most-asked questions was "Where do I put my main light?" People were really confused and apprehensive about it, and if you've ever felt like this, I've got good news for you (and it's something you've probably never heard before). First, you already know that your strobe will be up high on a light stand, aiming down at an angle (kind of like the sun aims down on us). With that in mind, the secret is that there are basically two places your front main light goes: either (a) directly in front of your subject, or (b) at around a 45° angle to them. Are there other places you can put it? Absolutely. Where do most pros wind up putting it, no matter whether they are in the studio or on location? In front or at around a 45° angle (by the way, more often than not, it's at around a 45° angle). Pick up any book on lighting, check out all the diagrams, and see for yourself—diagram after diagram will bear this out. No matter how intricate the set they're shooting on, no matter how many lights they have in the back or how they're lighting the background, their front light is almost always in one of these two places. Now, if they have a light behind their subject, guess where it winds up most of the time. (Wait for it…wait for it….) Either directly behind their subject, or behind them at a 45° angle. I know you were hoping it was more complicated than that, but it is what it is. So, the next time you're sweating about where to put your main light, if you put your light either directly in front of your subject, or at a 45° angle to them, just know— everybody else is pretty much doing the same thing.

Where to Put Your Softbox Demystified, Part II

Okay, let's say you chose the 45°-angle-to-your-subject lighting setup. Now what? Well, while that 45° angle is the right basic position, as you move your light even just a few inches in either direction, your lighting will change, so this is where you really massage your light to make it exactly what you want it to be. Picture an overhead view of your lighting setup and that the setup is the face of a clock, where your subject is in the center of the clock. The standard 45° angle is #2 above, but if you want more or fewer shadows on the opposite side of your subject's face, then you just rotate the light "around the clock." For example, the #1 position is more in front, and will light more of the face, so your subject will have fewer shadows on the far side of their face; #3 is more to the side, and they'll have lots of shadows on the other side of their face; and #4 is literally lighting their side, and the other side of the face will be totally in shadow. Now, which of one these lighting setups is correct? The one you choose, because they're all correct—they just have different amounts of shadows. When shooting a man, I tend to like #3 and #4. For a woman, I tend to like #1 and #2. But, I've used all four on both men and women, so it's really up to you. Just remember this: in all four of my examples, the subject is facing forward. If you want more light to fall on their face for any of these positions, just have them angle toward the light (called "playing to the light").

Let Lightroom Fix Your Color as You Shoot

If you shoot tethered in Adobe's Lightroom application (going straight from the camera, directly into your computer, so you can see the images appear at full-screen size on your monitor as you shoot), then you'll love this trick, which lets you color correct one photo and has Lightroom's tethering feature do the rest for you automatically. Start by handing your subject a gray card and ask them to hold it up near their face (you can buy a gray card at any photography store, or if you have my *The Adobe Photoshop Lightroom Book for Digital Photographers* or my *The Adobe Photoshop Book for Digital Photographers*, look in the back of the book—I've included a perforated gray card for you, so just tear it out and you're ready to go). Once your subject is holding the card clearly in the frame, take a shot. Now, go to Lightroom's Develop module, get the White Balance tool (it's in the top-left corner of the Basic panel), and click it on the gray card. That sets the white balance for this one particular image (you're almost there). Next, go to Lightroom's Tethered Capture window (shown above), and from the Develop Settings pop-up menu, choose Same as Previous (also shown above). Now, when you take the next shot, it will automatically apply whatever you did to the previous photo. Well, you fixed the color (white balance) of the previous photo, so it will automatically do the same thing—it will fix the white balance for every photo as it appears. How handy is that? You only have to do this gray card trick again if you change the lighting pretty significantly.

How to Set a Custom White Balance In-Camera

If you'd prefer to set a custom white balance in-camera (rather than having Lightroom correct your white balance for you, as shown on the previous page), I would recommend using something like an ExpoDisc, which is a white balance tool used by a lot of pro photographers. Here's how it works: You start by putting the ExpoDisc over the end of your lens (it looks like a thick lens filter) and switching your lens to Manual focus (if you don't, your camera might not let you actually take a shot). Then, aim it at the light source (not at your subject—aim it directly at the main softbox you're using) and take a shot. Now, in your camera, you're going to assign that image you just took as your white balance reference image. Here's how: On Nikon DSLRs, before you take the shot, hold the WB button, then turn the dial until your White Balance is set to PRE, then release the WB button, and press it again until the letters "PRE" start blinking in your LCD panel on the top of your camera. That's your cue to take your shot (you have 10 seconds to take it), so aim your camera at your softbox and fire off a shot. You should now see GOOD appear in the LCD panel. That's it—your custom white balance is set (don't forget to turn your lens back to Auto focus, though). On Canon DSLRs, put the ExpoDisc over the front of your lens, aim at your softbox, and take a shot. Now, press the Menu button on the back of your camera, scroll down to Custom WB, and press the Set button to bring up the next screen, then press Set again to choose that shot you just took as the white balance reference photo. Lastly, press the White Balance Selection button on top of your camera, then rotate the Main dial until you see Custom WB appear in the LCD panel (don't forget to turn your lens back to Auto focus).

Taking Your Existing Strobes On Location

If you want to use your studio strobes on location, all you need is a way to power them by battery, since you probably won't be able to just plug them into a wall socket. You used to have to buy specialized strobe heads that only worked with a proprietary battery pack, but in the past couple of years, we've seen battery packs appear where you can just plug a standard 120v household-style plug right in, which means that now you can take your existing studio strobes just about anywhere. I've been using a very small, very conve-nient, very lightweight pack called the Paul C. Buff Vagabond Mini Lithium, and it works pretty darn well (it's reasonably inexpensive in the context of studio lighting, where nothing is actually reasonably inexpensive). You can pick one up for around $239 (direct from www.paulcbuff.com). It has two 120v outlets and a rechargeable battery that charges in about 3 hours—you get around 200 full-power flashes per charge. Now, the important phrase there is "full-power" because, unless you're shooting out in direct sunlight, you probably won't need to be firing these strobes at full power (more likely, half power or less), so if you fire at a lower power, you'll get a lot more flashes out of each battery charge. A lot more!

Chapter Four

More Tips on Lenses

Going Way Beyond Which Lens to Use

When you look at a camera body, you can understand why it's so expensive. After all, it's got a built-in computer (that's why it has a screen, and tons of menus you can navigate through, and you can set it up so it performs a bunch of tasks automatically, just like any other computer), so it kind of makes sense why it's so expensive. But lenses don't have any of that stuff. There is no computer. There is no screen. There are no menus. Besides being different lengths, they all pretty much look like they did 50 years ago, so you can't say they've spent a ton of money on looks. At the end of the day, it's a black tube with a round piece of glass on the end of it. Last time I checked, black tubes aren't very expensive, and a whole bunch of glass will only get you around 10¢ if you recycle it, but take that glass and put it on the end of a black tube, and it suddenly costs like $1,800. I mean, seriously, how can this be? So I did some research into this, and although this has been a closely guarded secret within the industry for many years, I'm here to blow the lid off the real reason lenses are so expensive today. Apparently, there is a "lens cartel" operating out of an undisclosed location deep within Cheyenne Mountain in Colorado and, by carefully manipulating the distribution and production of lenses, they are able to keep the prices of these lenses sky high. They are, however, apparently very concerned about a Russian lens cartel, and their fear is that the Russians might try to fly vast shipments of underpriced lenses in through Canada and across the U.S. Border, where they would release these lenses to U.S.-based camera stores. To counter this, they have created a sophisticated tracking system, with a bunch of expensive monitors (using satellites abandoned by the U.S. military), but I was able to crack this system using just a 2,400-baud modem and a "back door" password named after the reclusive professor's son who created all this. It was way easier than I thought.

Why Your Background Is Still in Focus at f/2.8

You've probably heard by now that if you want to put the background behind your subject out of focus, you choose a "wide-open" aperture setting like f/4 or f/2.8, but there's something they're not telling you. For that to work, you actually have to zoom in somewhat on your subject. So, if you're using a wide-angle lens (like an 18mm, 24mm, 28mm, and so on), even at f/2.8, unless your subject is really, really physically close to the lens, you're not going to get that out-of-focus background you're looking for. So, to get that soft, out-of-focus f/2.8 or f/4 background you're dreaming of, switch to a telephoto lens, and know that the tighter in you are, the more out of focus the background will appear. So, at 70mm, it's going to look a little blurry. At 85mm, even more so, as long as you're fairly tight in on your subject—move back 10 feet from your subject, and you lose it. At 120mm, you're getting nice and blurry backgrounds when you're zoomed in, and if you zoom in tight at 200mm, that background behind them is blurry city.

What You Need to Know About Lens Compression

42mm *210mm*

You may have heard a lot of talk, especially when it comes to shooting portraits, about "lens compression" and how different focal lengths offer different types of lens compression. What this is all basically about is one thing: the background behind your subject, and how far away that background seems to be. For example, when you're shooting a portrait of somebody (or something, like the archway above, for that matter) at a wide angle, like 28mm or 35mm, the background behind them is going to look like it's waaaaaayyy behind them (it actually exaggerates the distance between them). That's handy to know, because if you want to make it look like a huge sweeping scene with lots of depth between your subject and the background, shoot at a wide angle. However, if you zoom your lens to around 120mm and shoot the same subject at around the same size (which means you'll probably have to take a few steps back, since you just zoomed in), the background will now look quite a bit closer to your subject (even though your subject and the background are still in the exact same place). Now, zoom in even tighter on your subject (to around 200mm), and the background looks like it's even closer behind them. This is because when you zoom in tight like this, the compression effect the lens creates makes the distance between your subject and the background seem much shorter or more compressed. A lot of portrait and wedding photographers use this to their advantage because that compression also compresses your subject's facial features, which looks very flattering.

Seeing a Real Preview of Your Depth of Field

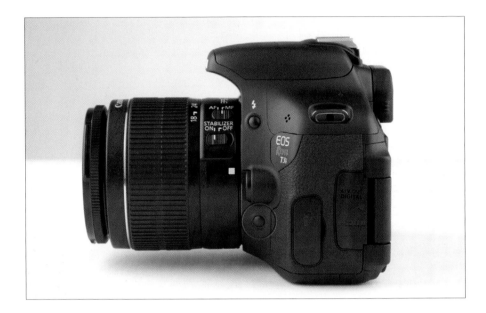

Unfortunately, when you choose an f-stop that would give you a really shallow depth of field, like f/1.8 or f/2.8, your viewfinder doesn't really give you a preview of how your soft, out-of-focus background will look. For you to really see how the background is going to look, you need to use your camera's depth-of-field preview button. This button is usually located on the front of your camera, close to the side of the lens. Press-and-hold this button and then look in your viewfinder and it gives you a much more accurate preview of how your image will look with the f-stop you've chosen.

Auto-Correcting the Fisheye Lens Effect in Photoshop

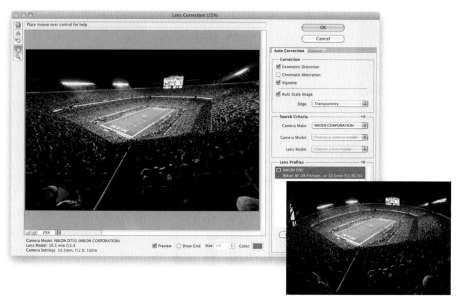

Before: Rounded

A fisheye lens is one of those lenses that you don't pull out very often (because a bunch of fisheye photos can get really old, really quick), but if you use them at the right time, they can be really fascinating. I use mine sometimes for cityscapes, or shooting in tight quarters, but mostly I use them for sports photography, where they look for sweeping shots of stadiums and indoor arenas, or I hold it up high over a group of players celebrating after the game, or I hold it down real low as the players take the field. Not everybody likes the rounding effect the fisheye gives, and if that sounds like you, don't worry—you can use Photoshop to automatically remove the rounding and leave you with what looks like a super-wide-angle shot, rather than a rounded fisheye shot. Just open the image in Photoshop, then go under the Filter menu and choose Lens Correction. When the dialog appears, click on the Auto Correction tab, and turn on the Geometric Distortion checkbox. The filter will look at the EXIF data embedded into the shot when you took it to find out what kind of lens you used, then it will automatically apply a correction that removes the "fishiness" and, instead, gives you that flat, super-wide-angle look. Now that you've learned how to remove the roundness, you'll probably find that some shots look better rounded and some look better flat, but at least now you've got two choices from just one lens.

Shoot at the F-Stop You Bought the Lens For

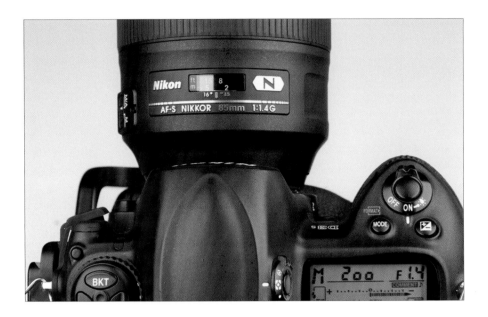

Fast lenses are pretty darn expensive these days (take a look at fast prime lenses, like the Sigma 85mm f/1.4 for Canon, which runs almost $1,000, or Nikon's 85mm f/1.4, a hugely popular lens with wedding and portrait photographers, yet it costs around $1,700). If you bought one of those lenses (or any fast lens, like a zoom that's f/2.8), you didn't buy it to shoot it at f/8 or f/11. You paid that money for the f/1.4, so when you pull out that lens, you want to be shooting it at f/1.4. That's the look, that's the f-stop, and that's the effect you paid for when you bought that expensive lens. So, make darn sure you're getting your money's worth by shooting it at the f-stop you bought it for.

How to Deal with Lens Fogging

The curse of the fogged lens generally happens to travel photographers who are shooting in warmer climates (which is generally where most people head for vacation—warmer climates), and it strikes when you leave your nice air-conditioned hotel room (or cruise ship cabin or car), and step out into the warm air, and your lens gets so fogged up that, for the next 20 or 30 minutes, it is unusable. There are two ways to deal with this: one way is to plan ahead to avoid the fogging, and another is what you do when it's too late (you're in fog town). We'll start with avoidance. The most popular way to beat the fogging up front is to put your lens in a clear, plastic Ziploc bag and store that bag inside your suitcase in your room, so it stays warm, and away from the air conditioning. Then you keep your lens in the bag until you're outside your room and ready to start shooting, and since your lens has been kept warm and sealed, it won't fog up when you put it on outside. If it's too late and your lens is already fogged, you can use a special fog eliminator cloth (a pack of three runs about $5, so go ahead and order them now, because by the time you need them, if you don't have them, it will be too late). Nikon actually makes their own brand of Fog Eliminator Cloths (you can find 'em at B&H Photo), but since all glass is made of…well…glass, I imagine they'll work just fine on Canon lenses, as well (just don't tell anyone they're made by Nikon. Don't worry—I'll keep it between us).

Avoiding Sensor Dust from Your Body & Lens Caps

When you take your gear out of your camera bag, what's the first thing you do? You take the cap off the body of your camera, and the rear lens cap off the end of your lens that connects to the camera (the mount). At that moment, you're holding two of the major sources of sensor dust, and what you do with them next can make all the difference between a clean, spotless sensor, or one that will soon have more spots than a Disney Dalmatian. I know a lot of photographers that will put those caps into their pants pocket, so they don't lose them (huge mistake, but at least you won't lose them), or they toss them back into their camera bag (so they can collect dust and junk there. Yikes), or hopefully, they'll put them in a zippered pocket in their camera bag (which isn't all that bad, but isn't great). Here's a great tip to keep junk (and lint, and other stuff) from getting in either cap: screw them together. That's right—turn the two caps so they face each other, and twist to screw them into each other. Now nothing gets in there. I'm still not sure I'd stuff them in my pants pocket, but now if I did, at least I'd feel a whole lot better about it.

How to Focus Your Lens to Infinity

If you're going to try to shoot something that's particularly hard to focus on (for example, let's say you're photographing fireworks, or a lightning storm way off in the distance [and by the way, that's exactly where you want to be when photographing lighting—way, way off in the distance]), then you can set your focus to a setting called "infinity," where everything way off in the distance will be in focus. To use this infinity focus, start by focusing on something visible a little way in front of you, then switch your lens to Manual focus mode (you do this on the lens itself—just switch from Auto focus to Manual). Now, turn the focusing ring on the lens itself (it's usually down closer to the end of the lens) all the way to the right (on Nikons) or all the way to the left (on Canons), until you see the infinity symbol (∞) appear on the distance scale on the top of the lens. Now you're focused out to infinity and things off in the distance will be in sharp focus, even if they're too far away to actually focus on (like the moon, or stars, or Justin Bieber).

Don't Shoot at the "Beginner" Focal Lengths

I hear from a lot of photographers who are frustrated because, compared to "everybody else," they think their shots look kind of "average." Now, consider this: if you're a beginner and you buy a new camera, chances are it comes in a kit with something like an 18–55mm lens (called a "kit lens," which is a very inexpensive, usually plastic, lens, which is generally not very sharp, lacks contrast and clarity, and so on). But let's put quality issues aside for a moment and think about this: your average beginner is going to take nearly all their shots in that 18–55mm range, right? So how do you keep your shots from looking "average?" One way is to avoid shooting with the kit lens, or at the very least, avoid shooting in that 18–55mm focal length or your shots will be at the same focal length as your average beginner. So, although I hesitate to tell you that "the secret to better-looking shots is to buy a longer, better-quality lens," because that won't do it alone, I can tell you this: it surely helps. You don't have to spend a lot on your longer lens (it can even be a used lens), but whatever you get will almost undoubtedly create sharper, higher-quality, and more contrasty images and you'll be out of that 18–55mm beginner's land.

If You Can't Afford Another Lens, Do This

If you can't afford a longer lens (although, check out Sigma's 70–300mm for around $170), and you have to shoot with the kit lens, stay at the 18mm wide-angle focal length, and avoid the 55mm length at all costs. So in short—go wide!

Where to Hold a Long Lens to Steady It

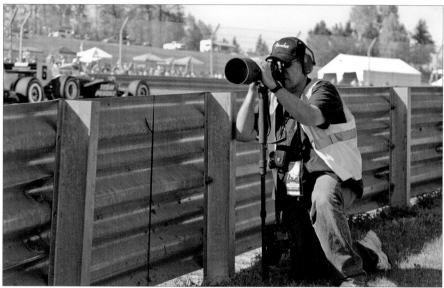

DAVE MOSER

If you're shooting with a long lens (like a 300mm or a 400mm), there's actually a place where you should hold the lens to help steady it while you're shooting, even when it's supported on a monopod. That spot is down at the end of the lens where the lens hood is. Your left hand gently rests on the end of the lens barrel (as shown above), which helps reduce the vibration and keeps your long lens steady while you shoot.

Which Lens for Outdoor Portraits?

There is no one lens for outdoor portraits, but if there is one lens that is really hot right now for outdoor portraits, hands down it has to be the Canon 85mm f/1.8 or the Nikon 85mm f/1.4. These lenses have a nice focal length for portraits, but the real reason everybody loves them is for the insanely shallow depth of field they provide (if you get your subject so they pretty much fill the frame, the background goes so soft and out of focus that you'll never want to shoot anything else). You hardly see a professional wedding or senior portrait photographer not shooting an 85mm to death right now, and the reason is it looks great and people (clients) love its almost cinematic look. The only downside is, of course, that since it's the lens that everybody wants to shoot, and since it does all this magical stuff to the background, it isn't cheap. It's a business investment (the Nikon 85mm f/1.4 sells for around $1,600, but the Canon 85mm f/1.8 sells for only around $400, so that's actually a pretty good deal). Also, don't forget about 85mm lenses from Sigma (for both Canon and Nikon), which many photographers swear by, and they're usually much less expensive than Nikon or Canon lenses.

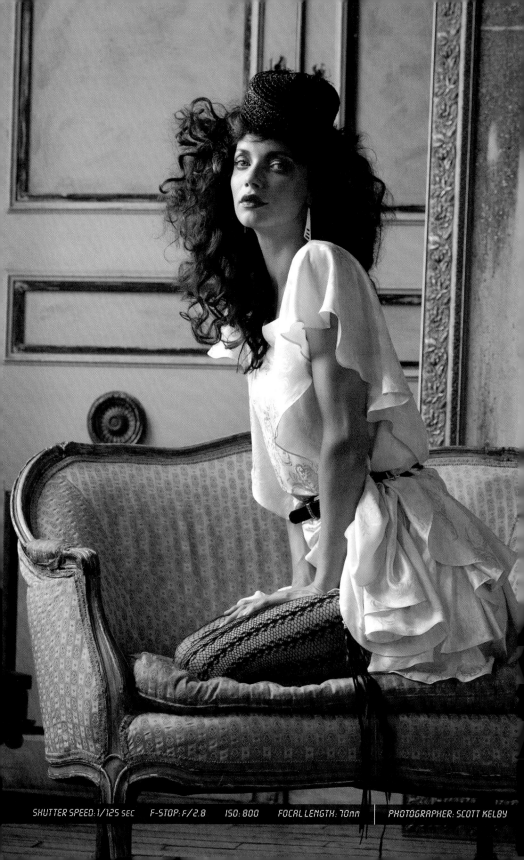

Chapter Five

Pro Tips for Shooting in Natural Light

How to Take Advantage of the Most Beautiful Light on Earth

You know what I like best about shooting in natural light? It's free. That's right, you don't need a wireless trigger, or light stands, or batteries, or gels, or softboxes, or any of the other stuff photographers lug around in Pelican cases, and that takes forever to set up, and then, invariably, doesn't fire, or doesn't fit, or you forget to bring it. Because, then, you wind up yelling at your assistant, but your assistant isn't really your employee—it's your friend that's just helping you out. And now you've gone and yelled at her, so you look like you're "in charge" on the set, and while that might be fine with an employee who is kind of paid to put up with your BS (belligerent shouting), she is actually someone you met at Applebee's when you were on your lunch hour, and your friend Mark knew her from when he worked at the mall. So, really, she's just helping you out to be a friend, and she's not even a real photography assistant at all, so you couldn't expect that she'd just somehow know exactly how high to put that light stand, because after all, she's a clothing designer, and what she really wanted to do was the styling for the shoot. But, here she is futzing around with a light stand, which was exactly what she didn't want to be doing on a Thursday afternoon, but now she's doing something she didn't want to be doing in the first place, and she's only there as a favor to Mark, who introduced the two of you, and you're yelling at her about something she has never been trained on. Now she's got tears in her eyes, because this whole thing reminds her of the time her ex-boyfriend wanted to take her jet skiing, but then he yelled at her when she untied the line, because he never told her when to untie it. So, now she's bawling and you're mad, and this whole thing could have been avoided if you had either: (a) shot in natural light or (b) eaten at Chili's that day instead.

Beautiful Backlit Shots

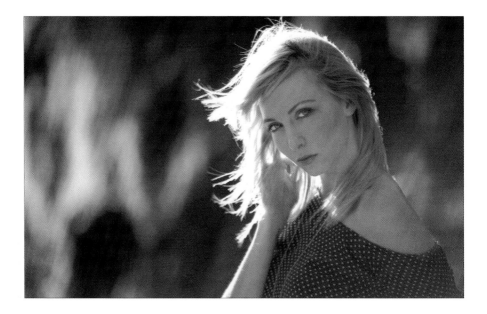

If you want to add some visual interest to your outdoor shots, look for backlight oppor-tunities, especially when shooting people. Backlit images bring a drama and dimension you don't often see, except from pros. How do they do it? First, position your subject so the sun is directly behind them, with no light falling on their face, so they look like a silhouette. Then, switch your camera's metering mode to Spot Metering, and aim your focus point on your subject's face. By doing this, you're telling the camera, "This is the most important thing in the photo—make sure it's properly exposed." Now, when you take the photo, it will make your subject's face much brighter. The rest of the photo will get brighter, too, but in most cases that's okay, because what's behind your subject is the sun (which is usually pretty bright anyway). If you're shooting in aperture priority mode (which is what I shoot in outdoors in natural light) and you think the entire photo is too bright, back it off by using exposure compensation (where the camera makes what it thinks is the proper exposure, but once you look at it, you disagree and want to override that and make the photo darker or lighter). On a Nikon, hold the exposure compensation (+/–) button on the top, and then move the command dial on the back to the right to either –0.3 or –0.7 (you'll see this in the top control panel), and then take another shot (the whole shot will either be ⅓ or ¾ of a stop darker). On a Canon, turn the power switch to the top position (above On), look at the LCD panel on top, then use the quick control dial on the back to override the exposure either –0.3 or –0.7, and then take the shot and see if you need it darker—if it's too dark, try again.

Shooting Silhouettes

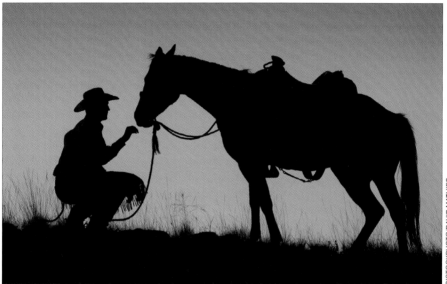

©ISTOCKPHOTO/DAVID MATHIES

Backlit silhouettes of your subject (whether your subject is a person or a flower, or a horse, or a cowboy, and so on) can look wonderful as long as the shape of your subject makes it instantly obvious exactly what it is. This is why subjects that are by themselves often work best. If two people are together hugging, a black silhouette of them some-times just looks like one big blob—you don't see them as two people hugging. As for your camera, the trick to getting great silhouette shots is to pretend your subject isn't there, and just shoot the scene like you were shooting a landscape shot (so I would shoot it in aperture priority mode, or you can switch your camera to landscape scene, if your camera has that). If you try to expose for your subject, your camera will try to properly expose for your subject (let's say it's a cowboy at sunset), and then it won't actually be a solid silhouette. So, just pretend you're there to shoot the sunset, and the rest will fall into place. Remember the trick—pretend your subject isn't there, and just shoot it like you would a landscape (with the sun behind your subject), and you're gold!

Jay's Trick for Not Missing the Shot

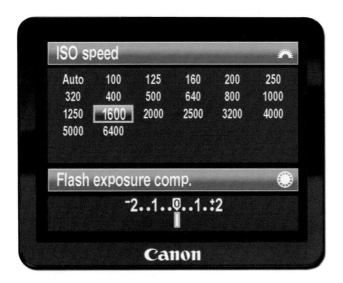

I learned this tip the hard way from my friend Jay Maisel, who is one of the living leg-ends of American photography, as he showed me a shot he had taken while the two of us were walking around in downtown New York City one afternoon. I had the same shot. His was tack sharp. Mine wasn't. We had the same exact camera make and model. He asked me what ISO I was shooting at. I was at 200 ISO. He was at 1600 ISO (which means his shutter speed was fast enough to get a really sharp hand-held photo. At 200 ISO, mine wasn't). He chuckled at me and kept walking. I now shoot at 1600 when I'm walking around, because I'm not going to miss the shot next time because it's a little blurry. If you ever get the choice between a little noisy (from the high ISO) or a little blurry, choose a little noisy.

How to Make Sure Your Sunset Looks Dark

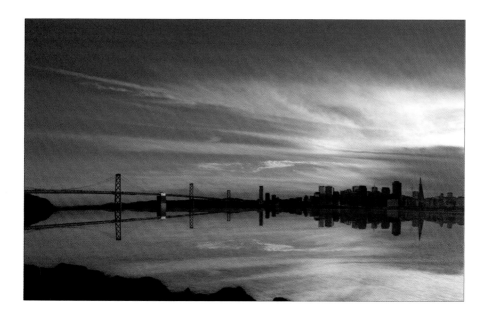

If you're shooting a sunset, it should look dark, right? But if you're shooting in aperture priority mode (that's the mode I shoot in when I'm shooting in natural light), or maybe programmed (or program) mode, your camera is probably going to try to make a "proper" exposure, because it doesn't really realize that you're trying to shoot a sunset, and you'll wind up with a sunset that's more like an hour or so before sunset. The trick is to force your camera to take a darker shot. You can do this using the exposure compensation trick I talked about on page 74 (about shooting backlit shots), or you can do this: Switch to pro-grammed mode (on a Nikon; program mode on a Canon), aim at the sunset (focus on a cloud to the left or right of the setting sun, if possible), then press-and-hold your shutter button down halfway. Look inside your viewfinder and see what f-stop and shutter speed your camera chose for this shot (let's say it's f/8 at ½oo of a second). Remember that setting (f/8 at ½oo of a second) and switch to manual mode (don't freak out—this is easy stuff). Then, set your aperture to f/8 and your shutter speed to 200 (it generally doesn't say ½oo of a second. It'll just say 200). Now, your job is to make the sky darker. Easy—just change your f-stop from f/8 to f/11 and voilà—your sky is darker than your camera would have taken in program or aperture priority mode, and your sunset looks great. If you want it even darker, try f/14 or f/16, and you'll see a rich, dark, beautiful sunset.

Tips for Using a Reflector Outdoors

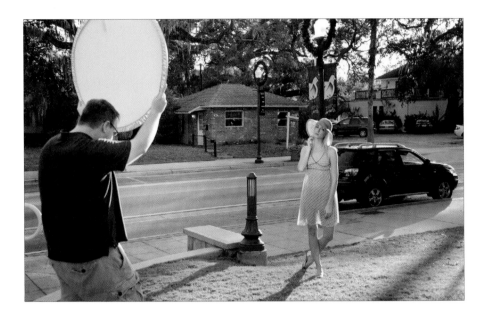

If you want your reflector panel to be your main light outdoors (bouncing the sunlight back toward your subject), then you need to position your subject so they're in the shade. Not deep in the shade, just near the edge of whatever you have them standing under. So, if they're standing under the overhang of a building, have them stand where they're almost out in the sun. If it's under a tree, don't let them get way under it—the best "shade light" is out near the edges of the tree. Now that they're in the right position, put your reflector in the right position. First, don't hold it down below them bouncing the light up into their face. This unflattering "up lighting" is usually reserved for Halloween, as it tends to make people look a bit creepy. Your job with the reflector is to mimic the sun, so hold it up high (over your head, or ideally, have your assistant hold it over their head) and tilt it so the reflected sun hits your subject from above. Next, when shooting outdoors, don't use a white- or silver-sided reflector—use a gold reflector, so your light doesn't look too white, like you took a studio strobe on location. Also, don't forget you can bend the edges of your reflector, so you don't evenly light your subject—if you just want to light their face, bend the bottom of the reflector up a bit, so it doesn't light their body. Lastly, if you're shooting right out in the midday sun, instead of using it to reflect light, use it to block the sun—put it right over the subject's head (the closer the better, but just outside your frame), so it's between the sun and your subject. Now, although you might have to raise your ISO a bit (to raise your shutter speed) to shoot in the shade of your reflector, at least the quality of your light is dramatically better.

Control the "Power" of Your Reflector

One of the handiest tools for controlling light outdoors is a basic $20 reflector. It's incredibly handy because it's lightweight, folds up to a small size, and most importantly, you don't have to plug it in, and its battery never runs out (well, since it doesn't have a battery). But, over the years, I've heard people say that the weakness of the reflector is that you can't turn the power up/down like you can with a flash. Well…that's only kinda true, because you actually can control the amount of light a reflector reflects onto your subject by how far away the reflector physically is from your subject. The closer it is, the brighter the reflected light becomes. So, if the reflected light is too bright, then just move the reflector farther away. What's a good distance for a reflector used outdoors to bounce some sunlight back into your subject? About 8 to 10 feet from the subject is a great starting place. If you want the reflected light brighter, move in tighter, as seen above. Easy enough.

How to Deal with Underexposed Daytime Shots

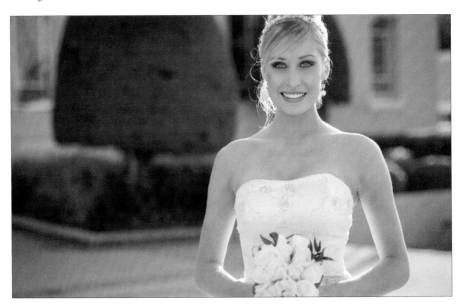

Here's a tip I learned from wedding photographer Cliff Mautner, who is an absolute genius when it comes to shooting outdoors in direct sun in aperture priority mode (which is what I recommend and use for shooting outdoors in natural light). If your subject is wearing light clothes (like a bride in a white gown, for example), your camera's meter is going to see all that brightness in the gown and adjust the shutter speed to make the shot dark (which will make your subject's face dark, especially if you have your subject positioned so the sun is behind her, which it should be, by the way—don't shoot people with the sun over your shoulder, the sun should be behind them). The trick is to override what the camera thinks the proper exposure should be (it thinks it should be dark) and use exposure compensation to increase the exposure by ⅓ or ¾ of a stop (or maybe even 1 full stop or more). Here's how it's done: On a Nikon, hold the exposure compensation (+/–) button on the top of your camera, and then move the command dial on the back to the left to either +0.3 or +0.7 (you'll see this on the top control panel) and then take a shot (the whole shot will either be ⅓ or ¾ of a stop brighter). On a Canon, turn the power switch to the top position (above On), look at the LCD panel on top and use the quick control dial on the back to override the exposure by either +0.3 or +0.7, then take the shot and see if you need it brighter. If your subject's face doesn't have enough light on it, increase that exposure compensation a bit more (to +1.0; a full stop), and take a test shot to see where you're at, and so on, until you nail it. So, in short, the trick is: if the scene is too dark, use exposure compensation to override the camera and then overexpose the image a bit.

The Trick for Shooting at Night

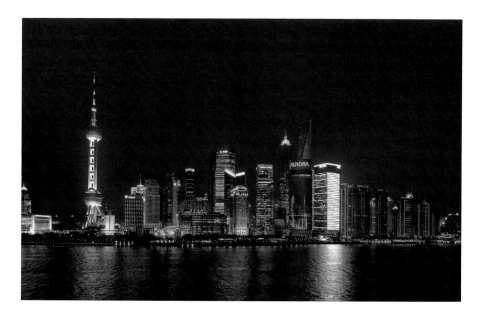

If you're shooting outdoors at night, one of the best tips I can give you is to not shoot with one of your camera's standard modes, like aperture priority (A on a Nikon or Av on a Canon), or any of the preset modes, like landscape or portrait. Those all work pretty well during the day, but shooting at night, and getting the night sky to be that really dark blue or black that you're seeing with your eyes, often isn't going to happen with one of those modes, because they'll make the whole image too bright. After all, your camera doesn't know it's night, so it's just doing its job of trying to make a proper exposure. That's why I feel that the real secret to shooting at night is to shoot in manual mode. To do that, you'll need to use the meter inside your camera's viewfinder (this is so easy to do, you'll be amazed, so don't let this freak you out one little bit). So, switch to manual mode and dial in a starting shutter speed (at night, you'll be on a tripod, so try something like ¹⁄₃₀ of a second to start). Let's also choose an f-stop to start with. How 'bout f/8? Okay, good. Now, look in your camera's viewfinder. On a Nikon, the meter shows up either on the far right or bottom of your viewfinder; on a Canon, it appears at the bottom of the viewfinder. There's a big line in the center of your meter, and then little lines that go above it and below it (or to the left and right). If you see lines above the line, it means that if you shot right now, your shot would be too bright (overexposed), so try moving your sub-command dial (or quick control dial), which chooses the f-stops, until you see those lines go away (which means—perfect exposure). Now, that may be correct (technically), but if that night sky isn't nice and black (or dark blue), keep turning that dial until it underexposes.

Shooting Light Trails

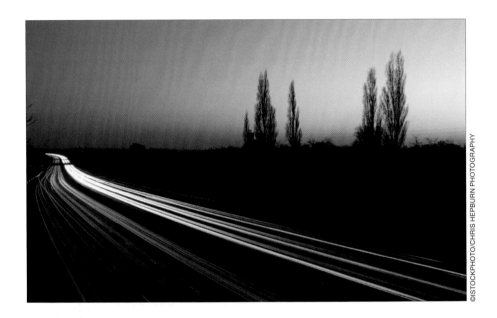

©ISTOCKPHOTO/CHRIS HEPBURN PHOTOGRAPHY

When I think of light trail shots, I always think of the light trails from cars driving at night, and they're easier to shoot than you might think. You just need a tripod and cable release (to keep everything from moving even a little bit while your shutter is open, and it's going to be open for a few seconds—long enough for the lights to move. By the way, the longer your exposure, the longer those light trails will be). Once your camera is on the tripod, and your cable release is ready to go, change your shooting mode to manual, then dial in an f-stop that makes everything in focus (like f/11), and then start with a shutter speed of 15 seconds (you may have to increase it a bit to 20 seconds or more, but this is a good starting place). Make sure your ISO is at its cleanest setting (for most Nikon DSLRs that would be 200 ISO, and for Canons 100 ISO). When you see a car coming into your view, just press your cable release, wait 15 seconds, then take a look at the image on your LCD and decide if you need to increase your shutter speed to 20 seconds or so (remember, longer shutter speeds mean longer light trails, so it's at least worth a try). That's pretty much all there is to it.

Where to Shoot Light Trails

One of the most popular, and interesting, locations for shooting light trails is a high vantage point—either on an overpass, or a bridge, or someplace where the cars are below you.

Shooting Star Trails

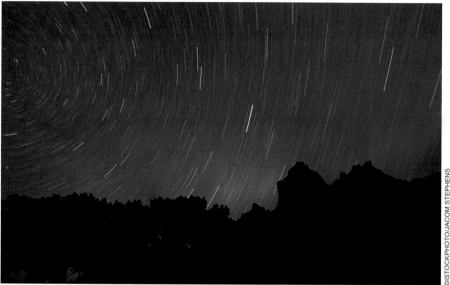

©ISTOCKPHOTO/JACOM STEPHENS

Start by choosing a clear night sky for shooting, far away from the lights of the city, and try to compose your shot so there is something low in the foreground (like the tops of mountains, or a silhouette of treetops, or even houses), and compose it so the moon isn't visible in the shot (its reflected light will mess up the rest of the shot). Next, you'll want to set up your camera (which should be on a tripod, with a cable release attached) facing north (use a compass or a compass app on your smart phone to figure out which way to aim), then find the North Star and put it in the center or on the very edge of your image. Set your lens's focus to "Infinity" by switching your lens to Manual mode (flip the switch right on the lens), then turning the focus ring on the camera all the way until you see the infinity symbol (which looks like this: ∞) on the top of the lens (that way, your lens doesn't try to refocus at some point, which would trash the image). Then, set your ISO to 200 (for Nikons) or 100 (for Canons) to get the cleanest image possible. Next, switch your shooting mode to manual, and set your aperture to as low a numbered f-stop as your lens will allow (for example, f/4, f/3.5, or f/2.8) to let as much light in as possible. Now, set your shutter speed dial to bulb mode (which means the shutter will stay open as long as you hold the shutter button down), then press the shutter button on the cable release, turn on the lock, and start your timer, then unlock at the amount of time you're willing to invest (no less than 20 minutes, but ideally an hour or more) and you're there! On the next page, we'll talk more about the gear you'll need for shooting star trails.

The Gear for Shooting Star Trails

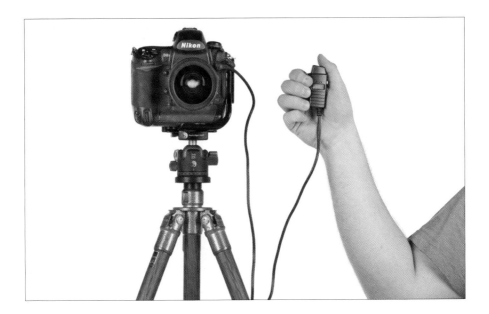

This isn't a lesson in shooting long-exposure images, this is a lesson in shooting really, really, really long-exposure images (like 1 hour or more). Because you'll need to keep your camera absolutely still for a minimum of 20 minutes, but probably more like an hour or more (the longer the exposure, the longer the star trails will be), you want to use a really sturdy tripod, and use a ballhead that won't slip even a tiny bit during that hour (or two or more). You're also going to need a cable release, so you don't have to stand there holding your shutter button down for an hour (a cable release can lock your shutter down for as long as you need). Also, depending on the time of year, and your location, it might get quite cold out where you're shooting, and you could get a frost buildup on your lens. Believe it or not, your exposure is so long that you can wipe your lens with a cloth and it won't affect the shot, so if frost is a possibility, you'd better bring along a clean cloth. If you do bring a small flashlight (it's going to be mighty dark out there), make sure you don't shine it into the lens when you're wiping away that frost—keep that far away.

Another Reason to Avoid Shooting at High ISOs

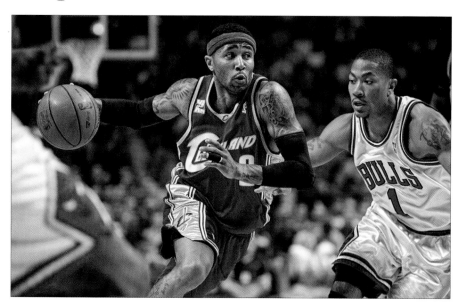

Today's higher-end cameras are getting better and better at shooting at high ISOs with very low noise, and today, with my Nikon D3S, I routinely shoot at 4000 ISO for nighttime or indoor sporting events, and people always comment that they can't see any noise. It's true. You can hardly tell there's any noise there at all, and what's there is absolutely minimal—less than shooting at 400 ISO on a film camera. So, if you can hardly see any noise at 4000 ISO, why do I hate shooting at 4000 ISO? It's because at 4000 ISO (or almost anything above 2000 ISO), you lose color saturation, your image has visibly less contrast, and you lose some detail, too. Sure, you don't have all that noise, but you don't have as good a quality photo as you'd have at lower ISOs. So, although sometimes to freeze motion under the lights, I have to shoot at 4000 ISO (to get my shutter speed to $\frac{1}{1000}$ of a second), you can definitely see a difference in the quality of your image and that's why before you think, "Hey, I'll just bump the ISO way up," know that there's a bit of a tradeoff. It's certainly not unacceptable, but just so ya know—it's there.

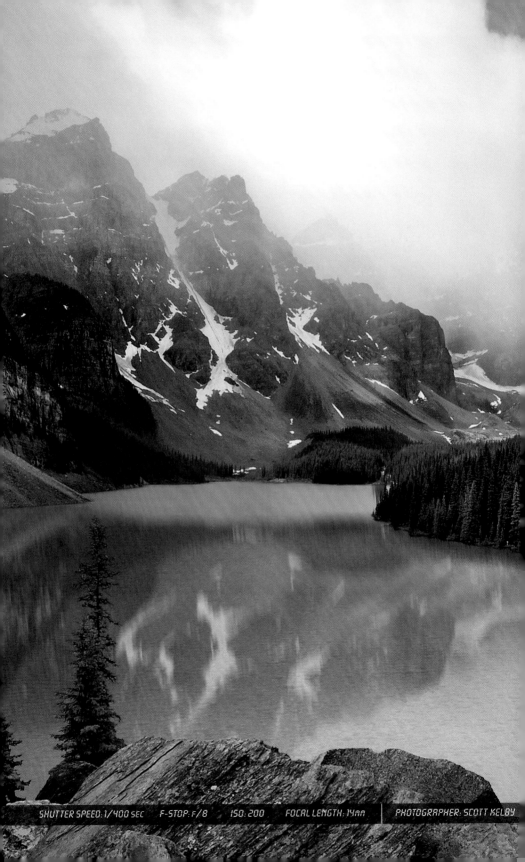

Chapter Six

Shooting Landscape Photos Like a Pro

Yet Even More Tips for Creating Stunning Scenic Images

I think one of the most appealing things about being a landscape photographer is not only are you coming back with amazing photos, but you get to experience some of the best of what nature has to offer while you're doing it. I'll never forget this one time I was shooting in Montana's Glacier National Park. I got up around 4:15 a.m., so I could head out early and be in position for a dawn shoot. When I reached the lake overview, it was still pitch dark, and I remember setting up my tripod and watching it blow right over in the freezing wind that whipped off the lake. I just laughed and set it right back up, attached my camera gear to the ballhead, and realized that I'd better not let go of the rig or it, too, might blow over. I didn't want to give up my spot, because I had a pretty good vantage point (at least it looked like a good one in the dim moonlight). So, there I stood, out in the freezing, bitter cold, where each gust of wind was like a thousand knives jabbing right through me. I'm standing there shivering in the piercing cold, and then it started to rain. Not snow. Nope, that would have been pretty. It was rain. A driving rain that felt like a massive army of Lilliputians were firing their tiny arrows at me, but I just stood there in the bone-chilling cold like a wet, frozen statue, with my cracked, frostbitten fingers barely able to grip my tripod. I silently prayed for the sweet mercy of death to come upon me and relieve me of this frigid hostile misery. It was just then when I looked over and saw another photographer, who had just set up his tripod about 14 feet from me, slip on the ice that had formed on the overlook. I stood there and watched as he and his tripod, expensive camera and all, slid down the side of the embankment. I could hear him moaning for help, but I just couldn't stop smiling as I looked over and saw his Tamrac camera bag still up on the overlook beside me. I nearly pulled a muscle as I tossed his gear-laden bag into my rented SUV and quickly drove away, thinking to myself, "Man, this is what it's all about."

You Don't Need Fast Lenses for Landscapes

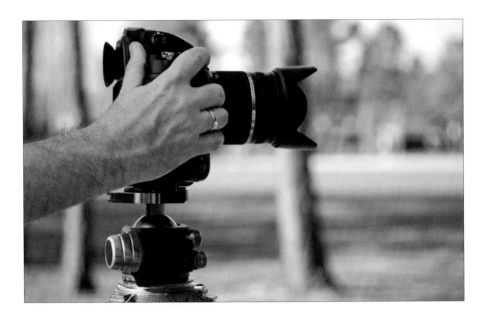

I've talked with a lot of folks over the years who think they need to buy really fast glass for shooting landscapes (lenses that shoot at apertures like f/2.8 or f/4). But, when it comes to shooting landscapes, this is the last place you'll get to take advantage of those fast apertures. In fact, you'll more likely be shooting at f/16 or f/22, which just about every lens out there already has. Plus, you'll hopefully be shooting on a tripod most, if not all, of the time, so your shutter can go as slow as it needs to go to make a proper exposure. Keep these things in mind when you're buying your next landscape lens, and you might be able to save quite a few bucks.

Three More Tips for Silky Waterfalls & Streams

Back in volume 1 of this book series, I talked about setting your f-stop to f/22 to help you get a silky water effect when you're shooting waterfalls or steams. But, what if you set your camera to f/22 and you want the water to be even silkier? Here are three more things you can do to slow down your shutter speed even more (which is the secret to silky water—the slower your shutter speed, the silkier the water): (1) Add either a 1.4x, or ideally a 2x, teleconverter to your lens. These magnify the distance of your lens so you can get in a little tighter, but the tradeoff is you lose either 1 or 2 stops of light. Normally, you might think that's bad (and normally it is), but if you actually want to lose a stop or two of light, which we do because it makes the shutter speed longer, then it's a big win for shooting waterfalls and streams. (A big "Thanks!" to my buddy Moose Peterson for this tip.) (2) Use your lowest possible ISO (for example, some Nikons let you go below their native [cleanest] ISO setting of 200 to settings called Lo 0.3 or Lo 1, which are kind of like using ISO 100 and make your shutter speed slow down. Again, this is exactly what we want. You'll lose a tiny bit of sharpness and contrast at Lo 1, but you'll wind up with a slower shutter speed, which is good). And lastly, (3) put a polarizing filter on your lens. These are used to cut reflections in water and windows and stuff like that, and they're also used to darken the sky. But, for our purposes they do something equally important—they make us lose a couple stops of light, which (say it with me) slows our shutter speed even more and is exactly what we need to get really smooth, silky water. Add these three tips to your bag of silky water tricks.

Long Exposure B&W, Part 1 (the Accessories)

Although this is a four-part technique, don't let that scare you out of trying it—it's very simple to do. To make images like this, which are often taken during daylight, your camera's shutter has to stay open quite a long time, which would normally make your image a white, blown-out mess. So, what's the trick? You'll need a neutral density (ND) filter, which darkens the scene (by like 8 to 10 stops of light), so you can shoot long exposures like this in broad daylight (don't put it on your camera yet, though—you'll see why in a minute). Because your shutter will be open for literally minutes at a time, you're going to need to shoot on a tripod. But, you'll also need one other piece of gear: a cable release (a cord that attaches to your camera to fire the shutter button, so you don't move the camera by pressing the button with your finger. They make wireless shutter releases for many cameras—it just depends on your camera model).

Scott's Gear Finder

Hoya's 9-stop ND x400 ND filter for around $63–$120 (depending on size)

LEE Filters' Big Stopper 10-stop ND Glass Filter for around $160

B+W's 10-stop #110 ND filter for around $56–$228 (depending on size)

Long Exposure B&W, Part 2 (the Settings)

Now you'll need to set up your camera to take the long-exposure images. The first step is to set your camera to manual mode (don't worry—even if you've never shot in manual mode, you'll be able to do this). Next, set your shutter speed to a setting called "bulb" mode. When your shutter speed is set to bulb mode, your shutter will stay open as long as you hold down the button on your cable release (which you'll need to do to create these long exposures). In some cases, you'll be holding this button down for minutes at a time, but luckily, most cable releases these days come with a lock slider. So, once you press-and-hold the shutter button on the cable release, you can turn on the lock, so you don't have to worry about standing there holding the button down for a long time, or worry about your thumb slipping off the button and ending your exposure early. Also, because your shutter will be open for a while, you want to make sure you're shooting at the cleanest possible ISO (this will keep you from having too much noise appear in your image). On most Nikon DSLRs, that's 200 ISO, and on most Canon DSLRs, that's 100 ISO. Lastly, choose an f-stop that will put everything in focus (ideal for landscape shots like this). I generally shoot these at f/11. So, just to recap: we picked up an ND filter (but didn't put it on our lens yet), our camera is on a sturdy tripod, we attached a cable release to our camera (or we're using a wireless release), we've switched to manual mode and set the shutter speed to "bulb," we've set our camera to shoot at the cleanest possible ISO, and we set our f-stop to f/11. Okay, we're not done yet, but we're getting close.

Long Exposure B&W, Part 3, (the Setup)

The reason I had you wait to put your ND filter on your lens is this: it will make things so dark, your lens won't be able to see anything to focus on, so we set the focus before we put the filter on. Here's how: (1) First, aim your camera at the scene you want to shoot and compose your photo just the way you want it. Then, (2) press your shutter button halfway down to set your autofocus. Now, (3) on the barrel of your lens, switch your focus to Manual. That way, your focus won't get messed up once you put the filter on. With your focus set, go ahead and attach your ND filter to your lens. And, believe it or not, there's something else that could ruin your long exposure—light sneaking in through your viewfinder. Some DSLRs actually have a little switch that puts a cover over the viewfinder, but if your doesn't, but put a small piece of black gaffer's tape over it (we use gaffer's tape, because it comes off easily when you're done, without removing the finish from your camera, lens, or almost anything you'd want to stick it to).

Long Exposure B&W, Part 4 (the Shot)

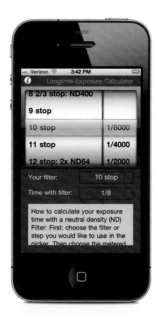

Everything's set and ready to go—it's time to take your shot. There's just one question kind of hanging out there: How long do you keep that shutter button held down to make a proper exposure? Well, of course, you could just experiment with different amounts of time, and after a few tries, you'll get it figured out, but there's a faster way: If you have an iPhone, go to the App Store and download the free LongTime Exposure Calculator app, which does all the math for you. You tell it which kind of filter you're using (8-stop, 10-stop, and so on), and it tells you how long to keep the shutter open. If you don't have an iPhone, you're not out of luck. Photographer Alex Wise created a free handy chart in PDF format, which you can download and print out (and keep in your camera bag), and it tells you how long to leave your shutter open for various ND filters (here's the short link to it: http://bit.ly/tKs1aj). Once you know how long to leave that shutter open, you're ready to shoot. So, press-and-hold the cable release button, lock it into place, and then just release the lock at the time you calculated using the app, the free PDF chart, or by just figuring it out using your watch. That's it. (*Note:* To see how I convert the image to black and white, check out the video I created for you. You can find it on the book's companion website.)

Keeping Your Gear Dry Outdoors

You can buy all sorts of sophisticated rain covers if you wind up shooting in rainy weather quite a bit (take a look at Think Tank Photo's Hydrophobia® covers, which are awesome, but expensive), but the problem is that if the weather unexpectedly turns bad, chances are you might not have a rain cover with you (if you have a small camera bag, it probably won't fit). That's why I keep a package of OP/TECH Rainsleeves in my camera bag at all times. They're not fancy, but they're small enough to always have with you in your camera bag (and they work with lenses up to 18" long). Plus, they're cheap as anything—you can get a pack of two for around $6. I've had to use them before, and they do a pretty decent job for those times you get caught by surprise.

Use Grid Lines to Get Straight Horizon Lines

There's nothing worse than a crooked horizon line, and back in the first volume of this book series, I talked about using a double level that fits into your hot shoe mount on the top of your camera as one way to make sure your camera is level. If you don't feel like buying one of those, here's something that can help: Turn on your camera's Grid lines. Depending on your camera, these might already be on by default, but if not, when you turn them on, it adds horizontal and vertical lines to your viewfinder, which can be really handy in lining up your horizon line (I use this quite a bit—I just put one of the horizontal lines right along the horizon and I can see right in the viewfinder if my horizon line is straight). On Nikon DSLRs, to turn this feature on, go under the Custom Settings menu, under Shooting/Display, and choose Viewfinder Grid Display. Toggle the menu to On and click the OK button. (*Note:* This feature is not available on Nikon D3 series cameras.) On Canon DSLRs, go the Set-up 2 tab, under Live View/Movie Shooting Settings, and turn Grid Display On.

Instant Duotones for Landscape Images

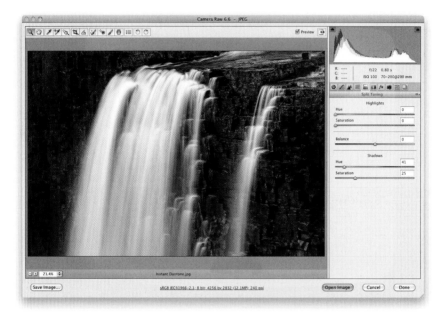

If there's one place where duotone effects look great, it's on landscape images (they can work great for some portraits, too, but I always felt they were born for landscapes). They've always been kind of a pain to create, which is why I've felt photographers don't use them more often. But, I've got a technique for people who use Photoshop's Camera Raw or Lightroom that is so simple, you'll be creating great looking duotones in literally seconds. The first step is to convert the image to black and white. In Camera Raw (PS), go to the HSL/Grayscale panel and turn on the Convert to Grayscale checkbox. In Lightroom, in the Develop module, just press the letter V on your keyboard. Now, go to the Split Toning panel, but don't touch the Highlights sliders at all. Instead, go to the Shadows section and increase the Saturation amount to 25. Next, drag the Hue slider over to somewhere between 25 and 45 (that's usually where I stay for my own work, but you can choose any Hue setting you'd like—just drag the slider to choose a different hue) and you're done. That's it. Done. Finis. Really.

Amplifying Size in Your Landscape Images

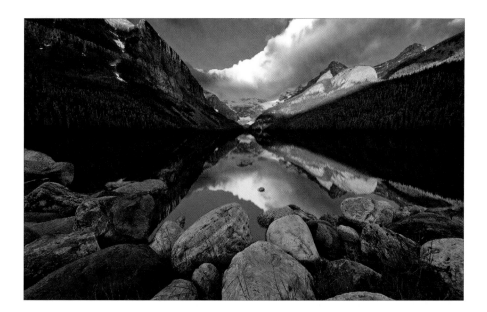

This is an old trick we use to give our landscape images a real sense of size and scope. It's going to sound amazingly easy, but it happens to work amazingly well. The trick is to first use a wide-angle lens, then position yourself so there's something right in your foreground (a rock or a series of rocks, a small tree, a flower, etc.), and then you get in nice and close to it. When you take the shot, it makes it look as though there's a lot of distance between that rock and objects in the background, and it gives your images this huge sense of scope, even though the rock and background objects may only be 100 feet apart. Try it the next time you're out, and you'll be surprised at the "bigness" this brings to your landscape images.

Need a Darker Sky? Lower the Brightness

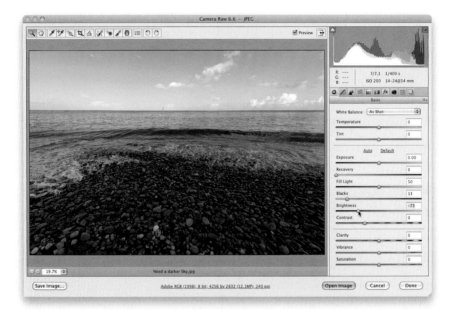

If I think the sky in a shot I've taken looks too light or too bright, I immediately know what to do—lower the Brightness. This essentially lowers the midtones, and it turns light blue skies into deep, rich blue skies fast. You can do this in Photoshop (or Photoshop Elements) with Camera Raw or in Lightroom's Develop module: just drag the Brightness slider to the left and watch the sky as you drag. If things get too dark, increase the Fill Light slider a bit until it looks right again. If you have to increase the Fill Light so much that the photo looks washed out, just increase the Blacks a little until it balances out. That'll do the trick! If you don't want to use Camera Raw or Lightroom to darken your skies (even though it's the easiest and most powerful way), you can lower your image's midtones by using Photoshop's Levels command (Command-L [PC: Ctrl-L]): just drag the center Input Levels slider (the gray triangle right below the center of the histogram in the Levels dialog) to the right. That'll darken the sky for ya. If everything else gets too dark, now it gets kinda tricky, which is why I recommend doing all this in Camera Raw (or Lightroom). By the way, you don't have to have shot in RAW to use Camera Raw—it edits TIFF and JPEG images, as well. From Adobe Bridge, click on the TIFF or JPEG image and press Command-R (PC: Ctrl-R) to open the image in Camera Raw. From the Elements Editor, choose Open (PC: Open As) from the File menu, click on the TIFF or JPEG, then choose Camera Raw from the Format (PC: Open As) pop-up menu, and click Open. Now, you can edit away. *Note:* If you're using the Lightroom 4 public beta (or, presumably, the "real" Lightroom 4 when it comes out), the Brightness slider is gone, so you'll have to use Exposure.

Shoot Before a Storm or Right After It

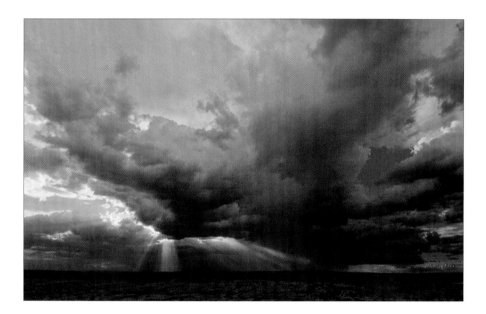

If you missed shooting your landscape photos around dawn or dusk (the two times of day when the absolute best light for shooting landscapes appears), you might still have an opportunity to create a really dramatic image if you see a storm rolling in or out of your area. That's because right before a storm, or right after one, you'll often find some really dramatic skies and enough cloud cover to create some really great light (rather than the harsh afternoon light we're usually saddled with). Interesting atmospheric stuff like this really looks great in photographs, so keep an eye out for these bonus shooting opportunities during the day (just play it very safe and avoid shooting in thunderstorms or anything dangerous. Remember, we're not on assignment for *National Geographic*. If we miss "the shot," it's not like we're going to miss getting the cover that issue. So, just play it safe at all times).

Doing Time-Lapse Photography

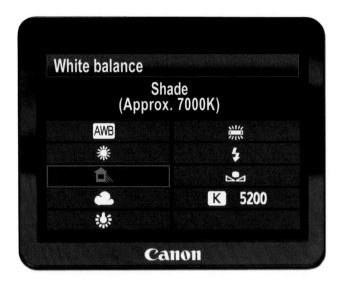

Time-lapse photography is great for showing things like a complete sunrise or sunset, or cloud movement across the sky, or stars moving across the night sky—basically, the progression of time throughout a landscape in a fraction of the time that has actually transpired (you shoot lots of still frames and then you turn those into a video). I explained how to set this up back in volume 3 of this book series, and even did a video on how to put all your shots together into a movie. But, here are two tips for when you're shooting time-lapse: (1) switch to manual mode (so your exposure doesn't change), and (2) don't use Auto White Balance (so it doesn't change, either).

Seek Out Still Water for Reflections

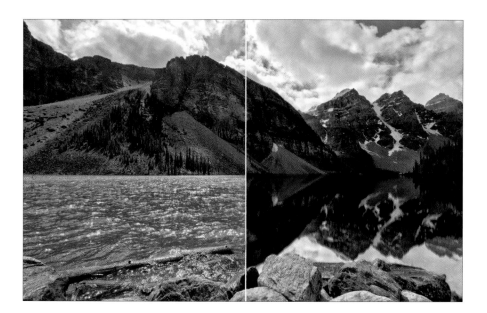

If you're shooting a charming little harbor, or a nearby lake, nothing looks lamer than choppy water. It almost doesn't even matter how amazing the surrounding scenery looks—if the water is choppy or has lots of little waves, it really hurts the overall image. That's why when we find a lake or harbor with still, glassy water, that alone almost makes the shot (thanks to the glassy reflections it creates). So, keep your eyes peeled for that glassy water while you're searching out your landscape shooting locations, and you'll already be halfway to creating a great shot. Now, your best bet for finding still water is first thing in the morning, right after sunrise, before the winds pick up. If there's going to be a time of day that you're most likely to have that glassy water, with gorgeous reflections, it's morning, so you need to set your alarm to get up really early. Not only will you have a better chance of getting still water, but you'll also be shooting in some of the best-quality light of the day—if you're shooting near dawn or in the half hour or so after dawn. Also, if you do get up early, make sure you bring along your travel tripod—in lower light, you'll need something to hold your camera steady, or you'll come back with a series of the blurriest, still-water shots in great light ever!

> **What to Do If the Tip Above Doesn't Work**
>
> *If the water is choppy at dawn, then try the long-exposure trick at the beginning of this chapter, which will at least create silky water and look much better than choppy water. Plus, since you'll be shooting in lower light, getting a long exposure will be easier.*

Tip for Shooting Those Low-Angle Landscapes

One of the big tricks for creating really impactful landscape shots is to shoot from a really, really low angle (you spread out your tripod legs, so your camera sits less than one foot from the ground) using a wide-angle lens—it gives your images a larger-than-life look. However, comfortably composing your landscape photos can really be a pain when you're down low like that (which is precisely why so few photographers are actually willing to do it, which is also precisely why your shots will stand out if you do). If you think you're going to be doing a lot of shooting like this, you can save your back (and keep your pants from getting wet and dirty during dawn shoots) by buying a DSLR camera that has a swing-out LCD screen. These are becoming very popular for shooting video with DSLRs, and they're ideal for shooting these low landscapes. Just switch your camera to live view shooting mode (so you see the live image on your LCD before you've taken the shot—kind of like you would with a point-and-shoot camera), then tip the swing-out screen up toward you, so you can clearly see what the camera is seeing and use that to help you compose the shot. You can even shoot with your LCD in that same position. Believe me—your pants and your back will thank me.

Make Your Cloudy White Balance Even Warmer

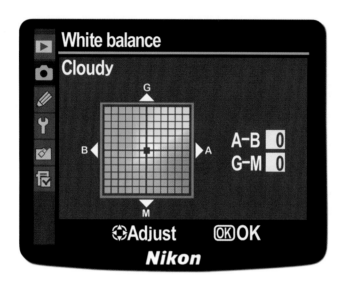

When I'm shooting landscapes, I generally set my camera's white balance to Cloudy to give my images a warmer look. However, if things start getting really overcast, the warm look I get from Cloudy almost disappears and my images look a bit cold again. So, I switch my white balance to Shade and that often does the trick, but sometimes the Shade preset looks too warm and yellow. In those cases, I just tweak my Cloudy white balance preset, so it's a little warmer. Luckily, this is really easy to do. On a Nikon, go to the Shooting menu, and choose White Balance. Scroll down to Cloudy and press the right arrow on the multi-selector. This brings up a color grid with your current white balance appearing as a dot in the center of the grid (shown above). To make your Cloudy preset warmer (Nikon calls this "fine tuning your white balance"), just use the multi-selector to move that little center dot over to the right toward A (amber; or diagonally down and to the right corner to add a little magenta in there, too). Now, press the OK button and you've created a warmer version of the Cloudy white balance. To return to the regular Cloudy preset, just choose it from the White Balance menu again. On a Canon, press the white balance selection button and then choose Cloudy. To make the Cloudy preset warmer (Canon calls this "White Balance Cor-rection"), under the Shooting 2 tab, choose WB SHIFT/BKT, and then press the Set button. A color grid will appear on your LCD with your current white balance appearing as a dot in the center of the grid. Use the multi-controller on the back of your camera to move that little center dot over to the right a bit toward A (amber; or diagonally down and to the right corner to add a little magenta in there, too), then press the Set button.

The Landscape Image Post-Processing Secret

I had been looking at the work of a few of my favorite landscape photographers a few years back and all their images seemed to have a particularly vibrant look to them—one that I wasn't able to easily reproduce in Photoshop (and I like to think I'm pretty decent in Photoshop). I finally asked one of them about it, and I was pulled over to the side and told about this plug-in and, in particular, a specific filter in this plug-in and a filter preset that a lot of these photographers were using to get "that look." Of course, I've been using it ever since I learned about it, and it's one of today's landscape photographers' secret weapons for making really warm, yet totally vibrant-looking, images. The plug-in is Nik Software's Color Efex Pro and the filter within that plug-in is called Brilliance/Warmth. It does an amazing job—once you click on it, click on the little pages icon to its right, and then choose the 06–Warm Colors preset. You can also tweak it with the sliders on the right and save it as a new preset. Nik Software lets you download a 15-day free trial of the Color Efex Pro plug-in, so you should at the very least give it a try. (By the way, I don't get any kickbacks or commissions whether you buy the plug-in or not. I'm just telling you about it because I use it, a lot of landscape photographers use it, and I think you'll totally fall in love with it. Then it can be your "secret weapon.")

What Helped My Landscape Photos the Most

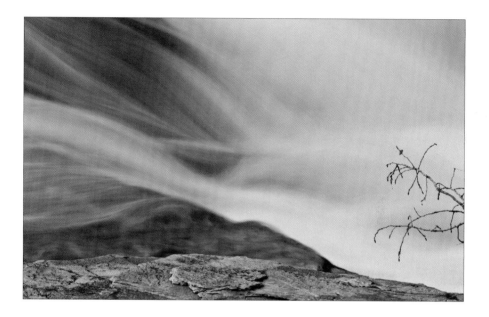

If I had to pick one single thing that helped my landscape photography improve the most, it was realizing that our job is to compose to remove distracting things from our images. One thing in particular to keep an eye out for is branches that extend into your image—either from the top, bottom, or sides of your frame. These are scene killers and you should go out of your way to avoid them when you're out shooting. Rocks make a nice foreground. Branches don't, so avoid them like the plague when you're composing your shots. When I teach landscape workshops, we do in-class critiques of students' shots from the week (we do them "blind" without mentioning the student's name), and the one thing we wind up pointing out the most are those little distracting things like power lines, plants, branches, and other little scene stealers. Often, all they would have to do is move one foot to the left or right, or point their camera two inches up or down, and it would eliminate the problem. But, you have to be aware of the problem in the first place to start avoiding that stuff. Take a look through your own landscape images and see if you can find distracting stuff in the background or along the edges of your image. Now, imagine how much better and cleaner they would look if that stuff weren't there. Your job is to compose to keep that stuff from being in your frame in the first place. When you become hyper-aware of that stuff and work to keep your background and edges clean and simple, I guarantee your work will move up a big notch.

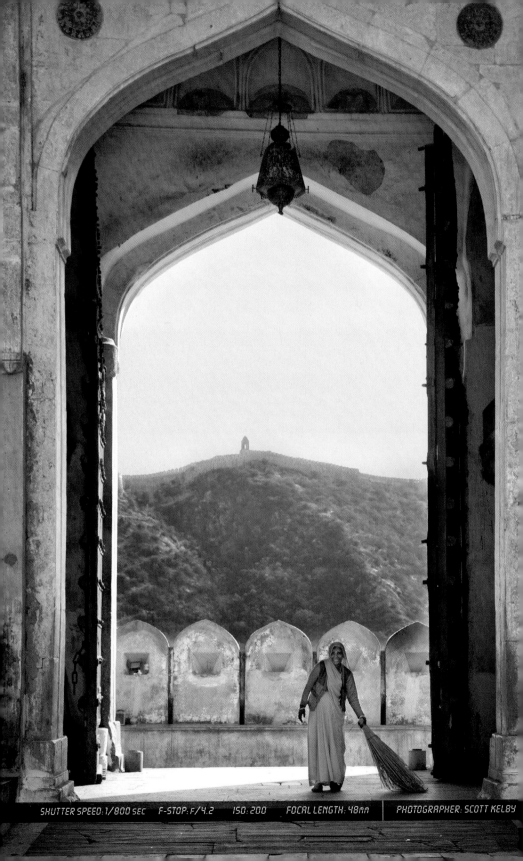

SHUTTER SPEED: 1/800 SEC F-STOP: F/4.2 ISO: 200 FOCAL LENGTH: 48mm PHOTOGRAPHER: SCOTT KELBY

Chapter Seven

Pro Tips for Shooting Travel Photos

How to Come Back with Images You're Really Proud Of

It doesn't matter what kind of photographer you classify yourself as (a wedding photographer, portrait photographer, landscape photographer, and so on), at some point, you're going to go on vacation, and because you're a photographer, you're going to take a camera, and because people know you're a photographer, they're going to expect you to come back with some amazing travel photos from your trip. This, of course, puts a tremendous amount of stress on you at a time when you took a vacation to relieve stress in the first place, so what you're really doing is trading one type of stress for another type of stress, and that is really stressful. So, I'm going to give you an absolutely can't-miss solution that will let you return from your vacation with some fantastic, iconic travel photos, no matter how short your stay in a particular city might be, and knowing you can pull this off in a minimum amount of time (30 minutes tops) will remove the stress and let you actually enjoy your vacation. Here's what you'll need to get started: a telephoto zoom lens, unobstructed access to your hotel room window, a chair, an inexpensive tripod, and about $10 cash per city. Start by going to a local gift shop and buying a set of postcards. Be picky here—don't just choose any set—choose a set that has the type of photos you'd like to call your own (don't worry, we're not going to hand these out and call them our own—they're obviously preprinted postcards). Take these back to your hotel, separate each card (they're usually perforated), and sit the first one on the chair, facing the window. Position your camera, on the tripod, with the soft light from the window at your back. Now, zoom in tight on the photo, so you don't see any white border around it (make it fill the frame) and take a photo of that postcard. Repeat this for the rest of the set, and then enjoy a day of stress-free vacationing, knowing that you nailed some shots for the folks back home. Hey, I never said this was the least bit ethical. I just said it would remove your stress.

Wait for the Actors to Walk Onto Your Stage

This is a wonderful travel photo technique and one I picked up from city life photographer Jay Maisel (I've tried it countless times now, and it works like a charm). When you find a really colorful wall in the city where you're shooting, walk across the street from it and just wait with your camera at the ready. A parade of people should pass by that wall in the next few minutes and, invariably, one or more of those people will have something colorful on that really stands out, or contrasts beautifully against that colorful wall, and you'll wind up with a captivating and colorful travel shot. If it's a rainy day, not only will your colors be nice and saturated, but there's a reasonable chance somebody will walk by with a red umbrella (against your yellow wall, or vice versa). All it takes is a little patience and some luck.

Leave Some Room for Your Subject to Walk

When you compose the shot we're talking about above (the one where you wait for someone to walk onto your set), make sure you compose that shot so there's a decent amount of room in front of the subject. That way they don't look "crowded" in the frame, which viewers find distracting in photos. They should have room to walk a few steps before they'd hit the edge of your image.

Look for That Classic "Lone Tree" Shot

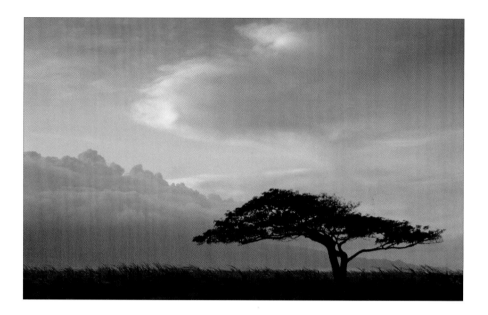

When you head to the outskirts of a city, keep an eye out for a shot that's always a pleaser—the "lone tree" shot. It can be in a field, or a meadow, or on the top of a hill, but if you keep your eye out for one, more often than not, you'll find one, and they make for really interesting photographs. Of course, you might find a row of three or four trees, so in that case, just frame the photo so it looks like there's only one tree (crop the other trees out while you're framing the shot, and leave a lot of empty space to the left, or right, of the one tree that you leave in the frame, and it will have that "lone tree" effect). Two more quickies: (1) your lone tree doesn't have to have leaves on it (I saw exactly that on the cover of a digital photography magazine this month), and (2) if it's a foggy day, you get extra points for including that nice foggy atmospheric effect (try that one as a black and white. Could be really sweet!).

Cheating the "Lone Tree" Look

If you're on vacation and you really want the "lone tree" look, but you're not able to find it by driving around the countryside, I know a place you can look where there usually are one or two trees to choose from (but if you use this tip, don't tell anyone where you found the tree). Just drive by the local golf course in the city where you're traveling. You're pretty likely to find a long flat area of grass (maybe the 8th hole) and then a lone tree or two just waiting for you. Don't tell anyone I told you this one.

Camera Bags That Won't Attract the Wrong Kind of Attention

If you're traveling in some exotic locations (or even some places here in the U.S.), it's very possible that your camera rig costs more than the people passing by you on the street make in a year (if you have high-end gear, maybe two years). That's why you don't want to go around advertising, "Hey, I've got a camera bag here full of expensive equipment!" Believe me, thieves know what an expensive camera bag looks like, which is precisely why camera bags that don't look like camera bags are getting so popular (almost every big bag manufacturer makes at least one "in disguise" camera bag these days). For example, Think Tank Photo makes the Urban Disguise line of camera bags that don't look like camera bags. Kelly Moore (http ://kellymoorebag.com) makes beautifully designed camera bags for women that look nothing like camera bags—you'd swear they were purses or totes. Lowepro makes one called the Exchange Messenger bag that looks…well…like a messenger bag. There are more out there, but the important thing is this: if you want to carry your gear safely and not raise the attention of thieves on the lookout for expensive camera gear, at least you've got some options.

Don't Draw Attention to Your Camera Make and Model Either

Savvy thieves know when they see a tourist carrying a camera like a D3 or a 1Ds Mark IV they've hit the jackpot, which is why you might consider putting a small piece of black tape over your brand and model. Also, don't use a camera strap that spells out the name of your gear, so it can be easily seen by anyone 10 feet away.

How to Avoid Blurry Travel Shots

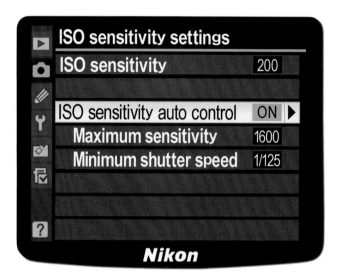

There are touching, hilarious, outrageous, beautiful, and totally unexpected things happening every day in the city you're visiting, and you don't want to miss one of those "moments." When you do capture one of those moments, there's a decent chance that the shot will wind up being blurry (it happens to travel photographers every day). If it's blurry, it's probably because your shutter speed fell below ⅟₆₀ of a second (unless that moment you caught happened directly out in the midday sun). That's why this tip (which I picked up from my buddy, Scott Diussa) is so important—it keeps you from "missing the shot" due to slow shutter speed by turning on your camera's Auto ISO feature. This tells your camera to automatically raise your ISO if it sees your shutter speed get too slow. In fact, when it's turned on, it won't let any of your shots get below a minimum shutter speed that you choose (I choose ⅟₁₂₅ of a second, because almost anybody can hand-hold a shot at that speed and it'll be in focus). To turn Auto ISO on, on a Nikon, go under the Shooting menu, under ISO Sensitivity Settings, go to ISO Sensitivity Auto Control, choose On, then choose ⅟₁₂₅ of a second as your Minimum Shutter Speed, and click OK (whew!). On a Canon, press-and-hold the ISO +/− button, then use the main dial until you see A (Auto) appear in the LCD on the top, then choose ⅟₁₂₅ as your minimum shutter speed. One last thing (for both Nikons and Canons) and that is "How high can you let the maximum ISO get?" Most DSLRs today can shoot at 800 ISO and it looks pretty decent, but I would still set your maximum at 1,600 ISO, because a photo with a little noise (which usually only other photographers will notice) beats the heck out of one that's even a little bit blurry (which everybody will notice).

My Favorite Travel Lenses

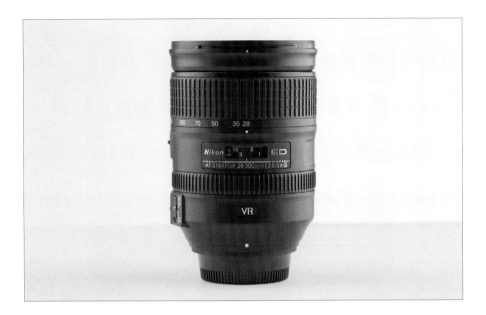

Back in volume 2 of this series, I mentioned that I like to keep my camera rig really light and simple when I'm on vacation, because after all, I'm on vacation (not on assignment). So, I usually go with just one lens that "does it all." With a cropped sensor camera like a Nikon D300S or a Canon 60D, I take my 18–200mm lens (both Nikon and Canon make an 18–200mm f/3.5–f/5.6 lens), so I can cover everything from wide-angle to tight zoom without ever changing lenses. For a full-frame camera, like a Nikon D700 or D3S, Nikon makes a 28–300mm f/3.5–5.6 (which is pretty close to the equivalent of the 18–200mm on a cropped sensor). This has become my "go-to" lens for travel, because once again, it covers it all (from wide-angle to tight zoom). For a Canon full-frame camera, like the 5D Mark II or 1D X, Tamron makes an affordable 28–300mm lens. If it's an important trip to somewhere really exotic, then you might want to consider taking a super-wide-angle (like a 12–24mm for cropped sensor bodies or a 14–24mm for full-frame bodies) for wide cityscapes or big sweeping scenes at a temple.

Don't Carry a Camera Bag—Carry a Lens Bag!

If you're only taking one extra lens (like I mentioned above), you might want to consider taking along a lens bag. They're smaller, they strap across your chest (much harder for anyone to swipe in big cities), and they're just big enough to hold a lens, a cleaning cloth, and a filter or two. Check out the ones from GoBoda. Really well-designed.

The Trick to Capturing Real Lives

When you walk into a foreign city with a big camera and a long lens, you stick out like a sore thumb and draw lots of attention. At first. But the longer you hang around a particular area, the more people realize you're harmless, and after a while, nobody's really paying much attention to you. That's the goal. To get to the point that nobody's really paying much attention to you (the opposite of the rest of our lives, right?). When they're not focused on you and what you're doing, they go back about their business, and when that happens, some real opportunities to capture memorable photos appear. The trick really is to camp out somewhere and just be patient. You can sit down at a sidewalk cafe, or perch yourself on a short wall, or even sit down on some steps, or on the ground and lean against a wall—just pick an area that's near the middle of everything, but not directly in it. Remember, your job isn't to be in the middle of everything, it's to have a good view of the middle of everything. So, from across the street, or from above on a bridge, or on a staircase, or anywhere just outside the middle is where you want to be. You're just "chillin'." You're not making a fuss, you're not messing with your gear, and you're not drawing attention to yourself. Just give everybody some time to get comfortable with you being there, and then you can capture real life as it unfolds in front of you. I promise you—your patience will pay off.

Tourist Removal Shooting Techniques

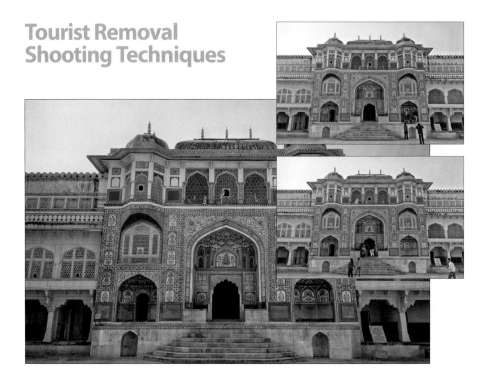

Tourists can make or break a scene. Sometimes, groups of people around a temple, church, or monument tell a story, but sometimes they just ruin what would otherwise be a really tranquil scene. That's why you need a strategy for "removing tourists" from your shot. First, I've found that patience alone can pay off big time in these situations, because if you just stand there and wait, you could luck out and, if only for a brief moment, have no tourists visible in the frame (that doesn't mean there are no tourists—it just means there aren't any in the particular spot you're aiming at). If that doesn't work, then your strategy changes to the "moving tourist" strategy, which is based on the fact that tourists don't stay in one place very long, and since that's the case, you're going to shoot a series of shots over a few minutes (not a few seconds—it usually takes at least three minutes). This trick works best if you're on a tripod, but you can hand-hold if you're the really patient type (don't leave the exact spot where you took the first shot). Once you're ready to shoot, take one shot, then wait until the main group of tourists has moved away from the area. Now, take another shot (I know, more tourists will be wandering around—that's okay, just take the shot). Wait a minute, and take another shot. This all takes place while tourists are wandering around what you're shooting. When you're done, you should have five or six shots of the exact same view. Now, go watch the video (on the book's companion website) to see how to use Photoshop or Photoshop Elements to make those tourists quickly and seamlessly disappear. You'll be amazed at how easy this is and how well it works.

Learn How to Work the Scene

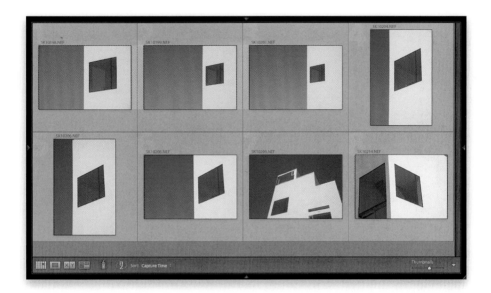

If you're walking around a city or village and you stop to take a photo, that means something caught your eye (enough to make you stop and photograph it, right?). Don't just take one shot, shrug your shoulders, and move on. Remember, something made you stop, so there's probably something there, and taking one quick snapshot probably won't uncover it. Your job as a photographer is to "work that scene" and find out what it was that captured your attention. The first step is simply to slow down—stop, look around for a moment, and see what it was that drew your eye in the first place. Was it the color, was it a doorway, an archway, was it some little feature, or something big? If you can figure it out, then you'll know what to shoot, but more often than not, we can't exactly describe what it was that made us stop and shoot, but it definitely was something. Your job is to find it, and to work that scene by trying these techniques: (1) Shoot the area with different focal lengths—shoot a few shots in really wide angle, then try 100mm, then zoom in tight, and see what you find. Stop and look at your LCD to see if you're getting close. If you see something that looks like it has possibilities, then (2) try changing your viewpoint. Shoot it from a very low angle (get down on one knee) or try shooting it from above (look for stairs you can shoot from or a rooftop angle). This can make the shot come alive. If that looks really good and you're getting close to nailing the shot, then (3) try varying your white balance (try changing it to Cloudy and see if having the shot look warmer looks better, or try Shade for a warmer look yet). Try all these things (work the scene) and my guess is one of those shots will bring a big smile to your face.

Finding Which Travel Photos You Like Best

If you want to take better photos on your next vacation, start by looking at the photos from your last vacation. In particular, look at the metadata (the information embedded into your camera at the moment you took the shot, which includes which lens you used, your f-stop, shutter speed, ISO, and so on). But don't look at all the shots from your last trip, just the "keepers"—the ones that wound up in your photo album or slide show, or as prints on your wall. In that metadata, look for a pattern. Are a lot of those shots taken with the same lens? If they are, you now know which of your lenses is your "go-to" lens for travel photography. Now, dig a little deeper. Is there a particular focal length you're using (in other words, are you mostly zoomed in tight on these shots, like to 170mm or 200mm, or are they all mostly wide-angle shots, like 18mm or 24mm)? Once you pick up a pattern there (let's say most of your favorites were shot at 24mm), you know that for travel you seem to prefer wide-angle shots. So, to increase your chances of coming back with shots you really like, shoot more wide-angle shots with your go-to lens for travel. You can dig even deeper if you like. Are a lot of your favorites taken with a slow shutter speed, which shows motion, or are they mostly high shutter speeds where you're freezing motion? This helps you, once again, find your travel photography shooting style, and if you shoot more shots with that lens, focal length, and shutter speed you seem to like best, you're more likely to come away with more shots that you love.

Shooting from the Roof of Your Hotel

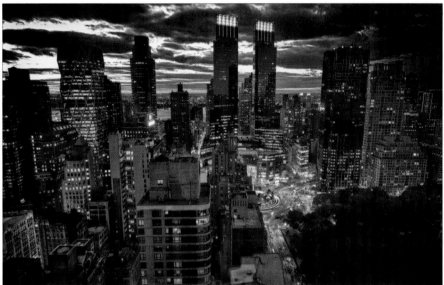

RAFAEL "RC" CONCEPCION

If you spot a high-rise hotel in the city you're visiting and you'd like to shoot a sweeping cityscape from their roof, it's pretty unlikely that they'll give you permission to shoot up there. Well, that is unless you're a guest in the hotel. I've found that if you're a paying guest in the hotel, and you contact the hotel concierge (or a friendly front desk staffer), you're fairly likely to get a few minutes to shoot on the roof (they will usually send you up there with a maintenance man or other hotel staffer). Also, if they have a rooftop lounge, and you want to shoot there in the off-hours when it's closed, they're usually more than happy to accommodate you—tripod and all. All you have to do is ask.

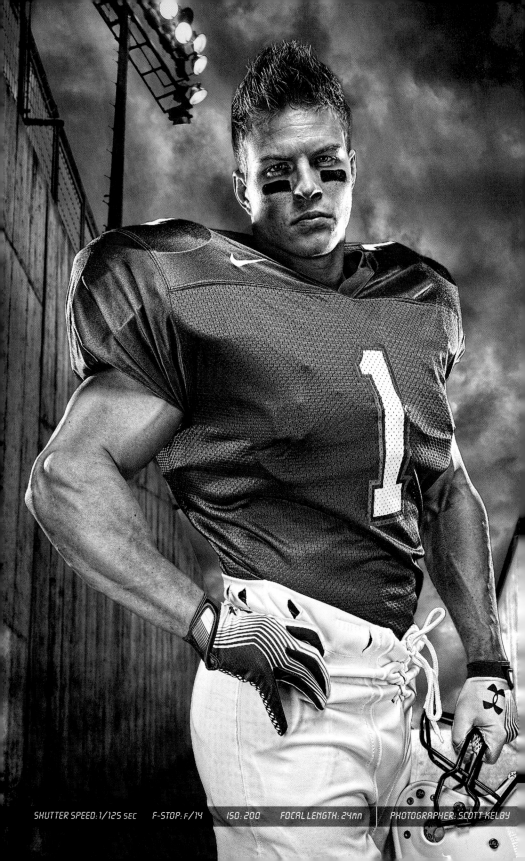

Chapter Eight

Shooting Sports Like a Pro

How to Get Professional Results from Your Next Sports Shoot

I know that these chapter intros are just here for a mental break, and they're not actually supposed to provide any useful information whatsoever, and I think I've done a fairly good job of living up to that lofty goal so far. However, I'm very passionate about shooting sports, and this is the only place I have to pass on a warning that is actually based in truth (or at least as based in truth as that movie *The Perfect Storm* was). Anyway, if you are a serious fan of college or pro sports, I want to tell you up front that you will rue the day you actually shoot on the field, because you will never, ever, ever, in a bazillion years even consider going back into the stands like a regular fan again. You will be literally ruined for life. Here's why: you get spoiled down on the field of play. It's a different game down there. It's not like what you see on television. You see, on TV, when you see a cornerback and a wide receiver jawboning back and forth before the snap, you figure they're trash talking. Talking smack. Occasionally, they are, but you know what they're mostly talking about? Nine times out of 10, they're talking about the gear the photographers on the sidelines are using. I was shooting an NFL game in Atlanta once, and I set up right near the line of scrimmage, and I heard the receiver say to the cornerback, "Dude, is he really trying to shoot this with a 200mm lens?" And the cornerback said, "I looked during the last time out—he's got a 1.4 tele-extender on there." Then, the WR said, "Did he have VR turned on?" The corner said, " Yup." Then, the WR said, "Dude, it's a day game. You know he's got to be at ¹⁄₁₆₀₀ of a second or higher" and just then the quarterback called an audible and yelled "Get me close to that guy with the 400mm f/2.8—I want to see if it's the new model with the nano coating." This goes on all game long, game after game, city after city. The players call it "camera smack" and just because you don't hear about it on TV, doesn't mean it's not happening.

A Tip and a Secret on Panning

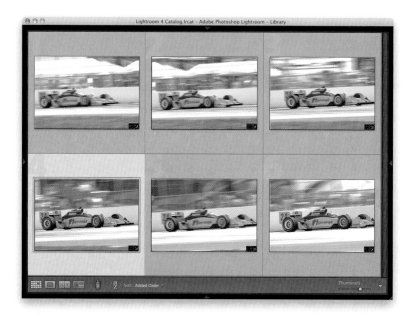

If you want to show motion in a sports photo, the trick (which I covered in volume 1 of this book series) is to use a very slow shutter speed (like ⅟₆₀ of a second or slower), while shooting in continuous shooting (burst) mode, and then pan right along with the athlete so most, if not all, of the athlete will be in focus, but the background will be totally blurred (it really creates a sense of speed). I have another tip and a secret to add to that. First, the tip: when you're panning, swivel your hips as you pan (don't just twist at the waist), and you'll get much smoother results. So, while you're swiveling, shoot a burst of shots, in continuous shooting (burst) mode, so you get a string of shots as you pan. This will make a difference, but here's something you don't hear pros talk about very often: if you take a burst of 30 shots as you pan with an athlete (or a car, if you're shooting motorsports), only expect one of those to actually have your subject in focus. The thing to keep in mind is you only need that one! I've gotten so many emails from people just getting into sports photography, and they've written things like, "I've got all these blurry, out-of-focus shots and only one out of 20 is in focus" and I write back to them, "Then you're doing it just right!" Now, are there working pros out there that, in a panning string of 30 shots, have three or more photos in focus? Absolutely! But how many of those do they send in to their magazine editor, or wind up in their portfolio? One. So now you know, if you see a bunch of blurry panning shots, but you see that one in the bunch that's right on the money, you're gold, baby, gold!

Finding the Right Shutter Speed for Panning

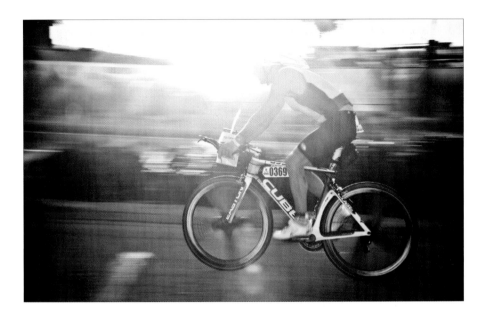

I have a lot of people ask me, "What's the right shutter speed for panning?" when shooting a subject like a runner, or cyclist, or racecar, etc. I hate to answer with a "that depends," but it kind of depends. I generally like to pan with my shutter speed at or below 1/30 of a second with a long lens (like 200mm or longer). However, if you use a wide-angle lens, 1/30 of a second won't be slow enough—you'll have to go much slower with your shutter speed when shooting with a 24mm, 18mm, or wider because of the lack of lens compression. You just won't see the motion like you do with a longer lens, so you'll have to back it way down to maybe 1/4 of a second or less.

Freezing Motion Trick for Motorsports

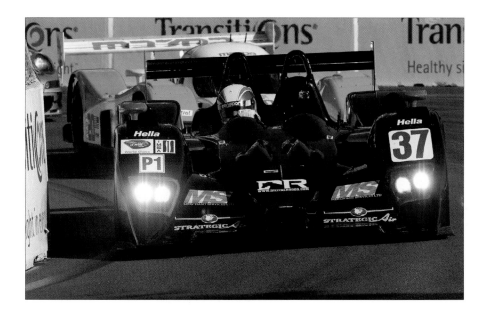

Back in volume 3 of this book series, I talked about shooting with a slow shutter speed for motorsports so you can see the wheels moving, which shows motion and speed (other-wise, if you freeze the motion, it looks like the car is sitting there parked on the track). However, there is one great situation where you can shoot at really high shutter speeds when shooting car racing (so you're pretty much guaranteed a super-sharp shot), and that is when you position yourself so the cars are coming almost straight at you. If you can't really see the sides of the wheels, you can't tell that they're not spinning (as shown above), so you can be sure you'll get lots of in-focus, super-sharp shots. Once you're in position, switch your camera to aperture priority mode, then shoot wide open at the lowest numbered f-stop your lens will allow (like f/4 or f/2.8), then (and this is key) focus your camera on the driver's helmet. If the helmet's sharp, the rest will be sharp. By the way, you don't actually need super-high shutter speeds to freeze the action if it's coming right at you—1/250 of a second will usually do the trick.

Shoot Slow-Shutter-Speed Panning Shots When the Yellow Flag Is Out

During a race, when the yellow flag is out, the cars are moving around the track much slower than usual, and this is a great time to capture some really nice panning shots at a slow shutter speed, simply because they're not moving fast. This makes your job of tracking the cars (and getting more in-focus shots while panning) much easier.

Your Problems Start at Night or Indoors

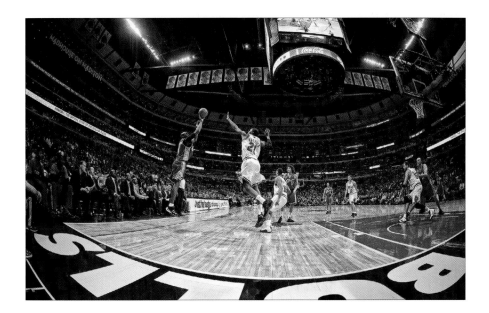

If you're shooting sports during the day, the world is your oyster, because you don't have to have lots of expensive equipment or crazy expensive lenses or any of that stuff. You can buy zoom lenses that go out to 300mm or 400mm for just a few hundred bucks from Nikon, Canon, Tamron, and Sigma (among others). For example, B&H Photo has a Canon 75–300mm f/4.0–5.6 Autofocus lens for less than $200. It's fairly small and weighs only a fraction of Canon's high-end 300mm f/2.8 lens, which costs around $7,300. (Yeouch!) But, since you're shooting in daylight, you can get away with it, and you'll get sharp, clean images (however, since you'll be shooting at f/5.6, you won't have as shallow a depth of field, so your backgrounds won't be as out of focus as with the $7,300 f/2.8 lens, but that $7,100 left in your pocket should help you get over that pretty quickly). So, when do you need to buy the really expensive camera body and heavy, crazy-expensive lenses? Only if you: (a) shoot primarily at night, (b) shoot indoor sports, or (c) you plan to shoot sports for a living. That's because, even in well-lit stadiums at night, to get to around the $\frac{1}{1000}$ of a second shutter speed you need to freeze the action, you'll have to shoot at f/2.8, and you'll still need to raise your ISO to at least 1600 (even shooting as low as f/4 in a well-lit NFL stadium, I have to shoot at 4000 ISO). Shooting at these higher ISOs without a camera body built for low-light shooting (like the high-end Nikon and Canon bodies— $5,000 and $7,000, respectively), the noise in your nighttime or indoor shots will pretty much destroy your images. So, shoot in the day, and you'll be able to afford to send your kids to college.

Turn Off VR (or IS) When Shooting Sports

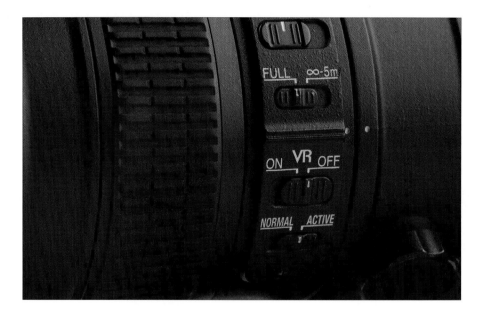

If you want sharper sports photos, and you have lenses that use VR (Vibration Reduction on Nikons) or IS (Image Stabilization on Canons), you should turn this off. There are two important reasons why: (1) the VR (or IS) slows down the speed of the autofocus, so it can stabilize the image, and (2) since you'll be shooting at fast shutter speeds (hopefully at 1/1000 of a second or higher), you don't get any benefit from VR (or IS), which is designed to help you in low-light, slow shutter speed situations. In fact, it works against you, because the VR (or IS) system is searching for vibration and that can cause slight movement. Normally, that wouldn't be a problem, because you want VR (or IS) to do its thing in low light, but in brighter light (and faster shutter speeds), this movement can make things less sharp than they could be, so make sure you turn VR (or IS) off.

The Advantage of Using Fast Memory Cards

Fast memory cards were made for sports shooters, because we usually shoot in continuous shooting (burst) mode (capturing 8, 10, or 12 frames per second while we hold the shutter button down for seconds at a time). These bursts of images are temporarily stored in a memory buffer in our cameras and then they're written to the memory card in our cameras. If you use a "slow card" (like a 133x speed), then you're likely to experience the heartbreak of a full buffer at some really critical moment. What that means is you're firing off these rapid-fire shots (click, click, click, click, click, click), but then your camera's memory buffer gets full because those images in memory aren't writing to the memory card fast enough. Even though we still have our fingers tightly pressed down on the shutter button, and the player with the ball is running right at you, and you're about to get the "shot of the year," you all of a sudden hear "click.........click.........click.......................click..........................click" and your frames per second drops to about 1 frame every 2 seconds. Ugghhh!!!! This is why fast cards (like 400x and 600x speed) are a big advantage for sports photographers—faster cards write data much faster, so the images in your camera's buffer leave the buffer much quicker (leaving room for you to take more continuous shots), so your chance of hearing the dreaded "click.........click.........click" of a full buffer goes way down (and your chance of capturing that key moment stays way up).

How the Pros Focus for Sports

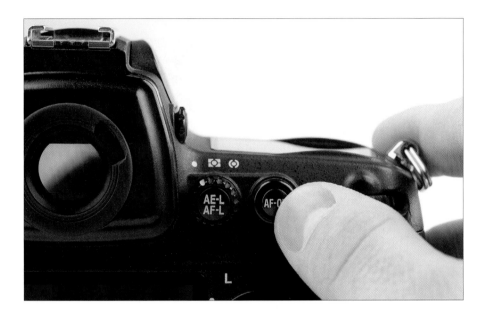

If you want to get more shots in focus, you've got to switch to back focusing (where you focus by pressing a button on the back of your camera body with your thumb, rather than focusing by pressing your shutter button). This makes a bigger difference than you'd think, because by separating the focus from the shutter button, your camera no longer focuses, then shoots—you've already focused on your subject with the button on the back, so now your shutter button just shoots. This back focusing helps to keep the autofocus from jumping off your subject when someone walks into your frame (which is a real struggle when shooting team sports), because if someone does walk into your frame (like a ref), you just take your thumb off the back focus button until they're gone (but keeping shooting) and when they're out of your frame, just hit the back focus button again. Generally, I just keep my thumb on that back focus button, aim at my subject, and then I don't have to worry about my focus—I just concentrate on my timing. To turn on this feature on Nikon DSLRs (well, most of 'em anyway), go to the Custom Setting menu and, under Autofocus, choose AF Activation, and set it to AF-ON Only. On Canon cameras (like the 7D or the 5D Mark II), press the Menu button on the back of the camera, go to your Custom Function IV-1 menu, and choose Metering start/Metering + AF start.

Why Many Pros Shoot Sports in JPEG

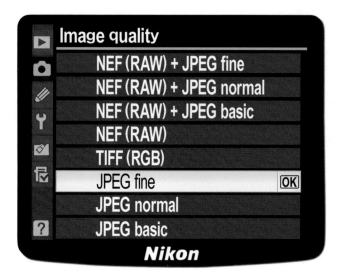

A lot of people are shocked when they hear that I shoot sports in JPEG format rather than RAW, but I'm not alone. Many of the pro shooters I know do the exact same thing for two key reasons (the first of which I covered in volume 1 of this book series): (1) You can shoot more continuous shots in JPEG format than in RAW, without filling your camera's internal memory buffer (see page 125 for more on the buffer issue). DPReview.com (a respected source for this type of data), broke it down this way:

Shooting in RAW: After about 17 RAW photos, your buffer is full.
Shooting in JPEG: You can shoot about 65 or so shots before your buffer is full.

If you're using fast memory cards (like 600x high-speed cards), that means that if you're shooting in JPEG, your buffer rarely gets full because of how fast the images write to the memory card, which clears up the buffer for more shots. (2) JPEGs take less time to process. JPEGs get contrast, color enhancements, and sharpening applied within the camera itself, so JPEG images look more "finished" right out of the camera and are nearly ready for publishing without a lot of tweaking. When you set your camera to shoot in RAW, it turns all those in-camera contrast, sharpening, and color enhancements off, because you've chosen to do all that yourself later in Camera Raw or Lightroom, which takes more time, as does resaving the images as JPEGs for publishing. You could shoot RAW+JPEG, but that has its disadvantages, including eating up memory cards much faster, and taking longer on import.

Using a Remote Camera

Having a second DSLR aimed at a different part of the field (or track, or arena, etc.) gives you a huge advantage, because you can cover twice the area and catch the shots and/or angles other photographers miss. For example, if you're shooting baseball from a dugout, and you want to cover the batter with your main camera, you can have a second camera aimed to cover second base. When you see a play happen at second base, you press a remote to fire your second camera. If it's mounted near you (or even on a tripod), you can just use a regular ol' cable release (or wireless cable release). If it's far away from you (like on the other side of the field, or down low on a horse track near the starting gate), you'll need two wireless transmitters (I use PocketWizard Plus IIs)—one connects to your remote camera with a small accessory cable, and you hold the other in your hand. When you see the action come into the view of your remote camera, you press-and-hold the remote button and it fires the shots (I always set my remote camera to shoot a burst of shots for as long as I hold the remote button down. I also pre-focus on the spot I want [like second base itself], then switch my focus to Manual, so it doesn't change when I press the remote button). Besides the wireless trigger, I would recommend: (1) a Manfrotto Super Clamp with a Manfrotto Variable Friction Magic Arm with Camera Bracket—this lets you mount the camera to all sorts of surfaces by just clamping it on, and then you can position it just how you like it. And, (2) you need to go to Home Depot or Lowe's and buy a safety cable or two to double secure your rig, so if something comes loose, your gear doesn't hit the floor, or worse yet, fall and hit somebody (a player, a fan, etc.).

Adding a Teleconverter to Get Really Tight

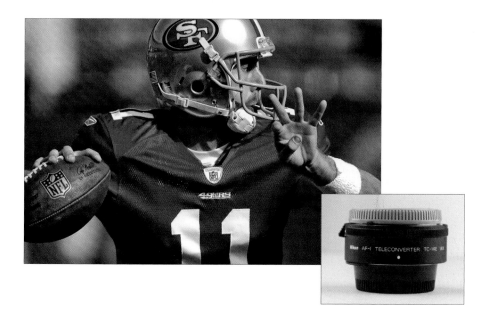

If you look at some of the really amazing sports shots out there today, many of them share something very specific in common—they bring you really, really close to the action. They bring you emotion and action that you'd miss from wide-angle TV shots, or from sitting up in the stands, or even from watching on the those giant stadium monitors. While I generally shoot a 400mm lens for almost every sport, I realized that I needed to get in even tighter—especially after having my portfolio reviewed by sports photography legend Dave Black, who encouraged me to put a 1.4x teleconverter in front of my 400mm lens (making it over 550mm in length) to get it even closer, and it made a tremendous difference. Whatever focal length you're shooting, a teleconverter is a fairly inexpensive way for you to get even closer to the action and take your sports shots up to the next level. (*Note:* This works best for shooting day games, or shooting in really well-lit situations, because putting on a 1.4x tele-extender makes you lose 1 full stop of light, so your f/2.8 lens becomes an f/4 lens, your f/4 becomes an f/5.6, and so on. If you use a 2x tele-extender, then you lose 2 stops. So, for daylight you'll be okay, but indoors, unless you have a camera body that shoots in low light with really low noise, it's kinda dicey, so keep that in mind.) By the way, Dave had a great quote for me about getting in close. He said, "Go big or go home!" He's right.

Why You Need to Shoot the Warm-Ups

The last thing you want to be doing at the start of the game is figuring out your settings and white balance. That's one of the two main reasons you need to show up early for whatever sporting event you're shooting and do this experimenting while the players are warming up. In almost every sport, about an hour before the event the players come out and go through pretty much whatever they're going to be doing when the game (or race) starts, and you want to be there shooting a lot during that warm-up. Not just so you get your settings down pat, and when the game starts all you have to worry about is capturing the moments, but also because, just like the athletes (or drivers) need to warm up before the start, you need to warm up, as well. If it's been a week or more since your last sports shoot, you need some time to shake the rust off and get back into the groove of panning with players, getting sharp on capturing the action, and just generally warming up. That way, when the game actually starts, you're not spending the first quarter (or period, or 20 laps) getting your settings and into the zone for shooting.

Shoot Little Details Surrounding the Event

A sporting event is more than the players on the field (that's why it's called an event). Today it's about the arena itself; it's about the fans; it's about all the sights and sounds that surround the event (if you shoot for a sports news service, they always ask for these types of shots to be submitted, as well). Since you're telling the story of the sporting event, it's about covering the details of the event. For example, when I'm shooting football, I always shoot a nice close-up of both teams' helmets (there's usually at least one sitting prominently on an equipment case in the bench area) or the football sitting there by itself just after the ref places it on the field for the next down. For baseball, I shoot a lone glove sitting on the bench, or some bats leaning against the wall in the dugout, or even a close-up of home plate. These storytelling shots are great to include in slide shows and always get a smile from the viewers, so make sure you keep these in mind to shoot between innings, quarters, periods, etc.

Getting More Football Shots In-Focus

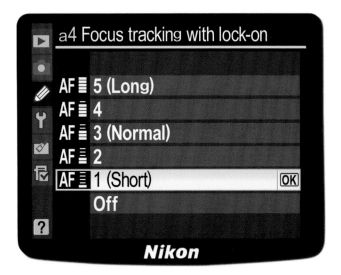

Although I use this tip primarily for football, this might help in a lot of different situations. There's a setting in many DSLRs that lets you choose how long your focus stays locked on your subject. By default, this Focus Lock-On is set to Normal, but for most of the football game, I leave it set to Short, so that way if I'm focused on the quarterback at the start of the play, but then he passes the ball, I can quickly swing over and catch the receiver and it refocuses on that player very quickly. However, there are times when I don't want my focus to leave the player quickly, and that's on kickoffs and punt returns. That's when I switch my Focus Lock-On to the Long setting. He's not going to pass the ball or hand off to anybody else (unless it's the final play of the game and they're behind one touchdown), so I need that focus to stay locked on him and not jump off him if another player (or a ref) crosses in front of him or nearby him (and of course, both teams are racing right alongside or in front of him, so there are players right nearby that might make your autofocus want to jump over to them). Just don't forget to switch it back to Short after the kickoff (or punt return). To change this setting on a Nikon, go under the Custom Setting menu, under Autofocus, and choose Focus Tracking with Lock-On, then choose Short during the regular game, and Long for kickoffs and punt returns. On Canon cameras (like the 7D), go to Custom Function III-1, which is AI Servo Tracking Sensitivity. Choose Fast for the regular game, and Slow for kickoffs and punt returns. *Note:* It's very possible that you'll run into a football photographer who does exactly the opposite of this, leaving his setting on Long the entire game. I personally haven't had a lot of luck with Long, but like everything else in photography, you'll find somebody that swears by it. So, which one is correct? Try 'em both and see (but again, I'm using the tip I shared here when I shoot).

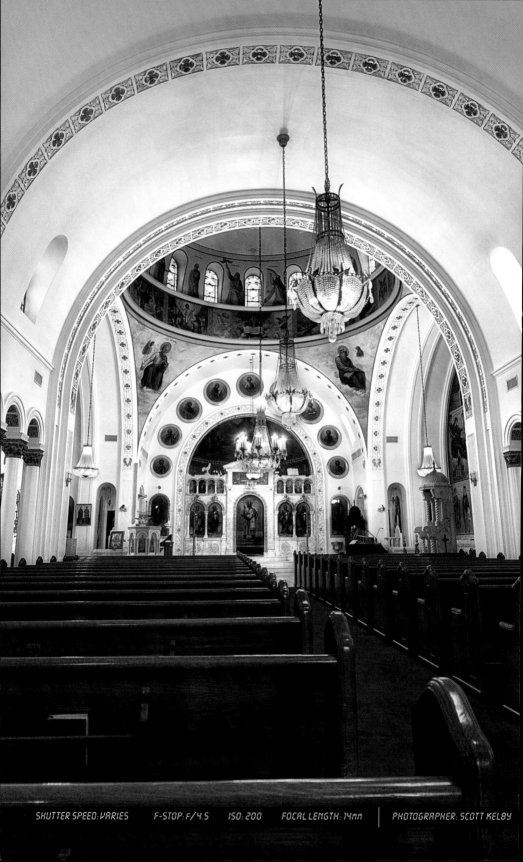

SHUTTER SPEED: VARIES F-STOP: F/4.5 ISO: 200 FOCAL LENGTH: 14mm │ PHOTOGRAPHER: SCOTT KELBY

Chapter Nine

Shooting HDR Like a Pro

How to Shoot and Process HDR Images

Anytime you mention HDR, it starts an argument, because there are both people who dearly love HDR and those who hate it with a passion that knows no bounds. Personally, I like HDR and I shoot them myself whenever I get a chance. However, I've found when I post HDR images online, I don't know what it is, but it brings out the worst in some people and they just have to post snarky comments like, "I'm sorry, but I hate HDR images" and other comments along those lines. After posting dozens of HDR images, I realized that people have an idea in their mind of what a "bad HDR" image looks like, and they apply that to any image a photographer notes is an HDR, so it's really not about the image any more—it's about the acronym HDR (which stands for High Dynamic Range). That's why I propose that we no longer use the acronym HDR and instead use the acronym "KMA" to describe our images. But, to appreciate this new acronym, we need to break it down to its basic form. Once you understand the nuances of the acronym, I think the entire HDR community will seriously consider adopting it. We'll start with the second letter, "M." When I post an image online, I'm posting one of "my" photos, so I think M is appropriate to represent the photographer that posted it. Then, I thought it would be cool to embed another popular acronym within our new acronym (kind of a Trojan horse acronym) and that would be the popular KISS (Keep it Simple, Stupid) acronym, which nearly everyone embraces, so we'll use "Kiss" as the first word. The third word in our acronym should be a short, ideally three-letter, word that describes people who write things like "I'm sorry, but I hate HDR images." So now, when someone writes something mean about an HDR you post online, you can respond by simply saying, "If you don't like HDR, you can KMA!"

Shooting HDR: The Gear

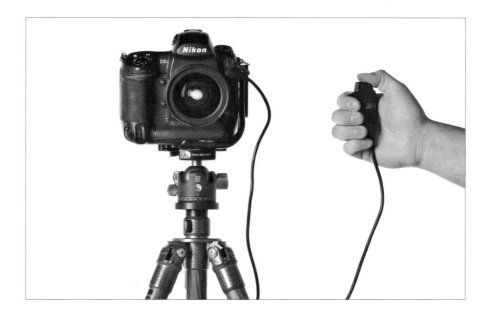

I was going to call this "The Essential Gear," but thanks to some pretty significant improvements in the software we use to create our HDR images, they're only essential if you're going to become a serious HDR shooter. You no longer absolutely need this gear to successfully shoot an HDR image, especially if you're just giving it a drive around the block to see if you like it. Now, if you try a few HDR shots, and you fall hopelessly and deeply in love with HDR (hey, this has happened to some of my friends—people who otherwise led normal, everyday lives until that point), then you should definitely invest in at least two pieces of gear that will give you better-quality HDR images. They are: (1) a decent tripod, unless you only plan on shooting HDR shots in really bright sunlight (which won't actually be the case, because some of the coolest HDR stuff is shot indoors), and (2) a cable release, so you don't wind up adding any extra vibration that might mess up your image. Now, there's a reasonable chance you already have both of these (especially if you've read any of the previous books in this series), and if you do, you should definitely be using both of these when you shoot your first HDR shot, because they will give you sharper images, and with HDR that sharpness is key. Also, since you might be considering just dipping your toe into the HDR pool of love, I want to let you know what the basic workflow will be, because it's a two-part process: the first part is shooting a particular way (hopefully using the gear just mentioned), because you know, up front, you want to create an HDR image, and the other part is combining these images into a single image and then adjusting that image so it looks good to you (more on all this on the following pages).

Shooting HDR: The Basic Idea

Before I get into specifics, I just want you to know two things: (1) shooting and toning HDR is actually fairly easy and probably way easier than you'd think, and (2) within the HDR community of photographers, no two seem to ever agree on anything, during any phase of this process, when it comes to making an HDR image. (Congress agrees more than HDR photographers do, as does the UN. Even lead singers and their bands agree more.) That being said, the first part of this process is shooting. You're going to set your camera up to shoot a series of shots of the same thing—without moving at all—and what you basically need is one regular shot, one shot that is underexposed (darker) by 2 stops of light, and one that is overexposed (brighter) by 2 stops of light—three images total of the exact same scene (some photographers shoot seven bracketed photos, or even 11, but for our purposes here, we're just going to use those three, which are enough to create a good-looking HDR image). If you use a Canon camera, and switch your camera to Av mode, set your f-stop to something like f/8 (see page 141), turn on Exposure Bracketing, and take three shots in a row, you'll have exactly what you need (one regular shot, one 2 stops darker, and one 2 stops brighter). That's the way Canon cameras and some Nikons (like the D7000) bracket—2 stops at a time. Some Nikons, however, only do 1 stop at a time, so you'll have to take five bracketed shots, even though you'll only use the first shot (normal), the second shot (2 stops darker), and the fifth shot (2 stops brighter). On the next page, we'll look at how to turn this bracketing on.

Setting Up Your Camera to Shoot Bracketing

First, I recommend setting your camera to aperture priority mode, so change your Mode dial to Av on a Canon DSLR or change your exposure mode to A on a Nikon. Okay, onto the bracketing: Exposure bracketing was actually designed to help us out in sticky lighting situations by taking more than one exposure of the same image. So, if you were off with your exposure by a stop or two (either you were too dark or too light), you could use one of those other images with the darker or lighter exposure—pretty clever when you think about it. Anyway, we use this feature to automatically take the exposures we need for HDR photos, because we actually need to combine a really dark photo, a regular photo, and a really bright photo into just one photo that will capture a larger range of light than our camera can capture in one single frame. Today, most DSLR cameras have built-in exposure bracketing, so all you have to do is turn it on. Of course, to make it extra fun for book authors, just about no two cameras turn this feature on in the same way. For Canon shooters (using a 50D, 60D, or a 7D), go to the second Shooting tab menu, and choose Exposure Compensation/AEB. Then, use the main dial on top of your camera to choose 2 stops in your LCD as the amount, and press the Set button. If you're a Nikon shooter, shooting a D4, D3, or D3S, there's a BKT button on the top left of your camera (shown above). Press-and-hold that button, then turn the main command dial on the back top right until it reads +1 in your LCD (this will take five shots. If you're using something like a Nikon D300, D300S, or D700, then just hold the (Fn) function button on the bottom left front of your camera (near the lens itself), and turn the main command dial on the back top right until it reads +5 (that chooses a five-shot exposure bracket). You are now set up to take your bracketed images for HDR.

A Canon Shooter's HDR Helper

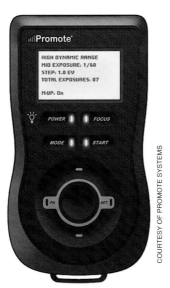

COURTESY OF PROMOTE SYSTEMS

The nice thing about being a Canon shooter when it comes to HDR is that you can do exposure bracketing in 2-stop increments (where most Nikon shooters can only bracket in 1-stop increments, which means they have to take five shots to create an HDR image, where Canon shooters can take just three). However, what if you're a Canon shooter and you actually want to take a wider range of bracketed images, like five shots or nine shots? If that's the case, you'll want to get a Promote Control (from http://promotesys-tems.com), which lets you do those wider range brackets on Canon cameras, like the 7D, 50D, and 5D Mark II. The shackles have been lifted—overshoot away! (Just kidding.)

How Many Bracketed Shots Should You Take? Three? Five? Nine? More?

Like everything else in HDR-land, there are people who argue that three bracketed images are all you need, but some photographers swear by five, and there are others that always take nine images. Which number is right for you? Here's a way to know: shoot the same exact scene three times—once with three, once with five, and once with nine (Canon shooters can use the tip above). Then combine each set into an HDR image, tweak each one, and see if you can see a marked difference in the final image. Just remember, the more bracketed images you take, the longer the processing will take and the faster you'll fill your memory cards. I'm just sayin'.

What If Your Camera Doesn't Have Bracketing?

Don't worry, even if your camera doesn't have built-in bracketing, you can still shoot bracketed frames to create your HDR image—you just need to know the trick. Of course, start by setting your camera to aperture priority mode (A on Nikons, or Av on Canons), then choose your f-stop for your HDR shots (I usually shoot at f/11). Now, take one shot, then use the exposure compensation control for your camera to take the next shot at –2 EV (that gives you the 2-stops-darker shot you need), then go the opposite direction to +2 EV and take your third shot (that gives you the 2-stops-brighter shot that you need). That's it—you've got all three images you need to make your HDR shot. Now, if you haven't used exposure compensation before, here's how to turn it on: On Nikon cameras, hold the exposure compensation (+/–) button on the top of your camera, and then move the main command dial on the back to the right until it reads –2.0 on the LCD on the top. Then do the same thing for your next photo, but change it to read +2.0. On Canon DSLRs, turn the power switch to the second On position, then use the quick control dial on the back of your camera to lower the exposure to –2.0 EV, and take a shot. Then, do the same thing for your next photo, but change it to +2.0 EV.

Which F-Stop to Use for HDR

Another thing photographers don't agree on is exactly which f-stop to use, but everybody pretty much agrees you need to use an f-stop that keeps a lot of your image in focus. Personally, I generally shoot my HDR shots at f/11 and most of the pros I know use f/8, but if you go on the web and search for this, you'll find people touting everything from f/1.8 to f/32. So, who is right? That's easy. Me! (Kidding. Totally a joke.) People make great cases for all different f-stops for the particular subject they're shooting, but if you're new to this, why not try f/11 for starters? If you're shooting indoors, though, try f/8 as f/11 may over-expose your images.

Understanding What "Post-Processing" Means

In this chapter, you'll see the phrase "post-processing," and that basically means anything you do to the photo using software after the fact (like editing it in Photoshop, or in an HDR application, like Photomatix Pro, or any image editing program).

Don't Shoot One Bracketed Shot at a Time

If you're going to shoot a series of bracketed HDR shots (like three or five bracketed frames), don't shoot them one at a time. Instead, switch your camera to automatically shoot a burst of all three (or all five) when you press-and-hold the shutter button down just once. Here's how: On Nikon DSLRs, you choose burst mode (called "Continuous High Speed") by going to the release mode dial on the top left of your camera and switching to CH mode. On Canon cameras, you press the AF•Drive button on the top right side of your camera, then rotate the quick control dial on the back until you see a little symbol that looks like a stack of photos next to an H on your LCD (this is called "High-Speed Continuous Shooting"). Now, once you've turned bracketing on, you just press-and-hold the shutter button until you hear that all three (or five, or more) bracketed shots have been taken. Besides just being plain easier to do it this way, you'll get less camera vibration and the shots will fire faster in burst mode than they would having to manually press the shutter button three or five times in a row. Plus, using this method, you won't forget how many frames you've taken and won't have to ask yourself, "Did I just shoot four or five?" (Hey, it happens.) Now, if you're shooting HDR at twilight/night, oftentimes the exposures are going to get longer. By using a cable release (with your camera on a tripod), you can take advantage of its lock switch (just press the cable release button and lock it into place). While it's easy to press-and-hold the shutter button for three or five shots during the day, you may introduce shake for the night shots.

Shooting Hand-Held HDR Shots

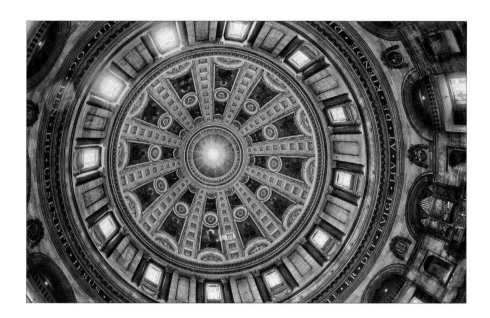

I mentioned at the beginning of this chapter that you don't have to shoot your HDR shots on a tripod thanks to some advances in the HDR software that actually align your images and remove any "ghosting" that might happen from movement (and both work amazingly well). Now, whether you can get away with hand-holding really comes down to just one thing: how much light there is where you're shooting. If you're shooting outside in the day, it's probably not going to be a problem, so just hold your camera steady and fire away. If you're indoors, or it's stormy out, or if it's night, then it gets tricky. Now, I've hand-held five bracketed HDR shots inside a church, and they all came out pretty sharp. However, since I knew the light was low, I did two things that helped a lot: (1) I leaned on a column in the church to help steady me and my camera—this makes a bigger difference than you'd think. (2) I broke one of the big rules of HDR, which is to also shoot at the lowest ISO possible, because in the low light of the church, the lowest possible ISO for me to hand-hold was 800 ISO. So, the shot does look a bit noisy (grainy), but at least it's sharp. I would say at this point, I probably shoot more hand-held HDR shots than I do on a tripod. But, if I have a tripod handy, then I usually put my camera on it and use a cable release (the problem is my tripod isn't always handy). So, in short, don't let the fact that you don't have a tripod keep you from shooting bracketed HDR shots—just do your best (and use tricks like leaning against solid objects) to keep yourself still through three or five frames. Then let the software do the rest (aligning and removing ghosting).

Which Types of Scenes Make Good HDR Shots

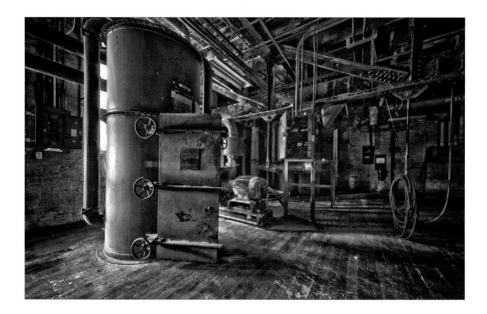

Since the process of shooting HDRs is pretty mechanical (the camera does most of the work), the real creativity of HDR photography is finding shots that look great as HDR images, because not everything makes a great HDR image. In fact, some types of images just look fantastic as HDR, while others, like photos of people, well…in short, I'd just avoid shooting HDR shots of people. So, what does look good? Start by looking for scenes that have a wide range of light—really dark areas and other parts that are really bright. HDR was made for situations like this (which is why you see a lot of dawn and dusk landscape shots in HDR). So, extreme changes in light will give you the expanded range part, but you'll still need subjects that make for great HDR images. Scenes with lots of texture (like metal, wood, old paint, fabric, concrete, aluminum, and so on) really look great for this, which is why you see so many great HDR shots of old buildings, factories, old restaurants, airplanes, classic cars, old motels from the 1950s, and anything run down. Also, sometimes really modern things make great HDR too, like buildings with wild architecture, airports, etc. Finding these things is really an art, and it's a lot of the fun of creating HDR images. If you want to see what kind of cool scenes are popular for HDR, visit a site called http://500px.com (go to the Popular Photos link). You will see some amazing images, including lots of HDR photography that will inspire you to search for places you've probably driven by a hundred times and never thought anything about (except maybe, "When are they going to tear down that old building?"). Now you'll be wrangling to find a way to get inside to shoot it!

Shooting HDR Panos

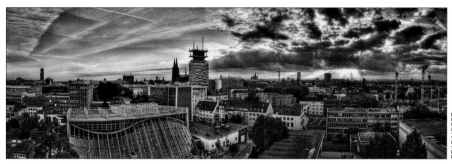

BRAD MOORE

Okay, this isn't hard to pull off (you absolutely can), but you've really got to want to do it, because it takes some time—both in the shooting phase and the post-processing phase. Here's why: First, you're shooting a pano, which means you're probably going to be shooting anywhere between eight and 12 images already, right? But, if you want it to be an HDR pano, you'll then have to shoot bracketed for three to five frames each (minimum) of those eight to 12 images. So, for example, if you shoot a Nikon D3S and your pano is going to be eight frames wide (moving from left to right), each of those eight frames will be bracketed at five frames each, so this one HDR pano will be comprised of 40 photos! (I told you this would take a while.) Anyway, here's how it's done: Step One: When you're ready to take the first frame, turn your exposure bracketing on (see page 138). Take the shot, but remember to press-and-hold the shutter button until it takes all five frames (or three; see page 137). Now, move to your second frame and repeat the process, shooting multiple bracketed photos each time you rotate your camera over a bit for the next frame, until you're done. Step Two: Process each frame individually (take the first three or five images and combine them into one HDR image, and so on). Once all your images have been combined, you should be back down to just eight frames that are all HDR single images. Now, open just those eight HDR images in Photoshop. Go under the File menu, under Automate, choose Photomerge, and ask it to use the images already open in Photoshop. Click OK to merge those HDR images into one wide panoramic image. Crop it down to size and add any additional post-processing to finish it off (see page 151).

Easily Find the Images You Bracketed for HDR

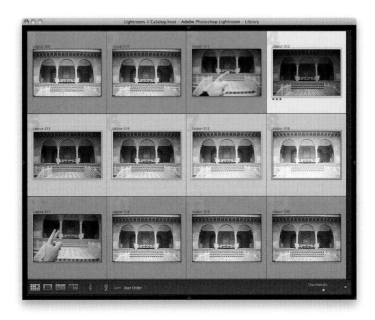

I hear from people all the time who shoot HDR images that they forget that they shot them because, in the hundreds of images they import into their computer (using anything from Bridge to Lightroom to iPhoto to Photo Mechanic), they can't instantly tell if their exposure was off a bit or if it's an HDR shot. This is particularly bad if you don't get a chance to look at your images the same day you shoot them, because there's a good chance you'll miss some here and there. That's why this tip, which I actually started using first when shooting panos, is so handy for making it easy to find your HDR-bracketed images When you're about to shoot your HDR image, before you turn on bracketing, hold one finger up in front of your lens and take a shot. Then, turn on bracketing, shoot your HDR-bracketed images, and then turn off bracketing. Now, hold two fingers up in front of your lens and take another shot. That way, when you're looking through the hundreds of shots you imported from your memory card, when you see a shot with you holding up your finger, that means, "Here comes an HDR." Now, if you shoot panos and HDRs, then put up three fingers to start your HDR and four when you're done. This is much handier than you'd think.

HDR Shots Generally Look Best If You Start with RAW Images

The more data your HDR image has, the better, so if you shoot in RAW, you'll get somewhat better results with your HDRs than you would shooting in JPEG. If you shot in JPEG already, no biggie, but if you get serious about HDR, you should probably start shooting at least those shots in RAW.

The Programs We Use for Creating HDR

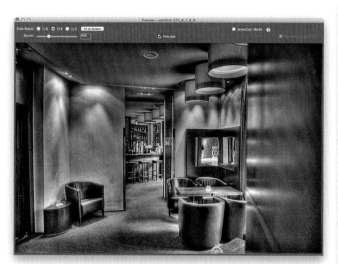

Once you've taken your exposure-bracketed shots, you need a piece of software to combine these separate images into one single HDR image. Although there are a number of HDR programs out there, everybody seems to use the same three: (1) Photomatix Pro (shown above; http://hdrsoft.com), which is made by a French company (but the program is in English) and is the most popular HDR application out there. Its advantages are that it definitely has its own signature look, and it creates your HDR image quicker than any other HDR application I've tried. (2) Photoshop CS5's (or higher) HDR Pro (www.adobe.com/photoshop). In Photoshop CS5, Adobe overhauled their HDR capabilities and now it does a pretty decent job—especially on hand-held HDRs or photos with ghosting. The presets it comes with are very, very lame, but see page 148 for help with that. The advantages are, if you already have Photoshop CS5 or higher, you already own a program that creates HDR images. And, finally, (3) Nik Software's HDR Efex Pro (www.niksoftware.com). This one is fairly new, but photographers have really flocked to it. Its advantages are that is has a great, easy-to-use interface, lots of presets, and features like built-in vignetting and the ability to tweak individual parts of your images. It wins the feature war for sure. So, which one is the right one for you? You can download demo versions of each of them for free (including Photoshop), so try them out and see for yourself. Try each on the same HDR image, so you can compare the results side by side. Since they all work a little differently and all three have their own look, you'll quickly find out which one is the one for you.

A Good Preset for Photoshop's HDR Pro

If you need to combine your bracketed images into a single HDR image, but you don't have either Photomatix Pro or Nik Software's HDR Efex Pro, but you have Photoshop CS5 (or higher), then you can use Photoshop's built-in HDR Pro feature (found under the File menu, under Automate) to combine the images and add the tone mapping. (*Warning:* If you have an earlier version of Photoshop [like CS4, CS3, or earlier], don't use the HDR feature at all. It's…it's…well…awful [sorry Adobe].) Back when CS5 first came out, the presets for tone mapping that came with HDR Pro were so lame that they were basically unusable, so I created one of my own that actually works pretty well for most images. I call it "Scott 5" (I know, it's a very creative name, but is it possible that I stole the name from the band Maroon 5? No, that would be too creative). Anyway, I'm going to share my settings with you here, so you can give it a try. You can see the settings above, but just in case, they are (from top to bottom): under Edge Glow, Radius: 176 px, and Strength: 0.47; under Tone and Detail, Gamma 0.76, Exposure 0.30, Detail: 300%, Shadow: 100%, and Highlight: –100%; under Color, Vibrance: 22%, and Saturation 26%. Lastly, I click on the Curve tab and add an S-curve like the one you see above on the right. This just adds an extra bit of contrast. You add points to the curve by clicking on the diagonal line, then dragging up or down. If you make a mistake, just click on a point and then press Delete (PC: Backspace). Now, once you enter these settings, you can save them as your own "Scott 5" preset by clicking on the icon to the right of the Preset pop-up menu up top and choosing Save Preset. That's it—you're all set.

Sharpening HDR Photos

HDR pros get pretty aggressive when it comes to sharpening their images, because one of the hallmarks of a good HDR image is the overall sharpness. That's why a lot of HDR pros use High Pass sharpening in Photoshop, which is just another form of sharpening, but the type of sharpening it applies is really punchy, and it's easy to adjust right after you've applied it to your image. Here's how to apply High Pass sharpening: Step One: In Photoshop, duplicate your Background layer. Step Two: Go under the Filter menu, under Other, and choose High Pass. Step Three: Drag the Radius slider all the way to the left, until the screen turns solid gray, then drag it back to the right until you see a decent amount of detail appear, but not so much that you start to see halos around the edges of everything. Step Four: At the top of the Layers panel, change the blend mode from Normal to Hard Light (for extreme sharpening) or for a little more subtle sharpening (and the one I prefer to use myself), choose Soft Light. If that still seems like too much sharpening, just lower the Opacity of this High Pass layer until it looks right to you. That's it.

Shooting HDR Shots at Night

Although we think of HDR for balancing extreme lighting situations, HDR images at night of cities, buildings, and cafes can be really fantastic. Here's the tip: when you shoot scenes like these, change your f-stop to f/16, and the lights at night will have beautiful star brights.

The HDR Look Without Shooting HDR

If you want a very HDR "look" to your images, but without actually shooting multiple images, download a Photoshop plug-in called Topaz Adjust (www.topazlabs.com) for around $50. Now you're just one click away from that look, because the plug-in has a bunch of built-in presets. For example, try Detail, or perhaps Clarity, or even Portrait Drama (found under the Vibrant Collection effects), which all have different HDR-type looks. If you really like that "Harry Potter surreal look" (as we like to call it), then try either Psychedelic or HDR Sketch, under the Stylized Collection effects (oddly enough, Psychedelic looks less psychedelic than HDR Sketch). Here, I chose the Heavy Pop Grunge preset found under the HDR Collection effects. So, if this plug-in does the trick, why shoot the three- or five-image regular HDR shots at all? Well, the plug-in doesn't capture any additional range of light, so it doesn't expand the range of what your camera captured—it just mimics the tone-mapping (the special effect part) of HDR photos. So, you really don't have an HDR photo—just one that most folks would assume is an HDR, especially at first glance.

Topaz Adjust Isn't Just for "Faking" HDR

A lot of the popular HDR pros out there actually use Topaz Adjust as part of their regular real HDR post-processing. They shoot in HDR, combine the images into a single image, then in Photoshop they use the effects of Topaz Adjust to tweak their images and give them a particular look. So, getting the Topaz Adjust plug-in isn't a bad idea, whether you want to apply it to single images or to multi-image real HDR shots.

What They're Not Telling You About HDR

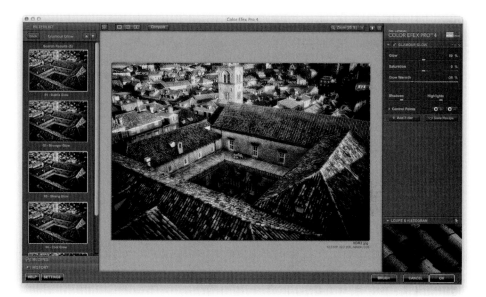

If you've done any research on shooting and processing HDR images, you probably know that you have to shoot bracketed photos, and then you need some program to combine those bracketed photos into one single image (like Photomatix Pro, or Photoshop's built-in HDR Pro, or whatever). But, a lot of folks are disappointed once they've combined their bracketed frames into one HDR image, because they say, "My shots really don't look like the ones I see on the web and in books. What am I doing wrong?" It's not that they're doing something wrong, it's just that there's something the pros do that few are willing to talk about. They take their compiled HDR images into Photoshop and do quite a lot of post-processing there, tweaking everything from the color to the sharpness, adding Clarity, and even running plug-ins like Nik Software's Color Efex Pro (in particular their Tonal Contrast and Glamour Glow presets, which are very popular for finishing off HDR images). They probably spend more time in Photoshop than they do in the HDR software itself. So, if you're wondering why your images don't look like theirs, it's because they're doing one more big step to finish off their photos. Just so you know.

Photoshop for HDR

We produced a book written by my buddy (and co-worker) RC Concepcion called (wait for it…wait for it…) *The HDR Book: Unlocking the Pros' Hottest Post-Processing Techniques*, and it focuses on exactly how to post-process your HDR images in Photoshop. The book is a huge hit, and you can pick it up wherever really cool books are sold. You'll love it.

Fixing Halos & Other HDR Problems

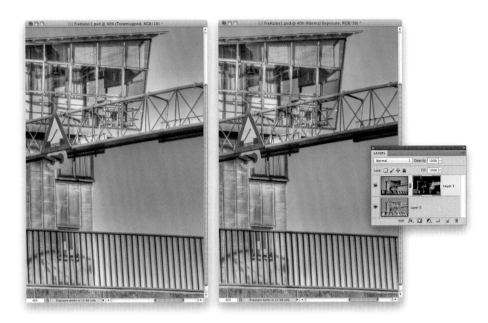

If you create an HDR image and see halos around parts of the image that look bad, or you have an area with some ghosting that wasn't fully removed by your HDR software, here's a trick to deal with these problem areas: Open your HDR image in Photoshop, then re-open the normal exposure image from your bracketed shots (before you converted it to HDR) in Photoshop's Camera Raw. We want to give it a little "HDR feel" before we use it, so increase the Clarity and Contrast quite a bit (use your judgment to get it looking nice and crisp), then click Open. Now, press-and-hold the Shift key and drag that normal image right over on top of your HDR image (holding the Shift key aligns this image perfectly with the HDR shot below it). Option-click (PC: Alt-click) on the Add Layer Mask icon at the bottom of the Layers panel to put a black layer mask over your normal image, and hide it from view. Get the Brush tool and choose a small, soft-edged brush, set white as your Foreground color, and paint directly over the problem areas (with halos or ghosting), and it paints back in the normal photo in just those areas (which is why you want to use a pretty small brush—this is supposed to be a subtle touch-up). This can really work wonders, because the problems only came about once you combined the images into an HDR, so that original shot is pretty clean. If, when you paint, the original areas look too obvious, try lowering the Brush's Opacity amount to 50% (up in the Options Bar) and try again. If you need to erase something, switch your Foreground color to black and paint it away. By the way, if you drag the original image on top and it doesn't precisely line up with the HDR shot (which is likely), then select both layers in the Layers panel, go under the Edit menu, choose Auto-Align Layers, and click OK in the dialog to use the Auto mode (you might have to re-crop a tiny bit after it does its alignment thing).

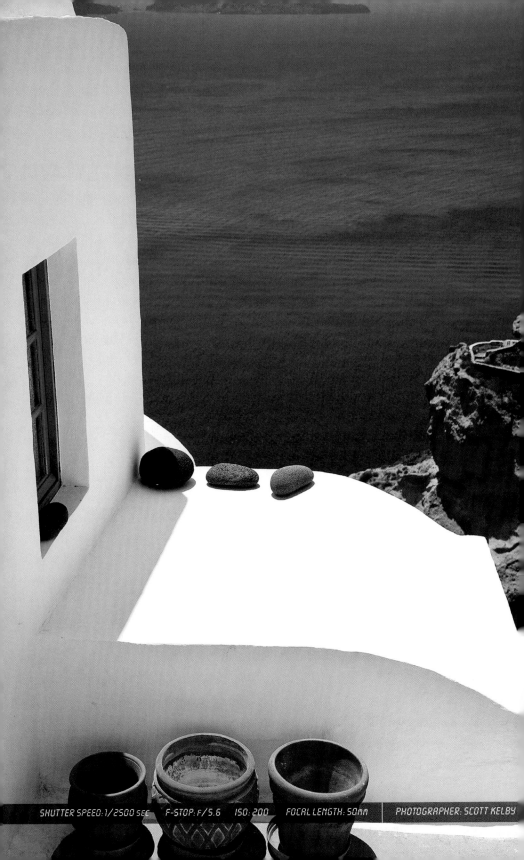

SHUTTER SPEED: 1/2500 SEC F-STOP: F/5.6 ISO: 200 FOCAL LENGTH: 50mm PHOTOGRAPHER: SCOTT KELBY

Chapter Ten

Pro Tips for Shooting DSLR Video

How to Get the Most Out of Your Built-In Video Capabilities

This is the first book in this series that has a chapter dedicated to shooting DSLR video, and when you think about it, it makes sense because you can hardly find a DSLR these days that doesn't have built-in HD video capabilities, so I thought it was time. But before you dive into becoming a DSLR filmmaker, there is a sad truth about the video industry that you'll need to come to grips with first, and that is: video accessories aren't like photographic accessories. They are insanely expensive. I think it's because, for years, anything to do with shooting or editing video had been so incredibly expensive (only big corporations with huge budgets could afford to create their own videos), and even though every DSLR now has video, the video industry really wants to embrace these photographers so they feel like real video producers. Of course, the only way to really experience the pain and suffering real video producers go through is to let them purchase a piece of video gear. Any piece of gear. It's a real shock to photographers, but if you don't believe me, try this: go to an online photo store and find a common accessory, like a polarizing filter, and write down its price (let's say it's $29). Now, go to an online video camera store and search for a similar polarizing filter for video cameras. The price will be around $300. This is why selling video equipment has been traditionally more profitable than running a Las Vegas casino. It's not just polarizers, though, because video production people have become accustomed to paying insane amounts for just about anything. For example, a box of paper clips, if purchased from a video accessories store, can run as much as $60. Maybe more. And forget about ordering things like a tube of toothpaste or some frozen waffles— they will require you to complete a credit application in advance. So, my advice to you is: never actually shoot video with your DSLR unless you are a rich doctor, lawyer, or you own a video accessories store.

You're Gonna Want an Eyepiece

If you're going to be using your DSLR as a video camera for any length of time at all, you're really going to want an eyepiece (something that covers the LCD monitor, so you can hold it up to your eye like you would a regular video camera). Not only is it more comfortable and easier to see when you're out in daylight, but by resting the eyepiece against your face, it helps steady your camera big-time by adding another point of contact to your body. You can spend a bundle on an eyepiece, but the one I like is pretty affordable (well, for a video accessory anyway, and if you think photo gear is expensive, video gear is for oil barons), because it starts by using a Hoodman HoodLoupe (I talked about these back in volume 2 of this book series, and basically it's a hood you hold over your LCD monitor so you can see it clearly, even in bright sunlight, that runs around $80). Then, you pick up their Cinema Strap accessory (around $20), which easily holds that loupe in place right over the LCD monitor, so it feels more like you're using a regular video camera, and it really makes a big difference. In fact, it's a big enough difference that if you're going to be shooting a lot of DSLR video, it's totally worth the hundred bucks (if you just said, "100 bucks??" in disbelief, welcome to the wonderful world of video accessories. A good rule of thumb I use is this: whatever you think an accessory would cost if it was just for photography, add a zero at the end for video).

Learn the Popular "Rack Focus" Technique

One of the most popular DSLR video effects makes use of perhaps the best thing about DSLR—the shallow depth of field you can get with camera lenses. The trick is to focus on something close to the camera (so your distant subject is out of focus), and then slowly focus on your subject. (I posted a video of this effect on the book's companion website mentioned in the introduction.) This is basically an unfocusing, then refocusing effect (called "rack focusing" in movie terms). It's simple to do, but you have to do it smoothly because it's done by manually turning the focus ring on the end of the lens until your subject looks sharp. Start by choosing an f-stop that will give you a shallow depth of field, like f/2.8 or f/1.8, leaving autofocus on for now, and focus on an object close to you in the foreground (if the object isn't fairly close, you'll lose the shallow depth of field effect). Once it's in focus, turn the autofocus off (right on your lens) and start your video recording. After a couple of seconds, smoothly rotate the focus ring on your lens until your subject is in focus. It seems kind of anti-climactic when you're doing it, but it looks very cinematic in playback.

How to Make Rack Focus Even Easier

There's an accessory called "DSLR Follow Focus" (around $60), which adds a large focus knob to your lens. You can mark the point at which your subject, or other things in your scene, is in focus with a grease pencil, so you can easily turn the knob and focus right on any spot in the scene and know that it's sharp.

Adding Effects to Your Video in Your Camera

Although I generally don't recommend using any of your camera's built-in tint filters or effects (like B&W, Sepia, Cyanotype, etc.) for still images (you're always better off shooting in full color and then, if you want to try any of those effects, adding them later in Photoshop, Lightroom, iPhoto, or whatever photo editing software you have. That way, you've still got the original full-color image), when it comes to shooting digital video, that's one place where I think the built-in filters come in handy. Especially for people who don't want the hassle or complexity of learning a whole video editing program just to be able to apply these effects, but still want these types of looks. If that sounds like you, then just apply them in-camera right onto your video by simply turning them on before you shoot your video. On Nikon DSLRs, you turn on these effects by going under the Shooting menu, choosing Set Picture Control, and then going under Monochrome, and choosing the effect you want to apply to your video. On Canon DSLRs (like the 7D), press the Picture Style Selection button, choose Monochrome, and then choose the effect you want to apply.

Shooting DSLR Video Drains Your Batteries Faster

Because your camera is working continuously when you're shooting video (instead of just coming to life for $\frac{1}{125}$ of a second here and there), it drains your batteries faster, so make sure you keep a spare camera battery with you.

Why You Want an External Mic

The built-in audio mic on your DSLR is…well…there's no polite way to say it, so let's just say if you actually want to hear what your subjects are saying, you should consider picking up an external mic that plugs right into your DSLR. Most DSLRs these days have a standard ⅛" mic jack (the size of a small headphone jack), so you can plug a better mic right in (see, even they know their mics are lame). You don't have to spend an arm and a leg to get a decent mic—the popular Tascam TM ST1 mic runs around $30, and it's small, lightweight, records in stereo, and is a big step up from your DSLRs built-in mic.

How to Break the DSLR Video Time Limit

Depending on which model of camera you have, you can shoot video for anywhere from 5 minutes to 12 minutes (and there are all sorts of conflicting opinions on why its limited to such a short time), but there's an easy way around it. If you pause your recording, even for just two seconds, it resets the video timer clock and you can start shooting again (so to shoot 36 minutes, you'd only have to pause twice, each time for just a second or two, and then you can keep right on shooting). Just pick a boring moment to pause.

Bad Audio = Bad Video

The quality and cinematic look of the video that today's DSLR cameras create is so good right out of the camera that you really don't have to work hard to make it look good— it's *gonna* look good. So what's the thing that's going to make your great-looking video come off cheap and amateurish? If it's anything, it's the audio. This is one big area that separates the pros from the amateurs—the pros have audio that matches the quality of the video, and if you have one without the other, it's not going to have that pro look in the end. Think of it this way: if you opened an Italian restaurant and you made your pasta fresh from scratch, would you then just open a jar of cheap spaghetti sauce and pour it on top? Of course not, because that cheap sauce would hide how great your handmade pasta really is. You have to have great pasta and a great sauce to make a pasta dish that's really special. It's the same way with video: it takes both parts—great video and great audio—to make a movie that's really special. So, if there's an area where you don't want to cut corners, it's the audio. If you can invest around $150, check out the Rode VideoMic shotgun mic, which mounts right on top of your camera or on a boom pole, and comes with a shock mount so you don't hear the rustling of the mic on the video as you move the camera. Nikon also has one, the ME-1, for $130. When you're ready to take your overall video quality up a big notch, this is the place to start.

Making Certain You're In Focus

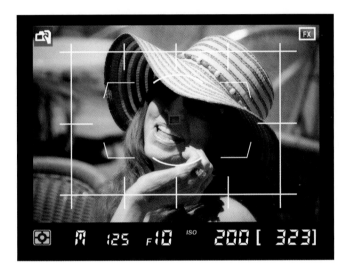

Most DSLRs require you to manually focus on your subject when shooting video, and that's made even trickier by the fact that you're not looking through your viewfinder to focus—instead, you're using the LCD monitor on the back of your camera, and if you're subject isn't really large in the frame, there's a fair chance they'll be at least a little out of focus. So, since you're already looking at the LCD monitor before you start recording, why not use the zoom button (the little magnifying glass with the plus sign) to zoom in tight on your subject and make certain they're in really sharp focus before you hit the depth-of-field preview button (on a Nikon) or the Start/Stop button (on a Canon). Of course, don't forget to zoom back out before you actually start recording (you knew that, right?).

Don't Shoot Video Vertical

I see photographers do this all the time, because we're so used to shooting in portrait orientation for stills, and while portrait (tall) shots look great in photography, a tall, thin rectangle is not how people are used to seeing movies and, not only does it make your video appear significantly smaller onscreen, it kind of freaks people out to see video in that format. Just remember: when you're shooting video, stay wide.

Why You Need to Lock Your Exposure

Canon

Nikon

When we're shooting stills in anything other than manual mode, we want the camera to examine each scene and pick the right exposure for what we're aiming at, and if we aim to the left or right, we expect it to adjust, right? Of course. While that works great for still images, it creates a disaster with video, because you don't want the brightness in the video changing every few seconds as you move the camera—it makes it look like the light in your scene is pulsating up and down, which is annoying as all get out. The way around this is to lock your exposure before you start recording, and that way your exposure will stay constant and you'll be side-stepping one of the biggest problems DSLR video shooters complain about. To lock your exposure, first get your exposure the way you want it before you start recording by aiming your camera at the scene, and then holding your shutter button halfway down to set the exposure. Now, on Canon cameras, you'll press-and-hold the AE Lock button (on the top right back of the camera, shown above on the left), and once it's locked, you can start recording. On Nikon cameras, it works best if you switch your metering mode to Center Weighted (it's the middle choice) before you press the shutter button halfway down to get your exposure set, so turn your Metering Selector on the top side of the camera to Center Weighted, then press the shutter button down halfway to set the exposure. Now, press the AE-L/AF-L button (shown above on the right), to lock that exposure and now you can begin recording without worrying about your brightness pulsating.

F-Stops Matter Here, Too, But…

Choosing your f-stop when shooting video matters just like it does when you're shooting stills—if you want the background to be soft and blurry (a shallow depth of field), then shoot at an f-stop like f/1.8, f/2.8, f/4, and so on, and if you want everything in focus, f/8 works great. But, there's something to keep in mind when shooting video, and that is: you can't just throw a flash up if you want to shoot at f/16 or f/22. If you want to shoot at f-stops like that (where everything's in focus for a very long range, like when you're shooting land-scape stills), you'll need to be outdoors in really bright light, or you 're going to have some really dark video. That's why, most of the time, you'll be shooting at f/8 or a lower numbered f-stop—you need a lot of light for video, so those higher numbered f-stops are usually only available to you outdoors in the daytime.

Why You Need Fast Lenses for DSLR Video

Since you can't use a flash to light your subject, most (if not all) of the time, you'll have to use the available light where you're shooting, and unless you're shooting outdoors all the time, you'll need to use fast lenses (like f/4, f/2.8, or f/1.8) to be able to shoot in those low-light situations. Both Nikon and Canon make 50mm f/1.8 lenses that are in the $125 range, and when you go into low-light situations (like a church for a wedding), you can pop that 50mm f/1.8 on your DSLR and keep right on shooting.

How to Avoid "Flicker" While You're Shooting

If there are fluorescent or mercury vapor lamps visible in your scene (pretty typical in stores, warehouses, and offices), or if you see televisions or computer screens anywhere in your scene, then you're probably going to see some flickering or pulsating from either or both of these. It's caused by the flow of electrical current, but luckily it's easy to fix. First, check to see if your camera has a flicker fix control (for example, the Nikon D5100 has a Flicker Reduction option found under the Setup menu. When you choose Flicker Reduction, it has a number of different frequency choices—just try each one to see which one works best). If your camera doesn't have any type of flicker reduction, you can do it yourself by adjusting your shutter speed. For example, in the U.S., the electrical system is based on 60 hz, so we have to shoot at a shutter speed of ⅟₆₀ of a second (or any derivative thereof, like ⅟₁₂₀ of a second, or ⅟₁₈₀ of a second, and so on). In Europe, the electrical system is at 50 hz, so you need to shoot at a derivative of ⅟₅₀ of a second (like ⅟₁₀₀ of a second, ⅟₁₅₀, and so on). That should do the trick.

Want More of a "Film" Look?

By default, many cameras are set to shoot video at 30 frames per second, which is a pretty standard frame rate for video, but a trick the pros use to get more of a film look (and less of a videotape look) is to slow the frame rate down to 24 frames per second. To do this on Canon cameras (like a 7D), go to your Movie menu (or Settings-2 menu, under Live View/Movie Function Settings), and when you choose your Movie Recording Size, choose 1920x1080 Full HD and choose 24p as your frame rate. That's all there is to it. On Nikon cameras, except for the D4, your frame rate is already set to 24 frames per second, so you're good to go.

For a More Film-Like Look, Turn Off Your In-Camera Sharpening

By default, your camera applies sharpening to your images (except when you shoot in RAW mode, and when shooting video, you're definitely not shooting RAW, so it's applying sharpening). If you want a flatter, more "film-like" look, turn off this in-camera sharpening. On a Nikon, go under your Shooting menu, chose Set Picture Control, and then choose Neutral. On a Canon, press the Picture Style Selection button and then choose Neutral.

Don't Touch That Aperture

When we're shooting stills, if we think we need a different aperture, we just change it, right? But when you're shooting video, you don't ever want to change apertures while you're recording or you'll see a very obvious lighting change right in the middle of your clip, which is generally a big no-no in video circles. So, don't do this unless you want people pointing at you at video parties and whispering, "She changed apertures in the middle of a clip." Nobody wants that.

Why Zooming on Your DSLR Is Different

When you zoom in/out on a traditional video camera, the zoom is very smooth because it's controlled by an internal motor—you just push a button and it smoothly zooms in or out, giving a nice professional look. The problem is that there's no internal motor on your DSLR—you have to zoom by hand, and if you're not really smooth with it, and really careful while you zoom, you're going to wind up with some really choppy looking zooms. In fact, since it's so tough to get that power-zoom quality like we're used to with regular video cameras, there are a bunch of companies that make accessories so you can make it look like you used a power zoom, like the Nano focus+zoom lever from RedRock Micro. It's two pieces (sold separately, of course, because this is video gear and therefore a license to print money), but luckily, neither is too expensive. First, you need the focus gear, which is sized to fit your particular zoom lens, and that runs around $45, but that's just for focusing (very nice to have, by the way), but then you add this zoom handle to it, for another $35 or so (also worth it), so you're into both for only around $80, but it sure makes zooming smoothly a whole lot easier.

How to Use Autofocus for Shooting Video

As you've probably learned, many DSLR cameras don't autofocus when you're shooting DSLR video, so then it's a manual thing, but that doesn't mean you can't use Autofocus to help you out. The trick is to use Autofocus before you start shooting, so basically, you turn on Live View mode, but don't start recording yet—instead, aim your camera at your subject, press the shutter button down halfway to lock the focus, then move the Auto-focus switch on the barrel of your lens over to "M" (Manual) mode, and you're all set. Now, the only downside is if your subject moves to a new location (even if it's two feet away), you have to do this process again (luckily, it only takes a few seconds each time you do it, and you get pretty quick at it pretty quickly).

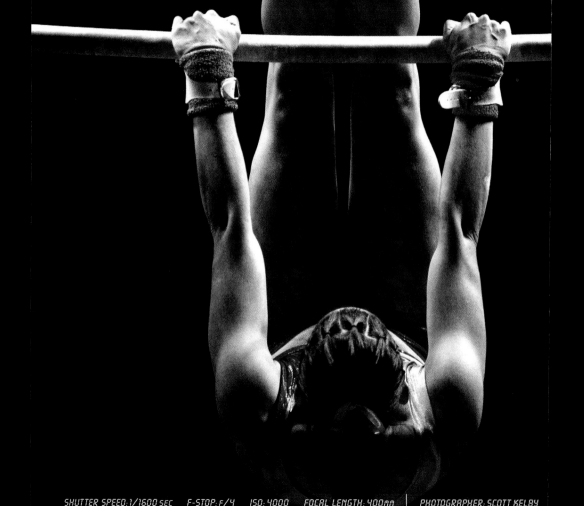

SHUTTER SPEED: 1/1600 SEC F-STOP: F/4 ISO: 4000 FOCAL LENGTH: 400mm PHOTOGRAPHER: SCOTT KELBY

Chapter Eleven

Pro Tips for Getting Better Photos

More Tricks of the Trade for Making Your Shots Look Better

One day, while doing research for an upcoming talk I was giving on the history of American photography, totally by accident, I stumbled upon something I clearly wasn't supposed to find. It piqued my curiosity, so I kept digging around, and the more I dug, the more shocking what I uncovered became. Soon, I had no choice but to share what I had learned with a well-known top photographer, and after my solemn promise to protect his identity at all costs, he was willing to not only corroborate my findings, but he let me in on a truly startling, highly-guarded, and explosive secret—one that, once revealed, will likely have a devastating effect on our entire industry, but this is a story that must be told. Deep breath—here we go. First, you need to know that there is a secret council of photographers called the Zeta 7, founded in 1946 in Bensonhurst, New York, with the sole purpose of protecting a set of hidden camera settings, techniques, and camera functions which, when used together, create professional-looking images every single time. The Zetas only share these secret settings with their Zeta Brothers as a way of ensuring only Zeta members will be able to create truly amazing images. Each year, the Zetas induct seven more hand-picked photographers into their order during a ritualistic blood oath ceremony (supposedly held in an abandoned New York subway tunnel that runs directly beneath the B&H Photo showroom on 9th Ave. and West 34th St.), where they are sworn never to divulge the inner workings of the order. Then, and only then, are they allowed to don the ceremonial robes for their one-time, candlelight access to the "sacred settings scroll," which contains those secret settings to getting pro-quality images, and this is why only a select group of top pros seem to get these amazing images time after time. Interesting side note: According to one Zeta who was excommunicated from the order, the secret password to enter the Zeta meetings is, "It's not about the camera." True story.

Fit a Lot More Shots on Your Memory Card

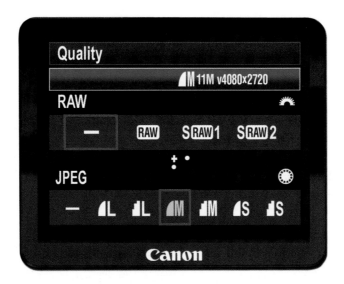

I mentioned back in volume 1 of this book series that, to have enough resolution to print a 16x20" print, you only needed an 8-megapixel camera. Of course, most folks will never print anything larger than an 8x10, so you could make the case that, for most photographers, 8 megapixels is actually overkill. That being said, what if you don't make prints at all? Today, most people's images wind up on the web, and if that's the case (and you shoot in JPEG mode), you might consider lowering the megapixels your camera shoots. Not the quality, just the size of the images. That way, you fit more images on your memory cards, you take up less space on your hard drive with your photos, and even Photoshop will run faster, because you're working with smaller file sizes. To do this on most Nikon DSLR cameras, go under the Shooting menu, under Image Size, and choose Medium. If you have a 12-megapixel camera, that still gives you an image size of 3216x2136 pixels, which is still more than enough resolution to print an 11x14" image. (Remember, this only takes effect if you shoot in JPEG mode, and make sure you keep your Quality setting on Fine.) On Canon cameras, on the Shooting 1 tab, go under Quality, and choose the first Medium choice, which on a 50D still gives you an 8-megapixel image (medium is even larger on a 5D or 5D Mark II).

You Can Use Smaller RAW Sizes on Canon Cameras

If you have a Canon DSLR, you can actually do this same trick on RAW images, as they offer Medium RAW and Small RAW. All the same features at half the size (or less).

Sneaky Trick When You Can't Use Your Tripod

More and more places, like museums, observatories on top of tall buildings, train stations, and even cathedrals, have very strict rules about not using tripods, but so far I haven't found a single one that has a rule about using a Manfrotto Magic Arm and Super Clamp. You just clamp it on something (like a railing or a pew, for example), and it holds your camera steady so you can shoot in really low light. Security guards are totally perplexed by them, because there's nothing in their rules about accessory arms. In fact, if they approach you and ask, "What is this?" You can say something like, "Oh, this is a way for me to keep my camera still without having tripod legs sticking out where someone might trip." (See, you're looking out for them.) Of course, you could add, "I have to use this because I have shaky hands." However, I would never stoop to using this slightly modified response, "I have to use this to steady my camera because of a medical condition," because a line like that would probably work every single time. I'm just sayin'.

When Exposure Compensation Doesn't Work

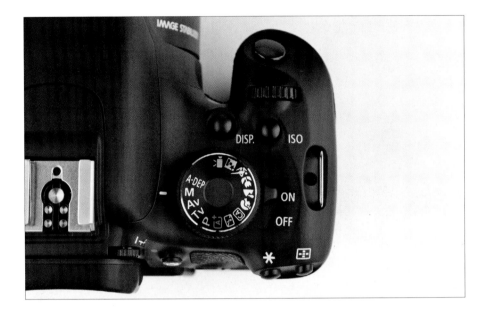

I think one of the most important things a new photographer can learn about their camera is how to use exposure compensation, which is basically where you don't agree with how the camera exposed the shot. It thinks it did a great job, but when you look at the LCD on the back of your camera, you think the image looks too dark or too bright (both are pretty common, especially in tricky lighting situations). Whatever it did, it didn't nail the exposure. Luckily, you can override the camera (it thinks it's right; you know it's wrong) by using exposure compensation. You can learn more about how to do this for your particular camera on page 74, but one thing that catches a lot of photographers about exposure compensation is this: it doesn't work if you shoot in manual mode. It only works in modes where the camera is figuring out the exposure automatically (like when you shoot in aperture priority mode, shutter priority mode, or program mode). But, here's where the camera companies "gotcha!": the dial for exposure compensation still moves when you're in manual mode and shows you the minus or plus number, even though it's not actually doing anything. So, you'll be looking in your viewfinder and it says you're at –1 stop or up 2/3 of a stop, but then you take the image and it looks exactly the same. That's what happens in manual mode, so if you shoot in manual and your exposure doesn't look right, exposure compensation won't help. This one's totally on you (in other words, you'll have to adjust your aperture or shutter speed until the image looks right to you. That's why they call it "manual").

Avoid Signs Because They Draw the Eye

If you're like me, and you're worried about things distracting your viewer from the story or subject you want them to see in your photo, keep a sharp eye out for any printed signs or text that might appear in your photos. We're all mentally programmed to read signs, and unless the sign is the subject of your image, your viewers will automatically start reading the sign, instead of looking at your subject. I learned this tip a few years ago from Jay Maisel, and I've seen it play out time and time again, whenever I showed an image with a sign somewhere in it. Even if it was in the background, it seemed that within a split second of me showing the image, the viewer was reading it aloud. So, in short, try to compose your shots so signs or text don't appear in them unless you want them to be the first thing your viewer sees (and reads!).

The "Gotcha" of Using Picture Styles

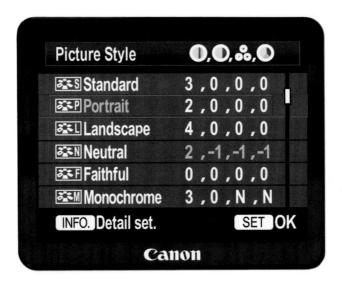

Picture styles, those in-camera color and contrast effects that let you, for example, have more vivid colors for landscapes, or a more neutral look for portraits, or a really vivid look for shooting in cities, etc., have a hidden "gotcha"—they don't get applied to your image if you shoot in RAW format. They only actually affect the image at all if you shoot in JPEG mode. What stinks about this is that, when you're shooting RAW, the preview you see on the LCD on the back of your camera is actually a JPEG preview, so you see the picture style being applied, even though when you open your RAW image in Photoshop or Lightroom, that picture style is long gone. If you shoot Nikon, and you shoot in RAW, but you really, really want to use these picture styles and actually have them applied to the image, you can buy Nikon's Capture NX program, which actually keeps the picture styles intact when you shoot in RAW. It runs about $130, so you have to really, really want to keep those picture styles in a bad, bad way. Of course, if you have Photoshop, Photoshop Elements, or Lightroom, you can use the camera profiles in Camera Raw's or Lightroom's Camera Calibration panel to apply these same picture styles to your RAW file.

Rotate Tall or Rotate Image or Both?

When it comes to rotate settings in your camera, there are actually two different ones that do two entirely different things, and knowing which is which can save you a lot of frustration. Rotate Tall (on Nikons, under the Playback menu) means that when you shoot vertical (tall), the camera will rotate the image on the LCD on the back of your camera (that way, you don't have to turn your camera sideways to see tall images). The other rotate setting is called Rotate Image (under the Setup menu), which means it embeds the orientation of the image right into the file, so when you open the image in Lightroom, or Bridge, or Photo Mechanic, etc., it automatically rotates the thumbnails of tall images so they don't come in sideways and have to all be manually rotated by you. On Canon cameras (like the 50D), go under the Set-up 1 tab, and choose Auto Rotate. If you choose On with an icon of a camera and computer monitor beside it, it rotates the photo both on the LCD on the back of your camera and your thumbnails when you import the photos onto your computer. If, instead, you choose On with just the computer monitor beside it, then it only rotates the image on your computer (your camera will still show it on its side). If you choose Off, it means there's no rotation at all—everything stays on its side, on your LCD and on your computer.

Reducing Noise in Low-Light Shots

If you shoot in low-light situations or at night, it's almost a lock that you're going to have some noise in your image (little red, green, and blue dots—kinda like film grain, but not nearly as endearing). Anyway, we used to have to buy plug-ins to get rid of noise, but in Photoshop CS5's (and higher) Camera Raw or Lightroom 3 (and higher), the noise reduction built right in is so good, we can pretty much skip using noise reduction plug-ins altogether. If you shoot in RAW, it works really brilliantly, because unlike most plug-ins, it removes the noise while the image is still a 16-bit RAW image. If you shot in JPEG mode (so it's already 8-bit), you can open that JPEG in Camera Raw or Lightroom and still use its Noise Reduction, but it's not quite as robust (because now you're kind of using it as a plug-in). To find this noise reduction, open your image in Camera Raw, then click on the Detail icon. In Lightroom, go to the Detail panel in the Develop module. There are five sliders in this section, but we're only going to focus on the two most important ones: Luminance and Color (you can leave the others set at their defaults). The Luminance slider is kind of the overall noise reduction amount slider—the more noise you see, the farther you'll need to drag it to the right, but be careful, if you drag it too far, your image will start to look soft and lose contrast. Without going into too much detail (this isn't a Photoshop book, after all), if you increase either the Luminance or the Color sliders and things start to look too soft, or you lose detail, or the colors look desaturated, that's what the other three sliders are for—to help bring some of those back (the names of those sliders help you figure out which one is which).

What People Looking at Your Photos See First

Knowing what your viewer's eye is going to see first in your photo can really help a lot in planning it out. Basically, the human eye is drawn to the brightest thing in the image, so if your subject is in the foreground, but behind him is a window with bright sunlight, their eye is going to go there first (not generally what you want). So, knowing that, you can recompose or relight the photo to make sure the brightest thing in the photo is precisely where you want your viewers to look. After the brightest thing, next they look for the sharpest, most in-focus thing, so if there's a very shallow depth of field, they lock right onto whatever's in focus (hopefully, your subject). Knowing these two things (where people looking at your photos are going to look first, and then where they'll look next) can really help you in creating photos where your viewer's eye goes right where you want it, by making sure that brighter and sharper areas don't appear somewhere else in your photos.

Keeping Your Camera Info from Prying Eyes

If you're going to be sharing your photos on the Internet, you're going to be sharing a lot more than your photos. That's because your camera embeds a ton of information about your camera gear, including your camera's make and model, the lens you used, your f-stop and shutter speed, and depending on the camera, perhaps the exact location where you took the photo, and even your camera's serial number (this info is called EXIF data or camera data). If you don't want strangers to have all this inside info on your camera and your photos, here's what to do: copy-and-paste your image into a new blank document. That way, it doesn't have any background info at all. To do that: Open your image in Photoshop (or Photoshop Elements) and press Command-A (PC: Ctrl-A) to select the entire image. Now, press Command-C (PC: Ctrl-C) to copy your photo into memory. Go under the File menu and choose New, and click the OK button (don't change any settings—just click OK). Now go under the Edit menu and choose Paste (or press Command-V [PC: Ctrl-V]) to paste your copied photo into the new blank document (and, of course, this new blank document has none of your camera information embedded into it). Lastly, since your image pastes in as a layer, you'll want to flatten your image by pressing Command-E (PC: Ctrl-E), and then save your document in whichever file format you like (I usually save mine as a JPEG with a quality setting of 10). That's it—your secret's safe! :)

Why JPEGs Look Better Than RAW Images

JPEG

RAW

I know what you're thinking, "I've always heard it's better to shoot in RAW!" It may be (more on that in a moment), but I thought you should know why, right out of the camera, JPEG images look better than RAW images. It's because when you shoot in JPEG mode, your camera applies sharpening, contrast, color saturation, and all sorts of little tweaks to create a fully processed, good-looking final image. However, when you switch your camera to shoot in RAW mode, you're telling the camera, "Turn off the sharpening, turn off the contrast, turn off the color saturation, and turn off all those tweaks you do to make the image look really good, and instead just give me the raw, untouched photo and I'll add all those things myself in Photoshop or Lightroom" (or whatever software you choose). So, while RAW files have more data, which is better, the look of the RAW file is not better (it's not as sharp, or vibrant, or contrasty), so it's up to *you* to add all those things in post-processing. Now, if you're pretty good in Photoshop, Lightroom, etc., the good news is you can probably do a better job tweaking your photo than your camera does when it creates a JPEG, so the final result is photos processed just the way you like them (with the amount of sharpening you want added, the amount of color vibrance you want, etc.). If you just read this and thought, "Man, I don't even use Photoshop…" or "I don't really understand Photoshop," then you'll probably get better-looking images by shooting in JPEG and letting the camera do the work. I know this goes against every-thing you've read in online forums full of strangers who sound very convincing, but I'll also bet nobody told you that shooting in RAW strips away all the sharpening, vibrance, and contrast either. Hey, at least now ya know.

When You Don't Need to Shoot on a Tripod

In volume 1 of this book series, I had a whole chapter about how the pros get really sharp images, and one of their secrets is that they're willing to use a tripod when most photographers won't. In fact, they're pretty freaky about it, but that's one reason why their shots are so tack sharp. So, do these pros ever not shoot on a tripod? Yup, and there are two occasions where it's really not that necessary: (1) When you're shooting flash. The super-short duration of your flash of light freezes your subject, so you don't have to worry too much about any movement in your image (which is why you don't often see tripods in the studio). And, (2) when you're shooting outdoors on a bright sunny day. That's because your shutter speed will be so fast (probably around 1/4000 of a second or higher) that you could almost throw your camera in the air while taking a photo and it would still take a sharp shot (although I wouldn't recommend testing that theory).

What to Do If Your Image Isn't Quite Good Enough to Print

If you've taken a shot that you really, really love, and it's maybe not as sharp as you'd like it to be, or maybe you've cropped it and you don't have enough resolution to print it at the size you'd like, I've got a solution for you—print it to canvas. You can absolutely get away with murder when you have your prints done on canvas. With its thick texture and intentionally soft look, it covers a multitude of sins, and images that would look pretty bad as a print on paper, look absolutely wonderful on canvas. It's an incredibly forgiving medium, and most places will print custom sizes of whatever you want, so if you've had to crop the photo to a weird size, that usually doesn't freak them out. Give it a try the next time you have one of those photos that you're worried about, from a sharpness, size, or resolution viewpoint, and I bet you'll be amazed!

When to Switch to Spot Metering

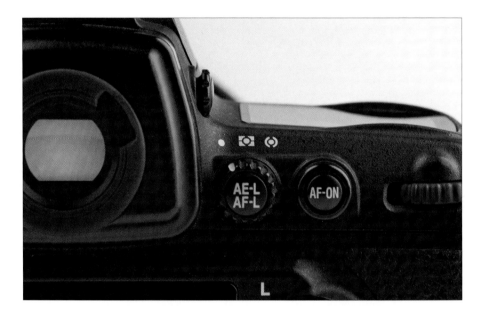

I get a lot of questions about when to switch to Spot metering (a metering mode that measures just one small area of the photo). I can tell you that 99% of the time, I leave my camera set to Matrix (or Evaluative on a Canon) metering (the standard metering mode that does an amazing job of getting you good exposures without having to break a sweat). However, there are times (few though they are) where I need to switch to Spot metering and those are where there's something in the image that I'm worried about being properly exposed. Now, do I worry about something being properly exposed when it's well-lit? Nope. Usually, it's when something that's really important is in bad light—like a shadow area of my photo. So, in short, when there's something in the photo whose exposure needs to be right on the money, I switch to Spot metering just for that shot, and then I switch back to Matrix (or Evaluative), which works wonderfully in 99 out of 100 situations.

Try Cinematic Cropping for a Wide-Screen Look

Last year, I came up with a style of cropping photos that kind of approximates what a wide-screen movie looks like onscreen (which is why I call it "cinematic cropping"). It really gives your image that wide-screen, almost panoramic look, and I find myself using it more and more. Luckily, it's easy to crop like this in either Photoshop, Camera Raw, or Lightroom. We'll start with Photoshop. Step One: Click on the Crop tool, then up in the Options Bar, in the Width and Height fields, for Width, enter 2.39, and for Height, enter 1. That's it. Now when you drag out the Crop tool over your image, it will be constrained to those cinematic crop proportions. In Camera Raw, just click on the Crop tool and, from the pop-up menu that appears, choose Custom Crop. When the dialog appears, from the pop-up menu, choose Ratio, and then type in 2.39 in the first field and 1 in the second. Now your Crop tool will be constrained to the cinematic crop proportions. Lastly, in Lightroom, press R to get the Crop Overlay tool and, from the pop-up menu to the immediate left of the Lock icon, choose Enter Custom. Enter 2.39 in the first field, and 1 in the second field, and click OK. Now your Crop Overlay tool will be constrained to the cinematic crop proportions, so just drag it out over your image and bring the cinematic feel to your images.

Sharpening Your Images for Print

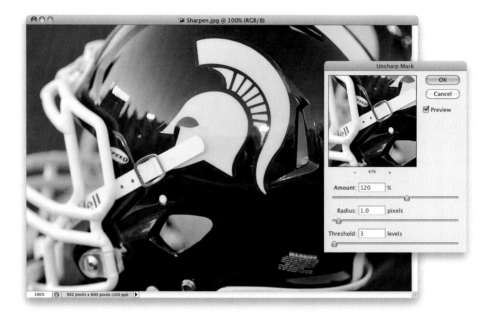

This should really be called "Oversharpening Your Images for Print in Photoshop," because that's pretty much what you do. Here's why: after you get your sharpening so it looks good onscreen, when you print your image, you'll think it looks a little soft and that's because you lose some of the sharpness you see onscreen during the printing process. So, to get around this, we oversharpen our images in Photoshop. Here's what to do: First, get the sharpening so it looks good onscreen (I use Photoshop's Unsharp Mask filter, and if you're looking for a starting place, try these settings: Amount: 120%, Radius: 1, and Threshold: 3). Now, if that looks good onscreen, start slowly dragging the Amount slider to the right, which increases the amount of sharpening, and as soon as you think "Ewwww, that's too sharp..." just stop. Don't backtrack the Amount slider— just stop. Now, I know you're looking at your screen and you're thinking, "This looks a bit too sharp" and if that's what you're thinking, your sharpening is probably right on the money. I know it's hard to print something that looks too sharp onscreen, but you'll have to trust that a little too sharp onscreen means a little just right in print. Also, if you're going to need to use this same image on the web and in print, before you apply this sharpening for print, duplicate the Background layer and apply your sharpening just on that layer (and rename this layer "Sharpened for print," so you'll know it's oversharp-ened). That way, you'll still have the original Background layer that's not oversharpened.

How to Rescue a Damaged Memory Card

Memory cards go bad. It happens. However, it never happens when you took a bunch of experimental photos that really don't matter. They only go bad when you shoot something really important. I believe, on some level, they sense fear. Anyway, if the unthinkable happens (you put your memory card into your card reader, and it appears to be blank when you know it's not), there are downloadable software recovery programs (some of them even free) that do a pretty amazing job, so all is usually not lost. However, if this happens, stop what you're doing, and start your recovery process immediately for the best chance of getting your images back (in other words, don't put the card back in the camera and keep shooting. Don't reformat the card. Don't do anything—just launch your recovery software right away). As for the recovery software itself, I've used SanDisk RescuePro software (you can download a free demo version at www.lc-tech.com/), and it has worked well (even on non-SanDisk cards), but my favorite is Klix, and maybe only because it's rescued the images on every card that's ever died on me (a friend turned me on to it after it saved his hide, too).

Keeping from Accidentally Erasing an Important Memory Card

If your camera uses SD memory cards, there's a small switch on the cards themselves that keeps them from being accidentally erased, or reformatted, or…well…anything. So, if you know you've got a card of shots that you want to protect, just pop the card out, slide the switch to Lock, and you're set.

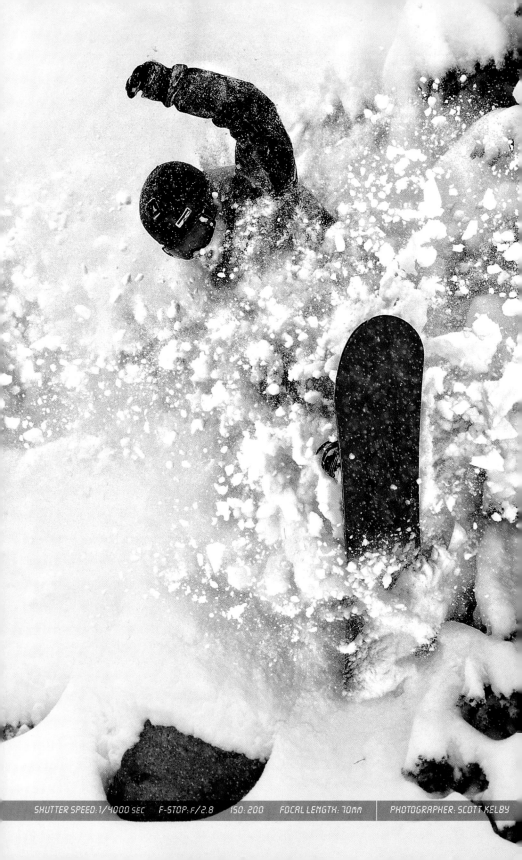

SHUTTER SPEED: 1/4000 SEC F-STOP: F/2.8 ISO: 200 FOCAL LENGTH: 70MM PHOTOGRAPHER: SCOTT KELBY

Chapter Twelve

Yet Even More Photo Recipes to Help You "Get the Shot"

The Simple Ingredients to Make It All Come Together

The most popular chapter in the previous three books in this series has been this chapter—Photo Recipes—and I have to tell you, as an author that really makes me happy, because I always like to add something at the end of my books that takes it up a notch. Kind of the "icing on the cake," or the "crème de la crème," or the "maple syrup on the spaghetti." Anyway, these photo recipes have become so popular that I actually created a DVD/book combo called (wait for it...wait for it...) *Photo Recipes Live: Behind the Scenes*, where I take the same photos I featured in volume 1 of this book series and recreate how to do them live, from scratch, all filmed in a very cool New York City studio. It turned out to be a huge hit, but of course, it would be inappropriate for me to mention that here (or that it's published by Peachpit Press, ISBN: 0-321-70175-5, street price around $30), so I won't mention it or its hugely successful follow-up, *Photo Recipes Live, Part 2: Behind the Scenes* (also published by Peachpit Press, ISBN: 0-321-74971-5, also street-priced around $30). Plugging those would be out of the question, so if you think that for one minute I'm going to mention that both of these have been made available by Peachpit Press (Pearson Education) as downloadable apps for the iPad (where they both only cost $19.99, which is insanely cheap by the way), then man are you way off. You see, I think that using what should be an utterly nonsensical page in the book and turning that into a thinly veiled advertisement for other training products I've produced, and then using that as a springboard to promote my daily blog at www.scottkelby.com, where you can find out when and where I'm teaching the live seminars I do for http://kelbytraining.com/live, well, you're just not going to see that type of stuff from me, because frankly, I deplore it when other authors do stuff like that. Not me, mind you. Just other authors. ;-)

The Recipe for Getting This Type of Shot

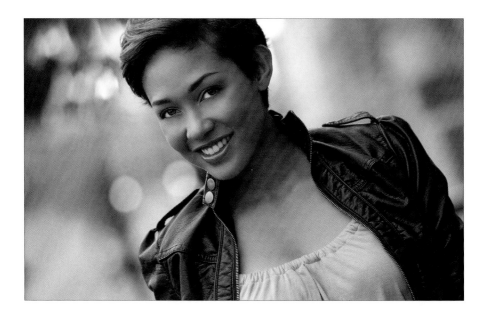

Characteristics of this type of shot: A soft, glamorous look, with the background way out of focus, and a soft-creamy look to the entire image.

(1) For this look, you're going to need a telephoto lens (this was shot with a 70–200mm lens out at around 200mm). By zooming in tight like this, it helps to put the background out of focus, but that alone isn't enough to make the background this out of focus. The other thing you need to do is shoot in aperture priority mode and use the smallest number f-stop you can, like f/2.8 or f/4 (if your lens will let you go that low).

(2) This is actually a natural-light shot, but the reason the light is so beautiful is because it's taken outdoors very late in the afternoon, maybe an hour and a half before sunset. To give the shot a bit more energy, tilt the camera at a 45° angle when you take the shot.

(3) To make the light even softer, have a friend hold up a 1-stop diffuser between your subject and the sun (it's large, round, and basically looks like a reflector, but instead of being silver or gold and reflecting light, it's white and translucent, so it allows some of the sunlight to come through, but spreads and softens it quite a bit). Have them hold the diffuser as close to your subject's head as they can get without it actually being in your frame, and it creates the beautiful, soft, diffused light you see here (the diffuser is above the left side of her head at a 45° angle). These diffusers are collapsible just like a reflector, and they're fairly inexpensive, too.

The Recipe for Getting This Type of Shot

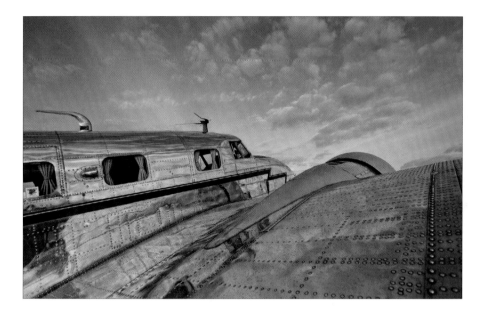

Characteristics of this type of shot: A sweeping wide-angle shot that makes the clouds look like they're arcing out from the center.

(1) You need to use a very-wide-angle lens (the wider the better), so the minimum would be an 18mm, but ideally a little wider, like a 14mm or 12mm. When you go this wide, it really spreads the clouds out, which is part of the effect.

(2) To give the subject that larger-than-life look, get down really low (I was on my knees when I took this shot) and get really close to the subject (I was right at the edge of the wing). This exaggerates the size of your subject when you shoot up close like this with a wide-angle lens.

(3) To get soft light like this on the plane and still have a blue sky, you'll need to shoot this just after sunrise, which means you'll probably be shooting in lower light than you would even an hour later. So, since you're shooting at a slower shutter speed, you'll want to be on a tripod. That way, your image is tack sharp.

(4) Lastly, to make the chrome really pop on this image, I used the Photoshop plug-in Nik Color Efex Pro (download the free demo from www.niksoftware.com), and I used their built-in preset called "Tonal Contrast."

The Recipe for Getting This Type of Shot

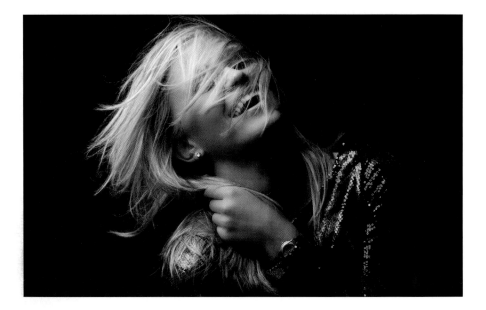

Characteristics of this type of shot: Dark, dramatic lighting that lights your subject's face, but then falls off very quickly (notice how the light falls off to black as it gets near the bottom of the photo, which adds to the drama).

(1) To get this type of shot, you just need one light with a small-to-medium-sized soft-box, up high and aiming straight down at the floor (think of aiming the light like it's a showerhead—tilted down as far as it will tilt on a regular light stand). Keep the power on the light about as low as it will go, since it will be so close to the subject.

(2) Start by positioning the light directly beside your subject, then slide it forward just a foot or two, and then angle it back toward your subject. Since this is only lighting one side of your subject, make sure your subject turns their body toward the light and keeps their chin up a bit, as well.

(3) To add to the drama, either use black seamless paper or position your subject at least 8 to 10 feet from the background, so your main light doesn't spill onto the background (that way, as long as it's dark in the room where you're shooting, the background will still be black). Lastly, to get the "hair in the face" look, have your subject bend over, then give them a cue to snap back up straight and shoot while their hair is still moving. It'll take a few tries to get a good shot, but luckily, the film is free. :)

The Recipe for Getting This Type

Characteristics of this type of shot: A dramatic sunset shot where your subject is lit with a single off-camera flash and the light falls off quickly from their face.

(1) The key to this shot is turning your subject into a silhouette, and then using the flash to do all of the front lighting for them. Position your subject so the setting sun is behind them. To see both your subject and a lot of the rest of the scene, use a wide-angle lens and put your subject off-center to the left or right (but don't get them too close to the edge or they'll distort).

(2) Next, your job is to make the sky much darker than it really is. Start by making sure your flash is turned off, then switch your camera to shutter priority mode (S), and set your shutter speed to $\frac{1}{125}$ of a second. Now, take a photo and look on the LCD on the back of your camera to see what f-stop your camera chose to make a normal exposure of the photo (let's say it reads f/5.6). Switch to manual mode (M), set your shutter speed to $\frac{1}{125}$ of a second, then enter an f-stop that is at least 2 stops darker than what it just read (so, if you were at f/5.6, try f/10 or f/11). This makes the sky *much* darker than it would be.

(3) Take another test shot, and now your subject should be a solid black silhouette against the setting sun. Turn your flash on and keep your flash power *way* down low (you only need a little bit of light), and take your shot. Also, either put an orange gel in front of your flash or change your White Balance to Cloudy.

The Recipe for Getting This Type of Shot

Characteristics of this type of shot: A "beauty style" shot with soft, bright light that limits the amount of shadows on the face.

(1) There are just two lights on the subject: the main light is a beauty dish that's directly in front of the subject, but up about two feet above her face, aiming down at her at a 45° angle. The other light is a large softbox (although the size doesn't really matter), aiming up at her at a 45° angle. Position the camera height right at her eye level.

(2) To keep everything in focus, from front to back, you'll need to use an f-stop that holds details (like f/11) and a long enough lens (like a 200mm) to give nice perspective.

(3) To make the background pure white, you'll need to aim a single strobe at it. It can be a bare bulb with a reflector (well, that's what I used anyway), and put it about 4 feet from the background, down low on a light stand, aiming upward at the background.

(4) If you don't have three lights, then use a reflector panel for the bottom light instead— just have your subject hold it flat at their chest level, as high as possible without being seen in the frame.

The Recipe for Getting This Type of Shot

Characteristics of this type of shot: An action sports shot with the motion frozen, a larger-than-life perspective, and with a popular sports special effect to finish it off.

(1) The key to this shot is getting a low perspective with a wide-angle lens, like a 14mm or 12mm lens, and then literally lying on the ground, shooting up at the subject (in this case, a snowboarder).

(2) This was taken in the middle of the day, in direct sunlight, in aperture priority mode, at f/2.8, and at that wide-open an f-stop, you get around ¼₀₀₀ of a second, which is more than enough to freeze the athlete in mid-air (you only need around ¹⁄₁₀₀₀ of a second or so to freeze action). Because your shutter speed is so fast, you can hand-hold a shot like this, no problem (plus, it would be really hard to pan along with the snow-boarder if you were on a tripod).

(3) To get that "blown-out" special effect look, you can use one of the built-in presets in the Photoshop plug-in Nik Color Efex Pro from www.niksoftware.com (you can download a fully working demo version from their site). The particular preset I used here is called "Bleach Bypass" and it replicates a popular traditional darkroom effect.

The Recipe for Getting This Type of Shot

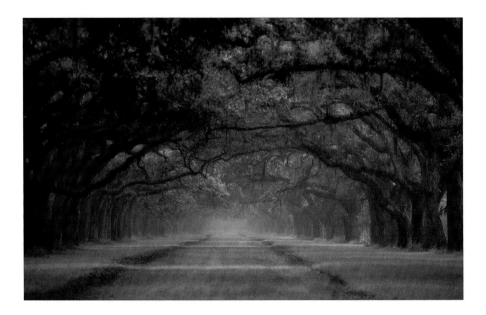

Characteristics of this type of shot: A soft, misty landscape with lots of depth and dimension.

(1) To get a shot like this, you have to either get up early and be in position before dawn (that's when this shot was taken) or shoot it late in the day, right around sunset. The foggy mist you see is a big part of landscape photography—it's called luck. You can increase your luck by visiting the same location more than once. This was taken the second day of shooting in the exact same location—the previous day had no mist whatsoever.

(2) This is shot in fairly low light (maybe 30 minutes after sunrise), so you'll need to be on a tripod to keep your camera still enough for a really sharp shot. You'll also need to use a cable release, so you don't introduce even a tiny bit of vibration by touching the camera when you press the shutter button. Also, shooting from a low perspective gives the shot its "bigness," so put your tripod down so low you have to shoot on your knees.

(3) To have detail throughout the image, I recommend shooting at f/22, an ideal f-stop for telling a big sweeping story. Also, to add visual interest, don't put the road in the dead center of the photo (because that's dead boring—notice how it's cheated over to the left a bit?) and don't put your horizon line in the middle of the photo, because that's what your average person would do, and you don't want your images to look average.

The Recipe for Getting This Type of Shot

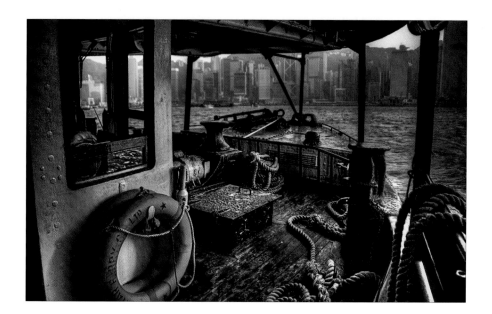

Characteristics of this type of shot: A dark, gritty, tone-mapped HDR shot taken on a moving boat.

(1) Part of the art of shooting any HDR photo is finding an image that makes a good HDR image. Anything with a wide range of brightness (the dark interior of the boat, versus the bright outdoors), along with features that have a lot of texture (note the wood floor, rope, the old metal on the boat, the life preserver, and the rusty boat parts that just scream, "Make me an HDR shot!"), generally works well.

(2) Because the boat is moving, you're going to need to steady yourself by leaning on a pole or a railing. You're going to need at least three bracketed frames to create a shot like this (see page 137)—one normal exposure, one that's 2 stops darker, and one that's 2 stops brighter. Because the boat is moving, you're going to need to shoot this same exact scene over and over, and hope that you have one set of shots where all three (or five) shots are in focus. Every set won't be, but just remember, you only need one. Don't be afraid to raise the ISO a little to get a faster shutter speed.

(3) Once you've got a set in focus, you'll need to combine those bracketed photos into one single HDR image using either Photoshop CS5's built-in HDR Pro or a Photoshop HDR plug-in (see page 147) and add the tone mapping that gives it that "HDR'd" look.

The Recipe for Getting This Type of Shot

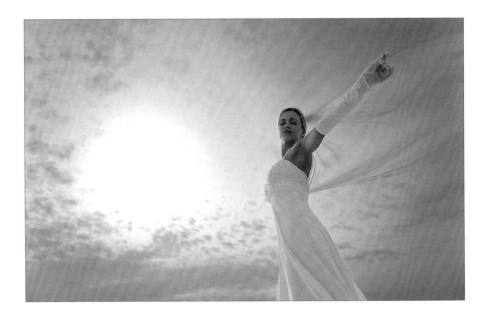

Characteristics of this type of shot: A bright, sunny shot with the sun clearly visible, but your subject isn't lost in the shadows.

(1) This is a very easy shot to pull off—you just need a simple pop-up reflector. Position your subject so the sun is behind them or to the side (in this case, it's beside her, but when she faces the camera, she's fully in shadows. That's what the reflector panel is for—to bounce some of that sunlight back into your subject's face). The reflector should be to the left of you, held up high over the head of a friend or assistant and angled toward your subject.

(2) This was taken on a beach, but the beach wasn't very pretty at all, with lots of vegetation right at the shoreline. So, the trick is to get down low, very low—lying down, in fact—and shoot upward at your subject with a wide-angle lens. Make sure you put your subject to one side or the other—don't center her.

(3) This is going to sound silly, but if you're shooting outdoors, buy a long veil. You'll thank me, because if any tiny bit of wind comes along, it does beautiful things all by itself. If there is no wind, create your own using a second reflector panel—literally have a second friend (or assistant, or passerby) fan your subject with that large reflector. It doesn't take much to make that veil take flight, and it creates a beautiful look.

The Recipe for Getting This Type of Shot

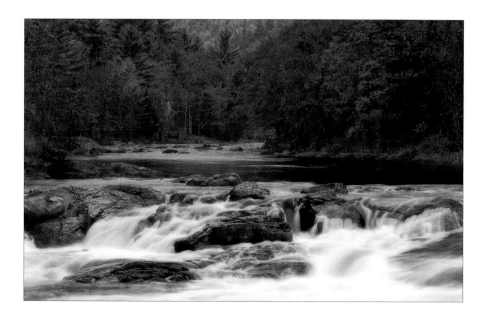

Characteristics of this type of shot: A soft-light landscape with smooth, silky water and lots of depth and dimension.

(1) To get soft light like this, you need to shoot about 30 minutes before sunset, or during a very overcast day (or, ideally, both). Here's why: you're going to need to use a slow shutter speed to make that water smooth and silky, so an f-stop like f/22 or even f/32 (if your lens will go that high) would be great.

(2) Because you're using a slow shutter speed (shoot this in aperture priority mode—set your f-stop to f/22 and your camera will pick a slow shutter speed), of course you're going to need to be shooting on a tripod, and I would recommend a cable release, as well. If you have a neutral density filter (an ND filter; see page 90), you can put it on your lens to darken the scene and make your shutter speed even longer (for a scene like this, just a 2- or 3-stop ND would do it). If you don't have an ND filter, just put a polarizer on your lens—it will darken the scene and slow things down, as well.

(3) The compositional key here is to make the rocks in the photo the stars of the show. Make them the subject and compose the scene, so they're right down in front. The way to shoot this, without risking life and gear by getting right in front of the stream, is to shoot it safely from the shore with a telephoto lens and close in tight on the rocks.

The Recipe for Getting This Type of Shot

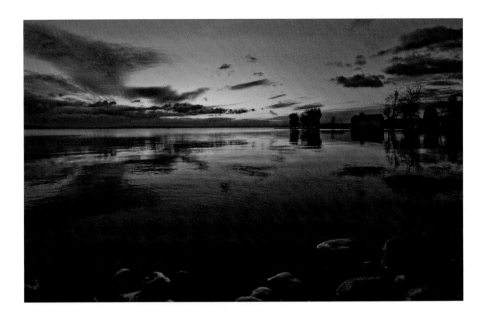

Characteristics of this type of shot: A sweeping landscape scene with a clear foreground, middle ground, and background.

(1) As you can tell, this is going to be a sunset or dawn shoot (pretty standard for great landscape photography), but the key to this shot is the composition. What makes a shot like this work is those rocks in the foreground of the shot. Without those rocks, it's just another shot of a lake. You need those rocks to anchor the shot with a foreground, so your shot has that depth that only happens when you have all three things in place: a foreground (the rocks), the middle ground (the lake, the trees to the right of center, and the boat house), and then the clouds in the background.

(2) Dawn or dusk shots like these always need to be shot on a tripod with a cable release to limit any vibration, so everything is tack sharp. To get those rocks in the shot, you need a very-wide-angle lens, like a 12mm or 14mm ideally (although an 18mm would still work), and you have to splay your tripod legs out and get down really low to capture those rocks at that low perspective. The best thing to do is sit on the rocks and get that tripod as low as it can go. Yes, it makes that big a difference.

(3) To keep everything in focus, from front to back, use an f-stop like f/22, which is perfect for these types of shots. Now, keep your fingers crossed for a cloudy morning.

The Recipe for Getting This Type of Shot

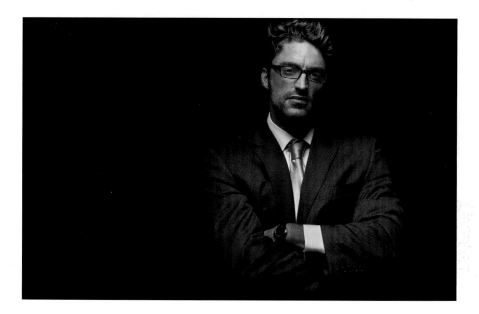

Characteristics of this type of shot: A dramatic corporate portrait with an editorial cover-shot look to it, with a fast falloff of light, where the subject's face is lit, but then it falls off to dark very quickly.

(1) This is an amazingly simple, one-light shoot. The light is a studio strobe with a beauty dish that's about 1 foot directly in front of the subject, but up about 2 feet above his head, aiming back at him at a 45° angle. That's it.

(2) Because this is supposed to be a dramatic portrait, you don't want to kill him with light, so keep the power of your strobe just about all the way down (if you're using a hot shoe flash instead, switch the flash to Manual mode and use ¼ power, and then see if it needs to be a tad brighter or if that's okay).

(3) Your subject isn't moving, and you're using flash, so you don't have to shoot this on a tripod. I would recommend shooting in manual mode. For your starting place settings, try f/11, so everything is perfectly in focus, and set your shutter speed to 1⁄125 of a second (that way, you don't have any sync speed issues). Lastly, move your camera's focus point directly onto his eye (the one closest to the camera), press-and-hold your shutter button halfway down to lock the focus, and keep it held down. Now, compose the shot the way you want (here, I put him way over to the right) and take the shot.

The Recipe for Getting This Type of Shot

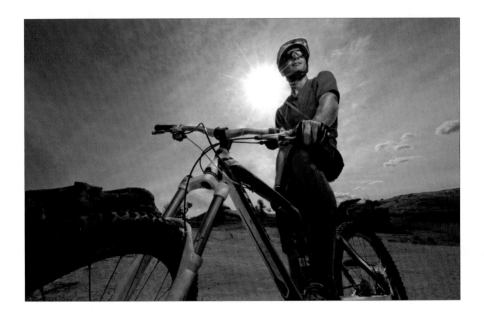

Characteristics of this type of shot: A location shoot with hot shoe flash, taken in bright, harsh mid-day sun.

(1) When shooting in the mid-day sun, the first thing to do is place the sun behind your subject (as seen here). At this point, your job is to make the sky behind your subject darker than it really is. To do that, start by turning your flash off. Then, switch to shutter priority mode, set your shutter speed to ½₅₀ of a second, and take a shot. Now, look at the photo on the back of your camera and make note of the f-stop your camera chose at that shutter speed.

(2) Switch to manual mode, enter ½₅₀ of a second for your shutter speed, then enter an f-stop that's 2 stops darker than what your camera chose in the previous shot (your flash is still turned off at this point). Let's say your f-stop was f/8. You'll need to change it to f/11 or f/13. Now, take another shot. The sky should be darker and your subject should be a backlit silhouette.

(3) Turn on your hot shoe flash and crank it up to full power. Make sure your flash has something in front of it to soften the light from it (a small softbox, a shoot-through umbrella, etc.). Move that flash in close to your subject (just outside your frame), then get down low on one knee with a wide-angle lens, and take a test shot. If the flash is too bright, lower the power and try again, until the light looks natural.

The Recipe for Getting This Type of Shot

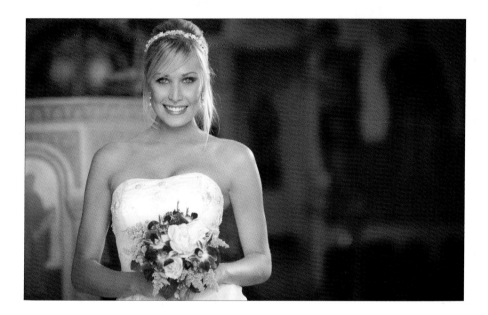

Characteristics of this type of shot: A mixture of natural light and a strobe create dimension and a feeling that the shot is all natural light.

(1) This is one you can try in the doorway of a church, but make sure the doors are pulled back enough so that you don't see them (this was a double-door opening here). Ideally, you'd want to find a door that is not facing directly into the sun, and then place your bride just inside the door, as seen here. Since there's no harsh light falling directly on her, the light is soft (like window light), but at the same time, it's kind of flat, which is why we want to add a strobe on one side to add dimension.

(2) The strobe, with a square 27" softbox, is just off the right side of the photo and behind the bride at a 45° angle, and it adds just enough light to make it look like natural light streaming in through a window.

(3) The strobe is running off a battery pack (it's often hard to find convenient power outlets in a church), is connected to a monopod (held by a friend), and is up higher than the bride, aiming down at an angle, like the sun would aim. To get the background out of focus, shoot at an f-stop like f/2.8 or f/4, if possible (use the lowest number you can). We generally shoot strobes in manual mode and, to make sure the strobe stays in sync with your camera, set your shutter speed at $\frac{1}{125}$ of a second.

The Recipe for Getting This Type of Shot

Characteristics of this type of shot: An HDR shot taken inside a dimly lit church, aiming straight up to capture the detail in the ceiling.

(1) This is trickier than it looks because: (a) most buildings that have a ceiling you actually want to shoot won't let you use a tripod; and (b) even if you could use a tripod, it's not easy to set one up with your camera aiming straight up (in fact, for many, it's impossible), so this is one indoor HDR shot you often have to hand-hold.

(2) Hand-holding in a dark church means you're going to need to raise the ISO quite a bit, or one or more of your frames is going to be blurry. Also, you won't be able to shoot at f/8 when it's kind of dark like this, so use the lowest number f-stop you can (in this case, it was f/3.5).

(3) To get this sweeping of an expanse, this was shot with a 10.5mm fisheye lens, but you could get almost as much from a 12mm or 14mm lens. The problem isn't how wide the lens is; the problem is keeping it still while you're taking the shot.

(4) You can get step-by-step details in Chapter 9, but set up your camera to shoot in burst mode and then turn on Exposure Bracketing. Gently press-and-hold the shutter button and hold as still as you can until all three (or five) exposures are complete. If there's anything to lean against to help steady yourself, that will make a big difference. To get the HDR look, you'll need to compile the bracketed frames into one single image (see page 147) and then finish them off in Photoshop or Photoshop Elements.

The Recipe for Getting This Type of Shot

Characteristics of this type of shot: Still, glassy water and a sweeping landscape.

(1) The key to this type of shot is to shoot it at dawn or just after dawn, because that's the most likely time to find glassy water with reflections like this. Literally an hour or so later, and in many cases, you will have missed your chance as the winds pick up and the water gets choppy. (*Note:* In this location, the water was only still right around dawn—by 10:00 a.m., it was so choppy you wouldn't want to shoot it even if the light was good.)

(2) Of course, in the low light of dawn, you'll need to be shooting on a tripod, using a cable release to minimize vibration, and you'd shoot at f/22 to take it all in.

(3) Besides the still, glassy water, what makes this shot is the lone red canoe off to the left. It helps to make up for the fact that there's nothing at the bottom of the frame to act as a foreground element. The red pulls your eye and gives the shot some visual interest, but it's still not as strong as a foreground element. Your job when composing a shot like this is to position your composition so the canoe appears in an interesting place in the photo (like off to the left). I could have just as easily walked to the left a bit and put that canoe right in the center of my image, which would have made it too obvious and drained all the energy out of the composition with its placement.

The Recipe for Getting This Type of Shot

Characteristics of this type of shot: The shadowless look of a ring light without the dark shadow glows and overly punchy light.

(1) If you want all the good stuff of the ring-light look (bright, fashion-looking lighting) without the halo shadows and super-punchy, not particularly flattering light, just position a very large softbox directly in front of your subject, aiming straight back at them (don't tilt it—it should be flat, straight up and down).

(2) Position your subject in front of a white seamless paper background (the light from the front light will light the white seamless since it's aiming directly at it, so don't position your subject any farther than about 4 to 6 feet in front of the softbox).

(3) Now, you are actually going to stand in front of that large softbox (one reason why it needs to be large), and then squat down a little so you are at your subject's eye level and the only part of you that is sticking up in front of the softbox is your head.

(4) Shoot in manual mode and use f/8 or f/11, so everything is perfectly in focus, and set your shutter speed to $\frac{1}{125}$ of a second. Aim your focus point at the eye closest to the camera, then press-and-hold your shutter button halfway down to lock the focus. Now, compose the shot the way you want and shoot. Start with your strobe at $\frac{1}{2}$ power and see if that's bright enough. If not, crank it up a bit until it looks like what you see above. I also added the Bleach Bypass filter in Nik Software's Color Efex Pro to finish it off.

The Recipe for Getting This Type of Shot

Characteristics of this type of shot: On-location flash, with just a hint of light.

(1) The key to this shot is how you position the flash. Mount your flash on a light stand and use a small softbox (or shoot-through umbrella, but I really think you get much better, more concentrated results from a small softbox like a Lastolite EzyBox).

(2) You want to position the light up higher than your subject, aiming down, so it's aimed at your subject's face, but the angle is such that the light then falls on the ground and doesn't spill too much on the background, so the rest of the scene falls to black. To keep from having the ground too bright, you're going to pull a trick that is half a camera trick, and half a Photoshop trick (like I mentioned in Chapter 2).

(3) Set your camera to continuous shooting (or burst) mode (you'll need to press-and-hold the shutter button until your camera takes two rapid-fire shots). The flash will fire with the first shot, but won't have time to recycle for the second shot, which is great, because you need one that shows the ground below your subject without flash. Open both photos in Photoshop. Get the Move tool, press-and-hold the Shift key, and drag the shot without flash on top of the one with flash. Option-click (PC: Alt-click) on the Add Layer Mask icon at the bottom of the Layers panel to hide the one without flash behind a black mask. Take the Brush tool, set your Foreground color to white, choose a medium-sized, soft-edged brush, and paint over the ground to bring the ground without the flash back in, for a very natural-light look.

Index

Perfect your photography from shoot to finish.

Adobe® Photoshop® Lightroom® 4 software lets you perfect your images, organize all your photographs, and share your vision — all with one fast, intuitive application.*

- **Get everything you need beyond the camera:** Organize, perfect, and share — Lightroom combines all your digital photography tools in one fast, efficient application. Use powerful yet simple automatic adjustments or take detailed control of every feature, from editing to sharing.

- **Get the best from every image:** Get the highest possible quality from every pixel in your images, whether you shot them with a pro DSLR camera or a camera phone. Lightroom includes a comprehensive set of state-of-the-art tools for tone, contrast, color, noise reduction, and much more.

- **Share effortlessly:** Craft elegant photo books and easily share your photographs on social networks or in web galleries, slide shows, prints, and more. Lightroom includes efficient tools to showcase your work for friends, family, and clients.*

Get your FREE 30-day trial at www.adobe.com/go/lr_books

"It's like having your own personal instructor."

Learn Online with the Pros™

Become part of the action as we take you behind the scenes of professional photo shoots and show you exactly how the pros do it, step-by-step, from start to finish. They share their gear, setup, settings, and tips and tricks that took them decades to master.

Learn lighting and flash with Scott Kelby and Joe McNally. Learn to shoot wedding portraits with legendary wedding photographers David Ziser and Cliff Mautner. Learn the pro's secrets to creating jaw-dropping Photoshop® effects for fashion photography with Frank Doorhof, or study composition, light, and compositing with Jeremy Cowart, and so much more!

UNLIMITED ACCESS
$199 PER YEAR OR **$24⁹⁵** PER MONTH

100 GUARANTEE

Visit Kelbytraining.com to subscribe or for more info.

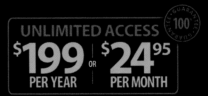

Kelbytraining.com™
EDUCATION FOR CREATIVES

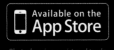

See the video at
Kelbytraining.com/trailer